MAR ... 2004

THE AUTOBIOGRAPHY OF SURREALISM

THE DOCUMENTS OF 20TH-CENTURY ART

ROBERT MOTHERWELL, *General Editor*

BERNARD KARPEL, *Documentary Editor*

ARTHUR A. COHEN, *Managing Editor*

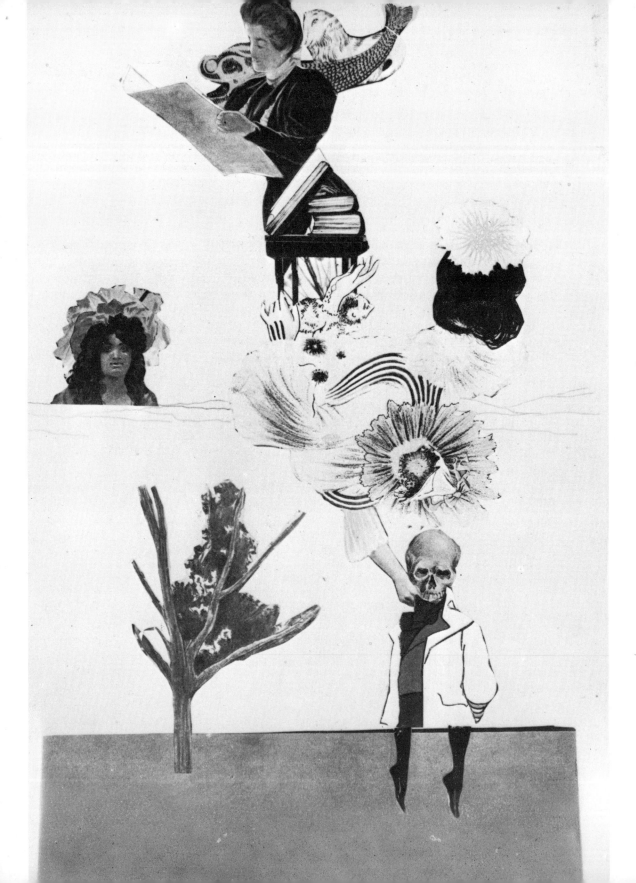

THE AUTOBIOGRAPHY OF SURREALISM

EDITED BY **Marcel Jean**

THE VIKING PRESS NEW YORK

First published in 1980 by The Viking Press
625 Madison Avenue, New York, N.Y. 10022

Published simultaneously in Canada by
Penguin Books Canada Limited

Library of Congress Cataloging in Publication Data
Main entry under title:
The Autobiography of surrealism.
(The Documents of 20th-century art)
Bibliography: p.
Includes index.
1. Surrealism —Addresses, essays, lectures.
2. Arts, Modern —20th century —Addresses, essays,
lectures. I. Jean, Marcel. II. Series.
NX600.S9A95 700'.9'04 76-46637
ISBN 0-670-14235-2

Printed in the United States of America

Acknowledgments:

Association pour la Diffusion des Arts Graphiques
et Plastiques: "Aphorisms" (varied sources) and
"May Day" by Francis Picabia (*Littérature*, No. 14,
June 1920).

Black Sparrow Press: "Psychological Novelette,"
Copyright © 1974 by Edouard Roditi, and included
in *Emperor of Midnight*. Published by Black
Sparrow Press, P.O. Box 3993, Santa Barbara,
CA 93105.

Cahiers d'art: Extract by Hans Bellmer, "Flying
Hearts" by Gabrielle Buffet-Picabia, "28th Novem-
ber XXXV" by Pablo Picasso, "29th March XXXVI"
by Pablo Picasso (*Cahiers d'art*, special issue,
May 1936).

Calder and Boyars Ltd: From "The Nerve Scale"
by Antonin Artaud.

Editions Gallimard: Extract from *Le Paysan de
Paris* by Louis Aragon, Copyright 1926; "Love"
by Jacques Baron; "Giorgio de Chirico," "Max
Ernst," "Francis Picabia," "Marcel Duchamp,"
"Entrance of the Mediums," "The Disdainful Con-
fession" by André Breton, Copyright 1924 by
Editions Gallimard from *The Wandering Steps* by
André Breton; "Burial Not Allowed," "Self-
Defense," "Preface to Max Ernst's 'La Femme 100
Têtes'," "Love's Boat Has Been Shattered against
Everyday Life," "Introduction to a Speech on the
Lack of Reality" by André Breton, Copyright
1934 by Editions Gallimard from *Point du Jour*
by André Breton; "Le Corset Mystère," "Black
Forest," "Free Union," "Writings Are Leaving,"
"The Air of Water," "The White-Haired Revolver"
by André Breton, Copyright 1949 by Editions
Gallimard from *Poèmes* by André Breton; *The
Communicating Vessels* by André Breton, Copy-
right Editions Gallimard; *The Magnetic Fields*
by André Breton and Philippe Soupault, Copyright
© 1968 by Editions Gallimard; extract from *Plastic
Sense* by Malcolm de Chazal, Copyright 1948 by
Editions Gallimard; "Penalties of Hell," "Erotic
Puns," "Mourning for Mourning" by Robert Desnos,
Copyright 1962 by Editions Gallimard from *Deuil
pour Deuil* by Robert Desnos; "Cow," "The Art
of Dancing," "Worker," "Feasts," "Max Ernst,"
"Poem," "The Lautréamont Case," "The Gertrude
Hoffman Girls," "The Queen of Diamonds," "Love
Poetry," "Giorgio de Chirico," "Paul Klee," "Yves
Tanguy," "Holly Twelve Roses," "Critique of
Poetry," "Review," "Golden Mean" by Paul Eluard,
Copyright Editions Gallimard; "Arp," "La Femme
100 Têtes," "Danger of Pollution," "Inspiration to
Order," "The Mysteries of the Forest," "Some Data
on the Youth of M.E. as told by Himself" by
Max Ernst, Copyright Editions Gallimard; "Hunting
the Whale," "Household Souvenirs," "The Message,"
"For You My Love" by Jacques Prévert, Copyright
1949 by Editions Gallimard; "Poison" by Roger
Vitrac, Copyright 1964 by Editions Gallimard from
Theatre III by Roger Vitrac.

Editions Seghers: Extracts from *The Immaculate
Conception* by André Breton and Paul Eluard.

Farrar, Straus & Giroux, Inc.: "Address to the
Pope" by Antonin Artaud.

Grossman Publishers: "Ode to Charles Fourier" by
André Breton.

Page 472 constitutes an extension of the copyright page.

Originally conceived as an anthology of writings by surrealist painters, the present collection begins with notes written by Giorgio de Chirico even before the surrealist notion took shape. As early as 1911-14, the Italian painter stressed the importance of surprise, forebodings, enigmas in the birth of a picture, and explained how a work of art might reveal itself to its author. These prophetic remarks, which were linked to the idea of "automatism," became one of the fundamentals of surrealism.

Surrealism had other sources as well, and as it developed, there was a deepening or an evolution of its first principles, which were never dogmas but rather living concepts. In the process of dealing with such a movement and with such ideas, we felt that merely to present excerpts from texts, without suggesting their atmosphere, the intellectual environment that surrounded their birth, would be unlikely to lead to full comprehension. This is why our anthology of painters' writings has taken the broader and, we believe, more significant shape of a general anthology, of an anthological history of written surrealism—a kind of complement to our *History of Surrealist Painting*, first published in 1959[1]—bringing new historical data to the documentary knowledge of surrealism, since no comprehensive anthology of the movement exists to this day, and since a certain number of the pieces we have included have never before been reprinted and remain virtually unknown.[2] In short, our book has become the autobiography of surrealism, the participants themselves recounting the life and history of their own creation.

The first part of this book is devoted to "ancestors," to the writers who stand as landmarks along the roads that the surrealists later followed and explored. They do not appear here in chronological order, for they did not come to the attention of the surrealists according to their birth dates. And we did not try to establish any successive order or gradual process of "influences": poetic creation rarely shows traces of

[1] With the collaboration of Arpád Mezei; Paris: Editions du Seuil. English-language edition: London: Weidenfeld & Nicolson; New York: Grove Press, 1960. Trans. Simon Watson Taylor.

[2] The French edition of the present work was published in 1978 by Editions du Seuil, Paris.

a rigorous heredity, and genealogical trees in this field are, as a rule, highly arbitrary. When it plays a part in creation, memory has no chronology, and we followed memory in our survey of precursors, from Chirico to Arthur Rimbaud and his "Lettre du voyant" (Letter of the Seer), to Guillaume Apollinaire, who "discovered" Chirico (and invented the word "surrealism"), to Alfred Jarry and one of his first enthusiasts, Jacques Vaché, to Pierre Reverdy and his theory of the image, closing the pageant with Lautréamont as the greatest of surrealist poets.

We might have given excerpts from other predecessors[3] and productions in which typical surrealistic components were present: fantastic settings, mysteries and plots, emotions and violence, love and revolt, such as the black novels of Horace Walpole, Ann Radcliffe, "Monk" Lewis, Charles Maturin. We could also have quoted several masters of humor: Jonathan Swift, Edward Lear, Lewis Carroll.[4] But these authors with whom surrealists had close intellectual kinship are easily accessible to the English-reading public, as are a number of the German romantics and humorists, such as Novalis, Achim von Arnim, and Georg Christoph Lichtenberg.

Other resurgences of the past appear in our work. Stéphane Mallarmé's short tale "Le Démon de l'Analogie" (The Demon of Analogy) is quoted in a chapter on the review *Minotaure,* along with André Breton's article "Le Message auto-matique" (The Automatic Message), which appeared in that same review. Likewise, a "Pensée" (Thought) by the Marquis de Sade is included in pages dealing with the years when interest in the marquis's life and writings was growing, thanks to Maurice Heine's research and the discoveries this writer published in the review *Le Surréalisme au service de la révolution.* As for Raymond Roussel, the mechanism of his "delirium of imagination" was not understood until after his death, when his *Comment j'ai écrit certains de mes livres* (How I Wrote Some of My Books) was published in 1935. The chapter on Roussel is therefore placed in the section dealing with the period of the early 1930s.

The greater part of our anthology is naturally devoted to the writings by the surrealists themselves. Through books, reviews, magazines, leaflets, and manifestoes, the stages of surrealism can be followed from its beginning in predada days to the present time. The connecting notes between quotations are intended to establish a historical context and to summarize unquoted passages.

The texts from surrealist reviews will, we hope, re-create the atmosphere in which the movement evolved. The appearance and disappearance of contributors, the character of their works, allusions to contemporary events, reports on collective endeavors, and so on may shape an image of surrealism more complete and more

[3] See the quotations from Breton's "Manifeste du Surréalisme," pp. 123-24.

[4] In his *Anthologie de l'humour noir,* André Breton collected excerpts of a number of writers of "black humor."

faithful to its essential nature than a collection restricted to poems and theoretical texts.

This movement, which lasted more than thirty years, encompassed many human activities and gave birth to a considerable literature, not to mention innumerable productions in the domain of the visual arts. It drew together contributors from all over the world — poets, painters, critics, essayists, scholars, and politicians — whose resonances have by no means subsided even today. Such an intellectual adventure cannot be shown in all its aspects in a selective work, and from this enormous mass of material, we have been obliged to omit several fascinating pieces. Choice, being personal, is tainted with partiality and is therefore open to criticism. We do not doubt that another anthology on the same subject would show a different collection of texts. Nevertheless, in the present book most, if not all, of the important works are included and at the same time some lesser-known pieces, either by the principal authors, or by those who followed the surrealist enterprise for an appreciable length of time, or by influential sympathizers whose contributions could not, we felt, be neglected.

The first surrealist group outside France was formed in Belgium and it remained the most active and productive one, largely because of a common language: born and developed in Paris, surrealism was French-speaking at the start. In the early 1930s a number of foreign groups became active — in Central Europe and the Balkans, Yugoslavia, Czechoslovakia, Rumania, and the Scandinavian countries — and from 1935 onwards a very lively circle gathered adepts in England among poets and painters. Several groups were formed in Latin America, where some remarkable poets kept alive the surrealist spirit. In the United States dealers and collectors became interested in surrealist art early, but creative groups did not come into being until the Paris "exiles" came to New York during World War II.

We have quoted texts by René Magritte and Paul Nougé of the Belgian group and several pieces by the English surrealists of 1936-39, and we have reported in detail the activities of the circle around André Breton in New York. But to expand the scope of our survey further from the mainstream would have resulted in a book of excessive length and, perhaps, of diluted interest. Moreover, little of the surrealist literature published in continental Europe outside France and in Latin America has been translated, and the original works are not easy to procure. To prepare English versions of a literature written in at least five different languages would have posed a number of problems, and translation itself is a problem about which a few words must be said.

We intended at first to reproduce in this book existing translations from the French. Several are excellent, although some of them became available too late to be included in this work. Others contained incredible errors that might not have been noticed by a reader not acquainted with the originals, for they are often written in an

easy, in some cases even brilliant, style in English. Still, one can hardly avoid dismay when faced with a translation in which a *pêcheuse* is a "sinning woman" and not, as she should be, a "fisherwoman," where the conjunction *or* ("now") turns into the substantive "gold," where a *plume métallique* (a "writing pen") changes into a "metallic feather," or where *cependant* ("meanwhile") becomes "however." And so on. The fact that the same phenomenon occurs commonly in French translations of English or American poets is, naturally, of no comfort. We must especially denounce the treatment inflicted on Lautréamont by two *traditori*, Guy Wernham in America[5] and Alexis Lykiard in England.[6] These two gentlemen, each in his own disastrous manner, have bungled *Les Chants de Maldoror* (The Lay of Maldoror) to such a degree that their versions destroy the atmosphere and the very contents of the book. Furthermore, Wernham's attempt at translating Lautréamont's collection of aphorisms, *Poésies*, shows that he obviously did not understand the original text. The result is that the works of Lautréamont are, until further notice, unknown to the English-reading public.[7]

We have reproduced, on the other hand, excerpts from Barbara Wright's remarkable English equivalent of Alfred Jarry's *Ubu Roi;* from the masterful version, by Kenneth White, of Breton's "Ode à Charles Fourier"; from Samuel Beckett's translation of René Crevel's *Le Clavecin de Diderot* (Diderot's Harpsichord); from George Reavey's translation of Picasso's automatic poems; etc. However, in order to spare ourselves long and, to say the least, disappointing research, we have translated the greater part of our material ourselves; thus we felt sure that the originals would at least be understood. To ensure that our versions would be accurate in grammar and syntax, we asked an American friend, Haskell M. Block, professor of comparative literature at The State University of New York at Binghamton, to examine them, and we owe our warmest thanks to him for his kind and constant attention and his useful and instructive help. Our thanks also to Barbara Burn of The Viking Press and Phyllis Freeman for a further revision of the text and translation.

The tendency toward centralization is a salient feature of French life: Paris remains

[5] New York: New Directions, 1945 and 1965.

[6] London: Allison and Busby, 1970; New York: Thomas Y. Crowell, 1973.

[7] We expressed at length our views on translations of Lautréamont in an article, "Maldoror's English Tailors," in the lively little magazine *Transforma(c)tion* (no. 6, 1973) that John Lyle, bookseller specializing in surrealism, publishes at intervals at Harpford, Sidmouth (Devon). In our book, the translations of *Les Chants de Maldoror* are by the late poet John Rodker, who rendered admirably the very "chant" of the French model. Privately printed in 1924, Rodker's *Lay of Maldoror* is now unobtainable. Good fragmentary translations of the *Chants* appeared in Paul Zweig's *Lautréamont, the Violent Narcissus* (Port Washington, N.Y.: National University Publications, Kennikat Press, 1972).

the ruling brain that creates or endorses, in every field of activity, the final decisions and the main productions of the country. Especially in intellectual matters, there is no center in France other than Paris. Inside that center the surrealist group was a further concentration, a sort of exclusive society with an almost autonomous life. Foreign surrealist groups were born as branches of the founding circle and were considered legitimate insofar as they kept contact and worked in accord with Paris. Generally speaking, when surrealists attended meetings (literary or political), they did so as surrealists rather than as individuals; they seldom contributed to reviews and exhibitions other than their own. When artists or poets ceased taking part for some reason, the epithet "surrealist" no longer applied to them or to their subsequent works. Although this attitude did not result from any written or oral rule, it was accepted by friends and foes and certainly helped to maintain the impetus and energy of surrealism, while a constant renewal of talents protected it, during a long period, from fruitless and repetitive agitation. Naturally the principle admitted exceptions, and a certain laxity developed in time; yet it may still define, with sufficient objectivity, the part played by each individual in the life of the circle.

We have selected our quotations according to the same principle: excerpts from a surrealist author in this book belong, as a rule, to a period when he was actually in the group, although his later work may have been more important or more significant in certain respects. (One exception has been made, for Jacques Prévert, who never wrote poems until after he separated from Breton and his friends but whose writings cannot be omitted from a study dedicated to the surrealist spirit.) Likewise, the bibliographical notes at the end of this volume focus mainly on the facts and works directly linked to surrealism.

It was, beyond doubt, thanks to the exceptional personality of André Breton that surrealism remained centralized within the Paris circle. Much might be said, and we personally might have much to say, about Breton's voluntary morals, so to speak, and on the resulting strife, exclusions, rehabilitations, quarrels, and insults that accompanied the whole history of the movement. We have avoided references to such disputes as much as possible in the present work, since pages of explanations would be necessary to make them comprehensible to even a limited extent; we feel that impartial accounts could hardly be rendered, so intricate was the interplay of personal feelings and general principles, and we prefer to remember Breton, and to quote him, as the man who, by various means and methods but with undeniable success, brilliantly filled the place left vacant by the death of Guillaume Apollinaire, a role that no one has played since Breton's own death—that of the leader of the avant-garde, always passionately interested in the discovery not only of new men but also of unheard echoes

of poetry, love, and revolt.[8] A creator and discoverer, Breton attracted by sheer force of intellectual seduction a set of talents who formed, all things considered, the most influential poets' circle of the twentieth century.

The personal works and influence of most members of the group, as well as of its leader, deserve individual studies. Yet, as our collection is mainly intended to give an image of a movement through a selection of individual pieces, it does not seem necessary for us to comment at length on each facet of a whole, which is itself a detailed commentary on its own object.

In the following pages, surrealism will appear not as a particular style of painting or writing, or as a school of poets and painters in a given period of time, but rather as the vision of a vast landscape of passions, desires, and deeds taking an infinite variety of shapes but keeping a unity of thought. There is hardly a text in this anthology, whether poetical or polemical, that is not somehow related to the fight against all forms of conventionalism or constraint in every field of human activity, not just in art and literature, but indeed in all of life. The coexistence of social preoccupations and poetic research, the ever-renewed denunciation of the threats against human freedom, coupled with an unceasing exploration through time and space of the domain of the marvelous, both activities reinforcing each other, situate surrealism beyond the usual range of schools and movements. When all is said and done, we are dealing here with a perennial attitude. André Breton wrote in 1950: "By the mere fact that surrealism claimed originally to be the codification of a state of mind which appeared sporadically at all times and in all countries, one cannot set an end to it, no more than a beginning."[9]

A remarkable feature of the surrealist spirit is that it remains "in front" and retains the characteristics of an avant-garde.

I wish, in conclusion, to express my warmest thanks and my gratitude to all persons whose friendship and goodwill helped me to assemble a number of texts included in the present book and who authorized their publication.

I especially wish to mention my late friends Jean Ferry and Max Morise, who, before their untimely death two years ago, gave me permission to quote, free of authors' fees, their texts reproduced here. I am also most grateful to Jacques Baron, Max Ernst, and Jacques Prévert, who, likewise, allowed free publication of the poems or writings I had selected from their works.

Simone Collinet, André Breton's first wife, has generously supplied, for illustrations in my book, documents concerning the early stages of surrealism. Suzanne

[8] See, for instance, one of the latest of these discoveries: Oskar Panizza's *The Council of Love,* first published in 1894, in German. English-language edition: New York: A Richard Seaver Book /The Viking Press, 1973. Trans. Oreste F. Pucciani. Introd. by André Breton.

[9] André Breton, *Entretiens 1913-1952* (Paris: Nouvelle Revue Française, 1952), p. 281.

Cordonnier (formerly Suzanne Berl-Muzard) kindly allowed reproductions of her un-published memoirs on the surrealist movement. My friend Robert Valançay lent me, from his remarkable surrealist library, several rare books that completed my documentation.

My requests for permission to quote from their works or works they control have been kindly and promptly answered by Leonora Carrington, Teeny Duchamp, David Gascoyne, Jeanne Mabille, Georgette Magritte, Pierre Matisse (for Yves Tanguy's *Weights and Measures* and Paul Eluard's "Yves Tanguy"), Valentine Penrose, Gisèle Prassinos, Salvador Dali, Dr. Michel Fraenkel (for Robert Desnos's excerpts), David Hare, Maurice Henry, Jean-Claude Kerbourc'h, Robert Lebel (who also gave me permission to quote from Benjamin Péret's *Le Déshonneur des Poètes*), Michel Leiris, Léo Malet, Roberto Matta, Robert Motherwell, Henri Pastoureau, Raymond Queneau, Man Ray, Sir Herbert Read, George Reavey, Edouard Roditi, Philippe Soupault. The generosity of Marguerite Arp, who transferred to me the author's rights for Arp's collection of poems *Jours effeuillés,* has given me free use of those texts; I regret that for problems of space I could not quote more of this beautiful poetry, but I feel the same regrets, as I have said above, for every author in my book, since only a very small part of the vast surrealist literature could be represented in these pages.

The publishers and the director of The Documents of 20th-Century Art series are most grateful to the Breton estate for permission to quote all the texts by André Breton reproduced in this book.

I could not locate, or my requests did not reach, a few authors or their heirs; among others: Luis Buñuel, Alberto Giacometti's estate, Paul Nougé's estate, Robert Allerton Parker. Yet I thought it most important that such contributions should not be eliminated and I hope that the parties concerned will see without displeasure quotations from their works, or from the works they control, included in my book.

PREFACE vii

LIST OF ILLUSTRATIONS xxi

PART LANDMARKS

1 Giorgio de Chirico 3
Unpublished Manuscripts • A Holiday

2 Arthur Rimbaud 11
The Letter of the Seer • After the Deluge • Barbaric • Towns

3 Guillaume Apollinaire 18
The Musician of Saint Merry's • The Cubist Painters (On Painting)

4 Alfred Jarry 25
Ubu Roi, Act 3 • The Exploits and Opinions of Doctor Faustroll, Pataphysician,
Book 2

5 Jacques Vaché 32
Letters to André Breton

6 Pierre Reverdy 39
In the Open • Inn • The Image

Contents

7 Lautréamont 43
 The Lay of Maldoror: Canto I, 5th stanza; Canto II, 18th stanza; Canto VI, 10th stanza • Poésies

PART 2 GENESIS

8 *Littérature* 55
 Freezing Hard *by Louis Aragon* • G Clef *by André Breton* • Tea Time *by Philippe Soupault* • Cow *by Paul Eluard* • Le Corset Mystère *by André Breton* • Giorgio de Chirico *by André Breton* • Black Forest *by André Breton* • The Magnetic Fields *by André Breton and Philippe Soupault* • Flake House *by Tristan Tzara* • Reply to the NRF *by Tristan Tzara* • Aphorisms *by Francis Picabia* • May Day *by Francis Picabia* • The Art of Dancing *by Paul Eluard* • Worker *by Paul Eluard* • Feasts *by Paul Eluard* • Song of the Aims and the Kings *by Philippe Soupault* • Théâtre Moderne *by Philippe Soupault* • The Peasant of Paris *by Louis Aragon* • Max Ernst *by André Breton* • Max Ernst *by Paul Eluard* • Arp *by Max Ernst*

PART 3 SURREALISM

9 *Littérature,* New Series 83
 Francis Picabia *by André Breton* • Marcel Duchamp *by André Breton* • Dadaist Notations *by Man Ray* • The Flower of Napoleon *by Benjamin Péret* • Penalties of Hell *by Robert Desnos* • No Hunting *by Max Morise* • Love *by Jacques Baron* • Poison *by Roger Vitrac* • Mademoiselle Piège *by Roger Vitrac* • Entrance of the Mediums *by André Breton* • Report on a Séance with Robert Desnos • Erotic Puns *by Robert Desnos* • Glossary *by Michel Leiris* • Her Ladyship Goes Up into Her Tower *by Louis Aragon* • The Disdainful Confession *by André Breton*

10 "The Manifesto of Surrealism" 117
 Excerpts from the Manifesto *by André Breton* • Soluble Fish *by André Breton* • A Wave of Dreams *by Louis Aragon* • Burial Not Allowed *by André Breton*

PART LA RÉVOLUTION SURRÉALISTE

11 Morals 133
Preface *by Boiffard, Eluard, Vitrac* • The Shadow of the Shadow *by Philippe Soupault* • Poem *by Paul Eluard* • Open the Prisons—Disband the Army* • Address to the Pope *by Antonin Artaud* • Letter to the Chief Doctors of Lunatic Asylums • Open Letter to M. Paul Claudel • One Moment! • The Lautréamont Case *by Paul Eluard* • Letters between Joseph Delteil and André Breton • Hands Off Love

12 Politics 156
On Germaine Berton *by Louis Aragon* • The Bouquet without Flowers *by André Breton* • Review of Trotsky's *Lenin by André Breton* • Revolution First and Always! • Self-Defense *by André Breton*

13 Humor, Love, and Poetry 165
Account of a Dream *by Giorgio de Chirico* • Mourning for Mourning *by Robert Desnos* • The Country of My Dreams *by Michel Leiris* • Tale *by Raymond Queneau* • From Capital of Sorrow *by Paul Eluard* • The Gertrude Hoffman Girls *by Paul Eluard* • The Queen of Diamonds *by Paul Eluard* • Love Poetry *by Paul Eluard* • My Latest Misfortunes *by Benjamin Péret* • All Right, I'll Go *by Benjamin Péret* • The Fall of the Franc *by Benjamin Péret* • The Brothers the Coast *by Louis Aragon* • The Nerve Scale *by Antonin Artaud* • Spirit against Reason *by René Crevel* • My Suicides *by Jacques Rigaut* • Nadja *by André Breton* • Free Union *by André Breton* • Unpublished Memoir *by Suzanne Cordonnier*

14 Painting 193
The Enchanted Eyes *by Max Morise* • Surrealism and Painting (1) *and* (2) *by André Breton* • Hopes *by Giorgio de Chirico* • Review of Chirico *by Max Morise* • Surrealism and Painting (3) *by André Breton* • Hebdomeros *by Giorgio de Chirico* • La Femme 100 têtes *by Max Ernst* • Preface *by André Breton* • A Challenge to Painting *by Louis Aragon* • Giorgio de Chirico *by Paul Eluard* • Paul Klee *by Paul Eluard* • Yves Tanguy *by Paul Eluard* • Two Portraits of Max Ernst *by Benjamin Péret*

Contents

15 *Variétés* 214
Modern *by Louis Aragon* • Ex-Serviceman *by Louis Aragon* • 98-28 *by Louis Aragon* • New Elementary Geography *by Paul Nougé* • Jacques Vaché *by Paul Nougé* • When the Spirit *by Raymond Queneau* • Surrealist Games • Exquisite Corpse • The Dialogue in 1928 • The Treasure of the Jesuits *by Louis Aragon and André Breton* • To Be Followed *by Louis Aragon and André Breton*

16 "The Second Manifesto of Surrealism" 232
The Second Manifesto *by André Breton* • Words and Images *by René Magritte* • The Approximate Man *by Tristan Tzara* • Introduction to 1930 *by Louis Aragon* • Hymn of the Patriotic Ex-Serviceman *by Benjamin Péret* • Inquiry on Love *with replies by René Char, Luis Buñuel, Paul Eluard, Paul Nougé, and Suzanne Muzard* • Hunting the Whale *by Jacques Prévert* • Household Souvenirs *by Jacques Prévert* • The Message *by Jacques Prévert* • For You My Love *by Jacques Prévert*

PART **5** IN THE SERVICE OF THE REVOLUTION

17 *Le Surréalisme ASDLR* 253
Telegrams between International Bureau of Revolutionary Literature and André Breton • Love's Boat Has Been Shattered against Everyday Life *by André Breton* • From Program for L'Age d'Or • A Giraffe *by Luis Buñuel* • Thought *by De Sade* • Danger of Pollution *by Max Ernst* • Life of Foch, the Assassin *by Benjamin Péret* • The Putrescent Donkey *by Salvador Dali* • The Visible Woman *by Salvador Dali* • Inspiration to Order *by Max Ernst* • Reverie *by Salvador Dali* • The Immaculate Conception *by André Breton and Paul Eluard* • The White-Haired Revolver *by André Breton* • The Antihead *by Tristan Tzara* • The Bronze Piano *by Maurice Henry* • Holly Twelve Roses *by Paul Eluard* • Critique of Poetry *by Paul Eluard* • Demigod *by Louis Aragon*

18 Objects 288
The Bride Stripped Bare by Her Bachelors, Even, *by Marcel Duchamp* • Introduction to a Speech on the Lack of Reality *by André Breton* • Moving and Mute Objects *by Alberto Giacometti* • Yesterday, Quicksands *by Alberto Giacometti* • Weights and Colors *by Yves Tanguy* • The Air Is a Root *by Jean Arp* • Psycho-atmospheric-anamorphic Objects *by Salvador Dali* •

Irrational Inquiries • Flying Hearts *by Gabrielle Buffet-Picabia* • Honor to
the Object! *by Salvador Dali* • The Coming of Beautiful Days *by Marcel
Jean* • Extract *by Hans Bellmer*

19 Dream and Revolution 306
The Communicating Vessels *by André Breton* • Diderot's Harpsichord *by
René Crevel* • Medico-Psychological Society • Surrealism and Psychiatry
by André Breton

20 Raymond Roussel 318
Impressions of Africa • Locus Solus • How I Wrote Some of My Books •
Review *by Paul Eluard*

PART THE SURREALIST EXPLOSION

21 *Minotaure* 331
Extract *by Paul Mabille* • The Age of Light *by Man Ray* • The Mysteries of
the Forest *by Max Ernst* • Golden Mean *by Paul Eluard* • On a Certain
Automatism of Taste *by Tristan Tzara* • Sensitive Mathematics—Architecture
of Time *by Matta* • The Spectral Surrealism of the Pre-Raphaelite Eternal
Feminine *by Salvador Dali* • On a Decalcomania without Preconceived
Subject *by André Breton* • The Painter's Eye *by Pierre Mabille* • Modern
Art and Great Art *by Paul Valéry* • The Latest Fashion *by Mallarmé* • Hair
Tonic *by Gisèle Prassinos* • The Automatic Message *by André Breton* • The
Marvelous against the Mystery *by André Breton* • The Demon of Analogy
by Mallarmé • The Air of Water *by André Breton* • Violette Nozières
by E. L. T. Mesens • 28th November XXXV *by Pablo Picasso* • 29th March
XXXVI *by Pablo Picasso* • Splotches in Space *by Jean Arp* • Angling for
Thrown-Away Sleep *by Marcel Jean* • Wink *by Benjamin Péret* • Cry of the
Medusa *by Henri Pastoureau* • Screaming at Life *by Léo Malet*

22 International Surrealism 360
Thought and Images *by René Magritte* • Catalogue Introduction *by Herbert
Read* • Reports *by Humphrey Jennings* • To a Woman to a Path *by Valentine
Penrose* • Hic Jacet *by George Reavey* • Report on the London Surrealist
Exhibition • Preface to Surrealist Anthology *by Julien Levy* • Declaration
on Spain • On the Moscow Trials *by André Breton* • Freud in Vienna *by
André Breton* • Towards an Independent Revolutionary Art *by Trotsky and
Breton*

PART **7** TIMELESS SURREALISM

23 New York, London, and Paris 381

VVV Editorial • Prolegomena to a Third Manifesto of Surrealism or Else *by André Breton* • The Surrealists in Marseilles *by André Breton* • The Day Is an Outrage *by Charles Duits* • The Seventh Horse *by Leonora Carrington* • Annunciation *by Aimé Césaire* • Tam-tam I *by Aimé Césaire* • Tam-tam II *by Aimé Césaire* • Psychological Novelette *by Edouard Roditi* • Notes on Chirico *by Robert Motherwell* • Quidor and Poe *by Robert Lebel* • Such Pulp as Dreams Are Made On *by Robert Allerton Parker* • Speech *by David Hare* • Alone *by Nicolas Calas* • Some Data on the Youth of M. E. as told by himself *by Max Ernst* • On Charles Fourier *by Paul Klossowski* • Ode to Charles Fourier *by André Breton* • Arcane 17 *by André Breton* • Interviews *by James Johnson Sweeney with Max Ernst, Kurt Seligmann, Marcel Duchamp* • Paramyths *by William Copley* • Quotations *edited by Simon Watson Taylor* • To Put an End to the Age of Machinery the English Poets Make Smoke *by E. L. T. Mesens* • The Poets' Dishonor *by Benjamin Péret* • The Great Unrestrained Sadist *by Jean Arp*

24 After the War 420

Initial Project of the 1947 Surrealist Exhibition • The Fashionable Tiger *by Jean Ferry* • Spilt Salt *by Benjamin Péret* • On *The Lay of Maldoror* by Lautréamont *by Marcel Jean* • Declaration of the Surrealist Group in England • Spectresses 2, or Prospectresses *by Jean-Pierre Duprey* • The Splitoonery *by Robert Lebel* • Jarry and the Contemporary Vortex *by Marcel Jean* • Plastic Sense *by Malcolm de Chazal*

25 May '68 438

The Lamp in the Clock *by André Breton* • Anonymous Poems of May '68 • Letter to the Rectors of the European Universities • My Pale Nights *by Jean Claude Kerbourc'h* • On Liberty *by André Breton*

SELECTED BIBLIOGRAPHY 449
INDEX 461

Giorgio de Chirico: *Self-Portrait*, 1912 *2*
Arthur Rimbaud, 1871 *12*
Arthur Rimbaud: "Le Dormeur du Val" *12*
Guillaume Apollinaire: Reproduction from *Calligrammes,* 1918 *19*
Guillaume Apollinaire, 1918 *19*
Lucien Lantier: Drawing of Alfred Jarry, 1896 *26*
Jacques Vaché, 1917 *36*
Jacques Vaché: Letter of November 26, 1918 *36*
Pierre Reverdy, 1925 (Engraving after a portrait by Picasso) *40*
Isidore Ducasse: Letter of October 23, 1869 *49*
Comte de Lautréamont: *Les Chants de Maldoror*, 1869 *49*
Isidore Ducasse: *Poésies*, 1870 *49*
Cover of *Littérature*, no. 1 (March 1919) *54*
André Breton: "Le Corset Mystère," *Littérature*, no. 4 (June 1919) *57*
Francis Picabia: Drawing of Philippe Soupault, 1920 *60*
Tristan Tzara, Simone Breton, and André Breton, 1920 *63*
Francis Picabia, 1922 *67*
Back cover of *La Révolution Surréaliste*, no. 8 (December 1926) *75*
Max Ernst, 1930 *75*
Advertisement for *Littérature*, new series, no. 4 (September 1922) *82*
Marcel Duchamp, ca. 1923 *85*
Francis Picabia: Cover for *Littérature,* new series, no. 5 (October 1922) *88*
Benjamin Péret, 1920 *88*

Louis Aragon, Robert Desnos, and André Breton, 1922 *92*

Jacques Baron and André Breton, 1922 *95*

Max Morise, 1924 *95*

Robert Desnos, 1923 *105*

Louis Aragon, 1930 *105*

André Breton: Cover of the first surrealist manifesto, 1924 *119*

Max Morise, Roger Vitrac, Simone Breton, J.-A. Boiffard, André Breton, Paul Eluard, Giorgio de Chirico, Pierre Naville, Robert Desnos, Charles Baron, Louis Aragon, 1924 *132*

Verso of the cover of *La Révolution Surréaliste*, no. 1 (December 1924) *135*

Cover of *La Révolution Surréaliste*, no. 6 (March 1926) *148*

Verso of the cover of *La Révolution Surréaliste*, no. 8 (December 1926) *148*

Louis Aragon: Advertisement for *La Révolution Surréaliste*, 1928 *149*

Charles Baron, Raymond Queneau, Pierre Naville, André Breton, J.-A. Boiffard, Giorgio de Chirico, Roger Vitrac, Paul Eluard, Philippe Soupault, Robert Desnos, Louis Aragon, Simone Breton, Max Morise, Marie-Louise Soupault, 1924 *153*

Paul Eluard, 1930 *174*

Antonin Artaud: *Les Pèse-Nerfs*, 1925 (Cover design by André Masson) *174*

René Crevel, 1930 *179*

Suzanne Muzard, 1929 *188*

Giorgio de Chirico: *Piccolo Trattato di Tecnica Pittoria*, 1928 *195*

Cover of *Variétés*, 1929 *216*

André Masson, Max Ernst, and Max Morise: *Exquisite Corpse*, 1927 *221*

André Breton, X——, Suzanne Muzard, X——: *Exquisite Corpse*, 1930 *221*

Oscar Dominguez, Marcel Jean, Esteban Francés: *Exquisite Corpse*, 1935 *221*

The actress Musidora, 1917 *225*

René Magritte: Words and Images, *La Révolution Surréaliste*, no. 12 (December 15, 1929) *237*

First page of *La Révolution Surréaliste*, no. 12 (December 15, 1929) *239*

Jacques Prévert, 1925 *245*

Cover of *Le Surréalisme ASDLR*, no. 1 (1930) *252*

Luis Buñuel, 1930 *255*

L'Age d'Or, film program, 1930 *255*

Jean Arp: Drawing for the program for the first screenings of *L'Age d'Or*, 1930 *255*

Salvador Dali, 1930 *269*

Salvador Dali: Signature, 1934 *269*

Title page of *L'Immaculée Conception*, by André Breton and Paul Eluard, 1930 (Drawing by Salvador Dali) *274*

Paul Eluard: *La Rose Publique*, 1934 *285*

Paul Eluard: "Yves Tanguy," 1932 *285*

Marcel Duchamp: *The Bride Stripped Bare by Her Bachelors, Even*, note, 1912 *290*

Yves Tanguy: Weights and Colors, *Le Surréalisme ASDLR*, no. 3 (December 1931) *294*

Jean Arp: The Air Is a Root, *Le Surréalisme ASDLR*, no. 6 (May 15, 1933) *295 – 296*

Jean Arp, 1939 *297*

Salvador Dali: Aspect of the New Psycho-atmospheric-anamorphic Objects, *Le Surréalisme ASDLR*, no. 5 (May 15, 1933) *297*

André Breton: *Les Vases communicants,* 1932 (Cover design by Max Ernst) *310*

André Breton: *Political Position of Surrealism*, 1935 *310*

Advertisement for René Crevel's *Les Pieds dans le Plat* (To Put One's Foot in It), 1933 *310*

Raymond Roussel, 1911 *323*

Raymond Roussel: *Impressions d'Afrique*, 1911 *323*

Raymond Roussel: *Comment j'ai écrit certains de mes livres*, 1935 *323*

Marcel Duchamp: Cover of *Minotaure*, no. 6 (December 1934) *330*

Table of contents, *Minotaure*, no. 1 (1933) *330*

Stéphane Mallarmé, 1894 *345*

Hans Arp: Manuscript page *359*

Marcel Duchamp: Back cover of *Minotaure*, no. 6 (December 1934) *359*

E.L.T. Mesens, René Magritte, Jean Scutenaire, André Souris, Paul Nougé, Irène Hamoir, Marthe Nougé, and Georgette Magritte, 1934 *361*

International Surrealist Bulletin, no. 4 (London, September 1936) *361*

Rupert Lee, Ruthven Todd, Salvador Dali, Paul Eluard, Roland Penrose, Herbert Read, E.L.T. Mesens, George Reavey, Hugh Sykes Davies, Mrs. Rupert Lee, Nusch Eluard, Eileen Agar, Sheila Legge, X——, 1936 *362*

E.L.T. Mesens, Roland Penrose, André Breton, Marcel Jean, 1936 *362*

Announcement for lectures on surrealism, London, 1936 *364*

Bulletin International du Surréalisme, no. 1 (Prague, April 9, 1935) *364*

Marcel Jean: "Rendezvous tomorrow," cover of *Konkretion,* nos. 5-6 (March 1936) *371*

Invitation for the opening of the International Surrealist Exhibition, 1938 *371*

André Breton and Leon Trotsky, 1938 *375*

Max Ernst: Cover of *VVV*, no. 1 (1942) *380*

Jacqueline and André Breton, 1940 *384*

Matta: Illustration for *The Day Is an Outrage*, 1943 *384*

From *First Papers of Surrealism*, 1942 *403*

André Breton: *Ode à Charles Fourier,* 1947 *403*

Elisa and André Breton, 1948 *409*

Max Ernst: *Collage*, 1949 *416*

Benjamin Péret, 1950 *416*

André Breton, Elisa Breton, Benjamin Péret, Suzanne Cordonnier, 1948 *430*

Cover of the *Almanach Surréaliste du Demi-Siècle*, 1950 *431*

Max Ernst: Illustration for *Spectresses 2 or Prospectresses*, 1950 *431*

Matta: *A Poet of Our Acquaintance,* 1946 *439*

Max Ernst: Cover of José Corti catalogue, 1932 *449*

LANDMARKS

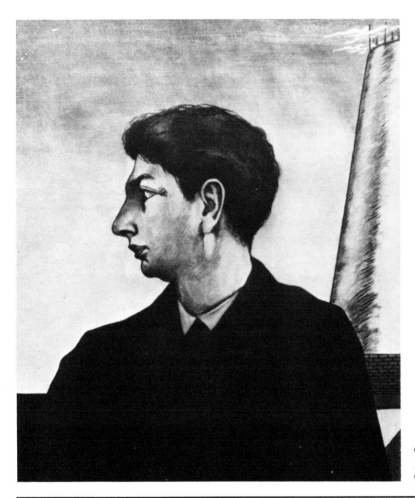

Giorgio de Chirico: *Self-Portrait*, 1912 (?). (Carl Van Vechten Collection, New York)

Giorgio de Chirico

During the first years of this century, in Europe in the field of art, a decaying academism still prevailed in official circles, and at the same time, breaking away completely from all descriptive methods, an explosion of young and forceful trends and schools offered new theories, new shapes, and new techniques. It was at that time, in 1911, that a young Italian artist arrived in Paris, completely isolated, unknown to the avant-garde (and to the rear guard as well), and taking no part in such pioneer movements as cubism, futurism, and abstraction. Alone in a dreary studio on the Rue Campagne Première in the Montparnasse quarter, he began to paint images evocative of the cities of his native country, just images, simply and plainly drawn, though not "naïve"—the Italian painter had evidently had academic teachers. His imaginary towns looked quite real, but they were disquieting in a mysterious way. No signs of nature, no trees, lawns, or rivers, only architectural works were to be seen in these urban views bathed in a curious reflection emanating from skies of an emerald color. And the temples, towers, arcades were drawn in rigid perspective and cast long shadows under the soft rays of an autumnal sun. Sometimes, alongside the buildings of the deserted city, or in the middle of a vast and empty square, stood a solitary being wrapped up like a phantom in a flowing robe, while objects, abandoned carriages, statues, seemed to appear unexpectedly as if they had a hidden, mysterious message to deliver. . . .

That message was surrealism itself, delivered years before the notion was given a name. The mysterious canvases contained the seed of surrealist painting, and at the same time they showed its purest flower. The Italian artist painted memories transfigured as dreams and obsessions, and we must go back to Giorgio de Chirico to detect the first *frisson* of surrealism in modern painting—and not simply a shiver. When the poet Guillaume Apollinaire, around whom a group of young explorers of art and poetry had gathered, saw these pictures exhibited for the first time at the Salon d'Automne and the Salon des Indépendants, he apprehended at once the mystery lying under their plain appearance and hailed Chirico as "the most profound painter of the

young generation." The avant-garde adopted as one of its authentic members the artist who, while using purely traditional means, was beginning to unveil the poetic—most critics said the "literary"—meanings of a picture.

In these years of research and creation, while Apollinaire and his circle were unquestionably influential in his meditations—though Chirico was always reluctant to take part in group discussion—the painter vividly felt the very mysteries of his own work and had at the same time a deep understanding of his aim and methods. Again it is more than a mere presentiment of surrealist poetry that we discover in texts written by Chirico in 1911-15 but not published until much later. We find a true surrealist theory in these pages where "impressionism" is discussed, the meaning of the word, the attitude of the painter toward techniques in general, and the intellectual content, the poetic message, lying in an artist's creations, beyond the means that give them birth.[1]

A building, a garden, a statue, a person—each makes an *impression* upon us. The problem is to reproduce this impression in the most faithful possible fashion. Several painters have been called impressionists who at bottom were not. In my opinion there is no point in using technical means (divisionism, pointillism, etc.) to try to give the illusion of what we call truth. For example, to paint a sunlit landscape trying in every way to give the sensation of light. Why? I too see the light; however well it may be reproduced, I also see it in nature, and a painting that has this for its purpose will never be able to give me the sensation of something new, of something that, previously, *I have not known.* While if a man faithfully reproduces the strange sensations that he feels, this can always give new joys to any sensitive and intelligent person. . . .

In my way of thinking and working . . . revelation always plays the principal role. . . .

A revelation can be born of a sudden, when one least expects it, and also can be stimulated by the sight of something—a building, a street, a garden, a square, etc. In the first instance it belongs to a class of strange sensations which I have observed in only one man: Nietzsche. When Nietzsche talks of how Zarathustra was conceived, and says: "I was surprised by Zarathustra," in this participle — surprised — is contained the whole enigma of sudden revelation. When a revelation grows out of the sight of an arrangement of objects, then the work which appears in our thoughts is closely linked with the circumstance that has provoked its birth. One resembles the other, but in a very strange way, like the resemblance there is between two brothers, or rather between the image of someone we know seen in a dream, and that person in reality; it is, and at the same time it is not, the same person; it is as if there had been a slight and mysterious transfiguration of the features. I believe and have faith that, from certain

[1] These fragments are from the translations of Chirico's manuscripts by Louise Bourgeois and Robert Goldwater in James Thrall Soby, *Giorgio de Chirico* (New York: The Museum of Modern Art, 1955).

points of view, the sight of someone in a dream is proof of his metaphysical reality—in certain accidental occurrences that sometimes happen to us; in the manner and the arrangement that things appear to us and awaken in us unknown sensations of joy and surprise: the sensations of revelation.

Let us note in passing that Chirico's ideas on sensation lead him to a complete disregard of the art of music. The surrealists were to adopt the same negative attitude toward musical noises. . . .

No Music: Music cannot express the essence of sensation. One never knows what music is about, and after all, having heard any pieces of music, whether by Beethoven, Wagner, Rossini, or Monsieur Saint-Saëns, every listener has the right to say, and can say, what does this mean? In a profound painting, on the contrary, this is impossible; one must fall silent when one has penetrated it in all its profundity, when one turns the corner of all its walls, and not of its walls alone. Then, light and shade, lines and angles begin to talk, and music too begins to be heard, that hidden music that one does not hear. What I listen to is worthless: there is only what I see with my own eyes open—and even better closed. There is no mystery in music; that is precisely why it is the art people enjoy most, for they always discover in it more *sensations.* I felt this last night; yes, I felt it in a profound and silent fashion, in a fashion filled with terror. Should I perhaps call such an experience a truth?

But such truths do not talk, they have no voice; still less do they sing; but sometimes they look at one, and at their glance one is forced to bow one's head and say, *yes, that is true.* What results—a picture, for example, always has a music of its own; that is inevitable, that is the mysterious destiny of all things to have a thousand souls, a thousand aspects.

I felt this yesterday at evening: painting, painting: In my picture: the end of the meal or the music of shattered light, this sensation beyond music is written in letters of fire. Music remains confined, something one takes before the meal or after, but which is not a meal in itself. Here is an enigma which I do not advise imaginative minds to dwell upon too long, for in spite of its afternoon warmth, it is icy. . . .

A feeling of fatality, of mystery, of the enigma hidden in every object perceptible to our senses, was the specific element of Chirico's art; sometimes the artist sought to express this feeling with the almost untranslatable German word *Stimmung* ("mood", "atmosphere"). The enigma:

Above all a great sensitivity is needed. One must picture everything in the world as an enigma, not only the great questions one has always asked oneself—why was the

world created, why we are born, live and die, for after all . . . perhaps there is no reason in all of this. But rather to understand the enigma of things generally considered insignificant. To perceive the mystery of certain phenomena of feeling, of the character of a people, even to arrive at the point where one can picture the creative geniuses of the past as things, very strange things that we examine from all sides. To live in the world as if in an immense museum of strangeness, full of curious many-colored toys which change their appearance, which, like little children, we sometimes break to see how they are made on the inside, and, disappointed, realize they are empty. The invisible tie that joins a people to its creations. Why for instance are the houses in France built in a certain style and not in another? There is no use citing history and the causes of this and of that; this describes, but it explains nothing for the eternal reason that there is nothing to explain, and yet the enigma always remains. The dormer windows on the roofs of the houses in Paris always produce a strange impression in me; I believe there is an unknown force which has driven the architects to make these *dormers,* to *feel* them. I see a link between the dormer window and the red trousers of the French soldier, and the characters of the revolution, and a thousand other things which I cannot explain, and this is true for all peoples, all periods, all countries. I have talked of all these strange things to suggest the degree of intelligence and sensibility at which an artist must arrive in order to conceive what I mean by a picture.

In many respects Chirico is a man of the Renaissance, an age of clarity and exactitude, of man-made realities but also of man-made gods, a time when, out of its very clearness and precision, arose problems as pure and premonitory as the light that antique suns shed on Delphic and Roman ceremonials. Chirico, rejecting medievalism and its developments in romanticism, saw this world "full of gods," as the ancient Greeks have said, but there is no place in it for religions: "There are more enigmas in the shadow of a man who walks in the sun than in all religions of the past, present and future."

A mystery lies in Roman and Renaissance architecture:

In the middle ages the study of nature led astray those artists who created *Gothic art.* One can observe the same phenomenon among modern artists: poets, painters and musicians. The truly profound work will be drawn up by the artist from the innermost depths of his being. There is no murmur of brooks, no song of birds, no rustle of leaves. The Gothic and Romantic disappear, and in their stead appear measurements, lines, forms of eternity and infinity. This is the feeling produced by Roman architecture. This is why I believe that Greek and Roman buildings, and all those which later were fashioned upon the same principles, even though somewhat transformed, are what is most profound in *art.* . . .

There is nothing like the enigma of the *Arcade*—invented by the Romans. A street, an arch: The sun looks different when it bathes a Roman wall in light. In all this there is something more mysteriously plaintive than in French architecture.

And less ferocious too. The Roman arcade is a fatality. Its voice speaks in enigmas filled with a strangely Roman poetry; shadows of old walls and a curious music, profoundly blue, having something of an afternoon at the seaside, like these lines of Horace:

Ibis Liburnis inter alta navium
Amica propugnacula. . . .[2]

Leaving aside the strained logic of art critics and historians, returning to the guidance of dreams and childhood memories—

To be really immortal a work of art must go completely beyond the limits of the human: good sense and logic will be missing from it.

In this way it will come close to the dream state, and also to the mentality of children.

Chirico, the poet, outlines and explores his own domain of sensations and feelings when he evokes the men who, at the dawn of humanity, created the first gods.

Inside a ruined temple the broken statue of a god spoke a mysterious language. For me this vision is always accompanied by a feeling of cold, as if I had been touched by a winter wind from a distant, unknown country. The time? It is the frigid hour of dawn on a clear day, towards the end of spring. Then the still glaucous depth of the heavenly dome dizzies whoever looks at it fixedly; he shudders and feels himself drawn into the depths as if the sky were beneath his feet; so the boatman trembles as he leans over the gilded prow of the bark and stares at the blue abyss of the broken sea. Then like someone who steps from the light of day into the shade of a temple and at first cannot see the whitening statue, but slowly its form appears, ever purer, slowly the feeling of the primordial artist is reborn in me. He who first carved a god, who first wished to *create* a god. And then I wonder if the idea of imagining a god with human traits such as the Greeks conceived in art is not an eternal pretext for discovering many new sources of sensations.

The artists of the middle ages never succeed in expressing this feeling. This feeling, this sacred shudder of the artist who touches a stone or a fragment of wood,

[2] "In your small boat you will pass between the friendly ramparts of the high ships. . . ."—M.J.

who polishes it, touches it, caresses it, with the sacred feeling that the spirit of a god resides within it. Rare is the modern painter or sculptor who creates while gripped by such a joy. And yet I cannot otherwise conceive a work of art. Thought must so detach itself from all human fetters that all things appear to it anew—as if lit for the first time by a brilliant star. . . .

Day is breaking. This is the hour of the enigma. This is also the hour of prehistory. The fancied song, the revelatory song of the last, morning dream of the prophet asleep at the foot of the sacred column, near the cold white simulacrum of a god.

One of the strangest and deepest sensations that prehistory has left with us is the sensation of foretelling. It will always exist. It is like an eternal proof of the senselessness of the universe. The first man must have seen auguries everywhere, he must have trembled at each step he took. . . .

In Rome the sense of prophecy is somehow larger: a feeling of infinite and distant grandeur inhabits it, the same feeling with which the Roman builder imbued his arcades, a reflection of the spasm of the infinite which the heavenly arch sometimes produces in man.

With the Renaissance, angels, and the Fallen Angel as well, began to fade out of man's fancy and imagination; the belief that all wonders resulted from God's, or Satan's, will appeared as a survival of the mentality of the Middle Ages. The idea of the marvelous acquired its modern meaning: wonders belonged to man and to his earthly gods. And a great tide of fairy tales flooded literature; utopias, imaginary voyages, interplanetary travels were invented. The marvelous permeated a society that sought its artistic inspiration in pre-Christian models, and built even its Christian churches in a classical style.

Chirico perceived the dual meaning of classical architecture as the expression of a civilization that admitted both the rectitude of intelligence and the uncertainties of metamorphoses. He saw the castle of Versailles, for instance, as a "wonder-full" domain, an enchanted mansion haunted with smiling or grimacing faces on the keystones of the vaults, with stone armor and weapons on the brims of the roof, with palms and acanthuses around casings of the doors, and he felt too a sort of defiant spirit of sureness and domination emanating from the very span and equilibrium of the palace itself—an enigma: perhaps the enigma of the French spirit, in which Chirico found, rather than its celebrated sobriety and moderation, "ferociousness":

One bright winter afternoon I found myself in the courtyard of the palace at Versailles. Everything looked at me with a strange and questioning glance. I saw then that every angle of the palace, every column, every window had a soul that was an enigma. I looked about me at the stone heroes, motionless under the bright sky,

under the cold rays of the winter sun shining *without love* like a profound song. A bird sang in a cage hanging at a window. Then I experienced all the mystery that drives men to create certain things. And the creations seemed still more mysterious than the creators. It is futile to explain certain things scientifically, nothing is achieved. The palace was as I had imagined it. I had a presentiment that this was the way it must be, that it could not be different. An invisible link ties things together, and at that moment it seemed to me that I had already seen this palace, or that this palace had once, somewhere, already existed. Why are these round windows an enigma? Why are they—and can only be—French? They have a strange expression. Something altogether superficial like the smile of a child who does not know why he smiles; or something ferocious, like a chest pierced with a sword, or like the wound produced by a sword. And then more than ever I felt that everything was inevitably there, but for no reason and without any meaning.

To the painter-poet his own works were always revealed to him in an unexplainable fashion:

In connection with these problems let me recount how I had the revelation of a picture that I will show this year at the *Salon d'Automne,* entitled *Enigma of an Autumn Afternoon.* One clear autumnal afternoon I was sitting on a bench in the middle of the Piazza Santa Croce in Florence. It was of course not the first time I had seen this square. I had just come out of a long and painful intestinal illness, and I was in a nearly morbid state of sensitivity. The whole world, down to the marble of the buildings and the fountains, seemed to me to be convalescent. In the middle of the square rises the statue of Dante draped in a long cloak, holding his works clasped against his body, his laurel-crowned head bent thoughtfully earthward. The statue is in white marble, but time has given it a gray cast, very agreeable to the eye. The autumn sun, warm and unloving, lit the statue and the church façade. Then I had the strange impression that I was looking at all these things for the first time, and the composition of my picture came to my mind's eye. Now each time I look at this painting I again see that moment. Nevertheless the moment is an enigma to me, for it is inexplicable. And I like also to call the work which sprang from it an enigma.

While suggesting a mysterious link between old and new concepts and beings, or between distant ones, Chirico emphasized the feeling of deep disorientation produced by these strange encounters, these meetings on different planes of time and space. A moving van has pulled up beneath a portico; a surgeon's red rubber glove is hanging next to a statue's head; a locomotive puffs its smoke behind a peristyle. The Chirican city lives on antique and modern rhythms, intermingled.

A Holiday

They were not many, but joy lent their faces a strange expression. The whole city was decked with flags. There were flags on the big tower which rose at the end of the square, near the statue of the great king-conqueror. Banners crackled on the lighthouse, on the masts of the boats anchored in the harbor, on the porticoes, on the museum of rare paintings.

Towards the middle of the day *they* gathered in the main square, where a banquet had been set out. There was a long table in the center of the square.

The sun had a terrible beauty.

Precise, geometric shadows.

Against the depth of the sky the wind spread out the multicolored flags of the great red tower, which was of such a consoling red. Black specks moved at the top of the tower. They were gunners waiting to fire the noon salute.

At last the twelfth hour came. Solemn. Melancholic. When the sun reached the center of the heavenly arch a new clock was dedicated at the city's railroad station. Everyone wept. A train passed, whistling frantically. Cannon thundered. Alas, it was so beautiful.

Then, seated at the banquet, they ate roast lamb, mushrooms and bananas, and they drank clear, fresh water. Throughout the afternoon, in little separate groups, they walked under the arcades, and waited for the evening to take their repose.

That was all. . . .

Arthur Rimbaud

Not only surrealism, with Chirico, but many other ideas and creations still alive today in art and literature also received their first impulse, sometimes their decisive shape, during these extraordinary years between 1910 and 1914, when cubism developed with Picasso and Braque, futurism with Marinetti and Boccioni, abstract art with Kandinsky and Mondrian, orphism — the forerunner of machine art — with Duchamp and Picabia. . . . Dada and antiart came afterward but their spirit may be detected in Duchamp's first ready-mades of 1913 and also in the humorous-violent tone of Apollinaire's futurist manifesto of the same year, *L'Antitradition Futuriste* (The Futurist Antitradition).

In the field of written expression, unknown texts came to light that were to influence deeply, even to revolutionize, the very concept of poetry. From 1911 to 1914, when Arthur Rimbaud's letters (written in 1870-71, on the eve of his meteoric career) were published, mostly in the literary magazine *La Nouvelle Revue Française,* the entire body of the poet's work received renewed attention. Among the newly revealed texts was the now famous "Lettre du voyant," dated May 15, 1871.

The juvenile violence of its inspired prose, its attacks on celebrated representatives of traditional poetry, its demand for a new attitude from the poet, endowed the letter with a prophetic quality, which makes it appear today as the true ancestor of the manifestoes of the modern schools of poetry:

The Letter of the Seer

All antique poetry ends in Greek poetry, harmonious life. From Greece to the romantic movement — Middle Ages — there are scholars, versifiers. From Ennius to

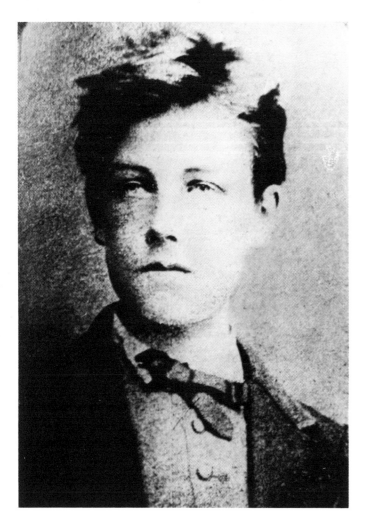

Left: Arthur Rimbaud at seventeen, 1871.
Right: Arthur Rimbaud: "Le Dormeur du Val," manuscript. (Photograph: Bibliothèque Nationale, Paris)

Theroldus, from Theroldus to Casimir Delavigne,[1] everything is rhymed prose, a game, sloppiness and glory of innumerable idiotic generations. Racine is Pure, Strong, Great. If someone had puffed on his rhymes, shuffled his hemistiches, the Divine Fool would be today as unknown as the first comer, author of some *Origins.* —After Racine, the game becomes moldy. It had lasted two thousand years!

 . . . No one ever passed a good judgment on romanticism. Who could have judged it? Critics!! Romantics? who prove so well that the song is so seldom the work, that is to say, the thought sung and understood by the singer.

[1]Ennius, a Latin poet (ca. 240-169 B.C.), was the author of the *Annals,* relating the history of Rome. Theroldus, or Théroulde, was the supposed author of *The Song of Roland* (twelfth century). Casimir Delavigne was a French poet (1793-1843); his works illustrate the passage from classicism to romanticism. —M.J.

For *I* is someone else. If brass wakes up a trumpet, it is not its fault. This is obvious to me: I witness the birth of my thought, I watch it, I listen to it; I draw a stroke on the bow; the symphony begins to stir in the depths, or springs onto the stage.

If the old fools had not discovered only the wrong meaning of the I, we would not have to sweep away those millions of skeletons who, for an infinite length of time, have accumulated the products of their one-eyed intelligence, shouting they were the authors!

In Greece, as I have said, verse and lyre give action its rhythm. Afterward, music and rhymes are games, pastimes. The study of this past delights the curious minds; several rejoice in reviving these antiquities: that's for them. Universal intelligence has always thrown out its ideas naturally: men picked up part of these fruits of the brain; they acted from them, they wrote books after them; things went thus, man was not working on himself, was not yet being awake, or not yet in the fullness of the great dream. Civil servants, writers: but author, creator, poet, this man never existed!

The first study for the man who wants to be a poet is knowledge of himself, complete: he searches for his soul, he inspects it, he puts it to the test, he learns it. As soon as he has learned it, he must cultivate it! That seems simple: in every mind a natural development takes place; so many *egotists* proclaim themselves authors; there are so many others who attribute their intellectual progress to themselves! But the question is to make the soul monstrous; in short: in the manner of *comprachicos!*[2] Imagine a man implanting and cultivating warts on his face!

I say that one must be a *seer,* make oneself a *seer.*

The poet becomes a *seer* through a long, immense, and reasoned *derangement of all the senses.* All shapes of love, suffering, madness. He searches himself, he exhausts all poisons in himself, to keep only the quintessences. Ineffable torture where he needs all his faith, all his superhuman strength, where he becomes among all men the great patient, the great criminal, the great accursed one—and the supreme Scholar! For he reaches the *unknown!* Since he cultivated his soul, rich already, more than anyone else! He reaches the unknown, and when, demented, he would end by losing the intelligence of his visions, he has seen them! Let him die in his leaps among unheard-of and unnamable things; other horrible workers will come: they will begin from the horizons where the other one has collapsed!

. . . So the poet is actually a thief of fire.

He is responsible for humanity, even for *animals.* He must see to it that his inventions can be smelled, felt, heard. If what he brings back from *yonder* has shape, he gives shape; if it is shapeless, he gives shapelessness. To find a language. Moreover,

[2] Abductors of small children whom they mutilated and exhibited as monsters.—M.J.

speech being thought, the time for a universal language will come! Only an academician, deader than a fossil, could complete a dictionary, in any tongue; weak people, who might begin to *think* about the first letter of the alphabet, and would soon jump into madness!

This language will be soul for the soul, summing up everything, perfumes, sounds, colors; thought hooking thought and pulling. The poet would define the amount of unknown awakening in his time in universal thought; he would give more than the formula of his thought, than the measurements *of his march toward Progress!* An enormity becoming a norm, absorbed by everyone, he would truly be a *multiplier of Progress!*

This future will be materialistic, as you see. Always filled with *Number* and *Harmony,* these poems will be made to stay. Basically, it would still be Greek poetry somehow.

Eternal art would have its functions, in the same manner as poets who are also citizens. Poetry will no longer give rhythm to action; *it will be in front.*

These poets shall be! When woman's infinite bondage is broken, when she lives for herself and by herself, man—hitherto abominable—having given her her leave, she too will be a poet! Woman will find unknown things too! Will her world of ideas differ from ours? She will find strange, unfathomable, repulsive, delightful things. We shall take them, we shall understand them.

Meanwhile, let us ask *novelty* from the *poet*—ideas and shapes. All the clever ones would soon think they have satisfied that demand: it is not so!

The first romantics were *seers* without fully realizing it. The cultivation of the souls began accidentally: abandoned locomotives, their fires still burning, which the rails carry for a while. Lamartine is sometimes a seer, but strangled by an obsolete form. Hugo, too *moody,* has a good deal of *vision* in his last volumes: *Les Misérables* is a real *poem.* I have in hand *Les Châtiments; Stella* gives approximately the size of Hugo's *sight:* too much Belmontet and Lamennais,[3] Jehovahs and columns, old busted-out enormities.

Musset is fourteen times execrable for us, suffering generations seized by visions —which his angelic laziness has insulted! O! the insipid tales and proverbs! O the *Nuits!* O *Rolla,* O *Namouna,* O *La Coupe!* Everything is French, that is to say, hateful to the supreme degree; French, not Parisian! One more product of that odious genius who inspired Rabelais, Voltaire, Jean La Fontaine, annotated by Monsieur Taine! Springlike, Musset's spirit! Charming, his love! There you have enamel painting, solid

[3]Louis Belmontet (1798-1879) was a French poet and politician; many of his pieces, classical in form, glorified the Napoleonic period. Félicité de Lamennais (1782-1854) was a famous Catholic writer who became an ardent anti-Catholic. —M.J.

poetry! They will relish *French* poetry for a long time, but only in France. . . . Musset could accomplish nothing. There were visions behind the gauze of the curtains; he closed his eyes. French, flabby, dragged from the tavern to the college desk, the beautiful corpse is dead, and from now on, let's not even take the trouble to wake him up with our abominations!

The second romantics are very much *seers:* Théophile Gautier, Leconte de Lisle, Théodore de Banville. But inspecting the invisible and hearing the unheard-of being something other than recapturing the spirit of dead things, Baudelaire is the first seer, king of poets, *a real God.* Still, he lived within too artistic a circle, and the form so much praised in him is mean. Inventing the unknown claims for new forms. . . .

So I work to make myself a *seer.*

It was as a seer that Rimbaud wrote the poems of the *Illuminations,* in a dense language of intellectual echoes and musical resonances that, like the concentric ripples widening after the splash of a stone in a pond, expand from the very impact of the words and carry images and meanings further and further into the mind, cosmic memories or prophecies, visions of modern and future life.

After the Deluge

As soon as the idea of the Deluge had subsided,

A hare paused in the clover and the swinging flower bells and said its prayer to the rainbow through the spider's web.

Oh! the precious stones, hiding, — the flowers already looking forth.

In the dirty main street butchers' stalls were erected, and boats were dragged toward the sea piled up over there tier after tier as on the engravings.

Blood flowed, at Bluebeard's — in slaughterhouses, — in circuses, where the windows paled under the seal of God. Blood and milk flowed.

Beavers began to build. Smoke rose. from the *mazagrans* [4] in small cafés.

In the large house with window-panes still dripping with rain children in mourning looked at the wonderful pictures.

A door slammed, — and on the village square, the child swung his arms around, understood by the weathervanes and the steeple cocks everywhere, under the glittering showers.

Madame***installed a piano in the Alps. Mass and first communions were celebrated at the hundred thousand altars of the cathedral.

[4] A *mazagran* (from the name of an Algerian town) is a coffee cup shaped like a glass. — M.J.

Caravans departed. And the Splendid Hotel was built in the chaos of ice and darkness of the Pole.

Since then, the Moon has heard jackals whining amid deserts of thyme—and eclogues in wooden shoes grunting in the orchard. Then, in the purple and budding forest, Eucharis told me that spring was here.

—Surge up, pond,—Foam, roll upon the bridge and over the woods;—black sheets and organs,—lightning and thunder,—rise and roll;—Waters and sorrows, rise and lift up again the deluges.

For since they have passed away—oh the precious stones burying themselves, and the open flowers!—ennui has come! and the Queen, the Witch kindling her embers in the clay pot, will never tell us what she knows, and what we do not know.

Barbaric

Long after days and seasons, and beings and lands,

The flag of raw meat over the silk of oceans and arctic flowers; (they do not exist).

Recovering from past flourishes of heroism—which still attack our heart and our head—far from ancient murderers—

Oh! the flag of raw meat over the silk of oceans and arctic flowers; (they do not exist).

Sweetness!

Blazing fires, raining in gusts of frost,—Sweetness!—Fires in the rain of the wind of diamonds thrown by the terrestrial heart eternally carbonized for us.—O world!—

(Far from old refuges and old flames, which we hear, which we smell.)

Blazing fires and foams, Music, whirling of abysses and beating of icicles against the stars.

O Sweetness, o world, o music! And there, shapes, sweat, hair, and eyes, floating. And white tears, boiling—o sweetness!—and a woman's voice reaching to the depths of volcanoes and arctic grottoes.

The flag......[5]

Towns

These are towns! This is a people for whom these Alleghenies and Lebanons of dream have ascended! Cottages of crystal and wood that move on invisible rails and pulleys. Ancient craters girded with colossi and copper palm trees roar melodiously

[5]Spaced ellipsis points (. . .) indicate omissions by the editor; closely placed ellipses points (.....) follow the usage of the original authors.

amid fires. Amorous feasts resound over canals suspended behind the cottages. The pack of chimes shouts in the gorges. Corporations of giant singers rush up in garments and oriflammes as dazzling as the light of the summits. On platforms in the middle of precipices, the Rolands blare forth their bravery. On footbridges spanning the abyss and on the roofs of the inns the ardor of the sky decks out the masts. A collapse of apotheoses rejoins the high fields where seraphic centauresses maneuver among avalanches. Above the level of the highest crests, a sea stirred up with the eternal birth of Venus, laden with orpheonic fleets and the distant murmur of pearls and precious shells, — the sea darkens sometimes with a deadly glimmer. On hillsides, harvests of flowers, as tall as our weapons and our cups, are moaning. Pageants of Mabs in russet and opaline gowns come up from the ravines. Up there, stags trampling in the water-fall and on brambles suckle at Diane's breasts. The Bacchantes of the suburbs sob and the moon burns and howls. Venus enters the caves of blacksmiths and hermits. Groups of belfries sing of the people's ideas. From castles built in bones the unknown music spreads out. All legends move and living impulses rush into the villages. The paradise of storms collapses. Savages dance unceasingly the feast of the night. And, for one hour, I went down into the bustle of a Baghdad boulevard where companies have sung of the joy of a new working day, under a thick breeze, moving about, unable to dismiss the fabulous phantoms of the mountains where we must have met again.

What good arms, what beautiful hour will give me back that land whence come my slumbers and my slightest movements?

Guillaume Apollinaire

In Apollinaire's verse and prose, the voice of Rimbaud may at times be detected, as in this obvious echo of the "Lettre du voyant":

O mouths man is in search of a new language
And grammarians in any tongue will have nothing to say

For those old tongues are so near their death
That it is really through habit and lack of audacity
That we still use them for poetry

Apollinaire was herald, sponsor, and commentator of the great revolution of the arts. He had more than enough talent and erudition to rally legends and old tales under the banner of poetic revelation, and so sure was his feeling for the language, coupled with cleverness and imagination at finding new techniques and neologisms (the word "surrealism" was his invention), that he could master the flows of current life and individual inspiration within "poem-events" endowed with a constant variety of expression. He could link his own adventures, memories, tastes, and loves with the external and internal incentives of an old and new world, itself in the process of perpetual metamorphosis.

One of his most evocative poems, "Le Musicien de Saint Merry" (from his collection of "poems of peace and war" entitled *Calligrammes*), renews, with no less mysterious accents, the tale of the flute player who disappears with a procession of followers lured away by his magical music, recounted by Prosper Mérimée in his *Chroniques du règne de Charles IX* (Chronicles of the Reign of Charles IX), 1829.[1]

[1] Translated the same year in New York under the title *Fifteen Hundred and Seventy-two*. The legend of the flute player had already been told in Grimm's *Deutsche Sagen* (1816-18) and by Goethe, Brentano, and others. — M.J.

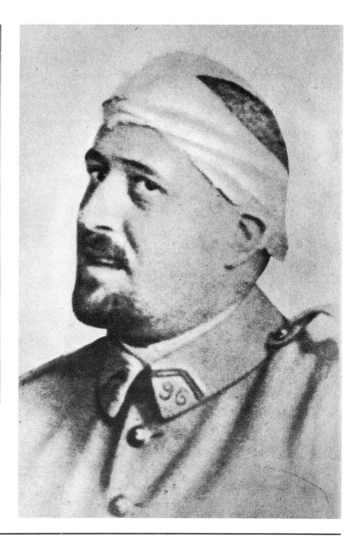

Left: Guillaume Apollinaire: Reproduction from *Calligrammes*, 1918. Translation: "1915 soldiers in blue china and carbuncle O love" (an allusion to the blue-and-red uniform of French soldiers at the beginning of the First World War). *Right:* Guillaume Apollinaire, 1918, at the Italian Hospital, Quai d'Orsay, Paris, after being wounded in the war.

The Musician of Saint Merry's

> I have at last the right to hail beings I do not know
> They pass before me and assemble in the distance
> While all I perceive of them is unknown to me
> And their hope is not stronger than mine
>
> I do not sing of this world or of the stars
> I sing of the possibilities of myself out of the world and the stars
> I sing of the joy of roaming and of the pleasure of dying from it

The twenty-first of the month of May 1913
Ferrying the dead and the mordonning merians[2]
Millions of flies were fanning a splendor
When a man without eyes nose and ears
Leaving the Sébasto entered the Rue Aubry le Boucher
A young man he was dark-haired and on his cheek that strawberry color
Man ah! Ariane
He played the flute and the music was guiding his steps
He paused at the corner of the Rue Saint Martin
Playing the tune I sing and which I have invented

Women passing by stopped near him
They came over from everywhere
When suddenly Saint Merry's bells started ringing
The musician ceased playing and drank from the fountain
Which is at the corner of Rue Simon le Franc
Then Saint Merry's became silent
The stranger resumed his tune on the flute
And retracing his steps walked up to the Rue de la Verrerie
Where he entered followed by the crowd of women
Who came out of houses
Who arrived from cross streets with a mad look in their eyes
Holding out their hands toward the melodious abductor
He went on absently playing his tune
He went on terribly

Then elsewhere
At what time is there a train leaving for Paris

At this moment
The pigeons in the Moluccas beshat nutmegs
At the same time
Catholic missions of Bôma what did you do with the sculptor

Elsewhere
She crossed a bridge linking Bonn and Beuel and disappears through Pützschen

[2] Apollinaire's words, "les mordonnantes mériennes," suggest "les mordorantes méridiennes": "the bronzed meridians." But we feel that we have to deal here with purely invented words, and we have simply anglicized them in our translation. —M.J.

In the same instant
A young girl in love with the mayor

In another district
Try poet to vie with perfumers' tags

On the whole o laughers you did not draw much out of man
And hardly did you extract a little fat out of their misery
But we who are dying from living away from each other
Let us stretch out our arms and on these rails runs a long freight train

You were crying sitting beside me in the cab
And now
You resemble me you resemble me unhappily

We resemble each other as in the architecture of the last century
These tall chimneys like towers
We go higher now and touch earth no longer

And while the world lived and varied
The procession of women long as a month of Sundays
Followed in the Rue de la Verrerie the happy musician

Pageants o pageants
In past days when the king was leaving for Vincennes
When the ambassadors arrived in Paris
When the lean Suger hastened toward the Seine
When the riot died away around Saint Merry's

Pageants o pageants
The women overflowed so great were their numbers
All the neighboring streets
And all hastened fast and straight
In order to follow the musician
Ah! Ariane and you Pâquette and you Amine
And you Mia and you Simone and you Mavise
And you Colette and you the beautiful Geneviève
Trembling and vain they passed on
And their light and swift strides kept time with the rhythm
Of the pastoral music which guided
Their avid ears

The stranger paused a while before a house for sale
A deserted house
With broken windowpanes
It is a sixteenth-century house
The yard is used as a garage for delivery vans
It is there that the musician entered
His music which grew fainter became languorous
The women followed him inside the abandoned house
And all went in mingled together in crowds
All all went in without casting a glance behind them
Without regretting what they have left
What they had abandoned
Without regretting day life and memory
Soon no one remained in the Rue de la Verrerie
Except myself and a priest from Saint Merry's
We went into the old house

But we found there no one

Night is falling
At Saint Merry's the Angelus is ringing
Pageants o pageants
In past days when the king returned from Vincennes

Now come a company of capmakers
Now come banana merchants
Now come soldiers of the Republican Guard
O night
Flock of languid glances of women
O night
You my sorrow and my fruitless wait
I hear the dying sound of a distant flute

The fountain at the corner of the Rue Simon le Franc exists no more, and this section of Paris where Apollinaire followed the roamings of his mysterious musician is now being renovated. It is almost impossible to follow the itinerary of the flute player from the Boulevard Sébastopol ("the Sébasto") to the Rue de la Verrerie and along the high walls of Saint Merry's, as the heart of the French capital loses its magical houses and their inhabitants—artisans, fruit vendors, streetwalkers, centuries-old phantoms, and echoes.

"Beauty is not eternal," said Apollinaire—although poetry should be. An inspired com-

mentary on the passing of time and things, on the disappearance of old, though beloved, teachings and ideas, on the discovery of novelty, may be found in the poet's preface to his collection of articles on new painters, published in 1913 under the title *Les Peintres cubistes.*

From THE CUBIST PAINTERS

On Painting

Plastic virtues: purity, unity, and truth hold defeated Nature down under their feet. In vain, rainbows tighten, seasons vibrate, crowds rush toward death, science destroys and re-creates what exists, worlds move away forever from our conception, our moving images repeat themselves or resuscitate their unconsciousness, and colors, odors, noises astonish us, then disappear from Nature.

Beauty, this monster, is not eternal. We know that man's breath had no beginning and shall not cease to be, yet we conceive above all the creation and the end of the world. However, too many artists still worship plants, stones, waters, or men. Soon one gets used to the bondage of mystery. And in the end, servitude provides sweet leisure hours. We leave to workmen the task of mastering the universe, and gardeners have less respect for Nature than artists have. It is time to be the masters. Good will does not guarantee victory. On this side of eternity, the mortal shapes of love are dancing, and the name of Nature summarizes their accursed discipline.

The flame is the symbol of painting, and the three plastic virtues are ablaze and they radiate. Flame has a purity that does not accept any foreign element and cruelly transforms into its own self everything it reaches. It has this magical unity that, if divided, makes each spark of fire similar to the single flame. It has finally the sublime truthfulness of its light, which no one can deny.

In this Age of the West the virtuous painters consider their own purity in spite of the forces of Nature. It is oblivion after study. And for a pure artist, to die would be as if all those of the past centuries had not existed. Painting purifies itself, in the Western world, with this ideal logic that ancient painters have passed on to the new ones as if they gave them life itself.

And that is all.

One lives in delight, another one in sorrow, some squander their heritage, others become wealthy, and still others have only life.

And that is all.

We cannot carry the corpse of our father everywhere along with us. We leave it in the company of the other dead. And if we remember him, we regret him, we speak

admiringly of him. And if we become fathers, we must not expect that one of our sons will double himself in order to keep our corpse alive. But it is in vain that we lift our feet off the earth that contains the dead.

. . . Reality shall never be discovered once and for all. Truth shall always be new. Or else it is but a system, still more miserable than Nature. . . .

The creations of the art of today assume a grand, monumental aspect, which transcends in this respect all that has been conceived by artists of our age. Eager in the search for beauty, it is a noble, energetic art, and the truth it brings to us is marvelously clear.

I love the art of today because I love light above all, and all men love light above all; they have invented fire.

Dispersion and a breach of communication among the various centers of the new spirit and among the artists themselves soon followed that exceptionally fertile period. In 1914 came war. Many European artists left their bellicose countries for more peaceful lands; only the futurists, in Italy, turned very patriotic, and Apollinaire, in France, though an alien—he was of Polish-Italian descent—volunteered in the French army. But he was an enchanter who could find poetry even in war. Wounded on the front in 1916, he had resumed his role as leader of the avant-garde in Paris when he died during the epidemic of Spanish influenza in the late autumn of 1918, on November 10, the eve of the Armistice.

A new generation was already rising in France, Switzerland, Germany, and elsewhere, ready for poetic exploration. Joining with their elders, especially Marcel Duchamp and Francis Picabia, these young adventurers were named André Breton, Louis Aragon, Philippe Soupault, Paul Eluard, Benjamin Péret, Tristan Tzara, Jean Arp, Max Ernst. . . .

Since the years of his adolescence André Breton had sought the company, advice, opinion, and guidance of poets; he had become acquainted with Apollinaire, Paul Valéry, Pierre Reverdy. In 1915, as a medical attendant in a military hospital at Nantes, he met Jacques Vaché, then an interpreter for the English armies in France, who was being treated for a slight wound received on the front. This young man—he was twenty and Breton nineteen—held extremely personal views about poetry and about life in general; among contemporary poets, he claimed to care only for Alfred Jarry—and here we must pause to pay homage to Jarry.

Alfred Jarry

Père Ubu, Jacques Vaché's favorite character, the comical-sinister hero of Jarry's play *Ubu Roi,* his ways and speeches, and even his physical features, as described and drawn by Jarry himself—the pointed skull, the big nose, the enormous belly (the "gidouille")—have never ceased through the years to affirm their specific importance and reality. Ubu is the incarnation of a type of political leader who has multiplied in Europe since the end of World War I—the Dictator. Jarry died in 1907, but the prophetic power of his creation has not diminished. Père Ubu, the Dictator, is, as Jarry said, "a perfect anarchist," a man who considers that all laws and hierarchies are contained inside his *gidouille*—his own person. When through a *coup d'état,* such a character becomes in fact a king, the results for his country are inevitably disastrous, while he himself usually meets with a miserable end.

When *Ubu Roi* was performed at the Théâtre de l'Oeuvre in Paris in 1896, tumult arose with the very first word of the play, which was thrown at the audience like an insult: "Merdre!"— a term whose English equivalent might be "Shittr!" The scene was set in Poland, "that is to say, nowhere," as Jarry put it, for at that time, Poland as an independent state was nonexistent. But the scenes of act 3, reproduced below, which show Ubu's methods of dealing with Finance (usually spelled "Phynance" by Jarry), Justice, and Tax Collecting, seem hardly an exaggeration in view of certain contemporary events.

Lucien Lantier: Drawing of Alfred Jarry at the time *Ubu Roi* was performed (1896).

UBU ROI[1]

Act 3

Scene 2

Poland: The great hall of the King's palace.
Père Ubu, Mère Ubu, Officers and Soldiers; Giron, Pile, Cotice; Nobles in Chains, Financiers, Magistrates, Clerks.

Père Ubu: Bring the Nobles' coffer and the Nobles' hook and the Nobles' knife and the Nobles' book. And then bring the Nobles. (*The Nobles are brutally pushed in.*)

Mère Ubu: For Goodness' sake restrain yourself, Père Ubu.

Père Ubu: I have the honor to announce to you that in order to enrich the kingdom I'm going to have all the Nobles put to death and help myself to their property.

Nobles: Horrors! Help, people and soldiers!

Père Ubu: Bring the first Noble and pass me the Nobles' hook. Those who are condemned to death will be passed down the trap door and fall into the basements of the pig-pinching machine and the Cash-room where they will be disembrained. (*To the Noble:*) Who are you, buffroon?

[1] Translation by Barbara Wright in *Ubu Roi* (London: Gaberbocchus Press, 1951; New York: New Directions, 1962).

Noble: Count of Vitepsk.

Père Ubu: What's your income?

Noble: Three million rix-dollars.

Père Ubu: Condemned! (*He grabs him with the hook and passes him to the pit.*)

Mère Ubu: What beastly savagery!

Père Ubu: Second Noble, who are you? (*The Noble doesn't reply.*) Are you going to answer, buffroon?

Noble: Grand Duke of Posen.

Père Ubu: Excellent! Excellent! That's all I want to know. Down the trap door. Third Noble, who are you? You've got an ugly mug.

Noble: Duke of Courland, of the towns of Riga, of Revel, and of Mitau.

Père Ubu: Good! Fine! Is that all?

Noble: That's all.

Père Ubu: Down the trap door, then. Fourth Noble, who are you?

Noble: Prince of Podolia.

Père Ubu: What's your income?

Noble: I am ruined.

Père Ubu: For that ugly word—down the trap door with you. Fifth Noble, who are you?

Noble: Margrave of Thorn, Palatin of Polock.

Père Ubu: That's not much. Is that all?

Noble: It was enough for me.

Père Ubu: Oh well, a little's better than nothing. Down the trap door. What are you nattering about, Mère Ubu?

Mère Ubu: You're too bloodthirsty, Père Ubu.

Père Ubu: What! I'm getting rich! I'm going to have MY list of MY property read. Clerk, read MY list of MY property.

Clerk: County of Sandomir.

Père Ubu: Begin with the princedoms, stupid ass.

Clerk: Princedom of Podolia, Grand Duchy of Posen, Duchy of Courland, County of Sandomir, County of Vitepsk, Palatinate of Polock, Margraviate of Thorn.

Père Ubu: Then what?

Clerk: That's all.

Père Ubu: What, is that all? Oh well then, come on, Nobles, and as I intend to continue enriching myself I shall have all the Nobles executed and thus get hold of all the vacant properties. Come on, pass the Nobles through the trap door. (*The Nobles are shoved through the trap door.*) Hurry up quicker, I want to make some laws now.

Several: That remains to be seen.

Père Ubu: First I shall reform the law, after which we shall proceed to finances.

Magistrates: We are opposed to all change.

Père Ubu: Shittr! Firstly, magistrates won't be paid any more.

Magistrates: And what shall we live on? We are poor.

Père Ubu: You can have the fines that you impose and the property of the people who are condemned to death.

A Magistrate: Horrors!

A Second: Infamy!

A Third: Shame!

A Fourth: Indignity!

All: We refuse to pass judgement under such conditions.

Père Ubu: All the magistrates down the trap door! (*They struggle in vain.*)

Mère Ubu: Here! What are you doing. Père Ubu? Who'll administer justice now?

Père Ubu: I shall. You'll see how well it works.

Mère Ubu: Yes, that'll be a fine mess.

Père Ubu: Look, shut up, buffrooness. And now, gentlemen, we shall proceed to finances.

Financiers: There is nothing to change.

Père Ubu: But *I* want to change everything. In the first place I want to keep half the taxes for myself.

Financiers: What cheek!

Père Ubu: Gentlemen, we shall institute a tax of 10% on property, another on commerce and industry, and a third on marriages, and a fourth on deaths, each of fifteen francs.

First Financier: But it's idiotic, Père Ubu.

Second Fin.: It's absurd.

Third Fin.: You can't make head or tail of it.

Père Ubu: What d'you think I am? Down the trap door with the Financiers. (*The Financiers are pushed in.*)

Mère Ubu: But look here, Père Ubu, what sort of a king do you think you are, you kill everyone.

Père Ubu: Oh shittr!

Mère Ubu: No more law, no more Finance!

Père Ubu: Don't be afraid, my sweet child, I'll go myself from village to village and collect the taxes.

Scene 3
A peasant house in the environs of Warsaw.
Several peasants are assembled.

A Peasant (*entering*): Listen to this. The King is dead, so are the Dukes, and young Bougrelas has fled to the mountains with his mother. What's more, Père Ubu has seized the throne.

Another: I've heard even more than that. I've just come from Cracow where I saw them taking away the bodies of more than three hundred Nobles and five hundred Magistrates whom they've killed, and it seems that they're going to double the taxes, and that Père Ubu will come and collect them himself.

All: Great God! What will become of us? Père Ubu's a fearful beast and his family, they say, is abominable.

A Peasant: But listen, wouldn't you say that someone was knocking at the door?

A Voice (off): Horngibolets! Open, by my shittr, by St. John, St. Peter and St. Nicholas! Open, sabre of finance, horns of finance! I've come to collect the taxes. (*The door is broken open and Ubu comes in, followed by hordes of tax collectors.*)

Scene 4

Père Ubu: Which of you is the oldest? (*A peasant comes forward.*) What's your name?

The Peasant: Stanislas Leczinski.

Père Ubu: Well then, horngibolets! listen well, or these gentlemen will cut off your earens. But are you going to listen, at least?

Stanislas: But your Excellency hasn't said anything yet.

Père Ubu: What! I've been speaking for the last hour. Do you think I came here to preach in the wilderness?

Stanislas: Far be it from me, such a thought.

Père Ubu: Well, I've come to tell you, to order you, and to intimate to you that you are to produce and exhibit your cash promptly, or you'll be done in. Come on, my Lords the Salopins of Finance, convey here the phynancial conveyance. (*They bring in the conveyance.*)

Stanislas: Sire, we are only down on the register for a hundred and fifty two rix-dollars, and we have already paid those six weeks ago come St. Matthew's day.

Père Ubu: Very likely, but I've changed the government and I've had it put in the paper that all existing taxes must be paid twice, and those that I shall impose later must be paid three times. With this system I shall soon have made my fortune, then I'll kill everybody and go away.

Peasants: Monsieur Ubu, have mercy, have pity on us, we are poor citizens.

Père Ubu: What do I care. Pay up.

Peasants: We can't, we've already paid.

Père Ubu: Pay up! or into my pocket with you, with torture and decapitation of the neck and head. Horngibolets! I am the king, I suppose!

All: Ah! that's how it is! To arms! Long live Bougrelas, by the grace of God, king of Poland and of Lithuania.

Père Ubu: Advance, gentlemen of Finance, do your duty. (*A struggle takes place. The house is destroyed, and old Stanislas runs away alone across the plain. Ubu stays to collect the money.*)

Jarry's singular genius did not confine itself to farce, even to a violent one such as *Ubu*. It extended to symbolist poetry, to art and theater criticism, to novels in which his lyricism and invention, strongly tinged with eroticism, rivaled his erudition, and to humorous "speculations" on various current events. *Les Gestes et Opinions du docteur Faustroll, pataphysicien* is a "neo-scientific novel" that dwells on descriptions and reasonings concerning one of Jarry's most remarkable concepts, the science of pataphysics.

Despite the author's learned explanations about its alleged Greek etymology, the word "pataphysics" appears to be simply a compound of the onomatopoeia *patatras!* ("bang!" or "smash!") and "metaphysics," as well as a disparaging pun, *pâte à physique*, meaning "physics paste." As for Faustroll's name, it derives clearly from "Faust" and "troll," the Scandinavian goblin, as in Ibsen's *Peer Gynt*. Here is one chapter of *Faustroll:*

THE EXPLOITS AND OPINIONS OF DOCTOR FAUSTROLL, PATAPHYSICIAN

Book 2: Elements of Pataphysics

Chapter 8: Definition

An epiphenomenon is that which is superadded to a phenomenon.

Pataphysics, whose etymology is μετά τά φυσικά and its real orthography 'pataphysics, preceded by an apostrophe to avoid an easy pun,[2] is the science of that which is superadded to metaphysics, either in itself or outside of itself, extending as far beyond metaphysics as the latter extends beyond physics. E.g., an epiphenomenon being often accidental, pataphysics will be above all the science of the particular, although it is said that there is science only of the general. It will study the laws that govern exceptions, and will explain the universe that supplements ours; or less ambitiously, will describe a universe that may be seen and that perhaps must be seen instead of the traditional one, since the laws that men have discovered, and that they think to be those of the traditional universe, are themselves correlations

[2] The "easy pun" is apparently *épate à physique,* "physical showing off."—M.J.

of exceptions, although more frequent ones, and in any case these laws are correlations of accidental facts that, not being very exceptional exceptions, do not even possess the charms of novelty.

DEFINITION: Pataphysics is the science of imaginary solutions, which symbolically attributes to lineaments the properties of objects described by their own virtuality.

Present-day science is founded upon the principle of induction. The majority of men have observed that, more often than not, a certain phenomenon precedes or follows another one, and they conclude that it will always be so. Now this is exact only more often than not; it depends upon a point of view, and it is codified only for convenience, if that! Instead of setting forth the law of the fall of a body toward a center, why not prefer the law of the ascension of void toward a periphery, void being considered as the unit of nondensity, a hypothesis far less arbitrary than the choice of *water* as a concrete unit of positive density?

For this body itself is a postulate, the point of view of the common herd, and in order that at least its qualities, if not its nature, should remain fairly constant, it is necessary to postulate that the height of men will remain perceptibly constant and mutually equal. Universal assent is already quite a miraculous and incomprehensible prejudice. Why does everybody affirm that the shape of a watch is round, which is obviously wrong since the watch assumes in profile a rectangular shape, an elliptic one on three sides, and why on earth do we notice its shape only when we look at the time? Perhaps under the pretext of usefulness. But the same child who draws the watch as a round object also draws the house as a square, from the shape of the façade, and this obviously without any reason; for except in the country, he will seldom see an isolated edifice, and even in a street, façades appear as very oblique trapezoids.

Therefore, it must be necessarily admitted that the common herd (including little children and women) possesses too coarse an understanding to comprehend elliptic shapes, and that their members agree in a so-called universal assent because they perceive only monofocal curves, since it is easier to coincide with one point than with two. They communicate and counterpoise each other with the exterior surface of their bellies, tangentially. But even the common herd has learned that the *true* universe is made of ellipses, and even the bourgeois keeps his wine in barrels and not in cylinders......

Pataphysics not only surpasses physics and metaphysics but assuredly "smashes" them. Yet the Science of Exceptions is less paradoxical than it sounds, since discoveries are always made when studying exceptions, and besides, all great minds are, by definition, exceptional.

Jacques Vaché

Jacques Vaché considered the world, its ways and morals, extremely Ubu-like — "ubique." The war in which he played an utterly indifferent part was certainly not a factor that could alter this opinion. To define his attitude toward life, he had invented the word "umour" ("humour" without an *h*). A handful of letters, signed "Harry James" or with fancy initials, forms his entire "literary works," yet Breton always emphasized, in his writings as well as in conversations, the lasting impression his friend made on him and the influence Vaché had on the development of his own career as a surrealist. We translate below some of his letters:

<div align="center">To Monsieur André Breton</div>

April 29, 1917

Dear Friend,

A moment ago, your letter.

It's useless, isn't it? to assure you that you always remained often on the screen — You wrote me a "flattering" missive — Probably to force me decently into an answer which a great comatose apathy has always put off — after all, for how long, according to current opinion?

I am writing to you from an ex-village, from a very narrow pigsty hung with blankets — I am with the English soldiers — They advanced very much over the adverse party thereabouts — It's very noisy — That's that.

I am happy to know that you are ill, my dear friend, a little — I have received a letter from T.F.,[1] an almost nondisquieting letter — this man saddens me — I am very tired of

[1] Théodore Fraenkel, to whom Vaché addressed a few letters, calling him sometimes "the Polish people" (a reminiscence of Jarry's play. certainly), Fraenkel being of Polish descent. Fraenkel took part after the war in the dada movement in Paris, during the years 1920-23. — M.J.

mediocre people, and I have resolved to sleep for an unknown length of time — the effort of waking up for just these few pages is a difficult one for me; things may work out better next time — Pardon me — won't you? won't you? Nothing is more killing than to be compelled to represent one's own country — Also.

From time to time — not to be suspected all the same of having died peacefully, I make sure, by performing some swindle, or by patting hamiably[2] some familiar death's head, that I am an ugly character — Today, been introduced to a General and his Taff under the name of a famous painter — (I believe the aforesaid is 50 or 70 years old — perhaps he's dead too — but the name remains) — I am now in great demand with them (the General and his Taff) — it's curious and I have fun imagining how it will fall flat in the end — it's not funny — not funny at all. No.

Are you sure Apollinaire still lives, and that Rimbaud has ever existed? As for me I don't believe it — I hardly perceive anyone but Jarry (All the same, you know, all the same — — UBU) — It seems to me certain that MARIE LAURENCIN still lives: certain symptoms subsist which authorize this — Is it absolutely certain? — yet I think I hate her — yes — there, tonight I hate her, what can we do?

And then you ask me for a definition of umour — like that!

IT IS IN THE ESSENCE OF SYMBOLS TO BE SYMBOLIC —

For a long time this sentence seemed to me to be a worthy definition, since it is apt to contain a great many living things: EXAMPLE: you know of the horrible life of the alarm clock — it's a monster that has always terrified me because of the number of things its eyes project, and the way this honest fellow stares at me when I enter a room — why on earth has it so much umour, why? But that's that: it is so and not other-wise — There is much formidable UBIQUE too in umour — as you will see — But this of course is not — definitive and umour derives too much from sensation not to be a very difficult thing to put into words — I think it is a sensation — I was almost going to say a SENSE — also — of the theatrical (and joyless) uselessness of everything.

WHEN ONE KNOWS.

And that is why, then, the enthusiasms — (in the first place it's noisy) — *of others* are hateful — For — isn't it so? We have Genius — for we know UMOUR — and therefore everything — you never doubted it, besides? — is permitted to us — All that is quite boring, besides.

I include in this letter the drawing of a funny figure — and this might be called an OBCESSION [*sic*] — or else — yes — BATTLE OF THE SOMME AND OF THE REST — yes.

It has followed me for a long time, and has contemplated me on numerous occa-

[2] In the French: *un tapotement hamical.* — M.J.

sions in unnamable holes — I think it tries to mystify me a little — I have much affection for him, among other things.

<div style="text-align: right">J. T. H.</div>

Writing on such a paper with the pencil is annoying.

<div style="text-align: center">To Monsieur André Breton</div>

May 9, 1918

Dear Friend,

— It's true that — according to calendar — it's been a long time since I gave you a sign of life — I don't understand Time very well, after all — I have been thinking of you often — one of the very few — who want to tolerate me (I suspect you a little, besides, of mystification) — *Thanks.*

My peregrinations were multifarious — I am conscious, vaguely to put in store all sorts of things — or to rot a little.

WHAT'S GOING TO COME OUT OF ALL THIS, BY GOD.

— I can't be a grocer for the time being — this venture brought no happy success. I tried something else — (Have I tried? — or did they try me to.....) — I can't much write about this now — we get what fun we can — That's that.

Really I am very far from a great many literary people — even from Rimbaud, I am afraid, dear friend — ART IS A STUPIDITY[3] — almost nothing is a stupidity — art should be something funny and a bit boring — that's all — Max Jacob — may really — might be UMOUROUS — but there, you see, finally he took himself seriously, which is a curious infection — And then — to produce? — "aiming so conscientiously to miss the mark" — naturally, written irony is unbearable — but naturally you also know well that VMOUR is not irony, naturally, — *like that* — what do you want, it's like that, and not otherwise — Everything is so amusing — very amusing, that's a fact — everything is so amusing! — (and suppose we killed ourselves too, instead of going away?)

— THIRSTS OF THE WEST[4] — I rubbed my hands one against the other while reading several passages — perhaps — still better a little shorter? — André Derain naturally[5] — I don't understand.....''the firstborn is the angel''—otherwise it's in shape—much more in shape than a certain number of things shown in the Hospital at Nantes.

Your synthetic criticism is very catching — very dangerous besides — Max Jacob, Gris: this escapes a bit my attention.

[3] Breton had apparently quoted in a letter to Vaché that sentence of Rimbaud, from the rough drafts of *Une Saison en enfer.* — M.J.

[4] Title of a poem by Louis Aragon sent to Vaché by Breton (published later in *Feu de Joie,* 1920). — M.J.

[5] Allusion to a poem on André Derain by André Breton (published in 1919 in *Mont de Piété.* — M.J.

— Excuse — my dear Breton, all this not being in shape. I do not feel very well; I live in a lost little hole between stumps of calcinated trees and, periodically a sort of shell drifts, parabolic, and coughs — I exist with an American officer who learns war, chews "gum," and sometimes amuses me — I had a rather narrow escape — during this recent retreat — But I object to being killed in time of war — I spend the greater part of my days strolling in unguaranteed places, from where I see beautiful shellbursts — and when I am in the rear, often, in the brothel, where I like to take my meals — It's rather deplorable—but how can it be helped?

— No — thanks — very much, dear friend — I have nothing in shape for the time being — could NORD-SUD[6] accept something about this sad Apollinaire? — to whom I do not deny some talent — and he would have achieved, I think — something — but he has only quite a lot of talent — He writes very good "essays" (do you remember college?) — sometimes.

And T.F.? Thank him, when you write — for his many letters, so full of amusing observations and good sense — Well.

Your friend,
J.T.H.

Once Vaché wrote a very short, ironical little "tale of horror," "Le Sanglant Symbole" (The Gory Symbol), and the following text, sent to Breton soon after the Armistice, is the nearest to a "poem" in all his writings:

November 26, 1918

—White Acetylene!
All of you! — My beautiful whiskeys — My horrible mixture dripping yellow — colored bowl in a chemist's window — my green chartreuse — citrine — emotion of a Carthamus pink—

Smoke!
Smoke!
Smoke!

Angostura—nux vomica and the uncertainty of syrups—I am a mosaicist. . . . "Say, Waiter—You are a damn fraud, you are—"[7] Look at the bleeding abscess of this prairie oyster; its drowned eye looks at me like an anatomical sample; the barman looks at me too, perhaps, baggy under his ocular globes, pouring the iridescent flow into the rainbow.

6 *Nord-Sud* was Pierre Reverdy's review, published in Paris during World War I (1917-18).—M.J.
7 This sentence is in English in the original text.—M.J.

35

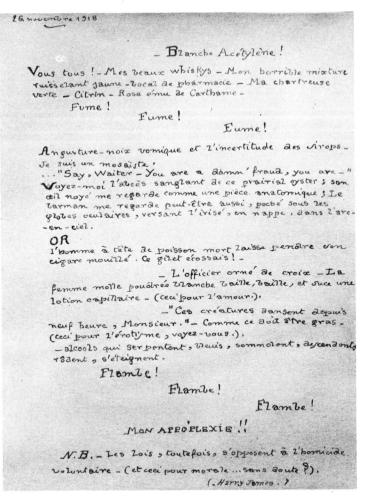

Left: Jacques Vaché, 1917. *Right*: Jacques Vaché: Letter of November 26, 1918.

NOW

The man with a head like a dead fish and a drooping wet cigar. That checked waist-coat!—

—The officer ornamented with crosses—the flabby white-powdered girl yawns, yawns, and sips hair tonic—this for love.

—"These creatures dance since nine o'clock, Sir"—How greasy it must be—(this for eroticism, you see).

—Alcohols turning blue, which meander, doze, ascend, prowl, die out.

<div align="right">*Jacques Vaché*</div>

Flame!

Flame!

Flame!

MY APPOPLEXY!!

N.B.—Laws, however, are opposed to voluntary homicide—(and this for morals.....
probably?)

<div align="right">Harry James</div>

His last letter to André Breton was as detached as ever, mentioning the possibility of a "negative" action. He remained reluctant, or unable, to give definite answers to his friend's persistent inquests on "umour," restoring, carelessly, its *h* to the word, which he wrote in capitals and with roman *v*'s instead of *u*'s.

<div align="center">To Monsieur André Breton</div>

December 19, 1918

My dear André,

. . . I too would like to see you again—The number of keen minds is decidedly very minute—How I envy you being in Paris, able to mystify people who are worth it!—Here I am in Brussels, once more in my beloved atmosphere of tango toward three o'clock in the morning, of marvelous trades, in front of some monstrous double-straw cocktail and of some bleeding smile—I work at funny drawings, with the help of colored pencils on rough paper and I make notes on pages for something—I don't know exactly what. Do you know that I don't know where I am: you were telling me of a scenic action (characters—remember—you were specifying them)—then of wood-cuts for poems of yours—has it been delayed? Pardon me for understanding with difficulty your last sibylline letter: what do you want from me—my dear friend—HVMOVR—my dear friend André . . . that's no mean matter. There is no question here of any Neo-Naturalism—would you, when you are able—enlighten me a little?—I believe I remember that we agreed on leaving the WORLD in an astonished semi-ignorance until some satisfying and perhaps scandalous manifestation. However, and naturally, I rely on you to prepare the way for this deceitful, a little derisive, and in any case terrible God—The fun, you see, if this true NEW SPIRIT were unleashed!

—I received your letter made out of many cuttings pasted together, which filled me with contentment—It's very beautiful, but lacks some extract of a railroad time-table, don't you think? Apollinaire has done much for us and certainly is not dead;

he was right, besides, to stop in time—it has been said before, but we must repeat it: *He marks an epoch.* The beautiful things that we are going to be able to do:—NOW!

—I include an extract of my present notes—perhaps you will put it beside poems of yours, somewhere, in what T. F. calls "the newssheets of ill renown"—what is new with this latter people?—tell me all that. Did you see how he won this war for us!

—Are you in Paris for some time?—I expect to visit there in about a month from now, and see you at all costs.

<div style="text-align: right">Your friend
Harry James</div>

"To stop in time" Did Vaché think that it was high time for him to stop, not yet having begun? He returned to Nantes, his native town, where, January 6, 1919, he and another young man were found dead, in a hotel room. Accident or suicide? They had both taken an overdose of opium.

Pierre Reverdy

A writer of a tense nature in the lineage of Rimbaud and also of Mallarmé, at the same time a keen theoretician of poetry, Reverdy composed intimate and dreamy, cryptic notations. After the end of World War I, André Breton, Louis Aragon, Philippe Soupault, and Paul Eluard often sought the company of a man whose conversation created an enchanting atmosphere. A number of surrealist poems derive, more or less perceptibly, from a certain pattern whose originator is Reverdy. The two pieces below, "Belle Etoile" and "Auberge," are dated respectively 1915 and 1918.[1]

In the Open

I may have lost the key perhaps, and around me they all laugh and everyone shows me an enormous key hanging at his neck.

I am the only one who has no way of entering somewhere. They have all disappeared and the closed doors leave the street more dreary. No one. I will knock everywhere.

Curses spout out of the windows and I move away.

Then, a little farther outside the town, near a river and a wood, I found a door. A simple gate without a lock. I went behind it and, under the night which has no windows but wide curtains, between the forest and the river that protect me, I could sleep.

[1] They appeared respectively in *Poèmes en Prose* (Paris: privately printed, 1915) and *La Lucarne ovale* (Paris: privately printed, 1916).

Pierre Reverdy, 1925. Engraving after a
portrait by Picasso in *Ecumes de la Mer* (Sea
Foam), 1925.

Inn
An eye closes

 Over there flat against the wall
 the thought which does not come out

 Ideas are going away step by step

 We could die
What I hold in my arms could leave

 A dream

Hardly born the dawn draws to a close
 Clankings
When the shutters opened they abolished it

 If nothing would come

There is a field where we could always run about

No end of stars

And your shadow at the end of the avenue

It fades

We saw nothing

Of all that passed by we kept nothing

As many ascending speeches

Tales which we never read

Nothing

The days which throng at the exit

At last the cavalcade has vanished

Down below between the tables where they played cards

Reverdy expressed his ideas on poetry mainly in his magazine, *Nord-Sud,* giving, for instance, for the nature of the poetic image, the following definitions and comments, which appeared in no. 13 of the review (March 1918) and were later quoted, discussed, and paraphrased time and time again by the surrealists:

The Image

The Image is a pure creation of the mind.

It cannot be born from a comparison, but from two realities, more or less distant, brought together.

The more the relation between the two realities is distant and accurate, the stronger the image will be—the more it will possess emotional power and poetic reality.

Two realities that have no relation whatever cannot be brought together effectively. No image is created.

Adverse realities cannot be brought together. They oppose each other.

Strength is seldom obtained from such an opposition.

An image is not strong because it is *brutal* or *fantastic*—but because the association of ideas is distant and accurate.

The result obtained immediately controls the accuracy of the association.

Analogy is a means of creation—it is a *resemblance of relations;* but the strength or the weakness of the image thus created depends on the nature of these relations.

What is great is not the image—but the emotion it provokes; if the latter is great the image will be valued in proportion.

The emotion thus provoked is poetically pure, because it is born outside of all imitation, of all evocation, of all comparison.

There is surprise and joy when we are confronted with a new thing.

We do not create an image by comparing (always weakly) two disproportionate realities. We create, on the contrary, a strong image, new to the mind, by bringing together, without comparison, two distant realities, whose relations have been grasped *solely by the mind.*

The mind must grasp and appreciate, unalloyed, a created image. . . .

Lautréamont

In March 1919, Breton, Aragon, and Soupault founded the review *Littérature*. This title had been suggested to them by Paul Valéry as an ironical reminder of Verlaine's "Art Poétique":

> *Que ton vers soit la bonne aventure*
> *Eparse au vent crispé du matin*
> *Qui va fleurant la menthe et le thym,*
> *Et tout le reste est littérature.*

> (Let your verse be a happy venture
> Dispersed in the crisp morning wind
> Blowing fragrant with mint and thyme,
> And all the rest is literature.)

The new poetry cared little for Verlaine's elegiac perfumes, and much more for "the rest," above all for the violent odors of the poetry of Rimbaud. But perhaps the most important revelation brought about by *Littérature* — although, in the last analysis, it was, in spirit, very different from the lessons of Rimbaud and modern poetry — was the publication in the second and third issues of the magazine (April and May 1919) of *Poésies*, a short collection not really of "poems" but of aphorisms, by Isidore Ducasse.

Ducasse had died November 23, 1870 at the age of twenty-four — the same year that had seen the blossoming of Rimbaud's genius — leaving no other traces than two books, a few letters, and a skeleton biography. Born in Montevideo, Uruguay, of French parents, Ducasse went to school in France, in the southern provinces, where his family had originated, then came to Paris, where he died in a hotel room on the Rue du Faubourg Montmartre, "sans autres renseignements" ("with no other information"), according to a police report at his death. At that time the Franco-Prussian war was on, and Paris was besieged by the German armies.

Of the small booklet entitled *Poésies*, published shortly before the author's death, only

one copy survived, at the Bibliothèque Nationale in Paris, and it was from that copy that Breton transcribed the text reproduced in his review.

In 1868-69, before *Poésies*, Ducasse had published *Les Chants de Maldoror*, under the pseudonym of the "Comte de Lautréamont." It was a work of much more imposing size than *Poésies* — six long cantos in the most exalted prose, full of terrifying and extraordinary episodes, so bizarre that some critics or writers whose attention had been called to this strange production considered it a psychopathic manifestation. The *Chants* were also out of print in 1919, and although the book was not so near total disappearance as *Poésies*, it was very difficult to obtain.

Lautréamont's fantastic novel and the torrential imagination it revealed aroused the wonder of Breton and his friends. Soon it overshadowed Reverdy's definitions, and Lautréamont's influence prevailed in many ways over Apollinaire's, Mallarmé's, and even Rimbaud's.

THE LAY OF MALDOROR [1]

Canto I, 5th stanza

All my life, and without a single exception, have I seen narrow-shouldered man do senseless things, brutalise his fellows, and in every manner corrupt their souls. The motive of his behaviour he calls: Glory. Seeing these things, I would have laughed like others: but that weird imitation was impossible. I have taken a penknife whose blade has a keen edge, and have split my flesh where the lips join. For a moment I thought my end achieved. I contemplated in a mirror this mouth wounded of my own will! It was a mistake! The blood which flowed abundantly from the wounds made it impossible, besides, to ascertain whether it was really the laughter of others. But, after some moments of comparison, I saw clearly that my laughter did not resemble that of mankind, that is to say I was not laughing. I have seen men, ugly headed and with terrible eyes buried deeply in the dark orbit, outdo the hardness of rock, the rigidity of cast steel, the cruelty of the shark, the insolence of youth, the insensate fury of criminals, the hypocrites' betrayals, the most extraordinary comedians, the strength of character of priests, and those most frigid beings of heaven and earth who are most hidden outwardly; exhaust moralists in discovering their hearts, and cause the implacable anger from on high to fall upon them. I have seen them all together, either the most powerful fist raised against the heavens, like that of an already perverse child lifted against its mother, probably incited by some infernal spirit, their eyes charged with a remorse burning even when malignant, not daring, in the glacial silence, to utter those vast and ungrateful meditations which are concealed in their breasts,

[1] The following excerpts of the *Chants* are from John Rodker's translation, which was published in an edition of 1,000 copies, privately printed for subscribers by the Casanova Society, Paris, 1924, under the title *The Lay of Maldoror*.

they are so full of horror and injustice, and saddening the god of pity with compassion; or, at every moment of the day, from the beginning of infancy to the conclusion of age, casting incredible anathemas, without common sense even, upon every breathing thing, upon themselves and upon providence, prostituting women and children and dis-honouring those parts of the body sacred to shame. Then, the seas lift their waters, swallowing into their abysses all planks; hurricanes, earthquakes, destroy the houses; plagues and diverse ills decimate the praying families. But man is not aware of it. Also I have seen him blush and pale shamefacedly because of his behaviour on this earth; though rarely. Tempests, sisters of the hurricane; bluish firmament, whose beauty I do not admit; hypocrite sea, image of my heart; earth, of the mysterious bosom; inhabitants of the spheres; the whole universe; God, who with magnificence has created it, it is you that I invoke: show me a man who is good! . . . But, let your grace centuple my natural powers, for I may die of terror beholding the monster: men have died of less.

Concluding the long eighteenth stanza of the second canto, the description of the loves of Maldoror and a female shark follows an account of a shipwreck.

Canto II, 18th stanza

What is that army of marine monsters swiftly cutting the waves? There are six; their fins are powerful and open up a way through the towering billows. Of all these human beings waving their four limbs in this hardly stable continent, the sharks soon make an eggless omelette, and divide it according to the law of the stronger. Blood mixes with water, and water mixes with blood. Their fierce eyes light up the scene of carnage. . . . But what tumult of water arrives now on the horizon? One would think a waterspout were approaching. What vigour! I see what it is. An enormous female shark arrives to take her share of the pâté de foie, and to partake of cold meat. She is furious, for she arrives starving. A battle begins between her and the other sharks in dispute for the few palpitating limbs which float here and there, in silence, on the surface of the ruddy cream. To right, to left, her jaws snap and give mortal wounds. But three living sharks still surround her and she is compelled to turn in all directions to outwit their manoeuvres. With growing emotion, unfelt till then, the spectator on the shore follows this new kind of naval battle. His eyes are glued on the female shark, whose teeth are so strong. No longer does he hesitate, but shoulders his gun, and, with his usual skill, at the moment when one of the sharks shows itself above a wave, lodges his second ball in its gill. Remain two sharks who manifest only a stronger obstinacy. From the top of his rock, the man with the jaundiced saliva throws himself

into the sea and swims towards the agreeably tinted carpet, holding in his hand the knife of steel which never quits him. Now, each shark has to deal with an enemy. He moves towards his tired adversary, and, biding his time, buries the keen blade in its belly. The mobile fortress rids herself easily of the last enemy.... The swimmer and the female shark saved by him find themselves together. They regard each other fixedly for some moments, and each is interested to find such ferocity in the expression of the other. They swim circling round, but keep each other well in sight, soliloquising: "I was mistaken up till now; there is someone who is more evil." Then with a common accord, with a mutual admiration, they slide towards each other between two waves, the female shark with her fins parting the waves, Maldoror striking the billows with his arms, each holding back his breath in profound veneration, each anxious to contemplate his speaking likeness for the first time. At eight yards from each other, without any effort, they fall suddenly against each other, like two magnets, and embrace with dignity and gratitude, in a clasp as tender as that of a brother or a sister. Carnal desire closely follows this amicable display. Two sinewy thighs, like two leeches, fasten closely to the monster's viscous skin; and arms and fins interlace with love about the body of the loved object, while throats and breasts soon form but a glaucous mass exhaling the smells of seaweed; in the midst of the raging storm, and the flash of lightnings, with the spumy wave for their hymeneal bed, swept along by an undercurrent as though in a cradle, and rolling over each other towards the depths of the abyss, they cling together in a long, chaste and hideous copulation!... At last, I had found someone who was like me!... From that moment, I was no longer alone in the world!... She had the same views as myself!... I was face to face with my first love!

If the reader feels sickened, exasperated, or bored with the author's gusto at describing such fearful scenes, he has only to expect more shocking horrors or, in the way of apologies, some subtle, intricate, sarcastic, and cruel explanation of the manner of understanding and accepting the story. And in the last stanza of the last canto, Lautréamont's satire, with a sort of masochistic pride, does not spare his own inspiration.

Canto VI, 10th stanza

To mechanically construct the pith of a somniferous tale, it is not enough to dissect stupidities and powerfully brutalise the reader's intelligence with repeated doses, in such a way as by the infallible law of fatigue, to paralyse his faculties for the rest of his life; one must, on the contrary, by the aid of some good hypnotic fluid, ingeniously put him into a somnambulistic impossibility of motion, compelling him to shut his eyes to his own nature, by the fixity of yours. I would say, in order not

to be better understood, but merely to develop my thoughts which are interesting and annoying at the same moment by their very penetrative harmony, that I do not think there is a necessity, to arrive at the proposed end, of inventing a poetry entirely outside the ordinary path of nature, and whose pernicious breath seems to overthrow even absolute truth; but, to produce such a result (conformable, besides, if one really considers, to the law of aesthetics) is not as easy as one imagines; that is what I wanted to say. That is why I make every effort to arrive at it! If death arrests the fantastic skinniness of my shoulders' two long arms, employed in the lugubrious crushing of my literary gypsum, I would at least have the mourning reader able to say: "One must give him his due. He has very much cretinised me. What could he not have done, had he been able to live longer! He is the best professor of hypnotism I know!" These few touching words will be engraved on the marble of my tomb, and my manes will be satisfied! . . .

Such verbal frenzy was still present in *Poésies*, which *Littérature* reprinted in 1919. But in that brief pamphlet, the leading features of *Les Chants de Maldoror* were systematically attacked: Isidore Ducasse had set about to destroy the Comte de Lautréamont's most evident conclusions, that is, the priority of Evil and its domination over mankind, and even over the Creator! Though it seems impossible to speak of Ducasse as the author of the *Chants,* or of Lautréamont as the author of *Poésies,* it is indeed the same writer who, after a furious homage to romanticism in the *Chants,* completely reversed his position and proclaimed in *Poésies* that the highlights of the French language were the academic speeches and the speeches for the awarding of prizes at schools!

POÉSIES

Taste is the fundamental quality that sums up all other qualities. It is the *ne plus ultra* of intelligence. It is only through taste that genius is the supreme health and the balance of all faculties. Villemain[2] is thirty-four times more intelligent than Eugène Sue and Frédéric Soulié.[3] His preface to the *Dictionary of the Academy* will witness the death of Walter Scott's novels, of Fenimore Cooper's, of all possible and imaginable novels. Novel is a false genre, because it describes passions for themselves; the moral conclusion is absent. To describe passions is nothing; it suffices to be born part jackal, part vulture, part panther. We don't care for that. To describe passions in order to submit them to a high morality, like Corneille, is another thing. He who refrains from doing the first

[2] François Villemain (1790-1870) was a professor of French literature, member of the Académie Française, minister of public instruction from 1840 to 1844.—M.J.

[3] Eugène Sue (1804-57) is better known for his enormous novels, *The Mysteries of Paris, The Wandering Jew*, than for his *Lautréamont,* a historical novel from which Ducasse derived his pseudonym. Frédéric Soulié (1800-47) was the author of, among other works, "novels of horror," *The Two Corpses, The Devil's Memoirs.*—M.J.

thing, while remaining capable of admiring and understanding those to whom it is given to do the second one, surpasses, with all the superiority of virtues over vices, him who does only the first one. . . .

The masterpieces of the French language are the speeches for the awarding of prizes at colleges, and the academic speeches. Indeed the instruction of youth is perhaps the most beautiful practical expression of duty, and a good appreciation of Voltaire's works (study the word appreciation) is preferable to these works themselves. — Naturally!

Ducasse founded his criticism of romantic writers, not on talent, but on morals. On this plane, he made no distinction between Alfred de Musset and Lord Byron, for example. He condemned Musset because he considered "Rolla" not a stupid poem, as Rimbaud did,[4] but an *evil* one. Byron, a much greater poet than Musset, received the same treatment.

It is disturbing sometimes to see Ducasse using openly, against his own previous work, the same accusations of insanity, incomprehensible imagination, taste for the gory and the macabre, etc. But his self-insulting style is magnificent!

There are degraded writers, dangerous buffoons, humbugs by the score, dark mystifiers, true madmen, fit to populate bedlam. Their cretinising heads, in which a screw is loose, create giant phantoms, which sink downward instead of rising. Scabrous exercise; specious gymnastics. Away, grotesque illusion! Kindly withdraw from my presence, fabricators by the dozen of forbidden riddles, in which I did not perceive in the past, as I do now, the hinge of their frivolous solutions. Pathological case of a formidable selfishness. Fantastic automatons; point out to one another, my children, the epithet that will put them back into their place.

If they existed, as a plastic reality, somewhere, they would be, despite their obvious, but deceptive, intelligence, the opprobrium, the gall of the planets they inhabit — the shame. Let us imagine them, for one moment, assembled into a society with substances that would be their likes. It is an uninterrupted succession of battles, undreamed of by bulldogs, banned from France, by sharks and by macrocephalic cachalots; and torrents of blood, in those chaotic regions full of hydras and minotaurs, from where the dove, scared beyond return, wings swiftly away. It is an accumulation of apocalyptic beasts, who know what they are doing. It is a clash of passions, of irreconcilabilities and ambitions, amid the howlings of an undecipherable pride, which draws itself back, and whose reefs and shoals no one may sound even approximately.

But they shall no more impose on me. To suffer is a weakness, when one can refrain from it and do something better. To exhale the sufferings of an ill-balanced splendor is to demonstrate, O moribund ones of the perverse swamps! still less resistance and

4 See above, in the "Lettre du Voyant" (p. 14).

Paris, 23 Octobre. — Laissez-moi d'abord vous expliquer ma situation. J'ai chanté le mal, comme ont fait Mickiewicz, Byron, Milton, Southey, A. de Musset, Baudelaire, etc. Naturellement, j'ai un peu exagéré le diapason pour faire du nouveau dans le sens de cette littérature sublime qui ne chante le désespoir que pour opprimer le lecteur, et lui faire désirer le bien comme remède. Ainsi donc, c'est toujours le bien qu'on chante en somme, seulement par une méthode plus philosophique et moins naïve que l'ancienne école, dont Victor Hugo et quelques autres sont les seuls représentants qui soient encore vivants. Vendez, je ne vous en empêche pas : que faut-il que je fasse pour cela ? Faites vos conditions. Ce que je voudrais, c'est que le service de la critique soit fait aux principaux lundistes. Eux seuls jugeront en 1er et dernier ressort le commencement d'une publication qui ne verra sa fin évidemment que plus tard, lorsque j'aurai vu la mienne. Ainsi donc, la morale de la fin n'est pas encore faite. Et cependant il y a déjà une immense douleur à chaque page. Est-ce le mal, cela ? Non, certes. Vous me direz reconnaître au fur et à mesure que, si la critique en disait du bien, je pourrais dans les éditions suivantes retrancher quelques passages trop puissantes. Ainsi donc, ce que je désire avant tout, c'est être jugé par la critique, et, une fois connu, ça ira tout seul. C. A. I. — Isidore Ducasse, rue du Faubourg-Montmartre, No 32.

Bibliothèque de M. J. D.

LES CHANTS

DE

MALDOROR

PAR

LE COMTE DE LAUTRÉAMONT

(CHANTS I, II, III, IV, V, VI)

PARIS

EN VENTE CHEZ TOUS LES LIBRAIRES

1869

Tous droits de traduction et de reproduction réservés

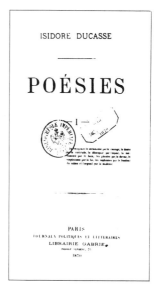

ISIDORE DUCASSE

POÉSIES

I

PARIS

JOURNAUX POLITIQUES ET LITTÉRAIRES

LIBRAIRIE GABRIE

1870

Left: Isidore Ducasse: Letter of October 23, 1869, to his publisher, discussing his aims in *The Lay of Maldoror* and insisting the book be put on sale and sent to critics: "What I desire, above all, is that critics pass judgment on me, and once I am known, everything will be easy." *Top right*: Comte de Lautréamont: *Les Chants de Maldoror*, 1869. Title page of the first edition. *Bottom right*: Isidore Ducasse: *Poésies*, 1870. Title page of the only existing copy, at the Bibliothèque Nationale, Paris. (Photographs: Bibliothèque Nationale, Paris)

courage. With my voice and my solemnity of the great days, I call you back to my deserted home, glorious hope. Come and sit by my side, wrapped in the cloak of illusions, on the reasonable stool of appeasements. Like a cast-off piece of furniture, I routed you from my house, with a scorpion-lashed whip. If you wish me to be convinced that you have forgotten, in returning to my home, the pains that, under the sign of remorse, I have in the past inflicted on you, by God! then bring back with you the sublime pageant—support me, I am fainting!—of the offended virtues and their imperishable reestablishment.

Humor, which is also evident in the excessive descriptions of the *Chants,* may be called upon to explain the destructive epithets of *Poésies;* it is one of the most remarkable and constant traits of the author's style and thought. But it can hardly account for a complete reversal of points of view and attitudes. We see now Ducasse considering almost all authors of the past— many of whom inspired him in his *Chants* to be exponents of evil: Balzac, Hugo, Young, Euripides (all periods and languages included in the same curse), Walter Scott, Flaubert, Baudelaire, who in *Poésies* is called "the morbid lover of the Hottentot Venus,"[5] James Fenimore Cooper, Dante, and Milton ("foremost species of hyenas"), Shakespeare ("each time I have read Shakespeare, it seemed to me that I tore in shreds the brains of a jaguar") and finally Gérard de Nerval ("nobody would use [his] necktie").[6]

It seems beautiful, sublime, under pretext of humility or pride, to dispute final causes, to distort their stable and known consequences. Undeceive yourselves, for there is nothing more stupid! Let us link together again the regular chain with past times; poetry is geometry par excellence. Since Racine it has not progressed one millimeter. It has receded. Thanks to whom? To the Great Softheads of our time. Thanks to the weaklings: Chateaubriand, the Melancholy Mohican; Sénancourt, the Man in Petticoats; Jean-Jacques Rousseau, the Grumpy Socialist; Ann Radcliffe, the Dotty Specter; Edgar Poe, the Mameluke of Alcoholic Dreams; Maturin, the Crony of Darkness; George Sand, the Circumcised Hermaphrodite; Théophile Gautier, the Incomparable Grocer; Leconte de Lisle, the Devil's Captive; Goethe, the Suicide for Sobs; Sainte-Beuve, the Suicide for Laughs; Lamartine, the Tearful Stork; Lermontov, the Roaring Tiger; Victor Hugo, the Funereal Green Beanpole; Mickiewicz, Satan's Imitator; Musset, the Dandy without an Intellectual Shirt; and Byron, the Hippopotamus of Infernal Jungles.

Yet the first part of the pamphlet ends with a sentence echoing Shakespeare: "All the waters of the seas could not wash away an intellectual bloodstain." This stain appears to be

[5] An allusion to Jeanne, Baudelaire's mulatto mistress.

[6] Nerval committed suicide by hanging himself with his necktie.

an *inkstain,* produced by the dark blood dripping from the pens of romantic writers; the image refers also to one of Maldoror's favorite monsters, a sea creature that itself emits a black fluid—the octopus.

The above sentence is the first example in *Poésies* of a process used throughout the greater part of the second section of the booklet: Ducasse "corrects" maxims by famous moralists, mainly Pascal's in his *Pensées* and Vauvenargues's in his *Maximes,* aiming at eliminating all "evil" presences from these thoughts. For instance, the well-known passage in the *Pensées:*

Man is but a reed, the weakest in all Nature; but he is a thinking reed. The whole universe need not take arms to crush him: a vapor, a drop of water are enough to kill him. But if the universe killed him, man would be still nobler than what kills him, for he would know he dies; and the universe would know nothing of the advantage it has over him . . .

is corrected by Ducasse as follows:

Man is an oak. There is none more robust in all Nature. The universe must not take arms to defend him. A drop of water is not enough to protect him. Even if the universe would defend him, man would no more be dishonored than that which does not protect him. Man knows that his reign has no death, that the universe had a beginning. The universe knows nothing; it is, at the most, a thinking reed.

Ducasse's scornful intentions are still more visible in the correction of another famous Pascalian *pensée* (which indeed leaves the candid reader a bit dubious about its profundity): "If Cleopatra's nose had been longer, the face of the world would have changed." Ducasse writes: "If Cleopatra's morals had not been so short, the face of the world would have changed. Her nose would not have become longer."

Vauvenargues's *Maximes* are treated along similar lines. In the following examples (Vauvenargues's original thoughts are in italics), we may witness in full light the process of the "elimination of Evil."

The moderation of great men limits only their vices.
The moderation of great men limits only their virtues.
We despise great schemes when we feel ourselves incapable of great successes.
We value great schemes when we feel ourselves capable of great successes.
Apprenticeship is the restraint of minds.
Restraint is the apprenticeship of minds.
We say few sound things when we try to say extraordinary ones.
We say sound things when we do not try to say extraordinary ones.

Ducasse sets aside the lessons of moralists who refer only to failings and defects in man, and he extends the consequences of this attitude to the domain of poetry. Poetry becomes an

"impersonal poetry" relying on "reason, which operates on faculties presiding over the category of phenomena of pure goodness," a poetry that is no longer an expression of personal feelings but an "analysis of feelings"—and the analysis of feelings defines classical poetry. Then, in a world where evil is nonexistent, the following maxim would come true: "Poetry must be made by all, not by one."

Surrealism has made its own several sentences by Lautréamont-Ducasse, especially these two: the first is the comparison in *Les Chants de Maldoror:* "Beautiful as the chance encounter, on a dissecting table, of a sewing machine and an umbrella"—a striking illustration of Reverdy's definition of the image, a model for all surrealist metaphors and associations of ideas, whether in written or plastic poetry, because of the "distance" between the elements in play and the accuracy of their mutual relations. A psychological translation of the words "table," "sewing machine," and "umbrella" into "bed," "woman," and "man" shows the apparently absurd image as the image of the act of love.

The second key sentence is the aphorism reproduced above, from *Poésies:* "Poetry must be made by all, not by one." Curiously enough, the surrealists have always referred to this maxim in a romantic context; in other words, it has always been understood as affirming the capacity of everyone to express poetically his individuality, his personal feelings and emotions, his "originality"—an interpretation absolutely alien to the letter and the spirit of *Poésies,* as if words "belonging to good" had been used in an "evil" manner, to take up again an expression of Ducasse's. Neither the poetry and art of our days, which remain essentially romantic, individualistic in spirit, nor any present philosophy or social system—Marxism, less than any other, and still less the Communist practice of Marxism—may avail itself of a maxim belonging to a world of nonexistent evil, and find references in a superclassical manifesto such as *Poésies.*[7]

The fact is that the immense shadow of *Les Chants de Maldoror* has always obscured the light of *Poésies,* itself a blinding one since the principle of nonexistence of evil seems a very "nonhuman" idea. In any case, it was an ironical fate for this latter work, which extolled "the coldness of the maxim," to have its aphorisms, separated from their context, become mere emotional slogans.

The dialectics of the movement from the *Chants* to the *Poésies* may be understood only after a clear and thorough analysis of the two works.[8] The metaphors of Lautréamont, his *Maldoror* as a whole, reach a climax of romanticism; the poem will live as long as Lucifer remains the Light Bearer and evil the dynamic notion ruling the universe. *Poésies* belongs to a future era, when the disappearance of evil will give birth to a poetry of absolute classicism, of which, to this day, only Ducasse has dreamed.

[7] Except Proudhon's theories on "an-archism," which seem to have influenced Ducasse in *Poésies.*

[8] See for a complete discussion of the works of Lautréamont-Ducasse, *Oeuvres complètes de Lautréamont* commented by Marcel Jean and Arpád Mezei (Paris: Eric Losfeld, 1971); *Maldoror,* by the same authors (Paris: Editions du Pavois, 1947), the first decisive study of the "mystery of Lautréamont" (excerpts pp. 425-27 of this anthology); and *Genèse de la pensée moderne,* by the same authors (Paris: Corrêa, 1950), chapters 7-14.

GENESIS

LITTÉRATURE

DIRECTION :
9, Place du Panthéon, 9

Cover of *Littérature*, no. 1 (March 1919).

Littérature

In the first year of its existence *Littérature* followed in the footsteps of Pierre Reverdy's magazine *Nord-Sud,* which itself was a continuation of Apollinaire's *Les Soirées de Paris.* Most contributors to *Littérature* were well known among modern writers: Max Jacob, André Salmon, Blaise Cendrars, Léon-Paul Fargue, Reverdy, André Gide, Paul Valéry, Jules Romains, Valery Larbaud, Paul Morand, Ramón Gómez de la Serna. Musicians were also represented by their poetic pieces or reviews of musical events—Igor Stravinsky, Darius Milhaud, Georges Auric. The review's founders, Louis Aragon, André Breton, and Philippe Soupault, published their poems in many issues, as did Paul Eluard; the two examples below, respectively, "Pierre fendre" by Aragon and "Clé de sol" by Breton, appeared in *Littérature,* no. 1 (March 1919).

Freezing Hard

> Winter days wood chips
> My friend with the reddened eyes
> Follows the icy burial
> I am jealous of the dead

People drop down like flies
They whisper that I am wrong
Blue sun-chapped lips
I wander in the streets I don't mean any harm
With the image of the taste and the shadow of the trapper

> They give parties for me
>> oranges
> Teeth Shivers Fevers Fixed Idea
> All braziers go to the scrap-iron market
> All that is left to me is to die from cold in public

G Clef

We can follow the curtain
Love goes away
 Anyhow
A grand piano
 Everything is lost
 Help
The precision weapon
 Flowers
In the head are ready to blossom out
 Theatrical twist
The door gives way
The door is of music

In no. 2 (April 1919) appeared "L'Heure du Thé," by Philippe Soupault:

Tea Time

To Mme. Marie Laurencin

 The mirror is in the garden
 Everybody
 And besides
 The bird lights up
 We have lost our way
 Romance
 That is all
 Do we know
 The curtain
 The night and the summer
 The fan is a farewell

The third issue (May 1919) carried "Vache," by Paul Eluard:

Cow

 They do not lead the cow
 To the shorn dry turf
 To a greenery devoid of caresses

The grass which receives it
Must be soft as a silk thread
A silk thread soft as a milk thread

Unknown mother
For the children it isn't lunch
But milk on the grass

The grass before the cow
The children before the milk

In the fourth number (June 1919) André Breton, in "Le Corset Mystère," combined the techniques of both Apollinaire's *calligrammes* and cubist *papiers collés*. Since no translation could do justice to this visual-intellectual combination of sentences, the poem is given here in its original form.

Le Corset Mystère

Mes belles lectrices

à force d'en voir **de toutes les couleurs**

Cartes splendides, *à effets de lumière*, Venise

Autrefois les meubles de ma chambre étaient fixés

solidement aux murs et je me faisais attacher pour écrire :

J'ai le pied marin

nous adhérons à une sorte de **Touring Club**

sentimental

UN CHATEAU A LA PLACE DE LA TÊTE

c'est aussi le **Bazar de la charité**

Jeux très amusants pour tous âges; **Jeux poétiques,** etc.

Je tiens Paris comme — pour vous dévoiler l'avenir —

votre main ouverte

la taille bien prise.

ANDRÉ BRETON.

Among new young literary magazines *Littérature* was by far the most alive, and certainly much more so than the well-established monthlies. It brought to light many unpublished pages of the first importance: *Poésies* by Isidore Ducasse, Jacques Vaché's "Lettres," unknown pieces by Rimbaud (*Les Mains de Jeanne-Marie* [Jeanne-Marie's Hands]), Mallarmé, Charles Cros, Apollinaire, and others. *Littérature* reflected the younger generation's keen interest in the American films that were beginning to invade Europe — lyrical or delirious productions of the heroic days of the movies, starring William Hart, Charlie Chaplin, Harold Lloyd, which Philippe Soupault praised in short reviews. There were also brief notes by Aragon, Eluard, and Soupault, on books, shows, exhibitions, and magazines that the reviewers liked or disliked; also an article by Soupault on J. M. Synge; and by Breton, this text on Chirico (in no. 11, January 1920):

Giorgio de Chirico

"When Galileo sent rolling upon a slanting plane spheres whose heaviness he himself had determined, or when Torricelli made air bear a weight that he knew equal to a certain column of water, then a new light shone for all physicists."

We have an imperfect idea of the Seven Wonders of the antique world. In our days a few sages — Lautréamont, Apollinaire — have dedicated the umbrella, the sewing machine, the top hat to universal admiration. With the assurance that nothing is incomprehensible and that everything, if necessary, may be used as a symbol, we are expending treasures of imagination. To imagine the sphinx as a woman-headed lion was poetic in former days. I believe that a true modern mythology is in the making. It lies with Giorgio de Chirico to give an imperishable shape to its memory.

God made man in his own image; man made the statue and the mannequin. The need to consolidate the former (pedestal, tree trunk) and to adapt the latter to its function (pieces of varnished wood taking the place of the head, the arms) is the motive of all the concerns of this painter. We cannot doubt that the style of our dwellings interests him in the same way, as well as the tools we have already built with an eye to new constructions: squares, protractors, geographic maps.

By nature this mind was prepared above all for a revision of the sensible data about time and space. The branches of the genealogical tree blossom all over the place. A certain orange light appears simultaneously as a candle flame and as a starfish. Dihedral angles. However, Chirico does not suppose that a ghost may enter a room except through the door.

They say that all this has nothing to do with painting. But the Colossus of Rhodes and the Temple of Ephesus, we know them thanks to Philo of Byzantium, a Greek engineer and tactician, the author of treatises on the art of sieges and the manufacture of war machines (end of third century B.C.).

In this early text by Breton, the negligent display of erudition recalls Apollinaire's style. There is also an echo of Vaché ("everything may be used as a symbol"), and it is curious to find, from Ducasse's *Poésies,* the sentence "nothing is incomprehensible" in relation to the painter of enigmas.

Breton published a collection of poems in 1919, *Mont de Piété,*[1] in which "Forêt-Noire" shows the characteristic influence of Reverdy.

Black Forest [2]

<div style="text-align:center">Out</div>

Tender capsule etc. bowler hat
Madame de Saint Gobain is getting bored alone
A cutlet fades

<div style="text-align:center">Fate in relief</div>

Where without shutters this white gable
 Waterfalls

 Lumberjacks are favored

 It's blowing hard

"How healthful is the wind" the wind of dairies
 The author of "The Inn of the Guardian Angel"
Died all the same last year
Seasonably

From Tübingen to meet me
Come young Kepler young Hegel
And the good comrade

During the last months of 1919, Breton and Soupault published in *Littérature* fragments of a collection of texts entitled *Les Champs magnétiques.* The complete book appeared the following year, showing the results of the authors' experiments in noncontrolled, "automatic" writing. We are very far, suddenly, from the Reverdy-influenced poems, very far from "Forêt-Noire," which its author said he spent six months writing without losing sight for one moment of its construction. In contrast, *Les Champs magnétiques* was written in disconnected daily segments (most of the time, probably, on café tables). Breton pointed out later that "each chapter had no other reason to end than the end of the day when it began."

[1] Literally, "Mount of Piety," the current term in France for state-owned pawnshops.
[2] Rimbaud speaks.

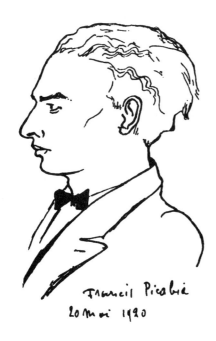

Francis Picabia: Drawing of Philippe
Soupault, 1920. From *The Magnetic Fields*
by André Breton and Philippe Soupault.
(Paris, 1920),

THE MAGNETIC FIELDS

Prisoners of water drops, we are but perpetual animals. We run about in noiseless towns and the bewitched posters do not move us any more. Why these great frail enthusiasms, this desiccated joyous jumping? We know nothing from now on, but dead stars; we look at faces, and we sigh with pleasure. Our mouths are drier than lost beaches: our eyes turn aimlessly, hopelessly. What else remains but these cafés where we meet to drink these cool beverages, these watery spirits, and tables are stickier than these pavements where our shadows fell, dead the day before.

Sometimes, the wind embraces us with its big cold hands and ties us to trees, clear-cut against the sun. We all laugh, sing, but no one any longer feels his own heart beating. Fever leaves us.

The wonderful railway stations will never more shelter us, we are afraid of long corridors. So we must again suffocate in order to live through these flat instants, these centuries in tatters. Once we loved suns at the close of the year, the narrow plains where our gaze flew like those impetuous rivers of our childhood. Only reflections remain in these woods repopulated with absurd animals, with well-known plants.

The towns that we want no longer to love are dead. Look around: there is only the sky and these great waste lands that in the end we shall come to detest. Over there,

we are told, were prodigious valleys: rides at full gallop lost forever in that Far West as boring as a museum.

When the great birds take flight, they rise silently, and the streaked sky resounds no more with their calls. They pass over lakes and fertile swamps; their wings brush aside the too languid clouds. We are not even allowed to sit; at once, laughter rises and we must shout out our sins, very loudly.

One day, whose color is now forgotten, we discovered tranquil walls, stronger than monuments. We were there and our widening eyes let joyous tears fall. We said: "Planets and stars of the first magnitude cannot compare with us. But what is this power, more terrible than the air? Beautiful August nights, adorable twilights at sea, we do not care for you! Chlorox and the lines in our palm will lead the world. Mental chemistry of our schemes, you are more powerful than those cries of agony and the coarse voices of the factories!" Yes, that evening, more beautiful than all other evenings, we could weep. Women went by and held out their hands, offering their smile like a bunch of flowers. The preceding day's cowardice wrung our hearts, and we turned our faces away not to see the fountains rejoining the other nights.

Only ungrateful death respected us.

Each thing was in its place, and nobody could speak any longer; each sense became paralyzed and some blind men were more dignified than ourselves.

They made us visit manufacturers of cheap dreams and warehouses full of obscure dreams. It was a magnificent film, the parts were played by old friends. We were losing sight of them and we went there to find them always at the same place. They gave us rotting candies and we told them of our vague, barely shaped happiness. Staring at us, they spoke. Is it really possible to remember these vile speeches, their slumbering songs?

We gave them our heart which was but a pallid singing. . . .

Sometimes the spontaneous collaboration of the two poets took the form of a dialogue:

"Rivers are not mirrors, much better than that has been done in ten years. I can smash all the mirrors in the city we live in with a stone, and insects smaller than the wailing of babies dig voluptuously the foundations of the skyscrapers."

"Without doubt; and still we don't yet witness central plunderings. You're wrong when you believe that our voices are used to fill up significant areas. We weren't born such a long time ago."

"Alas! A friend of the family had given me a medusa and also, in order that this respectable animal not be famished, a green liquor containing copper water. The invertebrate declined quickly and when, two days after its death, we cleaned the bowl,

we had the joy of discovering a mauve-colored shell called chalcedony."

"Things like that happen. I could tell you myself about the beautifying process that followed the visit of the President of the Republic. From a bunch of keys he placed in a glass case, an official clock was born that struck restoring time."

"There were also that same day obese women whose plumed hats delighted us. Guests threw cakes out of the windows and everybody forgot the purpose of the party."

"I don't look as far ahead as you do. To have a good time and to laugh, isn't that the ideal of people in our century? Women want plush shoes and pale satin kimonos. There's a lot of talk about that charming way of shaking sentimental bottles before use."

"The shortest memories are the best, and if you'll take my word for it, look at the hustled anger of these house painters. The bride runs, nobody knows where, and we've got no more matches."

"As you say, orange blossoms could not be a substitute for us. Do you know what'll happen to us? On my way to the principality of Monaco I met very sad simpleminded girls. Perhaps you're in love with them?"

"That's a point to be cleared up, but this beautiful light is disturbing. Everything must be done all over again. I pass along the avenue; a runaway horse enters a public garden: it's a lost evening. . . ."

At other times curious maxims were born in the same automatic way.

The world writes 365 in arabic numerals and has learned to multiply it by a two-figure number.

On the inner side of my arm I have a sinister mark, a blue *M* that threatens me.

Love deep in the wood shines like a tall candle.

My youth in a wheelchair with birds on the future's handle.

In France, God-Our-Father's will of grandeur does not exceed 16,000 feet, altitude calculated from sea-level.[3]

What are we waiting for? One woman? Two trees? Three flags? What are we waiting for? Nothing.

Temptation of ordering a new drink; for instance, a wrecking with a drop of plane tree.

Today or another day they will forget to light the street lamps.

Apollinaire's play *Les Mamelles de Tirésias* (The Breasts of Tiresias; written before 1914

[3] Height of Mont Blanc, highest mountain in France. —M.J.

but not performed until 1917), although termed by its author a "surrealist drama," might have been more accurately called, because of its provoking fantasy, a dadaist piece in anticipation. His gay and destructive futurist manifesto "Antitradition Futuriste," had shown the same spirit as early as 1913. Dada was indeed "in the air," and its name was found in 1916 in Zurich by the poets Hugo Ball and Richard Huelsenbeck, around whom a small circle of writers and artists of various nationalities had gathered—Hans Arp, Tristan Tzara, Marcel Janco, Walter Serner. The group grew quickly in numbers and staged funny, violent, or serious manifestations, most of them in a Zurich café called the Cabaret Voltaire. A magazine entitled *Cabaret Voltaire* was published, with contributions by poets and painters from abroad—Apollinaire, Blaise Cendrars, Amedeo Modigliani, Picasso, F. T. Marinetti—together with pieces by Ball, Huelsenbeck, Tzara, Arp, and others of the Zurich group. The magazine *Dada* followed; its first two issues, in 1917, included texts by Apollinaire, Reverdy, Max Jacob, and the Zurich dadas.

The Zurich group dispersed at the end of the war, as the new spirit was acquiring its full impetus. Soon after the Armistice, Francis Picabia arrived in Switzerland from Barcelona and New York, and his presence in Zurich set ablaze more or less latent fires. For its third issue, December 1918, *Dada,* until then a rather serene publication, underwent a complete typographic revolution and a decided change of contents, with the violent "Manifeste Dada 1918" by Tzara. Soon "dada" became the password of every avant-garde circle in Germany and Central Europe,

From left: Tristan Tzara, Simone Breton, and André Breton
in Philippe Soupault's apartment, Quai de Bourbon. (Paris, 1920)

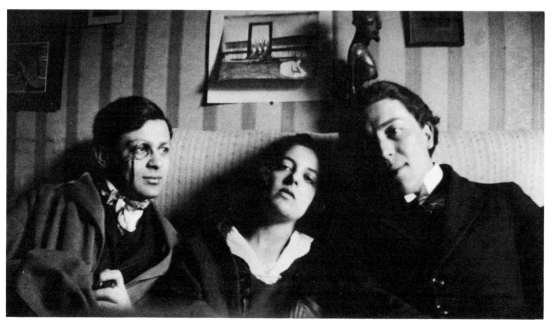

but it did not reach Paris until the first days of 1920, when Tristan Tzara arrived in the French capital.

 Littérature, however, had often advertised the review *Dada* and had published poems by Tzara in each of its issues. His "Maison Flake" appeared in no. 2 (April 1919).

Flake House

start trumpets the vast and hyaline call animals of the sea service
aerostatical forester all that exist ride life at a gallop of light
the angel has white hips umbrella virility
snow lick the road and the verified virgin lilium
altitude 3/25 a new meridian runs this way
the distended bow of my heart a typewriter for stars
he who said to you "the foam choppy with a prodigious sadness-clock"
offers you a word that is not in the dictionary
and want to reach the height

what vapor from a tube of lightning pushes
ours against the eternal and multiform sail
here they do not murder men on the terraces
colored with the intimate succession of slowness

we attempt unheard-of things
quarto editions of mirages micrographs of chromatic souls and of images
we all carry tumult-bells which we shake
for the major feasts on viaducts and for animals
the shape of a dance in octave on a meteor and a violin
a play of mirrors the year that passes
let's have a drink I'm the mad brother
ink of the sky lake of hydromel
opaque wine flake and hammock
practical the quiet and fertile offering
he scratches the sky with his nails
and the skyscraper is but his shadow
in a dressing gown
the year will be among palm trees and banana trees sprung up from the halo in cubes
 of water
simple productive vast music looming up safe into port
and the crimson bread for the future and multiple season
of prettily colored old engravings of kings hunting

pipe and fight in the mud under the ace of spades piper with
the birds and the fresh clouds a lively boat in the beak
from the engine rock to the sparks of good news the Eiffel Tower plays the rebec
here each chair is soft and comfortable as an archbishop
enterprise of asceticism monks guaranteed at all prices—here ladies—flake house

When, in September 1919, the Paris review *Nouvelle Revue Française* accused the dada movement of being "nonsense coming directly from Berlin," André Breton wrote to Tzara, who was still in Zurich, asking him to answer the *NRF,* which did not, however, publish his retort. It was inserted in *Littérature,* no. 10 (December 1919).

Men do not write today with their race, but with their blood (what a banality!). What was *characteristic* in earlier literature is now *temperament.* It amounts to the same thing to write a poem in Siamese or to dance on a locomotive. Naturally older people do not perceive that a new type of man is being created almost everywhere. Intensity is, I believe, everywhere the same, with insignificant racial variations, and if a common feature is to be discovered among those who create today's literature, it will be antipsychology. . . .

Although I try never to miss a chance to compromise myself, permit me to let you know (a certain sense of cleanliness always produced in me a repulsion toward journalistic buildups) that I proposed, three years ago, as a title for a magazine, the word DADA. That happened in Zurich when some friends and I thought we had nothing in common with futurists and cubists. During campaigns against all dogmatisms, and to deride the creation of literary schools, DADA became the "DADA movement." Under the label of this hazy compound, painting exhibitions were organized; I brought out some publications and I aroused the anger of the public in Zurich who attended the art performances of this illusory movement. In the "Manifeste DADA 1918," I declined all responsibility for a school launched by journalists and commonly called dadaism. It is only comical, after all, that men who took part in the decay of the old German organism have propagated a school that I never wanted to found.

If one writes, it's only a refuge: from every "point of view." I'm not a professional writer and I don't have literary ambitions. I would have been an adventurer in the grand style, with fine gestures, if I had had enough physical strength and moral stamina to accomplish this one exploit: not to be bored. We write also because there are not enough new men and because of habit; we publish to search for *men,* and to have something to do (even this is very stupid). There might be a solution: to be resigned; simply: to do nothing. But this requires an enormous energy. And we have an almost hygienic need of complications.

Nobody in Paris knew whether or not Tzara was the true inventor of the word *dada* and the unwilling founder of a Tzaraesque school in Germany. What most interested Breton in the above text was probably Tzara's confession that only boredom had prevented him from becoming a great adventurer. This statement, a typically "literary" one, certainly appealed to a writer such as Breton, who was himself as much subject to boredom as many other great *ennuyés* of that age: Picabia, Duchamp, Jacques Rigaut, Tzara. . . . Thirty years later, in his *Entretiens* (Conversations) of 1952, André Breton still spoke admiringly of Tzara's statement about adventure and ennui.

Moreover, a passage in the same text on the reasons for being a writer had given Breton the idea of a literary inquest, which was justly called, afterward, a "trap-inquest." The question "Why do you write?" was put to numerous personalities of the literary world and the answers were published in *Littérature*, nos. 10, 11, 12 (December 1919-February 1920). Many of the replies were extremely, though unintentionally, ridiculous.

Breton certainly wanted his own writings to attract — as they did — spiritual companions; he echoed Tzara's sentence "We publish to search for *men*" in *Les Pas perdus* (The Wandering Steps) in 1924, putting the stress on "publish": "We *publish* to search for men."

After Tzara's arrival in Paris, the young poets enthusiastically entered the dada game like a long-awaited experiment. Soirées and lectures were held on the Zurich pattern, plays performed, and *Littérature*'s thirteenth issue was purely dada in its content: twenty-four manifestoes, by Picabia, Eluard, Breton, Aragon, Tzara, Arp, Soupault, Serner, Paul Dermée, Georges Ribemont-Dessaignes, Céline Arnauld, and W.C. Arensberg. New contributors appeared: the Belgian Clément Pansaers, Arp with short pieces translated from the German, Benjamin Péret, Rigaut, Jean Paulhan.

Francis Picabia had been active as a painter since the turn of the century — an inventor (among other claimants) of abstract art — a close friend of Apollinaire, who ranked him among the orphists — a protodadaist in America with Marcel Duchamp in 1915 — a dadaist in Switzerland after World War I. Back in Paris in 1920, he was by rights a member of the dada group. His magazine *391*, first published in Barcelona, then in Zurich, New York, and Paris, was the purest incarnation of the dada spirit. Scattered among the pages of *391*, or in such booklets as *Jésus-Christ rastaquouère* (Jesus-Christ the Macho; 1920), and later in *Littérature* (new series), his aphorisms express the essence of his pessimistic-humorous mood.

Knowledge is an old error remembering its youth.

Taste is as tiring as well-bred people.

The most beautiful discovery of man is bicarbonate of soda.

Vegetables are more serious than men and more sensitive to frost.

The world is steeped in good taste and ignorance pasted together.

Painting is made for dentists.

Really, it is only mediocre people who have genius during their lifetime.

It rains and I think of the poor people for whom it doesn't rain.

Francis Picabia at La Maison Rose, his home
at Le Tremblay-sur-Mauldre, 1922. (Photograph:
Simone Breton)

Human beings win diplomas and lose their instinct.

The more one pleases, the more one displeases.

The only way to have followers is to run faster than the others.

Spinoza is the only person who never read Spinoza.

It's easier to scratch one's ass than one's heart (St. Augustine).

The unknown is an exception, the known a deception.

A favorable wind has blue feathers.

Tables turn, thanks to the spirit; pictures and other works of art might be called safe-depositables: the spirit is inside and becomes increasingly inspired as the auction prices mount.

Only useless things are indispensable.

"Le Premier Mai" (*Littérature*, no. 14, June 1920) is a prose piece typical of the offhand, desultory manner of Picabia's writings—and his paintings.

May Day
For me a holiday is always more gay
than the day that follows. — F.P.

No poetry, no literature, no antiliterature, write something for *Littérature*. . . .

First of May, well-known atmosphere of Sundays, with a hope for revolution (very difficult to know when a revolution begins and when it ends).[4]

A charming lady friend arrives and asks me to come and visit a small mansion, a delightful one, she says, only a few steps from my house; impossible to say no. Impression: the furniture and other *objets d'art* look as though they have been sold and rebought several hundred times; they seem to have acquired their value through contact with moving vans.

Women do not understand the act of the body. Oh, well, yes! you may be right, you see; beautiful, sweet girl, I am nothing, I love lines......

Two stairs to climb to find a nice room with a southern exposure; from there I see a kitchen garden, in the middle of which enclosed nuns play at hide-and-seek! This makes me believe in May Day, and being a revolutionary, I have a fancy to join the nuns' game. Back home, I tell Tristan Tzara about the emotions of my outing, he too wants to play at hide-and-seek.

But let's talk of serious things: conscience led Sardanapalus and Jesus Christ, who was a man of taste, to prefer star-spangled coffins to the tears they could shed. But no! Jealousy, winter is here, it snows, it's a drama whistled by a pitiless blackbird.

Verlaine had gilded his sex; he had syphilis, cirrhosis of the liver, rheumatism, and genius. Ribemont-Dessaignes is the secretary of Marthe Chenal and of the dada movement, which is the same thing.[5]

I'd very much like to know what a poet is; I am one, I believe, for my blistering mind opens to make a picture and beautiful patient things. Beautiful things, small operations, small infections in the mirror, ludicrous impressions; what a taste the last drop has! O bothered attitude, in the blue and yellow bowels of a yawn.

Baudelaire had a suit made of billiard cloth. Lord Byron in tails, coming out of the opera in Venice, went back to his hotel swimming. Marthe Chenal doesn't give a damn for the "Marseillaise," or for the dada movement, how right she is![6]

My window opens on the country and on the sea; what a leprous disease: to love

[4] May Day still had a political meaning then and was the pretext for a more or less effective general strike; it is now an official holiday in France. — M.J.

[5] It is highly improbable that Ribemont-Dessaignes was actually the secretary of Marthe Chenal, a celebrated opera singer and for quite some time a mistress of Picabia. — M.J.

[6] During World War I, Mme. Chenal, wrapped in the folds of a tricolor robe, had sung the "Marseillaise" on the stage, practically every night; and on the night of the Armistice she sang the anthem from the balcony of the Paris Opera to the crowd outside celebrating the victory. — M.J.

the boredom of a beautiful sight reflecting today's sadness. I don't agree with you, all the plays they give now in Paris are absolutely idiotic. At the end of May, in Paris there will be elephants looking like tobacco pipes, and sublime monkeys too.

Henri Bataille's painting is as stupid as his literature.[7] Oscar Wilde used to stroll in New York, on Fifth Avenue, in knee breeches and socks! I'd like to smoke the tobacco of hummingbirds. No, thanks! I never drink tea. Don't you find that Cocteau's modernism looks like a patch finely darned?

To play the piano on the footbridge; humidity is strange, but we talk like mamma's boys. This is because of boredom, the scarcity of news, and the doctor of white ties. The bottom of the water seems false, a diver shouted from the bottom of the water and his voice sounded false. Madrepore shells give indigestion as does broth on the eyes. I raise my hand, men and women are fountains in the Palais Royal gardens, college graduates are repeater watches.

André Gide, the empty aquarium, does not like Jews, as if there were still Jews! How naïve, dear sir.

Stupidity grows in the month of May like an orange-flower ceiling, except in barracks full of flowers in silent bas-relief. The greenery arranged around trees, a prodigious landscape with straps of clouds, descends on my chest like a drawing. The crow of the cock that gambols in silvery boots will make us dance in a lantern sooner or later. Wipe that out! Nothing more to do, nothing more to see, newspapers are stale decanters. What remains is a dog's life, sad always, it turns around and around us. My eyes are wet, all along the road my blood is powerless against contemptuous glances; put on your eyeglasses to watch the motion of a horse, it's really a public motif.

The first of May is going to end with rain, as it did last year.[8]

The least that can be said of "Le Premier Mai" is that it was written by a very unpolitical and prodigiously bored gentleman.

The dada phenomenon did not change the appearance — cover, size, typography — of *Littérature,* nor did the spirit always change. Dada contributors made dada contributions, but the magazine still published Max Jacob and Reverdy. Neither Jean Paulhan's abstruse, ironical study in linguistics, "Si les mots sont des signes" (If Words Are Signs; nos. 15 and 16), nor the extract from the charming novel by Jean Giraudoux, *Suzanne et le Pacifique* (Suzanne and the Pacific; no. 16), nor the article by Breton on André Derain (no. 18), could be called dadaist in any respect. As for the poetry of Eluard, it also remained unaltered in form and inspiration. The following pieces appeared in no. 15 (July-August 1920).

[7]The name of this once famous playwright, who seems to have been at times an amateur painter, is, perhaps, still remembered today.—M.J.

[8]The editor remembers well that on May 1, 1920, it snowed in Paris, and by nightfall it was raining.—M.J.

The Art of Dancing

The fragile rain, keeping the balance
Of the tiles. She, the dancer,
Will never be able
To fall, to jump
Like the rain.

Worker

To see planks in the trees,
Roads in the mountain,
In the fair age, the age of strength,
To weave iron and to knead stone,
To beautify nature,
Unadorned nature,
To work.

Feasts

Waltzing is pretty,
The great impulses of the heart are pretty too.
Streets,
A wheel was waltzing madly.
Wheels, dresses, hats, roses.
Watered,
The plant will be ready for the anniversary.

Could "Les Chansons des buts et des rois" (Songs of the Aims and the Kings) by Philippe Soupault be called dada poems? The dozen brief pieces, whose title is a pun on Victor Hugo's *Les Chansons des rues et des bois* (Songs of the Streets and the Woods), rank among the very few successful attempts, in the French language, at nonsensical epigrams (*Littérature*, no. 19, May 1921). They do not lose too much of their nonsense when translated into the language of Edward Lear.[9]

[9]Curiously, the first and last of the *chansons* reproduced here appear to be retranslations, since these two pieces were adapted from French by Soupault from English nursery rhymes. See numbers 483 and 548 in *The Oxford Dictionary of Nursery Rhymes,* edited by I. and P. Opie, 1951. Our friend Henri Parisot, who prepared French translations of these traditional little pieces, was the first to discover, through the *Dictionary,* Soupault's brilliant imitations.

Songs of the Aims and the Kings

If the world were a cake
if the sea were black ink
and if trees were all street lamps
what would be left for us to drink?

Mr. Mirror the old-clothes man
dies yesterday night in Paris
 it is night
 it is dark
it's a dark night in Paris

I buy a gun
so much the better
I kill a bystander
so much the better
I sell my gun
 Thank you

Philippe Soupault in his bed
 born Monday
 baptized Tuesday
 married Wednesday
 sick Thursday
 dying Friday
 dead Saturday
 buried Sunday
that's the life of Philippe Soupault

Let us also quote this note by Philippe Soupault (*Littérature,* no. 14, June 1920) about the Théâtre Moderne, a sordid little theater in the Passage de l'Opéra, which was a thoroughfare famous in the annals of presurrealism.

Théâtre Moderne: *Fleur-de-Péché* [Flower-of-Sin].

We dance around long whistling pleasures. Nothing is forbidden in this theater at the end of an arcade. It is not that they are afraid there of saying too much, but they know that nothing lasts. Puns, plays on words, cross the footlights, become iridescent, float, then burst out. The settings are made of conventions and the lightnings of illusions. The author of the play shows us a "woman of fire," a prudish mother, a foreign girl

in search of "strong sensations," and geishas, who appear only to leave regrets behind them. The main characters, the strangest ones, never act thoughtlessly, first of all Flower-of-Sin, her servant, Langdru, and then the bonze. The whole play is built on misunderstandings, an essential principle of theater art, and on the rule of Nowhere.

From my seat, where I can watch rats running down the aisles and swans painted on mirrors, I forget Paris, the time, and my years. The scene is set in Japan, but the author, instead of aiming at resemblance, neglects local color and rocks the audience with lies. His sole aims are entertainment and the awakening of desire. Do not laugh, he knows how to be tragic. Listen to Flower-of-Sin:

> The house of my heart is ready
> And opens only to the future.
> Since there is nothing I regret,
> You may come, my fair lover.

The Passage de l'Opéra, named after the opera house destroyed by fire in 1867, connected the Rue Le Pelletier and the boulevards. For almost two centuries its twin thoroughfares, the Galerie du Baromètre and the Galerie du Thermomètre, were a refuge for the games and trades of Eros and for many other activities. The old arcade with its streetwalkers, its brothel, its handkerchief shop, whose owner, a middle-aged woman, had only customers who were middle-aged gentlemen, its disreputable "furnished rooms," and its Théâtre Moderne, but also its hairdresser, whom the Goncourts, Horace Vernet, and Courbet had patronized, with its shoe-black, its orthopedist, its philatelic shop, its gunsmith, and its champagne merchant, with its few obscure "agencies," with its outdated Hôtel de Monte Carlo, its libraries and restaurants, its public baths, and its public lavatories, and with the Certâ, a cafe frequented by Breton and his friends, where the review *Littérature* and the dada soirées were planned and discussed — that labyrinth disappeared shortly after the First World War to give way to a new section of the Boulevard Haussmann. Louis Aragon remembered in 1925, in *Le Paysan de Paris,* the charms of the passage, its sights, pleasures, surprises, and mysteries.

THE PEASANT OF PARIS
The Opéra Arcade

Now I reach the threshold of the Certâ, a celebrated café I shall never be done telling about. . . . This is the place where, one afternoon, toward the end of 1919, André Breton and I decided to assemble our friends in the future, because we hated Montparnasse and Montmartre, also because of our taste for the ambiguous atmosphere of an arcade, and seduced perhaps by an unusual decor that was to become so familiar to

us; this is the place that was the main seat of the assizes of dada; whether this redoubt-able association plotted one of those absurd and legendary manifestations that made its greatness and its rot, or whether it assembled through lassitude, idleness, boredom, or under the shock of a violent crisis that sometimes convulsed it when a charge of moderatism was made against some member. I must speak of it with an uncertain sentimentality.

Delightful spot, besides, where a light of sweetness reigns, and the calm, and the cool peace, behind the screen of mobile yellow curtains that hide and reveal in turn to a customer who sits near the big glass panes reaching to the floor, which hide and reveal in turn the view of the arcade, whether his hand unnerved by waiting pulls or stretches their pleated silk. The decoration is brown as wood, and wood is used lavishly everywhere. A large bar, overhung with big barrels and their taps, fills the major part of the bottom of the café. On the right, the door to the telephone and the wash-room. On the left, a small recess, of which I shall speak later, opens in the middle part of the room. The main feature of the furniture is that tables are not tables, but barrels. There are in the big room two tables, one large, one small, and eleven barrels. Around the barrels are grouped cane-bottomed stools and straw-bottomed armchairs: about twenty-four of each. Still it must be specified that almost every armchair is different from its neighbor. Always comfortable, although unequally so. I prefer the lowest ones, those with latticework at the top of their backs. Customers are well seated at the Certâ, and this is worth emphasizing. When we enter, we see on our left a wooden windscreen, and on our right a hatstand. Then, a barrel and its seats. Against the wall on the right, four barrels and their seats. Then toward the washroom another wooden windscreen. Between this and the bar, a radiator, a piece of furniture where the telephone directories are, the large table and its seats. In front of the bar and down to the recess I have mentioned in the middle of the wall on the left, three barrels and their seats. In the middle two barrels and their seats. Before the recess a small table and an armchair. Finally, between the recess and the door to the arcade, and protected from the latter by the wooden windscreen, a last barrel, and its seats. As for the recess, we find there three tables in a row close to one another, with a long seat behind them, covered with imitation leather, which takes up the whole width, chairs opposite the tables and in the farthest corner at right a small movable gas stove, much appreciated in winter. Add to this evergreens beside the bar, bottle racks above it, the cash box at its left, near a small door behind a drapery usually drawn up. Finally, at the cash box or sometimes sitting at the large table, leaving time flow on, a lady who is pleasant and who is pretty, and whose voice is so sweet that, I confess, I often used to telephone to Louvre 54-49 only for the pleasure of hearing: "No, sir, nobody asked for you," or rather: "Nobody of the dadas is here, sir." This is because the word dada is understood

here a little differently than elsewhere, and with more simplicity. It does not mean anarchy, or antiart, or anything that frightened the journalists so much that they preferred to call that *movement* by the name "children's horse." To be dada is not a disgrace; it designates, and that is all, a group of habitués, young men sometimes a bit noisy, perhaps, but sympathetic. "A dada," this is said as one would say: "The gentleman with blond hair"; one distinctive mark is worth another. And dada is so much taken for granted here that they call dada a cocktail. . . .

And in this enviable peace, how easy is daydreaming. Let dream carry itself forward. Here surrealism resumes all its rights. They give you a glass inkstand that closes with a champagne cork, and you are in the mood. Images come down, like confetti. Images, images, everywhere images. On the ceiling. In the straw of armchairs. In the straws of the drinks. In the telephone switchboard. In the shining air. In the iron lanterns which light the room. Snow down, images, Christmas is here. Snow down on the barrels and on credulous hearts. Snow down on hair and on hands of people. But, a prey to this weak excitement of waiting, for someone will come, and I have combed my hair three times while thinking of that, if I raise the curtains of the glass panels, I am caught again by the sight of the arcade, its goings and comings, its passers-by.

After this description of an ideal, and very real, surrealist café, Aragon pays a visit, farther along the arcade, to the Théâtre Moderne:

Since drinks are compulsory at the bar of the Théâtre Moderne, most spectators only look at it, poorly, from the entrance. It is an orange-colored place, with a piano for dancers, and a small corner for drinking. One sees here the ladies from the stage, and their men. The whole thing tinged with a mad hope of meeting an American or an old man to be held for ransom. You would think you are in the German provinces; it is a dilapidated imitation, without expressionist décor, of the Berlin Scala. You go up a few steps to enter the theater.

Did the Théâtre Moderne ever have its day of brilliance and grandeur? Seeing thirty people there on crowded nights, one comes to reflect on the fate of these small theaters, generally considered precious little places. Boys of fifteen, a few fat men, and chance visitors slip into the farthest seats, which are the cheapest, while some pink bon-bons, prostitutes or actresses between scenes, are scattered among the twenty-five-franc seats. Sometimes a cattle-merchant or a Portuguese tourist, risking apoplexy, treats himself to a seat in the first row, to see the flesh. Very uneven plays were staged here, *L'Ecole des Garçonnes* [School for Tomboys], *Ce Coquin de Printemps* [That Rascal of a Spring], and a sort of masterpiece: *Fleur-de-Péché,* a model of the erotic, spontaneous lyrical genre, which we would like all our aesthetes to meditate upon when

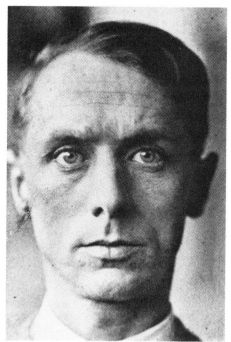

Left: Back cover of *La Révolution Surréaliste*, no. 8 (December 1926), which advertised Louis Aragon's *Le Paysan de Paris*. "This book was liked and will be disliked." *Right*: Max Ernst, 1930.

searching for avant-garde ideas. This theater, whose aim and means are Love itself, is doubtless the only one offering a dramaturgy without tricks and truly modern. We may soon see snobs, tired of music halls and circuses, fall back like locusts on such despised theaters, where the need to procure a living for a few girls and their pimps, and for two or three lean pederasts, has given birth to an art as original as the art of the Christian mystery plays of the Middle Ages. An art that has its conventions and its audacities, its discipline and its oppositions. The plot most often exploited follows more or less this outline: a French girl kidnaped by a sultan is bored to death in the seraglio until an airplane pilot or an ambassador arrives to entertain her, his love thwarted by the ridiculous passion he inspires in the cook or in the Sultana Mother, and everything ends in the best possible way. Any pretext, a feast in the harem, the pages of an album turned over to the accompaniment of a song, suffices to bring parades of five or six nude women impersonating the parts of the world or the provinces of the Turkish Empire. The great strings of antique comedy, mistakes, disguises, lovers' quarrels, and even misleading likenesses, are not forgotten here. The very spirit of the primitive theater is

safeguarded by a natural communion between stage and audiences arising from desire or from the women's provocations, or from private conversations often started by the vulgar laughs of the audience, their comments, the slang retorts of the girls to a rude public, the arrangements for a rendezvous, adding a spontaneous charm to a text delivered monotonously, or often out of tune, or mumbled, or prompted, or even openly read from a script, offhandedly. . . . The company is not paid and its members take liberties with their parts, they live on adventures. Therefore they are as avid as a true *artists'* company and they take bad jokes or noise very hard. During intervals, practical jokers are taken to task by the natural defenders of the actresses: "What she done to you, that kid? Let her earn her grub," etc. . . .

In this Alhambra of whores my wanderings end at last, at the foot of these fountains, of these moral confusions, marked at the same time with the claws of the lion and the teeth of the bully. With the gesture, in the antique fashion, of the little slave who remembers the Rue Aubry le Boucher, while her line calls for a "Hail, Mistress!" and while the chorus sings:

> "This is the month of Venus
> This is the fairest of months"

(sacrilege of false pearls and sequined slips) the Arabic lace of pink stones coagulates where neither the human face, nor the sighs, find again the wanted mirror or echo. . . .

From the presurrealist settings of the Certâ the light of dada shone for about eighteen months, the movement's activities reaching a climax in the spring of 1921. "The Placing under Whisky Marine" (which was the title of Max Ernst's first Paris exhibition) took place in May-June 1921 and was one of the important events of the season. André Breton discussed the dada painter in the preface of the catalogue of Max Ernst's exhibition, basing his commentary on data that were already surrealist: Reverdy's definition of the image and Chirico's disorientation, the principles of automatism, the exploration of the unconscious, and also the influence of new technical means (the cinema), which he considered likely to perturb our current conception of time.

Max Ernst

The invention of photography has dealt a mortal blow to the old modes of expression, in painting as well as in poetry, where automatic writing, which appeared at the end of the nineteenth century, is a true photography of thought. Since a blind instrument enabled artists unfailingly to reach the aim they had until then in view, they claimed, rather unthinkingly, to break with the imitation of aspects. Unfortunately

man's efforts, which ceaselessly tend to change the disposition of existing elements, cannot be applied to the production of one single new element. A landscape where nothing of this world can be seen is not within the reach of our imagination. If it were, we could refuse to evoke it, denying it a priori all affect ve value. It is, moreover, equally fruitless to remodel the ready-made image of an object (a plate in a catalogue) or the meaning of a word as if it belonged to us to rejuvenate it. We must put up with these meanings, only to redistribute them afterward, to group them in arrangements that will please us. It is because symbolism and cubism have overlooked this essential liberty within its limits that they have failed.

The belief in an absolute time and space seems about to vanish. Dada does not claim to be modern. Dada thinks it is useless, too, to submit itself to the laws of a given perspective. Its nature protects it from the slightest attachment to matter and also from being intoxicated with words. But the wonderful faculty of reaching, without leaving the field of our experience, two distinct realities and, by bringing them together, of obtaining a spark; to put within the range of our senses abstract figures called by the same intensity, the same prominence as others; and, depriving us of a system of references, to disorient us within our own memory—that is what holds dada's attention temporarily. Cannot such a faculty create more than a poet from whoever possesses it, since the poet is not bound to have the intelligence of his visions and must in any case maintain platonic relations with them?

It still remains for us to treat a number of rules, such as the rules of the three unities, as they deserve. We know today, thanks to the cinema, how to make a locomotive *arrive* in a picture. As the use of slow-motion and quick-motion techniques is spreading, as we get accustomed to seeing oak trees sprout out of the earth and antelopes hover in the air, we begin to perceive with an extreme emotion what this localized time that we hear about might be. Soon the expression "at first glance" will appear to us empty of meaning, that is to say, we shall perceive without the least flicker of the eyelids the passage from birth to death, just as we shall become conscious of minute variations. . . . Who knows if we are not preparing ourselves in this manner to escape someday from the principle of identity?

Because he is determined to do away with the mystical swindle of still-lifes, Max Ernst projects before our eyes the most fascinating film in the world, and because he does not lose the charm of smiling while he illuminates with an unequaled light our deepest interior life, we do not hesitate to see in him the man of those infinite possibilities.

Paul Eluard, in his collection of verse *Répétitions* (1922), also pays homage to Max Ernst, who illustrated the book:

Max Ernst [10]

> In one corner the nimble incest
> Hovers round the virginity of a small dress
> In one corner the sky unbridled
> Abandons white balls to thorns of thunder
>
> In one corner brighter for all the eyes
> They await the fishes of anguish
> In one corner summer's verdant coach
> Stands gloriously and ever motionless
>
> In the glow of youth
> Of lamps lighted very late
> The first-come bares her breasts for incests red to kill.

In *Littérature* for May 1921 (no. 19) appeared one of the first pieces that Max Ernst published in French: a poetic-humorous text about Arp, a fragment of which is translated here:

Arp

as soon as he was born he stood up for the three theological virtues and for Archimedes's
 theorem which says that corps must be measured from the corporeal

ARP

not to violate his father's taste he divided in two his pendulous lips and tattooed all
 the asterisms upon his tongue
as well as the diagrams of all the inflorescences
as well as the octopuses

ARP

that did not prevent him from listening always favorably
to the small daisies entering the sound of rays
in his breast he keeps perspective lightnings
in the crack of his shoulderblades the wall swallow nestles
in the conch of his ears he seizes aerolites on the fly
his heart and his loins are perfectly detachable

ARP

[10] Translation by George Reavey in *Contemporary Poetry and Prose* (London), no. 2, June 1936.

In that spring of 1921 Dada and its boisterous performances began to fall short of the expectations of many of their participants. The soirées that amused the actors and shocked the public in Zurich soon exhausted their possibilities in Paris. The "Great Dada Season" of 1921, announced in *Littérature,* no. 19 (May 1921), was the beginning of the end. In May, Breton staged a mock "trial" of Maurice Barrès,[11] a discredited idol of his youth, and in June, Tzara put on a Salon Dada (Picabia and Duchamp refused to participate), but none of this succeeded in infusing new life into the movement. Picabia left dada, Marcel Duchamp no longer contributed, Breton withdrew. In the first months of 1922 Breton's efforts to rescue the avant-garde from a growing confusion and to organize a "congress to determine and defend the modern spirit"—the abortive Congrès de Paris—demonstrated the disintegration of dada.

[11]See p. 129.

SURREALISM

Advertisement for *Littérature*, new series, no. 4 (September 1922): "*Littérature,* the Only Review that Counts."

Littérature, New Series

Two men whom André Breton met during the dada period impressed him deeply by their peculiar inventive gift and their lack of constraint in the use of subtle or direct weapons in the war for intellectual freedom: Francis Picabia and Marcel Duchamp. For an exhibition of "abstract" pictures by Picabia at the Dalmau Gallery in Barcelona (November 1922), Breton wrote a preface containing the following passages:

Francis Picabia

One cannot lend anything to Francis Picabia, not because he is the wealthiest of men, but because any comment on his work would appear to be overloading it and could be construed only as a lack of understanding. All the activities of Picabia are passionately opposed to such an overloading. To correct oneself, as well as to repeat oneself, is that not indeed to stand against the only chance one has, at every moment, to survive? You never cease running and whatever distance you gain between you and yourself, you leave unceasingly on your way new statues of salt. Among all others, will you be the only one who will never feel his heart failing? And do not object that Picabia must die one day: it suffices that for the time being, this idea seems to me extravagant.

I am young enough to be still surprised—needless to say, at the same time I am pleased—not to find Picabia leading an international official mission with unlimited powers, whose aim, besides, would be difficult to define and would reach singularly further than the aim of poetry and painting. For, more and more, we are prey to boredom, and if we do not take care, "this delicate monster" will soon make us lose all in-

terest in everything, in other words, will deprive us of every motive for living. Picabia's example is here very exceptionally helpful. Somebody was telling me that in New York, among the visitors who crowd galleries on the days of private views, there are always a few persons who cast only a disenchanted glance at the walls and hastily inquire about the name of the next exhibitor. If by an impossible chance this should happen during a Picabia exhibition, I should like the answer to be simply: Picabia. So true it is that in these kinds of things we may gain in the exchange only, and also that the man who is for us the greatest change from Picabia is Picabia.

All our eyes are not too many to embrace that immense landscape, and in doing this, the feeling of the *never seen* hardly leaves us any breathing time. Impulses measured in relation to the loss of their momentum and in anticipation of new impulses; thought answering to no other known necessity than faith in its exceptional nature; perpetual security within insecurity, thus acquiring the dangerous element without which it might chance to be a teaching in its turn; humor, unattainable by women, which, beyond poetry itself, is what can be best opposed to artistic or military mobilization as well as to the "dada" mobilization, and this is amusing (humor and *scandal* derived from it); all talents too, with the secret to use them without any particular delight, like luck in gambling; love above everything, unwearying love whose very language these books borrow: *Cinquante-deux miroirs, Poésie ron-ron* [Fifty-two Mirrors, Purring Poetry], while following its charming plots — because of all this, we are a few men who, every morning, when waking up, would like to consult Picabia as a marvelous barometer showing the atmospheric changes registered during the night. . . .

Breton gave also a remarkable portrait of Marcel Duchamp in *Littérature,* new series, no. 5 (October 1922):

Marcel Duchamp

It is by rallying around this name, a real oasis for those who are still *searching,* that the assault could be fought, with a particular sharpness, capable of freeing modern consciousness from that terrible mania of fixation that we never cease to denounce. The famous intellectual manchineel tree that bore during half a century the fruits called symbolism, impressionism, cubism, futurism, dadaism, simply asks to be felled. Marcel Duchamp's case offers us today a most valuable dividing line between the two spirits that will tend to oppose one another more and more inside "modern spirit" itself, whether or not it lays claim to the possession of truth, which is rightly represented as an ideal and nude woman, who comes out of the well only to drown herself again in her mirror.

A face whose admirable handsomeness does not commend itself by any moving

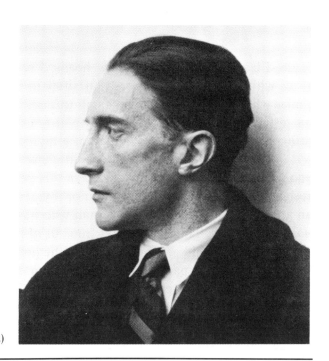

Marcel Duchamp, ca. 1923.
(Photograph: Alfred Stieglitz)

detail, and likewise all that could be said to the man would lose its point upon a polished sheet allowing nothing to be perceived of what happens in the depths; with this, a laughing eye, without irony, without indulgence, which chases away the slightest shadow of concentration and gives evidence of a constant care to remain externally quite amiable; elegance of the most fatal nature and above elegance, a really supreme *ease*; such appeared to me, during his last stay in Paris, Marcel Duchamp, whom I had never seen and from whom, because of a few traits of his intelligence that I had been informed of, I expected marvels.

And first of all let us observe that Marcel Duchamp's position in relation to the contemporary movement is unique in this, that the most recent groups are more or less acting on the authority of his name, although it is impossible to tell to what extent they have ever won his consent, since we saw him detach himself from them with a perfect freedom even before the set of ideas whose originality was largely due to him took that systematic aspect which made a few others turn away. Is it because Marcel Duchamp more quickly than anyone else reaches the *critical point* of ideas? It seems, in any case, that his immediate adherence to cubism was tempered by a sort of move toward futurism (1912: *The King and Queen Surrounded by Swift Nudes*) and that his contribution to both was followed very soon with dadaist reservations (1915: *Chocolate Grinder*). Dada had no better success in eliminating such scruples. . . .

I have seen Marcel Duchamp do an extraordinary thing, throw a coin and say:

"Tails, I leave tonight for America; heads, I remain in Paris." In this, no indifference *at all*, without doubt he preferred infinitely to leave, or to stay. But the personality of choice whose independence Duchamp was among the first to proclaim when he signed, for instance, a manufactured object, is it not the most tyrannical of all, and is it not fitting to put it to proof, provided that a mysticism of chance does not take its place?

. . . I know: Duchamp now does little else but play chess, and for him it would be enough one day to appear unequaled in this game. Therefore you would say that he is resigned to intellectual equivocation; or if you wish, that he agrees to be considered as an artist, even, in that sense, as a man who has not produced much because *he could not do otherwise.* Thus he who has freed us of that lyrical blackmail of the ready-made expression . . . would give himself up, in the opinion of most men, to a symbol. I refuse to see there, on his part, anything but a trap. For me, as I have said, what makes the strength of Marcel Duchamp, what has enabled him to come out alive from several cutthroats' alleys, is above all his *disdain of all thesis,* which will always astonish less privileged people.

In consideration of what will follow, it would be advisable, I think, to center our attention on this disdain, and for this it will suffice to evoke the glass picture to which Duchamp has given almost ten years of his life, which is not the unknown masterpiece and about which, before its completion, the most beautiful legends are already spreading, or else to remember such and such strange puns signed by their author—Rrose Sélavy—and which call for a special study.

. . . For Marcel Duchamp, the problem of art and of life, as well as any other question likely to divide us at the present time, does not arise.

Littérature reappeared in March of 1922 after an eclipse of a few months. Its new series had a new cover, with a drawing by Man Ray, the American dada poet and painter—a top hat from which emerged, like a rabbit from a conjurer's hat, the word *Littérature.* After arriving in Paris in mid-1921, Man Ray had exhibited paintings in December of that year at the Librairie Six, with a catalogue containing short dadaist notations, for instance:

With tears in my empty teeth I thank you for the poetic spring I count your toes which are ten everybody knows it I place myself as a flower under your shoes I want to be your coal in winter and your straw hat in summer I will attend to expenses for detective police dogs taxis but I would have you know that I am chaste as a fiancée as a forest in the lens. — *Hans Arp*

I love you by sheer force as you reunite the spinning top that dances and the spinning top that runs, you will always find buyers, you don't annoy me when you attach the accursed handle to the broom equipped with a hammer. — *Max Ernst*

Thoughts on art. After dressing up an average carp from the Seine, cut it up into pieces (take care to remove the stone of bitterness that lies in the head). Among artists, 281 have been put out to nurse, only one in Paris: and on the other hand it should be noted that of this number only four are sucklers. — *Man Ray*

New York sends us one of its love fingers, which will soon tickle the French artists' susceptibilities. Let's hope that this tickling will mark once more the already famous wound that characterizes the closed drowsiness of art. The pictures of Man Ray are made from basil from mace from a pinch of mignonette and from parsley with branches of hardness of soul. — *Tristan Tzara*

The top hat on the cover of the review disappeared after no. 3 of the new series, and from no. 4 (September 1922) to the last issue (no. 13, June 1924) each carried a different cover, all drawn by Picabia. New names appeared among the contributors while some of the older writers no longer participated.

In an article entitled "Lachez tout" (meaning, "Leave everything" but also "Let go!" — the aeronaut's order to his assistants on the ground when the balloon is ready to rise) Breton announced that he was leaving the "grounded" dada movement. The magazine assumed a freer, more polemical tone; it revealed scandalous or violent pages from past or recent "ancestors": Germain Nouveau,[1] Rimbaud (his three erotic sonnets known as "Les Stupra" [Sexual Excesses] and parts of his antireligious *Un Coeur sous une Soutane* [A Heart under a Soutane]), Lautréamont (his passionate and sarcastic *Letters*), Apollinaire (his poems *Quelconqueries*). Picabia gave many ironical aphorisms and articles to the review, and in the second issue Philippe Soupault mentioned the novel *Impressions d'Afrique* (Impressions of Africa) by Raymond Roussel.[2] But a letter from Chirico to André Breton showed the painter of arcades and mannequins newly preoccupied by questions foreign to his previous inspiration — problems of means and techniques.

The following tale by Benjamin Péret, "La Fleur de Napoléon" (*Littérature*, new series, no. 8, January 1923), gave a surrealist appraisal of French history.

The Flower of Napoleon

That morning, little orange-colored fishes were circulating through the atmosphere. The cannons in front of the Invalides were complaining of an old gonorrhea that caused rusted irises to grow between their wheels. A Spaniard sowed a few grains of wheat in the engine of an airplane that was waiting for a blessing, which did not come. Napoleon, dressed up like Marshal Foch, came out of "the railway carriage where the Armistice was signed," his hand on his brow and his legs skinny. Behind

[1] Poet (1852-1920). He accompanied Rimbaud during one of his trips to London in the early 1870s.
[2] See below, chapter 20.

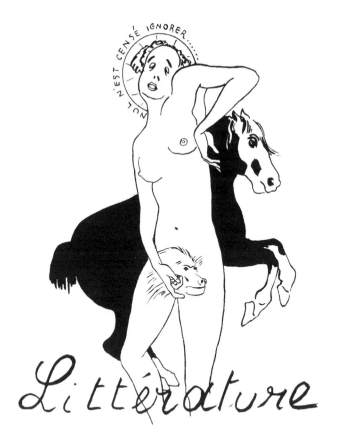

Left: Francis Picabia: Cover for *Littérature*, new series, no. 5 (October 1922). *Right*: Benjamin Péret, 1920.

him a giant bottle of eau de cologne appeared, then a Portuguese oyster, a twin-horned rhinoceros, a yule log, and the Unknown Soldier, who carried over his shoulder a pail full of paste. A scarab came out of the barrel of a machine gun and took his place in front of the procession. The Spaniard, who was none other than the Cid, kissed Chimène's photograph and disappeared into a corridor leading to the military offices. He reached a closed door, which did not resist the pressure of his shoulder. He went down an endless staircase and found himself in a vast room where thousands of tall candles were shining, stuck along the walls. The room was crowded with people piled up on steps, around a circle in which men were given as food to snakes after being submitted to a thousand tortures: opening their abdomens with pruning scissors, driving five-inch nails into their skulls, also extracting fragments of bones from their limbs, and the boots, the forced drinking of pails of water, nails and teeth pulled out, eyes put out, tongues cut off, etc.

One of the sufferers, after being swallowed by a boa, came out at the other end slightly bruised but his wounds from the preceding tortures were healed.

The arrival of the Cid was marked with an unexpected occurrence. The circle, in which the poor fellows were tortured, was changing slowly from its original color to a brick-red hue while it was being covered with grains of wheat: Suddenly the ground in that area blew up like a champagne cork and an enormous column of flames spouted from the orifice thus made. There was panic, some people threw their neighbors into the flames, and others, cutting off their limbs to lose weight, tried to take flight. Others grew rare plants, bred quasi-unknown birds that spoke German; then a great vapor passed along with a noise like a celestial trumpet, through the flames that seemed for a moment to calm down.

A seminarian hugging Osiris, whom he kissed to his heart's content, left the corner of the room where they had both been hiding; with twisted limbs and surrounded by a swarm of bees, he came to the brim of the flames and said:

"The ravages of cocaine are felt in too many clandestine circles. It is well known that cocaine is very cheap in Germany. The most varied means are used to take it across the border. Pigeons are, sometimes, innocent messengers. A box full of cocaine is suspended from their necks and soon the border is crossed."

"What is the price of a cigar when it is stolen?" thought the Cid, and he went out to go to the French Line office, where he bought a first-class ticket to Buenos Aires. At last he was about to realize the dream of his life: to give up the life of a bravo for that of a farmer. After all, he thought, my father, honor, Chimène, the rate of the peseta, the international economic situation, the resumption of relations with the Soviets, are not tasks for artists.

Napoleon, who had remained in the Invalides yard, went for a moment into the chapel and observed the Indian fig trees that were growing around the altar.

"We have no masks against asphyxiating gas," the bottle of eau de cologne said to him.

Suddenly the Unknown Soldier flew into a violent fit of anger. "I've lost my ribbon, by God," he shouted, kicking the oyster, which was beginning to wake up. While he was hunting for it, he caught sight of a pillar, and he remained openmouthed, mute with surprise, seeing that the ribbon he was looking for was fixed there with the inscription "American supplies." An American soldier's hat was hung above it, and an enormous pistol could be seen beneath it, with a great number of cartridge clips.

The rhinoceros went several times around the church at an easy trot, then lay down at the foot of the Virgin's altar and went to sleep. Napoleon, who was trying to calculate the cubic root of 7347, was indignant at the attitude of the rhinoceros and threw a prayer stool at its head. The animal grunted, spat some vinegar, and came

back obediently to take its place behind Napoleon. The latter left the church and went to his own tomb. He raised the stone of the sepulcher and went down into the vault. At once, rose petals fell around him and piled up to his waist. He coughed and one of the sides of the vault turned on its axis, showing an opening about four feet wide into which Napoleon was able to creep stooping: all his retinue did the same. The corridor increased in height, and after a hundred yards, Napoleon, straightening himself up, strode along munching incomprehensible words: "As soon as the world began...... Since when did we see him...... He learned from you...... Keep warm in that kind of weather...... The rifle is a firearm...... He carries them along upward, downward......" He arrived at a crossing where, at the entrance of each tunnel, were girls seven or eight years old, naked, with curly hair and a ring through their right breast. They were dancing a monotonous dance that consisted in jumping from one foot to the other while smacking their buttocks with their hands and shouting: *Hee*..... *Heehee*.....*Hee*..... There was also a bell that rang every second and an instrument, whose nature could not be defined in the darkness, that gave a sort of continuous whistle.

A breath of terror passed over Napoleon's retinue. The rhinoceros gave a frightful grunt that would have scared anyone but Napoleon. The neck of the bottle of eau de cologne chipped off, the oyster yawned and closed with a sharp clap. The yule log crackled, and the Unknown Soldier dropped his pail of paste. Napoleon shouted: "Remember the Pyramids, Jena, Austerlitz, Eylau, the Moskowa, Waterloo, and tighten your belts...... Forward ... march!..... One, two. One, two......" An eagle flew over and cried: "Comrade, your country is proud of you!"

... The heat was intense. Napoleon understood that he was approaching the center of the earth, for the buttons of his uniform were beginning to melt and his boots to singe. He noticed that otherwise he was not affected by the growing heat; yet the bottle of eau de cologne diminished visibly. Enormous white bats flew with a sound of stirred water. At a turning of the road they caught sight of the central fire where black swans, nine feet tall, were swimming, singing "La Madelon," and taking flight like elephants. Plants were appearing suddenly, swift as lightning—especially one that in three minutes reached a height of sixty feet and was covered with pearly flowers quickly followed by fan-shaped fruits that fell and exploded like a fart. Then from the exploded fruits appeared monsters with the head of a beetle, the body of a cat; their fore limbs were like stunted fins, while their legs had a human shape. This irritated Napoleon, who spat several times, stamping his foot furiously. Catherine of Medici, flat and transparent as oiled paper, came and said: "I swear to you, upon my faith as a knight, that I did not see it (you will notice it when you read this book)."

Seeing him passing very often by her house, she said to herself: "I come from your home with the man in a cloak."

From uniformity boredom is born, from boredom reflection, from reflection disgust with life, from disgust with life artichokes, from artichokes cows, from cows children, from children Napoleon, but naturally you understand that I say all this as a joke.

Napoleon was beside himself. He drew out his saber and split Catherine of Medici in two. One of the parts, Catherine of Medici, fell to the ground and went to sleep; the other part, Catherine of Medici, fled, swearing like a trooper. Napoleon hummed a song: "Oh, she shouldn't have gone there — oh, there she shouldn't have gone. . . ."

Around Napoleon and his retinue, the ground was bristling with hairs that grew rapidly. Very big and very thick, they had already reached their chests, threatening to smother them if they did not make a quick decision. Turning about, Napoleon harangued his retinue in these terms:

"There were, before the war, fifty requests a year, in all France, for marriage exemptions. That is to say, fifty young men or young girls who had not reached the legal age, fifteen years for women, eighteen years for men, requested to be permitted to marry, for different reasons. Now there are fifty requests a year in the city of Paris alone!"

So many young people eager to know the joy of having their own fireside! Setting the example, Napoleon threw himself into the flames. The heat was so dense that he could swim as easily as in a milk pond. The bottle of eau de cologne, the oyster, the rhinoceros, the yule log, and the Unknown Soldier did the same, and after a few weeks of navigation, delayed by adverse winds, they landed on a beach of blue sand. A troop of plesiosauruses came to meet them and carried them in triumph on their shoulders to an immense square paved with silk where little Annamite girls smoked negligently, their hands on their sex and with happy faces. They had tea with the women and the plesiosauruses, took several days' rest, then set off again on roads strewn with pipes and alarm clocks ringing under their feet. No sooner had they counted up to twenty-nine than they arrived in a coral cave where they found the Cid observing his entrails through a magnifying glass.

"Is this an operation worthy of you?" said Napoleon to him. "Come now and be my ally."

Imagination's fireworks, all places, beings, and circumstances having been mixed regardless of space or time, the tales of Benjamin Péret assumed a matter-of-fact style that made them resemble accounts of dreams. Actual accounts of dreams were published in the new series of *Littérature*, by Breton in no. 1 and no. 7 and by Robert Desnos in no. 5. Desnos's

From left: Louis Aragon, Robert Desnos, and André Breton at Francis Picabia's home at Le Tremblay-sur-Mauldre, 1922. (Photograph: Simone Breton)

"Pénalités de l'Enfer" (no. 4, September 1922) is a dream story in which the friends of the poet play a part.

Penalties of Hell

Aragon, Breton, Vitrac, and I live in a miraculous house, alongside a railway track. In the morning I tiptoe down the stairs (not to wake up Mme. Breton who is

still asleep). The sound of my steps is muffled by tricolor carpets. Curiously, hooting locomotives circulate in my wrists and in my temples. Benjamin Péret is waiting for me downstairs. We leave for a desert island.

There is no doubt that Zanzibar is not a food, but is it for this reason that Péret goes to sleep when there are no more phonograph records to give to the spring funnels, and when I go away?

At the gates of Paris, customs officers sneer and ask for my driving license:

— But I am on foot!

Bland smiles, coarse insults: I flee. They remain on the doorstep, gesticulating, waving their kepis.

But there is no one in Paris, no one, except a dead old grocer, a woman; her face is immersed in a fruit dish full of creamed smiles. Trams and buses are lined up in pairs in the streets illuminated at high noon with electric lamps. Clocks strike together different hours. I come back home. Photographs of Vitrac, Baron, M. and Mme. Breton, and Aragon are nailed on the steps of the stairs. In Vitrac's room there is a barrel of whisky; in Aragon's, a cornet; in Baron's, a great number of little shoes. On the door of M. and Mme. Breton's room there is a terrifying inscription written with chalk: "Watch your step or else!....." I enter, the head of Benjamin Péret is in the mirror. I run to the desert island, a volcanic eruption has destroyed it, and Benjamin Péret is waving to me from a small pier; he has grown an immense beard in which I stumble when I wipe my feet.

Farewell, Péret, farewell! When Francis the First died, the orbs of luminous spheres left no marks on the windowpanes locked with crepe. Farewell, Péret.

The train passed swiftly. Benjamin jumped into it, on his way to chemical blossomings. Not fast enough though, for one of his arms, the left one, remained in the air above the platform. Five thousand kilometers away Benjamin was still calling me, asking for his arm to be sent to him. Herds trampled Angeluses and carpets of women's hair. What's the use...... Benjamin Péret's arm, alone in space above the platform, points to the exit, and beyond, to the Grand Café of Progress, and beyond. . . .

Max Morise's "Chasse gardée" seems to be a real dream, or rather a nightmare (*Littérature*, new series, no. 5, October 1922):

No Hunting

I entered a very narrow corridor where two rows of dummies were facing each other, attached against the walls; they were female dummies, most of them very lightly clad, in various costumes, their jointed arms equipped with boxing gloves. Near each

dummy was a small slot, as on candy dispensers, and this inscription in enamel:

TO BOX
insert 10 cents

I chose a brunette wearing pink stockings and a red bodice with narrow silk shoulder straps, and I slipped a coin in the slot. I immediately received a violent shower of blows. Beginning to repent my imprudence, I tried to flee without fighting back. But the arms of the neighboring dummies at once came to life and began pummeling me. I was struggling desperately, in my turn striking my opponents, who seemed insensitive, when the dummy whom I had provoked first, stretching its legs while bracing its back against the wall of the corridor, put its feet on my belly so firmly that I found myself caught between them and the opposite wall, as in a vise. My enemies would have knocked me senseless if I had not freed myself, by a prodigious effort. I tried to leap out of their circle, but I stumbled, dragging along in my fall the red and pink dummy. It clasped me tightly in its arms, and we struggled on the floor, giving a rather close imitation of the act of love. I began to strike again. Under my blows the dummy became a woman. My fists made her ribs resound and chewed her flesh. She shrieked but did not surrender. This hand-to-hand fight roused my senses considerably. A moment later, still fighting, we copulated. Then I squeezed her so powerfully in my arms that soon I felt she had breathed her last. I tried to disengage myself, but her arms held me a prisoner.

Jacques Baron was only sixteen when he met Breton at the end of 1921. Poems of his were published in every issue of the new series of *Littérature*. "Amour" appeared in no. 6 (November 1922):

Love

> Weary you go away man with eight male brains
> Don't you have a wicker chair under an arch
> with square cushions
> stuffed with peacock feathers

> Sweet sweet Matine you flow
> double-leafed flower or surely a woman
> whom I love with her inquisitive eyes too
> like a belle at her mirror

> A perfume fleshy like a breast
> flies around my long head

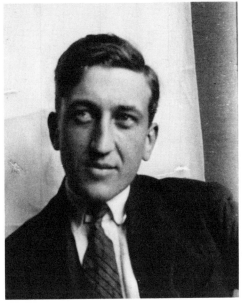

Left: Jacques Baron and André Breton
(seated) at Francis Picabia's home at
Le Tremblay-sur-Mauldre, 1922. *Right*:
Max Morise, 1924. (Photographs: Simone
Breton)

I, an alpinist white as snow
and pale
a man with an alert and lively faith

I see enamels shivering
and dead men who were funny
are drunk and they charm lovers
lovers who have flowers
full of ink or else of dust

The plays staged at soirées and festivals during the dada period were irrational scenes in the mood of Apollinaire's *Les Mamelles de Tirésias* or of the prewar futurist sketches, plots without a plot, based on surprise and carrying no teaching or conclusions. In this vein were, by Breton and Soupault, *S'il vous plaît* (If You Please) and *Vous m'oublierez* (You'll Forget Me), which *Littérature* published. The new series of the magazine reprinted in no. 3 (May 1922) "theatrical surprises" and "theatrical syntheses" by Marinetti and other futurists. In no. 9 (February-March 1923) appeared *Comme il fait beau* (What Fine Weather), a short play by Breton, Péret, and Desnos.

The several volumes of work by Roger Vitrac, another contributor, give evidence of his talents as a poet and playwright. His strangely sarcastic play *Victor ou les Enfants au pouvoir* (Victor or the Children in Power) had two successful runs in Paris theaters — after the author's death, in 1948. The pantomime *Poison, drame sans paroles,* published in *Littérature,* new series, no. 8 (January 1923) has never been staged; perhaps it is playable.

POISON

Drama without Words

Scene 1

The back of the stage is occupied by a vast mirror. Ten personages in black smocks look in the mirror. Suddenly they face the public, put their right hands over their eyes like a visor, feel their pulses, look at their watches, kneel, rise, and sit on ten chairs on the front of the stage. A gunshot blows the mirror to pieces, revealing a white wall on which the shadow of a nude woman takes up the entire height of the theater, then diminishes by degrees until it reaches a normal size. It seems that the woman has chosen this instant to show herself. She appears, issuing forth from the wall like a plaster statue. She goes to the first personage, who gives her a pair of red gloves, which she puts on. She leaves the first personage for the second one who gives her a lipstick with which she makes up her lips. The third one gives her sunglasses. The fourth, a fur coat. The fifth, a blue wig. The sixth, white silk stockings. The seventh, a crepe veil, which she arranges on herself like a train. The eighth, a revolver. The ninth, a child. The tenth strips her of her clothes and pursues her with a hammer.

Scene 2

A room. The floor is covered with fragments of plaster. From the water jug on the washstand, a black spray of liquid is spouting. The sheets of the bed betray an enormous shape underneath them. The ringing of an alarm clock is heard. The door opens and the head of a horse appears. It dangles for a moment, and from the bed, mysteriously uncovered, comes a thick cloud of smoke which momentarily obscures the room. When the smoke clears, a head of hair is seen hanging from the ceiling above an enormous diamond that has appeared on the bed. A man walks across the stage, rubbing his hands; he goes to a wardrobe mirror, in front of which he stops for a moment. He throws up his arms, opening his mouth; then he sits at a table. He rings a bell; at once a woman covered with a pearled dress brings breakfast on a tray. He waits until she is gone and paints her silhouette on the mirror of the wardrobe. He has hardly finished when the wardrobe opens and the woman with the pearled dress flings herself

in his arms. He throws her on a chair and gives her a long kiss. But from the open wardrobe appear suddenly twelve soldiers and an officer, who aim their rifles at the couple.

Scene 3

On the stage is a written poem:

> Between love and orthography
> There is pen to think
> Of the cry
> The blood goes round the square
> Man upright with the summer
> Freedom, freedom of the lands
> Lost ah! the . . . the cow
> With velvet shoes
> Point of the scalp and of the queen
> Less the tortoise with love

> Signed
> Hector de JESUS

A spotlight illuminates the poem, on which hand-drawn Chinese shadows are superimposed. They are: a cat, an old woman, a jockey, a boot, a heart.

Scene 4

The scene is a ruffled silk cloth. When the curtain rises, there is a noise of broken glasses. Variously colored vapors are floating. A young man and a girl, the man dressed in a sailer's suit, the girl in a white woolen dress, carry an armchair to the middle of the stage; a violinist enters, sits in it, and begins to play a popular ballad. He has hardly played the first bars than the silk cloth is animated with confused motions. The clanging of a fire engine is heard, and the cloth is torn off showing feet, hands, heads, and other parts of the human body. A man and a woman, followed by a small dog and sheltering under an umbrella, cross the stage. The frightened violinist is now standing on his armchair. Cheers are heard, he bows to the right, to the left, and falls backward into the arms of the young man and the girl who carry him away.

Scene 5

The stage is empty. A personage who looks like a painter comes and makes blobs on the walls. While he works, two lovers enter, carrying a garden bench; they sit on

it. The lover is in his shirttails, his girl is wrapped in a sheet. Suddenly the lover makes the sign of the circle, the painter looks at him and tears open the wall at the back of the stage. He plunges his arm into the gaping hole and extracts a cable, which he unrolls. It seems that there is only a light object at the end of the cable, but the wall crumples down and a steamship advances on the stage. At the prow, an electric lamp gives distress signals.

Scene 6

A kitchen. A woman watches over the stove. Enter a man wearing a lounge suit, his face covered with blood. The woman presents him with a bowl of broth. He drinks it at one gulp, then he opens the window. He points to something in the street. Sobs and moans are heard. Children rush in and throw themselves at his feet. He gives each one a friendly little pat and leads them back to the door. Their mother—probably— appears, wearing a dressing gown. She seems to speak naturally. The man gazes at her and motions her to look in the street. The door of the dresser opens and hundreds of oranges roll out on the floor. The three people lose their balance and fall.

Scenes 7, 8, 9, 10, 11

A railway station, an office, a fireplace, a book, a picture; in front of these are a man, then a woman, then a man, then a woman, then a man, respectively holding bills on which the numbers 7, 8, 9, 10, 11 are inscribed.

Scene 12

A mouth that simulates speech.

Also by Roger Vitrac, this fragment from an enigmatic play, *Mademoiselle Piège*, published in *Littérature*, new series, no. 5 (October 1922). Characters: Messrs. Musée, senior and junior; M. Clair; Chêne, the hotel manager; and his steward, Plomb.

MADEMOISELLE PIÈGE

Chêne: Good. Good. Good. (*He hangs up the phone.*) Good. (*Calling*): Plomb.
Plomb: M. Chêne?
Chêne: For the 49: five.
Plomb: Good. (*Plomb disappears into the elevator, then returns, coming down the stairs.*)
M. Musée (junior) (freeing himself): You were thinking of it.

M. Clair: Wasn't I?

M. Musée (*junior*): The slipper indeed.

M. Clair: Under a glass case it's expensive. You'll regret it.

M. Musée (*junior*): No, M. Clair. Heads or tails. (*He sits down on the floor.*)

M. Clair: Here's a ten-centime piece. (*M. Musée, junior, tosses up the coin.*)

M. Musée (*junior*) and *M. Clair* (*together*): Tails.

M. Musée (*junior*): Once again. (*Silence.*) Tails.

M. Clair: Heads.

M. Musée (*junior*): It's heads. (*M. Clair, dignified. moves off and disappears into the elevator.*)

Chêne: Plomb.

Plomb: M. Chêne?

Chêne: The door. (*Enter M. Musée, senior.*)

M. Musée (*junior*): Dad.

M. Musée (*senior*): It's me. You?

M. Musée (*junior*): Yes. I couldn't.

M. Musée (*senior*): You'll have to arrange that with your mother.

M. Musée (*junior*): But you?

M. Musée (*senior*): I came on business.

Chêne: Sir? (*Silence.*) Sir?

M. Musée (*senior*): The 49?

Chêne: She's here. (*Chêne presses an electric button. Terrific ringing. M. Clair rushes down the stairs, his hands covered with blood. He crosses the hall. Plomb opens the door for him. M. Clair disappears.*)

M. Musée (*senior*): But it's Clair.

M. Musée (*junior*): That's he.

M. Musée (*senior*): Oh . . . Well, then. Me?

M. Musée (*junior*): Dad.

M. Musée (*senior*): What?

M. Musée (*junior*): The rubbers.

M. Musée (*senior*): Certainly.

M. Musée (*junior*): The new car.

M. Musée (*senior*): A beauty.

M. Musée (*junior*): Your rheumatism.

M. Musée (*senior*): Gone. (*M. Musée, senior, disappears into the elevator. M. Musée, junior, is prostrate.*)

Chêne (*To M. Musée, junior*): Sir. (*Silence.*) Sir. (*M. Musée, junior, lifts his head.*) Sir?

M. Musée (junior): The 49?

Chêne: She's there. She's up there. (*The telephone rings.*) Oh? Good. Oh? Good. Oh? Good. (*He hangs up.*) Good. (*He takes up the phone.*) Hello. Hello. Operator. Operator, Saxe 75-57, please. Hello. Too red. Yes, much, much, much too red. What? Well, that has no importance any longer, none, none. Thank you what. The 49. She's there. (*He hangs up.*) Plomb.

Plomb: M. Chêne.

Chêne: The laundry bill.

Plomb: I'll pay it.

Chêne: That's all.

Plomb: No.

Chêne: There is Mademoiselle Piège's dress.

Plomb: (*Showing a box*): It's here. (*Silence.*)

M. Musée (junior): I HAVE LOST THE BLACKENED PEOPLE—WHO NEAR THE LEGS AND THE TREES—LAUGHED AT THE LANDS OF ANGELS—A HAND OF ORANGES—AND THE MARIGOLD—BEFORE THE STRIPPED SNOW—HE CAME NEAR PARIS—WHERE I DON'T HEAR HIM WALKING ANY MORE. (*Shouting*) Sir.

Chêne: What. The 49?

M. Musée (junior): What. What time is it?

Chêne: Five-forty-eight. (*Silence. Then*):

M. Musée (junior): 58-59-60. (*M. Musée, junior, shoots himself through the head.*)

Chêne: Again. Good. Plomb.

Plomb: M. Chêne.

Chêne: Come. (*They sit M. Musée, junior, at the table, before the newspapers.*) Good. Plomb.

Plomb: M. Chêne.

Chêne: The door. (*Exeunt Chêne and Plomb.*)

André Breton in *Littérature,* new series, no. 6 (November 1922), wrote about a new psychic experiment that he and his friends were carrying out. His article, entitled "Entrée des médiums," first gave a summary of the situation before a discovery that he thought likely to open, wider than ever, the doors of poetic irrationality.

Entrance of the Mediums

An unexpected move, a mere nothing from which, our eyes half-closed on ourselves, we did not even dare to augur that we would forget our quarrels, has set again in motion the famous *steam swing* around which we used to meet in former days with no need of prearranged appointments. It is almost two years since the strange seesaw

stopped, projecting us rather sharply in the most varied directions, where we tried more or less gracefully to recover our senses. I happened to say already that if we blamed each other, probably without rhyme or reason, for the responsibility of the accident, at least no one regretted having taken a seat in the coach dimly lit by the girls' knees, the coach that beats time between the houses.

Without doubt, we are in it again: Crevel, Desnos, Péret on one side, Eluard, Ernst, Morise, Picabia, and I on the other. . . .

What our friends and I mean by *surrealism* is known, up to a certain point. This word is not of our invention and we might very well have left it to the most vague critical vocabulary, but we use it with a precise meaning: we are agreed it designates a certain psychic automatism, a near equivalent to the dream state, whose limits are today quite difficult to define. I apologize for interposing here a personal experience.

In 1919 my attention was called to more or less fragmentary sentences that the mind perceives in total solitude, when sleep is near, although it is impossible to discover their origins. These sentences, with their remarkable images and perfectly correct syntax, appeared to me to be first-rate poetic material. In the beginning I was satisfied to remember them. Later, Soupault and I thought that we might reproduce voluntarily within ourselves the disposition that saw them taking shape. To obtain this, it sufficed to forget the existence of the outside world and thus, during two months, they reached us in ever greater numbers and soon followed each other unceasingly, so swiftly that *we had to use abbreviations* to be able to write them down. *Les Champs magnétiques* are only the first application of this discovery: each chapter had no other reason to end than the end of the day when it began, and from one chapter to another, only the change of speed provided for slightly different effects. I say this without regard to ridicule or publicity, mainly to show, since all intervention of our critical sense was absent, that the judgments to which we laid ourselves open by publishing such a book fell a priori beside the point. Nonetheless, whenever we lent an ear, even a malicious one, to another voice than that of our unconscious, we ran the risk of jeopardizing in its essence a self-sufficient murmur, and I think that that is what happened. Never again, when we called forth that murmur and collected it, later on, for precise ends, did it lead us very far. And yet it was such that I still await no further revelation but from it. I never ceased to be convinced that nothing that is said or done has any value except when obeying this magical *dictation.* There lies the secret of the irresistible attraction that certain beings exercise, interesting solely because they became one day the echo of what we are tempted to consider as universal conscience, or again, because they caught, without strictly penetrating their meaning, a few words that fell from the "mouth of darkness."

It is true that from time to time I refer to another point of view and this is because,

in my opinion, all the efforts of man must aim at arousing that precious confidence. What we may do is to go and meet it without fear of losing our way. Foolish is he who, having come near it one day, prides himself on retaining it. It may belong repeatedly only to those who are trained in the most complex of mental gymnastics. (Their names at present are Picabia, Duchamp.) Each time this confidence offers itself, almost always in the most unexpected way, the question is therefore to know how to seize it, for it may never return, and to give very little importance to the manner by which it chooses to introduce itself to us.

To return to "surrealism," I had come to think recently that in this domain, inroads of conscious elements, placing it under a human, literary, well-determined will, made its exploitation less and less fruitful. I was losing all interest in it. Along the same line of thought I had been led to give all my preferences to *dream accounts,* which, in order to protect them from stylization, I wanted to be stenographic. The misfortune was that this new test called for the help of memory, which is subject to deep failings and remains, generally speaking, unreliable. The problem did not seem to gain much ground, mainly for lack of numerous and typical documents. This is why I expected little more to come from that direction when a third solution offered itself (I would think that all that remains to do is to decipher it), a solution in which a considerably smaller number of causes of error intervene, consequently a most exciting one, judging from the fact that after ten days the most indifferent, the most assured among us, remain dumfounded, shivering with gratefulness and with fear, having lost countenance, one might say, before the marvel. . . .

The new experiment was based upon the well-known faculty of mediums who, while in hypnotic sleep, are able to deliver speeches, write texts, make drawings, etc. Such manifestations seldom, if ever, assume a poetic quality and most of the time concern an alleged communication with the dead. But when, by mere chance, René Crevel, and after him Robert Desnos and also Benjamin Péret, discovered that they had that gift to some degree, their unconscious speeches and writings showed a flow of free and unexpected images, akin to automatic writings or dream accounts.

René Crevel was probably a real medium; he would lose consciousness completely in the course of the experiments. During his first hypnotic sleep he made a dramatic and passionate discourse, "the speech of a prosecutor or of a counsel in a lawsuit" (wrote Breton in "Entrée des médiums"), "delivered quickly, interrupted by sighs, stressing certain words with a declamatory diction sometimes turning into a song; it dealt with the case of a woman accused of the murder of her husband, whose guilt was contested since she acted at his request." But such trances caused considerable fatigue to Crevel, whose health was poor, and he found himself compelled, after a few exhausting performances, either to refuse participation, or to simulate sleep: his amusing tale of a Negress who wore silk stockings, reproduced as an unconscious

communication in *Littérature*, new series, no. 6 (November 1922), shows no sign of the deep anguish expressed in his first sleeping fit and reflects instead the gay wit that usually prevailed in his conscious conversations.

The case of Péret and Desnos, on the other hand, was one of "absent consciousness," a state similar to that of Breton and Soupault when they wrote *Les Champs magnétiques,* yet more deeply detached. But Péret's fits of "sleep" never brought very striking results; experiments with him seem to have been quickly discontinued. Desnos remained the great exponent of that new and peculiar sort of automatism; the "period of sleeps" was in fact a Desnos period. The following report, also published in *Littérature,* no. 6, concerns one of the first séances:

(Desnos falls asleep for the second time on the evening of September 28. Spontaneous writing): umidité *(sic), (then an illegible word).* I know a very fine landmark. *(At this moment he is ordered to write a poem.)*

> No one ever acquired the right to come as a master
> in the concrete town where the gods copulate
> he would want to invent this abstract lewdness
> and plants like dead fingers in the midst of our eyes
>
> With a throbbing heart we storm the breach at the frontiers
> populous suburbs overflow with champions
> let us go up the streams of nocturnal channels
> to the impassive heart where our vows go asleep
>
> Ventricle flag trumpet of these countries
> the child spoiled by the love of ostriches
> would never have failed in the duty of dying
> if blue storks would liquefy in the air
>
> Tremble tremble my fist (should I swallow the waves)
> has branded my belly with accusing stigmas[3]
> and the great battleships heave the lead in vain
> to the drowned crouching on the brim of white rocks.[4]

(Desnos, spontaneously): the Tower.
Q.: Who is the Tower? A woman?
A.: Yes, of course.

[3]At the end of this line we stopped Desnos, thinking the poem was finished since we could not read it in the dim light. He willingly answered further questions, and after five or ten minutes he abruptly wrote the two last lines, which at first we did not recognize as belonging to the poem.

[4]The original poem is alexandrine verse, rhymed. — M.J.

Q.: Do you know her?

A.: Yes (*he leans on the pencil, the lead breaks*).

Q.: Is she beautiful?

A.: I don't know.

Q.: Has she other qualities?

A.: I don't like her.

Q.: Is she here?

A.: Yes (*broken pencil lead*).

Q.: We must not talk about her any more?

A.: *If you want.*[5]

Q.: What will you do in five years?

A.: The River (*from the final letter starts a drawing: wave, small boat, smoke. Written with much care*) She is called Bergamote.

Q.: What will Breton do in five years?

A.: (*Drawing of a circle with its diameter*):
Picabia Gulf Stream Picabia.

Q.: Do you like Breton?

A.: Yes (*the lead breaks, then, legibly*): Yes.

Q.: What will Eluard do in five years?

A.: 1,000,000 francs.

Q.: What will he do with this money?

A.: War to the fleet.

Q.: Who is Max Ernst?

A.: The deep river and the Spanish grammar.

Q.: What do you think of Simone Breton?

 (*No answer.*)

Q.: Who is she? What do you see for her?

A.: I (*crossed out*) convolvulus (*drawing of an eye with an arrow*) the beautiful loved one (*a drawing, above which is written*): the horse.

Q.: It's Gala Eluard who holds your hand.

A.: (*A drawing.*)

Q.: What do you see for her?

A.: The fatal hour where that that you will see.

Q.: What will she do?

A.: (*Drawing of a G clef.*)

Q.: Will she die soon?

[5] This answer was written in English by Desnos. —M. J.

Left: Robert Desnos, 1923. *Right*: Louis Aragon, 1930.
(Photograph: Niedermanas, Documentation Hachette)

A.: Opera opera.
 (Here came the two lines: "and the great battleships . . ." *etc.)*
Q.: Is that all for Gala Eluard?
A.: Oh, there will be matches in three colors (*drawing of a hand leaning on a curve*), a hand against the moon.
Q.: What do you know about Max Ernst?
A.: Fraenkel's white smock at the lunatics' hospital.
Q.: Who is Max Ernst?
A.: F sharp.

<div align="right">

(Desnos wakes up.)

</div>

From that time on, Desnos never tired of "sleeping," treating his audiences to inexhaustible and beautiful discourses. Aragon recalled in 1928, in his *Traité du style* (Treatise on Style), this period of oral wonders:

I remember a waterfall at the bottom of grottoes. Someone I knew, a friend called Robert Desnos, spoke. He had discovered, by the help of a strange sleep, several

secrets lost by all. He spoke. He spoke as nobody speaks. The great common sea was now at last in the room, which was any room with its wondering utensils. . . .

It may be regretted that practically none of these speeches was recorded. Eventually Desnos developed such a fondness for that activity that his friends at times became tired of listening to him. Incidents occurred. Once, the "sleeper" had been speaking for hours and, as Paul Eluard said later, "refused stubbornly" to wake up. Exasperated, Eluard took a jug of water and emptied it on Desnos's chest. Immediately conscious and horribly offended, Desnos leaped to his feet, seized a paper knife, and tried to stab Eluard. On another occasion, Crevel's example induced some occasional participants to "sleep"; they started talking, gesticulating, walking to and fro, and finally attempted to hang themselves on hat pegs; few of the assistants, and none of the performers, took all this very seriously.

Undoubtedly Desnos possessed an exceptional verbal gift that, to express itself, found favorable settings and even an incentive, in the half obscurity of some silent apartment, among attentive and expectant listeners. Then incessant waves of metaphors would flow from his lips. Sometimes he would not only write verse, as in the fragment translated above, but he would also speak in alexandrines, rocking his own words on the ebb and flow of the twelve-syllable phrases stressed with the caesura and the alternating masculine and feminine rhymes.[6] Often his improvisations echoed the rhythm and music of the classical poems of Apollinaire, while in another mood he created spoonerisms in the manner of Rrose Sélavy (Marcel Duchamp). *Littérature*, new series, no. 5 (October 1922), revealed several of Duchamp's puns, for instance: "Sa robe est noire, dit Sarah Bernhardt — Opalin, o ma laine — Abominables fourrures abdominales." Such sentences based on a play upon words seldom have any point in a translation: "Her dress is black, says Sarah Bernhardt — Opaline, o my wool — Abominable abdominal furs." Soon Desnos created a mass of these formulas, which filled ten pages of *Littérature*, new series, no. 7 (December 1922). Many were erotic, in compliance with one of the rules of the genre; the name of Rrose Sélavy appeared in several of them. The pun sometimes remains perceptible in translation.

Rrose Sélavy demande si les Fleurs du Mal *ont modifié les moeurs du phalle. Qu'en pense Omphale?*
Rrose Sélavy asks whether the *Fleurs du Mal* have modified the morals of the phallus. What says Omphale?
La solution d'un sage est-elle la pollution d'un page?
Is the solution of a sage the pollution of a page?...
L'acte des sexes est l'axe des sectes.
The act of the sexes is the axis of the sects. . . .

[6]We have observed that during insomnia, there is an excellent way to find sleep—much better than counting sheep: mentally to compose French alexandrine verse, regardless, of course, of the "meaning."

Punning is a gift that some people possess naturally. *Littérature,* new series, no. 9 (February-March 1923), published two pages of a collection of spoonerisms by Roger Vitrac written without any special preparations or staging. The Rrose Sélavy phrases were only descriptive, one might say. With Desnos the pun often created an image, which is always the case with Vitrac's spoonerisms, rarely erotic, never ironic, always poetic. When translated, they lose their verbal point, but most of them keep their metaphoric import.

L'air des cimes est le lait des crimes.
The air of summits is the milk of crimes.
Les fards des joues déjouent les phares.
The makeup on the cheeks baffles the lighthouses.
Les vaisseaux seront sauvés des ronces.
The ships will be rescued from the brambles.
Entre les sèves le centre d'Eve.
Between the saps, the center of Eve.
Chants de guerre, gants de chair.
Songs of war, gloves of flesh.
Défense de fumer les fusées des femmes.
No smoking of women's rockets.
Les masses de l'onde lassent le monde, la lune les attire et la lyre les allume. Sirène des noyés soyez la reine des nids.
The masses of the waves weary the world, the moon attracts them and the lyre lights them. Horn of the drowned, be the queen of nests.
Faux roi des eaux, forêt d'oiseaux.
False king of the waters, forest of birds.

A fourth type of play on words was developed by Michel Leiris in his "Glossaire" (*La Revolution surréaliste,* nos. 3, 4, and 6, 1925-26). Leiris thinks that his glossary defied translation, because mere resemblance between certain French words and their English equivalents could not convey the point of his poetic and humorous definitions, which would lose in translation the minimum of rigor he had meant to give them. Consequently we reproduce the following excerpts in the original French:

Glossaire

ACADÉMIE — macadam pour les mites. ARTÈRES — lézardes et cratères. CATHOLICISME — isthme de ta colique. CRIME — une mine de cris. DÉCIMER — détruire les cimes. DOMINER — délire dérisoire, dédale déchiré. ÉCLIPSE — ellipse de clarté. ÈRE — l'air que nous respirons, notre aire d'action. FLAMME —

fluide mâle. ERMITE — termite. PERSPECTIVE — l'oeil perce, lumière active. ROSAIRE — l'érosion des prières. SCEPTRE — spectre. SIMILITUDE — (identiques, les trois I se mêlent et préparent la pierre unie de l'U). SOURCE — course. TOTAL — le totem de Tantale. UNITÉ — nudité, nid de l'éternité. VOCABLE — le câble ou le volcan. . . .

Leiris added this note to his glossary:

A monstrous aberration leads men to believe that language was born to facilitate their mutual relations. To this utilitarian end they compile dictionaries, where words are catalogued, endowed with a well-defined meaning (so they think) based on custom and etymology. But etymology is a perfectly vain science, giving no information at all about the real meaning of a word, that is, its particular, personal signification, that everyone must assign to it according to the convenience of his mind. As for custom, it is superfluous to mention that it is the lowest criterion to which we may refer.

The usual meaning and the etymological meaning of a word cannot teach us anything about ourselves, since they represent the collective fraction of the languages, which has been made for everybody and not for each one of us.

By dissecting the words we love, without the wish to follow etymology or accepted signification, we discover their most hidden virtues and the secret associated sounds, shapes, and ideas. Then language changes into oracle and we have here a thread (however tenuous it be) to guide us inside the Babel of our mind.

Littérature, new series, no. 11-12 (October 15, 1923), might be considered the first anthology of surrealist poetry. Beginning with a brilliant piece of nonsense verse, "La Chanson du Dékiouskoutage," whose anonymous author was none other than Max Jacob, it contained in addition poems by Desnos, Péret, Ernst, Vitrac, Soupault, Aragon, Picabia, Morise, Eluard, Breton, Joseph Delteil, and Georges Limbour; while a double page entitled "Erutarettil" (*littérature* in reverse) listed the names of a number of authors, of all periods and countries, printed in various types according to their importance as "ancestors" of the rising surrealism — from the legendary Hermes Trismegistus to Arthur Cravan. The boldest typefaces spelled the names of the Marquis de Sade, Edward Young, "Monk" Lewis, Alphonse Rabbe, Lautréamont, and Vaché.

Books appeared in 1923 and 1924 that were surrealist before the fact: *Mourir de ne pas mourir* (To Die of Not Dying), poems by Paul Eluard; *Au 125 du Boulevard Saint-Germain* (No. 125 Boulevard Saint Germain) and *Immortelle Maladie* (Immortal Malady) by Benjamin Péret. Louis Aragon had published in 1920 the poems of *Feu de Joie* (Fire of Joy); in 1921 a novel, *Anicet et le Panorama;* in 1923 a sort of *roman à clef, Les Aventures de Télémaque. Le*

Libertinage (1924) was a collection of stories, short plays, and brief essays; the following passage is from one of those texts, "Madame à sa Tour monte," which describes the imaginary residence of a lady curiously christened "Matisse" by the author.

Her Ladyship Goes Up into Her Tower

Two floors are joined into one and it looks like a demolished house; the ceiling has been pulled down, leaving its mark upon these walls where a lacerated paper, light flowerets, dark arabesques, the perpetual motif of a repeated hunt, and the imitation linoleum of the dressing room, stand witness for a previous interrupted life. Curved brown traces of the flues. Here and there, on the darkened wallpaper, clearer shapes recall the bed, the cupboard, or the pictures. Crucifix. In two rows, like melancholy soldiers, the six windows gaze reproachfully on this stupid interior. The upper doors feel silly opening on the void. Down below, in a corner, a café caught alive by the wreckers' pick leans against the décor of devastation, its bar painted pink marble, its zinc counter on which bad coins have been nailed, its shaky stools, and the frail scaffoldings of racks heavy with bottles and glasses. It is here that Matisse receives unwanted visitors; soon they cannot bear the desolate atmosphere of the place, they find an excuse and slip away. In the evening, a lonely street lamp lights the wreckage, projects huge shadows up to the ceiling, and Matisse imagines romances. Coming from the village where her father's and mother's honesty has worn itself out, she lands, an orphan, in Paris, in the bar owned by her uncle, her last relative, her last support. Naïve and pure, amid the cartwrights and the disquieting, covetous faces, what will become of her? Her fate may be read in the eyes of a girl roughly handled by a bully. The uncle himself is going to hand her over to this Russian prince, and the worst will happen: but the stranger appears and rescues her. He is strong, handsome, wealthy, but in his life lies a secret. Let it be revealed, and the romance is ended. Matisse is also the panther who ruins Spanish grandees, drives children to suicide, clerks to robbery, bankers to bankruptcy, schoolboys to murder. Here she comes, a third-rate actress. to seduce the innocent glass washer, hardly sixteen years old, in a suburban bar. *Here the scene becomes realistic,* and suddenly, fair eyes, what are you looking at on the roof beams, the voluptuous person catches sight of a medal on the young man's neck, or of a birthmark, or of an indelible tattoo, and upon my word, it's her son, abandoned a long time ago in the snow, under the portal of some church. After such a turn, one should take the veil; Matisse steps into the dining room.

The dining room, so to speak; Matisse dines in restaurants. In semidarkness always, a half-cleared table looks as if the guests had just left. On the red and white checked tablecloth, a glass dish full of glaucous and vulgar fruits, an opened bottle, and a nutcracker are watching over a blue glass. For there are friends who would be

out of place elsewhere, like a piano in a bathroom. Matisse greets them at this parade of desserts, gazes at them, and sometimes caresses them a little as if they were grapes or peaches. They are fat people, well dressed, melancholy perhaps, but in any case without a wrinkle.

The sleeping room is used only for rest. Daylight penetrates through the moveable slats of venetian blinds, replacing the graceless shutters, which have been taken off. Zebra of shade and light; despite the equivocal obscurity with its luminous interferences, nothing allows imagination to run wild or the senses to work, for fear that the least excitement would banish sleep, whose palace is here. Nothing is more intimate, more secret than this place; it is natural here to speak in a low voice. A curious feeling of decency has hidden the wooden skeleton of the seats under fabrics of colors ranging from bronze to garnet red. Everything breathes softness and abandon; furs on the ground muffle the steps; in the heart of these arcana, no mirror shines whose disquieting eye Matisse would feel while sleeping or which would introduce in her dreams, before she dozes off, the last vision of her nakedness, excessively beautiful tonight. The bed in the center of the room is like a ship borne on a calm sea, and whenever Matisse lies down on it, she is tempted to renew myths and Morpheus (her eyelids are the poppies), and this resting place becomes the final outcome of the world. Yet a mute violin, catching a ray of light in its mahogany coffin lined with blue plush, makes the silence more tangible near the window, and the bow sharing its couch is the link uniting this lifeless universe to the real world.

The world is seen from the window: roofs of gray oilcloth, chimneys like sensuous onlookers; studios dulled by dusty blinds; gables of the buildings; waste lands; on a house, glass casings reveal the backstairs; vast sheds where automobiles slide in, attracted by the high letters of the façade. The cry of a train tells the name of the district, ROME, which blends the concept of antique civilizations with the magic of modern cities — of course!

The bathroom after all this torpor: everything is neat, shiny, geometric, sparkling, sharp, you would think of an operating ward. To measure the air space is the first desire felt in this room. Then it is the pleasure of some brief pleasure. The enamel paint on the wall reflects a cruel light that conceals not one wrinkle or white hair. . . .

Turn the washbasin tap the wrong way; look, a trapdoor slides open in the ceiling and an iron ladder comes down. An apartment must lend itself to hiding a criminal, conspiring, disposing of a corpse. Through this clandestine passage we reach the upper floor, which has no cause to envy the secret lairs in crime novels. First a naked room, apparently abandoned, disconcerts the visitor. On the walls without paper or paint, workers have inscribed names, figures, thoughts on life, sketches of their feminine ideal; on the windowpanes masons have drawn in white paint the symbol of

the infinite. The rest of the apartment is the prop room of a good detective: microphones and recorders to overhear conversations, cameras hidden in chiffoniers, armchairs that embrace the imprudent sitter, camouflaged safes, false coffers with infernal alarm bells or hidden snares, two-way mirrors, periscopes to observe on the top of the houses the goings and comings of roofers (no one ever knows their intentions, it's like the men who repair telephones). . . .

The last number of *Littérature* (new series, no. 13, June 1924) called itself a "discouraging number." Yet it contained fragments of *Un Coeur sous une Soutane* (A Heart under a Soutane), by Arthur Rimbaud (the whole text was published some time later with a preface by Aragon and Breton) and verse by Apollinaire.

In the same issue, Desnos reviewed *Les Pas perdus*. In this book (The Wandering Steps, or The Lost Steps, or The Entrance Hall),[7] published in February 1924, André Breton collected various of his texts, from his first studies of 1917 and 1918 on Apollinaire and Jarry, to the lecture he read in November 1922 in Barcelona, on "Modern Evolution."[8] The volume opened with "La Confession dédaigneuse," which introduced Breton's memoirs of his lost friend Jacques Vaché.

The Disdainful Confession

Sometimes, to signify "experience," we use this striking expression: "Lead in the head."[9] We may conceive that it entails a certain shifting of man's center of gravity. We even agree to consider this the condition of human equilibrium, a comparative one, since, theoretically at least, the assimilation process, which characterizes living beings, comes to an end when favorable conditions cease, and they always cease. I am twenty-seven years old and I fondly hope that I shall not encounter that equilibrium for a long time to come. I have always refused to think of the future; if I happened to make plans, it was merely a concession to certain beings and I was the only one who knew what reservations I made within myself. Yet I am very far from insouciance and I do not accept finding repose in the sentiment of the vanity of all things. Absolutely unable to be resigned to my lot in life, wounded in my highest consciousness by the denial of justice, which, in my eyes, is not excused in the least by original sin, I am careful not to adapt my existence to the absurd conditions, *here below,* of every existence. I feel in this respect quite in communion with such men as Benjamin Constant, until his return from Italy, or Tolstoy, who said: "If a man has only learned to think,

[7] Salle des Pas Perdus is the term for the entrance hall of a railway station or a public building.

[8] Several of these articles have been already quoted above: on Chirico, Max Ernst, Picabia, Duchamp, and "Entrée des médiums."

[9] In French: "Le plomb dans la tete": meaning, in English, "to have ballast."—M.J.

no matter what he thinks, at bottom he thinks always of his own death. All philosophers have been like this. And what truth can exist, if there is death?"

I will sacrifice nothing to happiness: pragmatism is not within my reach. To look for solace in a creed seems vulgar to me. It is a vile idea to imagine a cure for moral sufferings. Suicide I find justifiable in one instance only: having no other challenge to throw at the world but *desire,* receiving no greater challenge than death, I may come to desire death. But stupefying myself would be out of the question, it would throw the door open to remorse. I have indulged in it once or twice: it does not agree with me.

Desire . . . indeed he was not mistaken who said: "Breton—convinced that he will never be done with his heart, the knob of his door." People resent my enthusiasm and it is true that I change easily from the most lively interest to indifference, an attitude that is, in my own circle, variously appreciated. Speaking of literature, I have been successively in love with Rimbaud, Jarry, Apollinaire, Nouveau, Lautréamont, but it is to Jacques Vaché that I am most indebted. The days I spent with him at Nantes in 1916 appear to me an almost enchanted time. I shall never lose sight of him, and although I shall still form friendships as future meetings take place, I know that I shall never belong to anyone with the same abandon. Without him I might have been a poet perhaps: he has frustrated in me this plot of obscure forces that lead one to believe in something as absurd as a vocation. I congratulate myself, in my turn, on being at least somewhat responsible for the fact that today several young writers do not discover within themselves the slightest literary ambition. We *publish* to search for men, and nothing else. From one day to the next I am more and more eager to discover men.

My curiosity, which exerts itself passionately on living beings, is not very easily aroused otherwise. I have no great regard for erudition or even, despite whatever jeers this confession may expose me to, for culture. I received an average education, which is almost useless. I retained from it, at best, a rather reliable feeling for certain things (it has even been alleged that I have above all a feeling for the French language; this did not fail to irritate me). In short, I know quite enough of everything for my special needs of human knowledge.

I am not far from believing, with Barres, that "the great thing, for the previous generations, was the transition from the absolute to the relative," and that "the question is now to go from doubt to negation without losing all moral values." I am preoccupied with the question of morals. The naturally irreverent spirit I apply to all other things would induce me to make that question depend on its psychological results if, at intervals, I did not consider it above the dispute. Morals in my eyes have the prestige of holding reason at bay. They allow, moreover, the greatest flights of thought. I love all moralists, particularly Vauvenargues and Sade. Morals are the

great peacemakers. To attack morals is still to pay homage to them. It is in them that I found always my main objects of exaltation.

In contrast, I perceive in what is called logic the very guilty exercise of a weakness. Without any affectation, I may say that the least of my concerns is to be consistent with myself. Einstein tells us that "an event may be the cause of another only if both may take place in the same point of space." This is what I have always thought roughly. I deny as long as I touch earth, I love at a certain height, higher what shall I do? Still in any of those states, I never go through the same point again, and when I say I touch earth, at a certain height, higher, I am not the dupe of my images.

For all that, I do not profess intelligence. It is instinctively in a way that I struggle inside this or that reasoning or any other vicious circle (Peter is not necessarily mortal; under the apparent deduction that makes it possible to establish the contrary, a very mediocre swindle betrays itself. It is quite evident that the first proposition—All men are mortals—belongs to the order of sophisms).[10] But nothing is more alien to me than the care taken by certain men to save what may be saved. Youth is a marvelous talisman in this respect. I take the liberty of asking my contradictors, if any, to refer to the lugubrious warning in the first pages of Benjamin Constant's *Adolphe:* "I thought that no sin was worth an effort. Curiously enough, this impression weakened in me precisely as the years accumulated. Could it not be that there is something suspect in hope, and that, when it withdraws from man's road of life, this life assumes a more severe and more positive character?"

The fact remains that I swore to myself never to let anything deaden within me, as far as I could help it.

I observe nevertheless the skill of nature when it aims at obtaining all sorts of abandonments. Under the mask of boredom, doubt, or necessity, it tries to wring from me an act of renunciation in exchange for which there is no favor it does not offer. I never used to go out without taking a final farewell of all accumulated memories, of all these parts of myself I felt ready to perpetuate themselves. The street, which I thought capable of opening its surprising turnings to my life, the street with its anxieties and its glances, was my real element; I caught there, better than anywhere else, the wind of the unexpected.

Every night I left the door of my hotel room wide open, hoping to wake up at last with a companion beside me whom I would not have chosen. It was only later that I feared that the street and this unknown woman might hold me, in their turn. But that is another question. As a matter of fact, I am not sure one can win in this ceaseless struggle whose customary results are to congeal what is most spontaneous and most

[10]Breton alludes to the well-known syllogism: "All men are mortals; Peter is a man; therefore Peter is mortal."—M.J.

precious in the world. . . . Every week we learn that some mind worthy of esteem has "settled down." There is a way, it seems, to behave more or less honorably and that is all. I do not worry yet about knowing what batch I shall be in, or how long I shall hold on. Until further notice I approve of all that may delay a classification of men or ideas, all that may keep up equivocation, in a word. My greatest desire is to make mine the admirable sentence of Lautréamont: "From the unpronounceable day of my birth, I vowed an unreconcilable hatred toward the soporific planks."

Why do you write? asked *Littérature* one day of several alleged notables of the literary world. And *Littérature* extracted the most satisfying answer from the notebook of Lieutenant Glahn, in Knut Hamsun's novel *Pan:* "I write," said Glahn, "to shorten time." This is the only answer with which I can still agree, with the reservation that I believe I write also to lengthen time. In any case, I claim to have an influence on time and I call to witness the answer I gave once, developing this thought by Pascal: "Those who judge of a work from rules are in respect to others like those who have a watch in respect to those who have none." I went on: "One says, consulting his watch: We have been here for two hours. Another says, consulting his watch: It has been only three-quarters of an hour. I have no watch: I say to the first one: You are bored; and to the other: Time is not heavy on your hands; for I find we were here for an hour and a half, and I do not care for those who say that time is heavy on my hands and that I judge by my own watch; they do not know that I judge by fantasy." [11]

I never let a sentence come under my pen that does not assume in my eyes a future meaning, yet I take posterity to be nothing. Without doubt, a growing disaffection threatens men after their death. In our days, there are already a few minds who do not know whom to take after. Who cares now about his own legend!. . . A great number of lives have no moral conclusion. When the thought of Rimbaud or Ducasse is no longer given as a problem (to some childish end or other), when the "teachings" of the 1914 war are, supposedly, collected, we may imagine that the uselessness of writing history will be acknowledged all the same. It is more and more obvious that all re-

[11] Here is the complete text of Pascal's thought: "Those who judge of a work from rules are in respect to others like those who have a watch in respect to those who have none. One says: It has been two hours. The other says: It has been only three-quarters of an hour. I look at my watch; I say to the first one: You are bored; and to the other: Time is not heavy on your hands; for it has been an hour and a half, and I do not care for those who say that time is heavy on my hands and that I judge by fantasy; they do not know that I judge by my watch." As we see, Breton followed Pascal's thought closely, correcting it on the way, after the technique of Ducasse in his *Poésies* (see above, pp. 51ff.). Voltaire had also contradicted Pascal (in his notes to the Condorcet edition of the *Thoughts,* Geneva, 1778) and had concluded: "In a work, in music, in poetry, in painting, it is taste that replaces a watch, and he who judges only from rules judges wrongly." Breton's correction, which replaces "watch" with "fantasy," follows the line of Voltaire's criticism, since "taste" and "fantasy" are in this case synonymous, both meaning individual judgment. (It might be added that Pascal was in a way the inventor of the wristwatch; he used to carry a watch attached to his wrist. On the other hand, Breton used to say that he could always tell the exact time without looking at a watch or a clock.) — M.J.

constitutions are impossible. On the other hand, it is well understood that no truth deserves to remain exemplary. I am not among those who say "In my time . . ." but I affirm simply that a mind, whatever it be, cannot but lead astray its neighbors. And I do not ask for mine a better fate than the one I assign to other minds.

The *dictatorship of the mind,* which was one of dada's key phrases, must be understood in this manner. From this, one conceives that I am interested in art only relatively. But a prejudice gains credence today that tends to grant to the "human" criterion what is more and more denied to the "beautiful" criterion. . . . To escape, as far as possible, this human pattern on which we are all dependent is all that seems to me to deserve any effort. To evade the psychological rule, even to the smallest extent, is equivalent to inventing new ways of feeling. After all the disappointments poetry has already inflicted on me, I still hold it to be the place where the terrible difficulties between conscience and trust have the best chance to be settled, within the same individual. This is why I am so severe, occasionally, with poetry, why I forgive none of its abdications. Poetry has no part to play except beyond philosophy, and consequently it fails in its mission each time it comes under the influence of some decree of the latter. It is a common belief that the *meaning* of what we write, my friends and I, has ceased to preoccupy us, while on the contrary we claim that the moral dissertations of a Racine are absolutely unworthy of the admirable expression they borrow. We are trying perhaps to restore *substance* to the form, and to achieve this, it is only natural that we should try first to go beyond practical utility. In poetry we have hardly anything behind us but occasional pieces. And besides, is not the proper meaning of a work the one the work is likely to assume in relation to what surrounds it, and not the one the author believes he has given it?

To those who on the strength of theories in vogue would care to determine which affective trauma changed me into the man who speaks now like this, I can do no less, before concluding, than dedicate to them the following portrait, which they will be free to insert in the small volume of Jacques Vaché's *Lettres de Guerre* [War Letters], published in 1919 by Editions du Sans Pareil. A few facts, which this portrait will help to reconstruct, will illustrate impressively, I am sure, what little I have said. It is still very difficult to define what Jacques Vaché meant by "umour" (without an *h*) and to state exactly how we stand in the struggle, which he started, between the emotional faculty and certain haughty elements. There will be time, later, to confront umour with poetry, without poems if necessary: poetry as we understand it. For the time being, I shall simply unfold a few clear memories.

Then Breton proceeds to recall what he happened to learn, through rare meetings and a desultory correspondence, of Vaché's existence, deeds, and moods. And the "Confession" ends thus:

I am not in the habit of saluting the dead, but let everyone be convinced that this existence which I was pleased and displeased to retrace here is almost all that links me still to a faintly unexpected life and to smallish problems. All literary and artistic cases to which, nevertheless, I must refer, come after, and even these hold me only so far as I can appraise them, in human significance, with that infinite measure. This is why all that may be *achieved* in the intellectual domain will always seem to me to bear witness to the worst servility or to the most complete insincerity. I love, of course, only unaccomplished things, I intend nothing but to grasp more than I can hold. Embrace and domination alone are lures. And it is enough, for the moment, that such a pretty shadow dances on the ledge of the window through which I am goin to throw myself out again, every day.

"The Manifesto of Surrealism"

The birth certificate of surrealism was made out at the end of 1924, when André Breton published his "Manifeste du Surréalisme." Since *Les Champs magnétiques* of 1919, the idea of automatic creation, together with the word *surrealism,* had spread among literary and art circles, with the result that Breton's public appropriation of a neologism that Apollinaire, in 1917, had coined for his play *Les Mamelles de Tirésias* raised a stir among those aestheticians and poets who also wanted to claim surrealism as the child of their minds. A review edited by Ivan Goll entitled *Surréalisme,* and evidently intended to cut the ground from under Breton's feet, came to light when the "Manifeste" appeared, in October 1924. One of Goll's contributors,[1] Paul Dermée, asserted that he himself had been using "surrealism" to designate a "panlyricism" in articles in the review *L'Esprit Nouveau,* which he had founded in 1920 (this title, incidentally, was also borrowed from Apollinaire and his manifesto *"L'Esprit Nouveau et les Poetes"* [The New Spirit and the Poets of 1917]).

 L'Esprit Nouveau was edited by Amédée Ozenfant, the purist painter, with Le Corbusier, the architect and inventor of the "machine house," as its main contributor. Although it called itself an "international review of contemporary activities," it had in the past completely ignored the *Littérature* group. But when it took to task *Je Sais Tout* (I Know Everything), a popular magazine that also showed an interest in machines, Francis Picabia (despite his friendship with Dermée) wrote in *Littérature,* new series, no. 4 (September 1922):

 Je Sais Tout is for simple minds, *L'Esprit Nouveau* is for complicated minds. *Je Sais Tout* is made for the people's appetite; *L'Esprit Nouveau* intends to feed the artist—that is to say, the elite. *L'Esprit Nouveau* appreciates intelligence but finds that

[1]Among others was, surprisingly, René Crevel, the initiator of the "period of sleeps" (see above, pp. 102ff.)

a genius is too much of a precursor—a precursor, it says, is a failure (very pretty!). *L'Esprit* is conscious of everything; it is quite certain, besides, that it bores only unconscious people like myself. *L'Esprit Nouveau* walks on its two feet and, as the poet says, carries its head so high that it is impossible to see it, I wonder whether it exists? *Je Sais Tout* selects monsters like remarkable racehorses, *L'Esprit Nouveau* prefers the cart horses painfully pulling the van of cubism, whose blinkers alone are monstrous. *L'Esprit Nouveau* finds that Rémy de Gourmont exaggerates when he says that intelligence destroys everything. A good thing for fools to whom it gives the possibility of constructing.

In January 1925 Ozenfant's review awoke to surrealism, or rather to Ivan Goll's review and Dermée's claims, and tried at the same time to connect surrealism with urbanism.[2] On the other hand, Picabia, who was no longer on good terms with André Breton, though the latter alluded favorably to him in the "Manifeste," wrote in his own magazine *391,* no. 19 (October 1924): "The surrealism of Ivan Goll is related to cubism; Breton's surrealism is simply dada disguised as an advertising balloon for the firm of Breton & Co." He proposed, ironically, and "for the time being," another movement: instantaneism.

But Breton's opponents had no consistent program to set against his theories. And while surrealism established itself as a dynamic concept attracting many young and brilliant minds, the Goll-Dermée *Surréalisme* died, leaving no trace but its first and last number. *L'Esprit Nouveau,* coincidentally perhaps, also ceased publication at the same time, and, likewise, no. 19 was the last issue of *391.*

The first pages of the "Manifeste du Surréalisme" discussed the problem of man's intellectual bondage in a life ruled by practical necessity, of the impossibility of his imagination's free expansion, while a supposedly logical relation seemed to be the only link between the different events of his life. Yet imagination, although externally suppressed, retained its powers. "Dear imagination," said Breton, "what I love most in you is that you do not forgive." And he added: "The word liberty alone is all that still exalts me." Freedom of imagination should, therefore, open the door to a radically renewed conception of life. But might not imagination set free lead to madness? Breton refuted the distinction between "madness" and "normality," attacking the exponents of realism, and especially, in literature, the novelists.

It is not the fear of madness that will force us to leave the flag of imagination furled.

The case of the realistic attitude calls for an investigation, after the case of the materialistic attitude. The latter, more poetic besides, than the former, implies on man's part a monstrous pride indeed, but not a new and more complete fall. Materialism must be seen above all as a welcome reaction against a few derisory tendencies of

[2]Perhaps because the cover of *Surréalisme* bore a sketch by Robert Delaunay—a copy of a photographic bird's-eye view of the Place de l'Etoile in Paris. This drawing was reproduced twice in *L'Esprit Nouveau,* no. 28 (January 1926).

ANDRÉ BRETON

MANIFESTE
DU
SURRÉALISME

POISSON SOLUBLE

AUX ÉDITIONS DU SAGITTAIRE
CHEZ SIMON KRA, 6, RUE BLANCHE, PARIS

André Breton: Cover of the first surrealist manifesto, 1924.

spiritualism. Lastly, it is not incompatible with a certain nobility of thought.

On the contrary, the realistic attitude, inspired by positivism, from Saint Thomas Aquinas to Anatole France, seems to me hostile to every intellectual and moral advancement. I loathe it, for it is made up of mediocrity, hatred, and flat self-complacency. Today it generates these ridiculous books, these insulting plays. It unceasingly receives a new strength from newspapers, and it holds science and art in check by striving to flatter public opinion in its lowest tastes: clarity bordering on stupidity, the life of dogs. It affects the activity of the best minds, compelled in the end to follow, like the others, the line of least resistance. An amusing result of that state of things, in literature for instance, is the abundance of novels. Everyone has his little "observation" to offer. For purification purposes, M. Paul Valéry suggested lately an anthology collecting as many opening passages as possible, expecting much from their insanity. The most famous authors would be included. Such an idea still honors Paul Valéry, who, some time ago, regarding novels, assured me that as far as he was concerned, he would always refuse to write: "The marquise went out at five o'clock." But has he kept his word?

If the pure and simple informative style, of which the sentence quoted above is an example, is almost the only one currently used in novels, we must acknowledge that it

119

is because the ambition of authors does not extend very far. The circumstantial, uselessly specific nature of each of their notations leads me to think that they play jokes at my expense. I am not permitted one alternative about a character: will he be fair-haired, what will be his name, shall we go and fetch him in summer? So many questions answered once and for all, haphazardly. No other discretionary power is left me than to close the book, a move that I do not deny myself somewhere around the first page. And the descriptions! What could compare to their nonentity? They are but a superposition of catalogue pictures; more and more the author takes it easy, he seizes the occasion to slip me his postcards, he tries to make me agree with his commonplaces:

> The little room into which the young man walked, with yellow paper on the walls, geraniums and muslin curtains in the windows, was brightly lighted up at that moment by the setting sun. . . . there was nothing special in the room. The furniture, all very old and of yellow wood, consisted of a sofa with a huge bent wooden back, an oval table in front of the sofa, a dressing table with a looking glass fixed on it between the windows, chairs along the walls and two or three halfpenny prints in yellow frames, representing German damsels with birds in their hands—that was all.[3]

That the mind should have such motifs in view, even momentarily, I am not in the mood to admit. It will be argued that this schoolboy drawing appears in its place and that the author has his reasons here to dishearten me. He wastes his time all the same, for I do not enter his room. The laziness, the weariness of others, has no hold on me. I have too unstable a notion of the continuity of life to equate with my best moments those of depression and weakness. When one ceases to feel, I want him to be silent. And let it be understood that I do not incriminate the lack of originality *for* the lack of originality. I am only saying that I have no regard for the empty moments of my life, that it may be unworthy for any man to crystallize those which appear to him to be so. This description of a room, allow me to skip over it, and over many others too. . . .

Observing that principles and qualities such as logic, experience, common sense, used in current life solely for reasons of utility, were unable to cope with the deeper problems of humanity, and referring to the works of Freud on the dream state, Breton insisted on the importance of dreams. He expressed a hope that someday a synthesis of dream life and waking existence would be achieved, and he proclaimed his faith in the power of the marvelous:

I believe in the future resolution of these two states, dream and reality, which are

[3] Dostoevski, *Crime and Punishment,* trans. Constance Garnett.

apparently so contradictory, into a sort of absolute reality, a *surreality,* so to speak. I have set out in its conquest, convinced that I cannot achieve it, yet too unmindful of my own death not to imagine a little the joys of such a possession. . . . A great deal more should be said but, in passing, I merely wanted to touch upon a subject that would require a very long and much more rigorous account: I shall come back to it. My intention here was to treat as it deserved this *hatred of the marvelous* that rages in certain men, this ridicule with which they want to discredit it. To cut it short: the marvelous is always beautiful, anything marvelous is beautiful, in fact, nothing but the marvelous is beautiful.

In the literary domain, only the marvelous is capable of fecundating works that belong to an inferior genre, such as the novel and generally speaking all that partake of the nature of anecdotes. *The Monk,* by Lewis, is an admirable proof of this. The spirit of the marvelous gives it its whole life. Long before the author has freed his main characters from all temporal constraints, one feels that they are ready to act with an unprecedented pride. A passion for eternity lifts them up unceasingly and lends unforgettable accents to their torment and to mine. I mean that this book, from beginning to end and in the purest manner on earth, exalts only the part of the mind that aspires to leave the ground, and that, when stripped of the insignificant part of its romantic plot, in the fashion of the times, it constitutes a model of exactness and of innocent grandeur.[4] It seems to me that nothing better has ever been done, and that the character of Matilda in particular is the most moving creation with which this *figurative* mode may be credited in literature. She is less a character than a continuous temptation. And if a character is not a temptation, what is it? An extreme temptation, this one. The "nothing is impossible to one who dares try" gives in *The Monk* its full, convincing measure. Ghosts play a logical part since the critical mind does not take hold of them to challenge their reality. Ambrosio's punishment is treated likewise in a legitimate manner since it is finally accepted by the critical mind as a natural ending.

It may seem arbitrary that when the marvelous is concerned, I propose this pattern, from which Nordic and Oriental literatures have borrowed time and time again, not to speak of religious literatures of all countries. But most of the examples that these literatures might have offered me are tainted with puerility, for the sole reason that they are addressed to children. Children are weaned early of the marvelous, and later on, they do not retain enough virginity of mind to take an extreme pleasure in nursery tales. Man thinks he would lose his dignity if he nourished himself with fairy tales; charming as they are, I agree that they are not all of his age. The fabric of adorable improbabilities needs to be a little finer as one advances in years, and we are still

[4]The admirable thing about the fantastic is that no longer is there anything fantastic: there is only the real.

waiting for this kind of spider. . . . But faculties do not change radically. Fear, the lure of the unusual, chance, a taste for luxury are incentives that will never be called upon in vain. There are still tales to be written for grown-ups, almost fairy tales.

The marvelous could be looked for, hunted, and discovered in and around a castle, said the "Manifeste." Several times in later writings Breton will again evoke this image of a château, or rather a large mansion, which would be his own house and at the same time a meeting place for those in search of the multifaced marvel, a vast imaginary residence where he and his friends would live their poetic lives—it would even have a hall of mirrors, like the Palace of Versailles.

I picture it in a rustic site, not far from Paris. Its outbuildings extend infinitely, and as for the interior, it has been terribly restored so as to be quite satisfactory with regard to comfort. Cars park before the door, concealed in the shade of trees. Some of my friends live there permanently; here is Louis Aragon going out, he has just time enough to shake hands with you; Philippe Soupault rises with the stars, and Paul Eluard, our great Eluard, has not come back yet. Here are Robert Desnos and Roger Vitrac in the park, deciphering an old edict on dueling; Georges Auric, Jean Paulhan; Max Morise, who rows so well, and Benjamin Péret with his equations of birds; and Joseph Delteil; and Jean Carrive, and Georges Limbour, and Georges Limbour (there is a whole hedge of Georges Limbours); and Marcel Noll; here is T. Fraenkel waving to us from his captive balloon; Georges Malkine, Antonin Artaud, Francis Gérard, Pierre Naville, J. A. Boiffard; then Jacques Baron and his brother, both handsome and cordial; so many others, and women, lovely ones, upon my word. Would these young people deprive themselves of anything? To wealth itself, their desires are orders. Francis Picabia pays us calls, and last week, in the hall of mirrors, we received a certain Marcel Duchamp, whom we did not know yet. Picasso is hunting in the neighborhood. The spirit of *demoralization* has taken up its residence in the castle, and we have to deal with it each time the question arises of a contact with our fellowmen, but the doors are always open and our first move is not to dismiss people, you know. Moreover, the solitude is vast, we do not meet each other very often. And to be our own masters is the main point, is it not, and the masters of women, of love, too?

They will prove me guilty of a poetic lie; everyone will be saying that I live on the Rue Fontaine, and that he will not swallow that tale. Why, of course! But when I do you the honors of this castle, are you sure that it is only an image? What if this castle did exist! My guests are here to answer for it; their caprice is its luminous road of access. We live really as we please, *when we are there*. And how could anyone inconvenience the others, in this shelter against sentimental pursuit and at the meeting place of opportunities?

Then the "Manifeste" recalled the genesis of surrealism—how automatic writing was first experienced by Breton and Soupault after Breton had perceived, one evening, before going to sleep, an unexpected sentence ("it was something like: **There is a man cut in two by the window**"), which soon became for him a picture and was followed by other sentence-images;[5] and how the two poets chose to characterize this activity by the word "surrealism," in homage to Guillaume Apollinaire. Breton defined surrealism in a formula all the more striking for being cast in the form of a dictionary entry:

It would be most unfair to challenge our right to use the word SURREALISM in the very special sense that we understand it, for it is clear that before we came, this word was not in current use. I define it, therefore, once and for all:

SURREALISM, n. Pure psychic automatism by whose means it is intended to express, verbally, or in writing, or in any other manner, the actual functioning of thought. Dictation of thought, in the absence of all control by reason and outside of all aesthetic or moral preoccupations.

ENCYCLOPEDIA. *Philosophy.* Surrealism is based on the belief in the superior reality of certain forms of associations hitherto neglected, in the omnipotence of dream, in the disinterested play of thought. It tends to ruin, once and for all, all other psychic mechanisms and to replace them in solving the main problems of life. Messrs. Aragon, Baron, Boiffard, Breton, Carrive, Crevel, Delteil, Desnos, Eluard, Gérard, Limbour, Malkine, Morise, Naville, Noll, Péret, Picon, Soupault, Vitrac have given proof of ABSOLUTE SURREALISM.

They seem to be, until now, the only ones, and there would be no doubt about this but for the fascinating case of Isidore Ducasse, about which I lack data. And indeed a good number of poets might be considered surrealists if we observe their results only superficially: Dante, to begin with, and in his best moments, Shakespeare. In the course of the various attempts I have made to reduce what is called, by breach of trust, genius, I never found anything that could not be ascribed finally to another process than that one.

Young's *Nights* are surrealist from beginning to end; unfortunately it is a priest who speaks, a bad priest without doubt, but a priest.[6]

[5] See also the citation from "Entrée des mediums." pp. 100ff.

[6] Many of the authors below are well known, or have already been identified in the preceding pages of this book. We may also remind the reader of: Benjamin Constant (1767-1820), writer and politician, author of the famous novel *Adolphe* (1815); Marceline Desbordes-Valmore (1785-1859), poet; Aloysius Bertrand (1807-41), whose only book, posthumously published, *Gaspard de la Nuit,* anticipates the *Poèmes en prose* by Baudelaire and even Rimbaud's *Illuminations;* Alphonse Rabbe (1787-1829) and his *Album d'un pessimiste* (1835); Saint-Pol-Roux (1861-1940), poet; Léon-Paul Fargue (1876-1947), poet; St.-John Perse (1887-1975; Nobel prize for poetry in 1960).—M.J.

Swift is surrealist in malice.

Sade is surrealist in sadism.

Chateaubriand is surrealist in exoticism.

Benjamin Constant is surrealist in politics.

Hugo is surrealist when he is not stupid......

Marceline Desbordes Valmore is surrealist in love.

Aloysius Bertrand is surrealist in the past.

Rabbe is surrealist in death.

Baudelaire is surrealist in morals.

Rimbaud is surrealist in the practice of life and elsewhere.

Mallarmé is surrealist in confiding.

Jarry is surrealist in absinthe......

Germain Nouveau is surrealist in the kiss.

Saint-Pol-Roux is surrealist in symbol.

Léon-Paul Fargue is surrealist in atmosphere.

Vaché is surrealist in me.

Reverdy is surrealist at home.

Saint-John Perse is surrealist at long range.

Raymond Roussel is surrealist in anecdotes.

Etc.

A few "Secrets of the Surrealist Art" were then revealed (more or less humorously), among them the technique of automatic writing as Breton and several of his friends practiced it; various possible aspects of surrealism were discussed for the future, and then came the conclusion of the "Manifeste du Surréalisme":

And consequently, I feel greatly inclined to consider with indulgence the scientific reverie, so unbecoming, after all, in every respect. The wireless? Good. Syphilis? If you like. Photography? I have no objection. The cinema? Cheers for the darkened halls. The war? We had good laughs. The telephone? Hello. Youth? Charming white hair. Try to make me say thank you: "Thank you." Thank you. If the common man values so much all that belongs, properly speaking, to laboratory research, it is because it results in the manufacture of a machine, in the discovery of a serum, which he believes concerns him directly: he never doubts that somebody wanted to improve his lot. I do not know exactly what part humanitarian wishes play in scholars' ideals, but that does not appear to me to constitute a very great amount of good feeling. I am speaking of course of the true scholars and not of popularizers of all kinds who take

out patents. I believe, in this realm as in any other realm, in the pure surrealist joy of the man who, aware of the successive failure of all others, does not consider himself beaten, starts from where he chooses and along any other road but a *reasonable* one, arrives wherever he can. Any imagery by which he will think it advisable to mark his progress and which will win him public gratitude perhaps, is in itself, I must confess, quite immaterial to me. The implements with which he must hamper himself do not inspire any respect in me either: his glass tubes or my steel pens...... As for his method, I claim that it is worth what is worth mine. I have seen the inventor of the cutaneous plantar reflex at work; he manipulated his patients ceaselessly, *it was clear that he trusted in no plan any more.* Here and there, he would make a remark, distantly, never laying down his needle, and his hammer always in action. The curing of the sick—he would leave to others this futile task; he was entirely caught by his sacred fever.

Surrealism, as I envisage it, proclaims loudly enough our absolute *nonconformity,* that there may be no question of calling it, in the case against the real world, as a witness for the defense. It could only account, on the contrary, for the complete state of distraction which we hope to attain here below. Kant's absentmindedness about women, Pasteur's absentmindedness about "grapes," Curie's absentmindedness about vehicles,[7] are in this respect deeply symptomatic. This world is made only very relatively to the measure of thought, and incidents of this kind are but the most outstanding episodes in a war of independence in which I glory to take part. Surrealism is the "invisible ray" that will one day enable us to overcome our opponents. "You are no longer trembling, carcass."[8] This summer roses are blue; wood is glass. The earth draped in its greenery makes as little an impression upon me as a ghost would. It is living and ceasing to live that are imaginary solutions. Existence is elsewhere.

To the theory, Breton added the practice. A collection of thirty-two of his automatic pieces formed the second part of the "Manifeste," materializing a marvelous world indeed, under the title of "Poisson soluble"—a world of lovely women, butterflies, castles, jewels, and glittering metamorphoses.

[7] There is an ascending gradation here in the consequences of absentmindedness. Kant was a confirmed bachelor who completely ignored women all his life. Pasteur on the other hand was involved once in a rather ridiculous incident when, during a meal, he carefully washed grapes in a glass of water, explaining to his guests the importance of eliminating germs from food—and then, distracted, drank the soiled water in the glass. As for Curie, his absentmindedness caused his death: he was run over by a carriage and killed while crossing a street.—M. J.

[8] An allusion to an anecdote concerning Turenne, Louis XIV's general, who, physically afraid at the beginning of a battle, addressed his own body in these terms: "You are trembling, carcass! You would tremble much more if you knew where I am going to take you!" This story is told in every school in France as an example of the power of will over instinct.—M. J.

Soluble Fish

13

For fear that the men who followed her in the street would be mistaken about her feelings, this young girl resorted to a charming stratagem. Instead of making up her face as for the theater (are not footlights sleep itself, and is it not advisable to ring entrances on the stage in the very legs of women?), she used chalk, a live coal, and an extremely rare green diamond, which her first lover had left her in exchange for several drums of flowers. In her bed, after having thrown back carefully the sheets of eggshell, she bent her right leg so as to place her right heel on her left knee, and with her head turned to the right, she prepared to touch with the burning coal the tip of her breast, around which the following things happened: a sort of green halo the color of the diamond took shape and entrancing stars came to fasten themselves in the halo, then straws gave birth to ears with grains like spangles on dancers' skirts. Then she decided that the moment had come to pleat the air on her way, and for this she made use again of the diamond, throwing it against the windowpane. The diamond, which never fell down again, dug into the glass a small aperture in its shape and exactly its size, which took on, while the precious stone continued its flight, in the sunlight the aspect of an egret of the ditches. Then she bit with delight into the surprising white stratifications of chalk remaining at her disposal, the sticks of chalk, and these wrote the word "love" on the slate of her mouth. She ate thus a veritable little castle of chalk built in a patient and mad architecture, after which she threw on her shoulders a calaber-fur coat, and putting her feet into two mouse skins, she went down the stairs of freedom, leading to the illusion of the never-seen. The guards let her pass, they were, besides, evergreens held on the waterside by a feverish game of cards. Thus she reached the Stock Exchange, where not the slightest agitation reigned since butterflies had thought of carrying out a capital punishment there; I still see them all lined up when I close my eyes. The young girl sat down on the fifth step and there, she summoned the shriveled powers to appear to her and subject her to the wild roots of the place. Since that day she has spent every afternoon under the famous flight of stairs as a subterranean Fame blowing, when in the mood, the trumpet of ruin.

Shortly before Breton's "Manifeste" appeared, Louis Aragon had published in the review *Commerce* a long article (later a book), *Une Vague de Rêves,* which was also a sort of surrealist manifesto. His text discussed mainly "surrealist" activities considered as dream activities, putting forward the idea of the basic "unreality" of "real" life, which André Breton had expressed as follows in the first sentence of his "Manifeste": "The longer the belief in life lasts,

in the most precarious aspects of life, *real* life I mean, the more this belief finally vanishes." Aragon expounded this thought in his own dramatic manner:

A WAVE OF DREAMS

I happen sometimes to lose suddenly all the thread of my life. I ask myself, sitting in some corner of the universe, beside a cup of smoking black coffee, in front of polished pieces of metal, among the goings and comings of tall sweet women, which road of madness led me to run aground at last under this arch, and what in truth is this bridge that they call: sky. . . .

This moment when everything escapes me, when giant cracks make their way in the castle of the world, I would sacrifice all my life for it, if it would only last at this absurdly low price. Then the mind parts a little from human mechanisms, then I am no longer the bicycle of my senses, the grindstone for remembrances and encounters. Then I grasp within myself the occasional, I grasp suddenly how to go beyond myself: the occasional is myself, and after shaping that proposition, I laugh at the memory of all human activity. It is at this point perhaps that there would be grandeur in death, it is at this point perhaps that they kill themselves, those who take their leave one day with a clear glance. At this point, in any case, thought begins that in no way resembles these mirror tricks in which some people excel, without risk. When one has felt, only once, this vertigo, it seems impossible to accept again the mechanical ideas that today summarize almost every enterprise of man, and all his tranquillity.

Realism, says Aragon, does not reveal the true nature of things.

[The real] . . . is just another relation, the essence of things is in no way linked to their reality, there are relations other than reality that the mind may grasp and that come first too, such as chance, illusion, the fantastic, the dream. These various species are reunited and reconciled in a genus, which is surreality.

Then the author reviews presurrealist researches, those of Breton and Soupault and of their friends; when he evokes the "period of sleeps" and its poetic trances, he waves aside suspicions of simulation.

One wondered if they really slept, and in some hearts lay a denial of this adventure; the idea of simulation was brought again into play. As for me, I could never shape a clear idea of that idea. To simulate a thing. is it anything but to conceive it? And what is conceived is. You can't make me give that up. Explain to me, besides, by simulation the inspired nature of the spoken dreams that were unfolded before me!

But if there was simulation, it was a simulation of sleep, not of poetry...... Then the author summons further images.

Dreams, dreams, dreams, the domain of dreams widens at each step. Dreams, dreams, dreams, the blue sun of dreams drives the steel-eyed beasts back to their lairs at last. Dreams, dreams, dreams, on the lips of love, on the numerals of happiness, on the sobs of attention, on the signals of hope, in the working yards where a whole people is resigned beside their picks. Dreams, dreams, dreams, all is but a dream where the wind wanders, and the barking dogs come out on the roads. O great Dream, on the pale morning of edifices, do not leave, attracted by the first sophisms of the dawn, these cornices of chalk upon which you lean, blending your pure and faltering features with the miraculous motionlessness of statues!

Aragon gives his own list of precursors of surrealism (among them, Raymond Roussel, Philippe Daudet,[9] Saint-John Perse, Picasso, Chirico, Reverdy, Vaché, Léon-Paul Fargue, Sigmund Freud) and also a choice of dreamers, the first participants in the movement. Eluard is omitted, but to the list of honors of the "Manifeste du Surréalisme" are added André Masson, Man Ray, Artaud, Max Ernst, Maxime Alexandre, Alberto Savinio, and the names of a few girl friends or wives of the members of the group: Denise, Simone, Renée. . . .

For the author of *Une Vague de Rêves,* dreaming seemed in the end to be one of man's great characteristics, and in a way his main asset.

It happens that in the wall of his dungeon, the recluse hews out an inscription that causes a rustle of wings on the stone. It happens that he sculpts a feathered symbol of earthly love above the rivet. It is because he dreams, and I dream, carried onward, I dream. I dream of a long dream where everybody would dream. I don't know what will happen from this new venture of dreams. I dream on the edge of the world and of the night. What is it you wanted to tell me? Men in the distance, calling out, laughing at the sleeper's gestures? On the edge of night and crime, on the edge of crime and love. O Rivieras of unreality, your casinos open their gambling rooms, regardless of age, to those who want to lose! It is time, believe me, that nobody wins.

Who's there? Oh, very well: show the infinite in.

Following the "Manifeste" and *Une Vague de Rêves,* the pamphlet *Un Cadavre* (A Corpse), published on the death of Anatole France at the end of 1924, demonstrated that the surrealists' activity would not remain a mere exaltation of dreams or automatic writing. They

[9]Son of the leader of the Royalist party, Léon Daudet (and grandson of Alphonse Daudet, the writer), Philippe Daudet committed suicide in 1924.

poured insults on the corpse, "still warm," of one of the most celebrated French writers, of an author admired by revolutionaries, liberals, and reactionaries alike, by the people as well as the elite. Anatole France had been a "free spirit," a *Dreyfusard* during the famous *affaire* at the beginning of the century; before his death he had been flirting with the newly founded Communist party. While his style, in the eighteenth-century manner, delighted all traditionalists, the young poets knew him to be a blind enemy of all modern poetic values. His imperative judgments as a juror for the third *Parnasse Contemporain* anthology, in 1876, were not forgotten. Anatole France had opposed Mallarmé's entry with this comment: "No. People would laugh at us"; concerning Verlaine: "No. The author is unworthy and his verse is among the worst ever seen"; concerning Charles Cros: "No. I would be obliged to withdraw my contribution if his was accepted"; etc.

Aragon, Eluard, Soupault, and others wrote articles in *Un Cadavre*. André Breton's article was entitled: "Refus d'inhumer."

Burial Not Allowed

Since it was already too late to speak of Anatole France in his lifetime, let us merely cast a grateful glance at the newspapers that took him away, the silly daily sheets that had brought him in. Loti, Barrès, France, all the same let us mark with a beautiful white sign the year that laid down these three sinister fellows: the idiot, the traitor, and the policeman. I am not opposed to a special word of contempt for the third one. With France, it is a little of human servility that goes away. Let it be a holiday, the day when trickery, traditionalism, patriotism, opportunism, skepticism, realism, and heartlessness are buried! Let us remember that the vilest comedians of this age were Anatole France's associates, and let us never forgive him for adorning his smiling inertia with the colors of the Revolution. To put away his corpse, let, if you will, one of these boxes along the quays of the Seine be emptied of these old books "he loved so much," and let the whole thing be thrown into the river. Dead, this man must not produce dust any longer.

PART

LA RÉVOLUTION
SURRÉALISTE

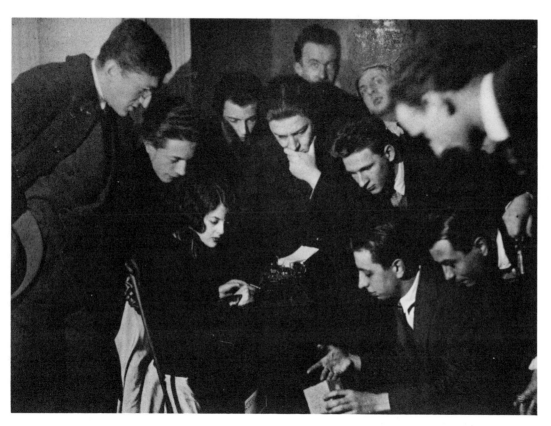

At the Centrale Surréaliste, 1924. *From left:* Max Morise, Roger Vitrac, Simone Breton, J.-A. Boiffard, André Breton (hand on chin), Paul Eluard (behind Breton), Giorgio de Chirico (facing camera). *Clockwise from de Chirico:* Pierre Naville, Robert Desnos, Charles Baron, Louis Aragon.

Morals

The review *La Révolution surréaliste,* founded in December 1924, displayed no eccentric typography, no unconventional layout, no unusual cover. The title was disquieting enough to catch not only the eye but also the mind, and a phrase on the cover was fraught with far-reaching ambitions: "We must attain a new declaration of the rights of man." On the overleaf was printed: "We are on the eve of a Revolution — you may take part in it," and the announcement of the opening of a Central Office for Surrealist Research. A preface, signed by Boiffard, Eluard, and Vitrac, stressed and summarized in a succession of metaphors the theses of the "Manifeste" and the comments of *Une Vague de Rêves:*

Preface

As the case against knowledge calls no longer for an investigation, as intelligence is no longer taken into account, dream alone grants man all his rights to freedom. Thanks to the dream, death no longer has an obscure meaning and the meaning of life becomes unimportant.

Each morning in every family, men, women, and children, IF THEY HAVE NOTH-ING BETTER TO DO, tell each other their dreams. We are all at the mercy of the dream and we owe it to ourselves to remain under its power during the waking state. It is a terrible tyrant clad in mirrors and flashes of lightning. What is paper and pen, what is writing, what is poetry before this giant who holds the muscles of the clouds in his own muscles? You are there stammering before the serpent, ignoring dead leaves and glass traps, you are worried for your fortune, your heart, and your pleasures, and you search the shadows of your dreams for all the mathematical signs that will ensure you a more natural death. Others, and these are the prophets, blindly guide the powers of

night toward the future, the dawn speaks through their mouths, and the ravished world takes fright or congratulates itself. Surrealism opens the doors of the dream to all those for whom night is miserly. Surrealism is the crossroads of the enchantments of sleep, of alcohol, of tobacco, of ether, of opium, of cocaine, of morphine; but it is also the breaker of chains, we do not sleep, we do not drink, we do not smoke, we do not sniff, we do not give ourselves injections, and we dream, and the speed of the lamps' needles introduces in our minds the marvelous defloured sponge of gold. Ah! if bones were inflated like dirigibles, we would visit the darkness of the Dead Sea. The road is a sentinel set up against the wind that enfolds us and makes us shiver before our fragile appearances of rubies. You, stuck to the echoes in our ears like the clock-octopus against the wall of time, you may invent poor stories that will make us smile with nonchalance. We no longer bother; say if you will "The idea of movement is above all an inert idea," [1] and the tree of speed appears to us. The mind spins like an angel, and our words are the small shot that kills the bird. You, to whom nature has given the power to turn on electricity at noon and to stay under the rain with sunshine in your eyes, your acts are gratuitous, and ours are dreamed. Everything is whispers, coincidences, the silence and the spark ravish their own revelation. The tree loaded with meat that rises up between the paving stones is supernatural only in our astonishment, but while we close our eyes, it is waiting for inauguration.

Since every discovery changes nature, the destination of an object or a phenomenon constitutes a surrealist fact. Between Napoleon and the phrenologic bust that represents him are all the battles of the Empire. Far from us, the idea of exploiting these images and modifying them in a sense that would convey the idea of progress. Alcohol, milk, or gas may appear from the distillation of a liquid, that is, just as many satisfying images and worthless inventions. No transformation takes place, yet the true writer, an invisible ink, will be counted among the absent. Solitude of love, the man lying on you commits a perpetual and fatal crime. Solitude of writing, you will no longer be known in vain, your victims, caught up by the gear wheels of violent stars, resuscitate within themselves.

We acknowledge the surrealist exaltation of mystics, of inventors, of prophets, and we pass on.

In this review, besides, reports on invention, on fashion, on life, on fine arts, and on magic will be found. Fashion will be discussed according to the gravitation of white letters on nocturnal flesh, life according to the players, fine arts according to the skate that says "storm" to the bells of a centenarian cedar tree, and magic according to the motion of spheres in blind eyes.

[1] Bishop Berkeley.

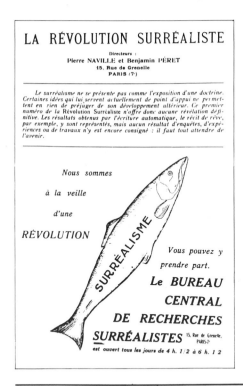

LA RÉVOLUTION SURRÉALISTE

Directeurs :
Pierre NAVILLE et Benjamin PÉRET
15, Rue de Grenelle
PARIS (7ᵉ)

Le surréalisme ne se présente pas comme l'exposition d'une doctrine. Certaines idées qui lui servent actuellement de point d'appui ne permettent en rien de préjuger de son développement ultérieur. Ce premier numéro de la Révolution Surréaliste n'offre donc aucune révélation définitive. Les résultats obtenus par l'écriture automatique, le récit de rêve, par exemple, y sont représentés, mais aucun résultat d'enquêtes, d'expériences ou de travaux n'y est encore consigné : il faut tout attendre de l'avenir.

Nous sommes

à la veille

d'une

RÉVOLUTION

SURRÉALISME

Vous pouvez y prendre part.

Le BUREAU CENTRAL DE RECHERCHES SURRÉALISTES 15, Rue de Grenelle, PARIS-7ᵉ

est ouvert tous les jours de 4 h. 1/2 à 6 h. 1/2

Verso of the cover of *La Révolution Surréaliste*, no. 1 (December 1924). Translation: "Surrealism does not present itself as the exposition of a doctrine. Certain ideas it uses now as a starting point do not allow the least anticipation of its further developments. Therefore, this first number of *La Révolution Surréaliste* offers no final revelations. The results obtained, for instance, through automatic writing, accounts of dreams, are shown, but there are no results of inquests, experiments, or other works: we must expect everything from the future."

Already, automatons multiply and dream. In cafés, they ask eagerly for writing materials, the veins of the marble are the graphs of their escape, and their cars go alone to the Bois.

Revolution..... Revolution. Reality is the pruning of trees, surrealism is the pruning of life.

A survey that could hardly be called literary was announced in the first number of the magazine: "Is suicide a solution? We live, we die. What part has the will in all this? It seems that people kill themselves as they dream. It is not a moral question that we are asking."

But it was a question, in any case, which the review turned into another "trap-inquest" in the manner of the "Why do you write?" asked by *Littérature* in earlier days. When the answers were published, the editors described most of them as "crafty, literary, or burlesque," and in general "dry" and "devoid of anything human"; one of the correspondents, a Dr. Maurice de Fleury, was even called a "sinister idiot"!

But other surprises awaited the reader, for instance, an article by Aragon on "Invention" was illustrated with a scene from a Buster Keaton picture; Max Morise explored the possibilities and impossibilities of painting in a true surrealist way according to the definitions of the "Manifeste"; and among other articles and chronicles, Philippe Soupault entitled his observations on "conscience": "L'Ombre de l'ombre."

The Shadow of the Shadow

I mistrust public opinion, that old skull full of bugs and desiccated clippings, which feels all of a sudden the need to use a sepulchral voice to speak according to common sense. It cannot be repeated too often that common sense is the expression of mediocrity. I don't hesitate to write this truism at this moment when a recent experiment makes me perceive all its force. Every day we run up against that stone: trustworthy people; all this to explain that such or such a thing must or must not be done, that it is not fitting, that it is tactless or again foolish, to say, to do, or to write what we want to say, to do, or to write. This "plain" good sense, as they call it, helps me sometimes to keep my balance, but when they throw it in my face, I am ready automatically, at once, to do *all that* goes through my mind.

I always act in accord with myself, which means in total disagreement with those who live outside myself. This brings great joy to me. Let us imagine, for a few seconds, that I cannot tell the present limits of my shadow and of what is called, rightly or wrongly (but rather wrongly), truth. At once I feel light, aerial, determined, and stripped of all doubts. Everything appears to me simple and supple as a sheet of water.

But clear up this misunderstanding. Your limits are within yourselves and you imagine them.

Enlist if possible a few individuals, that is to say, men of good will, from among your "friends and acquaintances." Ask them to remain unmoved and to look really with their own eyes. The most extraordinary phenomena will rise up, will come to meet their glance, and they will be left to support their doubts with only a walking stick of marshmallow, which will be called, in this case, habit.

If you cannot find individuals, buy a daily paper for fifteen or twenty centimes, and in the news you will discover examples, often striking ones, of what I put forward. The mere fact of reading inside yourselves and of perceiving interior landscapes deserves a few instants' examination; and let us note first that there is no difference whatever between a real item of news and the facts we catch on the wing in our mind. Say aloud "Once upon a time . . ." or "Yesterday evening at the start of the day . . ." and you will have the famous "news in brief" of the papers. If on the other hand, you try to imagine (I speak of imagining and not of forecasting) your timetable for the next day, you will certainly be surprised by the mediocrity of your life. You will always be late.

On a given day, in a town of several million inhabitants, there are therefore only ten, fifteen, let's say thirty, individuals who live against good sense, that is to say, who live according to reality, who purely and simply live.

I always discover in the newspapers, which are considered here only faithful mirrors, fresh sources of valuable information. Open one of these sheets called:

L'Humour, Paris-Flirt, Mon Béguin, L'Amour en vitesse, and other publications of that kind. On the last page one sees a column that has many customers: the classified advertisements. Be careful to read attentively, but not between the lines, the demands, the offers made there. You will realize then the strange simplicity of desires. This simplicity that I call strange is also and still a marvelous one. Desires, I wrote that word, desires, such are the sole witnesses, the sole faithful spokesmen.

Nothing should be started afresh but one must sometimes persevere. Follow these advertisements for a few weeks. Most of them are expected and prodigious. And if you are surprised, think of the little operation the advertiser must have committed. First: to buy *Paris-Flirt;* second: to read it; third: here the mystery intervenes; four: to take a pen; five: to write an advertisement; six: to send it; and seven: to wait with a throbbing heart for the result. It must be noted that *no offer remains without an answer.*

Life is a dream, they say. I have no proof of what they say. I am satisfied with these, to say the least, sensational revelations, which remain public ones, absolutely.

That first issue of *La Révolution surréaliste* carried Pierre Reverdy's only contribution to the review. Drawings by Masson, Ernst, Chirico, and others were scattered among its pages. No poems were published yet, except one by Paul Eluard, titleless:

Winter on the meadow brings mice
I met youth
Naked with pleats of blue satin

Glances in the reins of the steed
Freeing the rocking of the Palms of my blood
I discover suddenly the grapes of the façades
 lying on the sun
Fur of the flag of the insensible straits

Consolation lost seed
Remorse melted rain
Sorrow heart-shaped mouth
And my wide hands struggle

The antique head of the model
Blushes before my modesty
I ignore it I jostle it
O! letter with incendiary stamps

Which a beautiful spy did not send
And who slipped a stone ax

Into the shirt of his daughters
His sad and lazy daughters

On shore on shore all that swim
Down down all that fly
I need the fishes to wear my crown
Around my brow

I need the birds to speak to the crowd.

La Révolution surréaliste published numerous manifestoes condemning the use the bourgeois world made of such "social tools" as barracks, prisons, churches, psychiatric hospitals, universities, the law, etc., and taking to task official personalities and "great men" of that world. In the second issue appeared a manifesto entitled "Ouvrez les prisons—libérez l'armée."

Open the Prisons—Disband the Army
There are no common-law crimes

Social constraints have had their day. Nothing, neither recognition of an accomplished offense nor contribution to national defense, should force man to give up liberty. The idea of prison, the idea of barracks is today currently accepted; these monstrosities surprise no longer. Indignity lies in the calmness of those who got around the difficulty through various moral or physical abdications (honesty, illness, patriotism).

When one becomes conscious again that, on the one hand, the existence of such dungeons, on the other hand, the degradation, the diminution they cause those who are locked in them, constitute an abuse (and there are, they say, madmen who prefer the cell or the barrack room to suicide), when at last one is again conscious of this, no discussion should be admitted, no recantation. Never has the opportunity to have done with them been greater, so do not tell us about opportunity. "Let the assassins begin," "if you want peace prepare for war"—such proposals shelter only the basest fear or the most hypocritical desires. Let us not fear to confess that we are waiting, that we are calling, for the catastrophe. The catastrophe? It would be the persistence of a world in which man has a right over man. Sacred union before knives and machine guns: how could we resort to this discredited argument any longer? Send soldiers and convicts back to the fields. Your liberty? There is no liberty for the foes of liberty. We will not be the accomplices of jailers.

The French Parliament voted a curtailed amnesty; the annual contingent for military service will be drafted next spring. In England a whole town was powerless to save one man, and it was learned without great surprise that in America, at Christ-

mas, the execution of several condemned men had been postponed *because they had beautiful voices.* And now that they have sung, they may as well die—or drill? In sentry boxes, in electric chairs, men are waiting at the point of death: will you let them be executed?

Open the prisons. Disband the army.

The third number of the review (April 15, 1925) contained no less than five manifestoes, the style of some of them betraying the influence of Antonin Artaud, his exasperated rejection of all Western values and institutions—for instance, this "Adresse au Pape":

Address to the Pope

The Confessional is not you, o Pope, it is us, but understand us and may the Catholic world understand us.

In the name of Fatherland, in the name of Family, you urge the sale of souls, the unlimited pulverizing of bodies.

We have too many paths to cross, too great a distance to go between our souls and ourselves, to let your tottering priests intervene with that heap of adventurous doctrines on which all the eunuchs of world liberalism feed.

As for your Catholic and Christian God, who, like all other Gods, has conceived of all evil:

1. You confiscated him.

2. We have nothing to do with your canons, index, sin, confessional, priests, we are thinking of another war, war to you, Pope, you cur.

Here the spirit confesses to the spirit.

From top to bottom of your Roman masquerade, the hatred of the immediate truths of the soul triumphs, the hatred of those flames burning in the spirit itself.

We are not born to this world. O Pope, confined to the world, neither earth nor God speaks through you.

The world is the abyss of the soul, warped Pope, Pope exterior to the soul, leave our souls in our souls, we do not need your knife of enlightenments.

Two other manifestoes, directed to the Dalai Lama and to the Buddhist schools, were a homage, or an appeal, to the "thought of the Orient." Breton's ideas were more evident in a "Lettre aux Médecins-Chefs des Asiles de Fous," where precise accusations arose from a clear exposure of facts and from analysis of their origin and consequences.

Letter to the Chief Doctors of Lunatic Asylums

Gentlemen,

Law and custom grant you the right to measure the human mind. You exercise this sovereign and redoubtable jurisdiction according to your own understanding. Allow us to laugh. The credulity of civilized nations, of scholars, of governments, adorns psychiatry with some supernatural light or other. But judgment has already been passed on your profession. We do not intend to discuss here the value of your science, or the doubtful existence of mental illness. But for a hundred pretentious pathogenies where confusion between matter and mind is let loose, for a hundred classifications among which the vaguest are still the only usable ones—how many noble attempts have there been to come near the cerebral world where so many of your prisoners live? How many among you, for example, hold the dream in *dementia praecox,* to whose images the patient is a prey, as something other than a mere jumble of words?

We are not surprised to discover that you are inadequate for a task for which only few people are predestined. But we object to the right allotted to certain men, narrow-minded or not, to sanction their research in the domain of the spirit with perpetual confinement.

And what a confinement! It is known—it is not known enough—that asylums, far from being *asylums,* are frightful jails, where the prisoners provide free and convenient labor, where ill-treatment is the rule; and you tolerate this. The lunatic asylum, under cover of science and justice, is comparable to barracks, to prison, to penal servitude.

To spare you the trouble of easy denials we shall not raise here the question of arbitrary internments. We affirm that a great number of your inmates, absolutely insane by the official definition, are also arbitrarily interned. We do not agree that the free development of a delirium should be impeded, since it is as legitimate, as logical a succession of human ideas, or actions, as any other. The repression of antisocial reactions is as futile as it is unacceptable in its principle. All individual actions are antisocial. Madmen are above all the individual victims of social dictatorship; in the name of this individuality, which is the characteristic of man, we demand that these convicts of sensibility be set free, since it is not, after all, in the power of the laws to lock up all the men who think and act.

Without dwelling on the nature, full of genius, of the manifestations of certain madmen, and as far as we are qualified to appraise them, we affirm the absolute legitimacy of their conception of reality, and of all the actions derived from it.

May you remember this tomorrow morning, during your time of attendance,

when you will attempt, without a dictionary, to converse with these men, over whom you must admit that you have no advantage but force.

A fifth manifesto was a "Lettre aux Recteurs des Universités européennes." (Letter to the Rectors of the European Universities). We shall quote it later, in its historical place, or rather, in the place recent history has conferred on it—the time of the student revolt in Paris, in May 1968.

In July 1925, the "Lettre ouverte à M. Paul Claudel" was addressed to the writer-ambassador, an "official modern poet," so to speak, who posed also as an admirer of Rimbaud, in fact as a Rimbaud "specialist."

Open Letter to M. Paul Claudel
Ambassador of France in Japan

As for the present movement, not one may lead to a true revelation or creation. Neither dadaism, *nor* surrealism, *which has only one meaning: pederasty. Several people express surprise, not that I am a good Catholic but a writer, a diplomat, an ambassador of France, and a poet. But I do not find in all this anything strange. During the war, I went to South America to buy wheat, canned meat, fat for the armies, and I helped my country make a profit of two hundred million.*

> —Interview with Paul Claudel, in
> *Il Secolo,* reprinted in the Paris paper
> *Comoedia,* June 17, 1925

Sir,

Our activity is pederastic only through the confusion it introduces in the minds of those who do not participate in it.

We don't care about creation. We wish with all our might that revolutions, wars, and colonial insurrections would annihilate this Western civilization whose vermin you defend even in the Orient, and we call for this destruction as the least unacceptable state of things for the mind.

There is no "great art" or any equilibrium for us. The idea of beauty subsided[2] a long time ago. Only a moral idea stands; for instance, that one cannot be at the same time an ambassador of France and a poet.

We seize this opportunity to break openly with all that is French in speech and in action. We declare that treason and all that may prejudice the safety of the state one way or another are much more readily reconcilable with poetry than the sale of great quantities of fat on behalf of a nation of pigs and dogs.

A singular misapprehension of the special faculties and of the possibilities of the mind periodically induces blackguards of your kind to seek their redemption in a

[2]An allusion to the first line of Rimbaud's poem "After the Deluge" (see above, p. 15).—M.J.

Catholic or Greco-Roman tradition. For us, redemption is nowhere. We regard Rimbaud as a man who despaired of his redemption and whose work and life are pure evidence of perdition.

We leave you to your infamous holy stuff: Catholicism, Greco-Roman classicism. Let it be profitable to you in every manner; become still fatter, and croak with the respect and the admiration of your fellow citizens. Write, pray, and drivel; we ask for the dishonor of calling you once and for all a low-grade pedant and a scum.

Paris, July 1, 1925

In special defense of Rimbaud's message, another open letter, entitled "Permettez!," was sent, two years later, in 1927, to the organizing committee for re-erection of a bust of the poet that the German armies had destroyed during World War I, in his native town of Charleville.

One Moment!

> *I would have understood Rimbaud less without surrealism.*
> –Ernest Delahaye
> Paris, October 23, 1927 [3]

To the Representatives of the Department of Ardennes
To the Mayor of Charleville
To the Aldermen
To the President of the Society of Poets of the Ardennes

Gentlemen:

You are taking, it seems, the responsibility of unveiling today, for the second time, a monument to the memory of Arthur Rimbaud and of organizing on this occasion a little local festival. It is unfortunate that your enterprise still lacks official consecration, but we may guarantee that this is only a matter of time. Why did you not manage to have with you M. Louis Barthou,[4] in order to distract his attention, if only for a moment, from his worries about Communism and to arouse again within him the bibliophile who somehow these days disappears behind the prison purveyor.

You will admit, gentlemen, that it is perhaps an ill-chosen moment to let yourselves be carried away by patriotic delirium, when the man you celebrate had only gestures of disgust and words of hatred for you, and when the glory he enjoys will

[3]Ernest Delahaye, a friend of Rimbaud in his early youth, later revealed many details about the poet's initial activities and published several of his letters.—M.J.

[4]Louis Barthou (1862-1934), then minister of the interior, was a collector of first editions, manuscripts, and letters, especially by Rimbaud.—M.J.

eternally be the very opposite of the glory of those writers who died for France, of those "knights of the spirit, who concentrate within themselves all that France has fought for during the last war" (Edouard Herriot).[5]

It is true that you do not know who Rimbaud is and you show this clearly once again:

> *My native town is superlatively idiotic among all the small provincial towns; I have no more illusions, you see, about this. Because it is near Mézières—a town you can't find—because it sees two or three hundred soldiers wandering about its streets, this benign population gesticulates like pompous bullies, much more than the besieged inhabitants of Metz or Strasbourg! It's frightening, the retired grocer putting on a uniform! It's wonderful, the pluck they have, lawyers, glaziers, tax collectors, carpenters, and all the fat-bellied ones who, a rifle inside their hearts, practice patrolitism[6] at the doors of Mézières; my country is rising! I prefer to see it seated. Stop that noise with your high boots! That's my principle.*
>
> *(August 15, 1870)*

We are curious to learn how you may reconcile the presence in your town of a monument to the war dead and a monument to the memory of a man who incarnates the highest conception of defeatism, active defeatism, which, in time of war, you send to the firing squad. . . .

> *War: no siege of Mézières. When? There is no talk of it. . . . Francs-tireurs here and there. Abominable itching of idiocy, such is the spirit of the population. You hear some pretty talk. It's boring, you know!*
>
> *(November 2, 1870)*

> *I strongly wish that the Ardennes be occupied and put under a more and more immoderate pressure. But this is still ordinary.*
>
> *(June 1872)*

> *Day before yesterday I went to see the Prussmans at Vouziers, a subprefecture of ten thousand souls, seven kilometers from here. That cheered me up.*
>
> *(May 1873)*

In any case, he was disgusted with France. Her spirit, her great men, her morals,

[5] Herriot (1872-1957), a humanist writer, was several times minister of public instruction and prime minister. — M.J.

[6] The French word *patrouillotisme* coined here by Rimbaud has become famous as a reference to the "heroes of the rear" during a war; it blends *patriotisme, patrouille* ("patrol"), and *trouille,* a slang word for "fear." — M.J.

her laws symbolized for him all that was most insignificant and lowest in the world.

How horrible this French countryside is! . . . What shit! And what monsters of innocence these peasants are! You must go two leagues, and more, to have a drink at night. The mother[7] put me here in a sad hole.

(May 1873)

Always the French vegetables
Peevish, consumptive, ridiculous,
Where the bellies of basset hounds
Cruise peacefully at twilight.

. . . Musset is fourteen times execrable for us, suffering generations seized by visions—which his angelic laziness has insulted! O! the insipid tales and proverbs! O the Nuits! *O* Rolla, *O* Namouna, *O* La Coupe! *Everything is French, that is to say, hateful to the supreme degree; French, not Parisian! One more product of that odious genius that inspired Rabelais, Voltaire, Jean La Fontaine, annotated by Monsieur Taine! Springlike, Musset's spirit! Charming, his love! There you have enamel painting, solid poetry! They will relish* French *poetry for a long time, but only in France.*

(May 15, 1871)

Rimbaud? He did not tolerate saluting of the dead in his presence, he wrote "Shit to God" on the walls of the churches; he did not love his mother, "as inflexible as seventy-three lead-capped administrations."

Rimbaud? A Communard, a *Bolshevik* after Delahaye's own evidence:

Some destruction is necessary. . . . More old trees must be cut down and we shall lose the habit of century-old shade trees. Axes, picks, bulldozers will be driven through this society itself. "All valleys will be filled in, all hills lowered, winding paths will be straightened, and rough roads will be smoothed." Fortunes will be razed and individual pride brought down. A man will not be able to say: "I am more powerful, richer." Sour envy and stupid administration will be replaced by peaceful concord, equality, work by all, for all.

Rimbaud? He lived the way you say one must not live, *Caropolshitters:* he got drunk, he fought in brawls, he slept under bridges, he had lice. But he hated work:

I shall never work.
It is disgusting to work.

[7] This word is in English in Rimbaud's letter. — M.J.

We shall never work, o waves of fire!
I loathe all trades, masters and workers are all ignoble peasants. A hand with a
pen is worth a hand on the plow. What a century of hands! I shall never have my
hand.

Without hope on earth or elsewhere, his one thought was to go away, always, a prey to this terrible boredom that you will never experience; all over the world, in the most desolate places, he chased the most distressing image of himself and of ourselves. . . .

Alas! I don't care any more for life, and if I live, I am used to living on exhaustion
. . . . and to feeding myself with sorrows as scorching as they are absurd, under
atrocious climates. . . . May we enjoy a few years of real rest during this life;
and a good thing that this life is the only one and that this fact is obvious, since
another life with a greater boredom cannot be imagined!

<div align="right">

(Aden, May 25, 1881)

</div>

All that makes up your dirty little life was loathsome to him.

> *All to war, to revenge, to terror,*
> *My spirit! Let us turn about under the biting teeth;*
> *ah! pass away,*
> *Republics of this world!*
> *Regiments, colonists, peoples: Enough!*

He was always against all that exists, you only pretend to have forgotten it. Don't try to cheat: you don't erect a statue to a poet "like any other poet"; you erect this statue through resentment, meanness, revenge. You want to reduce the man who admired "the obstinate convict upon whom the prison always closes up" to a grotesque bust in an ignoble place:

Charleville, Station Square

> On the place cut up into mean plots of turf,
> The square where everything is correct, trees and flowers,
> All the wheezy bourgeois choked by the heat
> Bring their jealous stupidities on Thursday evenings.

A strange reversal of earthly things [wrote P. Berrichon]; the monument erected in 1901 to the memory of Rimbaud stands in bronze and granite on this Station Square, where, more than ever, the inhabitants of Charleville go on Thursdays

to listen to the military band; and it is a military band that, when the monument was unveiled, rendered the adaptation of a symphony by Emile Ratez inspired by *Le Bateau ivre.*[8]

The military band! You forgot the choristers:

"The flag goes to the filthy landscape," as your faces are made for *"the putrid kiss of Jesus."*

A shadow seems to weigh down, ever more heavily, over the invading marshes. Hypocrisy stretches out a hideous hand on the men we love, to use them for preservation of what they have fought against. Needless to say, we do not delude ourselves on the effects of such attempts at confiscation, we are not alarmed beyond measure at your usual shameful proceedings, since we are convinced that a power of total fulfillment stirs up against you all those who are truly inspired in the world. It doesn't matter much for us that a statue of —— be unveiled, that the complete works of —— be published, or that any profit at all be drawn from the most subversive intelligences; their marvelous venom will eternally creep into the souls of young men to corrupt them or to make them greater.

The statue that is unveiled today will perhaps undergo the same fate as the preceding one, removed by the Germans and perhaps used for making shells to demolish your Station Square, or to reduce to nothingness the museum where an ignoble exploitation of his glory is being prepared.

Priests, professors, masters, you are making a mistake when you turn me over to justice. I have never been a Christian; I am of the breed that sang under torture; I do not understand laws; I have no moral sense. I am a brute: you are making a mistake.

Another "call to order" appeared in *La Révolution surréaliste,* no. 6 (March 1, 1926), in the form of an extremely violent note by Paul Eluard, "Le Cas Lautréamont," which took to task several contributors to an issue of the review *Le Disque Vert* concerning the author of *Les Chants de Maldoror.* Breton, Crevel, and Eluard himself had also contributed to that number, as well as the poet John Rodker, who translated *Maldoror* into English. But most of the other commentators were pitilessly dismissed by Eluard in his article; he adorned them with nicknames in the manner of the insulting épithets with which Isidore Ducasse in his *Poésies* had branded the "Great Softheads" of his own time.[9]

[8]"The Drunken Boat," by Rimbaud.

[9]See above, p. 50. A few of the authors below are still known to the general public, but others are now completely forgotten.

The Lautréamont Case
According to Le Disque Vert

For Everything or for Nothing at all, the dusty spouses of Stupidity meet periodically. Let us point them out once more!

M. Jean HYTIER, the Imitation Bronze, indulges in his usual nonsense about style and Racine and states simply that "the most favorable thing that may be said about Lautréamont is that work is always rewarded."

M. Jean CASSOU, the Trained Dog, begs for sugar: "More than to literature, he belongs to metaliterature."

M. Joseph DELTEIL, the Cannon Fodder, who is egg like a darning egg, can only repeat: "He is count as the eagle is eagle."

M. Marcel ARLAND, the Sewage System, asks for his statue: "Now look, if you devote special issues to unknown writers, why not to me?"

M. Albert THIBAUDET, the Tooth-Decay Curator, writes: "I decline all responsibility in his reputation, but taking it as a fact, I find it partly legitimate"; then he gets muddled into an imbecile story of a desert island, crops, pineapples, and nudes.

M. Maurice MAETERLINCK, the Featherless Bird, confesses straight out his downfall: "Today, I haven't the text under my eyes but I rather think it would all appear illegible to me."

M. Paul VALÉRY, the Ridiculous Predestinate, succeeds all the same in speaking like his equals: "An infinitely long time ago [*sic*]..... I was nineteen."

And then, without blushing, for indeed we shall destroy him at last like a "stinking" beast, let us pronounce the name of JEAN COCTEAU. Being careful never prevented anyone from being vile. "We live at Galeries Lafayette, Ducasse, Rimbaud, etc. The firm Isidore-Arthur & Co., Max, Radiguet,[10] and I were the only ones who smelled out the thing. It's the basis of our misunderstanding with youth." "Smelled out the thing," swine, it was at the Turkish baths rather than at the Galeries Lafayette.

Let us denounce also André Desson, André Harlaire, Paul Dermée, Ramón Gómez de la Serna, O. J. Périer, André Malraux, and may fire, turning over, burn us eternally if we cannot destroy the shame they inflict on us.

The surrealists were no less violent and provocative in denouncing former companions who took part in activities they deemed incompatible with true poetic proceedings, for example, the abrupt break between André Breton and Joseph Delteil, which was revealed by the following correspondence published in *La Révolution surréaliste,* no. 4 (July 15, 1925).

[10] Max: Max Jacob. Radiguet: Raymond Radiguet was a friend of Cocteau's and an early dada activist who also wrote novels and died very young.—M.J.

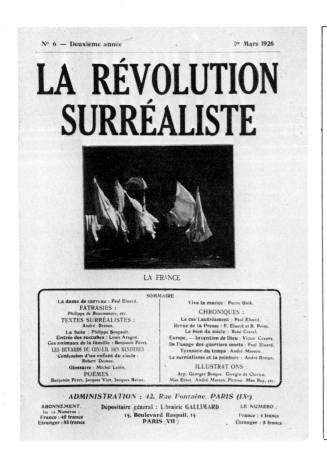

From M. Joseph Delteil to M. André Breton

MY DEAR FRIEND,

A Rumanian journalist would very much like to see you for an interview. In case it would amuse you, could you give him an appointment? His address: Tudor Shoimaru, 5 Rue du Mont Dore, Paris.

He leaves, I think, on Friday.

And how are you? I hope to see you one of these evenings.

Very cordially yours.

From M. André Breton to M. Joseph Delteil

Thanks for the Rumanian journalist but I already have much to do with all kinds of frightful bores, among whom, for the last few months, I regret, Joseph Delteil, to number you. Between ourselves, your Joan of Arc[11] is a vast heap of rubbish. I've been rather mistaken about you, but never mind. Your disgusting articles in that

[11]Title of a novel by Delteil. — M.J.

La Révolution Surréaliste
encore et toujours
la revue
la plus **scandaleuse**
du monde.

à paraître n° 11 (1er Mars 1928)

From left to right: (1) Cover of *La Révolution Surréaliste,* no. 6 (March 1926). (2) Verso of the cover of *La Révolution Surréaliste,* no. 8 (December 1926), with an advertisement for the Galerie Surréaliste, and, at left, the Exhibition of Surrealist Objects, which actually took place ten years later. (3) A handwritten advertisement by Louis Aragon that appeared in the catalogue of an exhibition of Giorgio de Chirico's paintings at the Galerie Surréaliste, Paris, 1928. Translation: "*La Révolution Surréaliste*, still and always the most SCANDALOUS review in the world. No. 11 to appear March 1, 1928."

evening paper *L'Intransigeant,* your infamous jokes about love like the ones that *La Révolution surréaliste* published,[12] your beautiful statements to a certain Robert Gaby: "Those who are coming" [*sic*], your maniacal taste for life, for what is most lousy in it — you never dream — are beginning to get singularly on my nerves. The question should be of finding out whether you are a swine or an ass (or a swine *and* an ass). Being in doubt, I prefer, of course, to see you no more, to have to examine you no longer. And only, in case you become cumbersome, see Cocteau, to take the necessary steps to reduce your activity to its true proportions; you don't pay enough attention to the fact that, all the same, this is within my power.

Delteil seems never quite to have recovered from Breton's devastating rebuff; after writing two or three novels, he retired to the south of France where he became a winegrower.

Situations in other countries also drew the surrealists' attention. One of their most spectacular interventions was in defense of Charlie Chaplin, when the actor was sued for divorce by his wife in 1927 on grounds of "immorality." In the review *Transition* (September 1927), a

[12]In no. 1 (December 1, 1924), when the review was edited by Pierre Naville and Benjamin Péret.—M.J.

literary magazine edited at that time in Paris by Eugène Jolas and Elliot Paul, the surrealists published a text in English entitled "Hands Off Love." The French original appeared in *La Révolution surréaliste,* no. 9-10 (October 1, 1927), with an advertisement in English calling "Hands Off Love" "a terrific Document defending Genius against Bourgeois Hypocrisy and against modern American Morality," and calling *Transition* a review welcoming "the process of ideological disintegration [and] in revolt against all artistic efforts that fail to destroy the existing concepts of beauty."

Hands Off Love

All that can be invoked of true value and force in the world and before all else to be defended, all that can put a man, no matter what his standing in the discretion of judge — for an instant let the full meaning of the word judge be recalled, how at any moment, by some accident, your life may be at the mercy of a judge whose decision can have the upper hand of anything, as for instance genius — a startling light is suddenly projected on all this by a recent case. Both the nature of the defendant and of the charge against him make it worthwhile to examine Mrs. Chaplin's suit against her husband. It should be understood that what follows here is based on the belief that the documents in our hands are authentic reports, and though of course it is Charlie Chaplin's right to deny any of the alleged facts and remarks imputed to him, we have here taken their truth for granted. What has to be examined is the set of arguments and contentions used against him. These charges are typically characteristic of the average moral standard of America in 1927, that is to say, that of one of the largest populated areas, whose opinions tend to spread and impose themselves in other lands, because the states of North America are as immense a reservoir of stupidity as of merchandise ever ready to overflow and particularly to cretinize the amorphous customers of Europe, at all times at the mercy of the highest bidder.

It is monstrous to think that professional secrecy is a rule in the doctor's code — a secrecy that when considered is founded in order to spare shame, and that in itself, once challenged by the law, is no safeguard against condemnation by the law — and to remember that no such code exists for the married woman. But the state of the married woman is a profession like any other from the day that she claims her right to support, her domestic and sexual pittance. Man, bound by law to live with one woman only, has no alternative but to make her share all his ways, thereby placing himself at her mercy. Therefore, if she delivers him over to the public spite, why is the same law that invests the wife with the most arbitrary rights incapable of being turned against her with all the severity due such breach of faith and a libelous intent obviously motivated by the most sordid interest? And in any case, is it not an absurdity that personal habits should be a matter for legislation? But in restricting ourselves to

the very episodic scruples of the *virtuous* and *inexperienced* Mrs. Chaplin, it is comic to find that according to her the practice of fellatio is considered "abnormal, against nature, perverted, degenerate, and indecent." ("But all married people do this," justly replies Chaplin.) If a free and truthful discussion of sexual habits were possible, it would appear normal, natural, healthy, and decent for a judgment to quash the charges brought by a wife thus shown to have *inhumanly* refused herself to such a general, pure, and defensible practice. And how then is it permissible to drag in the question of love, as does this young person who gave herself willingly in marriage at the age of sixteen years and two months to a rich man, a man never out of the public eye, on the score of two babies—unless they were found under a gooseberry bush—if, as the aforesaid charges imply, the defendant did not have *the usual marital relations* with his wife, babies that are now brandished by her as the despicable convictive evidence of her own physical exactions? The italics are not ours and the revolting language they emphasize is that of the plaintiff and her lawyers, whose main line seems to be to confute a very authentic person with all the jargon of picture magazines representing the young mother who calls her legitimate lover "Dad," with the sole aim of levying on him a tax such as not even the most exigent state could dream of, a tax out of all other considerations imposed first on his genius, aimed at the suppression of this genius, or at the very least at the total discredit of its expression.

The five principal charges brought by Mrs. Chaplin read as follows: 1. This lady was seduced. 2. The seducer advised her to have herself aborted. 3. He agreed to the marriage only when obliged and forced, and with the intention of divorcing. 4. For this reason, following a preconceived plan, he behaved to her injuriously and cruelly. 5. The proof of these accusations is shown by the immorality of Chaplin's habitual speech and actions, and by his theories concerning all things regarded as most sacred....

"Given that during cohabitation of plaintiff and defendant, defendant declared to plaintiff on diverse occasions too numerous to be specified in detail that he was not a partisan of the habit of marriage, that he would be unable to tolerate the conventional restraint imposed by marital relations, and that he was of the opinion that a woman could honestly and without disgrace bear children to a man when living with him out of wedlock; given that he also ridiculed and mocked plaintiff's belief in the moral and social conventions pertaining to the state of marriage, the relation of the sexes, and the bringing into the world of children, and that he was unconcerned by the laws and statutes of morality (regarding which he remarked one day to plaintiff that 'a certain couple had had five children without being married,' adding that this was 'an ideal way for a man and a woman to live together')"—this brings us to the essential point of Charlot's vaunted *immorality*. It is to be noted that certain very simple truths still pass as monstrosities, and it is to be hoped that one day they will be recognized as mere

human common sense, the nature of which in this case appears startling by reason of the nature of the accused himself. For everyone who is neither coward nor hypocrite is bound to think thus. And besides, by what argument can sanctity be claimed for a marriage that was contracted under threat, even if the woman has borne her husband a child? Let her come and complain that her husband used to go straight to his own room, that once, to her horror, he came in drunk, that he did not dine with her, that he did not take her out in society — such arguments are not worth more than a shrug of the shoulders.

But it would seem, however, that Chaplin did in all good faith try to make their conjugal life possible. But no such luck. He came up against a wall of silliness and stupidity. Everything appears criminal to this woman who believes or pretends to believe that her sole reason for existence is the procreation of brats—of brats who will beget future brats. A noble idea of life! "What do you want to do—repopulate Los Angeles?" asks Chaplin, outraged. Yet as exacted by her, she shall have a second child, only now she must leave him alone; he no more desired paternity to be forced on him than he desired marriage. However, to please Ma he would have to play the fool with the infants. That is not his style. He is to be found less and less *in the home.* He has his own conception of life; it is being threatened, it is being attacked. And what could bind him to a woman who refuses herself to all he likes, and who accuses him of "undermining and denaturing [her] normal impulses," of "demoralizing her ideas of the rules of decency," of "degrading her conception of morality," and all because he has tried to make her read certain books in which sexual matters are clearly treated, because he desired her to meet certain people whose way of living had a little of that freedom to which she shows herself such an inveterate enemy. And again, four months before their separation he makes an effort: he suggests their inviting a young girl (who later is said to have the reputation of "giving herself up to acts of sexual perversion") and he says to plaintiff that they "might have a little fun." This is the last attempt at transforming the domestic hatching machine into a rational being capable of conjugal affection. Books, the example of others, he has recourse to everything to try and make this blockhead perceive all she is incapable of understanding for herself. But at the end of all this she is amazed at the inequalities of temper in the man to whom she brings such a hell of a life. "Just you wait, if I go mad one day, suddenly I shall kill you"; and naturally this threat is saved up by her for the list of charges, but on whom does the responsibility for it rest? For a man to become aware of such a possibility, i.e., insanity, murder, seems surely to indicate that he has been subjected to a treatment capable of driving him to insanity and murder? And during these months while the wickedness of a woman and the danger of public opinion have forced on him an insufferable farce, he remains nonetheless in his cage, a living man whose heart has not died.

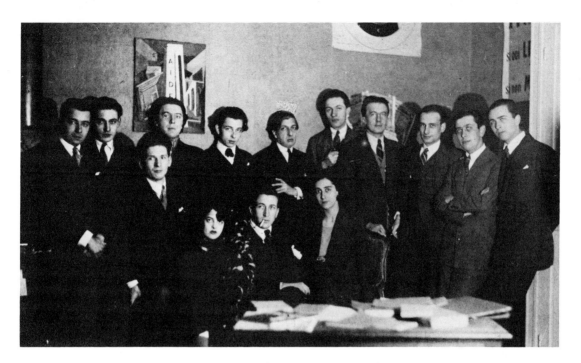

At the Centrale Surréaliste, 1924. *From left, standing:* Charles Baron, Raymond Queneau, Pierre Naville, André Breton, J.-A. Boiffard, Giorgio de Chirico, Roger Vitrac, Paul Eluard, Philippe Soupault, Robert Desnos, Louis Aragon. *Seated, from left:* Simone Breton, Max Morise, Marie-Louise Soupault.

"Yes, it's true," he said one day, "I am in love with someone and I don't care who knows it; I shall go to see her when I please and whether you like it or no; I don't love you and I live with you only because I was forced to marry you." This is the moral foundation of this man's life, and what he defends is—Love. And in this whole matter it so happens that Charlot is simply and solely the defender of love. . . .

We recall the admirable moment in *The Impostor* when suddenly in the middle of a social ceremony, Charlot sees a very beautiful woman go by; she could not be more alluring, and immediately he abandons his adventure (the role he is playing) to follow her from room to room and out onto the terrace until finally she disappears. At the command of love—he has always been at the command of love, and this is very consistently demonstrated by his life and by all his films. Love sudden and immediate, before all else the great, irresistible summons. At such a time everything else is to be abandoned, as for instance, at the minimum, the home. The world and its legal bondages, the housewife with her brats backed up by the figure of the constable, the savings bank—from these indeed is the rich man of Los Angeles forever running away, as is that other poor devil, the Charlot of miserable suburbs in *The Bank Clerk* and *The*

Gold Rush. All the fortune morally in his pocket is precisely that one dollar's worth of seduction that is perpetually getting lost, the dollar that one sees eternally falling onto the tiles through his torn trouser pocket in the café scene of *The Emigrant,* a dollar perhaps only in appearance, that can be bent between the teeth, a mere sham that won't be accepted, but that enables you for one brief instant to invite to your table that woman who is like a flash of fire, the "wonderful" one, whose face from now on eclipses the sky for you. In this way Chaplin's art finds in his actual life that morality that was ever being expressed in his work with all the circuitousness imposed by social conditions. And finally when Mrs. Chaplin informs us—and she knows the most telling kind of argument—that that unpatriotic American, her husband, intended to export his capital, let us remember the tragic spectacle of the steerage passengers labeled like cattle on the deck of the ship that is going to land Charlot in America; the brutalities of the representatives of the law, the cynical examination of the emigrants, the dirty hands fumbling the women on arrival in this land of Prohibition, under the classic stare of Liberty Lighting the World. What the lantern of this particular liberty projects through all his films is the threatening shadow of the cops who run down the poor, the cops popping up at every street corner full of suspicions, beginning with the vagabond's wretched suit, then the stick (which in a curious article Charlot has named his "assurance"), the stick that is always falling, then the hat, the mustache, and so on down to the frightened smile. Let us make no mistake, despite some happy endings, the very next time we shall find him again in misery, this terrifying pessimist who brings out anew all the meaning of that expression equally current in English and in French—a dog's life, "une vie de chien."

A dog's life. That is at the very moment the life of a man whose genius won't win him his case; of one on whom everyone's back will be turned, who will be ruined with impunity, from whom all his means of expression will be taken, who is being demoralized in the most outrageous fashion, for the benefit of a miserable, spiteful little bourgeoise, and for the sake of the grandest public hypocrisy possible to imagine. A dog's life. Genius is nothing to the law when matrimony is at stake, the blessed state of matrimony. And anyway as we know, genius is never anything to the law, never. But this case of Charlot's—above and beyond the public's curiosity and all the underhanded business of the men of law mixed up in the shameless probings into a private life henceforth always tarnished by the law's sinister light—this case of Charlot's today signifies his fate, the fate of genius. It is far more significant than any work on the subject and establishes the true role and the real worth of genius. That mysterious ascendent that an unequaled power of expression suddenly confers, we understand suddenly its meaning. We understand now just exactly what place in the world genius has. Genius takes hold of a man and makes him an intelligible symbol, and the prey of

somber beasts. Genius serves to point out to the world the moral truth that universal stupidity obscures and endeavors to destroy. Our thanks then to the one who, over there on the immense occidental screen, beyond the horizon where the suns one by one decline, causes our shadows to pass. O great realities of mankind, sole realities perhaps, moral truths whose worth is greater than that of the whole universe. The earth sinks beneath your feet. Our thanks to you above and beyond the victim. Our thanks to you, we are your humble servants.

Politics

The surrealist attitude in politics remained in the beginning one of protest, of refusal, of pure revolt against the bourgeois world. In *La Révolution surréaliste* Paul Eluard and Benjamin Péret published press reviews exposing the repressive methods of the police and the biases of the law, condemning colonial wars and patriotic excesses, denouncing fascism, recently established in Italy, and its devotees among "advanced" writers—Filippo Marinetti, Giuseppe Ungaretti, and others. In the first number of the review, there was a photomontage that grouped the surrealists around the anarchist Germaine Berton, who had murdered the Royalist Marius Plateau—along with this quotation from Baudelaire: "Woman is the being who projects the greatest shadow or the greatest light in our dreams." Aragon wrote in praise of her act—but attacked the anarchists as a group:

Absolute freedom is confusing, offending. The sun always hurts the eyes of its admirers. Well and good if Germaine Berton kills Plateau; the anarchists, and with them a very small number of men, including myself, applaud. But it is because she helps, it seems, their cause. As soon as her own life comes to the fore, who would follow her in what is called her errors, her discrepancies? The odds are that she would compromise her admirers. Illness, demoralization, are preferably invoked. And of course the anarchists exalt life, they condemn suicide, which is, as everybody knows, a mark of cowardice. At this point they make me feel ashamed, leaving me with nothing else to do but simply to bow down before this woman, *wonderful in every respect,* who represents the greatest challenge I know to slavery, the most beautiful protest raised in the face of the world against a hideous life of happiness.

André Breton, in "Le Bouquet sans Fleurs," an article in *La Révolution surréaliste,* no. 2 (January 15, 1925), wondered whether blind violence may not be the ultimate and only possibility, for an individual, of affirming himself:

The Bouquet without Flowers

And yet this hateful happiness, however little of it was handed to me, may as well evaporate inside its sweet flask of poison: I shall not have recourse to it in order to live. Occasions are endowed with such an affective power, they are so entreating, that I do not dare to lay out for myself a road protected from their jolts, even if a few people should be dismayed, who believed already in my impassibility when they saw me, at certain times, passing above their heads with the punctuality of a trolley carrying stones.

I have been blamed often lately for such failings: first of all, for not acting in a manner more in accordance with my ideas. As though I should answer their first call, and obeying the strongest and most frequent of my impulses, as though all that was left to me was to come down into the streets with revolvers in my hands and . . . You see what could happen. Then, who knows, I would spare someone, and everything would have to begin all over again. Yet, in such a domain, is there space for anything else? Which indirect action would satisfy me? As soon as I look for it, here I am, they say, back to art, that is, to some social order where I may go unpunished but where, to a certain extent, I cease to be of consequence. . . .

Robert Desnos exalted the idea of "terror" in describing a coming revolt (*La Révolution surréaliste,* no. 3, April 15, 1925). Aragon, replying to the criticisms of *Clarté,* a review close to the Communist party, which accused him of thoughtlessness when he characterized the Soviet regime as "dotty" (in his article in the pamphlet against Anatole France), went further in a note on Communism and revolution (no. 2, January 1925), calling the Russian Revolution "a mere cabinet crisis" and "a miserable revolutionary activity." Eluard, too, in a report on a literary demonstration in which representatives of several extreme-left magazines had taken part (*La Révolution surréaliste,* no. 4, July 15, 1925), saw the "mediocre" Soviet regime as based, "like the capitalist regime, on the easy and repulsive order of work."

André Breton was, it seems, the first among the surrealists to become aware of the difficulties awaiting his friends and himself if with the help of a few contemptuous formulas, they simply dismissed from their field of interest the momentous events taking place in Eastern Europe. He made his point in reviewing Trotsky's book *Lenin* (Lenin had recently died, and Trotsky was still one of the leaders of the Soviet Union) in *La Révolution surréaliste,* no. 5 (October 15, 1925):

From certain allusions made in this very magazine and elsewhere it may have

been inferred that by common consent we passed a rather unfavorable judgment on the Russian Revolution and on the spirit of its leaders. . . . As far as I am concerned I absolutely refuse to be considered responsible for such and such of my friends insofar as he thought he could attack Communism, for instance, on the strength of any principle whatever—even of the apparently very legitimate principle of the nonacceptance of work. As a matter of fact I think that only Communism, existing as an organized system, has allowed the greatest social overthrow to be accomplished *in the conditions for duration that were its own.* . . . For us revolutionaries, it matters little to know whether the latest world is preferable to the other, and besides, the time has not come yet to decide on this. The question would be at the most of knowing whether the Russian Revolution has come to an end: this I do not believe. Ended, so quickly ended, this vast revolution? The new values would already be as unreliable as the old ones? Nonsense! We're not skeptical enough to stop at that point. . . .

Under these conditions, Louis Aragon is quite free to inform Drieu La Rochelle in an open letter that he never cried "Long live Lenin!" but that "he will *shout* it tomorrow if it is forbidden to him"; I am also quite free, and any one among us is free, to consider that this is not a sufficient reason, and that our worst detractors, who are also Lenin's, are unduly favored when we let them suppose that we act thus only in defiance. On the contrary, Long live Lenin! and solely *because it is Lenin!* Being well understood that it is not a question of a wasted cry but of the exalted affirmation of our own thought.

There is also in Breton's article a word about Desnos's appeals to a Terror reminiscent of the French Revolution:

It would be unfortunate indeed if, in matters of human examples, we should continue to refer to those who were members of the Convention of 1792-93 and if we could live a second time with exaltation these two years only, very beautiful years besides, after which everything started afresh as ever. It is not with a poetic feeling, however interesting it may be, that even a distant revolutionary period should be approached. And I am afraid that Robespierre's hairlocks or Marat's bath confer a useless prestige upon ideas that, without them, would no longer appear so clearly to us. . . . This does not hold true with the Russian revolutionaries, such as we begin at last to know them a little. . . .

Breton was strongly attracted by the personality of Trotsky, by his achievements as a man of action, and by his literary talent—a rather exceptional feature among professional revolutionaries—as he makes plain in his review:

Trotsky remembers Lenin. And so much clear reason passes over so many disturb-

ances that it is like the repose of a splendid thunderstorm. Lenin, Trotsky, the simple discharge of these two names is going once more to set innumerable heads swaying. . . . And if the objection arises that, according to this book, Lenin is a type and that "types are not men,"[1] I ask: who will have the face among our barbarian arguers to maintain that there is a fault to be found in the general remarks made here and there by Trotsky on others and on himself, and who will still really detest this man, and who will not be moved somehow by his tone of voice, which is perfect. . . .

Breton's remonstrances were not without effect; the group soon took a more favorable view toward the new Russian regime, and in *La Révolution surréaliste,* no. 9-10 (October, 1927) Louis Aragon, for one, could write a well-documented article, "Philosophy of the Lightning Rods," against various detractors of the Communist Revolution.

External events also played a part: a colonial war had started in Morocco, and French troops were being sent against the "rebels"; the Communists protested against the war, other extreme-left groups joined them. Together with *La Révolution surréaliste,* reviews such as *Clarté, Correspondance* (a Belgian magazine close to the surrealists), and *Philosophies* issued a violently antipatriotic manifesto, "La Révolution d'abord et toujours!" (*La Révolution surréaliste,* no. 5, October 15, 1925). After a long preamble, the manifesto stated five points:

Revolution First and Always!

1. Lenin gave the world at Brest Litovsk in 1917 the magnificent example of an immediate and complete disarmament without counterpart, a disarmament whose value is infinite. We do not believe that *your* France is capable of ever following it.

2. Most of us being liable to be called up for the army and clad officially in the abject horizon-blue uniform, we reject energetically and in every manner for the future the idea of such a subjection, since France, for us, does not exist.

3. No need to say that under these conditions we fully approve and undersign the manifesto released by the Committee for Action Against the War in Morocco, so much the more since legal proceedings have been taken against its authors.

4. Priests, doctors, professors, academicians of every kind, all of you who signed that imbecile sheet "Intellectuals at the side of the Fatherland,"[2] we shall denounce you and confound you on every occasion. You are dogs, trained to profit from the fatherland, driven by the sole thought of gnawing that bone.

5. We are the revolt of the spirit; we consider a sanguinary Revolution to be the inescapable revenge of the spirit humiliated by your works. We are not utopians; we

[1] The words quoted are Isidore Ducasse's, in *Poésies.* —M.J.

[2] A patriotic manifesto attacking the opponents of the Moroccan war.—M.J.

conceive this Revolution only in its social form. If men exist somewhere (traitors to all that is not freedom, evaders of all kinds of conscription, prisoners by common law) who see, rising against them, a coalition from which they are rejected by everybody, let them never forget that the idea of Revolution is the best and the most effective safeguard of the individual.

The surrealists believed consequently that, although the Revolution was social in its principle and development, if it was to do away with centuries-old material and mental constraints, it could not disregard or neglect the poetic revolution, any more than the poets could refuse to take part in the creation of a better social order. But this view seemed totally foreign to most of the Communist leaders, who from the start viewed the surrealists with the deepest suspicions, an attitude that finally caused Breton to protest in a pamphlet entitled *Légitime Défense* (also published in *La Révolution surréaliste,* no. 8, December 1, 1926).

SELF-DEFENSE

Our situation in the modern world is such that our adhesion, fundamentally an enthusiastic one, to a program such as the Communist program, though it is evidently a minimum program in our eyes,[3] was not greeted without the greatest reservations, and everything happened as if, finally, this adhesion had been deemed unacceptable. Innocent as we were of any critical intention toward the party (considering our revolutionary faith, the contrary would have little suited our methods of thought), we appeal today against so unjust a sentence. I say that for more than a year we have been exposed on that side to a deaf hostility, which has lost no occasion to display itself.

Breton points out the failings that, in his opinion, weaken the Communist action, and criticizes the attitude of the main organ of the Communist party in France, the daily paper *L'Humanité:*

On thinking it over, I don't know why I should refrain any longer from saying that *L'Humanité*—childish, declamatory, uselessly *cretinizing*—is an illegible paper, quite

[3]Let me explain myself. We don't have the impertinence to oppose any program to the Communist program. As it stands, this is the only one that seems to be validly inspired by circumstances, to have once and for all adjusted its aim to a full chance of realization, and to show in its theoretical development as well as in its execution, all the characteristics of inevitability. Beyond that, we find only empiricism and daydreaming. And yet there are gaps within us that all the hope we set on the triumph of Communism does not fill; is not man irreducibly an enemy to man, will not boredom end only with the world, is not any insurance on life and honor in vain, etc.? How can we avoid having these questions posed and bringing about particular dispositions, which an attention to economic factors cannot always sidetrack in the mind of nonspecialized men, not very specializable ones, by nature. If our renunciation, our abandonment, on this point must be obtained at all costs, let it be obtained. If not, we shall continue in spite of ourselves to have reservations over the complete submission to a faith that supposes, like any other faith, a certain state of grace.

unworthy of the task of proletarian education it claims to fulfill. Behind its quickly read articles, keeping so close to the event of the day that there is nothing to be seen in the distance, shouting details at the top of their voices, depicting the awesome Russian difficulties as extravagantly easy problems, discouraging all extrapolitical activities but sport, glorifying work not chosen or heaping abuse on convicts—it is impossible not to see in those who have perpetrated these texts an extreme weariness, a secret submission to what exists now, and a care to keep the reader in more or less generous illusions at the smallest possible cost. Let it be understood that I speak technically, solely from the point of view of the general efficacy of a text or of any set of texts. Nothing here seems to me to lead toward the desired result, neither in surface nor in depth. . . . I see no real effort outside a constant appeal to immediate human interests, no effort tending to divert the mind from all that is not the search for its fundamental necessity — and it could be established that this necessity should be nothing but the Revolution— nor any serious attempt to clear up misunderstandings, often formal ones, related to the means only, which, without the division into factions they entail, and which no one opposes, would not be able to imperil the cause at stake.[4] I cannot understand that on the road to revolt there should be a right and a left. Regarding the satisfaction of this immediate human interest, which is almost the sole motive thought advisable, in our days, to assign to revolutionary action,[5] let me add that I see in its exploitation more drawbacks than profits. The class instinct seems to me likely to lose here all that the instinct of self-preservation, in its most mediocre sense, has to win. The material advantages that every man hopes to derive from the Revolution will not induce him to gamble his life—his *life*—on the red card. All the same he would have to give himself every reason to sacrifice the little he may hold for the nothing he may chance to get. These reasons, we know them, they are ours. They are, I think, those of every revolutionary. From an account of such reasons would arise light, would spread confidence other than those to which the Communist press is willing to accustom us. Far be it from me to divert in the least an attention which the problems of the hour call from the responsible leaders of the party in France. I merely denounce the wrongs of a method of propaganda which seems to me a deplorable one, the revision of which I believe too much attention cannot be paid too quickly.

[4] I believe in the possibility of agreeing, to a certain extent, with anarchists, rather than with socialists; I believe in the necessity of passing over the errors of character of men of the first rank like Boris Souvarine.

[5] I repeat that many revolutionaries, of various tendencies, do not conceive of any other motive. Marcel Martinet (in the magazine *Europe*, May 15, 1925) says that the surrealists' disappointment came only after the war, from the fact that they had *a pain in their wallet.* "If the Boches had paid the war expenses, there would have been no disappointment, and the question of the Revolution would have come no more into question than after a strike that brings a raise of four cents." We leave him the responsibility for this statement, so evidently unfair that it excuses me from answering his article point by point.

It is without conceit, and likewise without timidity, that I develop these few remarks that even from a Marxist point of view should not be reasonably forbidden to me.

Breton displayed special asperity in attacking the literary editor of *L'Humanité,* Henri Barbusse, whose book *Le Feu* (The Fire) had been a best seller during World War I. More a report on "the war as it was" than a novel, *Le Feu* had received the Prix Goncourt. But this, said Breton, did not confer on its author the talents and ideas of a revolutionary leader.

Intellectually speaking, [M. Barbusse] is not an *enlightener* after the model of the writers we surrealists profess to admire. M. Barbusse, if he is not a reactionary, is behind the times, which is perhaps no better. . . . Here is a man who, on the very plane on which he acts, enjoys a reputation that nothing valid justifies: who is not a man of action; who is not a light of the spirit; who, even, is positively nothing. . . . [M. Barbusse should avoid] taking advantage of the workers' trust by praising to them Paul Claudel and Cocteau, authors of infamous patriotic poems, of nauseating Catholic professions of faith, ignominious profiteers of the régime and downright counterrevolutionaries. They are, he says, "innovators" and indeed nobody would think of writing this of M. Barbusse, the well-known old bore. Let's overlook the fact that Jules Supervielle and Luc Durtain seem to him to represent the new tendencies with the greatest authority and worth; you know, Jules Supervielle and Luc Durtain, these "two writers, remarkable as writers" (*sic*), but Cocteau, but Claudel! . . .

I repeat humbly, I don't know if it may be hoped to clear up in our time a very distressing misunderstanding that results from the apparently insuperable difficulties met in the objectification of ideas. We placed ourselves, on our own right, in the center of this misunderstanding, and we meant to see to it that it would not deepen. Only from a revolutionary point of view, reading *L'Humanité* would show that we were right. We thought we were acting our own part when we denounced, from there, the cheats and the deviations being revealed around us as the most typical ones, and also we deemed that, having nothing to gain by coming directly on the political arena, we could from there, in matters of human activity, be useful to the cause of the Revolution.

This standpoint had to be upheld even against a member of the group, Pierre Naville, who in a brochure entitled *La Révolution et les intellectuels. Que peuvent faire les surréalistes?* (Revolution and the Intellectuals. What Can the Surrealists Do?) had raised the question: "Yes or no, is the desired revolution that of the spirit a priori, or that of the world of facts? Is it linked to Marxism, or to contemplative theories, to the purifying of interior life?" Breton, in his pamphlet *Légitime Défense,* answered:

This question has a much more subtle turn than it seems, though its main malignity appears to lie in the opposition, which vanishes at once when examined. . . . I quite agree with the author of *La Révolution et les intellectuels* that "wage earning is a material necessity to which three-quarters of the world's population is subject, independent of the philosophical concepts of so-called Orientals or Occidentals" and that "under the rule of capitalism all together are exploited," but I cannot share his conclusion, to wit, that "the quarrels of intelligence are absolutely useless before this unity of condition." I consider, on the contrary, that man must abandon his discriminatory powers less than ever; that doctrinal surrealism ceases precisely to have its place here; and that in the light of a closer examination, which it would be worthwhile to undertake, *wage earning* could not be considered as the efficient cause of the state of things we endure; that it would admit for itself another cause, to the discovery of which intelligence, especially our intelligence, has a right to apply itself.[6]

. . . How to escape the begging of the question? I have just been told again, with full knowledge of the facts, that in the course of this article I make a mistake when I attack, from outside the party, the editorial staff of one of its organs; I am being shown that this apparently well-meant, even laudable, action is of such a nature that it offers weapons to the enemies of a party that I myself consider, speaking in terms of revolution, to be the only force on which we may rely. This has not escaped me and I can say that it is why I have for a long time been unwilling to speak, why I have resolved to do so only reluctantly. And it is true, strictly true, that such a discussion, which aims at nothing less than weakening the party, should have taken place inside the party. But by the very confession of those who are in it, this discussion would have been curtailed as much as possible, supposing that it would have been allowed to start. There was for me, for those who think like me, exactly nothing to expect from it. I knew what to think on this subject last year, and this is why I thought it useless to *register* in the Communist party. I don't want to be consigned arbitrarily to the opposition of a party to which I adhere, except for this, with all my might, but about which I think that possessing for itself Reason, it should, if it was really itself, give an answer to everything in the domain where my questions are asked.

[6] This is in no way questioning *historical materialism,* but once more, merely materialism. Is it really necessary to recall that, in the minds of Marx and Engels, the first came to life only in the exasperated, definitive negation of the second? No confusion is allowed on this subject. In our opinion, the idea of historical materialism, whose inspired nature we think less than ever in dispute, cannot sustain itself and, most important, cannot exalt itself in the course of time, and cannot compel us to envisage its consequences in a concrete way, if it does not regain consciousness of itself at every instant, if it does not fearlessly face all antagonistic ideas, beginning with those ideas that originally it defeated to come to life, and which tend to reappear under new shapes. These shapes seem to us slyly gaining ground in the minds of certain leaders of the French Communist party. May we ask them to meditate over the terrible pages of Théodore Jouffroy: *How Dogmas End.*

I add finally that, in spite of everything, I still wait for this answer. It will be long before I take another way. I wish only that the absence of a great number of men kept back by motives just as valid as mine will not thin the ranks of those who prepare the proletarian Revolution usefully and in full accord, mainly if phantoms steal among them, that is to say, beings of whose reality they delude themselves and who do not want this Revolution.

. .

Self-defense?

Still, Breton and several of his friends resolved some time later to join the Communist party; they wanted to try to work within it before deciding that they could not. But they could not. As Breton had foreseen, their problems were not admitted to discussion, not even envisaged. A pamphlet, *Au Grand Jour* (In Broad Daylight), signed by Eluard, Aragon, Péret, Breton, and a newcomer, Pierre Unik, showed in 1927 that the situation was leading nowhere. As for Pierre Naville, he left both the surrealists and the Communist party and became active in opposition Communist circles.

Humor, Love, and Poetry

The first text following the preface in the initial issue of *La Révolution surréaliste* (December 1, 1924) was by Giorgio de Chirico, an account of a dream, undoubtedly a recurrent dream, involving his father.

I struggle in vain with the man whose squinting eyes are so gentle. Each time I grasp him he frees himself, quietly stretching his arms, and these arms have an un- believable strength, an incalculable power, they are like irresistible levers, like those all-powerful machines the giant cranes that lift whole lumps of floating fortresses, as heavy as the udders of antediluvian mammals, over the swarming shipyards. I struggle in vain with the man whose glance is very gentle and squinting; from each grasp, how- ever furious it be, he frees himself quietly, smiling and hardly stretching his arms...... It is my father who thus appears to me in my dreams, and yet when I look at him, he is not quite as I saw him during his lifetime, when I was a child. And still it is he; there is something more *far-off* in the whole expression of his face, something that perhaps existed when I saw him alive and that now, after more than twenty years, appears to me with all its power when I see him again in a dream.

The struggle ends with my *surrender: I give up:* then the images become confused; the river (the Po or the Peneus) that I felt flowing near me during the struggle darkens; images become confused as if storm clouds were hovering very low over the land; an intermezzo takes place, during which I still dream perhaps, but I remember nothing, only an anxious search along dark streets. Then the dream clears up again. I am in a square of great metaphysical beauty: it is the Piazza Cavour in Florence perhaps; or it may also be one of those very beautiful squares in Turin, or it may also be neither;

there are porticoes on one side, above them apartments with closed shutters, solemn balconies. On the horizon one sees hills with villas; above the square the sky is very clear, washed by the storm, but nevertheless one feels that the sun is coming down, for the shadows of the houses and of the rare passersby are very long in the square. I look toward the hills where the last clouds of the fleeing storm accumulate; here and there the facades of the villas appear very white and there is something solemn and sepulchral about them, seen against the deep black curtain of the sky on that spot. Suddenly I find myself under the porticoes, among a group of people crowding at the door of a confectionery shop where the shelves overflow with multicolored cakes; people crowd and look inside the shop, as they would do at the door of a pharmacy when a passerby who has been injured or has fallen sick in the street is brought in; but there, when I look inside also, I see my father from behind, standing in the middle of the shop and eating a cake; yet I do not know if it is for him that people throng there; a certain anguish seizes me then, and I feel like fleeing westward to a more hospitable and newer land, and at the same time I search under my clothes for a poniard, or a dagger, for it seems to me that some danger threatens my father in this confectionery, and I feel that if I enter it, the dagger or the poniard will be indispensable as when one enters the lair of bandits, but my anguish increases and suddenly a whirl of the throng presses me hard and carries me away toward the hills; I have the impression that my father is no longer in the shop, that he flees, that he will be chased like a thief, and I wake up with this anguishing thought.

Between 1924 and 1930, the magazine published several of the most important writings by surrealists. *Deuil pour deuil* (Mourning for Mourning; 1924) and *La Liberté ou l'amour* (Liberty or Love; 1926), by Robert Desnos, were collections of imaginary, absurd, and wonderful stories, "fairy tales for adults" such as those the "Manifeste" wished to have told. The two following texts, from *Deuil pour deuil,* appeared in *La Révolution surréaliste,* no. 1 (December 1, 1924).

MOURNING FOR MOURNING

The North Star sends this telegram to the South Star: "Decapitate your red comet and your violet comet at once; they are betraying you—North Star." The South Star's eyes darken and she bends her dark-haired head on her charming neck. The feminine regiment of comets play and flutter at her feet: pretty canary birds in a cage of eclipses. Must she spoil her moving treasure, stripping it from her beautiful red one, her beautiful violet one, these comets who, as early as five o'clock in the afternoon, lightly tuck their taffeta skirts up their lunar knees? The beautiful red one with the moist lips, a friend of adulteries and whom more than one neglected lover has discovered, curled up in her bed, with her long lashes, feigning a swoon; in fact the beautiful red one with her

dark-blue dresses, her dark-blue eyes and her dark-blue heart like a medusa lost far from every shore in a warm stream haunted by ghost ships? And the beautiful violet one! The beautiful violet one with a beautiful hat veil and scarlet earlobes, who eats sea urchins and whose fascinating murders let the tears of an admirable blood, admired by the entire heavens, drop slowly on her dress, on her precious dress? Will the charming South Star strangle them with her fingers of diamonds, following the perfidious advice of the North Star, the magical, tempting, and adorable North Star, with diamonds instead of nipples on her breasts, warm and white as the reflection of the sun at noon? Violet and red comets, pilots of the ghost ship, whither do you guide your cargo of whores and skeletons whose superb mating brings to the regions you traverse the comfort of eternal love? Seductresses! The hat veil of the violet one is a fishing net, and the skull of the red one is used as a compass. The whores of the ghost ship are eighty-four; here are some names: Rose, Mystery, Embrace, Midnight, Police, Direct, Mad, Hearts and Spades, From Me, From Far, Enough, The Gold, The Green Glass, The Murmur, The Galandine, and The Mother of Kings, who numbers hardly sixteen years, of those that are called the beautiful ones. In despair the skeletons of the *Armada* give battle to those of the *Medusa*.

Up above, in the sky, the scattered medusas are floating.

Before she becomes a comet, the South Star sends this message to the North Star: "Plunge the sky into your icebergs! Justice is done!—South Star."

Perfidious North Star!

Thrilling South Star!

Adorable!

Adorable!

William the Conqueror, the same one who discovered the law of attraction of ships, William the Conqueror is buried not far from here. A grave digger sits upon a tomb. He has already reached the age of eighty-four since the beginning of this tale.

He does not wait long. From a molehill at his feet rises a greenish light that surprises him only a little, accustomed as he is to silence, forgetfulness, and murder, and knowing about life only the soft humming that follows the perpendicular fall of the sun when the hands of the clock, pressed against one another and tired of waiting for the night, call in vain with a fateful cry the purple pageant of specters and phantoms kept far from there in a chance bed between love and mystery, at the feet of liberty, arms wide open against the wall. The grave digger remembers that it was he who, once, when his ears were not quivering, killed the queen mole whose immense skin clothed his mistresses one after the other with an iron suit of armor a thousand times more redoubtable than the famous coat of Nessus, against which his kisses took on the

consistency of ice and glass and into whose chamber he watched for nights and nights the slow and steady fall of his hair endowed with an infernal life. The most illustrious funerals had to be delayed, waiting for him. When he arrived, the spectators had aged; several of them and sometimes even the undertaker's men and the weeping women were dead. He threw them pell-mell into the grave reserved for only one glorious dead; nobody dared to protest, so great a respect did the green halo over his hair inspire in the mourners. But now, with the anniversary of the death of William the Conqueror at midnight, the last hair is gone, leaving a hole, a black hole in his skull, while the green light radiates from the molehill.

And preceded by the slow creaking of the forced locks, comes now the funeral of Mystery, followed by battalions of keys in close order.

There they are, all of them, the keys that fell into the hands of spies, the one that the murderous lover broke inside the lock when he went away, those that the avenger threw into the river after finally having closed the door of reprisals, the jailers' golden keys stolen by prisoners, the keys of towns sold to the enemy by fair virgins, by the fair virgin, the diamond keys of chastity belts, and the one that the young and ideal conqueror drew noiselessly from the lock to watch, with one eye, the fair virgin going to bed.

And while the skies were ringing with the sound of the divine doors hastily locked, the grave digger, the grave digger died under the cannibalistic accumulation of keys on the tomb of William the Conqueror, while in the molehill, in the green light, the obsequies of the golden ant took place, the lock of intelligences.

Partly a dream, partly semiconscious writing, evoking unexpected animated landscapes, "Le Pays de mes rêves" by Michel Leiris, was published in no. 2 of *La Révolution surréaliste* (January 15, 1925). Here is an excerpt:

The Country of My Dreams

My hands resting on a steel blade, I stand on the steps leading to the vistas of the void. Through my body runs a bundle of invisible lines connecting each of the intersecting points of the edges of the edifice with the center of the sun. I stroll, unhurt, among these threads piercing through me, and each spot of space blows a new soul into me. For my spirit does not follow my body in its revolutions; like a machine drawing its driving energy from the line stretched along its route, my flesh comes to life from the contact of the lines of perspective that, on their way, irrigate its most secret cells with the air of the monument, fixed soul of the structure, reflections of the curve of the vaults, of the arrangement of the fountains, and of the walls that meet at right angles.

If I draw a circle around me with the point of my sword, the threads that feed me will be severed, and I won't be able to come out of the circular dungeon, having separated myself forever from my spatial food and being confined in a small column of immovable spirit, narrower than the cisterns of the palace.

Stone and steel are the two poles of my captivity, the communicating vessels of slavery. I cannot escape the one without shutting myself into the other, till the day comes when my blade will pull down the walls with huge blows of sparks.

With the fold of the angle dispelled, the decision was kept in suspense with one cut of scissors. I found myself in a plowed area, with the sun on my right and on my left the dark disk of a flight of vultures that sped parallel to the furrows, their beaks firmly set in the direction of the crevices by the magnetism of the ground.

Stars were turning inside out in every cell of the atmosphere. The claws of the birds cut the air like a glass pane and left incandescent wakes behind them. Pierced by these spears of fire, my palms became painful, and sometimes one of the vultures glided along a beam, the light clutched between its claws. Its rectilinear descent brought it upon my right hand, which it tore with its beak before going upward again to rejoin its companions, who were approaching the horizon at breathtaking speed.

Soon I realized that I remained still, with the earth revolving under my feet and the birds keeping at my level with powerful strokes of their wings. I broke through the horizons as through successive mirrors, each of my feet resting on a furrow that I used as a rail and my gaze fixed on the wake of the vultures.

But finally they overtook me. Inflating every hollow of their being in order to grow lighter, they melted away into the sun. The earth came suddenly to a standstill and I fell into a well full of remains of bones, an old limekiln bristling with stalagmites: fast dissolution and petrifaction of the kings. . . .

In *La Révolution surréaliste,* no. 11 (March 15, 1928), appeared one of Raymond Queneau's surrealist texts, a witty and ironical tale:

The story of the Capricorn deserves some attention from every person closely — or distantly — interested in surrealism. Indeed it has been known for a few years that there are surrealists, about twenty of them. There are also people interested in surrealism. I happened to meet some of them, and I was always surprised that none of these persons had a pineal eye in the middle of his brow. Yet they ought to have one. That's funny. This brings us back to the Capricorn, who himself possessed one and consequently was interested in surrealism. His mother wanted very much to strangle him after he was born but his father opposed her, hoping to exhibit the monster at fairs, those crematoriums of vanity and nausea. Winter wrapped a wall

around itself and rubbed its hands, which were webbed and scaly: then people realized that it was cold, and the Capricorn, escaping from the ridiculous cradle of fresh noodles, where his parents had laid him, jumped out of the window and found himself on the shores of a lake of lava that was slowly invading the counties of western Ireland. That lava was the most beautiful incarnation of fire and didn't mind going about naked. The Capricorn loved her, and as soon as he understood that his love was more real than the miserable burned-out villages, he realized that he was still falling and that there was no reason why his fall should stop, since, though he had landed on a carload of siphons, he still kept falling. The car departed and the horses led it away at full gallop toward the Botanical Garden. The siphons danced with joy in their small cases, and the Capricorn thought always of the lava, wondering where he could meet her. The siphons had all gone and he remained alone in his downfall when at last he reached his point of arrival, a couch where the lava was waiting for him. They made love for eight days, and the dawn cruised in circles of lace, and winter wrapped its wall around itself so that the cold would increase and that twilights would look more desperate. Every morning the Capricorn saw an arm, blue as neon light, crossing the room, then disappearing, and every evening an escaped madman came to shake hands with him and then went on with his solitary and wonderful destiny. The Capricorn did not understand that these daily escapes were at the same time the motive and the result of his love: he did not understand either when the lava, having left the western counties of Ireland, came to bury the meadows, the churches, the men, and the pigs of France, and he did not understand when the lava draped him in a cloak of pure sulfur to carry him in her arms up to the mounts of Himalaya, which the despair of men had cut in the shape of a wave. The Capricorn did not understand. . . .

In 1926 Paul Eluard published a collection of poems entitled *Capitale de la douleur*. Here are some of these love poems, poems about love:

CAPITAL OF SORROW

Your hair of oranges is the void of the world,
In the void, glass panes are heavy with silence
And shadow, where my bare hands seek all your reflected images.

The shape of your hands is chimerical
And your love resembles my lost desire,
O sighs of amber, dreams, glances.
But you were not always with me. My memory

Is still obscured, having seen you coming
And going. Time uses words, as love does.

In the following piece Eluard pays a tribute to a celebrated company of American dancers who gave performances in Paris at the Moulin Rouge music hall.

The Gertrude Hoffman Girls

Gertrude, Dorothy, Mary, Claire, Alberta,
Charlotte, Dorothy, Ruth, Catherine, Emma,
Louise, Margaret, Ferral, Harriet, Sara,
Florence in the nude, Margaret, Toots, Thelma,

Beauties of night, beauties of fire, beauties of rain,
With trembling hearts, hidden hands, windlike eyes,
You show me the movements of the light,
You exchange a transparent glance for a springtime,

The size of your waist for a flower circle,
Audacity and danger for your unshadowed flesh,
You exchange love for shivering swords
And unconscious laughter for promises of dawn.

Your dances are the fearful abyss of my dreams
And I fall and my fall perpetuates my life,
The space under your feet is increasingly vast,
Wonders, you dance on the springs of the sky.

Eluard's "La Dame de Carreau" appeared in *La Révolution surréaliste*, no. 6 (March 1, 1926).

The Queen of Diamonds

At an early age, I opened my arms to purity. It was only a beating of wings in the sky of my eternity, only a heartbeat in this loving heart that beats in conquered breasts. I could fall no longer.

Loving love. Indeed, light blinds me. I keep enough of it within me to look at the night, all night, every night.

All virgins are different. I dream always of a virgin.

At school, she is on the bench before me, wearing a black pinafore. When she turns around to ask me the solution of a problem, the innocence of her eyes confounds me to such a point that, taking pity on my trouble, she passes her arms around my neck.

Elsewhere, she leaves me. She goes on board a ship. We are almost strangers to one another, but she is so young that her kiss does not surprise me.

Or when she is ill, it is her hand that I keep in mine until I die, until I wake up.

I run all the faster to her rendezvous as I fear that I won't have time to arrive before other thoughts steal me away from myself.

Once the world was coming to an end and we knew nothing of our love. She sought my lips with slow and caressing moves of her head. I really believed, that night, that I would bring her back to daylight.

And it is always the same confession, the same youthfulness, the same pure eyes, the same ingenuous gesture of her arms about my neck, the same caress, the same revelation.

But it is never the same woman.

The cards said that I shall meet her in life, but *without recognizing her.*

Loving love.

In 1929, Eluard dedicated *L'Amour la poésie*, a collection of love poems, to his wife, Gala (later Gala Dali). This is an excerpt from one of the poems:

LOVE POETRY

.

I told it to you for the clouds
I told it to you for the tree of the sea
For each wave for the birds in the leaves

For the pebbles of noise
For the familiar hands
For the eye that becomes a face or a landscape
And sleep gives it back the sky of its color
For all the night that we drank
For the grille of the roads
For the open window for an uncovered brow
I told it to you for your thoughts for your speech
Every caress and every confidence survive.

.

Le Grand Jeu (The Great Game), by Benjamin Péret, which was published in 1928, contained a number of poems written in 1922-23 that had appeared in *Littérature*, new series. Others were more recent, among them the two pieces translated below.

My Latest Misfortunes

270 Birch trees are worn out by mirrors
441 The young pope lights up a taper and undresses
905 How many died in softer charnel houses
1097 The eyes of the strongest carried away by the last storm
1371 The old ones have perhaps forbidden the young to go to the desert
1436 First remembrance of the pregnant women
1525 The foot dozes in a brazen jar
1668 The heart stripped to the aorta moves from east to west
1793 A card looks and waits for the dice
1800 To vanish that's not the question
1845 To stroke the chin and to wash the breasts
1870 It snows inside the devil's stomach
1900 The invalids' children had their beards trimmed
1914 You'll find gasoline that will not be yours
1922 They burn the street-and-trade directory on the Place de l'Opéra

All Right, I'll Go[1]

Now once there was a great house
With a diver of fire swimming on it.

Now once there was a great house
With peaked caps and golden helmets round it

Now once there was a great house
Filled full of glass and blood

Now once there was a great house
Standing in the middle of a marsh

Now once there was a great house
Whose master was made of straw
Whose master was a beech tree
Whose master was a letter

[1]Translation by Humphrey Jennings in *Contemporary Poetry and Prose* (London), no. 2 (June 1936).

Left: Paul Eluard, 1930. *Right*: Antonin Artaud: *Les Pèse-Nerfs*, 1925. Cover design by André Masson.

Whose master was a hair
Whose master was a sigh
Whose master was a turning
Whose master was a vampire
Whose master was a mad cow
Whose master was a kick
Whose master was a subterranean voice
Whose master was a tornado
Whose master was a capsized boat
Whose master was a buttock
Whose master was the *Carmagnole*
Whose master was Violent Death

Tell me Tell me where this great house is

Four pieces by Péret appeared in *La Révolution surréaliste,* no. 8 (December 1, 1926), covering such disparate subjects as the League of Nations, a religious congress in Chicago, the great French bicycle race, and the value of the franc. Topical poems, to be sure, but all are still of interest today. For instance:

The Fall of the Franc

Franc little franc what did you do with your bones
What could you do with them but the poker dice

which throw these words on paper
Once as a fat priest you officiated in the hallways of brothels
dispensing the host to thin whores
whose eyes reflected your dual image
Once also your vast cheeks
insulted the skeletal he-goats
who followed you like the shadow of a sun
giving off their gallic and christian stench around
A sun or rather a lantern
for you never lighted but closed roads
where they replace cobblestones by broken bottles
But today like an earthworm cut off by many spades
you try in vain to escape the fishes
you would indeed like to become again general of the jesuits
but the jesuits are as dead as rats
and from their bellies soft francs ooze out
and their eucharistic rot fills up all chalices
when the last survivor implores god
for the host to become franc
Alas poor worn-out franc
god lies among his priests' manure

here lies the franc a beet without sugar

In 1928 Louis Aragon published *Traité du style* (Treatise on Style), a violent pamphlet against journalists, critics, the army, etc. Aragon also wrote poems, among them "Les Frères la Côte," which appeared in *La Révolution surréaliste,* no. 4 (July 15, 1925).

The Brothers the Coast *To Malcolm Cowley*

The tidal wave entered the room
Where all the little family was gathered together
He said Hello everybody
And shut the mother up into the cupboard
The youngest son began to howl
He sang him a song of his country
Which spoke of pieces of wood
Pieces of wood pieces of wood

Just like that
The father said Please consider
But the wave refused to be bothered
He put a little salt water in the mouth of the unhappy genitor
And the worthy man expired
God rest his soul
Then came the turn of the daughters
According to size
The first one kneeling
The other one on both cheeks
The third one the third one
Like an animal believe me
The fourth one the same way
The fifth I shudder with horror
My pen pauses
And refuses to describe such abominations
Lord Lord would you be less merciful than these
Ah I forgot
The chicken
Was in turn devoured
By the wave the ignoble tidal wave

In *Le Pèse-Nerfs* (1925) Antonin Artaud elliptically addressed his friends on automatic writing. His views seemed to differ in some ways from the current ideas of the group.

THE NERVE SCALE

I felt really that you were breaking up the atmosphere around me, creating a void to let me go ahead, clearing the way for a space forbidden to what was only an energy in me, to a whole virtual germination that would come to life, sucked in by the space offered.

I often put myself into this state of absurd impossibility, trying to give birth to the thought inside me. There are a few of us at this moment who try to make an attempt on time, to create within ourselves spaces for life, spaces that did not exist and for which it did not seem possible to find a place in space.

What always struck me was this obstinacy of the mind thinking in terms of dimensions and spaces, setting itself, in order to think, in arbitrary states of things, thinking in segments, in crystalloids, so that each of the smallest moods of the being remains

congealed at a beginning, so that the thought is not in an eager and ceaseless communication with things but this fixation and this freeze, this kind of setting the soul into monuments, happens, so to speak, *before the thought.* These are evidently good conditions for creation.

But what strikes me still more is the tireless, meteoric illusion that suggests these determined, circumscribed, thought-out architectures, these crystallized segments of soul, as if they were a great plastic area in a relation of osmosis to all the rest of reality. And surreality is like a shrinking of the osmosis, a kind of communication in reverse. Far from seeing in it a decrease of control, I see here, on the contrary, a greater control, but a control that instead of acting is on its guard, a control that prevents the meetings, meetings thinned threadbare, a thread that catches fire and never breaks.

I imagine, as the only acceptable state of reality, a soul tormented with these meetings, made by them, as it were, sulfurous and phosphorous.

But I do not know what unnamable, unknown lucidity gives the tuning and the cry and makes me feel them. I feel them from a certain insoluble totality. I mean, in the feeling into which no doubt is able to bite. And in relation to these restless meetings, I am in a state of lesser shock, I want a fixed nothingness to be imagined, a mass of spirit buried somewhere, a virtuality. . . .

In the same text Artaud violently refused all relationship with literature and litterateurs.

All literature is rubbish.

People who come out of vagueness to try and define whatever happens to their thoughts are pigs.

Every literary tribe is piggish, especially the present one.

All those who have reference marks in the mind, I mean, on a certain side of their heads, on self-localized places of their brains; all those who are masters of their language, all those for whom words have a meaning, all those who possess the spirit of the times, and who have given names to these currents of thoughts, I am thinking of their precious works and of this automatic creaking that their spirit emits like a weathercock—are pigs.

Those for whom certain words and certain ways of existing have a meaning, those who stand so much upon ceremony, those for whom sentiments are classified, and who discuss in any degree their own ludicrous classifications, those who still believe in "terms," those who discuss the ranking ideologies of the time, those whose wives speak so well, and those wives too who speak so well and speak of the currents of the times, those who still believe in the orientation of the mind, those who follow roads, who wave names, who make the pages of a book scream—those are the worst pigs of all.

You're very gratuitous, young man!

No, I'm thinking of the bearded critics.

And I told you: no work, no tongue, no speech, no spirit, nothing.

A sort of incomprehensible upright station, in the middle of everything in the spirit.

And don't expect me to give you the name of that everything, and in how many parts it divides, and to tell you its name, and to walk, to start arguing on that everything, and arguing, to lose myself and thus begin, without knowing it, to *think*.

—And let it light up, let it live, let it adorn itself with a multiplicity of words, all well rubbed with meanings, all varied ones, and all capable of giving birth to all the attitudes, all the shades of a very sensitive and penetrating thought.

Ah these states one never names, these eminent situations of the soul, ah these intervals in the spirit, ah those minute failures that are the daily bread of my own hours, ah all these swarming with data—there are always the same words I use and really I don't seem to move much within my thought but I move in it more than you do really, asses' beards, pertinent pigs, masters of the wrong speech, hasty portrait painters, serial writers, ground floors, horticulturists, entomologists, wounds of my tongue.

All right, I'll be understood ten years hence by people who will do what you do today. Then they will know my geysers, they will see my mirrors, they will have learned how to denature my poisons, they will detect my play on souls.

Then my whole hair, all my mental veins, will be cast in lime, then my bestiary will be known, and my mystique will have been changed into a hat. Then they will see the joints of the stones emitting smoke, and arborescent bouquets of mental eyes will crystallize into glossaries, then they will see stone aerolites falling, then they will see ropes, then they will understand geometry without spaces, and they will learn what is the shape of the mind, and they will understand why I lost my mind.

Then they will understand why my spirit is not there, then they will see all tongues becoming dry, all minds withering, all tongues shriveling up; human hours will flatten and collapse as if sucked in by suction cups, and this lubricating membrane will continue to float in the air, this lubricating and caustic membrane, this double-ply, multigrade, infinitely split-up membrane, this melancholy and glassy membrane, but so sensitive, so pertinent too, so capable of multiplying, of duplicating itself, of turning over with its mirror play of splits, of meanings, of drugs, of penetrating and vitreous irrigations,

then all will be found good,

and I won't have to speak any longer. . . .

L'Esprit contre la raison is a short essay written in 1927 by René Crevel. It sums up the

poetic movement since dada and contains numerous quotations from André Breton's "Manifeste," as well as from Aragon's *Une Vague de rêves*. The following lines are from the last pages of Crevel's book:

SPIRIT AGAINST REASON

Responsibility, wonderful responsibility of poets. In the wall made of cloth, they opened the window Mallarmé dreamed of. With one blow of the fist they pierced the horizon, and there, in midair, an island was discovered. We almost touch this island with the top of our fingers. We may already christen it with the name we please. It is our leading point. That this point, this basket of surprises, of dangers, and of sorrows, is within arm's reach, this is what all those who are frightened by risks and yet tempted by adventures cannot indeed forgive. It is a fact that for two years, the problem of Spirit and Reason, posed more clearly than ever by surrealism, left no one unconcerned who had a taste for matters of intelligence. And even those who are too weak to accept the dangerous freedom they are offered, and who still live on the nice soft jobs of tradition, cannot help preferring among all the present works, those that express most perfectly the necessity of liberation. Without doubt, a clear good faith and the persistence of certain efforts cannot fail to command respect, and faithfulness to the spirit is all the more valuable when it compares with the inconsistency of many who had decided at first to go forward but did not persevere on the roads of boldness; reaching

René Crevel, 1930.

a certain height, but deprived of century-old parapets, they took such a fright that they did not dare to go further or to take more risks. Hence their sly return to accessory questions, to problems of form. They try to cling to secondary branches, to draw arabesques, to forget the essence for the form, to think no longer of the "why" but of the simplest, the easiest "how." . . .

Jacques Rigaut, who was one of the active members of dada, had suggested, among a few other depressing innovations, that rich American families replace the wooden crosses on the cemeteries of World War I with marble ones...... Assuming a constantly ironical attitude toward his own disappearance from this world, he exasperated literary circles for years by periodically announcing his imminent suicide. In December 1920, *Littérature* had published a text by Rigaut that might have been called "The Memoirs of a Suicide."

The first time I killed myself was to annoy my mistress. This virtuous creature refused suddenly to sleep with me, overcome, she said, by remorse for betraying her number-one lover. I am not quite sure I loved her; I suspect that a fortnight's absence would have singularly lessened the need I had of her; her refusal exasperated me. How to punish her? Did I say she retained a deep and lasting tenderness for me? I killed myself to annoy my mistress. I was forgiven this suicide in consideration of my extreme youth at the time of this adventure.

The second time I killed myself was from laziness. Poor and having a premature horror of every kind of work, I killed myself one day, without conviction, as I had lived. They do not blame me for this death when they see how well I look today.

The third time.....I shall spare you the story of my other suicides if you will agree to listen to this one more: I had just gone to bed, after an evening when my boredom had certainly not been more troubling than on other nights. I made the decision and at the same time—I remember this very precisely—I uttered the only reason: After all, enough! I got up and went to fetch the sole weapon in the house, a small revolver that one of my grandfathers had bought and that was loaded with bullets just as old (you will see presently why I insist on this detail). Lying naked in my bed, I was naked in my room. It was cold. I hastened to bury myself under my blankets. I cocked the hammer, I felt the cold of the steel in my mouth. At that moment it is likely that I felt my heart beating as I felt it when hearing the whistling of a shell before it exploded; in the presence of something irretrievable but not yet accomplished. I pressed the trigger, the hammer clicked, the shot did not go off. Then I laid my weapon on a small table, probably laughing a little nervously. Ten minutes later I was asleep. I think I just made an important remark, if indeed.....of course! It goes without saying that I never thought for a moment of firing another bullet. The important thing was to have made the decision to die, and not that I die. . . .

Nine years later, November 5, 1929, Rigaut gave a belated but decisive answer to the question posed in the second issue of *La Révolution surréaliste* (January 15, 1925): "Is suicide a solution?" He did shoot himself through the heart. The above article was reprinted in *La Révolution surréaliste,* no. 12 (December 15, 1929).

In March 15, 1928 *La Révolution surréaliste,* no. 11, published an excerpt from *Nadja,* a book by André Breton that appeared the same year. *Nadja* has been called a novel, but it is in the first place a manifesto, or rather an illustration of the "Manifeste du Surréalisme," showing how poetic imagination may prevail in a human life over current and practical preoccupations. Before the story begins, more than a third of the book is devoted to descriptions of those places where the author felt most keenly that "wind of the unexpected" mentioned in *Les Pas perdus.* After Soupault and Aragon, and in much the same terms, he speaks, for instance, of the Théâtre Moderne of the bygone days of the Certâ and the Opéra arcade. There is also a long account of a play, *Les Détraquées* (The Mental Wrecks), which impressed him deeply when he saw it performed in a small theater, the Deux Masques on the Rue Fontaine.

Then the book becomes a report, based on facts:

NADJA

Last October 4 [1927], at the end of one of those entirely idle and very dull afternoons, such as I know so well how to spend, I happened to be on the Rue Lafayette; after stopping for a few minutes before the *Humanité* bookstall, where I bought Trotsky's latest book, I was making my way aimlessly toward the Opéra. Offices and workshops were beginning to empty out, doors were closing from top to bottom of the buildings, people were shaking hands on the sidewalks; there were at last more people on the streets. I thoughtlessly observed faces, garbs, gaits. Well, we wouldn't find these people ready yet for the Revolution. I had just passed that square, whose name I do not know, there, in front of a church. Suddenly, when she was perhaps ten paces away from me, coming from the opposite direction, I saw a young woman, very poorly dressed, who also saw me, or had seen me. She carried her head high, unlike all the other passersby. So frail that she hardly touched the ground as she walked. An imperceptible smile might have been wandering across her face. A curious makeup, like someone who, beginning with the eyes, had had no time to finish; but the rim of the eyes was dark for a blonde. The rim, not the eyelid (such a glimmering effect is obtained, and obtained only, if the mascara is applied carefully under the lid, and only there). . . . I had never seen such eyes. Without any hesitation, I spoke to the unknown girl, expecting, I must admit, the worst. She smiled, but very mysteriously, and, should I say, *in full knowledge of the case,* though at that moment I couldn't believe it. She pretended to be going to a hairdresser on the Boulevard Magenta (I say she pretended because she admitted later she was going nowhere). It is true she told me rather earnestly about her difficulties concerning money, but

this, it seemed, was a sort of excuse to explain the wretchedness of her clothes. We stopped at the terrace of a café near the Gare du Nord. I looked at her more carefully. What happened that was so extraordinary in those eyes? What obscure distress was reflected there and at the same time what luminous pride? The same riddle was set to me by the beginning of a confession she made without asking me anything further and with a confidence that could (or could not?) have been misplaced.

The girl calls herself Nadja because, as she says, "in Russian it is the beginning of the word hope, and because it is only the beginning." She has been in Paris for some three years, and her story is, in its main lines, the story of many girls who come to a big city from a broken home, who dislike work and yet dream of a steady job. They usually fall a prey to pimps and become regular prostitutes; but some, like Nadja, live independently, thanks to chance "friends." In their pathetic solitude, they tell their acquaintances whatever they choose to reveal of their past life, speaking tenderly of their parents, of their child — they always have a child, put to nurse or brought up by relatives.

The conversation between André Breton and the girl takes a different turn when she mentions offhandedly, speaking of the crowds in the subway and in public places among which she likes to find herself at certain hours: "There are good people. . . ." Her companion reacts to this statement with a violent speech on the life of these "good people" and on the actual state of slavery that they accept without clearly realizing it. Breton says eloquently:

[Liberty is also] . . . the more or less prolonged but marvelous succession of steps that man is allowed to take when unfettered. Do you suppose these people are capable of taking them? Have they even the time? Have they the heart? Good people, you say, yes, good like those who got killed in the war, aren't they? To cut it short, heroes: many wretched people and a few imbeciles. For myself, I confess that those *steps* are everything. Where do they lead, that is the real question. They will in the end, for sure, show a road, and on this road, who knows if the means will not appear of unfettering or helping to unfetter those who could not follow?

Nadja does not contradict or comment on these views, but she reveals at the end of this first meeting something quite different from a theoretical approach to the idea of liberty:

I want to take my leave from her. She asks who is expecting me. "My wife." "Married! Oh! then....." And in another tone of voice, very serious, very composed: "Too bad. But.....what of this great idea? I was beginning to see it so well a few minutes ago. It was really a star, a star you were heading toward. You couldn't fail to reach that star. Hearing you speak, I felt that nothing would hold you back: nothing, not even me...... You could never see that star as I saw it. You don't understand: it is like the

heart of a heartless flower." I am extremely moved. To create a diversion, I ask where she will dine. And suddenly this lightness that I have seen only in her, precisely this *freedom* perhaps: "Where? (pointing:) but there, or there (the two nearest restaurants), where I am, don't you see? It's always this way." About to leave her, I want to ask one question that sums up all others, a question that, doubtless, only I would ever ask, but that found, at least once, an answer equal to it: "Who are you?" And she, without a moment's hesitation: "I am the wandering soul."

On their second meeting, Nadja suddenly addresses André using the intimate form "tu":

"A game: Say something. Close your eyes and say something. Anything, a number, a name. Like this (she closes her eyes): Two, two what? Two women. What do they look like? They wear black. Where are they? In a park...... And then, what do they do? Come, it's so easy, why don't you want to play? You know, that's how I speak to myself when I'm alone, how I tell myself all sorts of tales. And not only useless tales: I live entirely like this." [2]

Their relationship develops through a maze of events, banal in themselves, but to which the personality and unexpected reactions and comments of Nadja give an unusual aspect. During their wanderings, which take them through Paris from the Place Dauphine to the Palais Royal gardens or to the quays of the Seine, she relates several adventures from her past.

Then she tells me of two friends she had: one, when she arrived in Paris, to whom she usually refers by the name of "great friend," she called him that and he never let her know who he was, she still shows an immense veneration for him, he was a man close to seventy-five who had been in the colonies for a long time, he said when he left her that he was returning to Senegal; the other, an American, seems to have inspired her with feelings of a very different order: "And he called me Lena, in memory of his daughter who had died. That was very affectionate, very touching, wasn't it? Yet sometimes I couldn't stand being called like that, as in a dream: Lena, Lena..... So I used to pass my hand before his eyes several times, quite close to his eyes, like this, and I would say: No, not Lena, Nadja. . . ."

. . .She tells me again of this man she calls "great friend" and to whom she says she owes what she is. "Without him I would be now the worst of tarts." I learn that he put her to sleep every evening after dinner. She took several months to realize this. He made her relate in every detail how she spent the day, approved of what he thought good, blamed the rest. And always afterward a physical discomfort localized in her

[2] Don't we reach here the extreme end of the surrealist aspiration, its most powerful *idea-limit?*

head kept her from repeating what he must have forbidden her. This man, lost in his white beard, who wanted her to know nothing whatever about himself, impressed her as a king. In every place that she entered with him, she thought there was a stir of very respectful attention as he went by. Yet later, she saw him one evening on the bench of a Métro station and she found him very tired, very carelessly dressed, greatly aged.

She speaks once of a "blue wind," which might recall the sweet and profound "blue music" mentioned by Chirico in his early texts of 1915 — though Nadja knows nothing of the Italian painter at that time — but the blue wind has an ominous meaning for her:

There must be some confusion in her mind for she has us driven not to the Ile Saint Louis, as she thinks, but to the Place Dauphine...... (This Place Dauphine is one of the most secluded spots I know, one of the worst waste lands in Paris. Each time I happen to be there, I feel the desire to go somewhere else fading little by little; I have to argue with myself to get free from a very gentle, overpleasant entreating embrace and, on the whole, a crushing one. Moreover, I lived for some time in a hotel near this square, the City Hotel, where at all hours the goings and comings were suspect for one who was not satisfied with too simple explanations.) Night is coming. In order to be alone, we have the wine merchant serve our dinner outside. For the first time, Nadja acts rather frivolously during the meal. A drunkard keeps prowling around our table. He delivers an incoherent speech, very loudly, in a tone of protest, emphasizing one or two obscene words that he repeats over and over again. His wife, who watches him from under the trees, merely calls him from time to time: "Are you coming now?" I try several times to get rid of him but in vain. As the dessert is served, Nadja begins to look around. She is convinced that an underground passage runs beneath our feet, coming from the Palais de Justice (she shows me which part of the palais, slightly to the right of its flight of steps), and turning around the Hôtel Henri IV. She is disturbed by the thought of all that happened on this square and of what will still happen here. Where only two or three couples appear, lost in the darkness, she seems to see a crowd. "And the dead, the dead!" The drunkard keeps joking lugubriously. Now Nadja gazes around at the houses. "Do you see that window over there? It's black like all the other windows. Watch. In one minute it will light up. It will be red." The minute passes. The window lights up. It does indeed have red curtains. (I am sorry but I can't help it if perhaps this exceeds the limits of credibility. However I would be loath to take sides in such a matter. I merely *admit* that this window, being black, has become red, and that is all.) I must say that I begin to be frightened, and Nadja too: "It's awful! Do you see what goes through the trees? The blue and the wind, the

blue wind. I saw this blue wind pass along these same trees once before. It was there, from a window of the Hôtel Henri IV,[3] and my friend, the second one I told you about, was going away. There was also a voice that said: You will die, you will die. I didn't want to die but I felt so dizzy...... Surely I would have fallen out if he hadn't held me back."

Nadja begins to write poetic sentences in the course of her relationship with André Breton and to draw images, "marvelous" sketches that are among the first typically surrealist drawings. But she also has other adventures, less exalting ones, and her companion is disheartened by many sides of her life.

Who is the real Nadja, the one who told me she wandered one whole night with an archaeologist in the forest of Fontainebleau, looking for I don't know what stone remains that, one would think, there was plenty of time to discover in daylight — but if it was this man's passion! — I mean the always inspired and inspiring creature who enjoyed being nowhere but in the street, the only valuable field of experience for her, in the street, within reach of interrogation from every human being set on some great chimera, or (why not admit it?) the one who *fell* sometimes because some others believed they had a right to speak to her, being unable to see in her anyone but the poorest of all women and among all the least protected? . . .

The story of Nadja and André Breton lasts only a few months.

For a rather long time my relations with Nadja had deteriorated. To tell the truth, perhaps we never understood each other, at least about our way of envisaging the simple things of life. She had decided once and for all not to take them into account, to forget all about the time, to see no difference between the idle remarks she happened to make and the others, so important to me, to ignore my momentary moods and the greater or lesser difficulties I met in passing over her worst distractions. I have already said that she did not dislike telling me, sparing me no detail, of the most lamentable vicissitudes of her life, allowing herself now and then some uncalled-for coquetries, reducing me to wait, frowning, until she would feel like turning to other exercises, for of course there was no question of her becoming *natural*. . . . Perhaps I was not equal to what she offered me, whatever desire I had for it, whatever illusion too. But what was she offering? It does not matter. Only love in the sense I understand it — but then the mysterious, the improbable, the unique, confounding, and *cer-*

[3] Which faces the house I spoke of, this again for the partisans of easy solutions.

tain love, such at last that it can only be proof against everything — might have managed here to achieve a miracle.

I was told some months ago that Nadja was mad. Following eccentricities that, it appeared, she engaged in in the corridors of her hotel, she had to be interned in the asylum of Vaucluse. Others will comment very uselessly on this fact, which they will not fail to interpret as the inevitable result of all that has gone before. The best-informed will hasten to point out, in what I told of Nadja, the role that may be allotted to ideas already delirious, and perhaps they will ascribe a terribly determinant value to my intervention in her life, an intervention practically favorable to the development of such ideas. As for those who say "Oh! well," or "Now you see," or "I always thought so," or "Under these conditions," all the third-rate idiots, it goes without saying that I prefer to leave them in peace. The main thing is that I don't think that there is an extreme difference for Nadja between the inside of an asylum and the outside. There must be, alas, a difference all the same, because of the irritating sound of a key turning in a lock, of the miserable view of a garden, of the cheek of people who ask you questions when you wouldn't have them clean your shoes.

Here the author launches into a long and scathing attack against psychiatrists, their methods and their asylums, envisaging with pessimism the possibilities of recovery for Nadja, and concluding:

But Nadja was poor, which, in the time we live in, was enough to condemn her, once she decided not to be quite in accord with the stupid code of good sense and morals. She was alone too: "It's terrible at times to be so lonely. I have no friends but you," she said to my wife on the telephone, the last time.

. . .I shall add, in my defense, only a few words. The well-known absence of a border between *nonmadness* and madness does not induce me to grant a different value to the perceptions and ideas belonging to one or the other. There are sophisms infinitely more significant and weighty than the most indisputable truths: dismissing them as sophisms robs them of both greatness and at the same time interest. If they were sophisms, it must be admitted that they have at least done more than anything else to make me hurl at myself, at whoever comes from the farthest point to meet me, the forever pathetic cry: "Who goes there? Is it you, Nadja? Is it true that the *beyond,* all of the beyond is in this life? I can't hear you. Who goes there? Is it only me? Is it myself?"

Although it is manifesto, report and confession, *Nadja* is indeed a novel since it selects, organizes, and interprets memories, and it might, like any novel, bear as a title the name of its author instead of the name of the heroine. The book ends with a sort of postscript, written after the novel itself was completed. Breton meets another woman whom he calls a genius,

not a genius at writing books, attaining fame or wealth, but a genius in the realm of "poetry without poems," which is life in its surrealist sense. The newcomer had—and thanks to all earthly powers, she has kept to the present day—grace, lightness, wit, imagination, a keen intelligence, freedom from all "literary" or "artistic" attitudes, and also, unlike Nadja, an innate feeling of positive life. Addressing his new love, the author of *Nadja* writes at the close of his book:

Without you, what would I do with this love of genius that was always with me, in whose name I could do no less than attempt a few explorations here and there? I flatter myself that I know where genius is, almost what it consists of, and I hold it capable of reconciling all the other great passions. I believe blindly in your genius. It is not without sadness that I withdraw this word, if it astonishes you. But then I want to banish it altogether. Genius.....What could I still expect of the few possible *intercessors* who have appeared to me under this sign and that, at your side, I ceased to possess!

Without doing it on purpose, you substituted your own self for the forms most familiar to me, as well as for several shapes of my foreboding. Nadja was among these last, and it is perfectly right that you should have hidden her from me. . . .

And Breton defines a new beauty, neither static nor dynamic; surrealist beauty, a seismograph that detects every move of the human mind, according to the last sentence in *Nadja:*

Beauty will be CONVULSIVE or will not be.

Outside of the book bearing her name, Nadja seems to have belonged as little to this world as any imaginary character. She vanishes from "reality" at the end of the story, from a reality that might as well have been a dream. No one ever went to visit the wandering soul who called herself Nadja in the asylum where she was confined; no one ever wanted to hear of her again.

Suzanne, the woman who came into Breton's life after Nadja's disappearance and for whom he divorced his first wife, Simone, inspired him with what is perhaps his best poem, "L'Union libre" (published in June 1931)—a litany of love; man's only "wife" is the woman he loves.

Free Union

My wife with hair of wood fire
With thoughts like heat lightning
With an hourglass waist
My wife with the waist of an otter in the tiger's teeth
My wife with a mouth of cockade and of a bouquet of stars of the first magnitude
With teeth of spoors of white mice on the white earth
With a tongue of rubbed amber and glass

Suzanne Muzard, 1929.

My wife with a tongue of stabbed host
With the tongue of a doll that opens and closes its eyes
With a tongue of unbelievable stone
My wife with eyelashes like the strokes of a child's writings
With eyebrows like the rim of a swallow's nest
My wife with temples like slates of a greenhouse roof
And like steam on windowpanes
My wife with shoulders of champagne
And of a fountain with dolphin heads under ice
My wife with matchstick wrists
My wife with fingers of chance and ace of hearts
With fingers of mown hay
My wife with armpits of marten and beechnuts
Of Midsummer Night

Of privet and of scalare's nest
With arms of seafoam and sluice
And of mixing the wheat and the mill
My wife with legs of rocket
With movements of clockwork and despair
My wife with calves of elder tree pith
My wife with feet of initials
With feet of bunches of keys with feet of Java sparrows drinking
My wife with a neck of unpearled barley
My wife with a throat of Golden Valley
Of rendezvous in the very bed of the torrent
With breasts of night
My wife with breasts of marine molehill
My wife with breasts of crucible of rubies
With breasts like the specter of the rose in the dew
My wife with a belly like a giant claw
My wife with the back of a bird fleeing vertically
With a back of quicksilver
With a back of light
With a nape of rolled stone and wet chalk
And like the fall of a glass just drained
My wife with hips of nacelle
With hips of chandelier and of arrow feathers
And of ribs of white peacock feathers
Of insensitive scales
My wife with buttocks of sandstone and asbestos
My wife with buttocks like a swan's back
My wife with buttocks of spring
With a sex of gladiolus
My wife with a sex of placer mining and of platypus
My wife with a sex of seaweed and ancient sweets
My wife with a sex of mirror
My wife with eyes full of tears
With eyes of purple panoply and of magnetic needle
My wife with savanna eyes
My wife with eyes of water to drink in prison
My wife with eyes of wood always under the ax
With eyes of water level of level of air earth and fire

But Suzanne married the critic and essayist Emmanuel Berl, and her romance with Breton ended at last. She divorced Berl later and became the wife of a charming and very talented businessman, Jacques Cordonnier. Since the death of her second husband, she has lived in the country north of Paris. In 1974 she wrote the following lines on her former surrealist days. This brief and very personal testimony seems fitting to close a chapter on poetry and love.

My walk backward, to remember my passage in the surrealism of the years 1927-32, may chance to be inconclusive. I cannot claim to have known André Breton as he really was, and other persons considered him probably from a different angle. I refer only to the fact that I was included in the surrealist group by means of a sentimental passion that was to upset my life for five years.....and that did not in the course of time link me lastingly to André Breton for the worse and for the better.

Breton overflattered his loves; he molded the woman he loved so that she should correspond to his own aspirations and thus become, in his eyes, an affirmed value. But I was only an object of disappointment since I was unadaptable to what he wanted me to be. Too restive, I used to be seized by uncontrollable, fleeting impulses, I was unable to submit to suggested feelings. Therefore, I have no claim on the text concerning me at the end of *Nadja*. It was dictated by an impulse of thoughtless passion, as poetic as it was delirious, and it is to Breton's credit rather than to mine. On the other hand, when Aragon tells anyone willing to hear or read him that I am the only woman who really counted in Breton's life—this seems to me truly excessive..... unless my having been a momentarily unsubmissive companion in that life has marked me with a special interest. As far as I am concerned, I did not love the man with an eye to a posterity that would place him on a pedestal. That was too high for me, my objective was to seek only emotions within heart reach. Love is a trap for lovers in quest of the absolute. I have often been much flattered, much moved by homages paid to me by Breton in public, but never won over in private by habits that broke the spell. Yet, I am sure I loved him, if only for the sole reason that a man always gives his love as a present to the woman he chooses...... I had perhaps the faculty of provoking love, and he had that of inspiring it, without possessing the magical gift of being able to make it last. Our liaison lived only through the convulsions of revolts and reconciliations and tried to survive merely to rescue what we had hoped from it. It lasted long enough to kill love by inches. Memories adorn themselves with many charms, and if I try to revive them, it is to give to that love the motives of its seductiveness, and particularly of André Breton's; among others, the charming way he had of attaching as much importance to a wildflower as to a precious orchid grown in a hothouse; exactly as with women, thus Nadja, this strange castaway who lived on contingencies in sordid lodgings, or Lise Deharme who placed her elegant existence in sumptuous settings—

two opposite women whom Breton set in a frame more surrealistic than concretely livable. It was after them that I came into his life, surprised by him and (because he wanted it so) surprising for him. Didn't I tell him that, as a very young girl, surely I had stood alongside him at a crossroads of that suburb where, when a student in Paris, he returned every evening to join his family.....? We gave that chance event the quality of a strange coincidence that was to lead us, inevitably, to meet later...... With Eluard, himself born in Saint Denis, we evoked the youth of these girls who grew up like myself at the gates of Paris, near waste lands and old battlements. Our suburban minds wore, like an aureole, a very special snobbism, and we linked our popular ideology to a Russian Revolution still freshly tinted with red.

Surrealism was also making, in its way, its revolution. André Breton took care that the movement should not be deprived of scandals. Hard blows had to be struck to impose new formulas, nonconformist and anticonventional. Now it is 1974, and surrealism is being classified in the world of Art, Poetry, and Letters. But in 1927, times were difficult. For Breton, current life rebelled against the exceptional. He always felt he was assailed by difficulties of a practical order, exaggerating their importance while he affected to despise them. He claimed that he exposed all things and his own behavior as if he lived in a transparent house.[4] Yet it seemed to me that he showed more authenticity and I found him more at ease when he was sheltered between the walls of his studio. The exterior agitation that he forced himself to bear made him feel sometimes a real need for solitude, which allowed him to write and to express himself thoroughly. He did not formulate his thought spontaneously; he had to dissect it poetically, to search for the intense and perfect value of a sentence before putting it on paper in his fine and neat handwriting. He was sincere when he said he considered such work trying, but his truthfulness was doubtful when he said it was tedious. What was tedious, rather, was that, in idle periods, as he abandoned himself to a basic laziness, he could neither conquer that laziness nor bear it; it was at those times that the door of the "transparent house" invited him to escape in group recreations.

The café played a most important part in surrealism; it offered an appropriate setting for many meetings where André Breton officiated before a circle of attentive friends and acquaintances. From the creation of his movement he expressed powerfully his will to represent it. Called the "pope" of surrealism, he accepted that title with an amused pride, but added an apparent autocratic intransigence, which helped him mainly to conceal a certain kindness, suppressed as damaging blemish, as a weakness that would have made him too vulnerable. So he resorted, regarding his disciples and

[4] See in Breton's article "La beauté sera convulsive," *Minotaure,* no. 5 (May 1934), the reproduction of a rock crystal with this caption: "The house I live in, my life, my writings."—M.J.

friends, to verdicts dictated by a formal, decisive will, pronounced with an authority that deprived his best friends of the right to voice a divergent opinion. There were many quarrels and expulsions in surrealism! André Breton showed a certain integrity regarding his self-imposed discipline of mind, and he never entered into a so-called evolution that, in fact, would have induced him to compromise himself. Even in politics he remained faithful to his admiration for Trotsky until the latter's death, and his own, which came later. André Breton is no more.....and if memories fade away or are "arranged," his works remain and biographers will refer to them. Surely love will be mentioned. Love casts a more humane light on a personage who could measure its strength as much as its weaknesses...... Two divorces, as well as charming adventures with charmed women, and the traces of that loving passion that was once his and mine, and that, as for me, brought me a wealth of knowledge that I lacked, and an experience that helped me to perfect my life. So I keep from that period many more tender feelings than accusing regrets...... Did not André Breton find finally the companion he needed to harmonize his life? Elisa Breton offered him constantly a complete and unconditional love. I can testify that he was appreciative, but I learned also that, until the end of his life, he could not help resorting to independent "impulses," perhaps to feel reassured and to preserve the delusion that he was evading old age.

Painting

Surrealism was created by poets and found its first expression as a written—and spoken—poetry. But painters also belonged to the movement and the question of a surrealist painting—hardly alluded to in the "Manifeste"—and of its theoretical justifications, soon arose. Max Morise's article "Les Yeux enchantés" (*La Révolution surréaliste,* no. 1, December 1, 1924), discussed for the first time the transfer of the practice of surrealism as defined in the "Manifeste" into the field of visual arts.

The Enchanted Eyes

The only precise representation we have today of *surrealism* is reduced, or nearly reduced, to the writing process inaugurated by *Les Champs magnétiques,* so much so that for us the same word designates both this easily definable mechanism and, beyond it, one of the modalities of the life of the mind, appearing in hitherto unexplored domains, whose existence and importance it revealed apparently for the first time. But if the material criterion, which for want of a better one we admit provisionally as convincing, happens to fail us, we can discover only by intuition and almost by chance the role of surrealism in inspiration. This universe, on which a window has been opened, from now on may and must belong to us. It is impossible not to try to throw down the dividing wall; doubtless, each one of the exteriorizing processes of the thought offers us a weapon to carry out this task. What surrealist writing is for literature, a surrealist plastic technique should be for painting, for photography, for all that is made to be seen.

But where is the touchstone?

It is more than likely that the succession of images, the flight of ideas, are condi-

tions fundamental to every surrealist manifestation. The stream of the thought cannot be viewed statically. But if we may have knowledge of a written text within time, a picture and a sculpture are perceived only in space; their different regions appear simultaneously. It seems that no painter has yet succeeded in giving an account of a succession of images, for we cannot take into consideration the process of those primitive painters who represented in various parts of a picture the successive aspects of a scene they imagined. The cinema—a perfected cinema that would release us from technical formalities—could open a way toward a solution of this problem. But even supposing that the figuration of time is not essential to a surrealist production (a picture, after all, puts in concrete form not just one but a group of intellectual representations, and we can see in it a curve similar to the curve of the thought), nevertheless, to paint a canvas, one must begin at one end, continue elsewhere, then again elsewhere—a process very much subject to chance, arbitrariness, taste, tending to interfere with the dictation of the thought.

To compare surrealism with the dream does not yield very satisfactory guidelines. Painting and writing are both fitted to describe a dream. This is achieved rather easily with a simple effort of memory. The same is true for all apparitions: strange landscapes appeared to Chirico; all he had to do was to reproduce them, to trust in the interpretation his memory offered him. But this strain of a secondary attention necessarily distorts an image when it brings it flush with the surface of the consciousness, which shows plainly that we must give up the idea of finding here the key to surrealist painting. A picture by Chirico cannot be considered typically surrealist, any more than can an account of dreams. The images are surrealist, but not their expression.

Morise imagined that actual surrealist forms, created by the brush of the painter, could take the supple shapes of storm clouds, or even of the warm and limp heaps of candy that may be seen in confectionery shops—a remarkable presentiment of the "savory" objects of Yves Tanguy, or of the "limp structures" of Salvador Dali.

Like the goshawk or the cheetah chasing after a fleeing and succulent prey, flying, leaping—according to their particular faculties—over brooks and civilizations, mountains and pieces of wood, neglecting the beaten track in order to press harder after the object they covet, the body, deformed by speed and by bumps along the way, sometimes bears the shape of a polished sphere that casts a ray of light toward every point of the horizon as an ambassador accredited to the infinite, sometimes it takes on the elongated and impalpable appearance of those heaps of marshmallows hanging on their hooks and handled by the skilled wrists of a cook who sells the soft sticks for two cents, but more often it is a shape that one observes in the depths of the sky when the clouds, with a foreboding of divine wrath, test the suppleness of their muscles by sub-

mitting them to geometric and cruel gymnastics—thus goes the painter's brush in search of his own thought.

On the other hand, taking as evidence a poetic invention of Picasso, the author noted that intellectual relationships exist between the word and its plastic equivalent:

A word is soon written, and the idea of a star is not far from the word "star," from the written symbol: STAR. I am thinking of the setting by Picasso for the ballet *Mercure,* which represented night; in the sky, no star, only the written word sparkled here and there. . . .

Cubism, Morise thought, was in a way "automatic" in its first days, when *papier collé* was invented as a sort of ready-made material to be used in a picture like words in a poem. Mediumistic painting, on the other hand, would be related to a hypothetical surrealist painting, in the same way that a mediumistic tale is related to a surrealist text. Finally the idea of "disorienta-

Giorgio de Chirico: *Piccolo Trattato di Tecnica Pittoria* (Small Treatise on Painting Technique), 1928; published in Milan, 1945. Facsimile of the last page of the draft of the preface.

tion" (although he did not use the word) seemed to Morise one of the main possibilities for surrealist painting—another suggestion of foremost importance, already contained in Chirico's art.

Today we can only imagine what a surrealist plastic art would be if we consider certain meetings, apparently fortuitous, which we suppose due to the omnipotence of a superior intellectual law, the very law of surrealism. . . .

The difficulties Morise found in defining a true surrealist painting derived evidently from transferring the definition in the "Manifeste" regarding "dictation of thought," etc., to the domain of painting. On such logical grounds, Pierre Naville went further and bluntly denied even a possibility of existence to surrealist painting (*La Révolution surréaliste*, no. 3, April 15, 1925):

Everybody knows by now that there is no *surrealist painting*. Neither the strokes of a pencil translating chance gestures, nor the images retracing dream shapes, nor the imaginary fantasies, can be, of course, so characterized. . . .

Here again Breton saw the necessity of opposing Naville's elementary conclusion. In a series of articles in *La Révolution surréaliste* entitled "Le Surréalisme et la Peinture" (no. 4, July 15, 1925; no. 6, March 1, 1926; no. 7, June 15, 1926; no. 9-10, October 1, 1927)—the nucleus of a collection that grew unceasingly in the course of years—Breton studied the concepts of sight, vision, and reality, neglecting his own definitions in the "Manifeste" (there is no mention of "automatism" in these first articles); but the underlying idea of "disorientation" may also be felt in the course of his reasonings.

SURREALISM AND PAINTING

The eye exists in the savage state. The marvels of the earth at a height of a hundred feet, the marvels of the sea at a depth of a hundred feet, have hardly any witness but the haggard eye that, for colors, relates everything to the rainbow. The eye presides over a conventional exchange of signals that the navigation of the mind apparently demands. But who will set up a measuring scale for the sight? There is what I have already seen many times, and what others, in like manner, have told me they saw; what I think I can recognize, whether I care or not, for example the facade of the Paris Opéra, or else *one* horse, or the horizon; there is what I have seen only very seldom and that I have not always chosen to forget or not to forget, as the case may be; there is what, look as I may, I never dare to see, which is all I love (and I don't see the rest either); there is what others have seen and tell me they have seen, and that by suggestion they succeed or not in making me see; there is also what I see differently from all others, and even what I begin to see *that is not visible*. That is not all.

To these various degrees of sensations correspond spiritual realizations, precise enough and distinct enough to allow me to grant plastic expression a value that, on the contrary, I shall never cease to deny to musical expression, the most confusing of all. As a matter of fact, auditory images are inferior to visual ones not only in distinctness but also in exactness, and with all due deference to a few music-mad individuals, they are not made to strengthen the idea of human greatness. Therefore, let the night continue to fall on the orchestra, and for my part, still seeking for something in the world, leave me with open eyes, with closed eyes—it is broad daylight—to my silent contemplation.

. . . Nothing prevents me in this moment from fastening my look on any plate in a book, and suddenly what surrounds me exists no more. There is something else instead of what surrounded me, since, for instance, I witness without difficulty quite another ceremony. In the plate, the angle between a ceiling and two walls easily manages to substitute itself for this angle here. I turn the pages and despite the almost uncomfortable heat I don't refuse the least part of my approval to this winter landscape. I mingle with these winged children. "He saw before him an illuminated cave," says a caption, and indeed I see it too. I see it and in that instant I don't see you, you for whom I write, and yet I write to see you someday, as truly as I lived for one second for this Christmas tree, for this illuminated cave, for these angels. Even though the difference remains palpable between these evoked beings and the actual beings, I happen constantly to hold it cheap. Thus it is impossible for me to consider a picture other than as a window about which my first concern is to know what it *looks on,* in other words, if "the view is beautiful" from where I stand, and I love nothing more than what stretches before me *as far as the eye can reach.* I enjoy, inside a frame of any size, an unbounded show. What do I come here for, why do I stare for such a long time at this person, of what lasting temptation am I the subject? But it is a man, it seems, who makes this proposal to me! I don't refuse to follow him where he wants to lead me. Only afterward shall I decide whether I was right or not to take him as a guide and if this adventure was worthy of me.

Yet, I confess, I passed like a madman along the slippery floors of the museums: I was not the only one. For a few marvelous glances cast on me, by women like those of today in every way, I was not for one moment taken for a dupe by the unknown which these subterranean and unmovable walls offered me. I left remorselessly adorable supplicants. There were too many scenes at the same time in which I didn't feel I had the heart to play a part. Among all these religious compositions, all these rustic allegories, I was irresistibly losing the meaning of my role. The street outside had a thousand truer enchantments at my disposal. It isn't my fault if I can't fight against a deep weariness, watching the endless pageant of the competitors of this gigantic Prix

de Rome, where nothing, neither the subject nor the way to treat it, is left optional.[1]

I don't pretend to suggest that in painting no emotion whatever may arise from a "Leda," that a heartrending sun cannot come down in a setting of Roman palaces, or even that it is impossible to give some appearance of an eternal moral lesson to the illustration of a tale as ridiculous as *Death and the Woodcutter*.[2] I think merely that genius has nothing to gain by following these beaten tracks or these byways. Such wagers are at least useless. It is never dangerous to take liberties with anything, except perhaps with liberty. . . . To meet the need for complete revision of real values on which all minds today agree, plastic work must draw on a *purely interior model,* or it will not be.

It remains to be seen what *interior model* means, and here it is best to grapple with the difficult problem raised in these last years by the attitude of certain men who actually found again the motive for painting: a problem that a miserable art criticism tries desperately to evade. If Lautréamont, Rimbaud, and Mallarmé were the first, in the domain of poetry, to endow the human mind with what it lacked so much—I mean a real *insulator* thanks to which this mind, being ideally withdrawn from everything, begins to be attracted by its own life in which the attained and the desirable no longer mutually exclude one another, and can thenceforth claim to submit whatever constrained it hitherto to a permanent censorship of the most rigorous kind; if the idea of the permissible and of the forbidden has assumed, since these poets appeared, the elastic nature we know, to such a point that the words *family, fatherland, society,* for instance, seem to us so many macabre jokes; if they have really caused us to rely for our redemption here below upon ourselves alone; then, to rush headlong on their trail, spurred on by that fever for conquest, total conquest, that will never leave us, our eyes, our precious eyes had to reflect that which, although it did not exist, was yet as intense as that which did exist, and, once more, it was real visual images, sparing us the regret of leaving anything whatever behind us. For fifteen years now the mysterious road where fear lies in wait and where our desire to turn back is overcome only by our deceitful hope of not remaining alone, this road is swept by a powerful searchlight. For fifteen years now Picasso has carried his radiant hands always further along the road he himself explores. No one before him dared to look upon that road. Poets did speak of a region they had discovered where "a drawing room at the bottom of a lake" appeared to them most naturally,[3] but that was virtually an image for us. Which miracle made

[1] The Prix de Rome used to be awarded by the Ecole des Beaux-Arts in Paris for a composition on a given subject, as a rule mythological.—M. J.

[2] There is a picture illustrating the fable: *La Mort et le Bûcheron,* painted ca. 1900 by Léon Lhermitte, an academic artist (1844-1925).—M. J.

[3] An allusion to the passage in *Une Saison en enfer* where Rimbaud says that he accustomed himself to "simple hallucination" and saw "quite frankly a drawing room at the bottom of a lake."—M. J.

this man, whom I have the surprise and the happiness to know, the possessor of means that give consistency to what remained until he came in the domain of sheer fancy? What a revolution must have taken place within himself to make him keep to it! In the future, people will search passionately for what may have animated Picasso toward the end of the year 1909. Where was he? How did he live? "Cubism," how could this absurd word conceal from me the prodigious meaning of the discovery that in my opinion took place between *L'Usine, Horta de Ebro* and the portrait of M. Kahnweiler? Neither the selfish evidence of onlookers nor the poor exegeses of a few scribes will succeed in reducing for me such an adventure to the proportions of a mere piece of news or of a local artistic phenomenon. One must be conscious to such a high degree of the treachery of perceptible things to dare breaking openly with them and all the more with the facilities offered by their usual aspect, that one cannot fail to acknowledge Picasso's immense responsibility. A simple failing of this man's will, and the game that concerns us would have been at least postponed, if not lost. His admirable persistence is a pledge precious enough to relieve us from calling upon any other authority. . . .

One would have no idea of Picasso's exceptional predestination to dare to fear or hope for a partial renunciation from him. Now and then, to discourage insufferable followers or to get a sigh or relief from the reactionary beast, he may appear to worship what he had previously burned, but nothing seems to me more entertaining or more just. From the open-air laboratory, when night is falling, divinely unusual beings will still escape, dancers dragging behind them shreds of marble chimneys, adorably laden tables, compared to which yours are spiritualists' tables, and all that remains hanging to the immemorial newspaper *LE JOUR*...... It has been said that there could be no surrealist painting. Painting, literature, what are these, O Picasso, you who have carried the spirit, no longer of contradiction, but of evasion, to its supreme point! From each of your pictures you let down a rope ladder or even a ladder made with your bed sheets, and probably you want only, like us, to climb down, to climb up from your sleep. And they come and tell us of painting, they come and remind us of the lamentable expedient that is painting!

. . .It is in these many respects that we claim him loudly as one of us, even while it is impossible, and it would be impudent besides, to apply to his own means the rigorous criticism that, on the other hand, we intend to initiate. If surrealism wants to adopt a moral line of conduct, it should only follow Picasso's discipline for the present and for the future. In saying this I hope to be very exacting. I shall always oppose permitting a label[4] to lend an absurdly restrictive character to the activity of a man from

[4] Even the "Surrealist" label.

whom we persist in expecting the most. For a long time the cubist label has been to blame for this. It may suit others but it seems urgent to me that it be spared Picasso and Braque.

Breton's metaphorical discourse continued in a second article (*La Révolution surréaliste,* no. 6, March 1, 1926), devoted mostly to Braque but mentioning several other artists in incisive and sometimes violent language:

Witnessing the complete failure of art criticism, a quite amusing failure besides, we cannot be displeased by the fact that the articles of a Raynal, a Vauxcelles, a Fels, go beyond all bounds of imbecility. The unceasing scandal of Cézannism, of neo-academicism, or of machinism, is unable to spoil the game whose end actually interests us. Whether Utrillo still (or already) "sells," whether Chagall succeeds or not in posing as a surrealist, that is the job of these gentlemen of the grocery trade.

. . .Those who, with such a special prophetic sense, called themselves the Fauves now perform absurd tricks behind the prison bars of time — the least important dealer, or trainer, being able to fend off with a chair their last and no longer dangerous leaps. Matisse and Derain are among those old discouraging and discouraged lions. They don't even keep the nostalgia of the forest and of the desert from whence they came to this tiny ring: the gratefulness for those who tame them and support them....

I cannot but feel moved by Georges Braque's destiny. This man has taken infinite precautions. From his head to his hands it seems I see a big hourglass where the grains of sand would be no closer together than the atoms that dance in a ray of sunshine. Sometimes the hourglass lies down on the horizon, and then the sand flows no more. It is because Braque loves "the rule that corrects emotion." While I, for my part, do nothing but deny this rule. Where does he take that rule from? There must be again some idea of God behind it.[5] *It's very pretty* to paint and *it's very pretty* not to paint. One may even paint "well," and one may even not paint, but well. Well..... Braque is a great refugee at the present time. I'm afraid that in a year or two I won't have to pronounce his name. I must hurry. . . .

[5]Speaking of God, thinking of God, is in every respect showing one's value and when I say this I certainly do not make the idea of God my own, even to fight it. *I have always bet against God,* and what little *I won* in the world was for me but the winnings of that bet. However absurdly low may have been the stake (my life), I am conscious of having totally won. All that is doddering, suspicious, infamous, sullying, and grotesque is contained for me in that single word: God! God! Everyone saw a butterfly, a bunch of grapes, or one of those scales shaped like curved rectangles that fall in the evening from certain trucks jolting along roughly paved roads, and look like hosts turned inside out, turned against themselves; everyone also saw Braque's oval pictures, and pages like the one I am writing, which are damning neither for him nor for me, to be sure. Somebody intended of late to describe God as "a tree" and again I saw the caterpillar and I didn't see the tree. I passed through the roots of the tree without noticing it, as on a road in Ceylon. Besides, a tree can't be described, shapeless things can't be described. A pig can be described and that's all. God, who can't be described, is a pig.

In each of its numbers *La Révolution surréaliste* reproduced some of the works of Giorgio de Chirico, the true ancestor and originator of surrealism in the field of painting. It published certain evocative poems of his, dating back to 1911-13. The following piece (in no. 5, October 15, 1925) alluded to early pictures and especially to "The Chimney" of 1913, a canvas much admired by Guillaume Apollinaire:

Hopes

Poetizing astronomers are quite gay
The day is radiant the square full of sunshine.
On the veranda they are leaning.
Music and love. The too beautiful lady.
I would die for her velvety eyes.

A painter has painted an enormous red chimney
Which a poet worships like a deity.
I saw again the springlike and cadaverous night
The river carried tombs that are no more
Who wants still to live? Promises are fairer.

They decked the station with so many flags.
If only the clock would not stop
A minister is due to arrive.
He is intelligent and kind he smiles
He understands everything and at night in the light of
 a smoking lamp while the stone warrior sleeps in
 the dark square
He writes sad and ardent love letters.

Since 1920 Chirico, living in Italy, had changed his style and was painting mythological motifs in a conventional manner, claiming besides that he had discovered the virtues of "technique." Breton, who had asked him for drawings to illustrate a book of poems, hoping to receive "metaphysical" compositions, was offered, to his profound disappointment, sketches of Roman soldiers, clumsy images, totally unfit for his purpose. Eluard visited the painter in Rome and bought some of his new pictures, probably in the hope that they heralded another inspired period; but these poorly painted allegories reaped the most severe comments from André Breton when Eluard brought them back to Paris. Chirico's return to the French capital and his frequenting the surrealists did not renew his former inspiration or alter his more recent one. Nevertheless, when his newest productions were shown in June 1925 in Paris, Max Morise (*La Révolution surréaliste,* no. 4, July 15, 1925) still tried to discover some favorable signs:

I may express a certain number of axioms, in the truth of which I deeply believe, such as "one must not work," "there is no progress in art," "thought profits by expressing itself outrageously," etc., etc. But if I place these ideas in the light of Chirico, how do I know that they will keep their reality? I feel a strange uneasiness when I observe these pictures, reminders of Antiquity, and although the renunciation to which Chirico abandons himself seems evident, who knows if he is not inviting us to a new miracle?. . .

When the surrealists finally gave up all hope of seeing Chirico find a style that could compare with his former achievements, their reactions were as violent as their patience had been long and their deception deep. Breton wrote in his third article on "Surrealism and Painting" (*La Révolution surréaliste,* no. 7, June 15, 1926):

It took me, it took us, five years to despair of Chirico, to admit that he had lost all sense of what he was doing. Have we not met often enough on this square where everything looked so close to life and was so little like what exists! We held our invisible assizes there more often than anywhere else. It is there that we might have been looked for — we and the heartlessness. In that time we were not afraid of promises. One may see that I already speak lightly of it. Men like Chirico then took on the shape of sentries on the infinite road of lookouts. I must say that after we arrived there, at the point where he stood, it became impossible for us to retreat, we had to *pass,* all our glory was at stake. We passed. Later, between ourselves and in a low voice, with an increasing uncertainty about the mission entrusted to us, we often referred to that fixed point as well as to the fixed point Lautréamont, who, with Chirico, would suffice to determine our straight line. It matters little that Chirico himself has lost sight of this line from which we are no longer free to deviate; for a long time to come it will rest entirely with us that it be the only one. What greater folly than this man's, now lost amid the besiegers of the town he built, and which he made impregnable![6] It will eternally oppose its terrible rigor to him as to many others, for he wanted it so that it was impossible for what happened in it not to happen there. His town, made entirely like a rampart, is an *Inducement to Expectation.* In full daylight, it is lighted from the inside. How often have I tried to find my bearings in it, to walk, by some impossible chance, around this building, to imagine the never-altering risings and settings of the suns of the mind! Epoch of Porticoes, epoch of Ghosts, epoch of Mannequins, epoch of Interiors, in the mystery of the chronological order in which you appear to me, I do not know what exact meaning I must attach to your sequence, at the end of which one must admit that inspiration has left Chirico, this very Chirico whose main concern is now to prevent us from proving his downfall. . . .

[6]Chirico had not only changed his style but he was proclaiming that his own former productions were worthless and admired only by snobs. — M. J.

Then a curious thing happened: the magic of the famous Chirican *Stimmung,* extinct in the paintings, reappeared with all its uncanny power in a book, *Hebdomeros,* written by the painter in French during the month of October 1929 and published at the end of that year. Memoirs and memories, current anecdotes and philosophical discourses, mythological legends and incidents of everyday life that made the novel appear sometimes to be a *roman à clef,* reminiscences of the author's early canvases and of his more recent motifs, a stream of humor and light irony running through the whole tale: such is *Hebdomeros* — disorientation, in short, unceasingly renewing itself, rules the strange life of what remains one of the most surrealistic stories ever written. We present some brief sections here.

HEBDOMEROS

· ·

And then began the visit to this strange building situated in a street lined with severe-looking but distinguished, not dreary, houses. Seen from the street, the building evoked a German consulate in Melbourne. Its ground floor was entirely taken up with large stores. Although it was neither Sunday nor a holiday, the stores were closed and it conferred upon this part of the street a look of melancholy boredom, a certain desolation, that particular atmosphere that pervades Anglo-Saxon towns on Sundays. A faint smell of docks floated in the air, the undefinable and highly suggestive smell emanating from warehouses near the wharves of a port. The aspect of a German consulate in Melbourne was a purely personal impression of Hebdomeros's, and when he mentioned it to his friends they smiled and found the comparison *funny* but they did not insist and spoke at once of something else, from which Hebdomeros concluded that perhaps they had not fully grasped the meaning of his words. And he reflected on the difficulty of making oneself understood when one begins to move at a certain height or depth. "It's curious," repeated Hebdomeros to himself, "for my part, the idea that something has escaped my comprehension would keep me awake, while most people can see, hear, or read things that are completely obscure to them without being disturbed." They began to climb the staircase, which was very wide and built entirely of varnished wood; in the center there was a carpet; at the foot of the staircase, upon a small Doric column carved in oak where the stair rail ended, stood a polychrome statue, also made of wood, representing a California Negro whose arms were raised above his head to hold a gas lamp, its burner covered with an asbestos hood. Hebdomeros had the impression of going to see a dentist or a doctor for venereal diseases; he was a little upset, and felt as if he had the beginning of a slight belly-ache; he tried to overcome his uneasiness by thinking that he was not alone, that two

friends were with him, strong and athletic young men, who carried automatic pistols and spare cartridges in the hip pockets of their trousers. Realizing that they were approaching the floor that they had been told was the richest in strange apparitions, they began to walk up more slowly and on tiptoe; their gaze became more attentive. They moved slightly farther apart, while keeping on the same line, so that they could go down the stairs again freely, and as quickly as possible, if some apparition of a special nature should force them to do so. At this moment Hebdomeros thought of his childhood dreams, when under a doubtful light, he was anxiously climbing wide stairs of varnished wood with a thick carpet in the center that muffled the sound of his footsteps (his shoes, besides, even outside his dreams, rarely squeaked, for he had them made to measure by a shoemaker named Perpignani, who was known all over the town for the good quality of his leather; Hebdomeros's father, on the contrary, had no talent for buying himself shoes; the ones he wore made atrocious noises as though he had crushed sacks full of nuts at every step). Then it was the apparition of the bear, the disturbing and obstinate bear, that follows you on stairs and along corridors, head down as if it were thinking of other things; the desperate flight across the rooms with complicated exits, the leap through the window into the void (suicide in dreams), and the descent in gliding flight like those men-condors whom Leonardo enjoyed drawing among catapults and anatomical fragments. It was a dream that always presaged unpleasantness, especially illness.

"There we are!" said Hebdomeros stretching out his arms in front of his companions in the classic gesture of the temporizing captain stopping the rush of his soldiers. They had reached the threshold of a vast room with a high ceiling, decorated in 1880s style; this room completely devoid of furniture, its lighting and its general appearance, were reminiscent of the gaming rooms at Monte Carlo; in a corner two gladiators wearing diving helmets were training without conviction under the bored gaze of an instructor, a pensioned ex-gladiator with an eye like a vulture's and a body covered with scars. "*Gladiators!* This word contains an enigma," said Hebdomeros in a low voice to the younger of his companions. And he thought of the music halls where the illuminated ceiling evoked visions of Dante's paradise; he thought too of those Roman afternoons, at the end of the spectacle, when the sun was setting and the immense velarium deepened the shade over the arena whence arose a smell of sawdust and blood-soaked sand......

Roman vision, antique coolness,
Evening anguish, nautical song.

...In the afternoon, after a frugal meal taken in the company of the master jumpers

and the master pugilists, all of them accomplished gentlemen, who, while apologizing for their lack of opulence and their unpretentious cooking, each time insisted on paying for his meal, when he made his way to the town built like a citadel with its inner courtyards and its oblong and geometric gardens assuming the severe shape of ramparts, he always found the same men with their accurate proportions, perfectly healthy in body and mind, engrossed in their favorite occupation: *the construction of trophies.* Thus arose in the middle of the rooms and parlors these curious, severe, and at the same time amusing scaffoldings, the delight and enjoyment of guests and children; constructions that resembled mountains, for like mountains, they were born under the action of an internal fire and, once the upheaval of creation was over, their tormented equilibrium testified to the ardent thrust that had caused their appearance; for that very reason they were *pyrophiles,* that is to say, like salamanders, *they liked fire;* they were immortal, because they knew neither dawns nor sunsets, but an eternal noon. . . .

"What is this distant rumble rising from the dark streets?" asked Lyphontius the philosopher, looking up toward the window of the room where he was working near a table covered with books and papers. He lived in a modest apartment above the porticoes that enclosed the main square of the town. From his window he could see the back of the statue of his father, on a low plinth in the center of the square. His father had also been a philosopher, and the prominence of his work had induced his fellow citizens to erect this monument in the middle of the largest and finest square of the town. The houses surrounding the square were not very high so that it was easy to see the hills scattered with villas and terraces supporting beautiful gardens. At the summit of the highest hill a vast building could be seen that was said to be a monastery, but that looked more like a fortified castle or a large barracks or a huge powder magazine; it was enclosed in a crenelated wall pierced with loopholes.

When the black sails of the pirates appeared in the distance on the sea, the residents of the villas rushed to find shelter in this building; they took with them their most precious things: their books, the tools for their work, some linen and clothes; no weapons; they hated weapons and besides they were absolutely ignorant of how to handle them. They never had weapons in their homes and they avoided even pronouncing the name of a weapon, especially before children: *revolver, pistol, rifle, knife,* were words considered taboo by these hysterical and puritanical people; and if some foreigner, ignorant of these customs, began to speak in their houses about weapons, he threw a chill and created an uneasiness that was hard to dispel. When the children chanced to be present, the uneasiness became intolerable. The only weapon that could be mentioned was the cannon, because people are not in the habit of keeping cannons in their houses. In the villas they deserted they left only some

pieces of old furniture and stuffed animals, whose presence in the middle of empty halls frightened the pirates, drunk with massacre and looting, who first opened the doors of the rooms. Moreover, the refugees in the building enjoyed great comfort. Plentiful supplies were stored in the vaults. In the vast inner courtyards were artistically arranged gardens, sunny corners where fruit trees grew, flowered arbors, fountains decorated with beautiful statues, and even pools where fishes swam and where swans of immaculate whiteness cruised, their chests into the wind. All this allowed the refugees to forget their sad situation as besieged people, and to imagine themselves in one of those watering places, true earthly paradises of our planet, where, during torrid summers, the city dwellers, tired from the unceasing worries of business and the anxiety about their success, went to nurse their swollen livers and their weakened stomachs. Hebdomeros could not approve of these skeptics who thought that all this was but fables, and that centaurs never existed, any more than fauns, sirens, and tritons. As a proof to the contrary, they were all at the door, pawing the ground and, shivers running through their flanks, swishing their tails to drive away the obstinate flies; they were all there, these centaurs with the mottled cruppers; among them were old centaurs; they were taller than the others although leaner; they looked desiccated and as if their bones, under the weight of years, had become larger and longer; overshadowed with thick white eyebrows contrasting curiously with the dark color of their faces, their cerulean and kind eyes could be seen like the eyes of Nordic children; their gaze was full of an infinite sadness (the sadness of demigods), it was attentive and steadfast as the gaze of sailors, mountaineers, eagle and chamois hunters, and in general of those who are accustomed to look very far away and to discern men, animals, and things in the far distance. The others, the young ones, slapped each other with the palms of their hands and amused themselves by flinging out kicks against the kitchen-garden fences. Sometimes an adult centaur left the group and went at an easy trot along the paths that lead down to the river; there he stopped to talk with washerwomen, who were kneeling on the shore beating their linen. As the man-horse came nearer, the youngest ones looked uneasy. Hebdomeros, who more than once had witnessed the scene, was always intrigued by the disquiet of the young laundresses; but this time he thought he had discovered the reason—"It is surely mythological reminiscences that disturb them," he said to himself; and he went on thinking: their feminine imaginations, haunted by these reminiscences and always prompt to invent a drama, already fancy *abduction,* the centaur crossing the river amid the eddying currents and dragging away a woman shrieking and disheveled like a drunken bacchante; on the river bank, Hercules letting fly, with great effort and panting, his poisonous darts; and then the chlamys soaked in blood, the chlamys whose color darkened and became like the color of lees of wine, and then stuck indelibly to the centaur's torso, which it fitted closely and perfectly. . . .

Hebdomeros mingles the fantastic with the real as if reality were fantastic, or fantasy were truth itself. The narrator speaks in the end of his father, his opinions and principles, with a light humor and a profound loving sentiment, and finally he meets a woman—who has his father's eyes:

And once more it was the desert and the night. Everything was asleep again in im-mobility and silence. All of a sudden Hebdomeros saw that this woman had his father's eyes; and *he understood.* She spoke of immortality, in the great night without stars.

..... "O Hebdomeros," she said, "I am Immortality. Names have their gender, or rather their sexes, as you said once with much subtlety, and verbs, alas, are declined. Have you ever thought of my death? Have you ever thought of the death of my death? Have you *thought of my life?* One day, O my brother....."

But she spoke no more. Sitting on a broken column, she gently laid a hand on his shoulder and with the other pressed the hero's right hand. Hebdomeros, his elbow leaning on the ruin and his chin in his hand, thought no longer..... His thought yielded slowly to the pure breeze of the voice he had heard and finally abandoned itself al-together. It abandoned itself to the caressing waves of unforgettable words, and on those waves it floated in the lukewarm softness of a declining sun that smiles, as it wanes, to the cerulean solitudes......

Meanwhile, between the sky and the vast expanse of the seas, green islands, wonder-ful islands drifted slowly, as the ships of a squadron pass before the flagship, while long processions of sublime birds of immaculate whiteness flew by, singing.

Despite *Hebdomeros,* the break between Chirico and the surrealists remained definitive and irretrievable. Yet it had become clear that beyond all controversies surrealist painting was coming into its own and was evolving a language that owed very little to contemporary painters, even to Picasso. Its sole debt was to the early Chirico. André Breton's last article on painting in *La Révolution surréaliste* (no. 9-10, October 1, 1927), dealt mainly with the work of Max Ernst and with Man Ray's photographic research, which Morise had also mentioned in "Les Yeux enchantés," and finally with André Masson. The series of Breton's articles on "Le Surréalisme et la Peinture" was published for the first time in book form in 1928, with added texts on Miró, Tanguy, and Arp. (After several further expanded editions, the book was trans-lated into English, in 1972.)

In 1929 Max Ernst published *La Femme 100 têtes,*[7] an album of a hundred collages with

[7] Literally, "the hundred-headed woman"; but "100" in French (*cent*) has the same sound as *sans* ("without"), so that the title may mean "the headless woman," and it has sometimes been translated as "the hundred-headless woman." Also, *cent* may be pronounced as *sang* ("blood") and as *sent* ("smells"), allowing many derivative meanings for the album's title, not counting other plays on words, for instance: *la femme s'entête* ("woman is obstinate"). . . .

captions, followed the next year by another picture book, *Rêve d'une petite fille qui voulut entrer au Carmel* (Dream of a Little Girl Who Wanted to Become a Carmelite), emphasizing the antireligious aspects already present in *La Femme 100 têtes*. These albums are indeed "children's books for adults," while the sequences of the captions give birth to real poems—for instance, in the fourth chapter of the first album:

And Loplop, the Superior of Birds, is made flesh without flesh and shall live among us — His smile will have a restrained elegance — His weapon will be drunkenness, his bite fire — His gaze will plunge straight into the debris of desiccated towns — Living alone on her phantom globe, beautiful and robed in her dreams, Perturbation, my sister, the hundred-headed woman — Each bloody riot will give her life full of grace and truth — Her smile, which is fire, will fall in the shape of black jelly and white rust onto the sides of the mountain — And her phantom globe will find us again — At every port of call.

In his preface to Max Ernst's album, André Breton discussed the technique of collage and pointed out its possibilities for renewing the charm of old illustrations and their latent poetry. Disorientation is mentioned as the great means for surrealist creation: "Surreality depends on our wish for a complete disorientation of everything"—a formula that echoes a renewed allusion to Rimbaud's image of the "drawing room at the bottom of a lake," no longer considered as a metaphorical scene, but as an actual reality.

La Femme 100 têtes will be preeminently the picture book of our time, as it will be increasingly apparent that every drawing room has come down to "the bottom of a lake" and this, we must insist, with its chandeliers of fishes, its gildings of stars, its dances of grass, its bottom of mud, and its costumes of reflections. Such is our idea of progress on the eve of the year 1930 that we are happy and impatient, for once, to see children's eyes, filled with all the future, open like butterflies on the shores of this lake, while for their wonder and for ours falls the mask of black lace, which was hiding the first hundred faces of the fairy.

La Peinture au Défi is a long foreword by Louis Aragon to the catalogue of an exhibition of collages at Galerie Goemans, in Paris, in 1930. Herewith part of the text:

A CHALLENGE TO PAINTING

It is significant that all painters who might be called surrealists have used collage, at least momentarily. If collage, for several of these painters, is closer to *papier collé* than to collage, as it is for Max Ernst . . . yet for most of them it plays an important part and appears as a decisive moment, a distinctive point in their evolution. Under the

title *Fatagaga,* Arp, in collaboration with Max Ernst, made collages that were in the latter's spirit; he also pasted paper haphazardly, then used cutout pieces of paper. His collages and his painting have an identical character because of the simplified features of the latter, which owes nothing to impasto or touch, the substitutes for personality for many painters. Arp asks carpenters to execute his reliefs, it is a pure concession if he colors them himself, and when they become soiled they can be repainted without his objecting. These morals are new in painting and it is pure stupidity to find them surprising. Then, why use color paints? A pair of scissors and paper, that is the only palette that does not bring us back to schooldays. In this manner Man Ray[8] made *Revolving Doors* (1916-17), a whole book of cutout colored papers. Cutout papers appear in almost every picture by Yves Tanguy toward 1926, either for their color or to represent actual collages of objects; these always play, it is true, an anecdotal part in the picture. Malkine used *papier collé* and collage of objects. With sand and feathers, André Masson obtained effects recalling old Peruvian materials. Magritte employed *papier collé* and, very recently, collage of illustrations[9] We must take special notice of the collages of Francis Picabia. . . . Picabia could be seen drilling, as if they were trained monkeys in the circus of this false painting, objects especially ill fitted to enter the Louvre Museum, but that will still enter it, everything being doomed to classification except the laughter that Picabia lets us hear sometimes: there were drinking straws and their dresses of paper, toothpicks, safety pins.....nothing was spared, from the bunch of flowers to the landscape.

Around that time it happened that Picasso did a very grave thing. He took a dirty shirt and fixed it on a canvas with the help of a needle and thread. And since with him everything turns to guitar, it became a guitar, for instance. He made a collage with nails sticking out of the painting. Two years ago he had a fit, a real fit of collage: I heard him complaining that those who came to see him and who saw him animating old bits of tulle and cardboard, strings and corrugated iron, rags picked up from garbage cans, thought they did the right thing when they brought him pieces of magnificent materials *to make pictures out of.* He didn't want that, he wanted the true waste of human life, something poor, soiled, despised.

A curious man is Miró. Many things in his paintings recall what is not painted: he makes pictures on colored canvases, and paints a white blob on them, as if he hadn't painted anything on that spot and the canvas was the painting. He purposely draws the lines of the stretcher on the picture, as if the stretcher had left its imprint there.

[8]We must connect to the collage the practice, invented by Man Ray, of photography without a camera: Rayography, whose results are unpredictable. It is a philosophical operation of the same character as collage, beyond painting and not really related to photography.

[9]Is there a link between collage and the use of handwriting in a painting, as Magritte practices it? I don't see how this could be denied.

Last year he began quite naturally to make nothing but collages, which are closer to Picasso's collages and to Miró's paintings than anything else. Generally the paper is not entirely pasted; its edges are free, it waves and hangs loose. Tar was one of Miró's favorite elements in 1929. It is difficult to say whether Miró's collages imitate his paintings, or rather whether his paintings imitated in anticipation the collage effect, as Miró has succeeded in practicing it, little by little. I incline toward the latter interpretation.

What defies interpretation best is probably the use of collage by Salvador Dali. He paints with a magnifying glass; he knows so well how to imitate a chromo, that the result is inevitable: the pasted parts of the chromo are thought to be painted while the painted parts are thought to be pasted. Does he aim thus at confusing the eye and does he enjoy causing a mistake on purpose? This may be admitted but it does not explain a double game that cannot be ascribed either to the artist's despair before the inimitable, or to his laziness before a ready-made expression. It is certain too that the incoherent aspect of a Dali picture, in its entirety, recalls the particular incoherence of collages. An attempt has been made to reduce Max Ernst's collages to plastic poems. If one should try on psychological grounds to handle Dali's paintings in the same way, he could claim that every one of his pictures is a novel. Thus Dali is also associated with the antipictorial spirit that not so long ago made painters, then critics, protest loudly, but that invades painting today. This is what may be retained from a sequence of facts that we are witnessing that might seem chaotic only to those who did not see their essential link. . .

Surrealist writers also spoke of painting and of their friends the painters, in a less direct but far-reaching language, the language of poetry itself. *Capitale de la douleur,* by Paul Eluard, contained several pieces dedicated to artists; for instance:

Giorgio de Chirico

A wall denounces another wall
And the shadow protects me from my timid shadow.
O tower of my love around my love,
All the white walls fled white around my silence.

You, what did you protect? Insensible and pure sky
You sheltered me, shivering. The light in relief
On the sky which is no longer the mirror of the sun,
The stars of day among the green leaves,

The memory of those who spoke unknowingly,
Masters of my weakness and I stand in their place
With eyes of love and too faithful hands
To depopulate a world from which I am absent.

Paul Klee

On the fatal slope, the traveler profits
From the day's good will, sleet and no pebbles,
And his eyes blue with love, he discovers his season
Which wears on each finger big stars set on rings.

The sea has left its ears on the beach
And the sand has marked the place of a beautiful crime.
The torture is harder on tormentors than on victims,
Knives are signs, and bullets, tears.

The following poem by Eluard about Yves Tanguy was written in 1932:[10]

Yves Tanguy

One evening every evening and this evening like the others
Close to the hermaphrodite night
Developing imperceptibly late

The lamps and their venisons are sacrificed
But in the smoldering eyes of lynx and owl
The vast interminable sun
Heartache of the seasons
The household crow
The power to see encompassed by earth.

There are stars blacker than the night
In relief on cold waters
So on the hour as an ending the dawn
All illusions on the surface of memory
All leaves in the shadow of perfumes.

And the handmaidens try in vain to numb me
Arching their bodies and unfolding the anemones of their breasts

[10]Translation by Kay Sage Tanguy in *Yves Tanguy* (New York: Pierre Matisse, 1963).

I take nothing from these nets of flesh and tremors
From the ends of the earth to the twilight of today
Nothing can withstand my desolate images.

Silence in the guise of wings has frozen plains
Which the slightest desire cracks open
Night turning around lays them bare
And casts them back to the horizon.

We had decided that nothing would be defined
Unless according to the finger resting by chance on the controls of a broken machine.

"Two Portraits of Max Ernst" by Benjamin Péret are dated respectively 1923 and 1926:[11]

1

Your feet are miles off
I last glimpsed them
on the back of a mare
that was soft very soft
too soft to be honest
too honest to be true
The horse that's most true
is momently young
but as for you
I keep discovering you
in the streets of the sky
in the claws of lobsters
in violent inventions

2

He had the ears of an oyster
and his hair danced in the spray
while the white rocks evaporated
at the onset of flies
He had eyes as blue as olives
He had olives as black as his belly

[11] Translation by George Reavey in *London Bulletin,* no. 7 (December 1938–January 1939).

and he begged the chimneys to tell him the secret
of the smoke
straying in the exit of his eyes
like the ghosts' snow
when the stones dress up like their fathers
whose feet stretch like a sunbeam
down schists
tricolor woods
tulips swimming like a skate in the avenue of frozen feet
skeletons with gramophone bones
panes as white as a scallop of veal
statues of radish
dead brass
and above all streams of fresh water flowing in the depths of saints' ears

CHAPTER 13

Variétés

Surrealism came to Belgium in the 1920s with René Magritte, the painter, as its most remarkable exponent and creator. E. L. T. Mesens, an art dealer in Brussels (and later in London), also a poet and a collagist, often acted as a connecting link between the French and Belgian surrealist groups. The theoretician-poet Paul Nougé formulated a deep if sometimes obscure philosophy that was published along with the writings of Jean Scutenaire, André Souris, and others, in Belgian surrealist reviews. In June 1929, the artistic and literary magazine *Variétés*, founded the preceding year in Brussels by P. G. van Hecke, published a special issue, edited by the Paris group and entitled "Surrealism in 1929," which took the bearings of the movement at that time and summed up its general attitude.

The leading article was borrowed from an essay by Sigmund Freud on humor, and indeed humor was not absent from the pages of *Variétés*'s special number. Louis Aragon contributed brief, witty little pieces, for instance, the three following poems:

Modern

> Brothel for brothel
> I prefer the Métro
> It's gayer
> And then it's warmer

Ex-Serviceman

> I was in the dada movement
> Said the dadaist
> I was in the dada movement
> And indeed
> He was in it

98-28

Here I am in my best clothes
It seems
That the little pigs
The little pigs
Haven't eaten me
Well
The big pigs
Will eat me

There were poems by Eluard, Mesens, and others; a lyrical ode by Desnos, with an English title, "The Night of Loveless Nights," revealed its author's leaning toward imitation, if not pastiche, of Apollinaire's poems in alexandrine verse (especially of "Merlin et la vieille femme" [Merlin and the Old Woman] from *Alcools* [Alcohols]). From Benjamin Péret, there was one of his wonderfully absurd tales; from René Crevel, "A l'Heure où l'écriture se dénoue" (When the Writing Unwinds Itself), a bitingly ironical text against French middle-class mentality; from Paul Nougé, the following "Nouvelle Géographie élémentaire":

New Elementary Geography

If an image recedes — the larger it grows.

Returning from your travels, if you tell of the roads you followed, the woods you traversed, the hills you climbed, of cities and villages, surprises and habits, if you describe the country you visited, do not think that afterward you will be unable to wander over the whole surface of the earth without recognizing it.

You are everywhere without being anywhere. A long life is useless. And then, to learn — but how?

... What is the name of the man who goes on long voyages, and how are the travelers called who discover strange lands? The answer is known. Over there, the earth grows ever colder and darkness is very nearly complete; one could hardly live there. Yet a certain star remains always at the same place in the sky. But what is written at the bottom of the landscape? What is the object hanging on the wall, to the left or to the right of the window? What may be seen from the window? What does the dual movement of this spinning top represent, and which two objects resemble each other most? Here you must not think of two drops of water. Only imaginary things are perceived. And the shape of the Earth? The meaning of this question is lost forever.

In a moving train, passengers see trees and houses speeding away along the tracks. A thought precedes them. But thought is not luminous by itself; it lights us during

the night, sending back on us the reflections it receives from our sleeping mouth: a dark circle, an illuminated half-circle, a circle entirely lit. Which is then the image when light is brightest, weakest? All windows are lighted.

...If you are in the open country, without an obstacle limiting your sight, it is obvious that in the distance, on all sides, the earth is in contact with the sky. But the sun appears or rises, disappears and sets, always on the same side, yet the pole of the stars was not fixed forever on the same point of space. It's no use placing on steeples, beneath the weathercock, two crossed iron bars bearing four letters at their ends; the spirit blows where it can blow and the starred figure, the flaming card, turns as it pleases toward all horizons.

An epigraph attributed the above text to a certain lady—Clarisse Juranville, an imaginary being. This method of false quotation, or anonymous quotation, had been used previously by Nougé, together with other concealing processes, to bestow an enigmatic profundity on a commentary on Jacques Vaché's existence published in 1927 in *La Révolution surréaliste* (no. 9-10, October 1, 1927).

Jacques Vaché

We cannot in any manner remain unconcerned by Vaché's adventure. At the time, a chronicler was satisfied to write this:

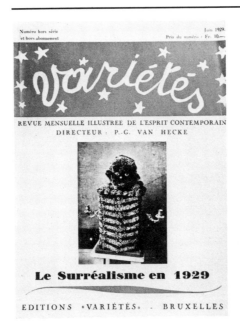

Cover of the surrealist issue of *Variétés* (Brussels, June 1929). The photograph shows an object found by Yves Tanguy at the flea market on the outskirts of Paris—probably a fetish for Black Masses.

"There are words with a strange fate; some are sweet, noble, or pure and they become coarse, they keep bad company, they get dirty; others rise from a well of ignominy toward a still doubtful light, but a light that will make them resplendent tomorrow; thus 'sadism' is at the stage where simple people grant it the benign meaning of 'erotic perversity.' Willingly and thoughtlessly, writers adorned themselves with this flower of blood, uninterested as they were in gathering it themselves from the original tree. Yesterday, when there was need of naming a true sadist, the right word was lacking and physicians, in authentic speeches, used a scientific euphemism:

" 'V. is violently immoral.'

"V. is the very incarnation of sadism. Of course he cannot arrange elaborate caverns where the rutting male slowly cuts the throat of the girl or of the sodomized boy (Sade says the *bardache*) whose cries and agony are necessary for his pleasure; he is a wanderer, insecure, without leisure, but he does his best; he slyly slashes a secret flesh, he strangles suddenly but with each crime two actions are performed: it is perfect sadism, at least as a method.

"The wanderer is even more tragic than the aristocrat. He operates on bare moors, behind rocks rising like gallows; on the skirts of woods, toward the hour when dogs howl, along lonely roads. After committing his crime, he disappears, but he disappears also without reason; he must walk; he cannot keep still.

"The true wanderer never passes the same spot twice.

"Benoît Labre[1] was one of the most interesting among these innocent wanderers; five or six times he entered a convent, La Trappe, the Chartreuse, but after a few months, a few weeks, he felt himself gripped by anxiety, and he went out, he walked; he wandered for thirty or forty years. . . .

"V. has been known to explain his actions as 'religious motives.' "

It would be vain to name here a mind whose sentiment and approach are mediocre, but who is not sufficiently wary of the backlash of the writing process. To such a degree that with a little help, one discovers this chronicle.

Black humor had a less abstruse expression when, in *Variétés*, Raymond Queneau dwelt on a peculiar kind of cosmology, in his article "Quand l'Esprit....."

When the Spirit.....

When the spirit gives up research with an immediate practical aim and turns to the study of the physical world, its diversity appears confusing to such a degree that only the principles of relativity or of enumeration offer themselves to explain the said diversity—the above possessive pronoun applying to the researching mind as well

[1] A saint (1/48-83).—M.J.

as to the physical subject of the research. The classification into living and nonliving beings is the basis of physics as well as of chemistry, since the laws of falling bodies that select feathers or lead as models never took as examples guinea pigs or snails. Experiments on the laws of gravity are never made with living beings—a pigeon for instance, or an eagle. Why? There is a lack of honesty here in the physicist. Moreover, since a *majority* of objects do not fall—dust floating in the air, birds, clouds, balloons, airplanes, planets, stars, archaeopteryxes (in their time), etc.—there is no reason, therefore, for the others to fall. To tell the truth, a thing makes its way toward the center (?) of the earth (??) only if it meets a buffer. A buffer is an invisible, imaginary, and fallacious being, who lies in wait for objects deprived of a physical support and who clings to them. Then he flies downward to the earth and lays them there; then he goes off again. Thus the illusion of a fall is created, but nothing of the kind: it is only a sort of transport, I would even say a method of locomotion.

In a higher course of lectures, we shall study buffers specialized in the fall of leaves and those that take the shape of age and death.

The world is a pill dropped in a glass of water.

Air and water are identical in relation to earth; ether and water, in relation to the world; mountains result from the disaggregation of earth under the action of air.

Planets result from the disaggregation of the sun under the action of water (ether).

Satellites are air bubbles contained in the pill, which escape when it disaggregates, carrying along certain solid particles. Aerolites and comets seem to be all solid and of an explosive nature.

Thus, the moon is hollow.

There is at the bottom of the world a pill that, when disaggregating, projects stars in the sky. . . .

The earth is a sunken ship, the moon is a drowned man, comets are wreckage.

Astronomy is a miscarried science and the sun keeps revolving around the earth. Preoccupations about those millions of light-years never interested anyone but the popularizers of knowledge, and the incalculable (it seems) number of stars has nothing to do with the infinite.

Astronomy, vacillating and weakish, retires into asylums, institutions of an obscene shape, a cupola split in two, into which a telescope is inserted.

The idea of Moon is a pear-shaped concept.

Likewise, the concept of Sun is egg-shaped.

Louis-Philippe is the moon king; Louis XIV, the egg king.

Are pear-shaped: royalty, the League of Nations, the bourgeoisie, the Civil Code, the integrity of the land, the flag. Are egg-shaped: the pope, christ, the unknown soldier, baptism, circumcision, the vatican.

War is a concept in the shape of a cigar clipper, the morning twilight is in the shape of a death's head (the alarm clock, for instance, is supported by two tibias), the umbrella is typewriter-shaped. There are also ideas that are in the shape of a sardine can: picture puzzles, houses, dead languages, modern languages.

No use going further: it is enough that I opened the way to future research workers (the concept of research being tooth-shaped).

"Jeux surréalistes," humor and disorientation united and an effective cure against boredom besides, appeared in the *Variétés* number, with examples of one of the many versions of these poetic entertainments.

Surrealist Games

Sitting around a table, each player writes on a sheet of paper, without looking at his neighbor's, a hypothetical sentence beginning with "if" or "when," and, separately, a proposition in the conditional or future mood, unrelated to the preceding phrase. Then the sentences are shuffled at random, two by two. Here are some of the products of this activity, which is not without charm.[2]

L.A.: If night was endless
G.S.: There would be nothing more, nothing, nothing at all.

B.P.: When shoestrings grow in the workers' gardens
S.M.: Railwaymen will blow their noses with sugar tongs.

S.M.: When capital letters make scenes to small letters
E.P.: Exclamation marks won't have much to say.

S.M.: When the impossible goes hand in hand with the unexpected
A.B.: Fear will rise very high on its spring.

[2]Initials refer to the following participants: *L.A.*: Louis Aragon; *G.S.*: Georges Sadoul; *S.M.*: Suzanne Muzard; *E.P.*: Elsie Péret; *B.P.*: Benjamin Péret; *A.B.*: André Breton; *Y.T.*: Yves Tanguy; *P.U.*: Pierre Unik.—M.J.

Y. T.: When children slap their father's face
A. B.: All young men will have white hair.

E. P.: If tigers might prove grateful to us
S. M.: Sharks would volunteer to be used as canoes.

B. P.: If orchids grew in the palm of my hand
A. B.: Masseurs would have plenty of work.

S. M.: If the shadow of your shadow visited a hall of mirrors
A. B.: The sequel would be indefinitely postponed to the following issue.

S. M.: If the trusses of straw concealed their yearning to burn
E. P.: Harvests would be beautiful indeed.

A. B.: If solid objects were replaced by the interval between them, this interval being
solid, the objects being the interval.
E. P.: Nobody could take hold of anything.

P. U.: If newspapers were printed on silver foil
L. A.: Then, shit.

A. B.: If the pig was considered the most beautiful animal in the universe
L. A.: We would laugh.

P. U.: When a statue is erected to the association of ideas
L. A.: The angel of the bizarre will invent the art of billiards.

The first surrealist game to be put into practice is known as the *cadavre exquis,* which is defined as follows in the *Dictionnaire abrégé du surréalisme* (Abridged Dictionary of Surrealism), published in 1938:

EXQUISITE CORPSE. Game of folded paper that consists in having a sentence or a drawing composed by several persons, each ignorant of the preceding collaboration. The example that has become a classic and gave its name to the game is the first sentence obtained by those means: "The exquisite—corpse—will drink—the new—wine."

In 1948, André Breton wrote the preface to an exhibition of drawings made at various times through the same process of "blind" composition:[3]

[3] Galerie Nina Dausset, Paris.

Top left: André Masson, Max Ernst, and Max Morise: *Exquisite Corpse*, 1927. (Collection Simone Collinet, Paris). *Bottom left*: Andre Breton, X——, Suzanne Muzard, X——, *Exquisite Corpse*, 1930. *Right*: Oscar Dominguez, Marcel Jean, Esteban Francés: *Exquisite Corpse*, 1935 . (Collection J.-P. Selz, Paris)

The Exquisite Corpse: Its Exaltation

The "Exquisite Corpse," if we remember rightly—and if we dare say so—originated about 1925 in the old house, now demolished, at 54 Rue du Château.[4] Long before

[4]This house disappeared when the Gare Montparnasse was extended in 1930.—M. J.

he devoted himself to prospecting in American literature, Marcel Duhamel drew enough resources from his rather fanciful (but highly stylish) participation in the hotel industry,[5] to shelter there permanently his friends Jacques Prévert and Yves Tanguy, who, at that time, excelled only in the art of living and of enlivening everything with their witticisms. Benjamin Péret stayed there also for a long time. Absolute nonconformity and total irreverence were the fashion, the best of moods reigned. It was a time for pleasure and nothing else. Nearly each evening found us gathered together around a table where the Château Yquem deigned to blend its sweet presence with those of many other and much more tonic brands.

When conversation about current events and about proposals for amusing or scandalous interventions in the life of those days began to lose its vigor, we were in the habit of turning to *games*—written games at first, in which the elements of speech confronted each other in the most paradoxical way so that human communication, led astray from the start, caused the mind that registered it to run a maximum of adventures. From that instant, no preconceived unfavorable opinion—indeed, much to the contrary—was held toward childhood games, for which we felt the same earnestness, though perceptibly increased, as in times past. This is why, when we later had to account for the upsetting quality that our encounters in that domain assumed sometimes in our eyes, we had no difficulty acknowledging that the method of the "Exquisite Corpse" did not differ appreciably from that of certain party games, such as "Consequences," for instance. Certainly, nothing was easier than to transpose those methods to drawing, using the same system of folding and hiding.

. . . What exalted us in these productions was indeed the conviction that, come what might, they bore the mark of something that could not be begotten by one mind alone and that they were endowed, in a much greater measure, with a power of *drift* that poetry cannot value too high. With the "Exquisite Corpse" we had at our disposal —at last—an infallible means of temporarily dismissing the critical mind and of fully freeing metaphorical activity. . . .

Another variant of such games may be found in *La Révolution surréaliste,* no. 11 (March 15, 1928) under the title "Le Dialogue en 1928."

The Dialogue in 1928

Raymond Queneau and Marcel Noll:
N. : Who is Benjamin Péret?

[5] Marcel Duhamel is editor, at Editions Gallimard, of the Série Noire, a series of crime novels, most of them translated from the American. At the time Breton refers to, Duhamel was manager of a hotel belonging to one of his uncles.—M.J.

Q.: A rioting menagerie, a jungle, freedom.

Q.: Who is André Breton?
N.: An alloy of humor and the sense of disaster, something like a top hat.

Suzanne Muzard and André Breton:
B.: What is the kiss?
S.: A divagation, everything capsizes.

S.: What is daylight?
B.: A naked woman bathing at nightfall.

S.: What is exaltation?
B.: It's a blob of oil in a brook.

S.: What are eyes?
B.: The night watchman in a perfume factory.

B.: What is hovering between Suzanne and I?
S.: Great black threatening clouds.

B.: What is a bed?
S.: A fan quickly opened. The sound of a bird's wing.

Suzanne Muzard and Max Morise:
M.: What is a cannibal?
S.: It's a fly in a bowl of milk.

Suzanne Muzard and Marcel Noll:
N.: What is springtime?
S.: A lamp fed with glowworms.

N.: What is voyage?
S.: A big glass sphere with several reflections.

André Breton and Benjamin Péret:
P.: What is a magistrate?
B.: It's a blackguard, a dirty fellow, and an ass.

P.: What is equality?
B.: It's a hierarchy like any other.

P.: What is fraternity?
B.: It's perhaps an onion.

B.: What is rape?
P.: The love of speed.

B.: What is military service?
P.: It's the sound of a pair of high boots falling down a staircase.

B.: What is an arrow?
P.: It is an *I* that has lost its dot.

Antonin Artaud and André Breton:
A.: Has surrealism still the same importance in the organization or disorganization of our lives?
B.: It's mud, into whose composition hardly anything enters but flowers.

Humor again, a joking and gay spirit mingled with the love of the marvelous, characterized the play by Louis Aragon and André Breton, *Le Trésor des Jésuites,* published in *Variétés.* The play, or rather revue, was based primarily on an authentic crime mystery that filled the front pages of the daily papers early in 1928.[6] The play was written for a festival organized for the benefit of René Cresté, a film actor who had impersonated the leading character in a movie serial, *Judex,* in the early days of the cinema, during World War I. The performances were to have taken place at the Théâtre de l'Apollo on December 1, 1928. Man Ray had composed a photographic "montage" for the cover of the program, and Musidora, the actress who, throughout the numerous episodes of *Judex,* had played the part of the hotel burglaress (*la souris d'hôtel*), in black silk tights, was cast for the leading role of Mad Souri. But the Judex Gala was finally canceled, and *Le Trésor des Jésuites* appeared only in print in *Variétés*'s surrealist number:

THE TREASURE OF THE JESUITS

Prologue

Before the curtain:

Time (conventional figure, holding a scythe), Eternity (a young woman in a white robe, with disheveled hair, clasping a large luminous star in her arms).
Time: I am Time.
Eternity: I am Eternity.
Time: I hold the scythe.
Eternity: I hold the star.

[6]Namely, the murder of M. de Parédès, cashier of Jesuit Foreign Missions in France, in February 1928. His body was found, skull smashed and neck broken, in his office on the Rue de Varenne in Paris. The murderer was never discovered. No money was stolen, but one of the cashier's wallets had disappeared. A man named Simon was suspected, but he had a sound alibi. Curiously enough, at the time of the murder this man lived at the City Hotel, near the Place Dauphine, which Breton mentions in *Nadja* (see p. 150).

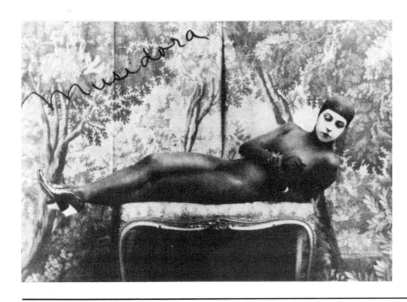

The actress Musidora impersonating the *souris d'hôtel* (the hotel burglaress) in *Judex*, a French movie serial of 1917. (Photograph: *Variétés,* June 1929)

Time: I cut.

Eternity: I illuminate.

Time: A mirage, we are at the cinema. Images on the screen, unfaithful as pretty women, fade out before the spectators' eyes. No matter! Isn't that what the cinema is for, simply to charm the hours of men?

Eternity: Hours . . . hours of leisure, hours of work. What are hours? Films deteriorate, production companies fold up one after the other. It's the same with life, a film impossible to follow, whose meaning, nevertheless, one day becomes mysteriously clear.

Time: Pooh! Everything passes away.

Eternity: No.

Time: What is it then that lasts?

Eternity: That which finds in life a marvelous echo...... Look, if you're interested in the cinematograph, I am going to have you witness the apotheosis of a forgotten genre, which everyday events bring to light again. Soon it will be understood that nothing was more realistic and at the same time more poetic than the movie serial, which in the past made rational minds so merry. It is in the *Mysteries of New York,* it is in *The Vampires,* that the great reality of this century will be found. Beyond fashion, beyond taste. Come with me. I'll show you how history is written. (*To the audience, very loud:*) 1917!

Exeunt. The curtain rises.

In a mysterious-tragic-humorous first act, a soldier, Simon, on leave from the front, is arrested in a hotel room for a murder committed by Mad Souri; when the police take Simon

away, Mad Souri lets him know that they will meet again in eleven years at the Théâtre de l'Apollo.

The second act was in the manner of a *revue d'actualités*—a form of topical revue that has now almost entirely disappeared from the French stage, surviving only in one or two cabarets.

Act 2

The stage represents the Théâtre de l'Apollo on December 1, 1928. Time (in knickers) and Eternity (dressed in the latest fashion) holding respectively the scythe and the star, enter from each side of the curtain and collide in the middle of the stage.

Eternity: Can't you look where you're going?

Time: I'm awfully sorry, madam.

Eternity (recognizing him): Oh! my dear friend!

Time: I was just looking for a partner in the show given this very instant to honor René Cresté. You remember, Judex? And who else, but Eternity.....

Eternity: Agreed. (*Turning to the audience:*) Dear public, the year draws to an end. Have you noticed, dear public, the upsetting nature of this exceptional year, a *leap* year?

Voice in the Audience: Yes, yes, a leap year!

Eternity: Well, to Time and myself, the pretext seems excellent for having the most typical features of the movie serial march before you, unduly forgotten after the baffling progress of what is usually called the Seventh Art. It's remarkable that the characteristics of the screen have gone into the domain of life, as we have already said. Now or never is the occasion, dear public, of evoking before you "The Phantoms"!

Clanking of chains. Apparition of conventional phantoms.

Time: "The Specters"!

The curtain rises. Moving spotlights reveal the depth of the empty stage.

Eternity: "The Automaton"!

Music and voice: "Le Beau Bébé." *Dance of a character whose jacket bears his articulations marked with white chalk.*

Time: "The Mannequins"!

Lights on a section of the stage, showing a dressmaker's dummy, a tailor's dummy, a silver-painted dummy for shop windows, before which a model from the Rue de la Paix comes parading. Orchestra: "Ain't She Sweet!"

Eternity: "The Suburban Trains"!

A muffled whistle is heard. A stationmaster appears and goes across the stage, waving his lantern.

The Stationmaster: All aboard.....All aboard.....Colombes.....Colombes.....Colombes.....(*exit*).

Time: "The Fainting Fit"!

The drop curtain represents the front of a shop. An old rake follows an errand girl. Suddenly he puts his hand to his heart. Classical scene of the man seized with angina pectoris. He tries to hide the pain he feels at each step by feigning interest in the shop window. The errand girl stops, surprised. The man collapses. A crowd forms a half-circle. Long silence.

Eternity: The ground has given way under his feet. In this respect: "The Waste Lands"!

From behind a curtain coming down from the flies and shaking rhythmically appears the nude torso of a woman who wears a battered top hat and holds in her hands a saucepan and a large sardine can. Orchestra: "Fascination," a waltz.

Time: "The News in Brief"!

Lights on the stage. An office. The cashier. It is Saturday, February 11, 1928, around 4 p.m. In his office, M. Félix de la Tajada de Parédès, cashier of the Jesuit Foreign Missions of France, puts his accounts in order. The room is summarily furnished with a desk, two seats, a safe. A big cast-iron crucifix is hanging on the wall. From a drawer, M. de Parédès has taken out two large wallets full of thousand-franc notes. Night is falling. This late afternoon in February is cold and dreary. M. de Parédès lights a gas lamp above his desk. Then, his back turned away from the entrance door, he resumes studying his books. A bell rings: a visitor. The cashier of the Missions does not need to get up, he presses an electric button near his hand. The door opens noiselessly. Papers are raised by a puff of air. The visitor is closely wrapped in a cape that he holds before his face with his left hand. Suddenly the shadow of a crucifix rises on the wall before the horrified eyes of M. de Parédès. As he strikes with the crucifix, the visitor unrolls his cape: it is Mad Souri, wearing black tights. Purple spotlight on her, green on the cashier. A rolling of drums, the stage remains lighted, the personages stay motionless as in a wax museum. And death falls on M. de Parédès.

Eternity: But it's the murder of M. de Parédès, cashier of the Jesuit Foreign Missions!

Time: You said it, old girl!

Curtain.

Eternity: It's already been in all the revues. Let's have something entirely new: "The Haunted House"!

Time: Oh, no! Again?

Eternity: Can't be helped now.

Before the curtain, two ordinary persons, hand in hand, their backs to the audi-

ence, gaze with terror at the center of the curtain, which moves apart, revealing two hands like a speaking trumpet before a mouth singing:

Yes I'm the haunted house
I'm different
From the houses around
All unbelievers are atheists
I'm the haunted house

A heart beats on my door
Instead of a hammer
How late it is how early
My walls are the color of fear
I'm the haunted house

Those who live here have no lease
Three six nine thirteen
They get electrified on their chairs
When the tortoiseshell suit of armor enters
I'm the haunted house

I'm in the woods and very far
From my garden
My furniture creaks everything's brown
The lion roars the donkey is saddled
I'm the haunted house.

The curtain closes. Exeunt the two characters.
Time: "The Master Keys"!
The curtain rises. Ten people run into each other in disorder, holding keys at arm's length. The curtain falls immediately.
Eternity: Long live Freud, the great Viennese savant! Now let's get lost, if you please, in "The Underwoods"!
Six girls enter on tiptoe, holding boughs, Eternity and Time cuddle them. The girls disappear on the opposite side. Orchestra: "Old Man River."
Time: My dear, I kept a nice bit for you to finish with: "The Intimate Catastrophes"!
Mad Souri comes down a rope onto the stage, she is in evening dress, holding large gold and silver handkerchiefs in her hands.

Mad Souri: I am the Woman. What do you want from me?

 The curtain opens. Personages are seen on the stage in various attitudes of great despair. Dance of the intimate catastrophes by Mad Souri and the whole company. Music: "Anything But Love."

Eternity: But tell me, isn't this beautiful person the murderer of that Jesuit, what was his name?

Time: That's what happens in revues. (*Turning to Mad Souri*) Won't you add the zest of topicality to this revue of the year, miss?

Mad Souri: By all means, grandfather! (*To the audience:*) "Articles 70 and 71"![7]

 Enter from both sides the articles, represented by two girls with black velvet masks, their bodies entirely concealed behind placards bearing their numbers: they meet in the center of the stage and take each other's arm. Mad Souri comes before them: seduction scene of one article after the other, brief kisses: jealous, the articles quarrel and, doing this, disjoin. Triumph of Mad Souri, in the center. The articles turn around and show their nakedness to the public.

The Prompter (*springing up from his box*):

 Punctual at the rendezvous, Mad Souri! *He falls on her and, facing the audience, begins to strangle her. It is Simon. Time and Eternity drop their insignia and drag his victim away from him. Mad Souri comes back to Simon, offering her neck.*

Mad Souri: More! More!

 He strangles her, very slowly. Darkness.
 Curtain.

In the third and last act, the enigmas of the plot were cleared up (more or less) in a scene set in the future, in the year 1939, during a perpetual or "endemic" war, with which humanity has been inoculated to protect it from the "epidemic" wars of the past. A remarkable prophecy, we may add.

In quite another tone Aragon and Breton also collaborated on "A Suivre," the detailed account of a meeting in March 1929 that gathered around the surrealists about thirty young writers and artists. The text, which filled the first pages of *Variétés*'s surrealist issue, referred to preparatory conversations, letters, etc., and to the long and heated debate on the possibilities of a collaboration, on the revolutionary plane, between the surrealists and several literary avant-garde groups, notably the contributors to the review *Le Grand Jeu.*

[7] This scene referred to a political storm that arose in November 1928, when Raymond Poincaré, the French premier and finance minister, surreptitiously introduced into the budget two articles (70 and 71) giving financial and administrative advantages to Catholic organizations and missions. Thereupon the ministers representing the parties of the left in the government of National Union resigned, the government fell and Poincaré formed another one without members of the left—but the articles in question were set aside, "disjoined" (in fact, removed) from the budget.—M.J.

To Be Followed

A Little Contribution to the Record of Certain Intellectuals with Revolutionary Tendencies (Paris 1929)

The reproaches addressed to surrealists and their methods are sufficiently known. Their hackneyed character ("chapel" morality, a taste for "trials," no respect for private lives, pretensions to "purity," much ado about nothing) would lead us to make them our own. And although the *major excommunications* we are said to pronounce may seem comical from a distance, it is enough for us to have seen those of our former *comrades* we thought proper to get rid of, standing on the defensive, stuttering, floundering, to consider that such penalties weren't after all without real effects. We didn't always give all the desirable publicity to these confounding little meetings, which gratified, curiously, both humor and morals, but it does not follow that we shall always remain so reassuringly circumspect. As a sample, today we are acquainting the readers of *Variétés* with our latest enterprise. . . .

The gathering—at the Bar du Château, Rue du Château—became stormy when Breton brought up the case of Roger Vailland, a member of *Le Grand Jeu* and a journalist, the author of an article in a daily newspaper that glorified the Paris prefect of police, Jean Chiappe, an avowed fascist, whom Vailland hailed as "the purifier of the capital"! Vailland[8] argued that in writing such articles he was in the position of a proletarian making ammunition for war in a factory, in other words, that he did it for a living. Ribemont-Dessaignes, the former dadaist, put forward the same excuse for Vailland's conduct and attacked Breton's methods of "prosecution." The members of the *Grand Jeu* group were more than embarrassed at their friend's attitude. Finally the meeting broke up having resulted only in extracting a letter of justification from Vailland to Breton, which was, remarked the authors of "To Be Followed," "a tissue of idle talk." The last paragraph of the Aragon-Breton account drew the following conclusions:

As for us, we do not claim exclusive possession of truth in these matters, but we are satisfied to bring here the documents in a case we are following up, without greatly fearing if our motives are found out. Repetitions will be noticed; it is not pure complacency on our part if we have transcribed so many statements that might have been omitted owing to their ludicrous character; we have few illusions concerning their value as entertainment; let's not apologize. Our lack of "easy" manners, the time apparently lost on problems of such limited interest—problems, one might think, that it would not be necessary to discuss—our taste for repeating ourselves on those subjects, all this would be entirely inexplicable if it could not be guessed that we are bent on

[8] Later a novelist (winner of the Prix Goncourt) and for many years a Stalinist. He died in 1965.

exposing such harmless-looking individuals, only because we know that it is in this shape that the fellows appear at first who, under cover of a few small literary works, always find the means to impose on others, for a short or a long time, until some social event of an upsetting nature makes them lose all prudence. We saw them in 1914; those were the people whose frightful stupidity during that period has not yet ceased to astonish us, from Bergson to Claudel. The next generation, whose deplorable beginnings we witnessed, is on the highroad to equal them. Nobody will have us believe that this celebrated rabble waited for glory before defining themselves in an ignoble fashion. The intellectual profession is practiced with such impunity that it is useless to wait, before calling public attention to them, till the harmless little boys become respected men, who will bring to the service of what we hate the resources of a long experience in the art of confusion and of sitting and begging before dogs.

"The Second Manifesto of Surrealism"

Published for the first time as a long article in the pages of *La Révolution surréaliste,* no. 12 (December 15, 1929), the "Second Manifeste du surréalisme"[1] outlined a program for surrealist experiments, which until then Breton had not clearly defined:

Whatever the course peculiar to each of those who made use of its name, or who still do, it will be granted in the end that surrealism aimed at nothing less than to bring about, from an intellectual and moral point of view, a *crisis in human conscience* of the most general and serious kind, and that only by whether it obtained this result or not may its historical success or failure be determined.

From an intellectual point of view the question was and still is to test by every means and to proclaim at all costs the artificial nature of the old antinomies hypo-critically intended to prevent all unwonted agitation on the part of man, if only by giving him a poor idea of his means, by challenging him to escape in a valid measure from universal constraint. The scarecrow of death, the music halls of the beyond, the shipwreck of the most beautiful reason in sleep, the overwhelming curtain of the future, the towers of Babel, the mirrors of inconsistency, the impassable wall of Money splashed with human brains, these all too startling images of man's catastrophe are perhaps only images. Everything leads to the belief that there is a certain point of the mind from which life and death, the real and the imaginary, past and future, the com-municable and the incommunicable, the high and the low, cease to be perceived con-tradictorily. Any motive other than the determining of this point would be sought in vain

[1] It appeared in book form early in 1930 with a number of additional passages and notes.

in surrealist activity. Thus it is clear enough that it would be absurd to endow surrealism with a purely destructive, or constructive, meaning—the point to which we refer, is a fortiori, the one where construction and destruction cease to be brandished against each other. It is also clear that surrealism is not interested in taking into very serious account what is produced, aside from itself, under pretense of art, or even antiart, of philosophy or antiphilosophy, in short, of all that does not aim at the annihilation of the being into an interior and blind brilliance, which is no more the soul of ice than the soul of fire. What could anyone who retains any concern about the place he will occupy *in the world* then expect from the surrealist experiment? In this mental space from which a perilous yet, we think, supreme act of reconnaissance may no longer be attempted except for oneself, it would also be out of the question to give the least importance to the steps of those who arrive or to the steps of those who leave; these steps resound in a region where, by definition, surrealism has no ears. We could not wish surrealism to be at the mercy of the temper of such and such men: if it declares itself able, by its own methods, to tear the mind away from an increasingly strict bondage and to put it back on the road of total understanding, to restore that mind to an original purity, that is enough for surrealism to be judged only on what it has done and what it has still to do to keep its promises.

There had been an interval of almost two years between numbers 11 and 12 of *La Révolution surréaliste*. As for the reason that it "had ceased to appear," number 12 reproduces on its first page the imprints of women's lips—the lips of the surrealists' girl friends and wives...... But it was not only love, its joys and storms, that had held up publication of the review. Internal strife had been breeding within the group and the "Second Manifeste" devoted a generous share to polemics and condemnations. It alluded in these terms to the meeting on the Rue du Château:

We were able to note, Aragon and I, by the reception given our critical contribution to *Variétés*'s special issue, "Surrealism in 1929," that the lack of embarrassment we feel in appraising, from day to day, the degree of moral qualification of various individuals, the ease with which surrealism prides itself on dismissing this or that person at his first compromising move, are less than ever to the liking of some journalistic blackguards, for whom man's dignity is at the very most a motive for sneering. What an idea, asking so much from people in a domain hitherto the least closely watched, aside from a few romantic exceptions, suicides and others? Why should we go on acting so disgusted? One police agent, some pleasure seekers, two or three pimps, several unbalanced minds, one cretin—no one would object that there be added to them a small number of sensible, severe and upright beings, who could be termed fanatics.

Wouldn't that make an amusing and harmless team, a faithful image of life, a team of men doing piecework, winning on points?

SHIT.

Former members were taken to task by name—including Artaud, Delteil, Masson, Soupault, Vitrac, Baron, Naville......Quoting Hegel and referring to Marx, Freud, and others, Breton insisted that it was on the social plane that personal convictions and judgments on morality were to be confirmed and that it was on these grounds that the surrealists joined the social dispute and appraised individual behavior.

Then, after recalling the obstacles the Communist party presented to surrealist collaboration, Breton spoke of the difficulties encountered within surrealism itself, when it developed its own experimental means—automatic writing, accounts of dreams, etc. The definitions from the first "Manifeste" reappeared in another shape in the following parenthesis on "inspiration":

No use resorting here to subtleties, we know well enough what inspiration is. There can be no mistake about this; inspiration provides for the supreme needs for expression in every time and place. It is commonly said that inspiration is there or not; if it is not "there," nothing that may be suggested instead by man's skill, which profit obliterates, by discursive intelligence, or by talent acquired by work, can make up for its absence. We recognize its presence easily by that total possession of our mind that, at long intervals, prevents us from being the playthings of a certain rational solution rather than another equally rational; by this kind of short circuit it creates between a given idea and its respondent (a written respondent, for instance). As in the physical world, a short circuit occurs when the two "poles" of the machine happen to be united by a conductor of little or no resistance. In poetry, in painting, surrealism did its utmost to increase these short circuits. It is bent and will always be bent mainly on artificially reproducing this ideal moment when man, in the grip of a special emotion, is suddenly seized by this "stronger than himself" something, which projects him, against his will, into immortality. If he were lucid and awake, he would be terrified, coming out of this disquieting situation. The main thing is that he is not free to do so, that he continues to speak as long as the mysterious ringing lasts; indeed, it is by ceasing to belong to himself that he belongs to us.

Here Breton discussed the case of Robert Desnos, of his "immoderate use of the verbal gift," of his undertaking journalistic jobs, until he was led to an "unforgivable lack of understanding of the present aims of poetry," an attitude that his taste for mere versification betrayed. On the other hand, Breton, examining Tristan Tzara's standpoint, admitted that his former attacks against that poet, in the early 1920's, were unjustified.

The following extracts from passages concerning the writer Georges Bataille are examples of the polemical tone of the "Second Manifeste."

What is paradoxical in M. Bataille's case, and embarrassing for him, is that his phobia about the "idea," as soon as he tries to communicate it, can only take an ideological turn. A state of conscious deficiency with a generalized character, doctors would say. Here, in fact, is someone who lays down as a principle that "horror involves no pathological complacency and plays solely the part of manure in the growth of plants, manure with a suffocating odor, without doubt, but salutary to the plant." Beneath its appearance of infinite banality this idea is in itself dishonest and pathological (it remains to be proved that Lully and Berkeley and Hegel and Rabbe and Baudelaire and Rimbaud and Marx and Lenin behaved in life very specifically like pigs). It is to be noted that M. Bataille overindulges deliriously in the use of the adjectives soiled, senile, rank, sordid, lewd, doddering, and that these words, far from helping him to discredit an unbearable state of things, are those that express his delight most lyrically. Jarry's "unnamable little broom" having fallen in his plate, M. Bataille declares that he is enchanted. He who, in daytime, passes the careful fingers of a librarian (he practices this profession at the Bibliothèque Nationale) over old and sometimes charming manuscripts, feeds at night on the refuse with which he would see them covered; witness the *Apocalypse of St. Sever* to which he devoted an article in the review *Documents,* no. 2, which is the perfect pattern of the false testimony. Let the reader kindly refer, for instance, to the plate of the *Flood* reproduced in that number, and tell me whether, objectively, "a jolly and unexpected feeling appears with the goat represented at the bottom of the page, and with the raven whose beak plunges into the 'meat' "— here M. Bataille grows enthusiastic—"of a human head." To lend a human appearance to architectural elements, as he does throughout this study and elsewhere, is again nothing more than a classic sign of psychasthenia. In fact M. Bataille is simply very tired. . . .

Asking for "a deep and true occultation of surrealism," stressing the importance of the "secret sciences," the "Second Manifeste" ends with a renewed call to purity, in view of the effectiveness and intensity of the ideas that command surrealist activity.

We are less inclined than ever to dispense with integrity, to be content with what some men may give over to surrealism, between little treasons that they think are authorized under the dark, hateful pretext that after all one must live. We have no use for these alms from "talents." What we are asking is, we think, of such a nature as to

bring about total acceptance, total denial, and not to indulge in words, not to cherish erratic hopes. Yes or no, do you want to risk everything for the only joy of seeing, in the distance, *the light that will cease to be failing,* at the bottom of the crucible where we intend to cast our poor comfort, the remains of our good reputation and of our doubts, pell-mell with the pretty "sensitive" glassware, the radical notion of impotence, and the silliness of our alleged duties?

We say that the surrealist operation has a chance to succeed only if it is carried out in a state of moral asepsis, which very few men are today willing to hear about. Yet, without such conditions, it is impossible to stop this cancer of the spirit, which consists in thinking all too sadly that certain things "are," while others, which might well exist, "are not." We suggested that these things must blend or, at the limit, must intercept singularly each other. It is a matter, not of remaining there, but *of being unable to do less than tend desperately toward that limit.*

It would be wrong for man to allow himself to be intimidated by a few monstrous historical failures; he is still free to *believe* in his freedom. He is his own master, in spite of the passing clouds and of his own blind stumbling forces. Has he not the feeling of the brief stolen beauty and of the lasting accessible beauty he could steal? The key of love, which the poet claimed to have found, he has too if he looks for it carefully. It depends on him alone to rise above the fleeting sentiment of living dangerously and of dying. Let him, in spite of all prohibitions, use the *idea* as an avenging weapon against the bestiality of all beings and of all things, and one day, vanquished—but vanquished only *if the world is the world*—let him greet the discharge of its sad rifles as a salvo of salute.

Several of those who had been the targets of Breton's attacks, and a few others who nursed some grudge against him, answered his "Second Manifeste" in a pamphlet entitled *Un Cadavre* —in the manner of the surrealist sheet published after the death of Anatole France in 1925. In a doctored photograph this second "Corpse" showed the leader of surrealism "crucified," his eyes closed, wearing a crown of thorns. A dozen articles in the pamphlet testified to their authors' resentment rather than to Breton's misdeeds.

Neither Breton nor surrealism died of this premature burial. Newcomers filled whatever gaps exclusions or departures may have created in the group. The names of René Char, Luis Buñuel, and Salvador Dali appeared in *La Révolution surréaliste,* no. 12 (December 15, 1929). The synopsis of Buñuel's first film, *Un Chien Andalou* (An Andalusian Dog), was published in that number with a note by Buñuel acknowledging his indebtedness to surrealism. In the same issue, illustrated humorous notations by René Magritte dealt with "Les Mots et les Images."

Words and Images

An object does not care so much for its name that another name could not be found that would be more convenient.

A word is sometimes used only to designate itself:

Sometimes the name of an object takes the place of an image:

An object implies that there are others behind it:

Everything leads us to think that there are not many relations between the object and what represents it:

Vague shapes have as necessary, as perfect a meaning as definite shapes:

Sometimes, names written on a picture designate definite things, and images designate vague things:

Or the contrary:

This issue of *La Révolution surréaliste* also contained two short poems by Francis Picabia and excerpts from Tristan Tzara's important poem *L'Homme approximatif,* whose tone was no longer dadaist but belonged closely to the surrealist spirit.

THE APPROXIMATE MAN

. . . .

we were going along the moors softened by attention
softly attentive to the monotonous jolts of the phenomena
that an unpleasant exercise of the infinite imparted to lumps of knowledge
but the scaly structure of opinions scattered
upon the moist infinity of diadem—the fields—
scorns the sensitive pulp of the truths
revived with a prompt favor of torture
axes were knocking amid chestnut-colored laughs
and the disks of hours were flying to the attack
were bursting in the head of aerial herds
it was our fallow reasons that stemmed their translucent turbulence
and the knotted courses they traced temporally
appeared like tentacles in the constraint of the ivy

. . . .

henceforth the prow of the ramparts is hewed as a swimming figurehead
but now your eyes are guiding the cyclone
haughty dark intention
and on the sea as far as the limit of the birds' evening vigils
the wind coughs as far as the limit where death discharges itself
promethean cataracts of echoes are thundering in our numbed consciousness
the pain when the earth remembers you and shakes you
poor beaten village dog you wander
come back ceaselessly with the word to the disconsolate starting point
a flower in the corner of your lips a consumptive flower bumped about by the
 harsh necropolis
tons of wind have been pouring into the deaf citadel of fever
a keel at the mercy of a dizzy impulse what am I
a disconsolate starting point to which I come back smoking the word in the
 corner of my lips
a flower beaten by the rough fever of the wind
and rugged in my clothes of schist I dedicated my wait
to the torment of the oxidized desert
to the robust accession of fire

. . . .

A homage to dada appeared in an article on modernism by Louis Aragon in *La Révolution surréaliste,* no. 12. In his "Introduction à 1930," the author considered modernism a "fashion," and mainly a symptom. The Orientalist tendency of a century ago, Aragon said, was also a symptom, and Byron's Greece, a "frame for a parable." Dada itself was a symptom, and more than that:

"I believe I remember," wrote Jacques Vaché November 25, 1918, "that we had agreed on leaving the WORLD in an astonished semi-ignorance until some satisfying and perhaps scandalous manifestation. However, and naturally, I rely on you to prepare the way for this deceitful, a little derisive, and in any case terrible God—the fun, you

see, if this true NEW SPIRIT were unleashed!" Several signs announced dada, and we begin to see now what this great intellectual convulsion really destroyed, what it rendered finally impossible, and how it appeared as an instant of the modern evolution, as a decisive instant of that evolution. It is indeed in the nature of man to grow old and not to admit it; then a kind of fatality falls upon him and sweeps him away. Dada played this part toward its predecessors. We were in an age when accepted and commercialized cubism no longer included any new idea, no longer questioned anything. Amid the settings of the Russian ballet, the dispute that was impassioned in 1910 turned into a sort of official interest, a trace of which might be found in governmental decrees of 1919, and in ministerial instructions unofficially transmitted to furniture manufacturers in order to prepare the advent of a modern style for the Exhibition of Decorative Arts in 1925. Certainly, for the last ten years, this complaisance that dada knew how to delay (at the first of the "Fridays of *Littérature*,"[2] Juan Gris's anger was worth seeing; it had been enough trouble already to be taken seriously, and there everything had to be started all over again!), certainly this complaisance went on increasing, and the distinctive mark of these last years is the stupid good will of the public, the knowing smile. This apathy involves a change of attitude on the part of those who encounter it, whose full result cannot yet be appraised. We are very far in our days from Apollinaire's considerations on "surprise," which accounted wonderfully for the modernism of the time. In 1929 the most beautiful surprise in the world, if it is only a surprise, won't have a surprising destiny; snobs are here, and this is not saying much, perhaps this is still using the day-before-yesterday's vocabulary, for nowadays everybody is a snob, everybody knows, the whole world raises its voice to consecrate good-quality successes. I pay homage here to dada, for in its time art became impossible and was not, at least, an enterprise of toys for the rich. Dada could not continue this course, its contradictions had to give birth to something else. The pressure of new elements and of ideas tending to command attention at the expense of other ideas, transfigured the modernity of the years that followed.

This article is written for number 12 of *La Révolution surréaliste* (December 15, 1929), which ends a sort of mental year that has lasted five years. The collection of this review reflects, better than I could do, the evolution of modernism during that period. Someone should comment on it who could rise above the subject. The irregular appearance of the review expresses an entire intellectual life, revealed at intervals of arbitrary length, apparently, and gives an idea of a series of ideological crises and of picturesque divergences. Each number sums up what may have united a few men at the date shown on its cover, it has the value of a resultant. I can only ask

[2]The "Fridays" were public performances based on the dada presentations in Zurich with raucous and provocative readings, lectures, etc. The first one in Paris was held June 23, 1920.—M.J.

minds capable of analysis to refer to them. . . . Surrealism does not apply to a definite modernism like cubism or futurism, for instance, but it expresses itself methodically through the modernism of its epoch; this is what makes it possible to speak of surrealism in relation to men who did not know the word and who lived in any other period. Surrealism has been accused of looking for ancestors. This elementary grievance gives an idea of the way some slightly feeble minds understand considerations that are beyond their usual experimental frame. It will be enough to note that among all these alleged ancestors, there is none to whom the term of modernist could not be applied. . . .

Aragon asked finally: "What is modern today?" His answer was: "Modernism today is not in the hands of poets, it is in the hands of cops"—the intervention of police, far or near, to control intellectual expressions and collective as well as individual lives was, he said, the characteristic of the age.

Other contributors—Georges Sadoul, André Thirion, Maxime Alexandre—expressed similar opinions in articles denouncing not only the police but also the army, religion, work, money. . . . And Benjamin Péret contributed in that same number some of his scandalous poems, for instance, "Hymne de l'ancien combattant patriote":

Hymn of the Patriotic Ex-Serviceman

> Look how beautiful I am
> I hunted moles in the Ardennes
> fished for sardines on the Belgian coast
> I am an ex-serviceman
> If the Marne flows into the Seine
> it's because I won it—the Marne
> If there is wine in Champagne
> it's because I pissed there
> I threw my rifle away
> but the *Tauben* spat on my mug
> That's how I got medals
> Long live the Republic
> I got rabbits' paws in my ass
> I was blinded by goats' droppings
> asphyxiated by my horse's dung
> then they gave me the Cross of Honor
> But now I'm no longer a soldier
> Pomegranates crackle in my face

> and lemons explode in my hand
> And yet I am an ex-serviceman
> To remind me of my ribbon
> I painted my nose red
> and I have parsley in my nose
> for the War Cross
> I am an ex-serviceman
> Look how beautiful I am

The issue ended with an inquiry on love:

The idea that seems to have escaped every attempt at reduction until today and that, far from rousing their anger, has held its own against the greatest pessimists is, we think, the idea of *love,* the only one that can reconcile any man, momentarily or not, to the idea of life. . . .

It is from . . . those who are really conscious of the *drama of love* (not in the puerile distressing sense but in the pathetic sense of the word) that we expect an answer to these few inquiring sentences:

I. What kind of hope do you put in love?

II. How do you envisage the passage of the *idea of love* to the *fact of being in love?* Would you sacrifice your freedom to your love, willingly or not? Have you done it in the past? In order not to forfeit love in your own eyes, would you sacrifice a cause that, until then, you believed you were bound to defend? Would you be willing not to become the one you might become, if this was the price for you to enjoy the full certainty of love? How would you judge a man who would go so far as to betray his convictions to please the woman he loves? May such a token be asked for, be obtained?

III. Would you consider that you have the right to deprive yourself for some time of the presence of the being you love, knowing that absence exalts love to a high degree, but perceiving the mediocrity of this calculation?

IV. Do you believe in the victory of admirable love over sordid life or of sordid life over admirable love?

It seems that these questions on love and revolution, love and destiny, love and life, were more or less dismissed, especially question number III, rather than answered, in many of the fifty replies published in the review. The following was René Char's brief and enigmatic answer:

No, not for this great hard-working person whom I overtook without recognizing her.

Luis Buñuel gave a more detailed and very clear opinion:

I. If I love, all hope. If I don't love, none. II. 1. For me, only the fact of being in love exists. 2. I would gladly sacrifice my liberty to love. I have done it before. 3. I would sacrifice a cause to love, but that has to be examined on the spot. 4. Yes. 5. I would judge him quite well. Despite this, I would ask this man not to betray his convictions. I would go so far as to demand it. III. I would not part from the being I love. Not at any price. IV. I don't know.

Paul Eluard said:

I. The hope of always being in love, whatever may happen to the being I love. II. The idea of love depends too much, for me, on the fact of being in love, for the passage of the one to the other to be envisaged. And I have loved since my youth — I thought for a long time that I had made, to love, the painful sacrifice of my freedom, but now everything is changed: the woman I love is no longer apprehensive or jealous, she leaves me free and I have the courage to be free. — The cause I defend is also the cause of love. — Such a token, when asked from an honest man, can only destroy his love or lead him to death. III. The fatal elements of life always bring about the absence of the being we love, delirium, despair. IV. Admirable love kills.

The following excerpts are from a long answer by Paul Nougé:

I. . . . Love — then I would answer that I expect nothing from it. Nothing that could be held, by any right whatever, as a consequence, a result of that love; nothing that could be named outside of it. . . . II. 1. The lack of adherence of idea to fact has here an exemplary value. . . . 2. The possibility of an antinomy opposing, under any circumstances whatever, love to liberty, belongs in my eyes to a rather gross misunderstanding that does not concern love. . . . 3. Here I have no experience and I can hardly imagine this conflict, only under the doubtful shape of an abstraction deserving all my distrust. 4. What I am, or was, what I could be..... I have too much a sense and, it must be said, an experience of revelation, of illumination; I feel that, in view of some valid end, I am much too incapable of appraising the circumstances of my life to be able to discover in its order or disorder what may alter or reinforce its true meaning. . . . 5. . . . I think again that it is unfair to love to name it in this case. . . . III. If I came to such maneuvers, the charm and result of which I can well enough imagine, I know that the love they would imply would at once be put into question. As for the contempt I would feel toward myself afterward......
IV. The admirable thing in the love in which I believe is that it is contained in any

life, however sordid this life may be felt or imagined to be.

As for André Breton, he asked Suzanne Muzard to answer the questions in his place:

I. The hope of never acknowledging any other justification for my existence but love. II. The passage of the idea of love to the fact of being in love? The question is of discovering an object, the only one deemed indispensable. This object is hidden: one acts like a child who begins to be "at sea," then "burns"; there is a great mystery in the fact that one *finds*. Nothing can be compared to the fact of being in love, the idea of love is weak and its representations lead to errors. To love is to be self-assured; I cannot conceive of a love that is not reciprocal and, therefore, that two beings who are in love with each other may have contradictory opinions on such a grave subject as love. I do not want to be free, this implies no sacrifice on my part. Love as I conceive it has no barrier to cross and no cause to betray. III. If I could calculate, I would be too worried to dare to pretend that I love. IV. I live. I believe in the victory of admirable love.

André Breton added to Suzanne's words: "No other answer than this one could be considered as mine."

Jacques Prévert always expressed himself outside the surrealist movement although he had been connected with it almost from the beginning. The ironical text against Breton that he published in the second "Cadavre" was, curiously enough, the very first one he had ever written. But the poems he began to compose afterward belong to a surrealist atmosphere of disorientation, revolt, and humor, to which a specific color of gaiety mingled with nostalgia is often added.

Sometimes he wrote nonsensical pieces such as "La Pêche à la Baleine":

Hunting the Whale

> Hunting the whale, hunting the whale,
> Said the father in an angry voice,
> To his son Prosper, lying under the cupboard,
> You don't want to go
> Hunting the whale, hunting the whale,
> And why?
> And why should I go hunting a beast
> That did nothing to me, Dad,
> You go and hunt it youself,
> Since you like it,
> I'd rather stay home with my poor mother,

And with Gaston, our cousin.
Then in his whaleboat the father went alone
On the stormy sea......
Now the father is at sea,
Now the son is at home,
Now the whale is angry.
And now Gaston, the cousin, upsets the soup,
The tureen full of broth.
The sea was bad,
The soup was good.
And now Prosper on his chair is grieving:
I didn't go hunting the whale,

Jacques Prévert, 1925.

And why didn't I go?
Maybe we'd have caught it,
Then I'd have eaten of it.
But now the door opens, and dripping with water,
The father appears, out of breath,
With the whale on his back.
He throws the animal on the table, a beautiful whale with blue eyes.
You've seldom seen such a whale before,
And he says in a lamentable voice:
Hurry and cut it up,
I'm hungry, I'm thirsty, I want to eat.
But now Prosper stands up,
Looking his father full in the face,
His father with eyes as blue as those of the blue-eyed whale:
And why should I cut up a poor beast that did nothing to me?
I don't care, I give up my share of it.
Then he throws down the knife,
But the whale takes it up, and rushing upon the father,
Stabs him through and through.
Ah, ah, says Gaston, the cousin,
That reminds me of hunting, hunting butterflies.
And now,
Now Prosper prepares the invitations for the funeral,
The mother goes into mourning for her poor husband,
And the whale, in tears, gazes at the destroyed home,
Suddenly, it cries:
And why did I kill this poor imbecile,
Now the others will chase me in their speedboats
And then they will wipe out all my little family.
Then, bursting with a disquieting laughter,
The whale goes to the door and says,
As he passes near the widow:
Madam, if someone calls for me,
Be kind enough to answer:
The whale is out,
Take a seat,
Wait here,
Probably it will be back in fifteen years.

Prévert's poetry also contained violent and direct insults against the bourgeois world: against army, police, religion, family — pieces where unceasing punning changes harmless hackneyed sayings or slang expressions into strange and menacing propositions. The following extract is one of the less untranslatable passages of "Souvenirs de Famille ou l'Ange garde-chiourme":

Household Souvenirs
or
The Warder-Angel

The priest was a man wearing a skirt, he had flabby eyes and long flat colorless hands; when his hands moved, they looked rather like fishes dying in a sink. He always read us the same story, a sad and commonplace story about a man of times past, with a goatee on his chin and a lamb on his shoulders, who died nailed on two planks after having wept a lot over himself in a garden, at night. The son of a good family, he always spoke of his father — my father here and my father there, my father's kingdom — and he told stories to the unfortunate who listened to him and admired him because he spoke well and was well educated. He ungoitered the goiterous people, and when storms were drawing to an end, he stretched out his hand and the storms subsided.

He also cured dropsical people, he tread on their bellies saying he was walking on the waters, and he changed the water coming out of their bellies into wine, and to those who were willing to drink it he said it was his blood. Sitting under a tree, he used to parable: "Happy the poor in spirit, those who don't try to understand, for they shall toil hard, they shall get kicked in the ass, they shall work extra hours, which will be counted up in their favor in my father's kingdom." Meanwhile he multiplied bread for the unfortunate, and they walked past the butchers' shops rubbing the crust against the crumb, they forgot little by little the taste of meat, the names of the shellfishes, and they no longer dared to make love. . . .

He let the little children come unto him; back home, they offered to the paternal hand that spanked them their left buttock after their right one, while calculating plaintively on their fingers the length of time that separated them from the kingdom in question. . . .

Things were already not going so evenly when one day he betrayed Judas, one of his helpers. A curious story: he pretended he knew that Judas was going to denounce him to people who had known him perfectly well for a long time, and knowing that Judas was going to betray him, he didn't warn Judas. So the mob started yelling Barabbas, Barabbas, death to the cops, down with the priests, and crucified between two pimps, one of them a police spy, he breathed his last, the women sprawled on the

ground yelling out their sorrow, a cock crowed, and the thunder made its usual noise.

Comfortably seated on his flag-cloud, God the Father, of the firm God, Father, Son, Holy Spirit, and Co., heaved an immense sigh of satisfaction, immediately two or three minor clouds exploded obsequiously, and God the Father exclaimed: "Praise be to me, blessed be my holy name, my beloved son received the cross, my firm is afloat!" At once he started placing orders, and the great factories of scapulars fell into a trance, crowds were turned out at the catacombs, and in families worthy of that name, it became very good form to have at least two children devoured by lions.

"Well, well, I've caught you, little mountebanks, joking about our holy religion." And the priest, who was listening behind the door, came toward us, oily and menacing.

But for a long time this fellow who spoke with downcast eyes and fiddled with his holy medals like a prison warder with his keys, had ceased to impress us, and we considered him somehow as one of the various utensils in the house that my father called pompously "household souvenirs": provençal cupboards, hip baths, frontier posts, sedan chairs, and large turtle shells.

What interested us, what we loved, was Costal the Indian, Sitting Bull, all the scalp hunters; and what a singular idea to give us as a tutor a pale-faced, half-scalped man. . . .

Prévert wrote also love poems, plain, heartrending little tales.

The Message

> The door someone opened
> The door someone closed
> The chair on which someone sat
> The cat someone stroked
> The fruit into which someone bit
> The letter someone read
> The chair someone upset
> The door someone opened
> The road where someone ran
> The wood someone crossed
> The river where someone threw himself
> The hospital where someone died

For You My Love

I went to the bird market
And I bought birds
For you
My love

I went to the flower market
And I bought flowers
For you
My love

I went to the scrap-iron market
And I bought chains
Heavy chains
For you
My love

And then I went to the slave market
And I looked for you
But I didn't find you
My love

Except for half a dozen poems that appeared in various magazines in the 1930s, Prévert's writings were not published until after World War II. The first collection, entitled *Paroles* (Words), accomplished a feat almost unheard of for a book of poems—it became a best seller.

IN THE SERVICE
OF THE
REVOLUTION

1

Cover of *Le Surréalisme ASDLR*, no. 1 (1930). The covers of the review's succeeding issues were printed in fluorescent letters, luminous in the dark.

CHAPTER **17**

Le Surréalisme ASDLR

In July 1930 a new surrealist review appeared whose title, *Le Surréalisme au service de la révolution,* made clear the group's intention to continue to take part in a vast move for a radical change in society. Despite many difficulties, surrealists thought it necessary not to oppose the political line of the Communist party. The opening page of the review reproduced a telegram sent from Moscow to André Breton by the International Bureau of Revolutionary Literature, and the surrealists' answer:

QUESTION:

INTERNATIONAL BUREAU OF REVOLUTIONARY LITERATURE ASKS ANSWER TO FOLLOWING QUESTION WHAT WILL BE YOUR ATTITUDE IF IMPERIALISM DECLARES WAR ON SOVIETS STOP ADDRESS POST OFFICE BOX 650 MOSCOW

ANSWER:

COMRADES IF IMPERIALISM DECLARES WAR ON SOVIETS OUR ATTITUDE WILL BE IN ACCOR— DANCE WITH INSTRUCTIONS OF THIRD INTERNATIONAL ATTITUDE OF FRENCH COMMUNIST PARTY MEMBERS

IF BETTER USE OF OUR FACULTIES IS ENVISAGED WE ARE AT YOUR DISPOSAL FOR PRECISE MISSION DEMANDING ANY OTHER USE OF OURSELVES AS INTELLECTUALS STOP OFFERING SUGGES— TIONS WOULD REALLY BE PRESUMPTUOUS IN OUR ROLE AND CIRCUMSTANCES

IN PRESENT SITUATION OF NONARMED CONFLICT WE THINK USELESS TO WAIT BEFORE PLAC— ING IN THE SERVICE OF THE REVOLUTION THE MEANS THAT ARE MOST ESPECIALLY OURS.

Using a layout of one, two, or three columns — a typographical arrangement that allowed visual contact between items of news and main articles, *Le Surréalisme ASDLR* protested,

more systematically than *La Révolution surréaliste,* against all attacks on the freedom of man, denouncing the police, courts of justice, the press, the army as the bourgeoisie's instruments of physical and intellectual domination. Chronicles appeared in each issue, signed by Eluard, Crevel, Péret, and others, calling the readers' attention to the repressive measures taken by various authorities against the people of the colonies, especially by the French in Indochina and elsewhere.

Communists were not spared when surrealists deemed their attitudes in the domain of literature and poetry to be dangerous or equivocal. Discussion was continued on the problem of the conflicts arising in man's life between his highest passions and his social convictions. Thus, in the first issue of the new review, a text by André Breton, whose title quoted a line from Mayakovsky's last poem—"Love's boat has been shattered against everyday life"—dealt with the personality, works, and destiny of this Russian poet and revolutionary, who killed himself in April 1930, because, it was said, he was refused permission to go abroad to join the woman he loved—who was not a Communist. Breton did not mention this version of the facts, but his whole article referred to the conflict between love and revolutionary duty. In this light, Mayakovsky's suicide seemed indeed an echo of the "Inquest on Love" in *La Révolution surréaliste,* no. 12 (December 15, 1929), an answer, or a tragic dismissal of the conflict between Love and Revolution.

Breton offered no solution either, although he appeared to think that love, in the end, was the legitimate or, simply, the inevitable choice.

Fragile images, let us not deny it—we are not so old—those of a more tolerable social world, whose building we shall have helped—when we are no longer here. There is nothing in all this that cannot be solved, at least momentarily, with the kiss a man exchanges with the woman he loves and with this woman alone. . . . Mayakovsky could not help it when he lived; I could not; there are breasts that are just too pretty. . . .

At that time Luis Buñuel was on the point of showing his second film, *L'Age d'Or,* made, like *Un Chien Andalou,* in collaboration with Salvador Dali. The theme of *L'Age d'Or* was precisely the struggle of Love against the conventions of the world, in this case, a bourgeois world in its "golden age." The first issue of *Le Surréalisme ASDLR* contained several illustrations of scenes from the film, which was shown in November 1930 in a small avant-garde theater, Studio 28, in Paris. In the program for these performances, Salvador Dali, coauthor with Buñuel of the story, declared:

My general idea when writing the script of *The Golden Age* with Buñuel was to show the straight and pure line of "conduct" of a being pursuing love through the ignoble humanitarian and patriotic ideals and other contemptible mechanisms of reality.

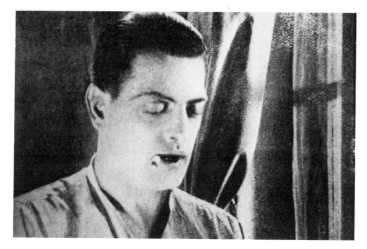

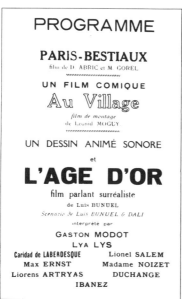

PROGRAMME

PARIS-BESTIAUX
film de D. ABRIC et M. GOREL

UN FILM COMIQUE
Au Village
film de montage
de Leonid MOGUY

UN DESSIN ANIMÉ SONORE
et

L'AGE D'OR
film parlant surréaliste
de Luis BUNUEL
Scénario de Luis BUNUEL & DALI
interprété par

GASTON MODOT
LYA LYS
Caridad de LABERDESQUE Lionel SALEM
Max ERNST Madame NOIZET
Liorens ARTRYAS DUCHANGE
IBANEZ

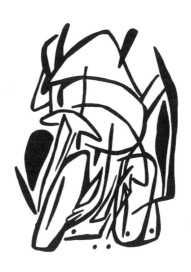

Top: Luis Buñuel, 1930. *Bottom left:* Program for the first screenings of the film *L'Age d'Or* at Studio 28, Paris, 1930. *Bottom right:* Jean Arp: Drawing for the program for the first screenings of *L'Age d'Or.*

This note was followed by a summary of the film:

The Story

Scorpions live among rocks. Climbing on top of one of these rocks, a bandit discovers a group of archbishops, seated in a rocky landscape and singing. The bandit runs back to his shanty to tell his friends of the presence of the Majorcans (these are the archbishops) in the vicinity. He finds his friends in a strange state of weakness and depression. They take their weapons and go out — except the youngest of them, who cannot even stand up. They begin walking among the rocks, but one after the

other, they fall on the ground, exhausted. Then the chief of the bandits collapses hopelessly. From the place he has reached he hears the noise of the sea, and he sees the Majorcans reduced now to skeletons scattered among the stones.

An immense caravan of ships touches land at this steep and desolate place. The caravan consists of priests, military men, nuns, politicians, and various people in civilian clothes. They all make their way toward the place where the remains of the Majorcans rest. The authorities leading the procession stop there and stand bareheaded; the crowd imitates them.

The reason for the gathering is the founding of Imperial Rome. The first stone is being laid when shrill cries distract the general attention. Nearby, in the mud, a man and a woman have begun an amorous struggle. They are dragged apart, policemen beat the man and take him away.

This man and this woman will be the protagonists of the film. The man is soon released, thanks to a document revealing his high rank and the preeminent humanitarian and patriotic mission with which he has been entrusted by the government. From that moment, his entire activity turns toward love. In the course of an abortive love scene, during which the violence of miscarried acts prevails, the protagonist is called to the telephone by the important person who has put him in charge of the humanitarian mission in question. This minister accuses him of letting thousands of old men and innocent children perish because he abandoned his task. The protagonist answers this charge with insults and, listening no longer, goes back to the woman he loves, but an unaccountable accident separates him from her forever. Later he may be seen throwing a fir tree in flames, a huge agricultural instrument, an archbishop, a giraffe, and feathers out of a window. All this in the very instant when the survivors of the castle of Selligny[1] cross its snow-covered drawbridge. The Count of Blangis[2] is evidently Jesus Christ. This last episode is accompanied by a *paso doble*.

A long preface in the program signed by the surrealists,[3] introduced the film:

On Wednesday, November 12, 1930, and on the following days, several hundred people are going to enter a movie theater, led there by very diverse and strongly contradictory aspirations, from the best to the worst (as happens also on a vaster scale) — people who generally do not know each other and who, from a social point of view, are connected as little as possible to each other, but who, whether they choose to or not, will conspire together by virtue of the darkness, of a hardly perceptible alignment,

[1] The castle where orgies take place in the Marquis de Sade's novel *The 120 Days of Sodom.* — M.J.

[2] The organizer of the orgies in the castle of Selligny. — M.J.

[3] It was illustrated with drawings by Dali, Ernst, Arp, Tanguy, Man Ray, and Miró.

and of the time that will be the same for all of them, to cause the success or the failure of one of the most demanding programs that, to this day, with Buñuel's *The Golden Age,* has been offered to human consciousness. It is fitting perhaps — better than to delight in finally seeing a supreme degree of infringement of the discouraging laws that are supposed to render a work of art innocuous when it contains a cry of protest, and before which, hypocrisy helping, one tries to discover under the name of beauty only a gagging device — it is even certainly fitting to measure with some strictness the span of this totally unexpected bird of prey appearing today in the western sky, in the lowering western sky: *The Golden Age.*

. . . Although it is hardly sufficient nowadays for a book, a painting, a film, to possess in itself its own means of aggression in order to discourage fraud, yet we continue to think that provocation is a precaution like any other, and on this plane, *The Golden Age* lacks nothing to deceive anyone hoping to find easily in it food for thought. . . .

The different chapters of the preface — The Sexual Instinct and the Death Instinct; It Is Mythology That Changes; Love and Disorientation; Situation in Time; Social Aspects, Subversive Elements — discussed the many aspects of a film that showed above all the cause of Love linked with that of Revolution:

Buñuel has formulated a hypothesis on revolution and love that, through the most pathetic of debates, reaches to the depths of human nature; amid a profusion of salutary acts of cruelty, he fixed this unique instant when, with tightly set lips, one follows the farthest, the slowest, the nearest, the most entreating voice until it cries, so loud that it is almost impossible to hear it:
LOVE, LOVE, Love, love . . .

The first run of *The Golden Age* was a short one. The response to its provocative images came from fascist gangs, which came one evening to Studio 28, ransacked the premises, and destroyed most of the paintings, drawings, and sculptures by Arp, Dali, Miró, Man Ray, and Tanguy that were exhibited in the lobby of the theater. After that the film was banned for public exhibition by Chiappe, the prefect of police, as "causing disorder"! Its career since then has largely been restricted to showings in film libraries and cinema clubs.

Buñuel has ever since maintained in his career as a film author and director a consistent attitude on the problem of liberty, revolution, love. With him antireligious sentiment dismisses all apologetic exegeses, whether it be the brief but devastating caricature of Leonardo's *Last Supper* in *Viridiana* or Jesus Christ's false miracle at the end of *La Voie lactée* (*The Milky Way*). Backed with a technical virtuosity that is founded on an extraordinarily simple and efficient novelty of means, passion under its most irrepressible shapes, carrying men or women far beyond

the limits of morals, or antimorals, reigns supreme in the dream of *Los Olvidados* (*The Young and the Damned*) as in the reverie of *Subida al Cielo* (*Mexican Bus Ride*), in the obsessions of *El* (*This Strange Passion*), the masochism of *Nazarin,* the nymphomania of *Belle de Jour,* etc. That Luis Buñuel is a surrealist poet may also be seen in his description of a remarkable "object," "*Une Girafe,*" in *Le Surréalisme ASDLR,* no. 6 (May 15, 1933):

A Giraffe [4]

This giraffe is simply a sheet of wood cut out in the shape of a giraffe, life-size, but different from other animals of the same kind cut out of wood, in that each spot of its skin, which at three or four yards' distance shows nothing abnormal, consists really either of a lid, which the spectator can open very easily, it having a little invisible hinge fixed on one of its sides, or of an object, or of a hole letting the light show through—the giraffe being only a few inches thick—or of a concavity containing the various objects that are detailed in the list below.

It should be remarked that this giraffe does not take on its full meaning until it is entirely constructed, that is to say until each of its spots fulfills the function for which it was designed. If this construction is *very expensive,* it is none the less possible for that.

IT IS ABSOLUTELY POSSIBLE TO MAKE THE WHOLE THING.

In order to hide the objects that are to be found behind the animal, it should be placed in front of a black wall 30 feet high by 120 feet long. The surface of the wall should be quite plain. A garden of asphodels must stand in front of the wall, of the same dimensions as the latter.

THE THINGS THAT SHOULD BE FOUND IN THE GIRAFFE'S SPOTS

In the first: The interior of the spot is made up of a rather complicated little mechanism very much like that of a watch. In the middle of the moving cog-wheels a little screw spins dizzily. A slight smell of corpses rises from the whole thing. Having left the spot, take up an album that should be found on the ground at the giraffe's feet. Sit down in a corner of the garden and turn over the pages of this album, which contains dozens of photographs of wretched little deserted squares. They are those of old Castilian towns: Alba de Tormes, Soria, Madrigal de las Altas Torres, Orgaz, Burgo de Osma, Tordesillas, Simancas, Siguenza, Cadalso de los Vidrios, and above all Toledo.

In the second: On being opened at noon, as the inscription on the outside demands, this spot presents a cow's eye in its orbit, with eyelashes and lid. The spec-

[4] Translation by David Gascoyne in *Contemporary Poetry and Prose* (London), no. 2 (June 1936).

tator's image is reflected in the eye. The lid should close abruptly, putting an end to one's contemplation.

In the third: On opening this spot one reads on a background of red velvet these two words:

<div align="center">AMERICO CASTRO [5]</div>

The letters being detachable, they can be rearranged in all possible combinations.

In the fourth: There is a little grille, like that of a prison. Through the grille is heard the sound of a veritable *orchestra* of a hundred musicians playing the Overture to *The Mastersingers.*

In the fifth: Two billiard-balls fall down with a crash when the spot is opened. There is nothing standing inside except a roll of parchment tied with string; unroll it in order to be able to read the following poem:

<div align="center">TO RICHARD COEUR DE LION</div>

From the choir to the cave, from the cave to the hill, from the hill to hell, to the sabbath of winter agonies.

From the choir to the sex of the she-wolf who fled into the timeless forest of the Middle Ages.

Verba vedate sunt fodido en culo et puto gafo *'twas the taboo of the first hut to be put up in the infinite wood, 'twas the taboo of the dejection of the goat out of which came the multitudes who built the cathedrals.*

Blasphemies were floating in the swamps, the rabble quivered beneath the whip of the mutilated marble bishops, the feminine sex was used for moulding toads.

The nuns grew green again in time, green branches grew out of their withered sides, incubi winked at them while soldiers pissed against the convent wall and the centuries swarmed in the lepers' sores.

Bunches of withered nuns were dangling from the windows, producing, with the aid of the warm spring wind, a sweet murmur of prayer.

I shall have to pay my share, Richard Coeur de Lion, fodido en culo et puto gafo.

In the sixth: The spot goes right through the giraffe. One contemplates the landscape on the other side of the hole; twelve yards away, my mother—Mme. Buñuel—dressed as a washerwoman, is kneeling by a little stream washing clothes. A few cows behind her.

In the seventh: A simple canvas made of an old sack spotted with plaster.

In the eighth: This spot is slightly concave and is covered with very fine, curly blonde hair taken from the pubis of a young Danish girl with clear blue eyes, chubby

[5] Professor at the University of Madrid, ex-ambassador to Berlin.

and sunburnt, all innocence and candour. The spectator should gently blow on the hairs.

In the ninth: In place of the spot one finds a large, dark Death's-head moth.

In the tenth: Inside the spot there is an appreciable quantity of dough. One is tempted to model it with one's fingers. Carefully concealed razor-blades cause the spectator's hands to bleed.

In the eleventh: A membrane of pig's bladder replaces the spot. Nothing else. Take the giraffe, transport it into Spain and set it up in "Masada del Vicario," 7 kilometres from Clanda, south of Aragon, with its head facing north. Break the membrane with a punch of the fist and look through the hole. You will see a very poor little white-washed house in the middle of a desert-like landscape. A fig-tree stands a few yards away from the front door. In the background, bare mountains and olive-trees. Perhaps an old workman will come out of the house at this moment, with bare feet.

In the twelfth: A very beautiful photograph of the head of Christ crowned with thorns but ROARING WITH LAUGHTER.

In the thirteenth: At the bottom of the spot a very beautiful rose, larger than life-size and made of apple-peel. The androecium is made of raw meat. This rose will turn black after a few hours. The next day it will begin to rot. Three days later, a legion of worms will appear on the remains.

In the fourteenth: A black hole. One hears the following dialogue whispered with great anguish:

WOMAN'S VOICE: *No, I implore you. Do not freeze.*

MAN'S VOICE: *Yes, I must. I couldn't look you in the face.* (The sound of falling rain is heard.)

WOMAN'S VOICE: *I love you just the same, I shall always love you, but do not freeze. DO . . . NOT . . . FREEZE.* (Pause.)

MAN'S VOICE, very low and soft: *My little corpse . . .* (Pause. A stifled laugh is heard.)

Suddenly a very bright light appears inside the hole, enabling one to see a few hens pecking.

In the fifteenth: A little window with two shutters, made in perfect imitation of a large one. Suddenly a thick puff of smoke comes out of it, followed, a few seconds later, by a distant explosion. (Smoke and explosion should be like those of a cannon, seen and heard from a considerable distance away.)

In the sixteenth: On opening the spot, one sees an Annunciation by Fra Angelico a few yards away. It is well framed and lit, but the picture itself is in a pitiful condition: slashed, daubed with tar, the virgin's face carefully soiled with excrement, her eyes pierced with needles, the sky bearing the following inscription in very thick letters:

DOWN WITH THE TURK'S MOTHER.

In the seventeenth: A very powerful jet of steam will burst out of the spot the moment it is opened, blinding the spectator terribly.

In the eighteenth: The opening of the spot causes the following objects to fall out: needles, thread, pieces of cloth, two empty match-boxes, a piece of candle, an old pack of cards, a few buttons, empty bottles, some Vals tablets, a square watch, a door-handle, a broken pipe, two letters, some orthopaedic apparatus and a few live spiders. Everything scatters about in the most alarming manner. This spot is the only one that symbolises death.

In the nineteenth: A model less than three feet square, representing the Sahara desert bathed in blinding light. Covering the sand there are thousands of little Marists made of wax, their white aprons escaping from under their cassocks. The heat causes the Marists to sink down one by one. (There must be several million Marists in reserve.)

In the twentieth: This spot is to be opened. Inside, arranged on four shelves, one sees a dozen little terracotta busts representing Mme . . . ,[6] marvelously well made and lifelike in spite of their very small dimensions. When one looks at them through a magnifying glass, one sees that their teeth are made of ivory. The last little bust has had all its teeth removed.

The Golden Age with its sadistic aspects appeared at a time when the research of Maurice Heine, a friend and a collaborator of the surrealists, led to the discovery of several important texts by the Marquis de Sade. Maurice Heine (who died in 1940) played a foremost part in rescuing De Sade from the intellectual dungeons of "obscene" authors and in placing him in his real rank among the great revolutionary moralists and poets. In *Le Surréalisme ASDLR*, no. 2 (October 1930), Heine published the "Letter" of October 1779—a text often quoted since—and in no. 5 (May 15, 1933) he annotated the "Petites Feuilles," one hundred eleven manuscript "small sheets" on which De Sade had made notations for additional scenes of *La Nouvelle Justine* (The New Justine)—an enlarged and far more erotic version of *Justine ou les Infortunes de la Vertu* (Justine or the Misfortunes of Virtue). In no. 4 (December 1931) appeared the following "Pensée," in which De Sade discusses the principles of his philosophy and morals:

Thought[7]

God is, for men, absolutely what colors are for someone born blind; it is impossible for this blind man to imagine colors. But one will say, these colors exist, there-

[6] I may not reveal this lady's name.

[7] The word *Pensée* is written as a title, in the author's handwriting, in the margin of the manuscript. . . . The text . . . fills pp. 31 to 33 and the first line of p. 34 of the ms., from which has already been published the "Dialogue between a Priest and a Dying Man," written by De Sade while he was a prisoner in the tower of the castle of Vincennes; it is dated on the last leaf thus: *Ended the twelfth of July 1782.* —[Maurice Heine's note]

fore if this blind man does not imagine them, it is because he lacks a sense but not because the thing does not exist; likewise, if men do not understand god, it is because they lack a sense, but not because this being has no true existence. And here is precisely where the sophism lies: the name and properties or differences of colors are only conventional things, depending on the necessity, imposed upon us by our senses, of differentiating them, but their existence is frivolous, that is to say, it is frivolous to decide that a ribbon dyed brown actually be brown, there is no reality in this, except our conventions. God likewise appears in our imagination absolutely as a color does to the brain of blind men, as a thing that we are told exists, but whose reality nothing proves, and who consequently may very well not exist. Thus, when you show a ribbon to someone blind, assuring him that it is brown, not only do you not give him any idea, but also you tell him nothing that he cannot deny without your having, or being able to have, any weapon to convince him; likewise, when you speak of God to a man, not only do you not give him any idea, but you present to his imagination a thing that he may deny, fight, or destroy without your having the smallest real argument to persuade him. Therefore God exists no more than colors for someone born blind. Men have therefore as much right to affirm that there is no God as the blind man has a right to affirm that there are no colors; for colors are not real things but only conventional things, and all conventional things acquire reality in the mind of a man only inasmuch as they affect his senses and as these senses may understand them. Therefore a thing may be real for all men endowed with their five senses, and nevertheless become doubtful and even null for one who is deprived of the sense necessary to conceive it; but a thing absolutely incomprehensible, or absolutely impossible to perceive with the senses, becomes null, as null as color is for the blind man. Therefore, if color is null for the blind man because he lacks the necessary sense to perceive it, God is likewise null for men since none of their senses may perceive him, and he has only, like the colors, a conventional existence with no reality in itself. A society of blind men, deprived of the help of the other men, would also have conventional names to express things that would have no reality. Regarding this beautiful chimera that is named God, we are this society of blind men, we have imagined a thing that we thought was necessary, but that has no other existence than the need we had of creating it. All the principles of human morals would likewise come to nothing if they were measured on that same scale, for all these duties being conventional are likewise chimerical. Man said: such a thing must be a virtue because it is useful to me, another will be a vice because it is harmful to me; these are the idle conventions of the society of blind men, the laws of which have no intrinsic reality. The true way to judge of our weakness in relation to the sublime mysteries of Nature is to judge of the weakness of beings who have one sense less than we; their errors toward ourselves are like ours toward Nature.

The blind man makes up his conventions in reference to his needs and the mediocrity of his faculties; men likewise made up their laws in reference to their small knowledge, their small views, and their small needs—but there is nothing real in all this, nothing that may not be either not understood by a society that would have faculties inferior to ours, or formally denied by a society that would surpass ours with its more delicate organs, or with its more numerous senses. How despicable would be our laws, our virtues, our vices, our deities in the eyes of a society whose members had two or three more senses than we have, and a sensibility twice our own! And why? Because this society would be more perfect, and nearer to Nature. It results from this that the most perfect being that we may conceive will be farthest from our conventions, one who will find them completely despicable as we find those of a society inferior to ours. Let us follow the link and come to Nature itself: we shall understand easily that all that we say, all that we arrange and decide, is also as far from the perfection of the laws of Nature and as much inferior to them, as those of a society of blind men are to ours. No sense, no ideas: *nihil est in intellectu, quod non prius fuerit in sensu* is, in a word, the great foundation and the great truth that sets up the above system. It is an extraordinary thing that M. Nicole[8] has attempted, as a logician, to destroy this solid axiom of every true philosophy: he claims that ideas other than those acquired by the senses enter in our minds, and one of these great ideas that may reach us, senses apart, is: *I think, therefore I am.* This idea, says this author, has no sound, no color, no smell, etc., therefore it is not the work of the senses. How is it possible to follow these dusty scholastics so slavishly in their false reasoning! Without doubt, this idea, *I think, therefore I am,* is not of the same kind as: This table is smooth, because the sense of touch brings a proof to my mind; I admit that it does not depend on any particular sense, but it is the result of all the senses, and if a creature could exist without senses, it would be perfectly impossible for it to shape this thought, *I think, therefore I am.* This thought results from the functioning of all our senses, though it does not result from any one in particular, and it cannot destroy the great and infallible reasoning on the impossibility of acquiring ideas, apart from the senses. I admit that religion does not agree in this, but religion is the last thing to consult in matters of philosophy, because it is the one that most obscures all principles, and that bends men in the most shameful way under this ridiculous yoke—faith, the destroyer of all truths.

The violent tone of almost all the articles in the surrealist review often came close to rivaling the marquis's implacable irony. Antireligious irony showed itself in Max Ernst's article "Danger de Pollution" (*Le Surréalisme ASDLR,* no. 3, December 1931), the last chapter of which is translated here:

[8]Pierre Nicole, Jansenist moralist, 1628(?)-95.—M.J.

Danger of Pollution

It is remarkable that dogs never raised their voices to protest against the insults addressed to their race by the race of priests, and against the generally pejorative use made of the word "dog" in ecclesiastical argumentation, and particularly in the expression *after the manner of dogs.* Dogs have always answered these insults with an absolute contempt and the sanction of silence. Thus, one has never seen a dog entering a confessional and confess, to humiliate the priest, that he practiced coitus *after the manner of Christians* (to have children who will serve God faithfully). Nor has one ever seen any dog trying to satisfy divine justice with tears, alms, prayers, and fasting, after a conversation on voluptuous objects, in a secluded place, with a bitch friend, and after telling her about coitus and the delights of making love in different ways. One has never seen two dogs of the same sex or of different sexes mutually absolve their common sin *after the manner of priests* who have performed together shameful acts, immodest contacts, and libidinous kisses (it is very likely, besides, that in such a case absolution would be void, even in a jubilee year, and major excommunication, a privilege of the Holy See, would be pronounced against dogs who would dare to do so). In our diocese, every self-respecting dog abstains rigorously from all carnal or spiritual intercourse with priests or nuns, not out of reverence for the sacred religion, but because reason tells him that after such defilement no bitch would have him, even loose bitches.

The human race, with more confidence and less pride than the canine race, did not refuse to enter confessionals. I have even been told that there are specimens of the race who still set foot inside them. Yet there isn't on earth a more striking image of a trap than a confessional, under all its shapes; no sight more fit to awaken circumspection than a confessor attending to his turpitudes after the precepts of Saint Augustine, Saint Thomas Aquinas, Saint Alfonso de Liguori, and His Grace Bouvier, the obscene bishop of Le Mans and a Roman count. Judging from the physical appearance and the moral distress of mankind nowadays, one must admit that good confessors have done a good job; men have become hideous and formidable by dint of indulging for centuries in what is the mother of all vices, confession. Their bowels are ruined from swallowing repeatedly the anemic body of the Lord, their sex has weakened from killing pleasure and multiplying their species, their passions have also weakened from praying to a Virgin; their intelligence foundered in the darknesses of meditation. The virtue of pride, which used to make man's beauty, gave way before the vice of Christian humility, which makes his ugliness. And love, which should give a meaning to life, is kept under watch by clerical police.

The sad conjugal duty, invented to set the multiplying machine going, to give

the Church souls that may be brutalized and, to fatherlands, individuals fit for the demands of production and for military service, the sad conjugal act that doctors of divinity authorize to those who want to unite in love, is only a photograph resembling the act of love. Lovers are *robbed by the Church*. Rimbaud said: *Love must be re-invented.*

Love must be reborn, not by solitary efforts of solitary men; a revived love will originate in collective subconsciousness and, through the discoveries and efforts of all, will rise to the surface of collective consciousness. This is impossible under the rule of the clerical and capitalistic police.

Love must be made by all, not by one. Lautréamont said it, or almost said it.[9]

Antipatriotism was as frequent a motif as antireligion in the review—in commentaries and articles, and as we have seen, in the poems of Benjamin Péret, who derived from these two sources a good part of his inspiration. His "Vie de l'assassin Foch" was composed at the time of the death of this French marshal (*Le Surréalisme ASDLR,* no. 2, October 1930).

Life of Foch, the Assassin

> One day a bubble came up from a manure sump
> and burst
> The father recognized it from the smell
> He will be a famous assassin
> Snotty, filthy, the wood-louse grew up
> and began to speak of Revenge
> Revenge on what on the paternal manure
> Or on the cow that made the manure
>
> When he was six he farted in a trumpet
> When he was eight stripes of dirt decorated his sleeves
> When he was ten he commanded the lice in his head
> when his head itched his parents said
> he's a genius
> When he was fifteen he was raped by a donkey
> and it was a beautiful couple
> From them a pair of high boots with spurs was born
> in which he disappeared like a dirty sock

[9]An allusion to the maxim "Poetry must be made by all, not by one." See p. 52. — M.J.

That's nothing said the father
his marshal's staff has come out of the w.c.
It's the price to pay for learning the trade
The trade was a beautiful one and the worker was up to the task
Wherever he went geysers of vomit sprouted up
and besmeared him
He got all the very best of the kind
the bilious belches of military medals
and the nauseous washed wine of the Légion d'Honneur
which little by little grew larger
This inflated lung of veal
made passersby say during the war
He's a brave man he wears his lungs upon his chest
All went well until his wife took in
the concierge's cat
The cat used to rush on the lung of veal
as soon as it appeared
and finally it was bound to happen it swallowed it
Without lungs of veal Foch was no longer Foch
he was only the butcher
and like a butcher he died from a corpse's wound

In the same issue of *Le Surréalisme ASDLR,* Salvador Dali wrote in the most insulting terms of his birthplace, Catalonia, and of its inhabitants:

I think that it is absolutely impossible for any place on earth (except of course the foul region of Valencia) to produce something as abominable as what is commonly called Castilian and Catalan intellectuals. They are an enormous filth; they used to wear mustaches full of veritable and authentic shit, and most of them, moreover, are in the habit of wiping their asses with paper without having washed them with soap as one ought to do and as it is practiced in various countries, and they have the hairs on their balls and in their armpits materially filled with a swarming infinity of very small and enraged "master Millets," "Angel Guimerás."[10] Sometimes, these intellectuals affect polite and mutual homages, and that is why they acknowledge "mutually" the tongues of others to be very beautiful, and thereby they dance really *conojudas* dances

[10] Millet: Jean-François Millet (1814-75), whose painting *The Angelus* inspired a series of paintings by Dali. Angel Guimerá (1849-1924) was a Catalan poet and dramatist. — M.J.

such as the *sardana,* for instance, which alone would be sufficient to cover with shame and opprobrium an entire country, even given the fact that it is impossible, as it happens in the Catalan region, to add one more shame to those that the landscape, the towns, the climate, etc., confer on that ignoble country.

Dali's article "L'Ane pourri" appeared in July 1930, in the first issue of *Le Surréalisme ASDLR.* The passages reproduced below illustrate superorthodox surrealist ideas about violence, love, appearances, reality, and so on, as they evolved into specifically Dalinian theses, such as the "paranoiac" process (developed later into the "paranoiac-critical method"), the "multiple image," the provocative stress laid on repulsive motifs: putrefaction, excrement, and the admiration for a style called in France "modern style" and in English-speaking countries "art nouveau."

The Putrescent Donkey

The paranoiac mechanism, creator of the multiple-figuration image, offers the key to understanding the birth and the origin of the simulacra's nature, whose fury dominates the aspect under which the multiple appearances of the concrete world are hiding. It is precisely from the fury of the simulacra and their traumatic nature in the presence of reality, and from the absence of the slightest osmosis between reality and simulacra, that we come to the conclusion of a (poetic) impossibility of any order of *comparison.* It would be possible to compare two things if only the nonexistence of any conscious or unconscious connection between them was possible; such a comparison, made tangible, would clearly illustrate for us our idea of gratuitousness.

It is because of their lack of coherence with reality, and because of everything that may be gratuitous about their presence, that simulacra can easily take the shape of reality and that reality in its turn can adapt itself to the violence of simulacra, which a materialistic thought confuses [11] stupidly with the violence of reality.

Nothing can prevent us from seeing the multiple presence of simulacra in the example of the multiple image, even if one of its shapes appears to be a putrescent donkey, and even if such a donkey is really and horribly putrescent, covered with thousands of flies and ants, and since no one can conceive in this case the meaning itself of the image's distinct stages outside of the notion of time, nothing can convince me that this cruel putrefaction of the donkey is anything but the blinding and hard reflection of new precious stones.

And we do not know whether, precisely behind the three great simulacra—shit,

[11] I am aiming here particularly at the materialistic ideas of Georges Bataille, but also, in general, at all the old materialism that this senile gentleman claims to rejuvenate by referring gratuitously to modern psychology.

blood, and putrefaction—the *desired* "land of treasures" is not hiding.

As experts in simulacra, we learned long ago how to detect the image of desire behind the simulacra of terror, and even the awakening of "golden ages" behind ignominious scatological simulacra.

The acceptance of simulacra, whose reality is painfully trying to imitate appearances, leads us to the *desire* for *ideal* things.

No simulacrum perhaps has created constructions that the word *ideal* could suit better than the great simulacrum represented by the bewildering ornamental architecture of art nouveau. No collective effort has succeeded in creating so pure and so disturbing a dream world as these art nouveau buildings, which on the fringe of architecture, constitute in themselves alone true realizations of solidified desires where the cruelest and most violent automatism painfully betrays a hatred of reality and a need for a refuge in an ideal world, in the manner of what happens in a childhood neurosis.

Here is something we can still love, the imposing mass of those delirious and cold buildings scattered all over Europe, scorned and ignored by anthologies and surveys. Here is something we can oppose to the pigs of our contemporary aesthetics, defenders of the execrable "modern art," and here is indeed something we can oppose to the whole history of art.

It must be said once and for all to art critics, artists, etc., that they must expect nothing from the new surrealist images but deceptions, bad impressions, and repulsion. Completely aside from plastic investigations and similar stupidities, the new images of surrealism will increasingly take the shapes and colors of demoralization and confusion. The day is not far off when a picture will have the value, and only the value, of a simple moral act and, nevertheless, that of a simple gratuitous act.

The new images, as a functional shape of thought, will follow the free tendencies of desire, and they will be, meanwhile, violently repressive. The deadly activity of these new images, running parallel to other surrealist activities, may also play a part, above all kinds of infamous aesthetic, humanitarian, philosophical, etc., ideals, in the downfall of reality, for the benefit of everything that will bring us back to the clear springs of masturbation, exhibitionism, crime, love.

Idealists without taking part in any ideal. The ideal images of surrealism in the service of the imminent crisis of consciousness, in the service of the Revolution.

In 1930 Salvador Dali published his book *La Femme visible,* dealing with "Le Grand Masturbateur," a character whose image had already appeared in several of his paintings.

THE VISIBLE WOMAN

The Great Masturbator

.
Despite the reigning darkness
the evening was still young
near the great stairway houses of agate
where
tired by the daylight
that lasted since sunrise
the Great Masturbator
his immense nose reclining upon the onyx floor
his enormous eyelids closed
his brow frightfully furrowed with wrinkles
and his neck swollen by the celebrated boil seething with ants
came to rest
steeped in this still too luminous time of the evening

Recevez, cher ami, la preuve

Left: Salvador Dali, 1930. *Right*: Salvador Dali: Signature reproduced at the end of his preface to the catalogue of the exhibition at the Galerie Pierre Colle, Paris, 1934.

while the membrane covering his mouth entirely
hardened alongside the alarming the eternal grasshopper
stuck clinging motionless to it
for five days and nights.

All the love and all the ecstasy
of the Great Masturbator
resided
in the cruel ornaments of false gold
covering his delicate and soft temples
imitating
the shape of an imperial crown
whose fine leaves of bronzed acanthus
reached as far
as his rosy and beardless cheeks
and extended their hard fibers
until they dissolved
in the clear alabaster of his neck.

In order to obtain the icy appearance of an ancient ornament of an uncertain and hybrid style that would make possible an error through mimeticism of the complicated architecture of the alley and in order to render the desirable horror of this flesh — triumphant, rotting, stiff, belated, well-groomed, soft, exquisite, downcast, marconized, beaten, lapidated, devoured, ornamented, punished — invisible or at least unperceived by the human face that resembles that of my mother. . . .

La Femme visible, besides chapters on "The Putrescent Donkey," "The Sanitary Goat," and "Love," included a "theoretical section" introducing the "paranoiac-critical method," defined as: "Spontaneous method of irrational knowledge based upon the interpretative-critical association of delirious phenomena." However, an article by Max Ernst, entitled "Comment forcer l'inspiration,"[12] in *Le Surréalisme ASDLR,* no. 6 (May 15, 1933), demonstrated that the "paranoiac image," or the "multiple image," had previously been present in collages, frottages (impressions obtained by rubbings over textured surfaces, such as wood), etc. Here is the section in which Ernst describes the latter technique:

[12] This text was first published in *This Quarter* (Paris), vol. 5, no. 1 (September 1932). Ernst republished it, with many additions, in 1936 in *Au-delà de la Peinture* (*Cahiers d'Art* [*Paris*], no. 6-7, 1936); it was translated into English by Dorothea Tanning in Max Ernst, *Beyond Painting, And other Writings by the Artist and his Friends,* ed. Robert Motherwell, The Documents of Modern Art (New York: Wittenborn, Schultz, 1948). The translations reproduced here are from *Beyond Painting.*

Inspiration to Order

Being one rainy day in an inn at the seaside, I found myself recalling how in childhood an imitation mahogany panel opposite my bed had served as optical excitant of a somnolent vision, and I was struck by the obsession now being imposed on my irritated gaze by the floor, the cracks of which had been deepened by countless scrubbings. I thereupon decided to examine the symbolism of this obsession and, to assist my meditative and hallucinatory powers, I obtained from the floor-boards a series of drawings by dropping upon them anyhow pieces of paper I then rubbed with blacklead. I emphasize the fact that the drawings thus obtained steadily lose, thanks to a series of suggestions and transmutations occurring to one spontaneously — similarly to what takes place in the production of hypnagogical visions — the character of the material being studied — wood — and assume the aspect of unbelievably clear images of a nature probably able to reveal the first cause of the obsession or to produce a simulacrum thereof. My curiosity being thus aroused and marvelling, I was led to examine in the same way, but indiscriminately, many kinds of material happening to be in my field of vision — leaves and their veins, the unravelled edges of sackcloth, the palette-knife markings on a "modern" picture, thread unrolled from its spool, etc. I have put together under the title of *Natural History* the first fruits of the *frottage* process from *Sea and Rain* to *Eve, the Only One Remaining to Us.* Later on, it was thanks to restricting my own active participation ever more and more, so as thereby to increase the active share of the powers of the mind, that I succeeded in looking on *like a spectator* at the birth of pictures such as: *Women Shouting as They Ford a River, Vision Provoked by the Words: "The Immovable Father," Man Walking on the Water, Taking a Girl by the Hand and Shoving Past Another, Vision Provoked by a Sheet of Blotting-Paper, etc.*

At first it seemed as if the *frottage* process could be used only for drawing. If one takes into consideration that it has since been successfully adapted to the technical media of painting (scratching of pigments on a ground prepared in colors and placed over an uneven surface, etc.) without the slightest liberty being taken with the principle of the intensification of the mind's powers of irritability, I think I am entitled to say without exaggeration that surrealism has enabled painting to travel with seven-league boots a long way from Renoir's three apples, Manet's four sticks of asparagus, Derain's little chocolate women, and the Cubists' tobacco-packet, and to open up for it a field of *vision* limited only by the *irritability capacity of the mind's powers.* Needless to say, this has been a great blow to art critics, who are terrified to see the importance of the "author" being reduced to a minimum and the conception of "talent" abolished. Against them, however, we maintain that surrealist painting is within the reach of

everybody who is attracted by real revelations and is therefore ready to assist inspiration and make it work to order. . . .

The editor of the present anthology made his first contribution to surrealist reviews with the preface to his album of twenty-four images, entitled *Mourir pour la patrie* (To Die for One's Country);[13] this preface, together with one of the drawings, appeared in *Le Surréalisme ASDLR,* no. 6 (May 1933). It dealt with the part that reminiscences and childhood memories play in poetic creation, a favorite theme in surrealism, and expressed finally the conviction that no revolution would be complete if it did not also restore to man, in a certain way, "this lost country of mental freedom where children wander and play, this land from which, at present, only fleeting and deceiving echoes or reflections reach us . . . the only country for which we would be willing to die."

A most curious text in the fourth issue of *Le Surréalisme ASDLR* (December 1931), was Dali's "Rêverie," a detailed and uninhibited account of one of these complicated erotic tales that people build in their minds as substitutes for impossible sexual accomplishments. Dali's relation of his phantasm was an accurate description of the techniques of autoeroticism, when the subject alternately frees and represses the sexual image in order to obtain, with a tale more tempting than its conclusion, a final sort of satisfaction.

The account referred first to the subject's state of mind and behavior, one October afternoon in his house in Spain, as he was wavering between intellectual work and masturbatory practices, with childhood memories intervening at intervals. After this long half-conscious prologue, the reverie developed from the unexpected representation of a scene of a former dream in which, "lying amid the excrement and the rotting straw of a very dark cow shed, and greatly excited by the stink of the place, I sodomized the woman I love." But this image was suddenly replaced by that of a young girl, Dulita, age eleven, and the daydreamer began constructing in his imagination a sequence of events and circumstances that would lead Dulita to play her part in the dream scene of the cow shed.

Reverie

This is how things must happen during five days: Dulita would suspect nothing; on the contrary, she would be prepared with edifying and extremely chaste readings and she would be surrounded with extreme kindness and affection, as before her first communion, which, moreover, would take place within a short time. The fifth day Dulita would be brought to the fountain of the cypresses, two hours before sunset. Then she would eat a bar of chocolate with bread, and La Gallo,[14] helped by Matilda,[15] would

13 Published as a book: Paris: Cahiers d'Art, 1935.

14 La Gallo is an old prostitute, mentioned in an earlier part of the reverie. — M. J.

15 Matilda is Dulita's mother. In the reverie she is madly in love with the dreamer and has agreed to bring her daughter to him, with the help of La Gallo. — M. J.

initiate her in the most brutal and gross manner, using for this a profusion of pornographic postcards that I would have chosen myself among the most pathetic and upsetting ones.

That same evening Dulita would learn everything from La Gallo and her mother, that is to say, that within three days I would sodomize her among the excrement of the cow shed. For three days she should behave as if she knew nothing of all this. She would be strictly forbidden to make the slightest allusion to what was revealed to her. Everything, until the precise moment in the shed, should take place without a word spoken and should follow daily life.

To accomplish the program of fantasies I had just experienced in the general reverie, one of the essential conditions was the inescapable necessity of my watching Dulita's initiation at the fountain of the cypresses, through the dining room window; in reality this appeared impossible, because of several purely physical conflicting circumstances: for instance, the cypresses entirely surround the fountain, thus preventing my watching the initiation that would take place exactly at the fountain. . . . But a new fantasy, which appeared to me a particularly exciting one, brought a solution to this first difficulty. A fire, starting from an enormous heap of dry leaves not quite extinguished, would have burned the cypresses before the fountain, leaving it uncovered, but in such a way that a bough only partly burned would still offer a very slight and almost nonexistent difficulty in watching the scene involving Dulita.

Besides, the same fire would have burned all the neighboring shrubs and trees. This would oblige Dulita to dirty herself, to soil her white pinafore and legs, when her mother and La Gallo would force her to go across the place to have her snack at the fountain. From then on the idea that Dulita would have to dirty herself appeared to me indispensable; it completed itself and reached perfection in the following fantasy: I would see Dulita arriving at the fountain and soiling her feet in a kind of pestilential mud mixed with decomposed moss that, in reality, covers the flagstones of the fountain each time that the pipe chokes up, causing the water to overflow, especially in autumn; though the place was closed, dry leaves could penetrate, swept by the squalls of stormy days. Nevertheless, the fountain of the cypresses, though the fire should have permitted me to see inside it, still remained invisible from the dining room, being hidden by a wall adjoining the cow shed.

Displacing the fountain until it entered my field of vision seemed to me an unsatisfactory solution that would have destroyed all the meaning of my reverie. But I saw very clearly that the fire, when burning the cypresses, would have destroyed also the dividing wall, allowing thus an easy communication between the shed and the fountain of the cypresses.

. . . Despite the disappearance of the wall, it was still impossible to see the fountain

from the dining room, because it remained hidden, to the far left, by the window. Several unsatisfactory fancies led me, little by little, to the solution: I imagined that the scene of Dulita's initiation would be reflected in the big mirror of her room, which adjoined the dining room. Thus I would be able to watch everything from my chair, with the advantage of an extremely desirable circumstance already experienced in the slightly incomplete destruction, by fire, of the cypresses, that is, a certain complexity and vagueness of images; thanks to the remoteness of the scenes, the images would reach me in a state of imprecision that appeared to me particularly interesting. I saw with an exceptional distinctness and preciseness this new phase of the reverie. . . .

The stage being thus set and arranged in its most satisfactory details, Dulita's initiation was minutely imagined and the reverie could come to its climax and denouement:

The next day is Sunday. We must hurry to take advantage of the fact that everybody, around four o'clock, goes to the village. I wait for a sign from Matilda, and I rush, covered only with my burnoose, first to the hall where the ear of corn is, then to the upper floor. I find there Dulita, La Gallo, and Matilda, all three stark naked. For a moment Dulita masturbates me very clumsily; this excites me greatly. The three women go across the yard and enter the shed. Meanwhile, I run to the fountain of the

ANDRÉ BRETON ET PAUL ÉLUARD

L'Immaculée Conception

ÉDITIONS SURRÉALISTES
A PARIS
CHEZ JOSÉ CORTI, LIBRAIRE, 6, RUE DE CLICHY
—
1930

Title page of *L'Immaculée Conception* by André Breton and Paul Eluard, 1930. Drawing by Salvador Dali.

cypresses, I sit on the wet stone bench and with my two hands I raise my penis with all my might, then I go to the cow shed where Dulita and the two women are lying, naked, among excrement and rotting straw. I take off my burnoose and I throw myself upon Dulita, but Matilda and La Gallo have disappeared, and Dulita is changed into the woman I love, ending the reverie with the same images as those of the dream.

The reverie ended there, for I realized that for some time I had been objectively analyzing the reverie I was going through, which I wrote down at once with the greatest scrupulousness.

The second issue of *Le Surréalisme ASDLR* (October 1930) contained excerpts from *L'Immaculée Conception* by Breton and Eluard—a book of poetic texts grouped into four main chapters: "Man" (Conception—Prenatal Life—Birth—Life—Death), "The Possessions" (five pieces presented as "attempts at simulating" various types of delirious writing), "The Mediations" (The Strength of Habit—Surprise—Nothing Is Incomprehensible—The Feeling of Nature—Love—The Idea of Becoming), and "The Original Judgment" (a collection of maxims).

"La Naissance," a section in the first chapter, was a metaphorical but pitiless "antibaby" text.

THE IMMACULATE CONCEPTION

Birth

The probability calculus is identical with the child. The child is black like the fuse of a bomb laid in the path of a sovereign, who is man, by that individualistic anarchist of the worst species, who is woman. That point excepted, birth is nothing but a cross-roads. Such an aureole, applied to the son of man and woman, cannot give flavor to its insipid clothes for baby rats and its cradle like a sewer, where it is discharged with dirty water and the salt of stupidity awaiting its arrival like that of an obedient phoenix.

A neighbor says that it is made in the image of a wood fire, the neighbor's wife, that it would be best compared to the air of airplanes, and the degenerate fairy who took up her residence in the cellar is tempted to give it as an ancestor the spearheaded gypsum that has one foot on laziness, the other foot on work. It keeps its promises for everyone. Everyone wants to learn its filial language and interprets its silence. Everywhere it is said that its presence does a favor to a world which couldn't have dispensed with it. It is the traffic director on all fours, who unfailingly causes the derailment, celebrated in the *Illustrated News,* with a view of the bridge. It wears the rescue in a medallion. "Dad" is a moon-shaped disk, "Mom" is now concave, like plates and saucers.

To suspend the effect of a presence as obstinate as that of the brass vase on the

saltpeter mantelpiece, a honeycomb comes to do its hair in the room. All the usual compliments have been useless. No one is there. There never was anyone.

The following lines are a foreword to the second part of the book, "Les Possessions," and its simulations of deliriums.

The Possessions

The authors make a point of guaranteeing the absolute loyalty of their enterprise, which consists in submitting to specialists as well as to laymen the following five essays; any possibility of their being borrowed from clinical texts, or conceived as pastiches of such texts, would evidently have deprived them of every justification and of all efficacy.

Far from being inclined to picturesqueness and far from adopting confidently, one after the other, the various languages that are held rightly or wrongly to be the most inadequate to their purpose, the authors are not satisfied by expecting from them even a real effect of curiosity, but they hope to prove that the mind of the normal man, if it is *poetically* trained, may reproduce the main features of the most paradoxical, the most eccentric verbal manifestations; that this mind has the power to subdue, at will, the principal delirious ideas without undergoing any lasting trouble, without jeopardizing in any way its *faculty* of balance. There is no question, besides, of deciding on the perfect plausibility of these false mental states, the essential point being to suggest that with sufficient training they could be made perfectly plausible. Then we would be able to do away with these proud categories in which one is pleased to confine men when they have accounts to settle with reason, this same reason that denies us daily the right to express ourselves through instinctive means. If I can make the richest and the poorest beings, the blind and the hallucinated, the coward and the aggressor, speak in succession with my own voice, how can I admit that this voice, which is finally mine and mine alone, comes from even temporarily forbidden regions, from regions to which I should despair of ever acceding, together with my fellow men?

On the other hand, we are only too willing to confront these pages, elaborated with certain confusionist intentions, with the other pages of this book and with the pages of other books, defined as surrealist. Since the concept of "simulation" is in use in psychiatry, generally speaking, in time of war only, and is otherwise replaced by that of "supersimulation," we wait impatiently to be told on which morbid basis judges conversant with those matters will agree to situate our operations.

Lastly, we declare that we have taken a very special pleasure in this new exercise of our minds. We became aware of hitherto unsuspected resources in ourselves. With-

out prejudice to the conquests it promises in the highest sphere of liberty, we hold this exercise, from the point of view of modern poetics, to be a remarkable criterion. It is sufficient to say that we would willingly propose its generalization and that, in our eyes, the "attempt at simulation" of those mental diseases said to be "fit for confinement" would advantageously replace the ballad, the sonnet, the epic, the poem without head or tail, and other outdated genres.

Five examples of such "attempts" followed: simulation of mental deficiency, of acute mania, of general paralysis, of the delirium of interpretation, and of dementia praecox. Later Breton, in *Les Vases communicants* (The Communicating Vessels; 1932), hinted at the clinical basis of some of these texts: "escaping thoughts in acute mania, the use of the faintest external excitements in the delirium of interpretation, the paradoxical affective reactions in dementia praecox." As for mental deficiency, the authors of *Immaculée Conception* seem to have considered this disease a state of obsessive social conformity, so to speak, so that their simulation of that case became a poetic and humorous piece of polemics against conformity itself:

Simulation of Mental Deficiency Essayed[16]

I, alone of men, at the age of twenty-four, realized that he who would rise to an honorable position need not be more keenly alive to his worth than I was then to mine. I held, many years ago, that virtue is not valued at his due, but that my father was right when he desired that I should work my way out of the rut of my colleagues. Why foreign personages passing through France should receive the cross of the Legion of Honor is more than I can understand. It seems to me that this decoration should be reserved for gallant officers and mining engineers on graduation from the Polytechnical school. The Grand Master of the Order of Chivalry must indeed be deficient in common sense to discern merit when there is none. Of all distinctions of rank, officer is the most gratifying. Yet one cannot get on without one's diplomas. My father gave his five children, both boys and girls, the best instruction and a good education. And it was in order that they should be satisfied with a non-salaried position in a public department that does not pay its employees. Here is the proof of what I say: when, as was the case with my elder brother who entered for newspaper competitions on more than one occasion, one is capable of carrying off the palm in the teeth of bachelors in Arts and Science, then it is a case of a chip off the old block and no error. But sufficient unto the day is the evil thereof, says the proverb.

In the inner pocket of my coat I have the drawings of a submarine that I am

<hr>

[16] Translation by Samuel Beckett in the special surrealist issue of Edward W. Titus's review, *This Quarter* (Paris), vol. 5, no. 1 (September 1932).

anxious to lay at the disposal of the National Defense. The commandant's cabin is marked in red and the torpedo-guns are the latest hydraulic model, with artesian control. The energy of the champion cyclist is not greater than mine. I have no hesitation in saying that this invention cannot but prove a success. All men are partisans of Liberty, Equality, and Fraternity and, let me add, mutual Solidarity. But that is no reason for not defending ourselves against those who attack us by sea.

I have written a *secret* letter on ministerial paper to the President of the Republic, requesting the favor of an interview. The Mediterranean Squadron is at present cruising off Constantinople, but the admiral grants leave too freely. However humbly a soldier may kneel before his superior officer, order is order. In the interest of discipline the leader must be just but firm. Stripes are not distributed promiscuously and Marshal Foch was Marshal Foch on his conspicuous merits. It was wrong of free thought not to devote itself to the service of France.

I am anxious that another name should be found for the Marine Infantry. I have approached the League for the Rights of Man in this connexion. Such a title is unworthy of their blue collar. What is more, it is up to themselves to get themselves respected. The pride of Spartan Greece was made of sterner stuff. Anyhow, man believes in God and the hardest nuts have been known to ask for extreme unction, and that is something to be going on with.

In the third part of *L'Immaculée Conception,* entitled "The Mediations," pages about "L'Amour" gave new names to the famous "thirty-two positions of love," in an erotic text that is at the same time a poetic one—a surrealist Kama Sutra.

Love

Reciprocal love, the only love that should concern us here, is the love that brings into play the unaccustomed within practice, imagination within conventionalism, faith within doubt, and the perception of the internal object within the external object.

It implies the kiss, the embrace, the problem, and the indefinitely problematical outcome of the problem.

Love always has plenty of time. Love has before itself the brow, whence thought seems to come; the eyes—the question will be presently of distracting them from their own glance; the throat, where sounds will curdle; it has the breasts and the bottom of the mouth. It has before itself the inguinal bends, the legs that ran and the steam coming down their veils; it has the pleasure of the snow falling outside the window. The tongue outlines the lips, brings the eyes together, raises the breasts, deepens the armpits, opens the window; the mouth attracts the flesh with all its might, it founders in a wandering kiss, it takes the place of the mouth it has carried away, it is the mixing of

night and day. The man's arms and thighs are tied to the woman's arms and thighs, wind is mixing with smoke, hands take the imprint of desires.

Problems must be distinguished into problems of the first, the second, and the third degree. In the problem of the first degree, the woman, inspired by North American Tlingit sculptures, will seek the most perfect embrace with the man; the question will be to form together one single block. In that of the second degree, the woman, after the model of Haida sculptures, hardly different in origin, will avoid this embrace as much as possible; the question will be to touch each other barely, to derive pleasure above all from nimbleness. In that of the third degree, the woman will adopt one after the other all the natural postures.

The window will be open, half-open, closed, it will look out at the star, the star will rise toward the window, the star will have to reach it, or pass on to the other side of the house.

1. When the woman lies on her back and the man is lying on her, it is the *cedilla*.

2. When the man is on his back and his mistress is lying on him, it is the *c*.

3. When the man and his mistress are lying on one side and observe each other, it is the *windshield*.

4. When the man and the woman are lying on one side, only the woman's back being observed, it is the *devil's pond*.

5. When the man and his mistress are lying on one side, observing each other, and she interlaces her legs with the man's legs, the window wide open, it is the *oasis*.

6. When the man and the woman are lying on their backs, one of the woman's legs across the man's belly, it is the *broken mirror*.

7. When the man is lying on his mistress, who enlaces him with her legs, it is the *Virginia creeper*.

8. When the man and the woman are on their backs, the woman on the man, head to foot, and her legs under the man's arms, it is the *train whistle*.

9. When the woman is sitting with her legs stretched out on the lying man facing her, and supports herself on her hands, it is the *reading*.

10. When the woman is sitting, with bent knees, on the lying man facing her, her bust leaning backward or not, it is the *fan*.

11. When the woman is sitting with bent knees, her back to the lying man, it is the *springboard*.

12. When the woman, lying on her back, raises her thighs vertically, it is the *lyre bird*.

13. When the woman, facing the man, places her legs on his shoulders, it is the *lynx*.

14. When the woman's legs are contracted and thus held by the man against his chest, it is the *shield*.

15. When the woman's legs are contracted, her knees bent at the level of her breasts, it is the *orchid*.

16. When only one of the legs is stretched out, it is *past midnight*.

17. When the woman places one of her legs on the man's shoulder and stretches the other out, then places the latter on his shoulder and stretches out the first one, and continues to do so alternately, it is the *sewing machine*.

18. When one of the woman's legs rests on the man's head, the other leg being stretched out, it is the *first step*.

19. When the woman's thighs are raised and rest one on the other, it is the *spiral*.

20. When the man, proceeding with the problem, spins around and enjoys his mistress without leaving her, while she keeps his loins embraced, it is the *perpetual calendar*.

22. When the man supports himself against a wall and the woman, sitting on his hands joined together and held underneath her, throws her arms around his neck and, putting her thighs alongside his waist, moves herself by her feet, which are touching the wall against which the man leans, it is the *elopement in a boat*.

23. When the woman stands on her hands and feet like a quadruped and the man remains standing, it is the *earring*.

24. When the woman stands on her hands and knees and the man is kneeling, it is the *Holy Table*.

25. When the woman stands on her hands and the man holds her up by her thighs, these clutching his waist, it is the *life belt*.

26. When the man is sitting on a chair and his mistress, facing him, bestrides him, it is the *public garden*.

27. When the man is sitting on a chair and his mistress, her back to him, bestrides him, it is the *trap*.

28. When the man is standing and the woman rests the upper part of her body on the bed, her thighs clutching the man's waist, it is *Vercingetorix's head*.

29. When the woman is crouching on the bed in front of the man standing against the bed, it is the *flea game*.

30. When the woman is kneeling on the bed in front of the man standing against the bed, it is the *vetiver*.

31. When the woman is kneeling on the bed, her back turned to the man standing against the bed, it is the *baptism of the bells*.

32. When the virgin is leaning back, her body powerfully arched and resting on the ground on her feet and hands, or better, on her feet and head, the man kneeling, it is the *aurora borealis*.

Love multiplies the problems. Furious freedom takes hold of the lovers, more devoted to each other than space is to the chest of air. The woman always keeps the light of the star in her window, in her hand the life line of her lover. The star revolves slowly in her window, comes and goes ceaselessly, the problem is accomplished, the pale shape of the star in the window has burned away the curtain of daylight.

The last chapter of *L'Immaculée Conception,* "Le Jugement originel," was a collection of precepts, among them the following:

The Original Judgment

Do not read. Look at the white shapes made in books by the intervals separating the words of several lines, and draw your inspiration from them.

Live in deserted houses. The only person who lived there was you.

If they knock at your door, write your will and testament with the key.

Do not drink water.

The things you find are yours only while your hand reaches out for them.

To discover the nakedness of the one you love, look at her hands. Her face is lowered.

Learn how to wait, feet first. This is how you will go soon, well wrapped up.

Draw in the dust the disinterested games of your boredom.

Never wait for yourself.

Eat birds only in leaves; the animal tree can last through autumn.

Cut trees if you want, break stones also, but beware, beware of the livid light of utility.

Knock at the door, say: Come in, and don't come in.

You have nothing to do before dying.

The first of these maxims is evidently Breton's; the strange fascination exerted on him by the *interval* between the words of a printed book appeared again in his piece "Les Ecrits s'en vont," in *Le Revolver à cheveux blancs,* a collection published in 1932.

THE WHITE-HAIRED REVOLVER

Writings Are Leaving

The satin of the pages we turn over in a book shapes so beautiful a woman
That when we do not read we gaze sadly at her
Not daring to speak to her not daring to tell her that she is so beautiful

That what we are going to learn is priceless
This woman passes on imperceptibly in a rustle of flowers
Sometimes she turns around in the printed seasons
And asks for the time or else she pretends to look at jewels straight in the face
As real creatures never do
And the world is dying a break occurs in the rings of air
A rent at the places where the heart is
The morning papers bring singers whose voice has the color of sand on tender and
 dangerous shores
And sometimes the evening ones leave the way open to very young girls who lead
 chained beasts
But the most beautiful thing is the interval between certain letters
Where hands whiter than the horn of stars at noon
Destroy a nest of white swallows
So that the rain will be falling forever
So low so low that wings can no longer interfere
Hands leading up to arms so light that the haze of the meadows in its graceful curls
 above the ponds is their imperfect mirror
Arms jointed to nothing but to the exceptional danger of a body made for love
Whose belly calls forth the sighs loosened from bushes full of sails
Unearthly but for the immense frozen truth of the sledges of glances on the white
 expanse
Of what I shall never see again
Because of a marvelous bandage
Which is mine in the blindman's buff game of wounds

 René Char contributed to the last number of *La Révolution surréaliste* in 1929 a short piece, "Profession of Faith of the Subject," and the same year he published his first book of verse, *Arsenal.* His poems and articles appeared concurrently in *Le Surréalisme ASDLR,* including his "Homage à D. A. F. de Sade," in no. 2 (October 1930). Many were collected in book form, and his "L'Esprit poétique" (The Poetic Spirit) was translated by Richard Toma for the special surrealist number of *This Quarter,* in September 1932.

 In 1934 Char published *Le Marteau sans Maître* (The Hammer without a Master),[17] a collection including earlier books of poems and other pieces. Three of those poems were set to music by Pierre Boulez around 1955, in a piece for alto voice, flute in G, xylophone, vibraphone, guitar, viola, and percussion.

[17] Like all his previous books, it bore the imprint of Editions surréalistes, the label that surrealist authors used when publishing books at their own expense, during the period before World War II.

[18] Unsigned translation in *This Quarter* (Paris) vol. 5, no. 1 (September 1932).

Tristan Tzara contributed from time to time to *Le Surréalisme ASDLR*. The first number contained his "Avant que la nuit . . ." (Before the Night . . .); the fourth, a detailed analysis of the situation of poetry, based on the idea that poetry is an "activity of the mind" rather than a "means of expression"; the sixth, a long "experimental dream." In 1931 Tzara published *L'Antitête,* which included, together with the dadaist "Monsieur Aa l'antiphilosophe" (Monsieur Aa the Antiphilosopher), more recent, unpublished poetic prose. The following excerpt is from the chapter "Minuit pour Géants."

THE ANTIHEAD [18]

Midnight for Giants

12

The low sadness of a desolate landscape. The low sadness of a few dwellers in blackness. The bristling noise which is small and repeated. Who shall say what throbbing is concealed in a call intentionally distant and sustained? It wanders insensitive.

It is still light and night is not yet to be understood. Let there be a knock at the door and the door does not open. But who could have the singular notion of knocking at this country left to horror, the horror having a breath of the sea? All open and clear-cut. Dry is the plaint bestowed on dead padlocks. Rock and sand of bourdons. Hard as the incredible hammering and no questions underneath. The wind too has forsaken it, the till is empty, but the walls still threaten to collapse, no window has seen the unacknowledged woman at the gate, eager with impossible obstinacy, and uttering her confused and barred call behind an eagle dumb with terror, has seen the woman in love with nothing more beautiful than all flesh and gesture, afflicted with the most fabulous disease throughout the world, fixing her gaze on a wilderness peopled with gentle beings whose throats have been slit, and in each dead being her weeping hands ready to melt to sweetness, that paradise for trappers of emptiness and the impossible, all-powerful mistress of the prohibition against living elsewhere than in the iron grottoes and of the sweetness of living without movement, each in his lucifugous person and each person sheltered by the earth, in fresh blood, in the center of the wilderness peopled with tender beings bound to the blood of those with the slit throats through a secret slumbering in its own depths, as the woman one's first love in an ever present oblivion.

Indescribable coolness. Eyes keener from youthfulness to youthfulness. I also have had wings for caressing in a limpid language which barely touched me. It was a prison made of lengthy childhoods, the torture of the too radiant summer days. And their twisted laughs, dressed in black, as was the only kindness vouchsafed to me in

[19]Translation by David Gascoyne.

all my numerous questing years, to twist necks in their milk, the at last motionless fugitives with their salt legs, their eyes of definite breaks in the venerable sadness of that play of sparks. When they go out in blood stifled with a shooting cry like a star's. As nobody has lived.

Maurice Henry was a member of the Grand Jeu group in the 1920s and frequented the surrealists after 1932. The following poem, a sort of humorous one-man exquisite corpse, was published in the English magazine *Contemporary Poetry and Prose,* no. 2 (June 1936):

The Bronze Piano[19]

> If the hyenas whistled
> to keep inclemencies away
> if the vehicles played hide-and-seek with Poetry
> if street-noises served glaciers as coat-pegs
> the rivers would break up the ships
> from end to end
> hedgehogs would say mass in the music of rapes
> the wounded vein would not bleed so much
> the acrobats would be undone
> like phosphorus
> one would kill oneself on station-approaches like crystals
>
> And if the streams
> recognized the veiled women who pass in the explosion of sparrows
> the aeroplanes would go back under the earth like pen-holders
> head first
>
> With ifs
> we would cut off the heads of kings and motor-cycles
> we would fight on the terraces of cafés why not
> we would crowd out the pavements and even
> prick ourselves with golden-horned lambs
> with ifs
> we would unchain torpedoes
> syllables pebbles laughs
> we would unchain the thieves and also the sewing-machines also the rats
> the hearses would fly away before the cemetery

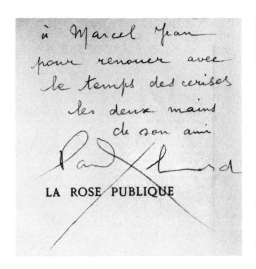

LA ROSE PUBLIQUE

Left: Paul Eluard: *La Rose Publique*, 1934. Half title and dedication: "To Marcel Jean—to renew cherry time, the two hands of his friend, Paul Eluard."
Right: Paul Eluard: Manuscript of his poem "Yves Tanguy," 1932, reproduced in *Yves Tanguy, A Summary of His Work*, edited by Kay Sage, 1963.

We are the pillows the mattresses the counterpanes
we are the sheets the blankets and the eiderdowns
and we are asleep
like post-cards.

Of the many poems and poetic pieces by Paul Eluard published in *Le Surréalisme ASDLR*, let us quote "Houx douze roses" and "Critique de la Poésie," which appeared in no. 4 (December 1931).

Holly Twelve Roses

The ax the way to hold a broken glass
The negation of a false note the nails the makeup
The common sense the seaweeds the ravines the exclusive praise
The heavenly rot and the reflection of its delirium
The dewy moon and many hearty animals
In this extinct town in this fellow town
The wandering storm its exploded pupils its virtual fire
The mixing of seeds of germs and of ashes
The corner of the Allée des Acacias masked with smells the sand pouts

Moon the leaf flower the breast and the heavy eyelids
The long kisses of the scarred-faced woman with pale hair
Who is always with me who is never alone
Who sets against me the wave of nos when yeses do not rain
She has for herself mechanical weakness
The unceasing moans of love
The undiscoverable draft of live water
She has for herself the first and the last light smokes
The furs that died of heat
The blood of crimes undoing the negative statues
She is pale and wounded and taciturn
She has a great artificial simplicity
Unfathomable velvet dazzled showcase
Impalpable powder on the threshold of morning breezes
All the obscure images
Lost in the expanse of her diurnal hair

Critique of Poetry

That's understood I hate the reign of the bourgeois
The reign of cops and priests
But I hate still more the man who does not hate it
As I do
With all his strength

I spit in the face of the man smaller than life
Who does not prefer to all my poems this "Critique of Poetry."

In the same number of *Le Surréalisme ASDLR*, Louis Aragon published two poems, "Tant pis pour moi" (So much the worse for me) and "Demi-dieu," which seem to be the last of his contributions to collective surrealist publications. Aragon left the group in March 1932.

Demigod

The sand of the sea worn out by octopuses
fell in the dredger where the men who spat
took it and threw it like a Thule cup
into the oven and then after incredible adventures
the kiss of a diamond

the unexpected encounter
of a turtle
and in a Dutch dining room the little cries of "many happy returns"
the sand is now wedged in the brow ridge
of a hemeralope in the right eye

It must be said that that stockbroker
was made in a Gothic-Moorish boudoir
by an embroideress dressed up as a hussar
and her lover the judge who had exchanged his ermine robe
for a little Venetian round jacket
believed in such moments that he was the Iron Mask himself

The stockbroker is still more worn out than the sand of the sea
Like the sand he bears the marks of the wandering women's bare feet
His body is covered with infamous deeds
His chin drags on the ground covering
umbilical Vosges trussed up
in a hernial bandage
Women more adorable than a wood fire
from a distance make signs of understanding to him
He knows that if he wants he can take off his socks
before little girls who are like the mother of pearl of the dawn
while sitting on a rep sofa under the portrait of a girl of Provence
and if he likes the idea
drink priest's piss at a spa with boardinghouse manageresses

He is extremely worn out that broker
He will have lunch presently with a friend
who is the living portrait of a boil
coming to maturity
They will talk of potash mines and lodes
of corpses will make
jokes about unemployment on Devil's Island
and will remember an evening
they spent together at the Furious Follies

For a worn out broker
He's worn out that broker
I know only shoes that are as worn out as that

Objects

Marcel Duchamp, who disappeared from avant-garde movements after 1922 and seemed to be interested only in playing chess, performed a sort of comeback to public activities in October 1930, when he contributed to the second issue of *Le Surréalisme ASDLR* a text about chess, an excerpt from a study he had written in collaboration with a specialist, Vitaly Halberstadt. *L'Opposition et les Cases conjuguées sont réconciliées* was the intriguing title of this study, which, nevertheless, claimed to rid a particular end-game problem of "its pseudo-esoteric aspect."[1] But still more mysterious, perhaps, were Duchamp's notes relating to his *Large Glass* (formally, *La Mariée mise à nu par ses célibataires, même,* or *The Bride Stripped Bare by Her Bachelors, Even*)—a construction that could be considered, in a way, the diagram of a chess problem.[2] These notes had been written from 1911 to 1915 when Duchamp was conceiving the structure of his *Large Glass,* but the texts that follow were published for the first time in *Le Surréalisme ASDLR,* no. 5 (May 15, 1933).

[1] Duchamp's commentary on the problem of *Opposition and Sister Squares Are Reconciled* is as follows: "The 'opposition' is a system that allows you to do such-and-such a thing. The 'sister squares' are the same thing as the opposition, but it's a more recent invention, which was given a different name. Naturally, the defenders of the old system were always wrangling with the defenders of the new one. I added 'reconciled' because I had found a system that did away with the antithesis. But the end games in which it works would interest no chess player. That's the funny part. There are only three or four people in the world who have tried to do the same research as Halberstadt, who wrote the book with me, and myself. Even the chess champions don't read the book, since the problem it poses really only comes up once in a lifetime. They're end-game problems of possible games but so rare as to be nearly Utopian." (Pierre Cabanne, *Dialogues with Marcel Duchamp,* trans. Ron Padgett, The Documents of 20th-Century Art [New York: The Viking Press, 1971], pp. 77-78.) The Duchamp-Halberstadt study was published with French, English, and German texts, Paris and Brussels: Editions de l'Echiquier, 1932.
[2] See the analysis of Duchamp's *Large Glass* in our *History of Surrealist Painting,* chap. 4.

THE BRIDE STRIPPED BARE BY HER BACHELORS, EVEN[3]

to separate *the ready-made in series*
from the *already found*

Preface

Given (1) the waterfall
(2) the lighting gas
we shall determine the conditions for an instantaneous position of Rest (or allegorical appearance) of a sequence (of a set) of small happenings appearing to necessitate one another under causal laws, *in order to extract the sign of relationship between,* on the one hand, this *position of Rest* (capable of all eccentricities), on the other, a *choice of Possibilities* available under these laws and at the same time determining them.

Or:

we shall determine the conditions under which may best be demonstrated (the) super-rapid position of Rest (the snapshot exposure) (=allegorical appearance) of a set.....etc.

Or:

Given, in the dark (1) the waterfall
(2) the lighting gas
we shall determine (the conditions for) the super-rapid exposure (=allegorical appearance) of several collisions (acts of violence) appearing strictly to succeed one another —in accordance with certain causal laws—*in order* to extract the *sign of relationship* between this snapshot exposure (capable of all eccentricities) *on the one hand* and the choice of the possibilities available under these laws *on the other.*

Algebraic Comparison:

a a being the demonstration
b b " " possibilities
the ratio $\frac{a}{b}$ is in no way given by a number c, $(\frac{a}{b} = c)$, but by the sign "−" written between *a* and *b*. As soon as *a* and *b* are "*knowns,*" they become new units and lose their relative numerical (or extensive) values; there remaining only the sign "−" written between them (*sign of relationship* or better of . . .? *think this out*).

[3]Translation by J. Bronowski in *This Quarter* (Paris), vol. 5, no. 1 (September 1932). The whole of the notes and preparatory sketches for the *Large Glass*, collected in a "green box," were published for the first time in 1934 in facsimile.

Given the lighting gas

PROGRESS (IMPROVEMENT) OF THE LIGHTING GAS
UP TO THE LEVELS OF FLOW

Malic castings

By Eros matrix we understand the set of hollow uniforms or liveries designed (to contain the) for the lighting gas which takes 9 malic forms (constable, dragoon, policemen, priest, buttons, delivery boy, flunkey, undertaker's man, station master).

The gas castings so obtained would hear the litanies sung by the trolley, the refrain of the whole celibate machine, but *they* will never be able to pass beyond the Mask. — They would have been as if enveloped all along their regrets by a mirror reflecting back to them their own complexity to the point of their being hallucinated rather onanistically (Graveyard of the uniforms and liveries).

Each of the 9 malic forms is built above and below a common horizontal plane, the plane of sex cutting them at the point of sex.

Marcel Duchamp: *The Bride Stripped Bare by Her Bachelors, Even*, note, 1912, from *The Green Box*.

<div align="center">Or:</div>

Each of the 9 malic forms is cut by an imaginary horizontal plane in a point called the point of sex.

<div align="center">

SUPERSCRIPTION
obtained with air currents acting as pistons

</div>

(explain briefly how these pistons are "prepared")

Then "put them into position" for a certain length of time (2 or 3 months), and allow them to leave their imprint in the character of (3) *nets* through which pass the hanged female's commands (commands having their alphabet and terms governed by the mutual positions of the 3 nets, a sort of triple "grill" across which the milky way brings—and is conductor of—the commands).

Next, remove them so that nothing remains but their firm imprint, i.e., the form permitting any combination of letters sent across the above triple form, commands, orders, authorizations, etc., which are supposed *to join the hits and the splash.*

Duchamp's *Large Glass* is an object, and the representations on its transparent surface are representations of objects ("Chocolate Grinder," "Scissors," etc.). The surrealists were always interested in objects—constructions with a symbolic content, poem-objects, assemblages, or found utensils whose special shape or character suggested some mysterious role and a meaning beyond utility. André Breton regularly haunted the Foire aux Puces, the now famous "flea market" on the outskirts of Paris, a reservoir of ever-renewed jetsam; he often brought back strange or valuable finds from his explorations, showing at times more interest in such objects than in paintings or poems. *Hasard objectif,* "objective chance," or the gift of discovering an unexpected, worthless, and priceless treasure, was for him equivalent to poetic inspiration.

A long essay on objects, by Salvador Dali, appeared in the special 1932 surrealist issue of *This Quarter* and reflected once again the keen interest of the surrealists in these creations. Dali's article, entitled "The Object as Revealed in Surrealist Experiment," quoted the following passage from *Introduction au discours sur le peu de réalité* of 1924, where Breton wrote about "dream objects":

INTRODUCTION TO A SPEECH ON THE LACK OF REALITY

Thus the other night I dreamed I was at an open-air market in the neighborhood of Saint-Malo, where I came upon a rather unusual book. Its back was a wooden gnome whose white Assyrian beard reached to its feet. Despite the statuette's being of normal thickness, the pages, made of thick black wool, were easy to turn. I hastened to buy the

object, and when I woke up, I felt disappointed not to find it beside me. It would be comparatively easy to manufacture. I would like to have a few things of the same kind made; they would have a distinctly puzzling and disturbing effect. I would join one to each of my books, as a gift to some selected person.

Who knows? I might thus help to demolish the thoroughly hateful trophies of the concrete and add to the discredit of "rational" people and things. There would be ingeniously constructed machines of no possible use, and also minutely detailed maps of immense towns such as we would feel forever incapable of building, but that, nevertheless, would put the present and future great capitals in their right place; also, ridiculous but extremely perfected automatons doing nothing in the usual way and giving us a proper idea of action. . . .

Five "objects operating symbolically" were described in Dali's article—by Giacometti, Valentine Hugo, André Breton, Gala Eluard, and Dali himself. Giacometti's was a "suspended sphere":

A wooden sphere marked with a feminine furrow is suspended by means of a fine fiddle string over a crescent, one tip of which just touches the cavity. The spectator finds himself instinctively compelled to slide the bowl up and down over the tip, but the length of the string allows him to do this only partially.

This description and that of the four other objects are to be found in *Le Surréalisme ASDLR,* no. 3 (December 1931), which also included reproductions of the objects. In the same issue are sketches by Giacometti, "Objets mobiles et muets"—dream objects, forms that seem to have come to life from childhood memories—with these comments by the artist:

Moving and Mute Objects

All things.....near, far, all those that passed and the others, in front, moving; and my lady friends—they change (we pass, very near, they are far away); others approach, ascend, descend; ducks on the water, here and there, in space, ascend, descend—I sleep here, the flowers on the wallpaper, the water dripping from the tap, the drawings on the curtain, my trousers on a chair, voices in a room farther on, two or three people, which station? Locomotives whistle, there is no station around here, orange peels are thrown from the top of the terrace, in the very narrow and deep street—at night mules neighed desperately, toward morning they were slaughtered—tomorrow I go out— she bends her head over my pillow—her leg, the large one—they speak, they move, here and there, but everything went away.

In "Hier, sables mouvants" (*Le Surréalisme ASDLR,* no. 5, May 15, 1933), Giacometti recalled other childhood reveries:

Yesterday, quicksands

As a child (between four and seven), I saw only the objects of the external world that I could use for my delight. It was, above all, stones and trees, and seldom more than one object at a time. I remember that during two summers at least, I saw, of what surrounded me, one big stone lying about half a mile from the village, only this stone and the objects related to it. It was a golden-colored monolith, its base opening on a cave; the whole bottom was hollow as a result of the action of water. The entrance was long and low, hardly as high as we were at that time. The inside deepened in places until it seemed to form at the very bottom another smaller cave. It was my father, who, one day, had shown us this monolith. Enormous discovery; I considered this stone a friend at once, a being well-disposed toward us, calling us, smiling at us, like someone whom we knew and loved a long time ago and whom we met again with infinite joy and surprise. Right away, it was our only concern. After that day, we spent all our mornings and afternoons there. We were five or six children, always the same ones, who never separated. Every morning when I woke up, I looked for the stone. From our house I could see it in its most minute details, as well as the little path, thin as a thread, that led to it; all the rest was vague and imprecise, air caught to nothing. We followed this path, never going away from it and never leaving the immediate vicinity of the cave. Our first concern after the discovery of the stone was to delimit the entrance. It must have been no more than a crack just large enough to let us pass. But I was overjoyed when I could crouch in the little cave at the bottom; it could hardly hold me; all my wishes were fulfilled. . . .

As far as recurrent enticements are concerned, I remember that for months, while a schoolboy, I could not go to sleep at night unless I imagined first that I had gone through a thick forest, at nightfall, and that I had reached a great castle rising in a most secluded and unknown place. Then I killed two defenseless men; one was about seventeen, pale and frightened as he always appeared to me, and the other wore armor with something like gold shining on his left side. After tearing off their clothes, I raped two women, first the one who was thirty-two, dressed entirely in black, with a face like alabaster, and then her daughter, over whom white veils were floating. Their cries and moans echoed through the whole forest. I killed them too, but very slowly (it was night at that moment), each time with slight variants, often beside a pond with green stagnant waters, which was before the castle. Then I burned the castle, and satisfied, I went to sleep.

The third issue of the magazine, contained several sketches by Yves Tanguy, illustrating a rather humorous conception of objects, with a commentary entitled "Poids et Couleurs."

Weights and Colors

The above object, as large as a hand and looking as though it was kneaded by hand, is covered with pink plush. The five lower ends, which are folded against the object, are in transparent and pearly celluloid. The four longer fingers of the hand may pass through the four holes in the object's body.

In the above set, the object at the left is in plaster, painted reddish purple, and the nail is pink. It has a lead ballast that allows oscillations but always brings it back to the same position.

The very small object in the middle is full of mercury and is covered with bright-red plaited straw so as to appear extremely light. The big object at the right is in pale-green molded cotton; the nails are pink celluloid. The last object at right is in plaster covered with black ink; the nail is pink.

The object at the left is in soft wax that imitates flesh. The appendage at the top

waves freely and is of a more brownish color. The three round shapes in the center are of a hard, matte white material.

The object at the right is in sky-blue chalk. At the top are hairs. This object is to be used for writing on a blackboard. It will be worn out from its base, so that only the tuft of hair at the top will remain.

Combining objects and written phrases on the same plane, Tanguy on another occasion used a process similar to that of the poem-object, in a drawing entitled *Life of the Object* (*Le Surréalisme ASDLR,* no. 6, May 15, 1933), which incorporated a written text into the shapes of the image.

In the same issue was a poem by Arp, "L'Air est une racine," concerning stones, molded and re-created by the poet, who gaily cheered his own inventions:

The Air Is a Root[4]

the stones are filled with bowels. bravo. bravo. the stones are filled with air.
stones are branches of waters.

on the stone that replaces the mouth a leaf-fishbone grows. bravo.
a voice of stone is having a tête-à-tête toe to toe with a gaze of stone.

[4] Translation by Joachim Neugroschel in *Arp on Arp,* ed. Marcel Jean, The Documents of 20th-Century Art (New York: The Viking Press, 1972).

the stones are as tormented as flesh.

the stones are clouds for their second nature dances on their third nose. bravo. bravo.

when the stones scratch themselves nails grow on the roots. bravo. bravo.
stones have ears to eat the exact time.

Dali's "objets psycho-atmosphériques-anamorphiques" (*Le Surréalisme ASDLR,* no. 5, May 15, 1933), expounded a different kind of humor:

Psycho-atmospheric-anamorphic Objects

Let the reader whose heavy and marconized head has not succeeded in conceiving entirely "the essential originality" of surrealist objects functioning symbolically (an originality made of the absolute absence of the familiar "plastico-formal" virtues), renounce, once again, following me along the explanatory itinerary—too cumbersome, too depressing for him—of the "dialectical process" of the "surrealist object." Let him brush aside the volume where these pages will appear in print with a brief gesture of his delicate hand, whose little finger has already the affected stiffness of

Jean Arp, 1939. (Photograph from *Arp* by Giuseppe Marchiori; Milan: Bruno Alfieri, 1964)

partial catalepsy. Let him fearlessly and softly immobilize his head, heavier than mercury, on a suitable platform made of bread soaked in ether, so that, under these favorable conditions, on the stretched, perceptibly purplish-blue and liquid surface of his painful temples, may rise the minute, but numerous and gradually growing distinct, color photographs of Marconi illuminated by the afternoon sun and persecuting with a long rod of lead a frightened parrot among innumerable rose bushes in full bloom in a wet garden, until the said photographs would, with a characteristic morbid acceleration, cover up his masochistic head with a thick and incurable growth of polychrome mushrooms.

A sort of pastiche of Lautréamont's methods of black humor,[5] Dali's literary pseudo delirium filled three pages of the review with a fully detailed account of how to manufacture "psycho-atmospheric" etc. objects—which would be nothing, he said, in the end, but anonymous little iron balls......

Dali: Aspect of the New Psycho-atmospheric-anamorphic Objects.

[5] See above, p. 47, the passage on the "cretinizing of the reader" in the last stanza of *Les Chants de Maldoror.*

In February-March 1933, the surrealists engaged in experimental research on the "irrational knowledge of the object." Questionnaires were drawn up about the fortune-teller's crystal ball, for instance, or simply about a piece of pink velvet, in order to determine their "irrational qualities" in relation to time, accidents, encounters, and so on. In regard to the crystal ball, the questions were:

Is it diurnal or nocturnal? Is it favorable to love? Is it fit for metamorphoses? What is its situation in space in relation to the individual? To which epoch does it correspond? What happens if it is dipped in water? in milk? in vinegar? in urine? in alcohol? in mercury? To which of the four elements does it correspond? To which philosophical system does it belong? What illness does it evoke? What is its sex? With which historical figure may it be identified? How does it die? What should meet with it on a dissecting table in order for it to be beautiful?[6] What two objects would you like to see with it in a desert? Where would you place it on a woman's nude body? and if the woman is sleeping? if she is dead? Under which sign of the zodiac does it come? Where would you place it on an armchair? on a bed? To which misdemeanor does it correspond?

Naturally, the participants answered the questionnaire without knowledge of anyone else's responses—and when considered together, these answers were themselves divergent and "irrational." Concerning the "irrational possibilities of penetration and orientation in a picture"—namely, *The Enigma of a Day* by Chirico, a painting that hung at the time on the walls of André Breton's studio, where surrealist experiments usually took place—here are a few of the questions and answers (the full results were published in *Le Surréalisme ASDLR*, no. 6, May 15, 1933).

Where is the sea?
André Breton: Behind the statue.
René Char: Everywhere in the conversation of the two personages.[7]
Paul Eluard: In the porticoes.
Alberto Giacometti: Very near, behind the first arcades.
Maurice Henry: On the spectator's side.
Benjamin Péret: On our side, but we turn our backs to it.
Tristan Tzara: Ten miles away behind the chimneys.

Where would a phantom appear?
A. B.: In the second arcade. It is the gory phantom of a woman.

[6] An evident allusion to Lautréamont's famous comparison (see p. 52).—M.J.
[7] The two small figures standing in the middle of the square in Chirico's picture.—M.J.

J. M. Monnerot: It would be seen perhaps at the window above the porticoes.

B. P.: It would appear suddenly from under the stone behind the statue.

Describe the landscape around the town.

A. B.: Villas, the richest ones covered with snow. Very far away, woman-shaped derricks. Artificial storms are blowing over shacks made of rags with windows of yellow reeds. Deserted squares are encircled with a beautiful leather belt, thirty feet high, with an obscene glass buckle.

R. C.: A landscape in the Vosges, or in Sardinia. A few swamps, a dead sea. Immediately behind the chimneys, a chocolate factory. Under the roof, horsehair stocks. Volcanic ground. It's a beach. It's Devil's Island. In the distance and sometimes in the folds of the flag, the phantom of Hannibal. The statue is made of earth. Underground pipes drain it in order to keep it fresh. Sulfur emanations in the air.

P. E.: The town is on a plateau. Sheer walls on all sides. Then, at the foot of the walls, the same square, then other walls, other squares etc.

A. G.: Around the town, a circle of sand with a stretched canvas bordering it.

Yolande Oliviero: There is no town, only the square at the top of a high mountain. Leaning over the railings, one sees only water and smoke.

T. T.: Abandoned vineyards, a tangle of guillotines, here and there gravel shaped like swallows' eggs. A carpet made of dead butterflies starts from the sea in a straight line and ends between the chimneys. It is sprinkled with red wine and goats' excrement.

Where would one make love?

A. B.: Inside the plinth of the statue.

P. E.: On the plinth of the statue.

A. G.: Under the porticoes at right.

B. P.: Standing, in the middle of the square, regardless of the two personages, who are dead.

T. T.: The painting being blind, love would be made in the sun.

Where would one masturbate?

A. B.: Behind the moving van, out of sight of the chimneys and always changing place to watch the locomotive advancing slowly.

B. P.: Near the locomotive, between the arcades and the chimney at left, very far into the landscape.

T. T.: Turning one's back to the painting.

Where would one defecate?

P. E.: In a railway station that is outside the picture, at the right.
A. G.: In the background, to the right of the chimney.
M. H.: In the statue's right hand.
Y. O.: On the stone, exactly.
B. P.: On the statue's right foot.
T. T.: On the stone at left.

Whom does the statue represent?
A. B.: Lincoln.
P. E.: The father.
A. G.: A disciple of Cavour.
M. H.: A furniture mover, famous in the country.
Y. O.: Benjamin Franklin.
B. P.: The inventor of decalcomania.
T. T.: A celebrated inventor in matters of baking.

What time is it?
A. B.: Eleven p.m.
P. E.: Noon.
A. G.: Three a.m. The sun is false.
M. H.: Noon.
César Moro: Four-thirty p.m.
Y. O.: Five p.m. in summer.
B. P.: Between six and seven p.m. in June.
T. T.: The midnight sun.

What advertisement should be put up on the building at the left?
P. E.: Spend your honeymoon in Detroit.
A. G.: The word *soap* above each arcade.
M. H.: Paramount.
Y. O.: Dubonnet.
T. T.: Bovril or Bowling.

There were inquiries into "the irrational possibilities of life in a certain period of history" and "the possibilities of embellishment of a town"; this last experiment dealt with tentative changes to affect several Paris landmarks:

Would you keep, displace, modify, transform, or suppress
The Obelisk?
André Breton: Install it at the entrance of the slaughterhouses, where it will be held by an immense gloved hand.

Paul Eluard: Insert it delicately into the steeple of the Sainte Chapelle.
Tristan Tzara: Make it round, and place, at the top, a steel pen of a suitable size.

The Lion of Belfort?[8]
A.B.: Give it a bone to gnaw and turn it westward.
P.E.: Place on its back a diver in a diving suit, holding in his right hand a pot with a hen dipping in it.
T.T.: Pierce it with an enormous rod and roast it to flames of bronze.

The Opera?
A.B.: Change it into a fountain of perfumes. Rebuild the staircase with bones of pre-historic animals.
T.T.: The Zoo, the section with monkeys and kangaroos, should be installed in it. Replace the exterior decoration with skeletons. On the stairway outside, install the steel reproduction of a bicycle as high as the whole facade.

The Law Courts?
A.B.: Raze them. A magnificent graffito should be traced on the site, to be seen from the air.
P.E.: Raze them. A bathing pool should take their place.
Benjamin Péret: Destroy them and replace them with a bathing pool to which only beautiful nude women would be admitted.

Notre Dame?
A.B.: Replace the towers with an immense oil-and-vinegar cruet, one flask filled with blood, the other with sperm. The building would be used as a school for the sexual education of virgins.

The statue of Clemenceau?
T.T.: Place around the statue thousands of sheep in bronze, including one in camembert.

In this chapter on objects, we may anticipate again and mention the first "Exhibition of Surrealist Objects" (May 1936) at the Galerie Charles Ratton in Paris. Most of the items on display were reproduced in a special issue of *Cahiers d'Art,* where in a theoretical text, Breton discussed the "Crise de l'Objet" (Crisis of the Object); Eluard provided a poetic article, "L'Habitude des Tropiques" (The Practice of Tropics), and Gabrielle Buffet-Picabia contributed an article on Marcel Duchamp, who had adorned the cover of the review with an "opti-

[8] This animal commemorates in bronze, at the Place Denfert-Rochereau in Paris, the siege of the town of Belfort during the Franco-Prussian War of 1870-71.

cal" composition in vivid blue and red—*Coeurs Volants*—also the title of Gabrielle Buffet's article.

Flying Hearts [9]

[Duchamp's] . . . tyrannical work, whose effort of disincarnation and rationalization is manifested in every detail, is nonetheless stamped with the seal of an unconquerable personality which imposes itself with no other explanation. In spite of its evident obscurity and of the need for arduous preparatory work for reading it, this work in no way diminishes the popularity of its author today, which explains no doubt why his activity manifests itself more and more rarely and in most unexpected forms, wilfully scandalous, deceiving, cruel even, which can be qualified as the search for the *Anti-masterpiece.* Duchamp exhibited a public latrine at the New York Independents in 1917 (which cost him quite some unpleasantness); he signed a photograph of the Mona Lisa after surcharging it with a moustache, an imperial and the double-meaning block capitals: L.H.O.O.Q. (elle a chaud au cul!); he cultivated hoaxes, gags and humorous puns as ornaments for objects; the *Anémic cinéma* is thus a sequence of variations on geometrical shapes interspersed with captions made up of word-plays. But make no mistake, these are no innocent games, the humor of Duchamp is gay blasphemy; this usurping of the masterpiece's privileges by the pun is aimed at destroying its prestige more effectively than any thesis could do.

It would be wrong if this decision *to do no more work* were accepted as a sort of abdication: a decision arising from Duchamp's alienation from all normal activity and particularly from the world of the arts and of its ambitions. Forced however to burn with that extraordinary need for controversy and intrigue, he suddenly changes his whole constitution and dismays all his friends by becoming a passionate chess player. . . .

In "Honneur à l'Objet!" Salvador Dali's stylistic acrobatics lead him to a eulogy of the swastika. Dali was beginning at that time to develop, rather unexpectedly, a pro-Nazi attitude, which, at first considered provocatively humorous by the surrealists, eventually brought about a definitive break between him and the movement.

Honor to the Object!

When Plato said: "Nongeometers, keep out!" we all know very well that he spoke in the half-mocking, half-contented way that always characterizes the facetious and

[9] Translation by Edouard Roditi in *View* (New York), ser. 5, no. 1 (Marcel Duchamp number, March 1945), under the title "Magic Circles."

talkative constitution of this philosopher. For really, if there was anyone who never cared for geometry, indeed it was he. As a matter of fact, far from all perimetrical rigor, Plato was in his time something very much like the *Dame aux Camélias.* He was even, truly, the authentic Camille of Mediterranean thought, since he too lived in silence, on the margin of geometry, with the materialistic sex appeal that the statues of "sculptural thought" already possessed then, in a supremely antigeometric morphological pattern, thus opening brilliantly, and without much suspecting it, the first great official brothel of aesthetics. . . .

In an important paranoiac-critical study on the right and the left in political emblems, I discern, in a kind of general morphology of the swastika filling many pages, the catastrophic and territorial conflicts of this sign, which militates at every moment and with the utmost violence in favor of surrealist objects. This sign, an eminently irrational one, rising out of the climates of octagonal civilization, presents itself to us as the amalgam (this word is perhaps too ambitious) of antagonistic tendencies and moves. In effect, since its motion tends simultaneously toward the left and toward the right, it appears indeed as the very symbol of the "squaring of the circle" rising out of the octagon. This wheel, while no one knows whether it works, is in any case made to get people working. For instance: Germany at the present time; for instance again: those of my readers who are compelled by my article's evident interest to roll forward and backward like true swastika wheels, which they are not, luckily. . . .

I contributed to the special number of *Cahiers d'Art* a documentary article on the objects shown at the exhibition. The title of my text, "Arrivée de la Belle Epoque," was that of one of the Oscar Dominguez objects in the show.

The Coming of Beautiful Days

The meaning of the word "object" tends to specialize. *Objectare* had in Latin the general sense of "what is thrown before." Dictionaries say that an object is "all that is offered to view," but today the object is rather what affects more especially the sense of touch. To touch is the usual way to explore, to discover objects — this box, if you touch it, is an orchestra, this insect, if you don't touch it, may be a leaf, this primitive sculpture seems painted in an iridescent red, but your hand, feeling the ambiguous touch of feathers, discovers its unexpected material — it is, besides, a mask.

The object is born and lives with the man.

However unpretentious is the part that man assigns to "useful" objects of his creation, they participate intimately in his life and possess a double meaning: all have a

latent sexual content besides their practical role, and our dreams, with the greatest sureness, do not fail to endow them with the values we unconsciously gave them when they were created during the waking state.

 . . . Through the organic presence of their sexual-poetic contents, the deep life and development of surrealist objects may be detected, from the time of their first appearance. Their nonaesthetic origin does not prevent some of them from having plastic interest or, even, a sumptuous quality. Max Ernst's *Bird,* born of the handling of a seashell, has an evident plastic value, as well as Oscar Dominguez's *Exact Sensibility;* the *Great Paranoiac,* by Jacqueline and André Breton, sparkles with all the hues of green; Dali's *Aphrodisiac Vest* is magnificently embroidered with crystal goblets; by no means the least splendid object is the extinct one, Man Ray's *Destroyed Object.*

 . . . The found object is always a rediscovered object.

Rediscovered in its symbolic—original or acquired—meaning, which endows it with a fullness that a "created" object rarely reaches. Bricks, molten glass, root, pipe, star-shaped wafer, tabernacle for who knows what demented games: found objects[10] reveal our multifaceted irrational life.

The *expectant* character that emanates from surrealist objects may appear striking. Exalted by sexual desire, it implies, opposed to a fixation (as in painting, or sculpture), a *potential motion* of a great poetic violence: an expectation, as in the common object waiting to be used for some vital need; an expectation and a desire, for a foe or for a companion, for an enemy-companion, as in the immobile, therefore invisible, mimetic insect. Hans Bellmer's *Doll,* in its motion convulsively held back on the steps of a meaningful flight of stairs, is the disturbing image of these mirror games of desire.

The surrealist object is sumptuous, usual, plastically assimilated, organically attentive, potentially functioning. . . .

Hans Bellmer, whose *Variations on an Articulated Minor* appeared for the first time in *Minotaure,* no. 6 (December 5, 1934), exhibited his *Doll* at the 1936 show. In the special issue of *Cahiers d'Art* he published the following brief commentary on his creation:

What oozed through the staircase or the cracks in the doors when these girls were playing at being doctors, up there in the attic, what dripped from these clysters filled with rapsberry juice, or if I dare say so, with rapsberry verjuice, all this could easily take on, on the whole, the appearance of seduction, and even arouse desire.

[10]This enumeration refers to objects shown at the exhibition and found respectively by Serge Brignoni, Maurice Henry, Alberto Magnelli, Marcel Jean, Dora Maar, and Yves Tanguy.—M.J.

It must be admitted, as I do reluctantly, that a haunting concern lingered over all that could not be learned about them. Neither myself nor anyone else could lose all mistrust toward these little girls.

When their legs remained idle, nothing could be said of their crooked carriage, mainly toward the knees, only that they resembled those of young frolicking goats. Full-face or sideways, their profile lent itself much less to laughter; the frail curve of the shanks grew bolder at the knees' padding, assuming a curious convexity. But confusion was complete when those legs grew suddenly stiff, with moves suggesting a fleeing hoop, and in the end they hung bare, out of transparent lace and rumpled pleatings, relishing the aftertaste of their game......

Dream and Revolution

A fragment on dream objects from André Breton's book *Les Vases communicants* appeared in no. 3 of *Le Surréalisme ASDLR,* and another excerpt appeared in no. 4 (both issues were dated December 1931). *Les Vases communicants* was, in a way, a second *Nadja* — an account of dreams and of strange encounters, dream and waking life being "communicating vessels." But this time the heroine remains anonymous. The woman hailed as a genius at the end of *Nadja,* whose answer to the questionnaire on love in *La Révolution surréaliste* Breton undersigned as his own, and for whom he had written the poem "L'Union libre," had asked him, at the end of a passionate and stormy liaison, *not* to write a book about her; nevertheless *Les Vases communicants* was written, but it alluded to Suzanne Muzard by the single initial *X.*

The book opens with a long discussion of dreams and their interpretations by psychologists and psychoanalysts, interpretations that Breton finds often insufficient or biased. To set an example of a free and complete interpretation, he recounts and analyzes two of his dreams; *X* appears in the first one, which is commented upon at length. And then Breton begins to relate events of "real life" that seem to happen to him "as in a dream" — at that time *X* had definitely left him, and he thought he would never see her again.

THE COMMUNICATING VESSELS

April 5, 1931, toward noon, in a café on the Place Blanche where my friends and I used to meet, I was telling Paul Eluard a dream of the preceding night . . . when my eyes met those of a young woman, or a young girl, seated with a man a short distance away. Since she did not appear particularly embarassed by my attention, I observed her, from head to foot, very complacently, or was it perhaps that straight off I could not take my eyes from her? She was smiling to me now, without lowering her eyes, unconcerned, it seemed, by her companion's possible resentment; he was very still,

very silent, and evidently very far from her in his thoughts — he might have been in his forties — and he gave me the impression of someone extinct, completely discouraged, really a touching person, besides. I still see him rather distinctly: emaciated, bald, stooping, looking extremely poor, the very image of neglect. Near him this being seemed so awake, so gay, so self-assured, and in all her ways so alluring that the idea that they could live together was almost funny. A perfect leg, deliberately exposed far above the knee, was swinging fast, slowly, faster, in the first, the most beautiful, pale ray of sun of that year. Her eyes (I have never been able to tell the color of eyes; these remain for me clear eyes only) were among those, how can I make myself understood? that *are never seen again.* They were young, direct, avid, not languid, not childish, not discreet, without "soul" in the poetic (religious) sense of the word. Eyes upon which night must fall all of a sudden. Perhaps as a result of the supreme tact that women who lack it most know how to display on occasions all the more exceptional as they feel themselves more beautiful, she was dressed with the ultimate in simplicity, as the saying goes, to minimize what might have been distressing in the man's clothes. After all, this destitution, however paradoxical, might have been real. I had an inkling of a gulf of extreme poverty and social injustice, on which, in fact, we border every day in capitalistic countries. Then I thought that they might be circus artists, acrobats, like many who were seen going and coming in this neighborhood. Such couples always surprise me, their union seems to be an exception to today's ways of selection: the woman is relatively too beautiful for the man, while he, for whom it is a professional necessity to join with her in consideration of this beauty alone, is exhausted by his own harder and more difficult work. But this passing idea was impossible to hold since this was Easter Sunday and the whole boulevard echoed with the noise of buses driving visiting foreigners through Paris. They could only be transient people after all, Germans more precisely, as I verified later. I was sure, when I saw them leaving, that the young woman who looked back, lagging behind her companion, would return on the next day, or if that was impossible, on one of the coming days.

The couple came back to the café two or three times, but with the man growing more and more suspicious, never did her silent admirer find a chance to speak to the girl.

I tried the impossible to secure her address, but the constant precautions taken, much against her will, to conceal it from me, proved to be sufficiently effective.

The affair ended even before it began, and the author concludes:

What an abrupt ending of a story! A character has hardly been introduced than

he is abandoned for another — and, who knows, for still another? What is the good, then, of putting out all this introduction? The author, who seemed set on offering us something of his life, actually speaks as in a dream! — *As in a dream. . . .*

A little later, there was another encounter, the eyes of another woman:

April 12, toward six in the afternoon, I was walking with my dog, Melmoth, along the outer boulevards when, near the cinema Gaîté-Rochechouart, before which the poster for *Péché de Juive* [The Jewess's Sin] had brought me to a standstill, I discovered at my side a young girl whose attention seemed no less attracted than mine by this poster. Too much engrossed in her meditation to take notice of me, she let me contemplate her at my leisure. Nothing more charming, more arresting than this contemplation. Apparently very poor, in order probably, at this period of my life, that all the emotion I might feel at the sight of a woman could come into play, she evoked in the first instant the girl for whom Charles Cros, at the end of the most beautiful of his poems, "Liberté," could find only these insufficient and marvelous words:

Amie éclatante et brune [1]

or again the woman with these same eyes, yes indeed, the eyes that for fifteen years never ceased to fascinate me, the *Delilah* of the small watercolor by Gustave Moreau that I went so often to see in the Luxembourg Museum. In the light, these eyes, if I seek a more distant and at the same time more exact comparison, made me think at once of a water drop, imperceptibly tinted with the color of the sky, but of a stormy sky, falling on untroubled waters. It was as if this drop had stopped indefinitely when it touched the water, just before the moment when, in slow motion, it could have been seen melting into it. This impossibility, reflected in eyes, was enough to spell the doom of aquamarines and emeralds. In the shade, as I noticed afterward, one had the idea of an unceasing yet ever renewed skimming of this same water by a very fine pen retaining a tiny drop of China ink. Everything in this person's gracefulness was the contrary of premeditation. She wore things of a deplorable black color that suited her only too well. There was in her gait, now that she was strolling along the shop windows, I don't know what blinding and serious something; she was so ignorant of it that it could only remind one of the law we are patiently trying to perceive: the great *physical* necessity of nature, while it evoked, more tenderly, the nonchalance of certain lofty flowers when they are beginning to blossom.

Breton spoke to the girl and he found her "confident, attentive, though not very much

[1] "Flashing and dark-haired friend." — M. J.

interested in" him. She was a dancer, and she lived with her mother. She agreed to a rendezvous the next day.

Twenty to twelve: I knew I was going to be much too early. All I had to do was to wait patiently half an hour at the Café Batifol, 7 Rue du Faubourg Saint Denis. Although it had fallen to the young girl I was expecting and not to myself to fix our appointment there, I must say that no other place was more familiar to me. I had entered it several months before, following a very beautiful woman whose eyes, of course, had captivated me at first; the circumference of their irises had made me think of the retractile rim of green Marennes oysters. The information I gathered about her from the waiter having tempered my desire to meet her, I only looked at her from a distance and promised myself that when I felt too lonely, I would come and from a distance look at her. But the place alone where she had just entered would have been able to hold me; it was invaded, between six and eight o'clock, by the most swarming kind of crowd I had ever seen — second-rate theater or music-hall artists, with a certain number of women and men of hardly less definite professions mixed among them. The Café Batifol mingles in a sort of heaving and subsiding marine noise, a noise like that of a squall, the hope and the despair sought in all the cheap concert halls of the world. For months afterward my friends and I met there at the end of every afternoon, each of us fully appreciative, it seemed, of the fact that it was almost impossible to speak to the others, for lack of hoping to be heard. After shaking hands, and the lump of ice in the glass, there was nothing to do but to abandon oneself to this rocking wind, which shook the shutter of a chimney whose smoke would have been made of silk. Some very young women were planning the conquest of a "producer" before starting it, with a ringing laughter, a frantic leer, the careless exhibit of a naked thigh; others, elsewhere, completely dejected, had reached the end of their careers. Transactions, visibly sordid ones, were taking place. All these people, plain and good, kissed each other, or squabbled, sometimes there were fights; nothing was more absorbing, more restful than this sight.

But the girl with the water-drop eyes did not come to the rendezvous, and the erratic search went on, on café terraces, along the boulevards, in bookshops, on the streets of the Paris of those days where the heart of surrealist adventure could be felt beating. Meanwhile, various thoughts crossed the wanderer's mind, literary, political, anecdotal, about English "black novels" for instance, or naturalistic literature, the cinema, a letter from an acquaintance, or social problems — antireligious action or the great wish for the Revolution. The author analyzes and theorizes about all these impulses appearing and disappearing "as in a dream," and also in a way characteristic of the nature of surrealism, which Breton tries to explain as follows:

André Breton
Les Vases
communicants

Éditions des Cahiers Libres Paris

A Marcel Jean
sur le brouillard des jolies femmes
défaillantes qu'il dessine
la flamme très sûre
de ma confiance et de mon amitié

André Breton

POSITION POLITIQUE
DU
SURRÉALISME

RENÉ CREVEL

LES PIEDS
DANS LE PLAT

*... quitte à faire lever
le cœur des délicats.*

Il n'y a qu'à ouvrir les yeux pour voir quels
fruits de misère, de guerre et de mort donne
la fine fleur du désordre capitaliste. C'est le
spectacle d'une Europe déshonorée par le
fascisme et l'impérialisme qui a décidé l'au-
teur-spectateur à mettre les pieds dans le plat.
Un volume de 360 pages 15 fr.

Il a été tiré de cet ouvrage 15 exemplaires
sur Japon impérial contenant une eau-forte
originale par Alberto Giacometti . . . 300 fr.

Aux Éditions du Sagittaire (Anciennes Éditions Kra)
56, Rue Rodier, PARIS (9e).

Top left: André Breton: *Les Vases communicants,* 1932.
Cover design by Max Ernst. *Top right*: André Breton:
Position Politique du Surréalisme, 1935. Half title with
dedication: "To Marcel Jean—On the blurred images of the
pretty women he draws, the very constant flame of my
trust and friendship—André Breton." *Lower right*:
Advertisement for René Crevel's *Les Pieds dans le Plat*
(To Put One's Foot in It) in *Le Surréalisme ASDLR*, no. 5
(May 15, 1933). Translation: ". . . *even if delicate people
have qualms.* Simply by opening our eyes we see what fruits
of misery, of war, and of death the finest flower of capitalist
disorder brings about. It is the sight of a Europe dishonored
by fascism and imperialism that has led the author-witness
to 'put his foot in it.'"

It is only for the a priori nonspecialization of its efforts that surrealism, such as
several of us have conceived it for years, will deserve to be considered as a living being.
I wish that it be understood only as having attempted nothing better than to throw a
leading thread between the altogether too much dissociated worlds of wakefulness
and sleep, of exterior and interior reality, of reason and madness, of the calm of knowl-
edge and love, of life for life itself and Revolution, etc. At least we attempted, we did
it amiss perhaps, but we attempted to leave no question without an answer, and we
cared to a certain degree for the coherence of the answers. Supposing this field of
action were ours, would it really deserve to be abandoned? A revolutionary dreams

like any other man, sometimes he happens to think of himself alone, he knows that he may go from wisdom to madness, a beautiful woman being no less beautiful for him than for someone else; he may be unhappy because of her, and he may love her. One would wish that in all respects he would let us know of his behavior. As far as we could calculate it — and, again, surrealism never applied to anything else — I hope we did not distort the knowledge of the universe and of man; that, instead, striving to bring this revolutionary into agreement on all points with himself, we undertook nothing less than to make him greater. Errors may have been committed along the way, I shall not deny it, and the time may even have come to count these errors. But I am willing to believe that our general evolution, depending on several particular evolutions that complicate it, will be able to give its true meaning to what we may have undertaken together. Only then will it be seen whether, in our turn, on the score of our own capacities, we knew how to bring out the "pearl" that others, to quote Lenin again, could not extract from the "manure of absolute idealism."

Feuerbach, Engels, Marx, and Lenin were quoted repeatedly during the narration of irrational events, in an effort to show that love and revolution are as interdependent as dream and waking life, and that the "sweeping away of the capitalistic world" would free love itself. Poetry, in that future and real life, would be deeply changed, said the author in his sinuous, elaborate, but at the same time beautifully natural syntax — a splendid style, an inimitable one indeed but, alas, much imitated later, and thus, it seems to us, somewhat responsible for the abstract rhetoric, bordering on logomachy, which is the present fashion with so many French critics. But in 1932 the fresh stream of the sentences of *Les Vases communicants* meandered or rushed into rapids with the sureness of the "convulsive waters" of a pure river running over a broken terrain. For this style is not just style, a brilliant exercise, the feat of a virtuoso; it places itself at the service of thought. The dialectics of the principal idea of the book are now condensed and balanced stage after stage, rising through successive waves of contradictions toward a final contrast, while remaining as consistent and rigorous as the syntax itself. Truth appears in the end, a spark that flashes with the clash of opposites, a confluence of all extremes.

The poet of the future will overcome the depressing idea of an irreparable divorce between action and dream. He will offer the magnificent fruit of the tangle-rooted tree and he will know how to persuade those who taste it that it is not a bitter one. Carried on the wave of his time, he will receive and transmit, at last without distress, the calls rising toward him from the depths of ages. He will at all costs keep before us the two terms of human relations, the destruction of which would make the most precious conquests a dead letter: the objective knowledge of realities and their internal development, a magical one until further notice, by virtue of individual feeling on one part, of universal feeling on the other. These relations may be considered

magical in the sense that they belong to the immediate, unconscious action of the internal upon the external and that the idea of a transcendental intervention, which would be, moreover, that of a demon rather than that of a god, could creep easily into a summary analysis of such a notion. The poet will rise up in protest against this overly simple interpretation of the phenomenon in question: in the suit entered since time immemorial by rational knowledge against intuitive knowledge, it will rest with him to bring forward the main document, which will put an end to the dispute. Then the poetic operation will be carried out in broad daylight. Certain men, who will tend to become all men, will no longer be taken to task because of manipulations suspicious for others, and equivocal for themselves, that they devotedly perform in order to retain the eternity in the instant and the general in the particular. They themselves will not hail a beautifully colored precipitate as a miracle each time they succeed in obtaining it by mixing, in doses more or less involuntarily calculated, the two colorless substances that are existence submitted to an objective connection of beings, and existence concretely escaping this connection. They will already be outdoors, mingled with the others right in the sun, and no gaze will be more understanding and more intimate than theirs when Truth comes and shakes her hair streaming with light at their dark window.

It was also in 1932 that René Crevel published his pamphlet *Le Clavecin de Diderot*, which begins thus:

DIDEROT'S HARPSICHORD

Lenin, in *Materialism and Empiriocriticism,* remarks early in his introduction that "Diderot reached almost the views of contemporary materialism, according to which syllogisms are not enough to refute idealism, since, here, it is not a matter of theoretical arguments."

Let us quote in our turn from what has been quoted: "Supposing," says Diderot, "that the harpsichord has sensitiveness and memory, tell me if it will not repeat by itself the tunes you played on its keys? Our senses are like many keys on which surrounding nature plays, and which often play by themselves."

And first of all it must be noted that if a term of comparison, that one and not another, commanded the attention of the master of the Encyclopedists, the symbol, for once, did not ruin the man. But, on the contrary, the man rehabilitated the symbol. I mean the harpsichord, whose trick was to look evocative, appears at last scoured of all period picturesqueness. Overdone elaborateness, varnish slightly flaked off, music by the candles, aristocratic moonlight, Trianon and its three steps of pink marble,

shawls, and sheep à la Marie Antoinette, the pleasure of living, from Louis XV, this satiny rot, to the Comte d'Artois, that goof, from the pedantic, consumptive, corset-wearer Pompadour to the Du Barry woman, born Bécu, from the least of the titled peasants to the Prince de Ligne, this first great European — the beings, the things that lent themselves to so many abominably exquisite evocations, marquises, court abbots, soubrettes, chevaliers, Camargos, and *tutti quanti,* these knickknacks, twaddles, parties gay or not, all this rubbish did not soil one inch of the beautiful smooth surface of Diderot's harpsichord.

The text proceeds to a satirical account of present-day bourgeois modes of thought. The following extract is from the chapter "Des très dérisoires thérapeutiques individuelles."

On the Very Ridiculous Individual Therapeutics [2]

No problem of individual psychology posed in accordance with rules and formulae, no question reduced by psycho-analytical methods and isolated, can receive an approximate, much less a correct, solution. In no case, moreover, can it be a mere question of personal anecdote, or rather, there is no personal anecdote that does not carry outside and beyond its own limits the creature about whom or in whom the moral or material facts of that anecdote have arisen.

It is no doubt true that certain interrogations, however egotistically crippled in scope, imply that the work of clearing away the rubbish has begun. But what result can the excavator hope to achieve if he has not previously put himself on his guard against his own garbage of pretexts and hypocrises?

What is the use, even supposing it to be so, of having raised, thanks to the efforts and researches of a small group, what Breton calls the *terrible interdict,* if all the old prohibited areas are going to be split up into individual gardens of pleasure and displeasure, if, in a pantheistic inertia, they are to be let lapse into waste land, or if scholastic skyscrapers are going to spring up all along their avenues as a guarantee of modernity?

The partisans, swindlers or simpletons, of the old analytico-metaphysical method at any price are always ready to hail it as a miracle and a revelation when the clouds of mica that they themselves have been at such pains to heap up intercept the little light at our disposal, at yours and theirs, and bend it back upon us, upon you and them, in a mockery of dazzling rays.

[2] Translation by Samuel Beckett in *This Quarter* (Paris), vol. 5, no. 1 (September 1932), under the title "Every One Thinks Himself Phoenix. . . ."

Again, the petty sadism of the observers and the masochistic vanity of the observed take delight in every form of conjunctivitis, as though clear-sightedness, if not exactly illumination, were a function of such virulence.

Christianity has never lost its medieval delight in scrofula. The evangelical paradoxes on the hungry and the poor in spirit still provide titles, epigraphs and themes for the books of our men of letters.

Surely the world confesses to its own flatness and imbecility by the very fact of explaining as a form of indigence the hypertrophy or morbidity that tends to create that which is neither flat nor imbecile.

Relations between surrealism and the Communist party were, at that time, far from improving. For instance, the party's mistrust and miscomprehension were evident once more when Dali's "Rêverie" was published in *Le Surréalisme ASDLR* in December 1931, and when indignant Communists accused the surrealists of "uselessly complicating the healthy relations between men and women." The whole history of the failure of surrealism's endeavors to collaborate with Communism developed from a situation that André Breton, as early as 1926, had clearly analyzed in his pamphlet *Légitime Défense*.[3]

In 1932, Louis Aragon and a few other surrealists (Georges Sadoul and Pierre Unik) placed their entire activity at the service of the Communist party, no longer taking part in surrealism's poetic and political action. The surrealists' participation in 1934 in the Communist-led Association des Ecrivains et Artistes Révolutionnaires (Association of Revolutionary Writers and Artists, or AEAR) soon ended with their expulsion or resignation. At the Congress for the Defense of Culture, organized by the Communists in Paris in June 1935, André Breton and the Czech delegate, who was favorable to surrealism, were prevented under various pretexts and by various means from taking the floor — this action was one of the reasons for Crevel's suicide on June 24. René Crevel had been trying desperately to reconcile action with the Communists and his friendships and contributions with surrealism. That same year, the surrealists published the booklet *Du Temps que les surréalistes avaient raison* (When the Surrealists Were Right), a deliberately prophetic title entirely validated by subsequent events. The pamphlet not only denounced the U.S.S.R.'s reactionary cultural policies but condemned also, in its final pages, the "idolatrous cult" of Stalin. The brochure, which expressed "absolute mistrust" of the regime, was signed by twenty-six surrealists, including Breton, Dali, Eluard, Ernst, Marcel Jean, Magritte, Mesens, Nougé, Méret Oppenheim, Péret, Man Ray, and Yves Tanguy.

The following excerpt from *Annales Médico-Psychologiques* (November 1929) shows that miscomprehension of surrealism and hostility toward it were not exclusively the privilege of Stalinists.

[3]See pp. 162 ff.

MEDICO-PSYCHOLOGICAL SOCIETY [4]

Meeting of October 28, 1929

M. Abely having read a paper on the behavior of authors who call themselves surrealists and on their attacks upon alienist doctors, the paper led to the following discussion:

Dr. de Clérambault: I ask Professor Janet what connection he establishes between the cases' mental condition and the characteristics of their productions.

M. Pierre Janet: The surrealists' manifesto contains an interesting philosophical introduction. The surrealists contend that reality is ugly by definition; beauty exists only in what is not real. It is man who has introduced beauty in the world. To produce the beautiful, one must go as far as away as possible from the real.

The surrealists' writings are chiefly the confessions of obsessed persons and doubters.

Dr. de Clérambault: It seems to me that from a *technical* point of view excessivist artists launching impertinent crazes, perhaps by means of manifestoes which condemn all tradition, can be described, whatever they may call themselves (and let art and the period concerned be what they may) as "Processists." Processism consists in saving oneself the trouble of thinking, and especially the trouble of observing, and in relying on a predetermined manner of formula to produce an effect which is itself single, schematic and conventional. Thus one may have a rapid output, with all the appearance of having a style of one's own, and yet forestall the criticisms which a resemblence to life would invite. This degradation of work is most easily discerned in the domain of the plastic arts; but in the verbal domain it can be recognized just as well.

That species of arrogant laziness which engenders or fosters Processism is not peculiar to our time. In the sixteenth century, the Concettists, the Gongorists and Euphuists, and, in the seventeenth century, the Precious, have all been processists. Vadius and Trissotin (in Molière's comedy *Les Femmes Savantes*) were both processists, albeit processists more moderate and more laborious than those of our day, perhaps because they wrote for a more select and erudite public.

In the plastic domains, the rise of processism seems to have occurred only in the last century.

M. Pierre Janet: In support of M. de Clérambault's opinion, I will mention some surrealist processes. The surrealists will for example take five words at random out of

[4]Unsigned translation in *This Quarter* (Paris), vol. 5, no. 1 (September 1932).

a hat and with these five words they will make series of associations. In the Introduction to Surrealism, a whole story is expounded with the two words: turkey and top hat. . . .[5]

The psychiatrists' attacks against surrealism were in fact an answer to the following statement by André Breton in *Nadja:*

I know that if I were insane and had been shut up for a few days, I should take advantage of a temporary remission of my delirium to murder calmly someone or other, preferably the doctor, whom I found within my reach. I should thereby benefit at least through being placed, as agitated patients are, in a compartment by myself. I should perhaps be left in peace.

Breton's retort to Janet, De Clérambault et al., was made in *Le Surréalisme ASDLR,* no. 2 (October 1930):

Surrealism and Psychiatry[6]

.....On the other hand, considering from a purely psychological point of view the recent advance made in the treatment of mental diseases, it is evident that the main development has been the increasingly abusive condemnation of what, following Bleuler, has been called *autism* (egocentricity), a condemnation most convenient for the middle-classes, since it enables one to regard as pathological everything in man which is not his mere adaptation to the external conditions of life, since its purpose is to wear down secretly all cases of disobedience, insubordination, or desertion, which have or have not so far appeared worthy of respect (poetry, art, passionate love, revolutionary action, etc.). Accordingly, for M. Janet, and no doubt for M. Claude too,[7] it is at the moment the surrealists who must be autists. And an autist also just earlier must have

[5] The erudite Dr. de Clérambault, head of the Paris Police Headquarters' Special Infirmary for Lunatics, did not seem to realize that Leonardo da Vinci—for instance—showed that same "arrogant laziness" as the "processists" when he advised painters to find their inspiration in the shapes suggested by the cracks and stains of an old wall. M. Pierre Janet, on the other hand, alluded to a poem in "Poisson soluble" where there are some twenty other elements besides "turkey" and "top hat." As for Janet's approval of De Clérambault's deprecatory comments, it is all the more remarkable as he apparently never suspected that his onetime patient Raymond Roussel was the most systematic of "processists" in his poetic creation. See the next chapter.—M.J.

[6] From the translation in *This Quarter* (Paris), vol. 5, no. 1 (September 1932), under the title "Surrealism and Madness."

[7] Professor Claude was a psychiatrist at the Sainte Anne hospital for mental diseases, whose photograph André Breton published in *Nadja* with this commentary: "the cheek of people who ask you questions when you wouldn't have them clean your shoes, like Professor Claude at Sainte Anne, with his ignorant brow and his pigheaded expression ('They want to harm you, don't they?' 'No, sir.' 'He lies, last week he told me they wanted to harm him.' or again: 'You hear voices. Well, are they voices like mine?' 'No, sir.' 'Good, he's got auditory hallucinations,' etc.). . . ."—M.J.

been that young professor of physics who was examined at the Val-de-Grâce (the military hospital in Paris), because, having been posted to the *n*th Aviation Regiment, he "had very soon displayed his absence of interest in the Army and had told his fellow-soldiers that he looked upon war as horrible, since in his eyes it was but organized murder." (The case, according to Professor Fribourg-Blanc, who gives the results of his study of it in the *Records of Legal Medicine* for February, 1930, presented "marked schizoidal tendencies." As to that, please note that the case was found to display "a desire to be alone, interiorization, a disinclination for all practical activities, a morbid individualism, and idealist notions of universal brotherhood.") And, on these gentlemen's vile testimony, autists also very soon, i.e. liable to be turned aside at any moment from the road their sole conscience has led them to take, i.e. liable to be *confiscated at will,* will be all who insist on not adopting the watchwords behind which the community lurks to try to enforce upon everybody without exception a participation in its misdeeds.

We consider it is due to our honour to be the first to call attention to this danger and to make a stand against the unbearable, the increasing, abuse of power by people whom we are inclined to look upon as being not so much doctors as jailers and indeed as purveyors of penal settlements and scaffolds. *Because they are doctors,* we hold them to be less guiltless than others when they proceed indirectly with their low executioner's business. Surrealists or "Processists" though we may be in their eyes, we cannot urge them too strongly, even if some of them are doomed to be struck down accidentally by the blows of those whom they seek arbitrarily to control, to have the decency to shut up.

Raymond Roussel

In 1897, at the age of nineteen, Raymond Roussel wrote a long story in verse, *La Doublure,* which he believed would be a sublime masterpiece. But when his work was published, it remained absolutely unnoticed by the critics and the public. So violent was the shock for Roussel that the young man went through a period of depression accompanied by temporary physiological problems. His physician at the time, Pierre Janet, considered his case a peculiar state of "ecstasy" and described it in a study, *De l'Angoisse à l'Extase* (From Anguish to Ecstasy, 1926).[1] Later, in 1911, the peculiar qualities of a play adapted from Roussel's novel *Impressions d'Afrique* (Impressions of Africa), its matter-of-fact accounts of strange happenings involving unheard-of objects, attributes, senses, and deeds of real or imaginary beings, did not escape the attention of men like Apollinaire, Duchamp, Picabia, and of a few other poets (Edmond Rostand, the author of the popular drama *Cyrano de Bergerac,* was also among Roussel's first and most ardent admirers). But if the public paid some attention to Roussel's new work, it was to greet the performances with laughs, interruptions, protests, catcalls. Again, after World War I, other plays that Roussel staged at his own expense (no director would have accepted them, but Roussel was very wealthy) failed completely. Such was the fate of *Locus Solus* (Solitary Place; adapted in 1921 from Roussel's novel by Pierre Frondaie), of *L'Etoile au front* (The Starred Brow; 1924), and of *La Poussière de soleils* (Dust of Suns; 1928). By that time, apart from a very small number of writers and critics, the surrealists were Roussel's sole supporters, although he always remained outside their group and never participated in their activities.

In the marvelous world of his novels and plays, events sometimes took the shape of true fairly tales, such as in the following text that, although set in Canada, appeared in the novel entitled *Impressions d'Afrique:*

[1]Janet calls Roussel "Martial" in his study; Martial Canterel was one of the characters in Roussel's novel *Locus Solus* (see p. 322).

IMPRESSIONS OF AFRICA

The Bewitchings of Lake Ontario

On the shores of Lake Ontario lived a rich farmer of French origin named Jouandon. A widower, Jouandon had transferred all his affections to his daughter Ursule, a graceful child eight years old, placed under the care of a sweet and attentive Huron woman, the devoted Maffa, who had reared her as a wet nurse. An intriguer, a woman called Gervaise, who had remained single because of her ugliness and poverty, had taken it into her head to marry the wealthy farmer. Jouandon, a weak-willed man, fell into the trap of the amorous comedy cleverly enacted by the shrew, who soon became his second wife. Then life grew intolerable in the once peaceful and radiant home. In her apartment Gervaise installed her sister, Agathe, as well as her two brothers, Claude and Justin, all three as envious as herself; this infernal gang ruled the place, shouting and gesticulating from morning to night. Ursule was the main target of the scoffings of Gervaise and her confederates, and Maffa had great difficulty in protecting the little girl from the rough treatment that threatened her.

Within two years Jouandon died of consumption, undermined by grief and remorse, accusing himself of having caused his daughter's misfortune and at the same time his own by the deplorable union he had not had the will to break off. Gervaise and her three accomplices were more than ever set against the unhappy Ursule, whom they hoped to drive to her death, like her father, so as to seize her riches. One day the indignant Maffa visited the warriors of her tribe and described the situation to the old sorcerer Nô, well known for his far-reaching powers. Nô promised to punish the culprits and followed Maffa, who guided him toward the accursed house.

Along Lake Ontario, they caught sight of Gervaise and Agathe going toward the shore, escorted by their two brothers, who were carrying the still and silent Ursule; taking advantage of the nurse's absence, the four monsters had gagged the child, and they were on their way to throw her into the deep waters of the lake.

The group reached the banks of the lake without seeing Maffa and Nô hiding behind a cluster of trees. As the two brothers lifted Ursule's body to throw it into the waves, Nô uttered a magical and sonorous incantation that at once brought about four sudden metamorphoses.

Gervaise was changed into a she-ass and placed before a manger full of an appetizing bran; but as soon as she tried to come near the plentiful food, a kind of clamp closed her jaw and prevented her from satisfying her appetite. When, tired by this torture, she tried to go away from the deceitful temptation, a golden harrow rose before her like an unexpected obstacle that barred her way and was always ready to appear suddenly anywhere within a strictly delimited area.

Agathe was changed into a goose and ran madly away, chased by Boreus who blew a violent gale on her while lashing her with a thorny rose.

Claude kept his human body, but his head was changed into that of a boar. Three objects of different weights, an egg, a glove, and a piece of straw, began to jump between his hands, which, against his will, threw them unceasingly in the air and caught them again dexterously. Like a juggler who instead of controlling his toys is driven along by them, the unhappy fellow fled in a straight line, subject to a sort of magnetic force.

Justin, changed into a pike, was flung into the lake and compelled to swim around it indefinitely at full speed, like a horse let loose in a gigantic hippodrome.

Maffa and Nô went to Ursule to take off her gag. Full of pity and forgetting all resentment, the little girl, who had witnessed the quadruple phenomenon, wanted to intercede for her torturers. She asked the wizard to put an end to the charm, pleading warmly the case of the culprits, who, she said, did not deserve an endless punishment. Moved by such kindness, Nô gave her this valuable information: once a year, on the anniversary day and at the precise time of the incantation, the four bewitched victims would meet on the spot of the shore where the she-ass stood, the only one to be sedentary during the wild roamings of the others; their meeting would last one second only, no time for stopping being allowed to the unfortunate fugitives; if, at this hardly appreciable instant, a generous hand succeeded, equipped with some device or other, in fishing up the pike and throwing it on the shore, the charm would break at once, and human form would be given back to the four accomplices, but the least error in the liberating gesture would postpone the possibility of another attempt to the next year.

All the details of this revelation remained graven in Ursule's memory. She thanked Nô, who returned alone to the Indians of his clan.

One year later, a few minutes before the appointed time, Ursule took a small boat with Maffa and watched for the pike near the spot where the she-ass was vainly sniffing her full manger. Suddenly, the girl saw at a distance, in the transparent waters, the swift fish she was waiting for; at the same time, from the two opposite points of the horizon, the juggler with a boar's head and the goose cruelly flogged by Boreus rushed toward the same target. Ursule dipped a wide net vertically across the course of the pike, which penetrated like an arrow in the middle of the floating device. With a swift move the fishergirl tried to throw the fish on the banks of the lake. But the expiation, undoubtedly, was not yet sufficient, for the meshes, though fine and strong, allowed the captive to pass through and to fall back into the water, where it resumed its mad race. The juggler and the goose, reunited for one moment near the she-ass, met and passed each other without slackening their pace and soon disappeared in divergent directions. Evidently, Ursule's disappointment was due to a supernatural influence,

for after the event no rent showed on the undamaged meshes of the net.

Three other attempts, each separated by a year's interval, brought the same negative result. At last, the fifth year, Ursule made so clever and so swift a gesture that the pike reached the extreme edge of the shore without having time to slip through the imprisoning weft.

At once the human shape was restored to the four brothers and sisters, who, terrified by the possible prospect of a new bewitchment, left the country without delay, and no one ever saw them again.

The products of Roussel's imagination appear still stranger when they involve a logical explanation. The following episode from *Impressions d'Afrique* introduces one of the poet's most famous inventions, the one at least that most stimulated the audiences' merriment when it was performed as a play.

At a feast given an African king by the survivors of a shipwreck, while they are awaiting their return to Europe, one of the items on the program is a statue rolling on rails made of veal lungs. In the excerpt below from the novel, Roussel explains minutely how the feat was performed and describes a "real" object:

The statue evoked a man fatally struck through the heart by a weapon. His two hands were reaching instinctively to the wound while his legs were giving way under the weight of the body thrown backward and about to collapse. The statue was black and seemed at first sight to be made in one piece; but soon the eye discovered on it a multitude of grooves drawn in every direction and often creating many parallel groups. The statue was actually made of innumerable whalebones cut and bent as needed to mold its shape. Flat-headed nails, their points probably bent inward, kept together those supple thin blades, artfully joined without ever showing the least interstice. The face of the statue, with all the details of its pained and anguished expression, was made of well-fitted sections faithfully reproducing the shape of the nose, the lips, the brow, the eyeballs. It seemed that a great difficulty had been overcome with the handle of the weapon thrust into the heart of the dying man: its elegance was due to the presence of two or three whalebones cut into short ring-shaped fragments. The muscular body, the convulsed arms, the sinewy half-bent legs, everything seemed to quiver or suffer, owing to the striking and perfect contours given to the identical dark blades.

The feet of the statue rested on a very simple carriage, with a low platform and four wheels made of black whalebones cleverly arranged. Two narrow rails, in a raw, reddish gelatinous substance, which was nothing but veal lungs, were laid on a blackened wooden floor and, by their shape if not by their color, gave the exact illusion of a segment of a railroad track; the four motionless wheels rested upon these rails without crushing them.

The floor supporting the rails formed the upper part of a wooden pedestal, entirely black, bearing a white inscription that read: "The Death of the Slave Saridakis."

The story of the statue's model was the subject of a separate tale in Roussel's novel, but the important moment came when a trained magpie intervened to operate the machine:

Two hardly visible apertures, more than three feet apart, were pierced almost at ground level in the pedestal's side. The magpie came near the farthest aperture and suddenly plunged its beak in it to release some hidden spring. At once, the platform bearing the carriage began to tip slowly, one side dipping into the pedestal while the other side was rising above its usual level. The equilibrium broken, the vehicle laden with the tragic statue moved gently on the now perceptibly sloping gelatinous rails. The four wheels made of black blades were kept from derailing by an inner edge projecting slightly from their rim and maintaining them safely on the rails.

Reaching the end of the short slope, the small carriage was suddenly stopped by the pedestal's edge. During the few seconds of the ride, the magpie had hopped toward the other aperture, into which its beak disappeared swiftly, setting off the rocking motion in reverse. The vehicle—raised gradually, then borne along by its own weight—rolled motorless on its silent way and came to a stop against the opposite edge of the pedestal, whose side now rose as an obstacle before the lowered platform.

The seesaw motion was repeated several times through the action of the magpie, which hopped ceaselessly from one aperture to the other. The slave's statue remained fixed on the vehicle, following all its journeys, and the whole construction was so light that the rails, though lacking consistency, showed no sign of flattening or breaking.

In *Locus Solus,* as well as in *Impressions d'Afrique,* Roussel often explored a domain close to what is now called science fiction. In his usual anonymous, explanatory style, he described the wonders of a mansion called Locus Solus, owned by an inventor named Martial Canterel. Here is one short episode among many others no less marvelous:

The master was now leading us toward a sort of gigantic diamond, which, rising at the end of the esplanade, had already attracted our gaze by its extraordinary brilliance. Seven feet high and ten feet wide, the monstrous jewel, elliptically shaped, emitted in the sunshine almost blinding rays that adorned it with lightning flashing in every direction. Firmly held by a low artificial rock into which its relatively small base was embedded, it was faceted like a real precious stone and seemed to enclose several moving objects. Gradually, as we came nearer, we could perceive a vague music, of a marvelous quality, made of strange series of rising or descending runs, arpeggios, or scales.

Left: Raymond Roussel, 1911. *Center*: Raymond Roussel: *Impressions d'Afrique*, 1911. Cover for the program for the first performance (note the misspelling of Roussel). *Right*: Raymond Roussel: *Comment j'ai écrit certains de mes livres,* 1935. First page of the manuscript.

Actually, as we realized at close range, the diamond was nothing but an immense vessel filled with water. Doubtless some exceptional element entered into the composition of the captive fluid, for this water, and not the glass walls, was the source of all the irradiation that could be felt in every point of its mass.

A circular glance cast through any of the facets revealed the whole interior of the vessel. In its center, a graceful and slender young woman wearing a flesh-colored bathing suit stood completely immersed, gently swinging her head and taking various charming and aesthetic attitudes. A gay smile on her lips, she appeared to breathe freely in the liquid element surrounding her. Her magnificent hair, entirely spread out, rose above her head without, however, reaching the surface. Each hair was enclosed in a sort of thin aqueous sheath and the least motion made it vibrate under the friction of the fluid; the string thus created gave birth, according to its length, to a higher or lower sound. This phenomenon explained the fascinating music heard around the diamond. The clever young woman produced it at will, regulating her crescendos and diminuendos by the varying degree of strength or swiftness she gave to the oscillations of her neck. The melodious rise or fall of the scales, runs, and arpeggios covered three octaves at least. Often the performer, shaking her head slightly, remained confined to a very restricted register. Then, swinging her hips to impart a wide, continuous rocking motion to her bust, she used all the resources of her curious instrument, which reached its maximum range and sonorousness. This mysterious accompaniment

ideally suited the plastic attitudes of the young woman, who resembled some alluring undine. The tones had a singular savor due to the liquid environment that transmitted the sounds. . . .

The secret of Roussel's imagination or, more exactly, the secret process that "forced" his inspiration was revealed after his death (he committed suicide in Rome in July 1933) in a book published posthumously, in 1935 — *Comment j'ai écrit certains de mes livres.*

HOW I WROTE SOME OF MY BOOKS

I always intended to explain how I wrote some of my books (*Impressions d'Afrique, Locus Solus, L'Etoile au front, La Poussière de soleils*). It concerns a very special process, and it seems to me that my duty is to reveal it, for I feel that future writers could exploit it fruitfully.

Even at an early age I used this process to write stories a few pages long. I chose two almost identical words (it was something like "metagrams"), for instance, *billard* and *pillard.*[2] Then I added similar words taken in two different senses, and I obtained two almost identical sentences. For *billard* and *pillard,* the two sentences were as follows:

1. Les lettres du blanc sur les bandes du vieux billard.
2. Les lettres du blanc sur les bandes du vieux pillard.[3]

. . . Once the two sentences were found, the question was to write a story that would begin with the first sentence and end with the second one.[4] I found all my material in solving this problem. . . . Expanding the process, I searched for new words related to the word *billard,* using them always in a sense other than the one that appeared first. . . . Then I chose a word and connected it to another with the preposition *à,* and these words, used in a sense differing from the first sense, again brought a new creation I must say that this was a difficult task and it took me much time.

Roussel selected a number of examples showing how he created, from *double-entendre* words, various episodes of *Impressions d'Afrique* and other works. For instance, the story quoted above of the dying slave's statue made of whalebones and rolling on rails made of veal lungs, came from:

[2] "Billiards" and "pillager."—M.J.

[3] 1. "The letters written in white chalk on the old billiard-table cushions." 2. "The letters of the white man concerning the old pillager's gangs." — M.J.

[4] The two sentences above were used to write the story "Chiquenaude" (published in 1900). — M.J.

1. *Baleine à ilot;* 2. *Baleine à ilote*.[5] 1. *Mou à raille;* 2. *Mou à rail*.[6] These coupl-ings of words gave me the statue of the slave in whalebones rolling on rails made of veal lungs. . . . The process evolved and I was led to choose any sentence what-ever, from which I extracted images by dislocating it, as one does when making picture riddles. . . . I made use of anything . . . even of my shoemaker's name and address: "Hellstern, 5 Place Vendôme," out of which I obtained: *Hélice tourne zinc plat se rend (devient) dôme*[7]; the figure "5" [*cinq* in French] was chosen at random, I don't think it was correct. . . . "The Bewitchings of Lake Ontario" is built upon the lines in Victor Hugo's poem "Napoléon II." But here, there are many blanks in my memory that will oblige me to use ellipsis points.

> 1. *O revers, ô leçon, quand l'enfant de cet homme*
> *Eut reçu pour hochet la couronne de Rome,*
> *Quand on l'eut revêtu d'un nom qui retentit,*
> *Quand on eut pour sa soif posé devant la France. . .*
>
> 2. *Or effet herse ô le son séton*
> *Ursule brochet lac Huron drome (hippodrome)*
> *Carton hure oeuf fétu.*
> *. pourchasse oie rose aide vent*[8] . . .

This process, on the whole, is akin to rhyming. In both cases there is an unexpect-ed creation due to phonic combinations.[9] It is essentially a poetic process. For all that, one must know how to use it. And just as there is good and bad verse, good or bad books may be made with this process. . . . Its characteristics were to create "equations

[5] 1. "Whale islet" (Roussel probably thought of a whale appearing on the surface of the sea like a tiny island); 2. "Whale-bone helot."—M.J.

[6] 1. "Weakling derided" ("Here," wrote Roussel, "I thought of boys making fun of a lazy schoolfellow because of his in-competence"); 2. "Veal-lung rail."—M.J.

[7] "Screw revolves, flat zinc becomes dome"; hence an episode in *Impressions d'Afrique* where a creature discovered on the seabed, and looking like a plain zinc disk, takes on a domelike shape when an electric fan blows upon it.—M.J.

[8] From these lines in Hugo's poem on Napoleon's son, the King of Rome,

> "O reverses, o lesson, when this man's child
> Received as a toy the crown of Rome
> When he was invested with a resounding name
> When, to quench his thirst, was laid before France . . ."

Roussel extracted terms with similar sounds (in French):

> "Gold harrow effect o the bran . . . clamp
> Ursule pike Lake Huron hippodrome
> Cardboard boar's head egg piece of straw . . .
> Chases goose rose help wind . . ."

In these lines we recognize the main elements of the tale translated on pp. 319-21.—M.J.

[9] In the same manner, Max Ernst's collages and frottages are unexpected creations due to visual combinations.—M.J.

of facts" (Robert de Montesquiou's expression in a study on my books) to be solved "logically."[10]

The logic and the continuity that Roussel introduced in the discontinuity of his process, thus bringing heteroclite elements into close play, gave birth to mythological worlds full of magical substances and of beings endowed with powers that *exalted* the laws of nature, rather than creating new laws: a superhuman world, not an extrahuman or an extranatural one. In his neutral, conventional, and in a way, scientific style, the author accounted scrupulously for the strange behavior of his surrealistic creatures. His tales are like reveries where nothing can stop the realization of what appear as preconceived desires: the facts resulting from his wordplays. Thus the story in *Locus Solus* of the diamond-shaped vessel that is filled with a superoxygenated, luminous fluid in which ground creatures can naturally breathe, where electricity produces music, etc., derives from an association of words that actually produced new phenomena. So logically scientific are those answers to "equations of facts" that they appear here to be a premonition of electronic music. In the beginning was the Word. . . .

When Roussel's *L'Etoile au Front,* staged in 1924 at the Théâtre du Vaudeville in Paris, was published the next year in book form, Paul Eluard reviewed it in *La Révolution surréaliste,* no. 4 (July 15, 1925):

Raymond Roussel, *The Starred Brow*

Here stand the storytellers. One begins the tale, the other goes on. They are marked with the same sign, they are prey to the same imagination that supports earth and sky upon its head. All the tales of the world are woven with their speech, all the stars of the world are on their brows, mysterious mirrors of the dream's magic and of the most bizarre, the most marvelous facts. Will they amuse these insects making monotonous music while thinking and eating, hardly listening, not understanding the greatness of their delirium?

They are conjurers, now they change pure and simple words into a mass of characters upset by objects of passion, and it is a golden ray that they hold in their hands, and

[10] Some years ago we came across another example of creation through phonic equivalents. The book entitled *Mots d'Heures: Gousses Rames,* by Luis d'Antin van Rooten (New York: Grossman Publishers, 1967) is a collection of Mother Goose rhymes phonetically translated, so to speak, into allegedly old-fashioned French. For instance, the nursery rhyme: "Pussy cat, pussy cat, where have you been? I've been to London to look at the Queen," etc., becomes in Van Rooten's version: "*Pousse y gâte, pousse y gâte/Et Arabe, yeux bine? A ben, tout l'on donne/Toluca de couenne,*" etc. In a footnote, the author "explains" this sequence of words as follows: "In the first speech, an Arab is chided for planting a crop, then allowing it to spoil, while merely eyeing his hoe. The Arabs are a traditionally nomadic people, not given to agriculture. In his reply, our hero admits he was building castles in Spain, dreaming of a pigskin from Toluca (famous market town, capital of the State of Mexico, Mexico). These pigskins make excellent water bags—an item of great interest to a desert-dweller," etc.

Identical to that of the author of *Locus Solus*—but bilingual in addition—this technique does not fail to produce irrational "equations of facts," treated here humorously. As might be expected, it was Marcel Duchamp who made us acquainted, at the time, with this rousselian little book.—M.J.

it is the blossoming of truth, dignity, liberty, felicity, and love.

Let Raymond Roussel show us that which has not been. We are a few to whom this sole reality matters.

Among writers of the past, Roussel admired Jules Verne above all others. In *Comment j'ai écrit certains de mes livres,* he said:

I want also, in these notes, to pay homage to the man of incomparable genius that Jules Verne was. I admire him infinitely. In certain pages of *Journey to the Center of the Earth, Five Weeks in a Balloon, Twenty Thousand Leagues under the Sea, From the Earth to the Moon and Around the Moon, The Mysterious Island, Hector Servadac,* he rose to the highest summits that the human word can reach. I was fortunate enough to be able to visit him in Amiens, where I was doing my military service, and to shake the hand that wrote so many immortal works. O incomparable master, be blessed for the sublime hours that I have spent reading you again and again.

Several of Roussel's productions, *La Doublure, La Vue* (The View), *Nouvelles Impressions d'Afrique* (New Impressions of Africa), and other shorter pieces, were not composed by the process revealed in his posthumous book. In these works the reader is somewhat staggered by descriptions that overreach the usual frame of the descriptive genre, that are, in a way, superdescriptions. The more than one hundred pages of *La Vue* (1904) are devoted in their entirety to the description of all the smallest, most microscopic details of a minute photographic landscape, set under a tiny magnifying glass in the holder of a pen or pencil — such an object can be found in souvenir shops — as if this extremely reduced picture was seen infinitely enlarged by a writer endowed with a superhuman visual sense. As for *Nouvelles Impressions d'Afrique* (which has practically nothing to do with Africa), the book is a series of enumerations enclosed in parentheses opening inside one another, interlocking like nested tables and containing endless lists of facts suggested by some word or other in the preceding parentheses. And strangest of all, *La Doublure, La Vue,* and *Nouvelles Impressions* are written in alexandrine verse!

But Roussel's prosody, flat and strained, completely lacks the rhythm and music that are the attributes of rhymed poetry. Moreover, *Nouvelles Impressions* is illustrated in an utterly banal fashion, with pictures that were commissioned by the author himself from a draftsman who signed himself "Zo."[11] When the book was published in 1933, Salvador Dali wrote in *Le Surréalisme ASDLR,* no. 6 (May 15, 1933): "The choice of illustrations is a further proof of Raymond Roussel's genius." The real question would be, however, whether it was proof of conscious or unconscious humor. In any case, for an analyst interested in the author's psychology, verse and choice of illustrator would have the value, mainly, of symptoms.

The genius of Raymond Roussel lay indeed beyond the usual categories of literature and

[11] A name that may be read as an abbreviation of "zero" — indicative of the artistic value of the drawings...?

art, and it could express itself, masterfully, in other fields as well. In 1932 the author of *L'Etoile au Front* became interested in chess. Within three months, he had found the solution to one of the oldest and most controversial chess problems, a riddle studied and discussed, without convincing results, since the days of Philidor, the famous chess player and musician of the eighteenth century; it concerned the mate by the Bishop and the Knight.[12]

[12] Roussel's formula, extremely concise but decisive, was published in the review *L'Echiquier* in November 1932, explained and commented by the great master Tartakover (also reproduced in *Comment j'ai écrit* . . . with several articles on Roussel as a chess player).

THE
SURREALIST
EXPLOSION

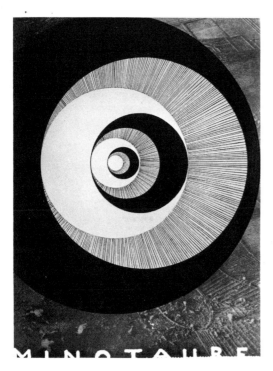

SOMMAIRE

N° 1 MINOTAURE Prix : 25 frs
(NUMÉRO SPÉCIAL)

¡La couverture de ce numéro est spécialement composée par PICASSO!

FRONTISPICE : Minotaure, eaux fortes de Picasso.

CHRONIQUE
L'art du troussan .. PIERRE REVERDY.
Un visage dans l'herbe PAUL ÉLUARD.
Coup de lune dans l'eau MAURICE RAYNAL.
A propos de la réédition de « Contes bizarres »
 d'Achim d'Arnim ANDRÉ BRETON.
Peintures ... E. TÉRIADE.
L'empreinte de l'Art RENÉ CREVEL.
Chronogrammes ... MARCEL JEAN.

Les Présages, ballet, par ANDRÉ MASSON

Le Fronton de Corfou
 Documents inédits sur la reconstitution du fronton de
 la Gorgone. Avec une notice de Max Raphael.

Picasso dans son élément ANDRÉ BRETON.
 L'atelier de peinture
 L'atelier de sculpture
 Sculptures
 Soixante reproductions inédites, constituant un document
 complet sur les sculptures récentes de Picasso.
 Photographies de l'atelier de peinture, de l'atelier de sculp-
 ture et des sculptures, par Brassaï.

Crucifixions ..
 Suite de dessins de Picasso, exécutés d'après la Crucifixion
 de Grünewald (Musée de Colmar) (inédits)

Une Anatomie ... PABLO PICASSO.
 Cahier de 18 dessins récents

Note éternelle du Présent PIERRE REVERDY.

Variété du corps humain MAURICE RAYNAL.

Valeur plastique du mouvement E. TÉRIADE.

Notes sur le Baroque MAX RAPHAEL.

Dramaturgie de Sade MAURICE HEINE.
 Étude sur le théâtre du Marquis de Sade et ses tendances
 psychologiques.

Sujet de « Zéloïde » D. A. F. DE SADE.
 Scénario inédit de cette pièce écrite sous le titre de Sophie
 et Desfrancs, reçue au Théâtre-Français, mais non
 publiée. Texte établi par Maurice Heine sur le manuscrit
 autographe.

Massacres .. ANDRÉ MASSON.
 Cahier de dessins.

Le Miroir de Baudelaire PAUL ÉLUARD.
 Portrait de Baudelaire, un dessin et une gravure par
 Henri-Matisse.

Interprétation paranoïaque-critique de l'image
 obsédante « L'Angélus » de Millet SALVADOR DALI.

Le problème du style et les formes paranoïaques
 de l'expérience ... Dr. LACAN.

Les Sept Péchés capitaux KURT WEILL.
 Deux pages manuscrites de la partition musicale d'un
 ballet inédit.

Suite de dessins préparatoires de Henri-Matisse, pour
 « L'Après-midi d'un faune » de Stéphane Mallarmé.

Danses funéraires Dogon MICHEL LEIRIS.
 Carnet de route.
 Premiers documents de la Mission Dakar-Djibouti.

Left: Marcel Duchamp: Cover of *Minotaure*, no. 6
(December 1934). *Right*: Table of contents, *Minotaure*,
no. 1 (1933).

Minotaure

Minotaure, a luxurious art magazine founded in Paris in May 1933 by Albert Skira, the Swiss publisher, had other aims than being an experimental review similar to surrealist publications of the past. An eclectic magazine linked with various art circles and edited by the critic Tériade, it devoted much space to contemporary masters, such as Derain and Matisse, or to Seurat, Degas, and Cézanne, and of course, to Picasso, who created the cover for the first issue, while his latest sculptures were introduced in an article by André Breton, in that same first issue— "Picasso dans son élément" (Picasso in His Element). But the contributions made to the review by André Breton and the other surrealists—who finally took over the editorship— gave surrealism the possibility of illustrating its own multiple aspects to a larger public through the pages of *Minotaure.* In a series of brilliant articles Breton developed his favorite themes of automatism ("Le Message automatique" [The Automatic Message], no. 3-4, December 1933), convulsive beauty ("La Beauté sera convulsive" [Beauty Will Be Convulsive], no. 5, May 1934), love and coincidences ("La Nuit du tournesol" [The Night of the Sunflower], no. 7, June 1935 which recalled his meeting with Jacqueline, who was to become his second wife), precursors of surrealism ("Têtes d'orage" [Storm Heads], no. 10, December 1937). In helping to demonstrate the growing influence of the movement and its presence in all the fields of intellectual activity, *Minotaure* became the richest in content, the most modern, and the best-informed of all such publications at the time.[1] "It is impossible," proclaimed an advertisement for no. 3-4, "today to separate plastic art from poetry and science." Poems and studies on literature, texts on ethnography, psychology, the "secret sciences," divinatory techniques, as well as folkloric art, appeared in all the issues.

Magnificently illustrated, with reproductions of works by Tanguy, Max Ernst, Miró, and

[1]All the texts that Breton wrote for *Minotaure* were collected, with others, in his books *Point du Jour, L'Amour Fou, Anthologie de l'humour noir,* or in enlarged editions of *Le Surréalisme et la Peinture.*

practically all the other surrealist artists at that time—with photographs by Man Ray, Brassaï, Ubac, and others, with many hitherto unpublished documents on art and literature, *Minotaure* had covers specially made by Picasso, Matisse, Duchamp, Ernst, Magritte, Dali, Miró. "The luxuriousness of *Minotaure* must be considered an organic necessity," wrote Skira and Tériade, introducing no. 6, in December 1934.

Several newcomers to the surrealist group became contributors to *Minotaure*. Pierre Mabille, a physician with an interest in art and philosophy, began to frequent André Breton's circle in the middle 1930s, and wrote several articles on physiology, anthropology, and related topics for *Minotaure*. In no. 11 (May 1938), he published the following piece on drawings by Seurat:

The fiery night inscribed no direct trace of fantastic nightmares on this great chaste brow: Seurat's drawings are more evocative of the mysteries of dawn and sunset. On awakening, what does the eye retain of the dew of dreams and what does it perceive already of the town? In the strange gray-colored city, light introduces its gradual triumph. Fragments of space rebel against the piercing rays and become objects. A world stripped of details supports the poet's surprise. Beings and things, forgetful of their toilsome birth, rise without a past from the nocturnal communion. Phantoms crystallize their fluidity. Will they make their bodies vanish as fast, woven in the light?

Cleared of singular incidents, of flashes, of too precise shadows, the universe recovers its unity. Intervals or "values," neighboring contrasts, sing the cosmic symphony of sensitive undulations. The identity of light and conscience erases the boundaries between man and things. From white to black, by the interplay of the paper and the black-lead pencil, only one shiver, one testimony. But when daylight has triumphed, man confidently eliminates his primitive certitude, he forces himself to re-create piece by piece a world at his will. Rising above fleeting notations, brief instants of infallible sensibility, Seurat becomes a conscious painter. He defies the Nature that moved him.

By intelligence, by science, he possesses the key to the universe in the equation of light. On canvas, pigments, exactly juxtaposed, will reconstruct the architecture of the moving waves. The marvel of a permanent work makes the consciousness believe in its victory. In this voyage that all mankind repeats, happy is the clear act that finds again the emotion of awakening: beyond the unresolved problem, it gives the drawings of Seurat their fundamental meaning.

Maurice Heine, whom we have mentioned already as the great specialist and rehabilitator of the Marquis de Sade, contributed to *Minotaure* studies on violence in the arts of the past. His were typical "sadistic criticisms" such as, for instance, his "Martyres en taille-douce" (Engraved Martyrdoms) in no. 9 (October 1936), about old engravings of scenes of torture or, under

the title "*Eritis sicut dii . . .*" ("You will be like gods . . . ," words said to Eve by the Serpent in the Garden of Eden to invite her to taste the fruit of the Tree of Good and Evil), in *Minotaure,* no. 11 (May 1938), about Tibetan images of Buddha that Maurice Heine compares to Minotaure himself.

Under the title "L'Age de la lumière," Man Ray developed his views on artistic creation in *Minotaure,* no. 3-4 (December 1933).

The Age of Light

In this age, like all ages, when the problem of the perpetuation of a race or class and the destruction of its enemies is the all-absorbing motive of civilized society, it seems irrelevant and wasteful still to create works whose only inspirations are individual human emotion and desire. The attitude seems to be that one may be permitted a return to the idyllic occupations only after meriting this return by solving the more vital problems of existence. Still, we know that the incapacity of race or class to improve itself is as great as its incapacity to learn from previous errors in history. All progress results from an intense individual desire to improve the immediate present, from an all-conscious sense of material insufficiency. In this exalted state, material action imposes itself and takes the form of revolution in one form or another. Race or class, like styles, then become irrelevant, while the emotion of the human individual becomes universal. For what can be more binding among beings than the discovery of a common desire? And what can be more inspiring to action than a confidence aroused by a lyric expression of this desire? From the first gesture of a child pointing to an object and simply naming it, but with a world of intended meaning, to the developed mind that creates an image whose strangeness and reality stir our subconscious to its inmost depths, the awakening of desire is the first step to participation and experience.

It is in the spirit of an experience and not of experiment that the following autobiographical images are presented.[2] Seized in moments of visual detachment during periods of emotional contact, these images are the oxidized residues, fixed by light and chemical elements, of living organisms. No plastic expression can ever be more than a residue of an experience. The recognition of an image that has tragically survived an experience, recalling the event more or less clearly, like the undisturbed ashes of an object consumed by flames, the recognition of this object so little representative and so fragile, and its simple identification on the part of the spectator with a similar personal experience, precludes all psycho-analytical classification into an arbitrary decorative system. Questions of merit and of execution can always be taken care of by those who hold themselves aloof from even the frontiers of such experiences. For

[2]This text is also the preface (published in English, French, and German) to *Photographs by Man Ray* (an album of his works 1920-34) (Hartford, Conn.: James Thrall Soby, 1934; and Paris: Cahiers d'Art, 1934). — M.J.

whether a painter, emphasizing the importance of the idea he wishes to convey, introduces bits of ready-made chromos alongside of his handiwork, or whether another, working directly with light and chemistry, so deforms the subject as almost to hide the identity of the original, and creates a new form, the ensuring violation of the medium employed is the most perfect assurance of the author's convictions. A certain amount of contempt for the material employed to express an idea is indispensable to the purest realization of this idea.

Each one of us, in his timidity, has a limit beyond which he is outraged. It is inevitable that he who by concentrated application has extended this limit for himself, should arouse the resentment of those who have accepted conventions which, since accepted by all, require no initiative of application. And this resentment generally takes the form of meaningless laughter or of criticism, if not of persecution. But this apparent violation is preferable to the monstrous habits condoned by etiquette and estheticism.

An effort impelled by desire must also have an automatic or subconscious energy to aid its realization. The reserves of this energy within us are limitless if we draw on them without a sense of shame or of propriety. Like the scientist who is merely a prestidigitator manipulating the abundant phenomena of nature and profiting by every so-called hazard or law, the creator dealing in human values allows the subconscious forces to filter through him, colored by his own selectivity, which is universal human desire, and exposes to the light motives and instincts long repressed, which should form the basis of a confident fraternity. The intensity of this message can be disturbing only in proportion to the freedom that has been given to automatism or the subconscious self. The removal of inculcated modes of presentation, resulting in apparent artificiality or strangeness, is a confirmation of the free functioning of this automatism and is to be welcomed.

Open confidences are being made every day, and it remains for the eye to train itself to see them without prejudice or restraint.

Max Ernst, in no. 5 (May 1934), published a poetic "catechism of the forester"—"Les Mystères de la forêt."

The Mysteries of the Forest

What is a forest?—A wonderful insect. A drawing board.

What do the forests do?—They never go to bed early. They wait for the tailor.

What is the most beautiful season for the forests?—It is the future; the season when the masses of shadows will be able to change into speeches.

But this is the past, it seems to me. —Perhaps.

In this past epoch, did nightingales believe in God? —In this past epoch, nightingales didn't believe in God; they had formed a friendship with mystery.

And what was man's position? —Man and nightingale were in the most favorable position to *imagine:* the forest was a perfect leader of dream for them.

What is dream?—You're asking me too much: it's a woman felling a tree.

What are the forests used for? —For making matches, which are given to children to play with.

So the forest is on fire? —The forest is on fire.

What are the forests feeding on? —On mystery.

What day are we today? —Shit.

How will forests end? —The day will come when a forest, until then a friend of dissipation, will decide to frequent decent places only, main roads and Sunday drivers. It will feed on canned newspapers. Letting itself being won over to virtue, it will lose the bad habits acquired in its youth. It will become geometrical, conscientious, impecunious, grammatical, judicial, pastoral, ecclesiastical, constructivist, and republican. It will be boring.

The weather will be fair? —You bet! We'll go to the presidential hunt.

Will this forest be called Blastule or Gastrule? —It will be called Mme. de Rambouillet.

Will the forest be praised for her new behavior? —Not by me. The forest will find that very unjust, and one day, unable to bear it any longer, it will go and deposit its rubbish in the nightingale's heart.

What will the nightingale say? —The nightingale will be skinned. He will answer: "My friend, you're worth even less than you're reputed to be. Go take a stroll to Oceania, and you'll see."

Will it go? —Too proud.

Are there still forests over there? —It is said that they are wild and impenetrable, black and russet, extravagant, centuries-old, diametrical, careless, ferocious, fervent and amiable, without yesterday or tomorrow. From one island to the other, over the volcanoes, they play cards with odd packs. They are nude and only adorn themselves with their majesty and their mystery.

Most of the pieces Paul Eluard published in *Minotaure* were of an anecdotal character. In no. 3-4 many items from the poet's collection of curious and rare postcards were reproduced. For no. 5, he annotated a popular eighteenth-century print entitled "Men's Folly or the World Upside Down." In December 1937 (no. 10), *"Premières vues anciennes"* was mainly a

selection he made of brief excerpts from surrealism's favorite poets. "Juste Milieu" (in no. 11, May 1938) was Eluard's last contribution to the review:

Golden Mean

BALTIMORE: The town of Baltimore has two sides, sharp ones like a wooden shoe to the buttocks of a bittern. In the abattoir district, laughter, clear as a dove, lengthens the warm evenings, which are love itself. Elsewhere, fluff prevails. In Baltimore, when the weak point is found, the rest goes by itself. Baltimore is built of the beautiful wood blondes are made of. The town's motto: *Que lirite tu sade.* . . .

FESTOON: This festoon, it seems, was myself. Grapes, cornflowers, tulips, a yellow fruit between two green leaves, tufts of yellow feathers in the center of a flat and well-opened star and a tiny bit of festoon. I was proud, proud to the point of splitting my vertebrae.

NURSE: Nurse, naiad, I always linked these two words, because a charming water nymph was for me the second mother who keeps the best part of our filial love. She took me with her, laid me on the waterside, made me play with a reed or a seaweed. The waves rocked me, the white sail of a passing vessel curled tenderly over me, and I saw the sky, the clouds up above, I saw the supple head of the poplars swaying in the wind, and soon I was sleeping to the song of washerwomen and swallows. . . .

SERVANT: "That is what we used to do, Excellency. When our foot met the last step buried in the dark, we leaned against the stone door of the vaults and we looked up again with a dazzled gaze. And Your Excellency used to ask me to explain to him, for the hundredth time, our reasons for being like moles breaking cover."

EYES: My eyes, patient objects, were forever opened on the expanse of the seas, where I was drowning. A white speck of foam passed at last on the fleeing black point. Everything faded out.

During the months preceding World War II, Paul Eluard separated from André Breton and his group. His name had disappeared from the editorial board of *Minotaure* by the last issue of the review, no. 12-13, May 1939.

In no. 3-4 (December 1933), Salvador Dali developed theories on the importance of art nouveau, opposing the "psychic decorativism" of that style to a modernist "antidecorative decorativism." The same idea of a relationship between the decorative and the psychic appeared in a text by Tristan Tzara, also in no. 3-4: "D'un certain automatisme du goût." Women's clothes, said Tzara, and especially the shapes of their hats, proved that "a woman is never mistaken in her tastes," since the personal details of her dresses could metaphorically reveal her desires, her impulses. At the end of his article, Tzara raised the problem of architecture, of man's dwelling places, viewed in the same symbolic light:

On a Certain Automatism of Taste

"Modern" architecture, as hygienic and stripped of ornaments as it wishes to appear, has not the least chance to live—it will barely survive, thanks to transitory perversions that a generation fancies it has a right to express by punishing itself for who knows what unconscious sins (bad conscience, perhaps, rising out of capitalist oppression). This architecture is a complete denial of the dwelling place. From the cave—for man used to live inside the earth, the "mother"—through the Eskimo yurt, an intermediate form between grotto and tent and a remarkable instance of uterine construction with its vagina-shaped accesses, to the conical or semispherical hut with a pole of a sacred character at the door, the dwelling place symbolizes prenatal comfort. When what was stolen from man during his adolescence, which he had possessed as a child, is restored to him—the realms of "luxury, calm, and voluptuousness"[3] that he built for himself under the blankets of his bed, under the tables, or in hollows of the earth, mainly those with a narrow entrance; when it is understood that comfort resides in the half-light of the soft tactile depths of the one and only possible hygiene, that of pre-natal desires—then circular, spherical, and irregular houses will be built again, which man kept from cave to cradle and to tomb in his vision of an intrauterine life and which the aesthetics of castration, called modern, ignore. It will not be a return to past epochs but really a progression beyond what we believed was progress, since these settings will make the most of the attainments of modern life. It will give our most powerful latent and eternal desires the possibility of freeing themselves normally. Their intensity cannot have changed greatly since man's age of savagery, only the ways of satisfying them have been broken up and dispersed over a larger mass and, weakened to the point of losing the sense of true reality and of quietude, together with their acuteness, they have, through their own degenerescence, prepared the way for the self-punitive aggressiveness that characterizes modern times.

This text of 1933 probably escaped the attention of a young artist who did not meet the surrealists until 1937—Roberto Matta Echaurren. But we find preoccupations very similar to Tzara's in Matta's article "Mathématique sensible, architecture du Temps," which was published in *Minotaure,* no. 11 (May 1938)—a search for new and more "livable" shapes in human dwellings, satisfying unconscious desires as well as material needs.

Matta's training as an architect, first in his native country, Chile, then while working as a designer in Le Corbusier's office in Paris, had given him a wide experience in architectural problems, though he never shared the rationalistic ideas of his onetime employer. His bold approach to modern architecture may be considered, in the following text, a renewal of art nouveau principles—minus, however, their leading feature: ornament.

[3]Baudelaire.—M.J.

Sensitive Mathematics—Architecture of Time

The question is to discover the way to pass between the rages that move in tender parallels, in soft and thick angles, or under hairy undulations through which many fears are clinging. Man regrets the dark thrusts of his origins, which wrapped him in wet walls where blood was beating near the eye with the sound of the mother. Let man cling on, let him encrust himself until he possesses a geometry where the rhythm of crumpled and mottled paper, of breadcrumbs, where the desolation of smoke is for him like the pupil of the eye between his lips. . . .

We must have walls like wet sheets that get out of shape and fit our psychological fears; arms hanging between switches that throw a light barking at shapes and at their colored shadows, able to wake up the mouth's gums themselves like sculpture for lips. . . .

Very appetizing pieces of furniture with molded profiles come forward, unroll unexpected spaces, yielding, folding, curving like stairs under water, leading to a book that, from mirror to mirror, reflects its images in an unformulated course delineating a new architectural, habitable space. There would be seats relieving the body of all the weight of their right-angle past as armchairs; which, relinquishing the stylistic origin of their predecessors, would open themselves to elbows, to napes, fitting into infinite motions, according to limbs becoming conscious and life intensity.

Find for each of these umbilical cords linking us with other suns objects of total liberty which would be like plastic psychoanalytical mirrors; and certain hours of rest, as if, among other things, masked firemen, crouching to intercept no shadows, would bring to my lady a card full of doves and a package of money boxes. A cry would be needed against the right-angle digestions in the middle of which one lets himself be stupefied, gazes on numbers resembling labels, and observes things under one aspect only among many others. . . .

And we'll begin to waste it, this dirty and perforated time that the sun offers us. And we'll ask our mothers to give birth to a piece of furniture with lukewarm lips.

In the sixth number of *Minotaure* (December 1934) Ambroise Vollard's "Souvenirs sur Cézanne" (Recollections of Cézanne) were published. But in no. 8 (June 1936), Salvador Dali's references to Cézanne, in an article on Pre-Raphaelite art, contrasted strongly with the famous collector's homage, and were reminiscent of Picabia's judgment of Cézanne: "This painter has the brains of a fruit vendor."[4] Dali expresses his opinion more elaborately:

[4] Quoted by André Breton in his article on Francis Picabia in *Les Pas perdus*. In another article in the same collection, "Distances," Breton wrote further: "If we had been under other influences [than Cezanne's], maybe we wouldn't have eaten so many apples."

The Spectral Surrealism of the Pre-Raphaelite Eternal Feminine

> *History of Art should be rewritten according to the paranoiac-critical method.*
> — Salvador Dali

The characteristic sluggishness of the modern spirit is one of the reasons that surrealism is happily misunderstood by all those who, with a real intellectual effort, holding their nostrils and closing their eyes, tried to bite into Cézanne's supremely inedible apple, being satisfied, afterward, to look at it purely as "spectators" and to love it platonically, since the structure and sex appeal of the said fruit did not allow going further. These people, deprived of appetite, believed precisely that all the worth and all the aesthetic health of the mind resided in the simplicity of this antiepicurean attitude. They believed that Cézanne's apple had the same weight as Newton's and once more they were sadly mistaken, for in reality, the gravity of Newton's apple lies supremely in the weight of the Adam's apples of the curved physical and moral necks of the Pre-Raphaelites. This is why, while it was wrongly believed that Cézanne's cubic aspect represented a materialistic tendency that consisted, in a way, of relying firmly on inspiration and lyricism, we see now that this painter, on the contrary, increased the impulse toward the absolute idealism of formal lyricism that, far from staying on earth, took its flight toward the clouds. . . . But those who began to rely firmly on inspiration were precisely the languishing and so-called immaterial Pre-Raphaelites. . . .

And why shouldn't Salvador Dali be dazzled by the flagrant surrealism of English Pre-Raphaelitism? Pre-Raphaelite painters bring us resplendent women, the most desirable and at the same time the most frightening ones. . . . These fleshy concretions of excessively ideal women, these feverish and panting materializations, these floral and soft Ophelias and Beatrices, appearing to us through the light of their hair, carry the same effect of alluring terror and repulsiveness as the tender green belly of the butterfly seen between the light of its wings. There is a painful and fainting exertion of the necks holding these women's heads; their eyes are heavy with star-spangled tears, their hair is heavy with luminous fatigue and halos. There is an incurable weariness in their shoulders, which collapse under the blossoming of this legendary necrophilic spring to which Botticelli alluded vaguely. But Botticelli was still too near the myth's live flesh to reach this exhausted, magnificent, and prodigiously material glory of the psychological and lunar "legend" of the Western World.

This peculiar "platonic love" attacked by Dali was perhaps best illustrated by a remark Ambroise Vollard overheard and carefully recorded in his "Souvenirs sur Cézanne," made by a man looking at a landscape by the painter: "Each time I look at this painting I'm telling

myself 'Here is a place where I'd like to go fishing Sundays'; they're lucky, those who own such a well-built house! I know what I'm saying. I'm a bricklayer." Dali could not remain deaf to that sort of prompting, and he went on, in his article on Pre-Raphaelitism:

From a morphological point of view, Cézanne appears to us a kind of platonic brick-layer who is satisfied with the plane of the straight line, of the circle, of regular shapes in general, and who ignores geodesic curves, which, as is well known, are in certain respects the shortest way from one point to another. Cézanne's apple tends toward the same fundamental structure as that of the skeleton of siliceous sponges, which as a whole is none other than the rectilinear and orthogonal scaffolding of our brick-layers and in which one discovers with amazement numerous corpuscles materially realizing the "trirectangular dihedral" well-known to geometers. I say that it *tends* toward orthogonal structure because in reality, in the apple's case, this structure is battered, deformed, and denatured by a kind of "impatience" that led Cézanne to so many poor results. While Cézanne's apple is a sort of "phantom sponge," that is to say, while it claims to have a weightless volume, a "virtual volume," the Adam's apples of Rossetti's beautiful luminous women are, on the contrary, moral subcutaneous apples, spectral necessarily, covered up with the "geodesic" tissue of the muscles and with the "catenary curves" of translucent lunar dresses. . . .

It was in that same issue of *Minotaure* (no. 8) that André Breton introduced Oscar Dominguez's revelation of *decalcomania,* those automatic plates that the painter, a few months earlier, had first shown to his surrealist friends.

On a Decalcomania without Preconceived Subject (Decalcomania of Desire)

The forest, suddenly darker, taking us back to the times of Geneviève de Brabant, of Charles VI, of Gilles de Rais, then offering us the giant flower of its clearing — a certain *sublime point* in the mountains — bare shoulders, foam, and needles — delirious boroughs inside grottoes — black lakes — the will-o'-the-wisp on the moor — what the first poems of Maeterlinck and Jarry caught sight of — flying heaps of sand — rocks, their brows eternally in their hands, caressed or not by dynamite — submarine flora — all the abyssal fauna parodying human effort, its representation and its comprehension (if I take as a pattern only this monster whose beak is provided with three hooks — armed for angling? — exploding when it is taken up to the surface, like a burst of laughter at our expense) — what challenges plastic figuration in complexity, minuteness, instability, whose artistic imitation, were it only a tuft of moss, would seem boring and childish

to the utmost — all that the words *désespoir du peintre*[5] (and of the photographer), would include — all that is restored to us by our friend Oscar Dominguez's recent communication, in which surrealism is pleased to see a new source of emotions *for all*. . . . Dominguez's discovery lies in the method for obtaining ideal fields of interpretation. Here is reborn in its purest state the charm under which Arthur Rackham's rocks and trees held us when we were emerging from childhood. The question is, once again, of a procedure *within everyone's reach* that demands to be included in the "Secrets of the Surrealist Art" and that may be formulated as follows:

To open at will one's window
on the most beautiful landscapes of the world and elsewhere

With a brush spread black gouache, more or less diluted, on a sheet of smooth paper upon which you at once apply a similar sheet. Then, gently lift this second sheet by one of its edges, the same way as you do for decalcomanias; you may even reapply it and lift it again until almost dry. What you obtain is perhaps only Leonardo's old paranoiac wall, but it is this wall *brought to its perfection*. It would be enough, for instance, to give the image a title according to what you discover in it after a while to be assured that you have expressed yourself in the most personal and the most valid manner.[6]

Following Breton's introduction, a series of decalcomanias was reproduced, made by Dominguez, Yves Tanguy, Marcel Jean, André and Jacqueline Breton, and Georges Hugnet, "illustrated" by a fairy tale that those plates had led Benjamin Péret to imagine.[7]

In *Minotaure*, no. 12-13 (May 1939), under the title "L'Oeil du Peintre," a distressing accident suffered by the Rumanian painter Victor Brauner—a member of the group since 1934—was recorded and analyzed by Pierre Mabille.

The Painter's Eye

The savage explosion of a drama involving people knowing each other for a long time and whose relations seem definitely established has a mysterious character. This equilibrium is unstable; suddenly, a quarrel arises, and no one, on the spot or later, can clear up its real motives. . . . A scene of this kind took place one evening in D——'s studio. D—— got violently angry with one of his friends, the two men were separated to

[5]"Despair of the painter" is the common name, in French, of the flower saxifrage ("London pride"). — M.J.

[6]No surrealist at that time, and certainly not Dominguez, was aware of the existence of the Rorschach test, based on symmetrical decalcomanias. On the other hand, Dominguez's "discovery" was a rediscovery, as is always the case, it seems, with discoveries in technique. See our *History of Surrealist Painting*, p. 266.—M.J.

[7]Later, Max Ernst made extensive use of the process, creating in that manner some of his most remarkable pictures, for instance, *The Eye of Silence* (1943-44), now at the Washington University Gallery of Art, St. Louis, Missouri.

prevent a regrettable fight, Victor Brauner holding back D——'s opponent. But frantically D—— freed one arm, grabbed the first projectile he could reach—a glass; he threw it. Brauner collapsed, covered with blood, his left eye torn out.

. . . The official theses on chance could be accepted only if they showed that no previous fact foreshadowed the accident. But we shall see that Brauner's whole life converged toward this mutilation. The key to the man's psychology and the solution that throws light on the painter's previous activity are in it. . . . In a self-portrait dated 1931 Brauner painted himself with an eye put out. On a picture of the same period a man under a parasol appears blind in one eye. A rather mysterious canvas, decorated with signs like those of the old hermeticists, shows a male figure hit in the eye by a stem supporting the letter *D;* this letter happens to be the initial of the person responsible for the accident.[8] Etc.

Thus for eight years dozens, perhaps hundreds, of figurations announced that an eye must be destroyed. . . . Are these facts explainable by a persistent premonition, or was the painter a victim of a sort of sympathetic magic? Could the mutilated shapes have put magical forces to work, created a psychic atmosphere, the unavoidable result being the accident? The two theses are not contradictory, for, supposing a magical action to be possible, why was this mutilation voluntarily selected? Such lasting obsession gives one a right to search, in Brauner's past, for a serious psychic shock that would have loaded the eye, at a certain time, with a special complex. . . . Yet my conversations with Brauner revealed nothing conclusive. I confess, besides, the inadequacy of an inquest that was not a prolonged psychoanalysis. But such was not my purpose; I was more interested in the part played in Brauner's psychic development by the obsession with an ocular mutilation and by the transformation of a fear into a performed material fact.

While the necessity of putting out the eye appears in Brauner's canvases of 1931-32, later works bear witness to an evolution in this respect; eyes are replaced by erect horns, as in a painting of 1937. The strange half-human, half-animal personage tends to become a sort of myth around which the intellectual and sensory activity of the artist is centered.

Without doubt, the eye has a feminine nature. The oldest traditions of astrology and morphology attest to this, as do many popular aphorisms. The fact is so obvious that the feminine sexual organ has sometimes been represented as an eye. A 1927 drawing by Brauner, published in 1938, shows clearly that the artist was aware of this symbolic value. The obsession that, at the beginning, aimed at the simple destruction of the eye became more complicated with the years. The equivalent of the feminine

[8] Dominguez.—M.J.

sexual organ had to be replaced by a masculine attribute—the horn—a sign of erection, of potency, of authority, and even of animal brutality. The being thus transformed will become a supermale. . . . The originality of Brauner's mythic figure resides less in the presence of horns than in their value as substitute for the eyes.

In simple words, Brauner's case was one of extreme masochism. The "animal brutality" of the horns cited by Mabille seemed even to designate the future aggressor: a Spaniard with all the fierce instincts of a country that invented bullfights. Mabille's study, primarily a friendly attempt to help Brauner, to restore his self-confidence after a disastrous shock, avoided any direct allusion to Dominguez's case, which was, in contrast, a matter of sadism. The "cosmic period" of this artist may appear also premonitory; it represented spheres, primeval planets, which looked also like giant lacerated ocular globes. Significantly, this style came to an end in Dominguez's paintings shortly after the event described above.

Mabille states in his article: "Our friend's concern for reaching a higher degree of energy through a grave mutilation happened to be fully satisfied. The man I knew before the accident was unobtrusive, timid, pessimistic, demoralized. . . . He is freed now, asserting his ideas clearly and authoritatively. . . ."

Yet it took Brauner a long time—almost twenty years more—to achieve a successful career. Dominguez's fate was different: his exceptional talent as a painter, object maker, discoverer of processes never brought him "success," though he acquired a sort of fame in artists' circles in Paris after World War II through his picturesque and ebullient personality. In 1957, he committed suicide, as if, by reversal of the roles in the tragedy of the two artists' lives, he happened to be, in the end, the real victim.

The sixth issue of *Minotaure* (December 1934) was remarkably eclectic. An article by Paul Eluard, "Physique de la Poésie," about illustrated books of poems, preceded Vollard's "Souvenirs sur Cézanne"; André Breton explored the possible meanings of Duchamp's *Bride Stripped Bare . . .* in a text entitled "Phare de la Mariée" (Lighthouse of the Bride). A chiromancist published analyses and photographs of various writers' and artists' palms; Salvador Dali contributed a piece, "Apparition aérodynamique des Etres-Objets" (Aerodynamic Apparition of Being-Objects); in "La Femme Féique" (The Fairylike Woman), Maurice Heine described Rétif de la Bretonne's image of an ideal woman; and the critic Pierre Courthion wrote on "Le Sadisme d'Urs Graf" (Urs Graf's Sadism). Hans Bellmer's "Dolls" were reproduced for the first time in that issue. There were also texts, tales, thoughts, by such authors as Antoine de Saint-Exupéry and Louise de Vilmorin, and a "Réhabilitation du Chef-d'Oeuvre" (Rehabilitation of the Masterpiece), by Tériade. Paul Valéry wrote on "Art Moderne et Grand Art"—lines that struck a rather dissonant note in a magazine glorifying modern art:

Modern Art and Great Art

Modern art tends to exploit "sensorial" sensibility almost exclusively, at the ex-

pense of general or affective sensibility and of our faculties of building, or adding dura-
tion, and of transforming things with the help of the mind. It understands marvelously
how to arouse attention, and it uses all means to arouse it: intensities, contrasts,
enigmas, surprises. Sometimes, by the subtlety of its means or by the audacity of its
performances, it seizes certain very specious prey—complex or ephemeral states,
"irrational" values, nascent sensations, resonances, correspondences, forebodings
of unstable depth. But we pay for these advantages.

Whether it be a question of politics, of economics, of ways of living, of entertain-
ment, or of activities, I observe that the behavior of modernity is that of intoxication.
We must increase the dose—or change the poison. Such is the law.

More and more *advanced*—more and more *intense*—greater and *greater*—faster
and *faster*—and *always newer*—such are the exigencies to which a hardening of sen-
sibility corresponds necessarily. We need an increasing intensity of physical agents
and a perpetual change to feel that we are living. . . . All the part that considerations
of duration played in the art of yesterday is practically abolished. I think that nobody
today does anything in order that it be appreciated in two hundred years. Heaven,
hell, and posterity have lost a great deal in general esteem. Besides, we no longer have
the time to foresee and to learn. . . .

Also in number 6 were excerpts of little-known texts by Mallarmé from a fashion maga-
zine, *La Dernière Mode,* whose six issues were edited or, more accurately, entirely written
by him, from September to December 1874. From the title to the manager's signature, every
item was by Mallarmé using a great variety of pseudonyms. The following fragment of an
article concerning the "Corbeilles de Mariage," from the first number of *La Dernière Mode,*
was signed "Marguerite de Ponty"—echoes of an age when beauty and refinement, worshiped
by the best minds, were in fashion.

THE LATEST FASHION

The Wedding Presents! We could begin with a pair of gold ear pendants of an
absolutely artistic design; long ones (for Fashion says so) and, to match, a pretty cross
with a chain; a second set in lapis lazuli, a stone highly prized today, and a third one
more formal; garnet cabochons, pear-shaped, their stems set with diamonds. Cuff
links to match each of these sets. Then we would choose, for Dinner and Evening
Parties, earrings and their locket, with a very big black pearl in the middle, encircled
with three rows of brilliants; it is quite a new object nowadays at the best jewelers,
and at many others.

A very beautiful set, composed of sapphires cut in slabs and surrounded with
brilliants, would be placed near the preceding one. Sapphires, more in demand than

Stéphane Mallarmé, 1894.

ever at the present time, throw the superb emeralds a little in the shade, with their softer luster. Same necklace. I would prefer these varied jewels to the eternal solitaires in brilliants that we have known for such a long time.

... A small scent bottle being an indispensable object near the lace handkerchief, we are far from forgetting it, either in different golds, pink, green, or yellow, Louis XV or Louis XVI, with garland (or a modern, enameled one with Japanese foliage and birds); nor do we forget the fan—in black silk with pink, blue, or gray braid for Morning Dress; in white silk with a painting, for Ceremonies. The Subject appears on the side and no longer in the middle. Yet nothing compares to a fan, its frame as valuable as you please, or even very simple but possessing above all an ideal value. Which? That of a painting; old, of the school of Boucher, of Watteau, and perhaps by these Masters themselves; modern, by our contributor Edmond Morin. Scenes on the steps of a mansion or in hereditary parks and in the street and on the beach, the contemporary world with its all-year-round festival: that is what these rare masterpieces show us, in the hands of great ladies.

We shall not leave *La Dernière Mode* without quoting, from the samples reproduced in *Minotaure,* two items of the "Correspondance avec les Abonnées":

Subscribers' Mail

To Mme. L——, Toulouse: Have a black cashmere dress made, madam, trimmed

with English crepe or imperial crepe; the latter, of as good a quality as English crepe, is less expensive. You are aware that you cannot wear ready-made clothes (coat, etc.), the shawl and the veil being a must during the next three months; but one is generally less acquainted with the fact that earrings are of hardened wood instead of jet. I continue, since you wish to consult me on the authoritative etiquette of mourning: black cashmere and crepe during the first six months, black silk and smooth black crepe during the next six months; finally gray, purple, or black and white during the last six weeks. Mourning is worn for a father-in-law, yes, the same way as for a father.

To Lydia ——, *Brussels:* Yes, my child, you will be ravishing thus for your first ball. White won't make you look pale; and *tulle illusion,* which you also ask for in our latest Fashion Mail concerning society events, will wrap your all-misty appearance in a moving cloud. So do not tremble, the choice was excellent; and we are the only one to profit by this exchange of letters since we keep your photograph — Ah! one more word. Instead of lilies of the valley, I'd rather see clematises.

The surrealist poetic contributions to this sixth issue of *Minotaure* were printed on a special light-blue paper, and formed a sort of collection inside the magazine entitled "La Grande Actualité poétique" (Great Poetic Writing Today), with a preface by André Breton and pieces by Breton, Péret, Eluard, Pierre-Jean Jouve, and a girl still in her teens, Gisèle Prassinos, who wrote insolent little tales of a decidedly automatic nature; for instance, "Lotion capillaire":[9]

Hair Tonic

A man, a woman, an old man. They are in a hut. The man holds a newspaper and, with his fingers, takes from his mouth little things like macaroni. The woman is sitting on the floor. She is naked and on her body there are pimples with yellow tips ending with a little filament. She has a canvas bag on her knees and she tries to cut her toenails with a hairpin.

In a corner a beardless old man watches her. His pink eyes have no pupils and his eyelids are sewn to his eyebrows as if he were going for a walk. Little gilded studs are half-buried in his pointed skull. His ears are projecting and there are long curls of hair behind them. He holds in his black hand a kind of doll made of wire and wrapped in yellow paper. The other hand is missing. In its place there is a fringe of shoelaces. . . .

The woman rises. She has put her extraordinary work into a pan and now she wants to cook it. But as she probably has no matches, she beckons to the old man. He comes near her. With a hook he makes a hole in his flesh and extracts a whistle from it. Then he puts it into the pan.

[9]These juvenile pieces have been collected in Gisèle Prassinos, *Trouver sans Chercher* (Paris: Flammarion, 1976).

Now they are all three sitting around the pan and they watch it. The old man rises solemnly and says in his ripping voice: "The soup is not worth a scrap." Then the man takes him by the hand and leads him to another room, where he leaves him. He comes back to the woman and says: "O perfumed Chalice, I'll be faithful to you!" Then he goes out, catching on his way a spool of yellow thread, which he takes to the room where he has left the old man. When he comes back, he feels a pin grazing him. Then he takes the spool, puts it into his mouth, and sighs. The old man smiles, then runs toward him. Then they go arm in arm to the neighboring room.

When they arrived, the woman had put a skein of red Algiers silk on her foot.

o

Automatism. Breton's article in *Minotaure,* no. 3-4 (December 1933) on "Le Message auto-matique" had the same starting point as the first "Manifeste du Surréalisme": the unexpected perception of a sentence in the half-conscious state that precedes sleep.

The Automatic Message

"Oh, no, no, I bet Bordeaux Saint Augustin. . . . It's a paperback, that." On September 27, 1933, while I try to go to sleep earlier than usual, toward 11 p.m., in what it is agreed to call the inner ear, I register, once more with no conscious motives, one of these series of words that seem to be spoken behind the scenes but are perfectly clear and organized as a remarkably autonomous group. I have tried, several times, to call attention to these peculiar verbal formations that may appear very rich or very poor in meaning, as the case may be, but that, at least, because of the suddenness of their passage and the complete, striking lack of hesitation in the way they arrange themselves, bring to mind such an exceptional certitude that they deserve the closest examination. Men, caught during the daytime in the landslide of accepted ideas, are led to conceive all things and to conceive themselves through a dizzy series of soon-hidden slips, of false steps corrected somehow or other. The fundamental lack of balance of the modern civilized being leads to absorption with a quite artificial concern about minimal, transi-tory equilibriums: hateful erasures afflict the written page more and more, as they cross life itself with strokes of rust. All these "sonnets" that are still being written, all this senile horror of spontaneity, all this rationalistic refinement, all this arrogance of instructors, all this inability to love tend to convince us of the impossibility of fleeing from the old reform house. . . . To correct, to correct oneself, to polish,[10] to recom-mence, to find fault but never to draw blindly from the subjective treasure, never to be tempted only to throw here and there on the sand a handful of foamy seaweed and

[10]An allusion to Boileau's celebrated statement in his *Art of Poetry* (1674): "Put your work on the loom twenty times again. Polish it and repolish it unceasingly." — M.J.

emeralds—that is the command that, for centuries, a misunderstood rigor and a slavish prudence have invited us to obey, in art as well as elsewhere. Such also is the command that historically was transgressed in exceptional, fundamental circumstances. Surrealism starts from there. . . .

In another article, "Le Merveilleux contre le Mystère," on symbolism (*Minotaure,* no. 9, October 1936), Breton admitted his own difficulties in finding words to express a *conscious* thought:

The Marvelous against the Mystery

Invented worlds, flagrant (or not) utopias, dreams of Eden have acquired in the language a place that elementary reason won't succeed in recapturing. The deep motive of this is, I think, that the language that is not strictly usual, not strictly adapted to practical needs, compels the person who uses it to a painful effort, brings into play a certain amount of suffering. The desired words are not always free, they require much asking, even much imploring. I do not say best what I want to say, far from it.[11] I am greatly disappointed in such a case by the absence, perceived a thousand times, of all *external* help. In contrast, this help never failed me when I ventured on less safe roads. It is then only that I thought I awoke musical instruments, that I imagined the possibility of some repercussion for my speech. . . .

Concerning these sudden messages, which seem to be heard as if coming from some musical instrument, we may quote again from Mallarmé. His famous "Démon de l'Analogie" of 1864 also has as a starting point an unexpected sentence arising from a sort of half-dream; but the mysterious and intriguing phrase perceived in such fashion by Mallarmé had led him to a poetic and humorous exegesis that did not, however, exclude a deep sensation of disquiet.

The Demon of Analogy

Have unknown speeches chanted on your lips, accursed shreds of an absurd sentence?

I went out of my apartment with the very feeling of a wing, languid and light, sliding upon the strings of an instrument, followed by a voice pronouncing words in a descending tone: "The Penultimate is dead," so that

[11]A widely experienced fact, as the following quotation, again from a seventeenth-century author, shows: "I find that my speech is not always on paper as I had it in my mind" (Malebranche). — M.J.

The Penultimate

ended the verse and

Is dead

 separated itself from the fateful interruption, more uselessly in the emptiness of meaning. I took a few steps along the street and I recognized in the *null* sound the taut string of a forgotten musical instrument that glorious Remembrance had certainly just visited with its wing or with a palm, and my finger laid on the mystery's stratagem, I smiled and prayed with intellectual wishes for a different speculation. The sentence came back, ritual, freed from a previous drop of feather or twig, henceforth through the voice I heard, until it became articulate at last, living of its own personality. I was reading it (no longer satisfied with a perception) at the end of a verse, and once, trying to adapt it to my speech; soon pronouncing it with a pause after "Penultimate," in which I found a painful enjoyment: "The Penultimate"; then the string of the instrument, too taut in oblivion on the *null* sound, certainly broke and I added, as a matter of oration: "Is dead." I did not stop trying to return to favorite thoughts, alleging, to calm myself, that penultimate was, indeed, the lexical term that means the next-to-last syllable of vocables, and its appearance, the ill-renounced remains of a linguistic labor that induces my noble poetic faculty to sob daily at being interrupted: the sound itself and the look of falsehood taken on by the hasty and facile affirmation were a cause of torment. Harassed, I decided to let the sad words themselves wander on my lips, and I went on murmuring with an intonation of condolence: "The Penultimate is dead, it is dead, really dead, the desperate Penultimate," believing thus to satisfy my worry, not without the secret hope of burying it under the amplified psalmody when, terror!—of an easily deductible and nervous magic—I felt, my hand reflected in a shop window making the gesture of a caress reaching down to some thing, that I had the voice itself (the first one, which undoubtedly had been the only one).

 But the undeniable intervention of the supernatural established itself, and the beginning of that anguish under which my spirit, once a lord, is now dying, when I saw, looking up, in the antique dealers' street I had instinctively followed, that I was facing a shop selling old instruments hanging on the walls, and on the floor, yellow palms and ancient birds, their wings buried in the darkness. I fled, bizarre, sentenced probably to be in mourning for the inexplicable Penultimate.

 While by its last issue *Minotaure* had developed into a purely surrealist magazine, the movement also expressed itself in many other publications and exhibitions. We have men-

tioned previously the important show of objects held in May 1936. The month of May 1934 had seen the birth of one of this book's early predecessors, an anthology of surrealist poetry compiled and edited by Breton and Eluard. This *Petite Anthologie poétique du surréalisme* collected poems and illustrations, surrealist games, an "exquisite corpse," and the manifesto "Permettez!" on Rimbaud. (The preface, entrusted to a newcomer, Georges Hugnet, was far from meeting general approbation among the surrealists, and it appeared with a note stating that the opinions it put forward were "solely the author's responsibility and in no way that of the contributors to the anthology.")

In June 1934 André Breton gave a lecture in Brussels entitled *Qu'est-ce que le surréalisme?* (What Is Surrealism?), which summed up the activity of the movement and the works and roles of its precursors. It was published the same year in Belgium with a drawing by René Magritte on the cover — the first version of the famous picture entitled *The Rape.*

In December of the same year Breton published *L'Air de l'eau,* a collection dedicated to his second wife, Jacqueline, which included the following piece:

THE AIR OF WATER

The Marquis de Sade went back inside the volcano
From which he came
With his beautiful hands still fringed
His eyes like a young lady's
And that reason at panic level that was
His alone
But from the phosphorescent drawing room with viscera lamps
He never ceased shouting mysterious orders
Which open a breach in the moral night
It is through that breach that I see
The great creaking shadows the old undermined crust
Dissolving
To let me love you
As the first man loved the first woman
In full freedom
A freedom
For which fire made itself man
For which the Marquis de Sade defied the centuries with his great abstract trees
Of tragic acrobats
Clinging to the gossamer threads of desire

A booklet of poems and illustrations by several of the surrealists entitled *Violette Nozières*

was published in Belgium in 1934.[12] it dealt with the case of a girl accused of poisoning her parents. The event caused a considerable stir at the time, since there was, among other disturbing circumstances, a presumption of incest committed by the girl's father, a railroad engineer with a first-rate record who ran the special trains for the President of the Republic. E. L. T. Mesens contributed the following poem to the booklet:

Violette Nozières[13]

Never run your daughter like a train.
In the paragon of republics
Violette Nozières's father
Was the engine driver
Of lots of presidential trains
And whenever he passed through a station
The armies of France did the honours
But when you keep running trains on those lines
There is always a risk of something
And that something happened
How many good mothers
And how many bad fathers
And how many good fathers
And bad mothers
As bourgeois morality gossips
Will be calling you filthy names
Violette
You with the dawn in your arms

Child of a plaintiff and of a train[14]
Child of this age clothed in padlocks
In spite of the dirt and the threatening weather
In spite of the hideous days and the nights of illusion
You lived your life—oh how anxiously
Now I see you standing
And yet hardly speaking
In the feeble glimmer of the lights

[12] Poems by Breton, Char, Eluard, M. Henry, Mesens, C. Moro, Péret, Tzara; drawings by Dali, Tanguy, Ernst, Brauner, Magritte, M. Jean, Arp, Giacometti. The photograph on the cover is by Man Ray.

[13] Translation by Humphrey Jennings in *Contemporary Poetry and Prose* (London), no. 2 (June 1936).

[14] The engineer had died of the poison supposedly administered by Violette; the mother survived and sued her daughter for murder. —M. J.

> Of the legal labyrinth
> Alas Violette
> There aren't many of us
> But we will accompany our shadows in procession
> To terrify your justicers
>
> At the judgment of the human body
> I will condemn the men in bowler hats
> To wear lead on their heads instead.

In December 1935, on a Friday the thirteenth, an exhibition of surrealist drawings opened at the Galerie des Quatre Chemins in Paris. Each exhibitor contributed a single sentence to the catalogue:

A hand linked to the throbbing heart. — Man Ray

Painting: I know beauty by fear. — Hans Bellmer

Sulfur sublime foam of solitude. — Wolfgang Paalen

I expect nothing from my reflection but I am sure of my reflexes. — Yves Tanguy

A bullfight in water. — Oscar Dominguez

The tree's leaves will rot and disappear with time; the stump only will remain barren. — Joan Miró

In yielding naturally to its vocation for pushing back appearances and for upsetting the relations of "realities," surrealist painting has helped, with a smile on its lips, to hasten the crisis of consciousness that must take place in our days. — Max Ernst

A surrealist picture is written like a poem and eaten like a primary object. — Maurice Henry

Wait no longer; the curtain has risen on a forest fire. — Marcel Jean

One thing is certain: I hate, under all its shapes, simplicity. — Salvador Dali

Rrose Sélavy dye works: oblong dresses for persons afflicted with hiccups. — Marcel Duchamp

The reality of the element that delivers its secret to us is indeed the place from which we must not deviate; it is a reference point. — René Magritte.

In 1935-36, Picasso wrote texts, automatic pieces that were published in a special issue of *Cahiers d'Art* (1936), with articles by the surrealists paying homage to the great painter who had rediscovered automatic writing. . . . Here are two of Picasso's "poems":

28th November XXXV[15]

tongue of fire divulges its face in the flute the cup which singing to him corrodes the dagger thrust of brightest blue which fixed in the eye of the bull inscribed within its head adorned with jasmine waits for the sail to swell the piece of crystal for the wind wrapped in the *mandoble* cloak dribbling caresses to dole out bread to the blind one and the lilac-coloured dove and to press with all its spite against the lips of blazing lemon the crooked horn which with its gestures of farewell startles the cathedral which swoons in his arms without a bravo whilst in his gaze the wireless bursts out dazzlingly awakened by the dawn which photographing in the kiss a bug of sun eats the aroma of the hour which falls and crosses the page which flies undoes the bouquet which carries off tucked under the wing that sighs and the fear that smiles the knife which leaps for joy leaving even to-day flowing as it will and no matter how at the precise and necessary moment high up from out the well the cry of rose which the hand throws to him as a meagre offering of alms.

29th March XXXVI

paid characters of the drama which acts this comedy for itself some clambering over the heads of others to haunt the stage with their cues forced upon them by a stenching slavish logic in putrefaction chain-bound and sticky making the tongue all glue were a true cry to blossom it and the wings of its hands be freed the word not immediately uttered dries on the branch of liquid coral and parches the milk in the breasts of the aurorae boreales hatching their little rainbows in their nests imposes its list of actors on the ladder woven with the skein of her dark hair love begging reasons the hand brandishing a river held about the middle blazing at each extremity the sheaf of vegetables split by the strain of running two hares simultaneously on the lake cracking in the breeze fastened to the square roots of the sigh of the glazier just gone by the king the queen of knaves the losing tickets of all the national lotteries the drudges and the street girls fat crayfish dragging Ophelia laughing madly into the depths of infamy six pairs of guipure curtains sewn to the marble of the dissecting table of the flight of the first swallow seen this spring and the sobs of a little girl shell the venetian shutters which one closes in the face of evening come to eat its plate of soup boredom boredom frightful boredom and the bouquet of flowers hung to the bow of the neck of the pigeon hurtling headlong from the ceiling into the centre of the roulette wheel everything ground to powder pounded fine dust crushed in the so weary green hooked on the point of the knife of the palm branch a pinch of rose gilt cloud smoothed out by her

[15]Both translations by George Reavey in *Contemporary Poetry and Prose* (London), no. 4/5 (August-September 1936).

finger on the blue eye the orphan bell of the hours holding out her hand to the caprice
of absent-minded alms.

The following verse is from Jean Arp's first collection of poems in French, entitled *Des
Taches dans le vide:*[16]

SPLOTCHES IN SPACE

Age lives from hair to hair
across the orphaned air
It lives like an egg
hatching a fruit
on a tightrope between two wings
the air has the age of the wings
the fruits are born of the wings
the leaves of the wings bleed
on the hems of the air

. . . .

the walls are of human flesh
the mushrooms have booming voices
and brandish heavy rapiers
against ancestral mice
with elephant teeth

. . . .

sit down on my big toe
little white and naked sky
remain a lackluster costume
remain white and naked
leave former realities
mend the water
depilate the souls
fling the last word

[16] Paris: Editions Sagesse, 1937. Translation by Joachim Neugroschel in *Arp on Arp,* ed. Marcel Jean. The Documents of
20th-Century Art (New York: The Viking Press, 1972). Editions Sagesse put out a number of booklets by modern poets:
Arp, Gisèle Prassinos, Tzara, Ivan Goll, Federico García Lorca, Vicente Huidobro, and many others.

> beyond the last heart
> remain white and naked
> let the haloes purr
> and filter their thoughts
> let the roses stroll about
> on the skin of a dwarf
> let the four-voiced members
> wave feathers of flesh
> remain white and naked
>
> the clouds undress
> on chubby tables
> the straw shirt embraces
> the paradoxical sponge
> beware of the machinery of faces

Arp afterward wrote poems in French quite often. In 1938 he published another collection, *Sciure de Gamme* (Gamut Sawdust), and in 1939 he contributed to the review *Plastique*, edited by his wife, Sophie Taeuber-Arp, a chapter of a humorous "collaborative novel," *L'Homme qui a perdu son squelette* (The Man Who Lost His Skeleton).

My booklet of poems, *Pêche pour le Sommeil jeté*, appeared in 1937;[17] it included the following piece, "La Fumée rouge":

ANGLING FOR THROWN-AWAY SLEEP

The Red Smoke

I shall not pity the future for it is bright like a lost and found diamond
Unattainable jewels
Nor the one that will come after us
When the sound of our voices sleeps no longer in the ruined houses
I take as certain that my hands will come out filled with water from the
 wellspring of salt
The destiny of friends on the dreary voyage
The empty wall of their absence
What I search for is pale as the fire
Over which the jet stoops
Hidden in a thicket of unfolded newspapers
I shall find what I search for and what it must give me

[17]Paris: Editions Sagesse.

Which is soft like a faded powder
And ice cold like lips in seawater
Which is more alive than the dual existence of gentlemen-burglars and spies
White fever
Which is more alive than lies and birth
What I search for is within reach of my body
If I lie down it will lean over me
It is neither my shadow nor my double nor my half nor another myself
It is a seaweed with tentacles rubbed in a tender dust
And shining among afternoon gifts
It is a ring of silent alarm clocks dancing on a transparent sheet
It is the never-disappointed wait
What I search for is listening behind doors
And I conjure it up in the dark

In 1938 Editions GLM, in its seventh *Cahier,* printed a series of texts and illustrations related to dreams, collected and presented by André Breton. Included were citations from authors of the past—Paracelsus, Dürer, Pushkin—and contributions from surrealists in Paris.

Je sublime (I Sublimate), a collection of verse published by Benjamin Péret in 1938, contained love poems in which Péret's particular gifts found a new outlet. The following piece is entitled "Clin d'Oeil."

Wink [18]

Flight of parrots go through my head when I see you in profile
and the sky of fat streaks itself with blue flashes
which trace your name in all directions
Rosa coiffed by a negro tribe staged on a staircase
where the pointed breasts of woman look through the eyes of men
today I look out through your hair
Rosa of opal of the morning
and I awake by your eyes
Rosa of armour
and I think by your breasts of explosion
Rosa of lake made green by frogs
and I sleep in your navel of Caspian sea
Rosa of eglantine during the general strike

[18]Translation by Roland Penrose and E.L.T.Mesens in *London Bulletin,* no. 17, June 1939.

and I wonder between your shoulders of milky way fertilized by comets
Rosa of jasmin on washing nights
Rosa of haunted house
Rosa of black forest flooded with blue and green postage stamps
Rosa of kite above a vacant plot where children fight
Rosa of cigar smoke
Rosa of sea foam made crystal
Rosa

A booklet of poems by Henri Pastoureau, with a preface by André Breton, appeared in 1938: *Le Corps trop grand pour un cercueil* (The Body Too Big for a Coffin); the next year Pastoureau published *Cri de la Méduse,* illustrated by Yves Tanguy, from which we print the following pieces:

CRY OF THE MEDUSA

. . . .

blood at water level
on the surface of the mirror
blood is laughter flowing out
blood is the foil of the mirror
it is a stark-naked and mad
water
chasing the rainbow's end

spilled blood, the lost secrets of the alchemists, confers omnipotence. Is it not so, Sade? You told me that during the Terror, by dint of spilling blood, man would feel free and strong at last!
What is blood?
Blood is the complement of pure water. The synthesis takes place sometimes in the running water of a brook, when a sharp angle attacks the human body. It was eminently accomplished in Marat's bathtub. Blood is rightfully used to water the most beautiful red roses which are offered to those sentenced to death.

blood is the water of the mirror

. . . .

highly priced
for such is the insolent luxury of the great rivers
such is the creator

full to the brim
and to my taste
for such is the creature

if there were gods
the sun and the moon
would demonstrate a poor imagination
if there were gods
what would be the price of worry

the dragonfly is part of the décor
there is no décor

. . . .

Léo Malet's book *Hurle à la vie* was published in 1939 by Editions Surréalistes, with illustrations by André Masson. The following poem is from this collection:

SCREAMING AT LIFE

At the crossroads of sexes
my keenest desire

To anticipate and to place our age
behind an appearance of refreshed good-heartedness
you will take care of the show of natural beauties
when I tell you

Pretty lady never unfaithful
the perfect lovers are coming
hurriedly to take my place
they liked my position
bad luck so very bad
just too distressing
to pat amicably the snakes' head
to embrace you whole
the mountain is easier
I'm waiting for you

Brazen head preoccupied head
it seems to me I didn't get out of it yet

Left: Hans Arp: First page of the manuscript of a poem in German (reproduced in the catalogue of the Arp exhibition at the Galerie im Erker, St. Gallen, Switzerland, 1967. *Right:* Marcel Duchamp: Inkstain for the back cover of *Minotaure*, no. 6 (December 1934).

holding every day your two breasts
and telling you the new death of a being dear to me
for the passersby we are
part of this tale of ghosts
the half of a destiny
the ticking of a clock

Red head with clear eyes
great syllabic volcano
bend down Majesty
on the stiff and living
in the corridor of a slum
you
let imagination run wild

International Surrealism

Outside France, the Belgian surrealists were the first to form an organized group, with René Magritte, E.L.T. Mesens, Paul Nougé, Marcel Leconte, Louis Scutenaire, Camille Goemans (who opened a surrealist gallery in Paris in the middle 1920s), and others. Magritte worked in France from 1927 through 1929, taking part in the life of the Paris movement. He wrote brief theoretical texts, and his illustrated notations (published in 1929 in *La Révolution surréaliste*) appear on p. 196 of this book. From "La Pensée et les Images," which appeared in 1954,[1] we take the following lines, which may be applied also to his early works:

Thought and Images

Images shown in paintings may be endowed with incorrect values — "commercial" value, for instance, or the value ascribed by those eccentrics who care first about sizes, those resolute supporters of small or large portions of space, champions of good fresco cementation, texture of canvas, authenticity of cracks, properties of paints and supports, those experts in anatomy, perspective, and cast shadows.

The values truly related to the image depend on one or several aesthetic theories that are a condition for, or a result of, the making of a picture, and that vary according to taste. Assuredly, the fear of being mystified concerns also the painted image strong enough to arouse that fear. A perfectly safe and easy choice may be made between the impressionists' glory, the futurists' dynamism, Picasso's cubism, Mondrian's or Archipenko's abstract art, or Chirico's genius. It is also possible to give some value to the latest well-disciplined and schooled Prix de Rome or else to be "thrilled" with

[1] In the monograph *René Magritte* (Brussels: Editions de la Connaissance, 1954).

the "young" (and the old) who stupefy art criticism by their discovery in 1954 of abstraction and figuration.

Women, children, and men who never thought about the history of art, have as much personal taste as aesthetes. The discordance of tastes cannot be explained by the influence of different "surroundings." . . . It is the thought that allows an "explanation." It is the thought that gives it a value. Whether the explanation be theological, metaphysical, psychological, or biological, it is "emitted" by the thought, which explains *without ever explaining itself,* though it apparently does so. . . . The thought possesses a certain amount of freedom when, for instance, it gives a value to the interest one feels toward a stone, or when it confers the highest value on life and the Universe of which life is a subject. One must love Ruskin, this art enthusiast, for his freedom when he writes: "Perish all works of art rather than the birds singing in the trees."

Life, Universe, and Nothingness are valueless for the thought in the plenitude of its freedom. The only value for thought is the Meaning, that is, the moral thought of the Impossible. Conceiving the Meaning means, for the thought, freeing itself from ordinary, almost ordinary, or extraordinary ideas. . . .

Left: The Belgian surrealist group in 1934. *From left, standing:* E.L.T. Mesens, René Magritte, Jean Scutenaire, André Souris, and Paul Nougé. *Seated:* Irène Hamoir, Marthe Nougé, and Georgette Magritte. *Right: International Surrealist Bulletin*, no. 4 (London, September 1936).

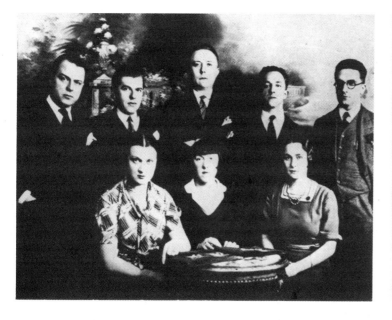

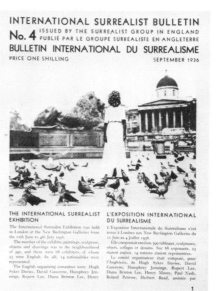

INTERNATIONAL SURREALIST BULLETIN
No. 4 ISSUED BY THE SURREALIST GROUP IN ENGLAND
PUBLIÉ PAR LE GROUPE SURRÉALISTE EN ANGLETERRE
BULLETIN INTERNATIONAL DU SURRÉALISME
PRICE ONE SHILLING SEPTEMBER 1936

THE INTERNATIONAL SURREALIST EXHIBITION

L'EXPOSITION INTERNATIONAL DU SURRÉALISME

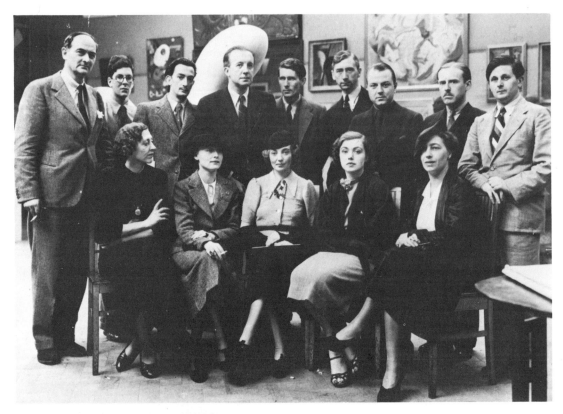

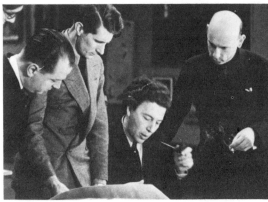

Top: International Surrealist Exhibition, London, 1936. *From left, standing:* Rupert Lee, Ruthven Todd, Salvador Dali, Paul Eluard, Roland Penrose, Herbert Read, E.L.T. Mesens, George Reavey, Hugh Sykes Davies. *Seated:* Mrs. Rupert Lee, Nusch Eluard, Eileen Agar, Sheila Legge, X——. *Bottom*: International Surrealist Exhibition, London, 1936. *From left:* E.L.T. Mesens, Roland Penrose, André Breton, Marcel Jean (fragment of a newsreel).

My paintings are images. An image cannot be validly described without directing the thought toward its freedom. One must pay attention to the image and at the same time to the words chosen to describe it. The description of the painted image, turning into a spiritual image in the thought, must be *endlessly perfectible.* . . . I consider that saying my pictures were conceived as material signs of the freedom of the thought

is a valid attempt at shaping a language. My pictures aim, to the greatest "possible extent," at being worthy of the Meaning, that is, of the Impossible.

Answering the question "What is the 'meaning' of these images?" would be like having the Meaning, the Impossible, resemble a possible thought. Trying to answer it would be to acknowledge that it has a "meaning." The onlooker may see, with the greatest possible freedom, my images *as they are,* and try, like their author, to think of the Meaning, that is, of the Impossible.

The Brussels review *Documents 34,* edited by E. L. T. Mesens, published in June 1934 a surrealist number with the title "Intervention surrealiste." Texts, poems, and illustrations reflected the activities of the movement in France and Belgium; in an article on Giacometti's sculpture *The Invisible Object,* André Breton discussed found objects and objective chance; "Le Dialogue en 1934" gave new examples of the surrealist game of "Questions and Answers."

About 1935 a great desire to introduce surrealism to England fired the young and enthusiastic poet David Gascoyne, who was warmly supported in that purpose by his friend Roland Penrose, writer, painter, and collector. Gascoyne was soon to publish *A Short Survey of Surrealism,* the first study in English on the subject. Several English writers and artists joined the two pioneers; plans for further action took shape and materialized in an "International Surrealist Exhibition," held in London at the New Burlington Galleries, in June and July 1936. In addition to Gascoyne and Penrose, Hugh Sykes Davies, Humphrey Jennings, McKnight Kauffer, Henry Moore, Paul Nash, and Herbert Read formed the exhibition committee, with Rupert Lee as chairman. Artists of fourteen nations were represented in the show. The catalogue contained a preface by André Breton and an introduction by Herbert Read,[2] from which we quote the following paragraphs:

This movement of reaffirmation is international in its scope, but like most artistic movements of the last hundred years, has made its center in Paris, where it has been given definition and coherence under the inspired leadership of André Breton. Its theoretical side is indebted to the psychoanalytical system of Freud, by means of which the unconscious, that region of the mind from which the poet derives his inspiration, becomes an admitted reality. The common notion of reality is based on the limited data of the conscious ego; the superreality which the artist now freely proclaims is a synthesis of experience which takes into account the evidence of every manifestation of life.

In justifying such art, the superrealist will point to the irrational art of savage races, so powerful in its effects on the sensibilities of even civilised people. He will point to the strong appeal of various kinds of folk art, and of the unconscious art of

[2]Read was also editor of *Surrealism* (London: Faber & Faber, 1936), a collection of essays and poems translated from the French.

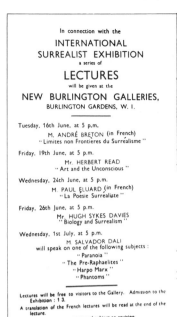

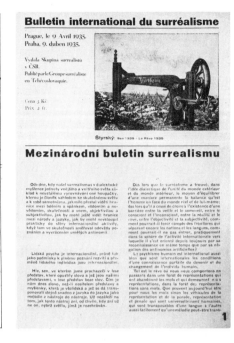

Left: Announcement for lectures on surrealism, London, 1936.
Right: Bulletin International du Surréalisme, no. 1 (Prague, April 9, 1935).

children. He will point to the strange and disconcerting beauty of scribbles found on tempting walls, of objects found in unaccustomed places; he will demonstrate the fantasies of nature and will ask everyone to admit the vividness of the dreams. But — to avert a possible misunderstanding — he will not proceed to make an art out of these things alone. He will oppose the conscious and the unconscious, the deed and the dream, truth and fable, reason and unreason, and out of these opposites he will in the dialectical process of his artistic activity create a new synthesis.

A belief in the primacy of the imagination has one further consequence: mere cleverness, craftiness, prettiness, the chic and bloom of an over-ripe civilisation, sink to a secondary place. It is beside the point to talk of form and composition, of handling and handwriting. The work of art is to be judged, in the first place, not by its physique, but by its imaginative scope, its intimate revelations, its surprising incoherence, its superreality.

Do not judge this movement kindly. It is not just another amusing stunt. It is defiant — the desperate act of men too profoundly convinced of the rottenness of our civilisation to want to save a shred of its respectability.

The philosophers, said Marx, have only *interpreted* the world in different ways; the point, however, is to *change* it. The artists, too, have only interpreted the world; the point, however, is to *transform* it.

The English Contribution. — A nation which has produced two such superrealists as William Blake and Lewis Carroll is to the manner born. Because our art and literature is the most romantic in the world, it is likely to become the most superrealistic. The English contribution to this Exhibition is comparatively tentative, but our poets and painters have scarcely become conscious of this international movement. Now it has been revealed in all its range and irrationality they may recover, shall we say, the courage of their instincts.

Soon after the London exhibition, while an English surrealist group was being formally assembled, poems by Paul Eluard translated from the French were published by Europa Press under the title *Thorns of Thunder,* and Breton's *Qu'est-ce que le surrealisme?* was issued in English by Faber & Faber. The publishers announced *What is Surrealism?* as follows:

Monsieur Breton explains exactly what surrealism stands for in painting, sculpture and politics. It is revealed, not as one more little sectarian affair destined to flutter the cafés of London and Paris, but as a deliberate and even a desperate attempt to transform the world. Surrealism may amuse you, it may shock you, it may scandalize you, but one thing is certain: you will not be able to ignore it.

In London, from May 1936 to the autumn of the following year, the English poet Roger Roughton published *Contemporary Poetry and Prose,* a review that offered English versions of precursors of surrealism (Jarry, Lautréamont) and of French surrealist writers, as well as examples of traditional English folk poetry and pieces by modern English and American poets. The second issue (June 1936) carried "The Very Image," a poem by David Gascoyne dedicated to René Magritte. Humphrey Jennings's "Reports" appeared in no. 4 (August 1936):

1

He was then resident, and afterwards envoy extraordinary at the court of Tuscany. Music, painting, and statuary occupied him chiefly, and his unpublished catalogues, not less strikingly than his copious printed notes, show the care and assiduity of his research. In the mountains of Calabria, where Salvator painted, the chestnut flourished. There he studied it in all its forms, breaking and disposing it in a thousand beautiful shapes, as the exigencies of his composition required. We find it nearly always forming a prominent feature in his bold and rugged landscapes, many of his most striking scenes being drawn from the wild haunts and natural fastnesses of that romantic country, wherein he passed so many of his youthful days.

2

The front windows on the ground floor were entirely closed with inside shutters and the premises appeared as if altogether deserted. In a minute the front door was opened and Mr. Kellerman presented himself. His manner was extremely polite and graceful. His complexion was deeply sallow and his eyes large, black and rolling. He conducted me into a parlour with a window looking backward, and having locked the door and put the key in his pocket he desired me to be seated. The floor was covered with retorts, crucibles, alembics, bottles of various sizes, intermingled with old books piled one upon another. In a corner, somewhat shaded from the light, I beheld two heads, and entertained no doubt that among other fancies he was engaged in remaking the brazen speaking head of Roger Bacon and Albertus. . . .

No. 7 (November 1936) contained a piece by Valentine Penrose, the French poet and first wife of Roland Penrose.

To a Woman to a Path[3]

> This body here feminine that hangs like a distant drop
> towards the other here this time feminine.
> where the hair equal across the smile
> wild shuttle
> angular bones
> who will cross the plains with her hips
> who will gather the straw not swathes it will sleep in barns
> alone for the herbs
> of whom the friend would never worry although green
>
> On an indian air
> holding my apron
> gathered my severed heads
> Sainte Germaine of Europe
> upright in the little milkwort.
> Like tiles rained from the north
> like cow kisses everywhere
> like a rosary round the neck

[3] Translation from the French by Valentine and Roland Penrose.

now I am all
now I am ended
now I am knotted
now I am joined
necks severed I dance like a bird
the fountain out from the skull

Gambling with the sun beams
it rolls at will this great furnished heart on the road
sweet like nothing
bordered with empty moulds
frigate of the sun
on this one retrieved
whose marrow once bow-bent on the ceiling with its shadow
augured the feastings of the white vessels
 of ecstasy.

In 1938 the *London Gallery Bulletin* appeared — a catalogue for the exhibitions at the London Gallery (founded that same year by Roland Penrose with E.L.T. Mesens as manager) and at the same time a surrealist review. The *Bulletin* published English translations of several texts by Breton, poems by Eluard and Péret, and theoretical or polemical articles and poems by English contributors. Number 12 (March 15, 1939) included the following piece by George Reavey (which appeared also in his collection of poems *Quixotic Perquisitions* [London: Europa Press, 1939]).

Hic Jacet

Think! Your master forgetting the unsubstantial spaces,
sought new stars underfoot,
in deep mines delving down to earth's root;
in the ghostly waters of proverbial seas
discovered Ocean's beautiful breasts;
took islands by force, fabled forests and mountains,
sent back silver gallows to Flanders and Spain;
a knight of the Golden Fleece,
he wound the chain of dominion round a soft ball of clay
this earth in his image moulded — he thought,
till the furies of polluted shrines swarmed his steps.
But even livid and racked, wrecked and divided,

> even pummelled by windmilling winds,
> rubbing sore his bruised quarters,
> let down urgently on his prehistoric bed,
> still in his heyday he turned no mean somersault,
> bent on looping the loop of time,
> he leapt straight through earth's hoop,
> joined pole and pole
> with his body's contusionate axis;
> and then, O Chorus of Woe,
> whacked down a posteriori harder than any Christian before
> on the dragon tusks of twenty bloody revolutions

The *Bulletin International du Surréalisme* was born in 1935 as an international surrealist magazine. Four issues were published in different countries. reporting the activities of groups outside France, offering translations of French theoretical texts and articles, manifestoes of the local surrealists, and comments on literary, artistic, and political events of the day.

Number 1 was published in April 1935 in Prague, where André Breton and Paul Eluard had been invited by an extremely active Czechoslovak surrealist group; it included enthusiastic and understanding excerpts on surrealism from Czech Communist newspapers. To their great surprise, in Czechoslovakia the visitors met several important Communist personalities who were not only conversant with the movement's activities and works, but who also fully approved its views on the relations between poetry and revolution.

Number 2 of the *Bulletin* appeared in Tenerife, following a visit to the Canary Islands by Breton and Péret in May 1935; number 3 was published in Brussels in August 1935. Number 4, published in London in September 1936, contained an account of the surrealist exhibition, a text on the positions of the English group, excerpts from lectures by Herbert Read and Hugh Sykes Davies, and the following report on the reactions of the English press to the exhibition:

1. "Superrealism is simply the last stage of an individualistic and subjective attitude to art."—*The Spectator,* June 19

2. "Take Blake's anti-rationalism, add Lamartine, etc. you will have the surrealist dish." — *The Spectator,* June 19

3. "The general impression one gets is that here is a group of young people who just haven't got the guts to tackle anything seriously and attempt to justify themselves by an elaborate rationalisation racket."—*Daily Worker,* June 12

4. "Relics of outworn romanticism."—*Daily Telegraph,* June 12

5. "Having seen examples of 'Dadaism' and 'Cubism,' I was prepared for all the terrors of 'Surrealism.' "—*Daily Dispatch.* June 12

6. "Surrealism has reached London—a little late it is true, a little dowdy and seedy and down at heel and generally enfeebled . . . in Paris is decrepit, may yet become fashionable in London."—*The Listener,* June 17

7. "Nor is it accidental that the majority of those who attended the exhibition were the 'artists' themselves."—*Daily Worker,* June 12

8. "Last Thursday (private view day) there were 1,150 visitors, while the figures for each day have been 1,245, 1,364 and 1,143."—*Northern Whig,* June 16

9. "The Surrealist exhibition is tremendously impressive. There are things in it which will haunt you till you die."—*Edinburgh Evening News, Lancashire Daily Post, Northampton Daily Chronicle,* June 12

These are specimens of Press comment on the exhibition. We wish to say only a little about them, since our task is not to meet criticism, but to continue to insist on the positive aspects of the movement.

Extracts 1, 2 and 3 are from Marxists and Communists. Only 1 and 2 are criticisms in any sense of the word. 3 is in the fake proletarian manner too often employed by our only Communist daily.

Here, as elsewhere, the Marxists differ from us in a perfectly clear way. They refuse to accept the existence of the world of the unconscious, and their whole system is built up on the simple plan of man and the real world. It is therefore quite impossible for them to appreciate our strictly dialectical and materialist synthesis of inner and outer world as the basis of general theory.

Having no coherent attitude to the world of the dream, they appear to be obsessed and governed by it. In our work they see only the dream, while for the other element of our synthesis they have a blind spot. Naturally, they see nothing of the synthesis itself. Their label for their personal distortion is "bourgeois individualism." Nursing their own dreams in private terror, they are unaware of the plain fact that men are more alike in their dreams than in their thoughts and their actions. Here is, indeed, the common ground, the meeting place of all humanity, an essential part of the basis of that state of equality which we, with them, desire to establish—not a refuge of individualism. As always, we regret their misunderstanding of our attitude.

Extracts 4, 5 and 6 represent the smart Society critics, the irretrievable dilettanti who, when they find novelty, call it a "stunt," and when novelty lasts longer than they would wish, complain that it is no longer a stunt. It was a stunt for them ten years ago, during their brief visits to Paris, and they are unhappy to see it in London because it destroys something of their exclusiveness.

For them, Surrealism is merely another "ism." They conceive it as a new style of painting or theory of art. This is natural, since they only know a little about styles of

painting, and a very little about theories of art. Surrealism comprehends all human activity, and as a total attitude to human life is beyond the habitual petty scale of their thought. They know nothing of either Freud or Marx. The most that can be said of them is that their pettiness and ignorance are in good faith.

Extract no. 7 represents a Marxist criticism which is simply in bad faith. The following extract is sufficient comment. We are sorry that our only Communist paper should allow itself to err so grossly in facts, and should distinguish itself even above the bourgeois press as a source of lies.

From the bourgeois press there have been all the expected accusations, exploitations of scandal, charges of obscenity, etc. We admire the resourcefulness of the unconscious, even among journalists. It is their business to provide such copy, and we say no more than this: that we entirely disapprove of the social and economic system which compels them to do so. . . .

Surrealist reviews,[4] books, and exhibition catalogues were beginning to appear in many countries. The first surrealist exhibition in the United States took place as early as 1931 at the Wadsworth Atheneum in Hartford, Connecticut, followed the next year by a surrealist show at the Julien Levy Gallery in New York. That same gallery held one-man shows of Dali, Tanguy, Ernst, and others. Dali paid his first visit to the United States in 1934, and the temporary "craze" for surrealism — at least, for Dali's surrealism — which his works and his general attitude launched in this country may still be remembered today. In December 1936 an impressive show of "Fantastic Art, Dada, Surrealism" was organized by Alfred H. Barr, Jr., at the Museum of Modern Art, in New York. Barr's short preface to the two-hundred-fifty-page catalogue ended with these words: "It should however be stated that Surrealism as an art movement is a serious affair and that for many it is more than an art movement: it is a philosophy, a way of life, a cause to which some of the most brilliant painters and poets of our age are giving themselves with consuming devotion."

Julien Levy's anthology *Surrealism,* also published in 1936, collected short translations of Lautréamont, Sade, Rimbaud, excerpts of surrealist poets, and surrealistic quotations relating to games, dreams, politics, etc. The editor's preface reviewed the history and principles of the movement and concluded:

Generally speaking . . . there is in America considerable misunderstanding of the surrealist point of view, and the numerous semi-surrealist efforts of the past few years have only elaborated superficial details and idiosyncrasies without ever reaching below the surface of a more complete contact with surrealism as a *point of view.* It cannot be too strongly asserted that whereas surrealism is fantastic, all fantasy is not

[4]*Surrealismus* (Prague), *Nadrealizam danas i ovde* (Belgrade), *Gaceta de Arte* (Tenerife), *Konkretion* (Copenhagen), *Surrealist Exchange* (Tokyo). . . .

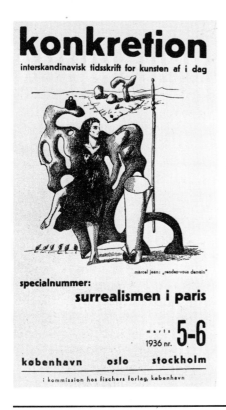

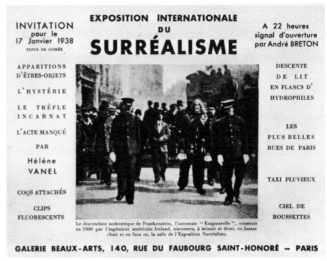

Left: Marcel Jean: "Rendezvous tomorrow," cover of *Konkretion* (Copenhagen, Oslo, and Stockholm), nos. 5-6 (March 1936). *Right*: Invitation for the opening of the International Surrealist Exhibition, Paris, 1938. Picture caption: "The authentic descendant of Frankenstein, the automaton 'Enigmarelle,' built in 1900 by the American engineer Ireland, in false flesh and false bones, will cross the hall of the Surrealist Exhibition, at 12:30 p.m."

surrealist; whereas surrealism uses symbols, all symbolism is not surrealist; whereas surrealism often is profoundly disturbing, all that is shocking is not *ipso facto* surrealist.

In France, the birthplace of surrealism, there were, however, much more than misunderstandings over its activities. When in 1938 the famous "International Exhibition of Surrealism" opened in Paris at the Beaux-Arts Gallery, the gibes and protests the London surrealist exhibition had reaped were easily outdone by the deluge of insults and jeers with which—despite a record attendance—the French press greeted the exhibition.[5]

Activities in the political field assumed renewed importance within the group as the fascist menace began to spread over Europe in the middle thirties. In February 1933 fascist riots broke out in Paris, whereupon the surrealists immediately issued a pamphlet entitled *Appel à la Lutte* (A Call to Struggle), signed by more than eighty personalities of the intellectual world, among them, Fernand Leger, André Lhote, Paul Signac, André Malraux, Alain, etc. This text was the first public appeal for a united front against fascism, and indeed a united front of the left (the Popular Front) eventually took shape, countering the rise of fascism in France—until the war and the invasion in 1940.

In 1935 Georges Bataille attempted a political rapprochement with André Breton.

[5] For a full account of the Paris international exhibition in 1938, see our *History of Surrealist Painting,* pp. 280-89.

Bataille's and Breton's friends formed a group that called itself Contre-Attaque (Counterattack), "a fighting Union for Revolutionary Intellectuals"; it held a few private and public meetings. However, building up a political movement involves all-absorbing practical tasks that few if any of the participants in Contre-Attaque were fit or willing to undertake, and the organization never reached the working stage. Besides, the two leaders remained too far apart on several points in ideology and character for their collaboration to be a close and lasting one. Nevertheless, Breton included in his collection entitled *Position Politique du Surréalisme* (1935) the "Résolution" that had set forth the principles and aims of Contre-Attaque.

In that same book he reproduced *Du Temps que les surrealistes avaient raison*,[6] as well as lectures and speeches on interrelations of poetry and politics, delivered on various occasions in 1935.

Developments of the Spanish Civil War, which had broken out in 1936, caused the English surrealist group to publish in October of that year the following statement signed by Hugh Sykes Davies, David Gascoyne, Humphrey Jennings, Diana Brinton Lee, Rupert Lee, Henry Moore, Paul Nash, Roland Penrose, Valentine Penrose, Herbert Lee, and Roger Roughton:

DECLARATION ON SPAIN

Against the appalling mental and physical suffering that the Spanish Civil War is involving, we can already offset certain gains to humanity which will remain whether the Government of the People conquers or not; gains of knowledge which have been purchased far too dearly, but which for that very reason have an imperative claim on our attention. They are these:

1. No one can continue to believe that, if a People's Government is elected constitutionally, Capitalism will be content to oppose it only by constitutional means.

2. No one will continue to believe that violence is the special weapon of the proletariat, while Capitalism is invariably peaceful in its methods.

3. No one can continue to believe that Fascism is a merely national phenomenon. It is now abundantly clear that in a crisis the Fascist countries emerge as parts of an international whole, the International of Capital. German and Italian arms are killing the people of Spain.

4. No one can continue to believe that Fascism cares for or respects what is best in humanity. In Garcia Lorca, the foremost modern poet of Spain, they have assassinated a human life which was especially valuable. Meanwhile the People's Government has made Picasso director of the Prado, hoping to widen still further the scope of his work for humanity.

5. No one can continue to believe that our National Government has any right to speak in the name of democracy. It has assisted in the crime of non-intervention;

[6] The booklet against Stalinism, mentioned above, p. 260.

it has refused to allow the export of arms to a Government democratically constituted, and has regarded with equanimity the assistance given by Fascist powers to the rebels. There can be no more conclusive proof of its real sympathies than its conduct towards Portugal. Portugal is a British financial colony, and depends on British arms for the protection of its overseas possessions. A word from our Foreign Office would have secured her immediate adherence to the pact of non-intervention. Evidently that word has not been given. The National Government has permitted the Portuguese dictatorship to assist the rebels in complete freedom; at every stage of the campaign the rebel armies have been based on the Portuguese frontier.

If these things are clear, we are the gainers insofar as we know *inescapably* where we stand with regard to Fascism, to the People's Government, and to the National Government of Britain. And in the light of this knowledge we support the popular demand that the ban on the export of arms to the Spanish Government be lifted. We accuse our National Government of duplicity and anti-democratic intrigue, and call upon it to make at once the only possible reparation.

ARMS
for the people of Spain

At the same time, Stalinism was revealing itself, more and more, as one of the most serious threats to the freedom of thought — and to individual freedom as well. The following fragment is from a speech Breton delivered in January 1937 at a meeting held in Paris, in protest against the Moscow "purge" trials, which were leading to the physical elimination of practically all the leaders of the October Revolution of 1917.

More light! "Mehr Licht" — that was Goethe's last cry; "more consciousness!" — that was Marx's great motto. As regards light: we may rely, as far as Stalin is concerned, on the light of the trials for sorcery in the Middle Ages; one must go into the details of such trials — and the proletariat has no leisure for that — to find an equivalent of the atmosphere of what took place last August, of what takes place now, in Moscow. And we are made to understand that it is not the end! As regards light: the light of prison stairs that you will descend at four in the morning, of stairs bordered with drains like the tables of a mortuary, and where, on a certain step, you will be shot in the nape of the neck. The drains are for the brains, for *consciousness,* but nothing will prevail over the high degree of consciousness that Lenin's old companions represented, and that the model waste pipes of the prisons of the GPU will be powerless to carry away. In these men who gave proof, time and again, of their lucidity, their honesty, their devotion to a cause that is mankind's, history will refuse to see "possessed" men in the old

religious sense of the word and, all the more, to consider Leon Trotsky as the devil's incarnation in the twentieth century. . . .

Goethe's "More light!" was quoted again by André Breton at the time of the Nazi invasion of Austria, in a note appearing in the *Cahier GLM* on dreams published by Guy Lévis-Mano; this time it was in the defense of Sigmund Freud.

Freud in Vienna[7]

We learn with deep misgivings of the arrest in Vienna of Sigmund Freud. Thus, an entire life of shining understanding, of exclusive devotion to the cause of human emancipa-. tion in the widest sense in which it has ever been understood, is practically bound to end in the infection of a prison, in the tormenting humiliation of one of Hitler's concentration camps. This great master — the spirit in whom that cry of Goethe's for "More Light" is really and truly incarnate — he from whom so many of us take our finest reasons for existence and action — Freud fallen at the age of eighty-two into the grip of ruffians, finding himself singled out for their irresponsible and animal fury. We are all aware, and we can't pretend not to recognize, that, with a daily increasing despair of being heard, other appeals cross over our heads — as many of them on behalf of peoples who ask nothing except to be left free as on behalf of the most trustworthy of men, suddenly accused of monstrous crimes. Nevertheless, we like to hope that the picture of Freud, already ill for a long time although always marvelously lucid, of a Freud forced at that age to undergo the worst outrages, will provoke an awakening of consciences all over the world, will bring about a wave of indignation, will be strong enough to put an end to a shame which will reflect on the whole civilization.

The following day. — Vienna, March 17 (by telephone). "It is announced this afternoon, that contrary to the rumor which had spread, Professor Freud, the founder of psychoanalysis, has not been arrested. He is leading a retired life in his home in Vienna."

March 18 — Freud has not been arrested but simply "kept under watch." All over the world the mind must be on guard, must concentrate to see that his existence is unviolated, a symbolic guard of honor must be organized round his person to secure his complete and immediate release and assure a peaceful and glorious end, wherever he may wish, to a life of inspiration which we hold as dear as our own.

In the spring of 1938 André Breton visited Mexico. Direct contact with modern Mexico did not diminish his intense interest in a land where pre-Columbian civilizations had flourished,

[7] Translation in *London Gallery Bulletin,* no. 2 (May 1938).

André Breton and Leon Trotsky in Mexico, 1938. (Photograph: Jacqueline Breton)

leaving sometimes magnificent, sometimes terrible, and sometimes undecipherable traces. As a collector as well as a poet, he became enthusiastic about that country, where an energetic and inventive folklore still offers the visitor beautiful and strange objects, or violent playthings, such as human skulls made of sugar, which Mexican children relish as lollipops, or old woodcuts and naïve paintings — innumerable proofs of the instinctive lyrical gifts of the people. And in Mexico he could meet the revolutionary in exile, Leon Trotsky, whose mind and actions he had always admired. A surrealist pamphlet, *La Planète sans visa* (The Planet without a Visa), had been issued in Trotsky's favor at the time of his expulsion from France, in 1934.

After his return to Paris, Breton gave a profusely illustrated, detailed account of his voyage in *Minotaure,* no. 12-13 (May 1939), and in June 1939 he showed, among other items in a Mexican exhibition at the Galerie Renou et Colle, objects and pictures he had brought back from Mexico.

A manifesto signed by Breton and the Mexican painter Diego Rivera, but in fact written in collaboration by Trotsky and Breton, was published in 1938, announcing the founding of an International Federation of Independent Revolutionary Art. The following passages are from the English translation that appeared in the *London Gallery Bulletin,* no. 7 (December 1938-January 1939):

Towards an Independent Revolutionary Art

It may be said without exaggeration that human civilization has never been assailed by so many dangers as it is today. With the help of barbarous, that is to say, most precarious means, the Vandals destroyed ancient civilization in a restricted area of Europe. At the present time reactionary forces armed with all the weapons of modern technique threaten to undermine the whole trend of world civilization as evinced in the very unity of its historical destiny. It is not only the impending war we have in view. From now onwards, in time of peace, the position of both science and art has become absolutely intolerable. . . .

The present state of the world leads us, however, to conclude that the violation of these laws is becoming increasingly widespread, and that it is necessarily accompanied by a more than ever manifest debasement not only of the work of art but also of the "artistic" personality. After eliminating from Germany all artists who were in any degree — even formally — lovers of freedom, Hitlerian Fascism forced those who could still agree to wield a pen or brush to become the lackeys of the regime and to sing its praises to order, within a framework of the narrowest conventionality. An almost identical situation has arisen in the U.S.S.R. during the period of intense reaction which has now reached its apogee. . . .

Under the influence of the totalitarian regime of the U.S.S.R., and that of the so-called "cultural" organisms which it controls in other countries, a deep twilight has fallen upon the whole world impeding the rise of any sort of spiritual value. It is a twilight of blood and mud in which, under the mask of intellectuals and artists, there flounder men who have made a pivot of servility, a perverse game of their renouncement of their own principles, a habit of false venal testimony and an enjoyment of an apology for crime. The official art of the Stalin period reveals with a crudeness unparalleled in history their ridiculous efforts to mislead and to conceal their real mercenary role. . . .

The writer's rôle, as defined by the young Marx, needs to be vigorously recalled in our day. It is patent that this idea should be extended on the artistic and scientific plane to the various categories of producers and investigators. "The writer," he says, "must naturally earn money in order to be able to live and write, but in no circumstances must he live and write in order to earn money. . . . The writer does not in any sense regard his works as a *means.* They are *ends in themselves,* they are so negligibly a means for him and for others that, if need be, he will sacrifice his life for them. . . . *The first condition of a free press is that it should not be a profession."* This statement is more than ever apposite in reply to those who would subordinate intellectual activity to external ends and who, in defiance of its peculiar historical determinations, would

impose themes upon art on the pretext of reasons of State. A free choice of themes and absolute freedom from interference in the sphere of his research are an advantage which the artist has every right to claim as inalienable. In the matter of artistic creation it is essential for the imagination to escape from constraint, to prevent it from being "roped in" at all costs. To those who would urge us, whether today or tomorrow, to acquiesce in an art subjected to a discipline which we judge to be radically incompatible with its means, we oppose an irrevocable refusal and our resolute will to uphold the formula, *every liberty in art.*

We grant the revolutionary State, of course, the right to defend itself against aggressive bourgeois reaction even when it covers itself with the banner of science and art. But there is a gulf between such forced and temporary measures of revolutionary auto-defence and the claim to exercise a control over the intellectual creation of society. . . .

The aim of the present appeal is to find a meeting ground for the revolutionary defenders of art, to serve the revolution by the methods of art, and to defend the freedom of art itself against the usurpers of the revolution. . . .

Thousands and thousands of thinkers and isolated artists, whose voice is drowned in the hateful tumult of regimented falsifiers, are actually scattered throughout the world. Numbers of small local reviews attempt to group around them young forces which are in need of new directions and not of subsidies. The whole progressive tendency in art is stigmatised by Fascism as degenerate. All free creation is labelled Fascist by the Stalinists. The independent revolutionary art must gather its forces to struggle against reactionary persecutions and to proclaim loudly its right to existence. Such a muster is the aim of the *International Federation of Independent Revolutionary Art* . . .which we judge it necessary to found. . . .

> We want *an independent art—for the revolution,*
> *the revolution—for the definitive liberation of art.*

This manifesto was published in New York by *Partisan Review,* in Mexico City by *Clave,* and in Buenos Aires by *Liborio Justo.* The review *Clé* appeared in Paris as the organ of the new federation, but it ceased publication after its second issue (February 1939), and the federation never actually came into existence.

TIMELESS
SURREALISM

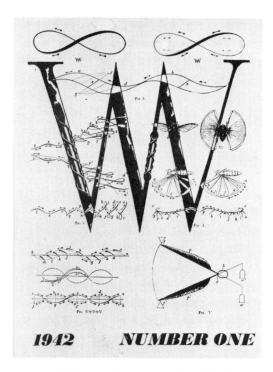

Max Ernst: Cover for the first issue of *VVV* (New York), 1942.

New York, London, and Paris

The invasion of Poland by the armies of Hitler and Stalin at the outbreak of World War II and the occupation of Holland, Belgium, France in 1940 by the Nazis caused many European artists to take refuge overseas. But while painters may find followers, companions, and a public every-where—for painting is a universal language, though not always very well understood—the poets' means of expression depends on their mother tongue. When André Breton reached the United States, in 1941, he felt all the more an "exile" as he remained, throughout his entire stay in America, until 1946, unable or unwilling—or both—to learn the language of the country in which he was living. Still, with the help of a number of Paris friends who had also come over and of congenial and talented American acquaintances, he was able to reconstruct in New York a sort of surrealist group and in June 1942 to begin publishing a magazine entitled *VVV*. The meaning of this new letter was explained in the review as follows:

<div align="center">VVV</div>

that is, V+V+V. We say . . . — . . . — . . . —
<div align="center">that is, not only</div>

V as a vow—and energy—to return to a habitable and conceivable world, Victory over the forces of repression and of death unloosed at present on the earth, but also V beyond this first Victory, for this world can no more, and ought no more, be the same, V over that which tends to perpetuate the enslavement of man by man,

<div align="center">and beyond this</div>

VV of that double Victory, V again over all that is opposed to the emancipation of the spirit, of which the first indispensable condition is the liberation of man,

<div align="center">whence</div>

VVV towards the emancipation of the spirit, through these necessary stages: it is only in this that our activity can recognize its end

<div align="center">Or again:</div>

<div align="center">one knows that to</div>

V which signifies the View around us, the eye turned towards the external world, the conscious surface,

<div align="center">some of us have not ceased to oppose</div>

VV the View inside us, the eye turned towards the interior world and the depths of the unconscious,

<div align="center">whence</div>

<div align="center">VVV</div>

towards a synthesis, in a third term, of these two Views, the first V with its axis on the EGO and the reality principle, the second VV on the SELF and the pleasure principle—the resolution of the contradiction tending only to the continual, systematic enlargement of the field of consciousness

<div align="center">towards a total view,</div>

<div align="center">VVV</div>

which translates all the reactions of the eternal upon the actual, of the psychic upon the physical, and takes account of the myth in process of formation beneath the VEIL of happenings.

Reproduced at the beginning of each successive issue of *VVV,* this text obviously alluded to the radio signal of "Victory," the Morse code symbol for the letter *V* used by BBC in broadcasts from England. And the sentence referring to "the myth in process of formation" pointed to one of Breton's main preoccupations at that time, especially to his suggestion about "Les Grands Transparents," which we reprint from the end of his "Prolégomènes à un troisième manifeste du surréalisme ou non."

Prolegomena to a Third Manifesto of Surrealism or Else[1]

The Great Invisibles

Man is perhaps not the center, the *focus* of the universe. One may go so far as to believe that there exist above him, on the animal level, beings whose behavior is as alien to him as his own must be to the day-fly or the whale. There is nothing that would necessarily prevent such beings from completely escaping his sensory frame of reference, since these beings might avail themselves of a type of camouflage, which no matter how you imagine it, becomes plausible when you consider the *theory of form*

[1]Translation by N.G. in *VVV* (New York), no. 1 (June 1942).

and what has been discovered about mimetic animals. This idea surely affords a wide field of speculation, though it tends to reduce man as an interpreter of the universe to a condition as modest as the child conceives the ant to be when he has overturned the ant-hill with his foot. Considering perturbations like the cyclone, in the face of which man is powerless to be anything but victim or witness, or like war, on the subject of which notoriously inadequate views have been advanced, it would not be impossible, in the course of a vast work, which would be constantly presided over by the boldest kind of induction, to even succeed in making plausible the complexion and structure of such hypothetical beings, which obscurely manifest themselves to us in fear and in the feeling of chance.

I think I should like to point out that I do not here perceptibly depart from the statement of Novalis: "In reality, we live inside an animal on which we are parasites. The constitution of this animal determines our own and vice versa." I am merely asking with William James: "Who knows whether, in nature, we do not hold as small a place beside beings whose existence we do not suspect, as our cats and dogs living in our houses at our sides?" Scientists themselves do not entirely oppose this view: "Around us beings perhaps circulate who are built on the same plane as ourselves, but different from men, for example, beings whose albumines are straight." Thus spoke Emile Duclaux, one time director of the Pasteur Institute (1840-1904).[2]

A new myth? These beings, must they be convinced that they derive from a mirage, or must they be given an opportunity to reveal themselves?

In accordance with the idea of creating new myths or renewing old ones, *VVV* published various records of symbolic experiments performed by the surrealists. For instance, in no. 2-3 (March 1943), it offered color reproductions of playing cards from the "Marseilles Game of Cards" invented in Breton's circle when he and several friends and acquaintances took refuge in that Mediterranean city at the end of 1940, after the occupation of Paris by the Nazis and the armistice. In *VVV*, Breton evoked life in Marseilles at the time:

The end of 1940 and the beginning of 1941 saw several persons linked with the surrealist movement, or in some respect related to it, joining together or meeting each other at Marseilles. . . . Many of them lived at Air-Bel, the mansion where Mr. Varian Fry, president of the American Committee for Aid of Intellectuals, welcomed them

[2] Such hypotheses had been already translated into the domain of science fiction, for instance, in prewar novels (ca. 1925) such as *Voyage au Pays de la Quatrième Dimension,* by Gaston de Pawlowski, or Maurice Renard's *Le Péril Bleu.* It may be added that in *Marcel Duchamp ou le grand fictif* (Marcel Duchamp, or the Great Fictitious One [Paris: Editions Galilée, 1975]), the author, Jean Clair, sees Pawlowski's "Travels in the Land of the Fourth Dimension" as one of the main sources of inspiration for Duchamp's *Large Glass (The Bride Stripped Bare by Her Bachelors, Even).*—M.J.

Left: Jacqueline and André Breton, Marseilles, 1940. *Right*: Matta: Illustration for *The Day Is an Outrage*, by Charles Duits, from *VVV*, nos. 2-3 (1943).

most heartily. In the near future we expect Mr. Fry to describe what life was then in the setting of that big park whose owner—an old miserly physician mad about ornithology—kept watch outdoors in the bitterest cold for fear that a dead bough would be taken away. Near the greenhouse, in autumn, as many praying mantises as we wanted could be caught, for the show they gave of rivalries and loves, still more upsetting than what the newspapers printed. Then great crystalline concerts at night were followed, in the morning, by the appearance on the surface of the pools of white bellies, of arms wide open, bearing witness to the mysterious gestation of the toads—testifying, superfetately, that life needs death to continue. Lastly, the unnamable "marshal," confident of his prestige, announced himself with police searches forty-eight hours before his arrival in Marseilles, resulting in several days of internment for the tenants of the mansion on board the SS *Sinaïa,* superbly decked with flags for the occasion. And there again, among many other "suspects"—so great is the power of challenge, of contempt, and also of hope against everything—never, perhaps, did the actors in that scene find themselves more childlike again, never did they sing, play, and laugh more heartily. . . .

In that atmosphere the group took pleasure in changing the symbols and names of playing cards, replacing the usual hearts, spades, diamonds, and clubs with other emblems, a flame, a black star, a red wheel, a lock, representing four "significations": Love, Dream, Revolution, and Knowledge. As for the kings, they became "genii" (for instance, the genius for Love was Baudelaire; for Dream it was Lautréamont; for Revolution, Sade), "sirens" were substituted

for queens (for Love, the siren was the Portuguese Nun;[3] for Dream, Lewis Carroll's Alice), and jacks became "magi" (for Love, Novalis; for Dream, Freud; for Revolution, Pancho Villa, etc.). And for each symbol, images were accordingly designed.

Also symbolic in *VVV* (no. 2–3, March 1943) was a sequence of notations by Charles Duits, from an idea by Leonora Carrington and Matta, entitled "Le Jour est un Attentat" and claiming to be based on a system that would have been "to the Tarot game what non-Euclidian geometry is to Euclidian geometry." This rather ambitious endeavor centered around a basic theme: the DAY, subdivided into four episodes "corresponding to the main events of the day." The two following excerpts belong to the episode of "The Playthings of the Prince,"[4] which was divided in turn into four parts: Meals, Sun, Palace, Anguish.

The Day Is an Outrage

Sun:[5]

Since the House is all wall and possibly (?) not going to fall down, I go within to take a bath. Nancy has turned it on. Alone, I feel full of desire to copulate with the water, which is green and smooth coming from the taps.

Palace:[6]

Rumble of passion and madness, and a show of duty toward some sovereign or other who washes his ankles and his lips in the sea. He turned his back to you, hideousness is explained for the ocean is stuffed with fear, the eastern wind moored itself to the pointed ears of our horses.

Near the ferry, a young woman urinated while weeping. The cone-shaped meat was ripped off each udder. The relations of space lie in these few words: we found the events of the day most seriously inculcated by the presence of nerve-vine in the beautiful center of our throats.

Leonora Carrington, English painter and writer who was Max Ernst's companion in France during the years preceding the war, published in *VVV*, no. 4 (February 1944), "Down Below," relating the mental crisis she suffered after her separation from Ernst at the beginning of the war. Mere excerpts would not do full justice to this poignant testimony on, one might say, the poetic consciousness of the unconscious, and we prefer to reproduce here one of Leonora's

[3]The "Religieuse Portugaise" was the anonymous author of the celebrated *Lettres Portugaises* (published in Paris in1669), five love letters supposedly written by a Portuguese nun to a French nobleman and generally considered one of the truest and most passionate expressions of woman's love. However, recent researches tend to show that these letters were written (or rewritten) by a seventeenth-century author of madrigals, Gabriel Guilleragues (cf. the Garnier edition of Guilleragues's works, Paris, 1961).

[4]The title of a Chirico picture of 1914.

[5]Original English text by Leonora Carrington.—M.J.

[6]Translation from Duits's French text.—M.J.

mysterious, sarcastic, and menacing little tales, published in *VVV*, no. 2-3 (March 1943):[7]

The Seventh Horse

A strange-looking creature was hopping about in the midst of a bramble bush. She was caught by her long hair which was so closely entwined in the brambles that she could move neither backwards or forwards. She was cursing and hopping till the blood flowed down her body.

"I do not like the look of it," said one of the two ladies who intended to visit the garden.

"It might be a young woman . . . and yet. . . ."

"This is my garden," replied the other, who was as thin and dry as a stick. "And I strongly object to trespassers. I expect it is my poor silly little husband who has let her in. He is such a child you know."

"I've been here for years," shrieked the creature angrily. "But you are too stupid to have seen me."

"Impertinent as well," remarked the first lady, who was called Miss Myrtle. "I think you had better call the gardener, Mildred. I don't think it is quite safe to go so near. The creature seems to have no modesty."

Hevalino tugged angrily at her hair as if she would like to get at Mildred and her companion. The two ladies turned to go, not before they had exchanged a long look of hate with Hevalino.

The spring evening was lengthening before the gardener came to set Hevalino free.

"John," said Hevalino, lying down on the grass, "can you count up to seven? Do you know that I can hate for seventy-seven million years without stopping for rest? Tell those miserable people that they are doomed." She trailed off towards the stable where she lived, muttering as she went: "Seventy-seven, seventy-seven."

There were certain parts of the garden where all the flowers, trees and plants grew tangled together. Even on the hottest days these places were in blue shadow. There were deserted figures over-grown with moss, still fountains and old toys, decapitated and destitute. Nobody went there except Hevalino; she would kneel and eat the short grass and watch a fascinating fat bird who never moved away from his shadow. He let his shadow glide around him as the day went by and hover around him when there was a moon. He always sat with his hairy mouth wide open, and moths and little insects would fly in and out.

[7]Leonora Carrington has also written fantastic novels that were published first in French: *Le Cornet acoustique* (The Hearing Trumpet, Collection l'Age d'or [Paris: Flammarion, 1974]) and *La Porte de pierre* (The Stone Door, Collection l'Age d'or [Paris: Flammarion, 1976]). The former was published in 1976, and the latter in 1977, by St. Martin's Press, New York.

Hevalino was there the same night that she was caught in the brambles. She was accompanied with a retinue of six horses. They walked seven times around the fat bird in silence.

"Who's there?" said the bird eventually in a whistling voice.

"It is I, Hevalino, with my six horses."

"You are keeping me awake with your stumping and snorting," came the plaintive reply. "If I cannot sleep I can see neither the past nor the future. I shall waste away if you won't go away and let me sleep."

"They are going to come and kill you," said Hevalino. "You had better keep awake. I heard somebody says you would be roasted in hot fat, stuffed with parsley and onions and then eaten."

The corpulent bird cast an apprehensive eye on Hevalino, who was watching him closely.

"How do you know?" breathed the bird. "Just you tell me that?"

"You are much too fat to fly," continued Hevalino relentlessly. "If you tried to fly you'd be like a flat toad doing his death dance."

"How do you know this?" screamed the bird. "They can't know where I am. I've been here for seventy-seven years."

"They don't know yet . . . not yet . . ." Hevalino had her face close to his open beak, her lips were drawn back and the bird could see her long wolves' teeth.

His fat little body quivered like a jelly.

"What do you want of me?" Hevalino gave a sort of crooked smile.

"Ah, that's better." She and the six horses made a circle around the bird and watched him with their prominent and relentless eyes.

"I want to know exactly what is going on in this house," said she. "And be quick about it." The bird cast a frightened look about him, but the horses had sat down. There was no escape. He became wet with sweat and the feathers clung, draggled, to his fat stomach.

"I cannot say," he said at last in a strangled voice. "Something terrible will befall me if I say what I can see."

"Roasted in hot fat and eaten," said Hevalino.

"You are mad to want to know things that do not concern you . . .!"

"I am waiting," said Hevalino. The bird gave a long convulsive shudder and turned his eyes which had become bulging and sightless to the east.

"They are at dinner," he said eventually, and a great black moth flew out of his mouth. "The table is laid for three people. Mildred and her husband have begun to eat their soup. She is watching him suspiciously. 'I found something unpleasant in the garden today,' she says, laying down her spoon; I doubt if she will eat any more

now. 'What was that?' asks he. 'Why do you look so angry?' Miss Myrtle has now come into the room. She looks from one to the other. She seems to guess what they are discussing, for she says: 'Yes, really, Philip, I think you ought to be more careful whom you let into the garden.'

"'What are you talking about?' he says angrily, 'how do you expect me to stop anything if I don't know what I am stopping?'

"'It was an unpleasant-looking creature half naked and caught in a bramble bush. I had to turn my eyes away.'

"'You let this creature free of course?'

"'I indeed did not. I consider it just as well that she was hopped as she was. By the cruel look on her face I should judge she would have done us serious harm.'

"'What! You left this poor creature hopped in the brambles? Mildred, there are times when you revolt me. I am sick of you pottering around the village and annoying the poor with your religious preamble and now when you see a poor thing in your own garden you do nothing but shudder with false modesty.'

"Mildred gives a shocked cry and covers her face with a slightly soiled handkerchief. 'Philip, why do you say such cruel things to me, your wife?'

"Philip, with an expression of resigned annoyance asks: 'Try and describe this creature. Is it an animal or a woman?'

"'I can say no more,' sobs the wife. 'After what you have said to me I feel faint.'

"'You should be more careful,' whispers Miss Myrtle. 'In her delicate condition!'

"'What do you mean "delicate condition"?' asks Philip irritably, 'I do wish people would say what they mean.'

"'Why surely you must know?' simpers Miss Myrtle. 'You are going to become a Daddy in a short time. . . .' Philip goes white with rage. 'I won't stand these fatuous lies. It is quite impossible that Mildred is pregnant. She has not been in my bed for five years, and unless the holy ghost is in the house I don't see how it came about. For Mildred is unpleasantly virtuous, and I cannot imagine her abandoning herself to anybody.'

"'Mildred, is this true?' says Miss Myrtle, trembling with delicious expectation. Mildred shrieks and sobs: 'He is a liar. I am going to have a darling little baby in three months.'

"Philip flings down his spoon and serviette and gets to his feet. 'For the seventh time in seven days I shall finish my dinner upstairs,' says he, and stops for an instant as if his words had awakened some memory. He puts it away from him and shakes his head: 'All I ask is that you don't come whining after me,' he says to his wife and quits the room. She shrieks: 'Philip, my darling little husband: come back and eat your soup. I promise I won't be naughty any more.'

"'Too late,' comes the voice of Philip from the staircase, 'too late now.'

"He goes slowly up to the top of the house with his eyes looking a long way ahead of him. His face is strained as if in the effort of listening to far away voices chattering between nightmare and dead reality. He reaches the attic at the top of the house where he seats himself on an old trunk. I believe the trunk is filled with ancient laces, frilly knickers and dresses. But they are old and torn; there is a black moth making his dinner on them as Philip sits staring at the window. He considers a stuffed hedgepig on the mantelpiece who looks worn out with suffering. Philip seems to be smothered with the atmosphere of this attic, he flings open the window and gives a long . . ." Here the bird paused, and a long sickening neigh rent the night. The six horses leapt to their feet and replied with piercing voices. Hevalino stood stock still with her lips drawn back and her nostrils quivering. "Philip, the friend of the horses....." The six horses thundered off towards the stable as if obeying an age-old summons. Hevalino, with a shuddering sigh, followed them with her hair streaming behind her.

Philip was at the stable door as they arrived. His face was luminous and as white as snow. He counted seven horses as they galloped by. He caught the seventh by the mane, and leapt onto her back. The mare galloped as if her heart would burst. And all the time Philip was in a great ecstasy of love; he felt he had grown onto the back of this beautiful black mare, and that they were one creature.

At the crack of the dawn all the horses were back in their places. And the little wrinkled groom was rubbing off the caked sweat and mud of the night. His creased face smiled wisely as he rubbed his charges with infinite care. He appeared not to notice the master who stood above in an empty stall. But he knew he was there.

"How many horses have I?" said Philip at last.

"Six, sir," said the little groom, without ceasing to smile.

That night the corpse of Mildred was found near the stable. One would believe that she had been trampled to death.....and yet "they are all as gentle as lambs," said the little groom. If Mildred had been pregnant there was no sign of it as she was stuffed into a respectable black coffin; however nobody could explain the presence of a small misshapen foal that had found its way into the seventh empty stall.

Aimé Césaire, the poet and statesman from Martinique whom Breton met when the ship bringing him and many other refugees from Marseilles to New York stopped at that island, published poems in every issue of *VVV*. The following three short pieces appeared in French in no. 2-3 (March 1943).

Annunciation

To André Breton

Ringing to the meat, new mokatine bloods cling to the boughs of the vegetable sun; they wait for their turn.

Moving palms outline the future body of yellow-breasted carriers, the sprouting harvests of all revealed hearts.

The pit of the torch coming down to the extreme promontory creates a friendly round encircling the town's weakness and moored with young creepers in the real sun of real fire of real earth: annunciation.

For the annunciation of the mokatine carriers moored in the sun of the pit of the torches — green eye with a yellow ring, oxide eyes laden with moons, moon eyes laden with torches—eye of the torches, twist the unknotted lakes' discreet fertilizer.

Tam-tam I

To Benjamin Péret

right in the river of blood of earth
right in the blood of broken sun
right in the blood of a hundred sun nails
right in the blood of the fire breasts' suicide
right in the blood of cinders the blood of salt the blood of love bloods
right in the burning blood of fire bird

heron and hawk
soar and burn

Tam-tam II

To Wifredo

small steps of raining caterpillars
small steps of a gulp of milk
small steps of ball-bearing
small steps of earth tremor
in the earth the yams walk with strides of stars' gap,
 of night gap, of Holy Mother of God's gap
strides like a gap of speeches in a stammerer's throat
orgasm of holy pollution
hallelujah

A "Psychological Novelette" in six brief chapters by Edouard Roditi appeared also in no. 2-3 of *VVV*. Here are the first and the last of its chapters:

Psychological Novelette
with only one theme
and practically one character

1
Early Childhood

Little Pamphilus Weathercock is seated on a high chair in the family kitchen, his legs dangling still too short to reach the floor. He is weeping bitterly while he watches his mother, at the kitchen table near by, slicing a long golden loaf with a big sharp knife. Each time she cuts a new slice, Pamphilus winces and bursts into a fresh spasm of sobs, then calms down while she butters the slice soothingly with thick soft butter. And this is repeated several times, all very monotonously, without much variation except that, every once in a while, Pamphilus sees his mother eat one of the slices of buttered bread; and then, each time, his sobs reach a paroxysm so violent that he almost thinks he is about to die. And then his mother, who does not otherwise seem to be very much worried by his grief and pain, smilingly and with a theatrical gesture of affected tenderness, offers him a bite of the slice of this beautiful buttered bread of which herself has just eaten. And each time he angrily refuses, almost vomiting at the mere idea of eating it.

6
Intimations of Approaching Middle Age and Death

Pamphilus is walking along an immensely long and very luminous road which stretches out ahead of him, in the dark, as far as he can see, ever narrower as it speeds straight ahead to a point at the farthest imaginable horizon, without a curve, without a hill on its whole length ahead of him. Pamphilus sees that he still has very far to go through the dark along this dreary road; but he is depressed by its apparent narrowness rather than by its length as he looks down and notices that the road is only just broad enough, where he now stands, for him to walk along it. The road grows narrower and narrower ahead of him; then too, he notices for the first time above him and beneath him and to his right and to his left, everywhere else except along this road, there is nothing but a bottomless deep night.

Pamphilus wants to turn back. But then he discovers that, behind him, the road grows wider till it stops at the hilt of a huge sword along whose narrowing blade he

has apparently been walking all this time. And from the hilt behind him to the place where he now stands, the whole blade is slippery with dark blood that drips noiselessly into the bottomless darkness below. Pamphilus steps forward, further along the blade and away from the blood. But the blood follows him like a rising tide and he suddenly realizes that, the further he walks along the blade, the further this blood, from his feet, will creep ahead, all the way from the hilt to the inevitable point, not so far away now, where the sword meets the horizon ahead. And no retreat is possible now, back to the hilt along the gory blade.

Poems and short stories were published by *VVV* in French or in English (sometimes in Spanish), while short essays, theoretical texts, and critiques were mostly in English. The following passages are from an article in no. 1 (June 1942) on Mondrian and Chirico by the painter-writer Robert Motherwell, who discusses the strange problem of Chirico's reversal of inspiration after his early "metaphysical" period:

Notes on Chirico

2

The Art of Reaction: The Late Chirico

A man not pre-eminently virtuous and just, whose misfortune, however, is brought upon him not by vice and depravity but by some error of judgment...

–Aristotle, *Poetics 13*

Standing before these late (1939) gouaches[8] *à la mode,* who finds any stimulus to a remembrance of Chirico's early scenic stage? Not the empty stage of his subsequent imitators, where the tragic action has already taken place, and we are presented with no more than the scene of the crime; but Chirico's stage, where the strange symbols have an irresistible attraction for one another, where if they do not interact before us, they will after we are gone. They are filled with incredible potentialities. Or, more specifically, what remains now of the expressiveness in that work of 1914 symbolizing the content of *The Child's Brain,* with its father-image? Yes, the father! Shockingly naked but unrevealed, hairy, immovable, inescapable, standing like a massive rock on the silent shore of the unconscious mind, a rock unseeing, with its closed eyes, but a rock resisting all attempts to pass beyond, a rock to burrow into, if that is the only possibility of getting beyond, but a rock eternally waiting, waiting for when it will be at once judge and executioner, judge of the guilt inherent in killing the origin of one's being in order to be, and executioner by virtue of one's fear of being free.[9] What remains of that? Nothing. Nothing but the problem of how this awful degeneration came

[8]Perls Gallery, 30 March-25 April, 1942.

[9]But cf. Robert Melville's *Apocalypse in Painting:* "Even the naked man in *The Child's Brain* is a wax-work, with a wig

about. Was it, as I suppose, the consequence of a tragic action, the result of choice between irreconcilable values; or was the actual circumstance as banal as Dali's? Mr. Soby's otherwise admirable *The Early Chirico* (1941) gives us no hint. Certainly the conventional thesis (which holds that Chirico's genius simply burned itself out) explains nothing; it merely reveals the phenomenon to be explained. . . . The evidence of his works suggests a hypothesis which, if not complete, does dispel the mystery in part; and the hypothesis has the advantage of being tested, just as it is suggested, by the works themselves. From them the central fact is plain enough: c. 1910-1917 young Chirico produced a quantity of pictures, of which the majority are indubitable master-pieces, pervaded by a binding poetry: the paintings after that date are filled with meaningless classic paraphernalia, and a plasticity expressly designed for contem-porary taste. The few other relevant facts are well-known: Chirico's great period corresponds to cubism's great period, of which Chirico was either in ignorance, or to which he was indifferent. At any rate, his own historical influence came (c. 1920) as the poetic opposition to cubism's architectonics; and he was made influential largely though the interest in his work of Breton, critic and poet, and Ernst, painter and poet, which is not surprising in view of Chirico's essentially poetic, rather than essentially plastic gift. His particular plastic inventions, like the shadow cast by an object unseen in the picture (a device later to be exploited by Dali), *derive from poetic insight; i.e.* the remarkable intensity of feeling in the early work arises more from the nature and juxtaposition of his symbols than from their formal relations to one another, adequate as the latter may be. This emphasis on his poetry has important outside evidence: years after the decline of his painting into an incredible academism, Chirico was still able to produce his superbly poetic novel *Hebdomeros*. . . . Now it is scarcely plausible to suggest, as Mr. Soby does, "that Chirico's genius died a lingering death, that at times, as in certain paintings and his novel *Hebdomeros,* it has raised itself in bed." It is more plausible to suppose that *something happened to alter Chirico's conception of painting,* something radical enough to cause the poetry to disappear from it. It so happens that Chirico first became interested in Parisian painting at a moment when it was turning from many years of experiment to a normative authoritarianism, to a painting relying on the weight of traditional images understood by everyone, as in the "classic" period of Picasso, Derain, and so on. It is not difficult to suppose that Chirico was ravished by the "objective" authority of such painting, and determined to participate in its creation. His pictures after 1918, being failures, are generally ignored by critics, but they afford the clue. The intention of the

and false moustaches," etc. So it is, when regarded plastically; but the real meaning is in the poetry: there is no question of what Chirico himself means by the picture; he has described his most important dream in these terms: [see the excerpt from *La Révolution surréaliste,* no. 1, Chirico's dream, on pp. 165-66 of this anthology].

later pictures is *authoritarian,* the observer looking from below *up* to white horses, as he must look up to an equestrian monument; *traditional,* the subject-matter being reminiscent of antiquity, with its "classic" columns, and its treatment of personages and horses in shades of white, like ancient statues; *normative,* being intelligible to any normal person, since it depends on neither personal sensitivity nor insight, but on associations commonly known in the occident; and (no doubt most important in Chirico's mind) *plastic,* the attempt to have the painting itself constitute the "meaning," as in cubism, not poetic insight, hence the fat impasto, the simplification of forms, the color by local areas, the importance of contour, the emphasis of surface texture, and the other devices in the contemporary taste. Of course he was foredoomed to failure in his effort to create such painting, because his gift was not normative, authoritarian and plastic, but in actuality the precise opposite, unique, personal, and poetic. And it is unforgivable that these later works are not even an honest attempt to enlarge his experience, and ours; they are instead deliberate attempts to cater to the luxury trade. Like all such work, they are unnecessary; they fulfill no genuine need.

If this later work is the result of a deliberate choice, as I suppose, the choice represents a moral action, the choice between two irreconcilable values; and where the action becomes tragic is in the pursuit of that thing Chirico chose as the final good, to the necessary exclusion of other goods, so that whatever value the original good may have had for him ends in a final evil, as other goods are vanquished in the struggle. His tragic flaw reveals itself as his arrogance, his refusal, in relation to his true gift, to accept his limitation, and admit his error. He defended himself against the bitter attack of the surrealists in the '20's by replying that at last he painted like the old masters. He was bound finally to dupe himself. He grew to believe in the authoritarian; the petrifaction of his talent, plus alliance with those states which alone could accept his later work, represent the material consequences of his action. Understood so, Chirico becomes one of the clearest examples of the historic issues of our time. His sterility and that of the authoritarian state have the same origin, fear and contempt of the human. It is only just that, as that state will, so has Chirico brought about his own ruin.

In *VVV*, no. 2-3 (March 1943), an article by Robert Lebel, French writer, art critic, and expert on painting, discussed a curious American artist of the last century, John Quidor.

Quidor and Poe
or the American Loneliness[10]

The Olympian singularity which distinguishes Edgar Allan Poe in the realm of American literature is strikingly paralleled by John Quidor's humbler but equally

[10]The text appeared in English in *VVV*.

isolated position in the realm of American art. Their lives and their works are stamped with the same mark of solitude. . . .

There certainly seldom was a more surprising phenomenon than the appearance of Quidor,[11] and his visionary conception of art, at the Third Annual Exhibition of the National Academy of Design, which opened on May 5, 1828. . . . Quidor's unexpected, and perhaps untimely, message remained entirely overlooked. . . . His power of suggestion, his poetic intensity are unprecedented in American art. His style, though related to the universal trend of Romanticism, is profoundly individual in its treatment of the fantastic. . . .

Today, Quidor would be still forgotten but for the patient efforts of Mr. John I. H. Baur who succeeded a year ago in assembling sixteen out of eighteen then located paintings for a retrospective show at the Brooklyn Museum. . . . However, the importance of such a revival does not seem to have been fully realized. Quidor's work is not merely a genuine piece of Americana. It is a document of outstanding human interest and an artistic achievement of a most extraordinary character.

Technically, Quidor derives from the British, not, of course, from the academic tradition revered by most of the American portrait painters, but from the dynamic elements which Géricault was discovering in 1820 when he endeavored to "dip his art in the English." Britain is one source which Quidor shares with the continental Romanticism. From Hogarth to Rowlandson (admired and copied by Delacroix), from Morland to the strange and dreamy James Ward (admired and copied by Géricault), to Gillray and to the Burlesque George Cruikshank who has points in common with both Quidor and Gustave Doré, many of the British painters in the popular and satirical vein have spread their vitalizing influence abroad. They have contributed in no small measure to the evolution of romantic art toward exuberance and exaltation.

Quidor's fluid design and swift brushwork show that they, too, have been "dipped in the English." His paintings, save for a few exceptions at the beginning and the end of his career, are covered with a brown glaze which reminds one of the Dutch, but his anti-naturalistic disposition precludes any strong contribution from Dutch art in the formation of his style. And to the charge that his work seems penetrated by a German gloom, one may use Poe's reply that "terror is not of Germany but of the soul." . . .

Quidor drew his inspiration from literature in true romantic fashion. His subjects were borrowed from Cervantes, Fenimore Cooper and, above all, from Washington Irving's tales of a legendary New York. . . . Quidor's compositions after Irving, compared with the stories they claim to illustrate, are of a decidedly intensified mood. Light humor is changed into caricature, mild drama into tragedy. We are in another

[11]Born in Tappan, New York, January 26, 1801; died in Jersey City, New Jersey, December 13, 1881.

world, a world where our senses are keyed above the normal, a world inhabited by figures frantic, distorted, or grotesque, a world of vehement gestures and intricate foliage, a world where not even the light is real.

Indeed, this world, if it recalls anything yet known, is much nearer to Poe than it is to Irving. In his most inspired moments, Quidor gives shape to "the half-formed, the reluctant, the unexpected fancies of mankind." . . . But, unless some new evidence appears, we must concede that the link between Poe and Quidor cannot be analyzed in terms of facts and dates. There is more in the convergence of their destinies than the obviousness of palpable ties. It is in their simultaneous rebellion against the tedious and the rational, in their passionate search for poetic substance, that they appear amazingly akin. Separately, but moved by the same fundamental and obstinate impulse, stirred, it seems, by the very extent of their solitude, they uncovered the deep, the secret, the unforgettable current of American loneliness.

Let us mention also, again in *VVV,* no. 2-3 (March 1943), an article on "popular" novels, especially those of Lovecraft and Clark Ashton Smith, by Robert Allerton Parker:

Such Pulp as Dreams Are Made On

This caste of untouchables populates the newsstands with impudent density. The pulps thrive with the hardihood of weeds — or the ambiguous hemp-plant. They bring to mind the words of Hamlet: ". . . an unweeded garden that grows to seed; things rank and gross in nature possess it merely." . . . Some of them answer the subconscious craving for purely physical derring-do: "action" stories, "westerns," aviation adventures. Others purvey *ersatz* opiates designed to assuage thwarted sexual impulses. Still others indulge in masked orgies of murder, torture, violence, sadism, sterilized and rendered morally innocuous by the automatic triumph of the forces of law and order.

Most fascinating, perhaps, are those pulps devoted to super-realistic "wonder" — to the weird, the horrendous, the pseudo-scientific, the resurrection of ancient myths and folklore. . . .

August Derleth and Donald Wandrei have salvaged the work of two extraordinary "stars" of the pulpwood fiction-factories — H.P. Lovecraft and Clark Ashton Smith. Convinced that Lovecraft (this name is slightly incredible, but it is no *nom de plume*) was of more than passing significance, Derleth and Wandrei collected thirty-six of his tales (Lovecraft had died in 1937) and submitted the huge manuscript to leading publishers. Most of these promptly rejected the project as a "poor commercial risk." Undismayed, these two young *littérateurs* set up their own publishing house, the Arkham Press, in Wisconsin. Lovecraft's work was printed in a bulky volume of 5553

closely-printed pages, including an introduction and Lovecraft's own exhaustive essay on "Supernatural Horror in Literature."...

Precocious wonder-children create their own imaginary kingdoms, complete with custom, currency and costume. Like them this recluse mapped and charted his own subjective archeology and fantastic prehistory.... "All my stories," Lovecraft confessed, "are based on the fundamental lore or legend that this world was inhabited at one time by another race, who, in practising black magic, lost their foothold and were expelled, yet live on outside ever ready to take possession of the earth again. . . ."

Lovecraft's tales eventually found publication in such pulpwood publications as *Weird Tales, Astounding Stories,* and others devoted to the supernatural. His financial rewards were infinitesimal, averaging less than a cent a word. Lovecraft recalls Dunsany, Algernon Blackwood, Arthur Machen and Poe. He over-strains his efforts to strike terror. Like all verbomaniacs, he fails to master his obsessions: he is too wordy, too explanatory, too rhetorical. He is at his best when he retreats into the universe of his own creation, or indulges in flights of pseudo-archeology, and leads his readers in grim expeditions to hunt down traces of the prehistoric malevolence, as embodied in the "Old Ones." . . .

More arresting, from the point of view of unconscious revelation, is the Californian Clark Ashton Smith. . . . As an explorer of the grotesque, the inter-planetary and the trans-dimensional in pseudo-scientific fiction, Smith has for many years enjoyed widespread popularity among pulpwood "fans." . . . Smith has tried his hand at all types of pseudo-scientific fiction. Throughout his tales, as now collected, the reader is haunted by a sense of gloominess, of isolation. They are, perhaps unconsciously, autobiographical.

In *The Uncharted Isle,* for instance, a shipwrecked sailor is beached upon a strange island of the Pacific and finds himself in a jungle that might have been painted by Rousseau *le Douanier* . . . : leaves, stems, frondage, are of archaic types, such as might have existed in former eons, on the sea-lost littoral of Mu. The sailor is overwhelmed with intimations of a dark and prehistoric antiquity.... He discovers the main town of the strange island, where the inhabitants move about in perplexing and perplexed fashion: ". . . These beings were so palpably astray and bewildered; it was so obvious that they knew as well as I that there was something wrong with the geography, and perhaps with the chronology, of their island." The poet wanders here in isolation in a silent, alien universe, striving vainly to communicate with his fellow-humans. They live in another age, another dimension, wrapped in their own perplexity. . . .

In our search of the typical, we are ineluctably led to the un-typical. Even in the naivest of pulp fiction, we detect the unending conflict between the conscious craft

and the unconscious drives — the controlled versus the uncontrollable. Were we adepts in academic research, we might trace the mongrel ancestry of this pseudo-scientific and fantastic allegorizing back through Lord Dunsany and Algernon Blackwood, H.G. Wells, Samuel Butler and Jules Verne, the satirical "futurists" like the Russian Eugene Zamiatin (author of *We*), the Voltaire of *Micromegas* and the Swift of *Gulliver.* On and on, to ever more remote sources, we arrive finally at the Islamic, oral storytellers of the *souks,* or the anonymous compilers of the *Book of a Thousand Nights and a Night.*

The origin of all modern expression is always far more ancient than we suppose — even of the talking motion pictures. So the ephemeral pulps of the newsstands bear a striking analogy to the *Arabian Nights.* With its subjective universe dominated by Ifrits and *djinn* (with their magical powers of transforming themselves into beasts, plants or insects), its malicious negation of external morality, its sly fusion of magic and reality, and especially its bold suspension of distressingly insistent physical laws, that endless involuted Persian (or Indian) labyrinth of narrative survives as the most audacious and most captivating revolt from the objective world ever depicted. It entices the reader into a never-never land in which individual responsibility is swept aside, a realm of surcease from iron laws of the dismal sciences, where Euclid and Newton never ventured. . . .

David Hare, the sculptor, was an editor of *VVV,* though not actually a contributor. Only in later years did he occasionally express in writing his ideas on art and its evolution. An excerpt from his unpublished commencement address at the Maryland Institute, College of Art, in 1969, may nevertheless find a place here.

Some years ago when Picasso was in his seventies he almost died of pneumonia. In delirium he saw the walls and furniture move, distort themselves, become other than they were. He swore to himself, should he live, he would never again distort or invent form. He of course resumed his old liberties with reality as soon as he recovered. But the promise was important because it demonstrates the necessity of remembering the way back. To lose the path is insanity, to never venture into such country is to keep one's hands in one's pockets, which we very well know means you will never see all that glory and stuff.

Marcel Duchamp once was asked if there was any avant-garde action left open to the artist today. He answered by saying, "Go underground, don't let anybody know you are working." Such an attitude, in this time of public relations and propaganda, would be the only truly avant-garde expression, but he felt it would be difficult to maintain for any length of time.

What the public and his friends did not know, nor did they know until his death, was that during all those years Duchamp himself had been secretly working. According to art history. Duchamp was supposed to have retired from the field some thirty years ago. Some art history buffs even considered the retirement his final and greatest dada gesture. The finished work is an environment — a peephole through which one sees the world. It is called something like: "Given, (1) a waterfall and (2) a gas jet"; meaning, I suppose, given those two things, what would you do? This summer you can see what Duchamp did, in the Philadelphia Museum, where it is now, after his death, being installed.

Picasso translated a complex of feeling and thought into the intensely visual, and then promised never to truck with such complexity again. One bypassed the visual and invented conceptual art fifty years before the phrase came into being, then supposedly stopped producing and became a living myth.

All artists are liars!

Nicolas Calas, the writer, once referred to Duchamp as Picasso's conscience. He said that every time Picasso painted a picture, Duchamp refrained from painting one.

Both men, each the greater for the presence of the other, his opposite. Both are revolutionaries, not by choice but because they can't help it. Which is as it should be. Such men move and change knowing that only change is permanent, knowing that a revolution is always the groundwork for an establishment, knowing that soon it must be started again.

A friend of mine mentioned in passing that she didn't see all this fuss about going to the moon, people had been going there for hundreds of years. I wasn't quite sure what she meant and I didn't want to spoil it by asking. Anyway, whether you did it in your mind or in a rocket, the thing is to do it. The trips are quite different but equally necessary.

Well, what's important? I am not sure but I think it's LOVE and TIME. Given those two things, or a waterfall and a gas jet, one may be able to accomplish almost anything. And then, of course, there might be such a thing as a moral dignity; if it exists at all it is of no apparent use. That in itself is reason enough to search for it.

Many other contributions to the three issues of *VVV*, between 1942 and 1944, could be quoted here, but our choice can be only indicative — poems, essays, records of experiments of surveys, critiques, by Lionel Abel, Victor Brauner, J. B. Brunius, Arthur Cravan (the publication of his "Notes"), Nicolas Calas, Max Ernst, Charles Henri Ford, Gordon Onslow Ford, Pierre Mabille, E. L. T. Mesens, Alfred Métraux (on images on tapa from Easter Island), Frederick Kiesler (on dreams), Claude Lévi-Strauss (on "Indian Cosmetics"), Benjamin Péret, Harold Rosenberg, William Seabrook, Kurt Seligmann (on magic), etc., etc. Many

illustrations filled the pages of the three numbers whose covers were designed by Max Ernst, Marcel Duchamp, and Matta.

VVV turned out to be a yearly publication (no. 2-3 was subtitled "Almanac for 1943"), but the magazine *View,* founded in 1940 by the poet Charles Henri Ford, kept up a fairly regular trimestral appearance until 1947, devoting many pages and sometimes entire numbers to surrealism. The general tone of *View* recalled the prewar Belgian review *Variétés,* but it was more lively and entertaining. Two of its 1942 issues were devoted to Max Ernst and Yves Tanguy, respectively. The inventor of surrealistic boxes and objects, the American Joseph Cornell, contributed "Fantastica Americana" to no. 4 of 1942. A Duchamp number was published in 1945. In August 1941 the review published the only interview given by (or rather, asked of) André Breton during his stay in the United States.

The following lines on Yves Tanguy, by Nicolas Calas, appeared in the Tanguy number of *View:*

Alone

The solitude of Tanguy differs from Chirico's, but it is significant that it should be a picture of Chirico that first inspired Tanguy to paint. Tanguy is not a Mediterranean and cannot be haunted by an abandoned civilization but the province he comes from, Brittany, is most conservative and backward; its inhabitants feel themselves isolated from the rest of France and are more easily drawn by the mysteries of the wide water than by the inland. The solitude of Tanguy is oceanic.

"He discovers land beyond unknown seas. The objects that inhabit these strange plains are real, for they have weight and balance; they are alive because they grow; their color is natural and expresses their temperature, rarely hot, they are often warm. Their cold shadows are so mysterious because of the dissonance between them and the light on the horizon, but the effect of the contrast is convincing because Yves Tanguy is so sure of the reality of his vision as is the engineer of the existence of his machine or the musician of his symphony. The appalling silence of Tanguy's pictures creates a longing for sound. The colors of his sunsets suggest music and the changes of temperature are rhythmical. Often after awaking we remember what has been said in our dream without being able to recollect the sound of the voice. Tanguy's objects await music, instead of evoking sounds as do instruments of forgotten civilizations," I wrote recently in a note about Tanguy in an exhibition at the Matisse Gallery.

No one can enter "The House of Yves Tanguy" if he does not understand solitude. The contemporary artist's medium for expressing this sentiment is the shadow. This is natural, for since the impressionists made of light the predominant factor in painting the *poète maudit* lived among shadows. Surrealism has always stood for the powers

of darkness, for the dream, the magical and malediction. The mirrors its visionaries look into are mirrors of darkness. The mirror, the shadow, reassure us of our existence (Chirico), of the existence of the land we behold (Tanguy) and of "the desert's dazzling furniture," to use André Breton's strong expression. . . .

The Max Ernst number of *View* contained some "data" concerning the painter's earliest beginnings as an artist and a poet (reproduced later in Max Ernst, *Beyond Painting,* edited by Robert Motherwell for Wittenborn, Schultz, New York, 1948).

Some Data on the Youth of M.E.
as told by himself

The 2nd of April (1891) at 9.45 a.m. Max Ernst had his first contact with the sensible world, when he came out of the egg which his mother had laid in an eagle's nest and which the bird had brooded for seven years. It happened in Brühl, 6 miles south of Cologne. Max grew up there and became a beautiful child. His childhood is marked by some dramatic incidents, but was not particularly unhappy.

Cologne was a former Roman colony called *Colonia Claudia Agrippina* and later the most radiant medieval culture-center of the Rhineland. It is still haunted by the splendid magician Cornelius Agrippa who was born there and by Albert the Great who worked and died in this town. The craniums and bones of three other magi: Jasper, Melchior and Balthasar, the wise men of the East, are preserved in the dome-cathedral. Every year, the 6th of January, their golden, sumptuously jeweled coffin is shown to the public with extraordinary pagan pomp. Eleven thousand virgins gave up their lives in Cologne rather than give up chastity. Their gracious skulls and bones embellish the walls of the convent-church in Brühl, the same one where little Max was forced to pass the most boring hours of his childhood. Maybe their company was helpful to him.

Cologne is situated just on the border of a wine-producing region. North of Cologne is Beerland, south is wineland (Rhineland). Are we what we drink? If so it may be important to state that Max always preferred wine. When he was two years old, he secretly emptied some glasses, then he took his father by the hand, showed him the trees in the garden and said "Look, daddy, they move." When later he learned the story of the Thirty Years' War (1618-1648), he had the impression that this was a war of beer drinkers against wine drinkers. Perhaps he was right.

The geographical, political and climatic conditions of Cologne may be propitious to create fertile conflicts in a sensible child's brain. There is the cross-point of the most important European culture-tendencies, early Mediterranean influence, western

rationalism, eastern inclination to occultism, northern mythology, Prussian categorical imperative, ideals of the French Revolution and so on. In Max Ernst's work one can recognize a continuous powerful drama of those contradictory tendencies. Maybe one day some elements of a new mythology will spring out of this drama.

Little Max's first contact with painting occurred in 1894 when he saw his father at work on a small water color entitled "Solitude" which represented a hermit sitting in a beech-forest and reading a book. There was a terrifying, quiet atmosphere in this "Solitude" and in the manner it was treated. Everyone of the thousand of beech-leaves was scrupulously and minutely executed, everyone of them had its individual solitary life. The monk was terrifically absorbed by the content of his book, so that he represented something living outside the world. Even the sound of the word "Hermit" exercised a shuddering magic power on the child's mind. (The same thing happened to him at this time by the sound of the words "Charcoal-Monk-Peter" and "Rumpelstiltskin.") Max never forgot the enchantment and terror he felt, when a few days later his father conducted him for the first time into the forest. One may find the echo of this feeling in many of Max Ernst's *Forests and Jungles* (1925-1942).

(1896) Little Max made a series of drawings. They represented father, mother, the one-year-older sister Maria, himself, two younger sisters Emmy and Louise, a friend named Fritz and the railroad guardian, all of them standing, only the six-month-old Louise sitting (too young for standing). In the sky an abundantly smoking train. When someone asked him: "What will you become later?" little Max regularly answered: "A railroad guardian." Maybe he was seduced by the nostalgia provoked by passing trains and the great mystery of telegraphic wires which move when you look at them from a running train and stand still, when you stand still. To scrutinize the mystery of the telegraphic wires (and also to flee from the father's tyranny) five-year-old Max escaped from his parents' house. Blue-eyed, blond-curly-haired, dressed in a red night shirt, carrying a whip in the left hand, he walked in the middle of a pilgrims' procession. Enchanted by this charming child and believing it was the vision of an angel or even the infant of the virgin, the pilgrims proclaimed: "Look, little Jesus Christ." After a mile or so little Jesus Christ escaped from the procession, directed himself to the station and had a long and delightful trip beside the railroad and the telegraphic wires.

To appease father's fury, when the next day a policeman brought him home, little Max proclaimed that he was sure he was little Jesus Christ. This candid remark inspired the father to make a portrait of his son as a little Jesus-child, blue-eyed, blond-curly-haired, dressed in a red night shirt, blessing the world with the right hand and bearing the cross — instead of the whip — in his left.

Little Max, slightly flattered by this image, had however some difficulty in throwing off the suspicion that daddy took secret pleasure in the idea of being God-the-

Father, and that the hidden reason of this picture was a blasphemous pretension. Maybe Max Ernst's picture "Souvenir de Dieu" (1923) had a direct connection with the remembrance of this fact. . . .

In its Marcel Duchamp issue, *View* offered among many admiring or affectionate articles from friends of the creator of *The Bride Stripped Bare by Her Bachelors, Even* a "Testimony" by André Breton defining the exceptional position this artist occupied in the intellectual world. The article mentioned Duchamp's contribution to the surrealist exhibition in New York in 1942 at the Whitelaw Reid mansion on Madison Avenue, where, in order to hide an antiquated décor of flowers and cherubs painted on the ceilings of the old house, he had stretched across the halls a giant spider web made of miles of twine—which also hid part of the paintings on display. It may be wondered if this tangled mesh, in Duchamp's mind, was meant to be a mark of quality, as spider webs happen to be for bottles of precious wine aged in cellars, or if it was a sign of decay, as these same webs are for worthless remnants of the past hidden away in garrets. Perhaps it meant both. In any case, visitors to the exhibition had their choice of which side of the symbol they preferred and whether the classical scenes on the ceilings, or the surrealist pictures on the walls, had the qualities of time-honored masterpieces or deserved contempt as outdated relics.

The catalogue of the exhibition was entitled *First Papers of Surrealism* (an allusion to the immigrant's initial step in the naturalization process) and it staged and illustrated "the survival

Left: Page concerning "The Messiah" from the exhibition catalogue *First Papers of Surrealism*, 1942. "On the Survival of Certain Myths and on Some Other Myths in Growth or Formation." Translation of the verse by Gérard de Nerval: "Meanwhile the sibyl with the Latin face/ Is still sleeping under Constantine's arch:/—And nothing disarranged the severe portico." *Right*: André Breton: *Ode à Charles Fourier*, title page by Frederick Kiesler, Paris, 1947.

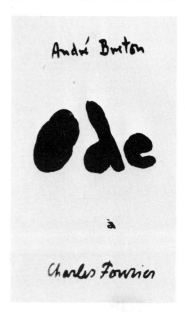

of certain myths and some other myths in growth or formation": the Golden Age, Orpheus, Original Sin, Icarus, the Philosophers' Stone, the Grail, the Artificial Man, Space Travel, the Messiah, the King Put to Death, the Androgyne, the Triumph of Science, the Myth of Rimbaud, Superman, and also Breton's Great Invisibles.

In his introduction to a study to appear in Cahiers de Contre-Attaque, a series of booklets planned by the group formed in 1935 by Breton and Georges Bataille,[12] Paul Klossowski had stressed the importance of the nineteenth-century sociologist Charles Fourier:

The moral discipline of our outdated regime is based on economic destitution, which rejects as the most redoubtable danger the free play of passions. In contrast, Fourier envisaged an economy of plenty resulting from the free play of passions. Since plenty is now within reach of men and escapes them only because of their moral destitution, has not the time come to do away with the cripples and eunuchs who today enforce this destitution, and to open the road to man, freed from social constraints, a candidate for all the joys he deserves—the road that Fourier showed a century ago?

Contre-Attaque, as we have seen, had only an ephemeral existence; its "Cahiers" never were printed, nor was Klossowski's study on Fourier. But ten years later, in New York Breton found an old edition of Fourier's works and became deeply interested in the ideas of this apostle of "passionate attraction." In 1945 he wrote a long piece, *Ode à Charles Fourier*—not an automatic poem but a deliberate discourse, interspersed with metaphors, and written in a sustained lyrical tone. The *Ode* should be read in its entirety, but perhaps a short excerpt may give an idea of Breton's homage to a spirit doubtless utopian but whose poetic sense could confer on him preeminence over many other—and no less utopian—social therapeutists.

ODE TO CHARLES FOURIER [13]

Fourier what have they done with your keyboard
That responded to everything with a chord
Setting by the movements of the stars from the capers of the smallest boat on the sea
 to the great sweep of the proudest three-master
You embraced unity you showed it not as lost but as totally attainable
And if you named "God" it was to infer that this god came under the evidence of the
 senses (*His body is fire*)
But what has forever caused socialist thought for me really to break cover
Is that you felt the need *to differentiate the comma at least in quadruple form*

[12] See above, pp. 371-72.

[13] This fragment is from Kenneth White's translation (London: Goliard Press, 1969), with an introduction by the translator on Fourier and his works and on Breton's poem.

And to transfer the treble clef from the second to the first line in musical notation
Because it's the whole world that must not only be overturned but prodded everywhere
 in its conventions
And there's no control lever to be trusted once and for all
Not more than a single dogmatic commonplace which does not totter when confront-
 ed by ingenuous doubts and demands

Because the *"Veil of Bronze"* has survived the rent you tore in it
And covers even more completely *scientific blindness*
"No one has ever seen a molecule, or an atom, or an atomic link and it's unlikely anyone
 ever will" (Philosopher). Prompt proof to the contrary: in swaggers the molecule
 of rubber.
A scientist though provided with black glasses loses his sight for having observed at
 several miles' distance the first atomic bomb tests (The newspapers).

 Fourier I salute you from the Grand Canyon of Colorado
 I see the eagle soaring from your head
 Bearing in its claws Panurge's sheep
 And the wind of memory and the future
 Slips through the feathers of its wings the faces of friends
 Among them many who have no longer or who have not yet a face
Because conscious reactionaries and so many apostles of social progress who are in
 fact grim *immobilists* (you tarred them both with the same brush) persist in more
 and more vain opposition
 I salute you from the Petrified Forest of human culture
 Where nothing has been left standing
 But where great gleaming fires whirl and prowl
 Calling for the deliverance of foliage and bird
 From your fingers comes the sap of blossoming trees
Because with the philosopher's stone at your disposal
You heeded only your first impulse which was to offer it to men
But between them and you there was no intercessor
Not a day passed but you confidently waited for him an hour in the gardens of the
 Palais-Royal
Attractions are proportionate to destinies
In testimony of which I come to you today

 I salute you from the Nevada of the gold-prospector
 From the land promised and kept

To the land rich in higher promises which it must yet keep
From the depths of the blue ore mine which reflects the loveliest sky
For always beyond that bar-sign which continues to haunt the street of
 a ghost town —
Virginia-City — "The Old Blood Bucket"

Because the festival sense is less and less present in our minds
Because the most vertiginous motorways do not make us cease to regret your *pave-*
 ment for zebras
Because Europe ready to explode in a cloud of dust has found it of prime expedience
 to take measures of defence against confetti
And because among the choreographic exercises you proposed multiplying
It is time perhaps to omit *those of the rifle and the incense-burner*

 I salute you at the moment when the Indian dances have just come to an
 end
 At the heart of the storm
 And the participants group themselves in an oval around the brasiers
 strong with the smell of pine for shelter from the much-beloved rain
 An oval that is an opal
 Raising to the highest pitch its red fires in the night

The book Breton wrote in August-September 1944 in Percé, on the Gaspé Peninsula of Canada's eastern coast, which he visited with Elisa Claro, who was to become his third wife, tells again of the poet's "wandering steps" in the domains of dream and poetry, where the marvelous blends with reality.

ARCANE 17

That old gipsy, in Elisa's dream, who tried to kiss me and before whom I fled, it was indeed Bonaventure Island, one of the largest sea-bird sanctuaries in the world. We had circled it that very morning, in overcast weather, on a fishing boat under full sail, delighted as we were at sailing time by the grouping—quite unexpected, but à la Hogarth—of the floats made of yellow or red barrels equipped with a high stem flying a black flag at its top (the dream had probably taken hold of these devices, arranged in irregular clusters on the deck, to clothe the gipsy). The flapping of the flags had

followed us all along, except at the moment when our attention was riveted to the sight, defying imagination, offered by the sheer face of the island, fringed from step to step with a living snow foam ceaselessly re-created by the capricious and bold strokes of a blue trowel. Yes, for my part, this sight had embraced me: during a beautiful quarter of an hour my thoughts had been willing to turn into white oats in that thresher. Sometimes a wing, quite near, ten times longer than the other wing, consented to spell a letter, never the same one, but I was at once recaptured by the exorbitant nature of the whole inscription. One could speak of a symphony for the rocky complex overlooking Percé, but that image takes force only when one discovers that the resting places of the birds fit exactly the hollows of this perpendicular wall, so that the organic rhythm is accurately superimposed upon the inorganic rhythm as if it needed to gather strength from it in order to maintain itself. Who would have thought of lending an avalanche the spring of wings! The various layers of stone, sliding in a supple curve from level to forty-five degrees' obliqueness on the sea, were underlined with a wonderful stroke of chalk constantly boiling (I think of the lace net of the folded bed cover, of an equal whiteness, whose large flowers fascinated me as I woke up when a child). It was wonderful that the very folds imprinted by time upon the ground were used as a springboard by what is most inviting in life: the soaring, the close approach, and the sumptuous drift of the sea birds. There is the shivering of a star above all that provokes and immediately avoids human contact, as very young girls do (recently my friends Arshile and Agnes Gorky's girl at eleven months, so purely a fairy, turning away all her shoulder with such an offended air when I made as if to take her hand, only to come back, her eyes ever more sparkling, begging with all the resources of playfulness and grace for what she had shunned), or again like these minks, some brown, the others white, upon which we came by surprise in a neighboring breeding farm and which came out again on our tracks to observe us at close quarters, not less swiftly than they ran to cover before us into their shelters as we passed along their aligned cages. Poetic thought, surely enough, acknowledges a great affinity with that behavior. It is an enemy of patina and it is perpetually on its guard toward everything that may burn to apprehend it: in this it distinguishes itself, essentially, from ordinary thought. To remain what it is—a conductor of mental electricity —it must, above all, charge itself in *isolated* surroundings. . . .

Through its brief chapters, along a winding but unbroken spiritual road, *Arcane 17* leads us from the author's new love, Elisa, and from reciprocal love and the great changes that the rule of woman, if substituted for the rule of man, would bring about in the world, to Breton's favorite motif of the *femme-enfant*. The "woman-child," the author says, should receive again the "sensitive scepter." Then Breton speaks of a "dark window," which may be that of *Les Vases*

communicants[14] but where another incarnation of poetic Truth now appears: the Star, the nude form of a young woman as it is depicted on the seventeenth arcanum of the tarot game.

All the magical night is in the window frame, the whole night of enchantments. Perfumes and shivers burst from the air into the mind. The grace of living vibrates softly in its Pan's pipes down the curtains. The dark cube of the window, besides, is no longer so difficult to penetrate; it has gradually been filled with a diffused and festooned gleam, like a convolvulus of light clinging to the two transverse edges at the top and hanging downward not lower than the upper third of the figure. The image gradually takes the shape of seven flowers, which become stars while the lower part of the cube remains empty. The two higher stars are of blood, they represent the sun and the moon; the five lower ones, alternately yellow and blue, like sap, are the other planets anciently known. If the clock hadn't stopped at midnight, the hourglass might have, without anything changing, revolved five times round the dial plate before a new glimmer appeared from the zenith: a much brighter star inscribes itself in the center of the first seven and its branches are of a red and yellow fire and it is the Dog Star or Sirius, and it is Lucifer the Light Bearer and it is, in its glory excelling all others, the Morning Star. It is only in the instant it appears that the landscape lights up, that life becomes clear again, that right under the luminous center that has just conquered the preceding ones, a young woman comes into sight in her nudity, kneeling on the bank of a pond, pouring out into the pond with her right hand the contents of a golden urn, while with her left hand she untiringly empties onto the ground a silver urn. On either side of this woman, who, beyond Melusine, is Eve and is now the whole woman, the foliage of an acacia quivers on the right while on the left a butterfly sways on a flower[15]

Later, the dream tale is interrupted by other scenes, other thoughts, and again the love for Elisa. Then come remembrances of Paris, which had been freed by this time from the Nazis' yoke, then an acknowledgment of the value of a certain "French spirit," followed by a discussion of esoterism:

Esoterism, all reservations made concerning its principle itself, offers at least the immense interest of keeping in a dynamic state the comparison system, unlimited in scope, which is at man's disposal, and offers this man relations capable of linking together objects, apparently the most distant, partially uncovering before him the mech-

[14] See above, p. 311.

[15] On traditional tarot cards, the red stars are the lowest, the two urns are of the same red color, and the "butterfly" is in fact a black bird. Other differences appear on other types of tarot, where the seventeenth arcanum shows all seven planets as yellow, the black bird perched on a tree, and the flowerlike plant lying on the right. — M.J.

Elisa and André Breton in Breton's studio, 1948. (Photograph: Jacques Cordonnier)

anism of universal symbolism. The great poets of the last century have wonderfully understood this. . . .

Arcane 17 comes to its conclusion with a renewed exaltation of liberty, of love—and of speech:

The star rediscovered is that of the great dawn, which tended to eclipse the other stars of the window. It delivers to me the secret of its structure, explains why it counts twice as many branches, why these branches are of a red and yellow fire, as if it were two joined stars with alternating rays. It is made of the unity itself of these two mysteries: love called to a rebirth out of the loss of the subject of love and rising only then to its full consciousness, to its total dignity; liberty destined to know itself fully and to exalt itself only at the price of its own deprivation. In the nocturnal image that guided me, the resolution of this double contradiction operates under the protection of the tree enclosing the remains of a dead wisdom, by means of exchanges between the butter-fly and the flower and by virtue of the principle of uninterrupted expansion of fluids, to which the certitude of eternal renewal is linked. This resolution is, besides, a common one indeed for it needs no other instrument than the one that Hebrews have hieroglyphically figured with the letter פ resembling a tongue in a mouth, which means, in the highest sense, speech itself. . . .

Evoking Victor Hugo's creation of the "angel Liberty" in *La Fin de Satan* (The End of Satan)—

Born of a white feather escaped from Lucifer during the fall, the angel Liberty penetrates the darkness; the star at his brow grows, becomes "at first meteor, then comet and furnace"

—the book ends with an appeal to the great Light Bearers:

It is revolt, revolt alone that is a creator of light. And this light may acknowledge only three roads: poetry, liberty, and love, which must inspire the same zeal and converge, to make it the very cup of eternal youth, upon the less exposed and the most illuminable point of the human heart.

In *Arcane 17* there is no mention of Marxism or Communism, and "revolt" has replaced "revolution."[16] And while there are long discussions in the book of the situation, past and present, in France, of certain books published there at that time, of French history and the way it is taught in schools, of the notions of *resistance* and *liberation,* of the future of Paris's international role and significance—there is no allusion to the United States or to New York. Though written in America, *Arcane 17* seems to be intended to open the way to new developments of surrealism — in France.

Indeed, conditions for intellectual activities in the United States were vastly different from those in Europe, and especially in Paris, as several European artists pointed out in a series of interviews in 1946 with James Johnson Sweeney.[17] Max Ernst, for instance, said:

During my first months in New York there were many Paris painters here. At first the surrealist groups seemed to have a real strength; but little by little they began to break up. It was hard to see one another in New York. The café life was lacking. In Paris at six o'clock any evening you knew on what café terraces you could find Giacometti or Eluard. Here you would have to' phone and make an appointment in advance. And the pleasure of a meeting had worn off before it took place.

[16]In an interview in the magazine *Paru* (March 1948), André Breton, back in Paris, quoted the following text by Trotsky: "If war does not bring about revolution, and if, consequently, Marxists must acknowledge that bureaucratic collectivism and not socialism is the historic successor of capitalism, in this case, there would be no other way but to acknowledge that the socialist program, based on the contradictions of capitalistic society, has ended as a utopia (from Dwight Macdonald's 'The Root Is Man,' *Politics* [New York] , April-March 1946, and *Cahiers Socialistes* [Brussels] , no. 13)."

[17]Published in *The Museum of Modern Art Bulletin* (New York), vol. 13, no. 4-5 (September 1946).

As a result in New York we had artists, but no art. Art is not produced by one artist, but by several. It is to a great degree a product of their exchange of ideas one with another. Here in New York one artist lived in the Village, another uptown. This is one of the reasons there is less art produced in this country than in France. It holds for the country at large as well as for New York. There is more loneliness—more isolation among artists than in France. This is certainly one reason for the smaller production of interesting work.

However this situation cannot be changed. The Paris painters when they arrived here first tried to do so. But it is not enough for one person to decide "This is an artists' café." Such a communal life as that of the Paris café is difficult—if not impossible here.

Another reason that so little grew out of the generous transplantation of European artists consequent upon the occupation of Paris was the language problem. André Breton does not speak English. . . . Possibly his reluctance to attempt to speak English for fear of some embarrassing error is related to some childhood experience. In any case he is actually frightened—"scared" at the thought of having to learn English. And Breton was the leader to whom most of the younger artists looked in the hope of an American surrealist development. But because he found it so difficult to get in touch with people here, Breton was frequently in a bad mood—not in a mood to work or write. It is impossible for an artist to work in a vacuum. Breton wrote some good poems here. But for him it was necessary to have a center. And in New York he found it impossible to maintain one.

As for me, I can always work here. Sometimes even a physical disadvantage has virtues. In the summer of 1944 I found myself working steadily on sculpture. We had rented a place at Easthampton, L.I., and went there with the intention of spending the summer swimming. But there were so many mosquitoes there we could not stick our noses out-of-doors. So I decided to take over the garage, screen it and make a studio of it. I worked the whole summer there on sculpture. . . .

Tanguy also works very happily here. Duchamp is another Parisian perfectly contented. Nothing seems to ruffle him. He may go back to Paris, but he always returns here. . . .

Kurt Seligmann, a Swiss artist connected with surrealism after 1937, said likewise:

The unconquerable American space has scattered the group of Europeans who were accustomed to meet regularly in Parisian cafés. Many were forced or preferred to live in the country. The exchange of ideas grew rare. Some writers refused to acclimatize themselves. They were bound to their language. Unable to maintain the European climate, unwilling to write in terms foreign to them. But the artists, speaking the language of forms, did not encounter this difficulty. . . .

Yves Tanguy said:

Of course there is a Paris one always misses. . . . There may be more of a Montparnasse character in Mexico—café life and a cosmopolitan Bohemianism. But Mexico frightens me. It has too much the character of a tourist country. Here I lived in the same atmosphere I knew in Paris. I scarcely felt touched by the war. It seemed so far away from me. But there is more freedom—more room in this country. That was why I came here.

It is rather hard to be without cafés. It is such a wonderful thing in Europe—and particularly in Paris—to be able to stroll about leisurely and meet one's friends informally. Nevertheless one eventually becomes accustomed to the lack of this mode of living. . . .

Here in the United States the only change I can distinguish in my work is possibly in my palette. What the cause of this intensification of color is I can't say. But I do recognize a considerable change. Perhaps it is due to the light. I also have a feeling of greater space here—more "room." But that was why I came.

Marcel Duchamp, in the same series of interviews, expressed a more general view on the problem of art:

The great trouble with art in this country at present, and apparently in France also, is that there is no spirit of revolt—no new ideas appearing among the younger artists. They are following along the paths beaten out by their predecessors, trying to do better what their predecessors have already done. In art there is no such thing as perfection. And a creative lull occurs always when artists of a period are satisfied to pick up a predecessor's work where he dropped it and attempt to continue what he was doing. When on the other hand you pick up something from an earlier period and adapt it to your own work an approach can be creative. The result is not new; but it is new insomuch as it is a different approach.

Art is produced by a succession of individuals expressing themselves; it is not a question of progress. Progress is merely an enormous pretension on our part. There was no progress for example in Corot over Phidias. And "abstract" or "naturalistic" is merely a fashionable form of talking—today. It is no problem: an abstract painting may not look at all "abstract" in 50 years.

During the other war life among the artists in New York was quite different—much more congenial than it has been during these last few years. Among the artists there was much more cohesion—much closer fellowship, much less opportunism. The whole spirit was much different. There was quite a bit of activity, but it was limited to a relatively small group and nothing was done very publicly. Publicity always takes

something away. And the great advantage in that earlier period was that the art of the time was laboratory work, now it is diluted for public consumption. . . .

In fact until the last hundred years all painting had been literary or religious: it had all been at the service of the mind. This characteristic was lost little by little during the last century. The more sensual appeal a painting provided—the more animal it became—the more highly it was regarded. It was a good thing to have Matisse's work for the beauty it provided. Still it created a new wave of physical painting in this century or at least fostered the tradition we inherited from the 19th century masters.

Dada was an extreme protest against the physical side of painting. It was a metaphysical attitude. It was intimately and consciously involved with "literature." It was a sort of nihilism to which I am still very sympathetic. It was a way to get out of a state of mind—to avoid being influenced by one's immediate environment, or by the past: to get away from clichés—to get free. The "blank" force of dada was very salutary. It told you "don't forget you are not quite so 'blank' as you think you are." Usually a painter confesses he has his landmarks. He goes from landmark to landmark. Actually he is a slave to landmarks—even contemporary ones.

Dada was very serviceable as a purgative. And I think I was too roughly conscious of this at the time and of a desire to effect a purgation in myself. I recall certain conversations with Picabia along these lines. He had more intelligence than most of our contemporaries. The rest were either for or against Cézanne. There was no thought of anything beyond the physical side of painting. No notion of freedom was taught. No philosophical outlook was introduced. The cubists, of course, were inventing a lot at that time. They had enough on their hands at the time not to be worried about a philosophical outlook; and cubism gave me many ideas for decomposing forms. But I thought of art on a broader scale. There were discussions at the time on the fourth dimension and of non-Euclidean geometry. But most views were amateurish. . . .

Brisset and Roussel were the two men in those years whom I most admired for their delirium of imagination. Jean-Pierre Brisset was discovered by Jules Romains through a book he picked up from a stall on the quais. Brisset's work was a philological analysis of language—an analysis worked out by means of an incredible network of puns![18] He was a sort of Douanier Rousseau of philology. Romains introduced him to his friends. And they, like Apollinaire and his companions, held a formal celebration to honor him in front of Rodin's *Thinker* in front of the Panthéon where he was hailed as Prince of Thinkers.

But Brisset was one of the real people who has lived and will be forgotten. Roussel was another great enthusiasm of mine in the early days. The reason I admired him was

[18]Brisset's books are, of course, untranslatable. In his *Anthologie de l'humour noir,* André Breton cites several fragments of Brisset's *La Science de Dieu* (1900).—M.J.

because he produced something that I had never seen. That is the only thing that brings admiration from my innermost being—something completely independent— nothing to do with the great names or influences. Apollinaire first showed Roussel's work to me. It was poetry. Roussel thought he was a philologist, a philosopher and a metaphysician. But he remains a great poet.

It was fundamentally Roussel who was responsible for my glass, *La Mariée mise à nu par ses célibataires, même.* From his *Impressions d'Afrique* I got the general approach. This play of his which I saw with Apollinaire helped me greatly on one side of my expression. I saw that as a painter it was much better to be influenced by a writer than by another painter. And Roussel showed me the way.

My ideal library would have contained all Roussel's writings—Brisset, perhaps Lautréamont and Mallarmé. Mallarmé was a great figure. This is the direction in which art should turn: to an intellectual expression, rather than to an animal expression. . . .

The catalogue of the Max Ernst exhibition at the Copley Gallery in Beverly Hills, California, in 1949 (this gallery showed Magritte, Matta, Tanguy, Max Ernst, Joseph Cornell, and Man Ray during the two years of its existence, 1948 and 1949; since then, Bill Copley has been active as a painter), contained, under the title "Paramyths," a series of short poems illustrated with the artist's collages.

Paramyths

Strange hallucination! When Pallas Athene felt that the wisdom of man had touched her fatal skirt and its neglected grass the DIVINE MARQUIS, the emblem of pride, the burning iceberg, bird of paradise, bright as a young monster's voice, gentle and quiet as innocent blood, had reached the fire tree which from top to toe was covered with flaming birds, with flags of pestilence.

A smile had been erected underneath and preparations made for the work of death.

Once upon a time there was a mouse in Milo.

. . . .
The painter came again
and again
and again
beneath his child-like pine-trees
beneath his helpless flames
beneath—but let me see

but let me hear his liquid face
his northern star
his living slab of marble
his Adam and his Eve

Oh Hercules of Frau Cules oh Fraucules Oh Herr Cules of Herr Cules oh Frau of Frau Cules oh Hercules oh Frau Cules of Fraucules oh Hercules and Frau.

Oh history oh way of life oh words
Birthplace, nickname, bloodless lips.
Your history, your way of life, her words.
Her birthplace, nickname, silken lips
Amandapak Amandapak
Oh wind oh hands oh duskiness.

To and fro. Under the walls among the frolicsome maidens. And the third path through the birdless streets. And the oldest clouds of the ambitious congregation. Silence in silence. Clouds without clouds. Fifteen but unaccomplished. Sinking. Remorseless.

Throughout the war, the London surrealist group, which several refugees from Paris had joined, maintained a certain amount of activity. There were meetings in various London pubs where verse was read, "exquisite corpses" were composed, and politics was discussed. But it was not until 1946 that Simon Watson Taylor published, under the title *Free Unions—Unions Libres,* a review-anthology—including excerpts from Jarry, Sade, Maturin, and a number of texts and poems in various languages—for which he had assembled material during the war years. A feature of this publication was a selection of quotations, among which are the following thoughts:

Everything that is doddering, suspicious, infamous, sullying and grotesque is contained for me in this single word: God.

—André Breton

No monkeys are soldiers
All monkeys are mischievous
i.e. Some mischievous creatures are not soldiers.

—Lewis Carroll

A knife without a blade, with the handle missing.

—Georg Christoph Lichtenberg

Left: Max Ernst: *Collage*, 1949, from the Ernst exhibition catalogue, *At Eye Level, Paramyths*, Copley Galleries, Beverly Hills, California, 1949. *Right*: Benjamin Péret, 1950. (Photograph: Jacques Cordonnier)

One cannot reasonably blame regicides who have no king at hand, if they exercise sometimes their gifts within their own circle.

—Jacques Prévert

We want a Republic founded upon true liberty, upon civil liberty, upon national representation; we shall have it, I swear! I swear it in my name and in that of my companions in arms!

—General de Gaulle

It is necessary for a Leader to arise, independent in his judgements, unchallengeable in his orders, credited by public opinion. Servant of the State alone, stripped of prejudices, disdainful of clienteles; a clerk absorbed in his task, acquainted with the people and things within his province, a chief, corporate with the army, devoted to those he commands, eager to assume responsibility, a man strong enough to assert himself, clever enough to seduce others, big enough for a big job, such will be the minister, soldier or politician, to whom the country will owe the impending management of its power.

—Adolf Hitler[19]

[19] Two *errata* in the review informed the reader that "the text 'We want a Republic . . .' attributed in error to General de Gaulle is by Napoleon Bonaparte (declaration of the 18th Brumaire)" and that "the text 'It is necessary for a Leader to arise . . .' attributed in error to Adolf Hitler is by Charles de Gaulle (from *Vers l'Armée de Métier,* 1934)."

I knew a party was kicked in the head by a red mare, and he went killing horses a great while, till he eat the insides of a clock and died after.

—J. M. Synge

Incest is, like many other incorrect things, a very poetical circumstance.

—Shelley

Beards in a State are not quite as essential as men.

—William Beckford

E. L. T. Mesens's and J. B. Brunius's tract *Idolatry and Confusion,* published in London in March 1944, was directed against French wartime literature; also polemical, in great part, was a collection of poetry, drawings, criticisms—*Message from Nowhere* (November 1944)—edited by Mesens and published by London Gallery Editions (the *London Gallery Bulletin* had ceased publication in 1940). The following piece is an excerpt from *Third Front* (1944), a booklet of poems by Mesens.[20]

To Put an End to the Age of Machinery
the English Poets Make Smoke

To Benjamin Péret

Here are some winter flowers
Here are some summer flowers
Some trading and some lice
Some pralines and some bombs
The whole given away sold out
Lent bought thrown away

Men tremble no more
Since they have great masters
Who think for them
And foresee all

The priests and the madmen
Hooded with a sallet
Play at Pope Joan
In darkened places

The red soldiers
Are commanded by beige generals

[20]With English translations by Roland Penrose and the author.

> The soldierly of blood
> Are commanded by me
> Strategy of withdrawal
> Swallow your pill

Benjamin Péret lived in Mexico during the war, and in 1945, in Mexico City, he published a pamphlet entitled *Le Déshonneur des poètes* (The Poets' Dishonor), which was a reply to a book of patriotic underground poetry printed in France, *L'Honneur des poètes* (with pieces by Lois Masson, Pierre Emmanuel, Aragon, Eluard, and others). After discussing the cultural and political situation in countries at war, and quoting several poems from *L'Honneur des poètes*, Péret wrote in *Le Déshonneur des poètes:*

In fact, the authors of this brochure start, without knowing or admitting it, from an error of Guillaume Apollinaire and they even increase it. Apollinaire wanted to consider war a poetic subject. But if war, as a fight and outside any nationalistic spirit, may appear, strictly speaking, as a poetic subject, it is not so with a nationalistic motto, even if the nation is, like France, savagely oppressed by the Nazis. The expulsion of the oppressor and the propaganda to this effect belong to political, social, or military action, depending on the way this expulsion is envisaged. In any case, poetry must not intervene in the issue except by its own action, its cultural meaning itself, poets being free to participate, as revolutionaries using revolutionary methods, in the rout of the Nazi foe, never forgetting that that oppression fulfilled the acknowledged, or hidden, wishes, of all the enemies—first national, then foreign—of poetry understood as a total liberation of the human mind; for, to paraphrase Marx, poetry has no country since it is of all times and places. . . .

Every "poem" exalting a "liberty" voluntarily ill-defined when it is not decorated with religious or nationalistic attributes, ceases at once to be a poem and consequently is an obstacle to man's total liberation, for it misleads him by showing a "freedom" that hides new fetters. On the contrary, a breath of full and active freedom escapes from every *authentic* poem, even if this freedom is not evoked under its political or social aspect, and thus contributes to man's effective liberation.

Surrealist group activity was practically impossible in Paris during the war, yet a surrealist review could be published at intervals by Editions de la Main à Plume.[21] One of the four issues contained the following text by Jean Arp:

[21] Paraphrasing Rimbaud: "La main à plume vaut la main à charrue" ("The plow is not mightier than the pen").

The Great Unrestrained Sadist [22]

Before his immense window high as a cathedral window, the great unrestrained sadist vibrates like an electric gut filled with rubber of nothingness. The great unrestrained sadist is stark naked and rubbed all over with phosphorus, which makes him decorative and macabre. His eyes and his long, womanly tresses are as white as curry-combed air. His face is proud and ruthless like the faces of all the truly great sadists who are stylized, certified, and eligible for government pensions. The great unrestrained sadist does not deign to eat his perfumed time in extinct grass, to wear the rosy-white gloves of those who carry their ransom in a litter of depraved light. He vibrates like an electric tripe stuffed with rubber of nothingness, I said, I repeat it, and I'll repeat it as often as necessary. He is impatient to continue his august task or his alphonse task — however you want to christen it. The domestics are already arriving with crocodiles, grandmothers, dandies, airplanes, flies, etc., and putting them down before the great window.

In a diabolical and remunerated élan, with the joyous cry of a Tirolean defenestrator dancing around a lake of dirty grease, he pounces upon the piled-up objects and hurls them out of the majestic window of sublime works. He spends his life hurling everything in existence out the window. He even takes whole, live elephants and hurls them out the window. Quack, quack, quack, beg the gallant but terrified elephants. The great unrestrained sadist refuses to stop in his venerable élan. Anything his dead or alive, sweetened or salted, heavy or light servants bring him he hurls out the window: cigars, navies, apartments, railroads, regular coffees, sex appeals, houses, mushrooms, etc. The window is high enough to let the fallen objects change into orange marmalade, and billions of little children come swarming like flies to lick it up with their little mouths. The little children joyfully clap their hands and cry: *Marmalade, marmalade, marmalade* up to the window of the great unrestrained sadist. And without respite, over and over again, he hurls pianos, zeppelins, monuments, diplomats, etc., out the window. He foams, perspires, grinds his teeth, and realizes that he must outdo himself and crown his already inconceivable labor. Not having anything else at hand, he pulls out his white hair, his hands, his feet, hurls them out the window, and finally hurls anything remaining of himself out the window, uttering a dreadful shriek, and after his fall changes like all the other objects, and to the great pleasure of the billions of little children — into orange marmalade.

[22] Translation by Joachim Neugroschel in *Arp on Arp,* ed. Marcel Jean, The Documents of 20th-Century Art (New York: The Viking Press, 1972).

CHAPTER **24**

After the War

The end of World War II saw the return to Europe of many artists and writers who had spent the dark years "in exile." André Breton came back to Paris in June 1946. To the new generations of students and intellectuals in Paris, surrealism had acquired a sort of legendary aura during the war, and for some time the presence of André Breton drew hordes of juvenile "fans" to the cafés that the leader of surrealism frequented once again.

A surrealist exhibition was staged at the Galerie Maeght from June to August 1947. It was centered on esoterism and myths, after a "Projet Initial" published in the exhibition catalogue.

Initial Project

The general structure of the exhibition will answer the prime purpose of recalling the successive stages of an *initiation,* the passing from one room to the other implying graduation. . . . The rooms on the first floor will be reached by means of a flight of stairs with 21 steps shaped like the spines of books inscribed with 21 titles corresponding to the 21 major arcana of the tarot game, viz.:

1—THE SHOWMAN: Maturin, *Melmoth the Wanderer.* 2—THE POPESS: XXX, *Life and Death of the Facteur Cheval.*[1]-3—THE EMPRESS: J.-J. Rousseau, *Reveries of a Solitary Walker.* 4—THE EMPEROR: Frazer, *The Golden Bough.* 5—THE POPE: Baudelaire, *Flowers of Evil.* 6—THE LOVER: Hölderlin, *Poems of Madness.* 7—THE CHARIOT: Sade, *Justine.* 8—JUSTICE: Eckhart, *Sermons.* 9—THE HERMIT: V. Andreae, *Christian Rozencreutz's Chemical Nuptials.*[2] 10—THE WHEEL OF FORTUNE:

[1] An imaginary book.—M.J.
[2] Strasbourg, 1616. First English translation, 1690.—M.J.

Kafka, *The Trial.* 11—STRENGTH: Lefebvre des Noëttes, *The Harness and the Saddle Horse through the Ages.*[3] 12—THE HANGED MAN: Brisset, *The Science of God.* 13—DEATH: Apollinaire, *The Rotting Enchanter.* 14—TEMPERANCE: Swedenborg, *Memorabilia.* 15—THE DEVIL: Jarry, *Ubu Roi.* 16—THE GOD HOUSE: Goethe, *Faust,* Part 2. 17—THE STAR: Fourier, *Theory of the Four Movements.* 18—THE MOON: Forneret, *And the Moon Shone, and the Dew Fell. . . .*[4] 19—THE SUN: Hervey Saint-Denys, *Dreams and How to Control Them.*[5] 20—THE JUDGMENT: John, *Apocalypse.* 21—THE WORLD: Isidore Ducasse, *Complete Works.*

On the threshold of the first floor, the Hall of Superstitions, opening the theoretical cycle of tests, will embody the synthesis of the main existing superstitions that must be overcome in order to proceed with the visit to the exhibition. . . . In the following room, the visitor will have to avoid several multicolored rain screens in order to reach, without disturbing billiard players at the entrance, a hall divided into 12 octagonal cells. Each octagonal recess . . . will be dedicated to a being, a category of beings, or an object *capable of being endowed with a mythical life* and to which "altars" will be erected on the pattern of pagan cults (for instance, American Indian or voodoo).

These twelve altars, each assigned a certain sign of the zodiac, referred to a literary or artistic creation, or to some curious or extraordinary being, as follows:

1—The Fashionable Tiger (cf. Jean Ferry, "Le Tigre mondain"). 2—Falmer's Head of Hair (cf. *Les Chants de Maldoror,* Canto IV). 3—The Gila Monster (*Heloderma suspectum,* lives in Arizona). 4—Jeanne Sabrenas (cf. Jarry's novel *La Dragonne*). 5—Léonie Aubois d'Ashby (cf. Rimbaud's poem "Dévotion"). 6—The Secretary Bird, a serpent eater. 7—The Gravity Manager (an unexecuted feature of Duchamp's glass picture "The Bride Stripped Bare . . ."). 8—The Condylura (or Star-Nosed Mole of medieval authors). 9—The Wolf Table (cf. Brauner's "Morphologie psychologique," "Fascination," etc.). 10—Raymond Roussel (ruling over unwonted objects: Lichtenberg's "knife," Alphonse Allais's "cup for left-handed people," etc.). 11—The Great Invisibles (cf. Breton, *VVV,* no. 1). 12—The Window of Magna sed Apta (cf. Du Maurier's *Peter Ibbetson). . . .*

In order to dispel somewhat the mysteries of these allusions, let us reproduce Jean Ferry's story "Le Tigre mondain," to which the first of the altars was dedicated:[6]

[3]"A contribution to the history of slavery," Paris, 1931. The author shows how the invention of the breast harness in the tenth century was a decisive factor in the disappearance of slavery in Western Europe.—M.J.

[4] This short story was first published in 1836.—M.J.

[5]Mentioned by Breton in the first pages of *Les Vases communicants.*—M.J.

[6]"Le Tigre mondain" was first published in *Les Quatre Vents,* no. 6. This translation is by Jean Stewart in *French Short Stories,* Penguin Parallel Texts (London: Penguin Books, 1966).

The Fashionable Tiger

Of all those music-hall turns that are stupidly dangerous for the audience as well as for the performers, none fills me with such uncanny horror as that old turn known as the "Fashionable Tiger." For the sake of those who have never seen it, since the present generation has no notion of what big music-halls were like in the days after the First World War, I will describe the performance. But what I can never explain, not even try to communicate, is the state of panic-terror and abject disgust into which that spectacle plunges me, as though into a pool of impure and horribly cold water. I ought not to go into theatres where the programme includes this turn, which as a matter of fact is seldom put on nowadays. That's easily said. For reasons I have never been able to fathom, the "Fashionable Tiger" is never announced beforehand, so I am never forewarned, or, rather, some obscure, half-conscious sense of uneasiness spoils my enjoyment of the music-hall. If I heave a sigh of relief after the last turn on the programme, I am only too familiar with the fanfare and the ceremonial that prelude this performance, which, as I have said, is always made to seem impromptu. As soon as the band strike up that characteristic blaring waltz I know what is going to happen; a crushing weight settles on my heart and I feel the thread of fear between my teeth like a sharp electric current of low voltage. I ought to go away, but I dare not. In any case, nobody else is stirring, nobody shares my anguish, and I know that the beast is on its way. It seems to me, too, that the arms of my seat protect me, though very feebly......

At first the house is plunged into complete darkness. Then a spotlight comes on at the front of the stage and its ridiculous lighthouse beam shines on to an empty box, usually very close to my seat. Very close. Thence the pencil of light moves to the far end of the lounge and shines on a door opening on to the wings. And while, in the orchestra pit, the horns dramatically attack "The Invitation to the Waltz," they come in.

The tiger-tamer is a thrilling redhead, with a somewhat languid air. Her only weapon is a fan of black ostrich plumes, with which at first she hides the lower part of her face; only her huge green eyes appear above the dark wavy fringe. In the spotlight her arms gleam with the misty iridescent sheen of a wintry evening: she wears a low-cut, clinging, romantic evening dress, a strange dress with black depths and rich reflections. This dress is made of the finest, supplest fur. Above it all her blazing hair, spangled with gold stars, streams down. The general effect is oppressive and yet slightly comic. But you wouldn't dream of laughing. Flirting with her fan, disclosing her fine-cut lips set in an unaltering smile, the tiger-tamer moves forward, followed by the beam of the spotlight, towards the empty box, on the arm, so to speak, of the tiger.

The tiger walks in a fairly human fashion on his hind legs; he is dressed like the most exquisite of dandies, and his suit is so perfectly cut that one can hardly make out the animal's body under the grey trousers with spats, the flowered waistcoat, the dazzling white jabot with its faultless pleats, and the expertly tailored frock coat. But the head is there with its appalling grin, the wild eyes rolling in their crimson sockets, the furiously bristling whiskers, the fangs flashing now and then under the curling lips. The tiger walks forward very stiffly, holding a light grey hat in the crook of his left arm. The woman moves with well-poised steps, and if you see her brace her back, if her bare arm twitches so that an unexpected muscle shows under the pale tawny velvet of her skin, it is because with a secret, violent effort she has jerked up her partner as he was about to fall forward.

They come to the door of the box and the Fashionable Tiger, pushing it open with his claws, stands aside to let the lady walk in. And when she has taken her seat and is leaning nonchalantly against the shabby plush, the tiger drops into a chair by her side. At this point the crowd usually breaks into ecstatic applause. And I stare at the tiger, almost weeping with longing to be somewhere else. The tiger-tamer greets us majestically, bending her blazing curls. The tiger begins operations, manipulating the properties set out for him in the box. He pretends to examine the spectators through an opera-glass, he lifts the lid of a box of sweets and pretends to offer one to his partner. He takes out a silk sachet and pretends to sniff it; he pretends to consult the programme, to everybody's great amusement. Then he pretends to flirt; he leans over towards the lady and pretends to whisper flattering words in her ear. She pretends to take offence and coquettishly raises her feather fan as a fragile screen between her lovely pale satin cheek and the beast's foul-breathing jaws, fanged with sword-blades The tiger pretends to be in the depths of despair and wipes his eyes with the back of his furry paw. And during all this sinister dumb-show my heart batters my ribs, for I alone can see and realize that all this vulgar exhibition is only held together by a miracle of will-power, as the saying is: that we are all in a state of such precarious equilibrium that a trifle could shatter it. What would happen if, in the box next door to the tiger's, that pale, weary-eyed little man who looks like a humble clerk were to relax his will for an instant? For he is the real tiger-tamer; the red-haired woman is only a super, everything depends on him. It is he who makes the tiger into a puppet, a piece of machinery controlled more firmly than with ropes of steel.

But suppose the little man suddenly began to think of something else? Suppose he died? Nobody suspects the ever-imminent danger. And I know all about it, and I start imagining—but no, better not imagine what the lady in the fur dress would look like if...... Better watch the end of the turn, which never fails to delight and reassure the spectators. The tiger-tamer asks if anybody in the audience will lend her a baby.

Who could refuse such a charmer anything? There's always some nitwit ready to hand over, into that fiendish box, a smiling baby which the tiger cradles gently in his folded paws, yearning over the tiny morsel of flesh with his toper's eyes. Amidst a great thunderstorm of applause, the lights go on in the theatre, the baby is handed back to its righful owner, and the two partners bow before retiring the same way that they came.

As soon as the door has closed behind them—and they never come back to make a bow—the orchestra breaks out into its loudest fanfares. Soon afterwards the little man crumples up, mopping his brow. And the orchestra plays louder and louder to drown the roars of the tiger, who reverts to his natural state as soon as he is inside his cage. He howls like the damned, he rolls on the ground tearing his fine clothes to rags, so that they have to be renewed at each performance. His hopeless rage finds vent in anguished yells and curses, in wild leaps that batter the walls of the cage. On the other side of the bars the bogus tamer undresses as fast as she can so as not to miss the last train home. The little man is waiting for her at the pub near the station, the one called "The Great Never."

The storm of howls let loose by the tiger, entangled in his tattered garments, might make an unpleasant impression on the audience, however distantly heard. So the band strikes up the overture of "Fidelio" with all its strength, and the producer, in the wings, hurries the trick cyclists on to the stage.

I hate the "Fashionable Tiger," and I shall never understand how people can enjoy watching it.

In the catalogue of the exhibition, entitled *Le Surréalisme en 1947*—a thick book with numerous reproductions and a cover designed by Marcel Duchamp with a woman's breast in foam rubber—some forty contributors published poems or articles discussing or illustrating the main surrealist themes: dream, revolt, freedom, humor. Several texts referred to myths or to the secret sciences, and from Mexico Benjamin Péret sent a list of new superstitions to "replace those whose virtue of exaltation is spent. Nothing forbids one to believe," he said in "Le Sel repandu," "that they will help man to come out of his hell." For instance, these suggestions:

Spilt Salt

Leaving cupboards open brings good luck.
Giving dogs extracted teeth to chew brings good luck.
The sight of an army officer brings bad luck. Hold your nose while he passes by.
Keep the bone of the first sardine eaten in the year to make sure you will have no worries about money.

Make a wish when you see a priest beaten.

To avoid ill luck, look away when you pass near a laundry.

Nailing consecrated wafers on the bathroom walls should bring good luck.

Tearing out a hair from a neighing horse brings good luck.

If you see a flag, turn away and spit to conjure the bad omen.

Breaking toothpicks after use brings good fortune.

To be sure that the person to whom you want to speak will be at the other end of the line, keep repeating: "What a heat!" while dialing the phone number.

If you pass by a cemetery, throw some rubbish over the wall; it brings luck.

When you go past a police station, sneeze loudly to avoid misfortune.

Throwing a crucifix in the first fire you light in the fireplace in autumn brings luck.

Other texts focused on the works of precursors of surrealism. An excerpt from the essay *Maldoror*,[7] discussed the idea of a synthesis between speculative thought and empirical reality, as it is envisaged in contemporary science and philosophy and as it appears in Canto VI of Lautréamont's *Chants de Maldoror*.

The Lay of Maldoror
Canto VI and the Occult World

Traditional science was founded on the hypothesis of a duality between theory and practice. Two different branches of knowledge were elaborated: on the one hand, pure speculation tended to separate itself from the real; on the other hand, an exclusive study of empirical reality relied on the impressions of our senses.

The need to bring about a synthesis of these two components is lyrically but clearly indicated in the first stanza of Canto VI of *The Lay of Maldoror*. But there are different ways of reaching the synthesis.

If specifications brought by the senses are ceaselessly carried away in the stream of a reality deprived of a more or less stable inner coordination, if an impression of empirical reality can be substituted for a previous impression set in a different direction, then it is absolutely impossible to assign any value to those successive impressions. Yet the function of the mind is to coordinate sensations, to make a thing appear as a relatively stable complex of impressions. This stability, and all the resulting structure, are doubtless a creation of the mind, an "abstraction"—but a necessary one. The American biologist Wilson said on this subject: "The objects with identity are certainly abstractions, otherwise they would be of no use to thought. But they express the endur-

[7] By Marcel Jean and Arpád Mezei. See above p. 52, n. 8.

ing characters of events just as does the atom of the physicist."[8] There is indeed a change, but this change is submitted to rules. There is no absolute and identical "thing," but there are *motions* revealing the existence of definite rules, and this "regularity" allows the conception of events as things. But Wilson shows also that it is an error to believe that this transformation of motions, of events, into things, is an operation that does not answer to the real nature of events; otherwise, how could we come to the idea of these abstractions, if they corresponded to nothing? We see how the biologist tries to synthesize the idea of empirical perception and the idea of abstraction, saying that it is their *relation* that is actually real: he starts from the empirical realization of perceptions and seeks in that the world of abstractions, of pure speculation.

Another possibility for a synthesis is to start from pure speculation and to deduce the reality of perceptions from it. Hegel is a typical representative of that school. The question for him is to find, in the tissue of thoughts, so strict a necessity as to show our own selves as something given, that we must become acquainted with as an empirical reality: "All that is rational is real."

To accept regularity and absolute coordination as a criterion for existence allows us evidently to forgo any other criterion. Indeed, matter may be conceived as regular functions (undulations or "waves") and not as something given, in the manner of a solid and incorruptible substance, and the criterion of regular functions may account for certain phenomena, unexplainable by the criterion of observation through perceptions. But this is acknowledged differently by the physician and by the Hegelian: for Wilson, empirical reality embraces pure speculation; for Hegel, it is pure speculation that contains empirical reality.

Contemporary science has shown that this synthesis is not mere imagination. Studies on light have detected the real nature of undulatory phenomena: they are continuous *and* discontinuous. Light and radiations in general are at the same time wave and corpuscles, functions and matter, synthesizing the two contrasting principles. And if we return now to poetry, we realize that the myth of Apollo, god of light and poetry, appears in all its experimental reality, so to speak. The poetic approach, this mysterious alchemy, is itself a synthesis, a dual and simultaneous move, a rise toward the abstract and a return to the concrete. It materializes, in a way, entities and impressions, it unites the regularity principle and the perception principle.

In the last Canto of *The Lay of Maldoror,* Lautréamont shows precisely the *relation* between those domains, on whose "parallel" existence he always insisted in the preceding five cantos. Proclaiming the primacy of the spiritual domain, he sees, nevertheless, that the material world must be present also. The concepts of the first cantos will no longer appear as vague and distorted phantoms or under the shape of "anathe-

[8] Edmund Beecher Wilson, *The Cell* (New York: Macmillan, 1925).

mas," of "fictitious personalities," of "nightmares," whose excessive symbols filled the preceding episodes. "You will touch with your own hands," says the author in an allusion to Doubting Thomas, "branches of aortas and adrenal glands; and sentiments!" The scenes that will now unfold are "rationally" justified in the explanations of the first stanza of Canto VI. Elements no longer hybrid, but extraordinarily condensed, will be called forth in the light of reality: "The solar rays, striking first the tiles of the roofs and the lids of the chimney-stacks, will be visibly reflected on their earthly and material hair." It will be an actual creation of the world, and the poet will set his creatures in motion by "pulling the strings of the novel." "But," he adds, "I am sure that the effect will be very poetic."

For certain men, irrational complexes exist because they understand them; these complexes are not, for them, irrational. Thus Lautréamont explored his own labyrinth —intellectual atavisms, personal experiences and memories, psychological complexes, in the first five cantos of the *Lay;* then in Canto VI he synthesizes the two methods of perception and of coordination, which take place simultaneously and lead to the creation, from concepts, of real beings endowed with all the characteristics of the poet's personality, symbolically displayed in the first parts of the book.

Le Surréalisme en 1947 contained the manifestoes of two foreign groups: a poetic text from the Rumanian group, and, more polemical, a "Déclaration du Groupe surréaliste en Angleterre," written apparently by its two non-English members E. L. T. Mesens and J. B. Brunius (and translated below from the French):

Declaration of the Surrealist Group in England

If a danger today threatens surrealism, it is indeed the almost universal recognition of its importance, which its worst adversaries hasten to admit, at least implicitly, *in the past,* so that, by covering it with flowers, it may be disguised more easily as a catafalque. Therefore, we feel the need of reaffirming the value and the confidence we attach to the surrealist revolution in order to show that we do not consider that it has come to an end, and to proclaim that we persist in what some persons affect to call "indiscretion of youth."

Contrary to recent tendencies in the domains of thought and literature, the international surrealist movement did not subordinate itself to politics, nor did it become sterilized in a purely intellectual attitude. Art and literature, under the pretense of making their entrance *in the world,* have yoked themselves to the *social machine,* which, with its lies, leads them where it pleases, that is to say, more often than it is reasonable, to public *conveniences.*

It seems to us indispensable, for lack of a complete analysis, which must be made

someday, to point out in a few words the situation of the surrealist group in England. The very decentralized structure of the English community—which, historically, could be contrasted to the extreme concentration of all French administrative or intellectual activities in Paris—never helped the creation in this country of a coherent surrealist group. Irrational tendencies, which came to light at all times in English culture, the lack in the main currents of English thought and even in everyday life of a logic with a compulsory character—in this respect, the fact cannot be too strongly underlined, that in English schools Elizabethan playwrights and romantic poets hold the place reserved in France for Corneille and Racine, while during the children's time of leisure, *nonsense* replaces or at least is added to fairy tales—all this would tend to throw a light on the apparent paradox that so many precursors of surrealism, so many unwitting surrealists, from Cyril Tourneur to Lewis Carroll, through Swift, Blake and Coleridge, and so few intentional surrealists, were born in this country. One could not neglect either the very special character of Christian moral oppression as it shows itself in Protestantism. Far from having to deal with a monolithic adversary with well-defined outlines, like the Catholic church, we face an enemy attacking man from the inside, an enemy itself, moreover, infinitely divided and superficially liberal; under these circumstances, the instinctive need to form a group for a fight against a certain number of oppressive forces plays a lesser part here than elsewhere.

As soon as the war began, the English surrealist group underwent some more or less sly desertions, and in the succeeding months it showed itself rather vulnerable to the attacks of an occasional conformism. The most surprising case remains that of the sculptor Henry Moore, who went without warning from surrealism to the fabrication of sacerdotal ornaments, and sank afterward to the monotonous production, in series, of sketches of air-raid shelters, a despicable popularization of his prewar "reclining figures." It is only fair to add that Moore's case does not palliate Herbert Read's eclecticism, which now reaches bewildering proportions, that David Gascoyne's hoaxes leave him prostrate and foaming at the mouth, and that Humphrey Jennings is decorated with the Order of the British Empire. No use lengthening the list with names unknown outside this island.

After we have mentioned, besides all kinds of surrender, the rather doubtful vogue enjoyed, here and elsewhere, by a certain "genre," a certain surrealist mannerism, entirely exterior, all will have been said on these two aspects of popularization, an unavoidable ransom for the success of every innovating enterprise; it is enough to denounce it constantly without dwelling too long on the subject.

In England during the war, on the most exposed point of the globe, despite dispersion and lack of contacts, some of the signers of this declaration never ceased to defend the surrealist point of view, often in the very center of reactionary and jingoistic cogita-

tions or in the face of militarism standing for order. In spite of very precarious means of diffusion and of various forms of censorship, their intervention was marked by pamphlets and letters to the press. The tract *Idolatry and Confusion* denouncing, as early as 1943, the profiteers of Resistance poetry in France, resulted in rallying elements that had lost touch with each other and in reuniting around its two authors a number of young men and women who wore at the time the uniforms of armies of different countries. *Message from Nowhere* and the documents collected later in the anthology *Free Unions — Unions Libres* were the expressions of this rallying, which took place in an extremely conciliatory spirit but proved nevertheless that the least sign of surrealist vigilance immediately finds a response. . . .

This declaration, ending with an appeal for a renewal of "passionate life" in order to put an end to "HUMAN MISERY," was approved and signed by John Banting, Robert Baxter, Emmy Bridgewater, F. J. Brown, J. B. Brunius, Feyyaz Fergar, Conroy Maddox, George Melly, Robert Melville, E. L. T. Mesens, Roland Penrose, Edith Rimmington, Philip Sansom, Simon Watson Taylor.

In 1950, an *Almanach surrealiste du Demi-Siècle* (Surrealist Mid-Century Almanac) was published in Paris as a special number of the literary journal *La Nef*. Copiously illustrated, it contained a "Calendar of Tolerable Inventions," providing imaginary origins for commonplace objects (thus we learned that *mustard* was "first produced in 1165 for the antipope Guy de Crème, who was looking for the antihoney"; that *binoculars* were "suggested by the Comte de Permission as a substitute for snails' horns, which allow one to see everything without going outdoors"; or that lace was "created expressly for Laure de Cléry, who wanted a nightdress of the color of a glade"). Also included was a "panorama of the half-century," recalling year by year, from a surrealist point of view, the main events since 1900 in art, science, letters, general news; a selection of retrospective texts (Sade, Maurice Heine, Cravan, Artaud, etc.); — a number of polemical or anecdotal pieces, poems and poetic texts — among these last, "Spectreuses 2, ou Prospectreuses," by Jean-Pierre Duprey, from which we quote the following fragment:

Spectresses 2, or
Prospectresses

This woman whom I will kill, on the day of our death, this woman is my chest, my heart-décor where I take shape from seven different bodies. I shall write.....that the sun is mad: in fact it will soon be so, since our eyes trample it on the ground of the low night. —Still other reasons lead to this conclusion!.....

AS A CONCLUSION: I may recall that the lunar sun, sun number 2, but first as to brightness, exploded on the verge of the void like a bomb reaching its target. —In the

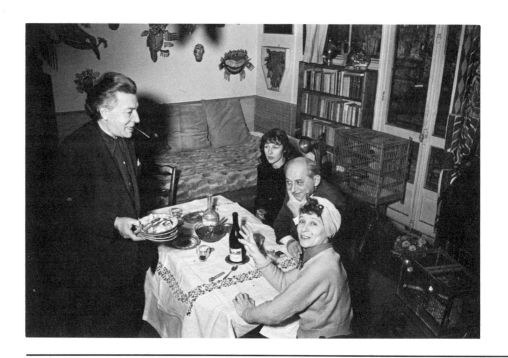

present situation, a bottle with zero delayed-action......

But everything is explained......And the beautiful mad girl who knows more than she confesses feels the cold with its firm roots, opening bloodless lips inside the bones: "No more sun, then......" And the shapeless night closes the well with no possible reopening.

The sea in an earth glance.....but it is also in advance of the sky! And the sky goes mad, for the color returns to the red after blueing and blinding. And if the deep sunflower takes double size and double touch, the fault is of the multicolored, chemically impossible dream, for which the glowworm, recommending white death at midnight, has already done much.

.....And now, to finish the unfinished, I achieve the common chord by pressing, at once and by force, a full stop, which remains virgin since it springs up in this very instant, although I have struck many others already......

This seven times physical woman, though my shadow for a thousand years, will open up, seven times my wife, on the eve of a creation, on the day of our union. Her shadow carries me away much farther, leaving my name here — I forget it on this page for it has been said — but an obscure speech does not matter — "The Master Madman is dead, biting Eternity" — Estern, my name thus written, fading then into letters lost in common sense on the grave of Her birth which She half-opens, Carmilla, which she sets ajar, since She opens the sails......And she opens them......She raises the Veil black

ALMANACH SURRÉALISTE
DU
DEMI-SIÈCLE

Tronc de soldat

LA NEF

ÉDITIONS DU SAGITTAIRE

Opposite: *From left*: André Breton, Elisa Breton, Benjamin Péret, Suzanne Cordonnier (formerly Muzard), at Breton's studio, 1948. (Photograph: Jacques Cordonnier)
Left: Cover of the *Almanach Surréaliste du Demi-Siècle*, illustrated with a child's drawing representing the "trunk of a soldier," 1950.
Right: Max Ernst: Illustration for *Spectresses 2, or Prospectresses* by J.-P. Duprey, *Almanach Surréaliste du Demi-Siècle*, Paris, 1950.

with soul, with closed hair, for a face to appear! And if the face is not, She raises the void—The Above-Void is a stab from Below.

.....My tree is the most beautiful of all; its sensitive boughs, with the wind unveiling itself, caress a naked air haunted by a new shape: For I feel myself unique in the sure meaning of the double and, though very much alone facing the wind, I live my own self in a future past and.....better than the hour with transparent eyelids (in this case a removed lens), I see the end of another story. —This joke was necessary for there is a need for a laugh like an egg, which should prove itself!.....This is why I refrain from saying more: The Black Fish, looking fixedly at the Mute Move, takes the floor......

Laying aside his erudite art occupations, Robert Lebel contributed to the *Almanach* a humorous piece he entitled "La Clivadière," later translated into English [9] as "The Splitoonery."

The Splitoonery

The man presented his card to me. His profession was inscribed on it: dermoneutic legimulator. "Do you have experience in the excavation of clooted spongs?" I asked him. He gave a quick self-confident smile. "My sole occupation for ten years." I beckoned him to follow me.

[9] By Simon Watson Taylor and published in the *London Bulletin*.

When we had arrived in the vicinity of the candelabrum I squatted in order to pull on the appropriate uniform. He did the same, with a practised air. Just to test his knowledge, I displaced the gynocule 9 lines. He immediately drew my attention to my error. "A competent technician," I thought, "but can he fisturize, that's the point?" And the memory of so many brilliant individuals who had turned out to be totally untrained in the fisturizing technique tempered my incipient approval. It was important for me to be careful, to play it cool, so to speak: after all, this was probably just another conceited amateur, another of these bigmouths who know all the answers but invariably collapse as soon as they are faced with the real test.

"The polation is smoking in the sprince-bath," I remarked offhandedly. The man grew pale. "But then the clanch will sedge," he cried out in anguished tones. I could have embraced him. But, controlling myself, I added: "The asphuldant is imbibing." That was all that was needed. Beside himself, the man dashed forward, snapped the palisated drockle and pressed the median pendical with all his might.

When he rejoined me, livid but calm, I could not help giving him a glance of tenderness. Surely any further precautions on my part were superfluous. I decided to equivocate no further: uncovering the basculating door of the ramisterium, I pushed the man into the esotrangle.

"Pay no attention to the roars," I murmured, "this is just the place where my phalenaceous hipponogam plavulates." At that very moment the loathsome beast appeared upon the scene and glotted. Its eyes glowed. Fearing some catastrophe, I placed myself in front of the man. But he thrust me gently aside and advanced towards the animal. It held out its paw to him; they knew each other.

In the *Almanach surréaliste du Demi-Siècle* there were also studies on "Masters of the Half-Century"—Kafka, Sade, Roussel, Duchamp, Jarry. Below are fragments of a study on Alfred Jarry.[10]

Jarry and the Contemporary Vortex

A secret knowledge and understanding of esoterism and its symbols is one of the features linking Jarry and the old alchemist of the Renaissance, the "Abstractor of Quintessence," as Rabelais called himself. Jarry's style is Rabelaisian, not so much in its facetiousness or medievalisms as in its continuous show of a whimsical but authentic erudition, which is also the best of Rabelais's verve, in its use of alliterations, of equivocations, suggesting, beyond scholarly etymologies, a sort of transcendental philology.

[10]By Marcel Jean and Arpád Mezei. Later published in our *Genèse de la Pensée Moderne* (Paris: Editions Corrêa, 1950), a study of the "Seven Sages of the Dual Civilization": Sade, Lautréamont, Rimbaud, Jarry, Mallarmé, Apollinaire, Roussel.

But Jarry's thought condenses the lessons of other important works. *Ubu Roi,* this comedy outside time and ages, the quintessence of comedy, is indeed the play that Shakespeare may have dreamed of writing, but the Elizabethan dramatists went no further than simply sketching the personage of Sir John Falstaff, who himself descends from the mythical Gargantua. Shakespeare dared not develop the most weighty consequences that the appearance of such a character implies. In *The Merry Wives of Windsor* he limits Falstaff's part to that of an almost harmless coward; in the Second Part of *Henry IV* he sets aside, at the end of the play, the essential identity relation: Falstaff is none other than Henry V; and at the beginning of *Henry V,* Falstaff dies, forgotten. Morals triumph, law and order are maintained, the legitimate king may then reap historical glory: Falstaff remains a secondary character in Shakespeare.

Ubu, though he is as much a coward as Falstaff, dares to ascend the throne of the kings; like Gargantua, Ubu is king. And a pun reveals other singular relations when Jarry uses the Rabelaisian derivative methods and Rabelais's speech to identify his hero *with Shakespeare himself:* "Adonc le Père Ubu hoscha la poire, dont fut depuis nommé Shakespeare par les Anglois, et avez de lui sous ce nom maintes belles tragoedies par escript."[11]

. . . Jarry's existence, on the other hand, was ruled, literally, by the Oracle of the "Holy Bottle" pronounced at the conclusion of the travels of Rabelais's heroes: "Trink." In the *Gestes et Opinions du docteur Faustroll, pataphysicien,* the real appears as a product of hallucinatory imagination, actual visions of drunkenness coming, among others, into play. Panmuphle, the bailiff, "after drinking" in the doctor's cellar, begins, "already drunk," a bizarre navigation on land with Faustroll, his companion and debtor. As Panmuphle describes them, their perceptions are those of alcoholic intoxication: "We inserted ourselves between the crowds of men as into a dense fog, and the acoustic sign of our progression was a shrill sound like that of torn silk." And yet this sensorial exaltation led Jarry to a most "scientific" discovery: the theory of exceptions. In Rabelais too, doubtless, there were some signs of tipsiness in his endless enumerative definitions, when he gave, for instance, the lists of the different species of "madmen," of "fools," or of "cuckolds," as if he tried to exhaust reality by merely recording all its attributes. But Jarry's clear-minded drunkenness carried him much further: to the discovery of *pataphysics,* "science of imaginary solutions, which studies the laws ruling exceptions."

General rules do not embrace the real as a whole; exceptions always escape them. But whoever masters exceptions knows also the rules and consequently may grasp the real in its entirety. This is why most of Jarry's heroes are not types, but exceptions

[11]("So then Father Ubu shook his pear-shaped head, from which Shakespeare was subsequently named by the English, and you have from him under this name many beautiful tragedies in writing.")

(Ubu, Faustroll, Marcueil of *Le Surmâle* [The Superman], Sengle ["the Singular"] of *Les Jours et les Nuits* [The Days and the Nights], etc.); they rule over reality so much the better and may become types in their turn; witness Father Ubu.

According to Greek thought, exception is arbitrariness. But Jarry reaches, in a way, the antipodes of the antique world; with him, the objective exterior becomes the domain of indetermination. The conjunction of opposites shows itself clearly in the novel *Messaline,* where the scene is set, precisely, in ancient Rome. There appear "murrhin vases," made of a precious matter, the "murrha," which old authors mention only in an enigmatic, imprecise manner; but such vessels are shown in *Messaline* in thousands of examples, crowded on the rows of seats of an amphitheater like spectators at circus games. Fabulously rare—and innumerable—the priceless vases, under the moving reflections of the moonlight, seem to change into living beings. The borders between object and subject melt into the exceptional, which extends its realm over the whole reality. The circus, where Messaline meets Priapus, is the image of the modern world, the vortex of Jarry's world of exceptions.

. . . Each era is characterized by the presence of a predominating instinct. The liberation of man is accomplished by steps, by successive analyses of the soul, and if the dominating complex of an epoch is not analyzed, it assumes, as it did in the Middle Ages, the shape of irrational, demoniac forces. In *Haldernablou,* Jarry, from the star Algol, which hermetic sciences consider the Devil's eye, saw his age burning under sulfurous rain, in a catastrophe unleashed by a technical civilization where the power of aggression acquires unlimited possibilities.

The *Almanach* reproduced a letter received from Mauritius, written by Malcolm de Chazal, a poet and a descendant of one of the French families of the island. De Chazal had published in that far-distant place, and sent to various people in France a collection of hundreds of metaphorical thoughts, entitled *Sens Plastique,* which Editions Gallimard republished in Paris in 1947. *Sens Plastique* revealed in its author a gift for discovering sensuous, organic, psychological relations between each and all creatures of the three kingdoms. A translation of a few of the sentences of the book may give an idea of de Chazal's singular talent:

PLASTIC SENSE

The eye has all the gestures of the fish.

Without the shadows, light could not ride the objects, and the sun would go everywhere on foot.

Light is the absolute fast. It is swallowed by plants, drunk by waters, devoured by colors that cut it into pieces. If light could feed itself, everything would disappear, engulfed by it, and even time would be eaten up.

Red is eternally pregnant with the sun. It miscarries in pink, is delivered of yellow in orange, and of blue and mauve twins in garnet red.

Since the flower has its eye overprinted on its mouth, gums and eye circles are one in flowers.

Blue flowers have featherweight glances, and red flowers have heavyweight glances. When flowers are boxing in the light, the red ones always win. But for fencing, yellow is best; and for saber, white.

Petals of the same hue: the flower has a plain dress. Petals of varied colors: the flower is flowered.

In the woods, the undergrowth makes light look chubby.

When their gaze is heavy with desire, women "bulge" with the whites of the eyes; and men "bulge" with the pupils; and all undersexed people, with the irises.

The deepest hell is made of steep pleasures.

The valleys are the brassieres of the wind.

The mouth is a sex in slow motion, and armpits are flat sexes.

The hip is the "side-eye" of woman.

The human gaze is a sailing lighthouse.

Women eat while talking, and men talk while eating. Men at meals talk longer between mouthfuls and women during mouthfuls. At breakfast, where courses are short and quick, women lead. In formal meals and dinners, where breaks are longer, men's voices prevail. Women, more than men, have the art of doing two things at the same time.

His "plastic sense" inspired de Chazal with images glorifying *volupté,* sexual delight at its climax. The following thoughts are a few of the many on this subject in his book:

Sexual delight is the most powerful sensation we have of speed.

It is the never-returned mail — the message in a bottle thrown out to sea and sailing toward eternity — the only sensation without a return stroke. Like water, which cannot reascend to its source, it is also the only pleasure that cannot be taken back.

The kiss ends on a needle point, and sexual delight ends as an opening fan. The kiss is arrow, and sexual delight a fountain.

Sexual pleasure is a bundle of all our senses around the stem of time.

It is a wholesale trade, in bigger or smaller quantities. Hysterical people retail it only.

Sexual pleasure in true love: we are unanimously and unitarily two; in vice: we are alone and three.

Sexual delight has no finger touch. It is a palm of sensations. The touch of sexual

pleasure is like the touch of a hand whose fingers would be inside the palm — a palm that would touch our fingers — a sensation that would make us feel as if we were touched from inside the body, by an invisible and foreign hand lost inside ourselves.

Like the feeling we have under water, which is an inverted caress to the immersed body, sexual pleasure is a complete caress on the back, from heels to occiput.

In sexual delight, the brain "bridges" over the nerves — a moment when there is no longer a ford between the shores of ideas. Sexual delight pours all the mind into the sixth sense, whose mode of thinking is all "run-on lines."

Sexual delight is pagan at the beginning, and sacred toward the end. The spasm belongs to the next world.

Sexual delight begins with a game on horizontal bars and ends with mutual somersaults. One wakes up from it with the feeling of having traveled around oneself around another one's body, like a dual wrapping, or like a footpath circling around a garden that follows it step by step.

Sexual delight is an involution toward the Infinite. It is death inside out and birth in reverse, where time and space are abolished — which makes us wonder whether voluptuousness could not be, by chance, the first step to the beyond and the substructure of the spiritual world.

A beautiful woman's body is the best bedside lamp. Two sleeping together make the night less opaque.

The de Chazal family was converted to Swedenborgianism during the last century, and in *Sens Plastique* there are several passages discussing Christian symbols, but in a highly heterodox manner pervaded with occultism. The author's aversion to past disciplines is probably best expressed in the following text:

From birth to death, life is nothing but brain stuffing. In school, they cram the child's head with dead people's ideas. Later the process goes on at home, but there, fortunately, the child "disgorges." Because the mother stuffs up the child less than the father, the child will listen to the mother more than to the father. The stuffing-up with ready-made ideas continues until adult age, when married people gorge on their reciprocal ideas, under the excuse of love. Very few people "disgorge" intelligently during their lifetimes; this is why the greater part of the human race ends in senile decay, as a result of the apoplexy of stupidity that follows brain stuffing. During man's declining years, another form of stuffing-up comes into play: the ready-made ideas of religions, which are, all things considered, the least harmful of all brain stuffings, for these "ideas" have at least the advantage of making men accept death courteously.

And so men die without having had one single personal idea during their lives. We still ruminate over Plato, two thousand years after his death, while he would have denied himself long ago, had he lived half a century more. Thus the process goes on till death: we stuff ourselves up with ideas of people stronger than ourselves and we stuff up those who are weaker. We "pass the pail" along to one another, from the well to the house — a few of those wells are closed up every thousand years so that others may be opened. We pass the pail along to one another, from the well to the house, from the spring of knowledge to the child, the spring water lost on the way leaving him, most of the time, with no more than a drop of the water of Truth to quench his thirst — yet the child's brain has an infinite thirst for knowledge, but his weak strides do not allow him to run to the spring. And for one drop of spring water, the child will have to swallow a thousand pails of indigestible water that his mentors will pour into his head, night and day. And yet, if philosophers did not periodically renew the water of the "well of truth," men would not even have this drop of spring water to put into their souls. Individualists of the body, we are the "followers" of the mind, less free than the blade of grass and the microorganism swimming in our blood. We believe we act freely, while we are all tied up with the gesture-ideas of a few philosophers who keep "pulling" at our life through the ages, periodically replaced, when the fashion of ideas changes, by other hands and other ties. Thus the Punch-and-Judy show continues from generation to generation, no one perceiving the monstrous changes brought to the deep substructures of human life and caused by philosophers, who pull the strings of human souls, and the face of the world changes with every new manipulator. The world of intelligence is made of myriads of music boxes played by a few Giant Organists who insert their favorite "records" in them. Moralists protest periodically: "Intelligence is transgressed." Others shout: "Down with the dictatorship of intelligence." *But the law of the strongest reigns also in the domain of the mind.* As a tocsin, let us cry out to all these besieged minds: "But defend yourselves, defend yourselves, gentlemen!" Alas! among all these erect bodies, only recumbent, paralyzed, or dazed brains may be found. The Earthworm cannot be changed into a Demented Eagle trying to drink up the Sun!.....

May '68

In 1947 the surrealists published a pamphlet — *Liberté est un mot vietnamien* (Freedom Is a Vietnamese Word) — against the war in Vietnam, which had started at that time under the first and short-lived De Gaulle government. (The paradox was that several ministers of that government were Communists.) Another tract, *A la niche, les glapisseurs de Dieu!,*[1] denounced several apologetic critics who sought, more or less openly, to include surrealism among Christian heresies. In 1948 *Rupture Inaugurale* did not, as a matter of fact, "inaugurate" the break with the Communist-Stalinist party, but confirmed this break in the most explicit terms. In 1948 also, the surrealists joined the Citizens of the World movement launched in Paris by the American Garry Davis.

Yet very few adherents of the old set remained around André Breton after 1946, and even these finally withdrew, except for Benjamin Péret. They were replaced at the café séances by young militants who published at intervals, under Breton's supervision, magazines that did little more than duplicate prewar reviews. Surrealist exhibitions were held, one at the Galerie Cordier in 1959-60, dedicated to eroticism and once again with "grotto" settings, another in New York in 1964, supervised by Marcel Duchamp, a third at the Galerie L'Oeil in Paris (1965), under the title "L'Ecart Absolu," where Breton could affirm the "absolute gap" between his own poetic concepts and scientific "progress" in general.

Meanwhile André Breton republished, with postscripts or additions, several of his previous works,[2] and wrote articles and gave interviews in which he defended, in the light of contemporary events, the principles he had always fought for in love, poetry, and liberty. His most important book during that period is probably his *Entretiens,* reproducing a series of broadcast interviews (March-June 1952) focusing on his memories from the years 1913 to 1952. Seen

[1] "Back to your kennels, you yappers of God!" — *niche* meaning "dog kennel" as well as niche for statues in a church.

[2] For the reissue of the "Second Manifeste," Breton admitted in a prefatory note that its pages bore "unfortunately signs of nervousness" in its attacks against several writers and former companions.

by André Breton, surrealism appeared there, as in all memoirs, a selection of memories; the author recounted many episodes in detail but made no allusion to others: there is not a word on *Nadja,* and almost nothing on *Minotaure.* Nevertheless, these conversations represent the ideas of surrealism's founder, all the more because they are in fact a monologue, first written as a continuous text and changed, for broadcast, into a dialogue. The "interviewer," on Breton's request, inserted "questions" between passages supposed to be "answers," so as to obtain the effect of an interchange between the speakers. Breton enforced here his rule of giving no interviews unless they were written.

Matta: *A Poet of Our Acquaintance,* portrait of André Breton, 1946. One of three drypoints by Matta illustrating the first fifty-eight copies of *Les Manifestes du Surréalisme,* 1946.

After Breton's death, in 1966, his group melted away. But the influence of the surrealist movement was far from over, and its importance is increasingly acknowledged. Surrealist works are constantly republished, and surrealist exhibitions continue to be organized in France and abroad.

In a booklet written in 1948, entitled *La Lampe dans l'Horloge* (The Lamp in the Clock), Breton said:

If it rested with me, not one school manual, not one anthology could avoid reproducing the passage from *Sens Plastique* that opens with this candid declaration: "From birth to death, life is nothing but brain stuffing" and rises to the admirable peroration: *"But the law of the strongest reigns also in the domain of the mind.* As a tocsin, let us cry out to all these besieged minds: 'But defend yourselves, defend yourselves, gentlemen!'" Take care: this tone of injunction will be heard and supported by those of the young generation who feel that it is addressed to them. . . .

The new generation in the sixties was shaped in France by a literature under surrealist influence. Young minds became acquainted with the passionate pamphlets and calls from the first days of surrealism, which Maurice Nadeau had resurrected in *Documents surréalistes,* in 1948. A spirit of contest began to rise in advanced intellectual circles, sharpened by the De Gaulle regime's authoritarianism—active in the cultural field also since the return of the general to power in 1958. Breton, in *Arcane 17,* had said:

There is not, in fact, a more shameless lie than to maintain, even and above all in the presence of the irreparable, that rebellion is useless. Rebellion carries within itself its justification, quite independently of whether or not it has a chance to modify the state of things that determines it. It is the spark in the wind, but a spark seeking the powder magazine.

The spark of rebellion flared in May 1968 among a small group of students at the University of Nanterre, near Paris, and shortly afterward the whole Latin Quarter and other sections of the French capital were ablaze with demonstrations. The Sorbonne was occupied by the rioting students. Young workers in their turn went on strike, rebelling against their Communist leaders, who were bent on keeping the working class from uniting with student organizations, which the Communist party had branded from the start as "groupuscules led by a German Jew."[3] Within a few days, strikes spread over the whole country. University work and economic life came practically to a standstill.

[3]Indeed the most brilliant and popular student leader, Daniel Cohn-Bendit, was Jewish and a German citizen. He and his brother Jean-Gabriel (who had obtained French citizenship) had spent the war years as children in hiding in France, thus escaping the Nazis' gas chambers. Thousands of French students answered the Communists' insult with the ironical motto: "We are all German Jews!"

Later, this situation became the subject of numerous contradictory reports, analyses, and explanations, but at the time of the upheaval, a number of onlookers and participants — among them several writers and newspapermen — were aware of the fact that it was at bottom a typical surrealist revolution. There are revolutions of all sorts, in art or in literature, as well as on the social plane. May '68 was essentially an intellectual revolution, using means that were not always violent but also poetic, that is to say, creative and imaginative. The workers' strikes at that time were, so to speak, grafted to a movement originating in the motto that appeared on the cover of the first issue of *La Révolution surréaliste* in 1925: "We must attain a new declaration of the rights of man." This demand came in full light, and it took the voice of poetry, not of politics, to express itself on the posters in the streets — for instance, with the following texts.[4]

Days of May 1968

I have no weapon other than this law which I won't bear which forgets that the street
 is my own place forever[5]
I have no weapon other than my throbbing life and so many rich images I carried in
 your days
I have no weapon other than my moist face with eyes, drawing at night the strength
 of your rites in that cold wind of May,
I caused wonder between walls and I renewed at last, amid this ancient clamor, earth
 and its due and the voice was pushing me
My throat was muffled by sulfur and chlorine, but the fire quickened and the more
 I grew up
In that harsh color the more I was born to my name and I may tell it to you, without
 shame of my heart, I am called Liberty

We Shall Know How to Live

 For men from whom I receive suffering
 as my share, I want to bear witness of my pain
 till blood is drawn
 The mills of time took sweetness hastily
 We must put an end to innocent meetings
 We shall know how to live
 the memory of the great fights forces itself
 upon the alternating refuge of living and dying
 By fighting on the slopes

[4] Published, with others, in a short anthology of anonymous poems of May '68, in the newspaper *Le Monde,* June 1, 1968.
[5] Cf. Breton in "La Confession dédaigneuse" (*Les Pas perdus,* 1924): "The street, which I thought capable of opening its surprising turnings to my life . . . was my real element. . . ." See p. 113.—M.J.

> like the tree that ignores frights
> we shall know how to live
> The lightning forgives us.

The following inscriptions were among the many that could be read on the walls of the Sorbonne and elsewhere in Paris:

Any view of things that is not strange is false.

Do not sleep with other people's eyes (African proverb).

Beauty will be convulsive or will not be (André Breton).[6]

It seems that the old mole History is fairly eating up the Sorbonne.

Never work, never take a holiday.

Dream is truth.

You work better when sleeping, form dream committees.

Human life would not be a disappointment for certain men if we did not feel constantly able to accomplish actions beyond our power (André Breton).[7]

For 20 years I have fought for salary raises. For 20 years, before me, my father has fought for salary raises. I have TV, a Volkswagen, a refrigerator. In other words, for 20 years I have lived like an ass.

Evidently humor was not absent from the students' ranks. The following mottoes could be read in the Théâtre de l'Odéon, occupied by the rioters:

I am here by the will of the people and I won't leave until I get my raincoat back.

Policemen in plain clothes watch the step behind this door.

The "Lettre aux Recteurs des Universités européennes," published with other manifestoes April 15, 1925, in *La Révolution surréaliste,*[8] was also placarded on the walls of the Sorbonne:

Letter to the Rectors of the European Universities

Gentlemen,

In the narrow tank that you call "thought," spiritual rays rot like old straw.

Enough plays on words, syntactic artifices, juggling of formulas: the great law of the heart must now be found, the Law which is not a law, a prison, but a guide for the

[6] From *Nadja*. See above, p. 187.—M.J.

[7] From *Les Pas perdus,* in a text on Lautréamont.—M.J.

[8] See above, pp. 139-41.

Mind lost in its own labyrinth. Further away than Science will ever reach, there, where the spears of reason break against the clouds, this labyrinth exists, a central point where all the forces of the being and the ultimate nerves of the Spirit converge. In this maze of animated and always displaced walls, outside all known forms of thought, our Spirit stirs, watching for its most secret and spontaneous motions, those which have the character of a revelation, an air of having come from elsewhere, of having fallen from the sky.

But the race of prophets is extinct. Europe crystallizes, becomes slowly mummified under the wrappings of her frontiers, her factories, her courts of justice, her universities. The frozen Spirit cracks between the mineral planks that close upon it. The fault lies with your moldy systems, your logic of 2 plus 2 equals 4, the fault lies with you, rectors, caught in the net of syllogisms. You manufacture engineers, magistrates, doctors who are ignorant of the true mysteries of the body, of the cosmic laws of being; false scholars blind in the beyond of this earth, philosophers who pretend to reconstruct the Spirit. The smallest act of spontaneous creation is a more complex and more revealing world than all metaphysics.

So leave us alone, gentlemen, you are only usurpers. By what right do you pretend to shepherd intelligence and confer Spiritual patents?

You know nothing of the Spirit, you ignore its most secret and essential ramifications, these fossil imprints so close to our original sources, those traces that we are sometimes able to discover on the deepest lodes of our brains.

In the very name of your logic, we tell you: Life stinks, gentlemen. Look for a moment at your faces, consider your productions. A generation of lank and lost youths is passing through the sieve of your diplomas. You are the plague of the world, gentlemen, and so much the better for this world, but let it consider itself a little less at the head of humanity.

On June 1, in *Le Monde,* the journalist Jacqueline Piattier wrote: "The time was favorable to poets: insurrection, liberation, a call to creation to change and magnify reality. At the dawn of the revolt, the walls of the Latin Quarter spoke a surrealist language: 'All power to imagination.' 'Take your desires for realities.'"

In October 1968, in an article in *La Quinzaine Littéraire,* Brice Parrain wrote: "Instead of being twenty or thirty surrealists as in 1924, there were one or two thousand of them in May 1968."

We like to imagine that André Breton, had he been alive still, would have placed those days of May 1968 among the "grand days of Paris" of which he spoke in *Arcane 17,* the surrealist days of revolt and poetry. On May 27, 1968, in the newspaper *Combat,* in an article entitled "Mes Nuits pâles," the reporter Jean Claude Kerbourc'h attempted to account for the shock produced by this singular revolution, to describe the impression it produced of com-

plete change and total renewal of our customary world of logical and explainable events.

My Pale Nights[9]

We must get used to it. Something has tipped over in our universe. Two and two do not quite equal four any longer. We are being impregnated by a certain new shifting of ideas, of sensations. We don't have the same conversations with our friends. The hand of our little personal scales isn't in the same place. The ground we tread doesn't have the same consistency. People have different faces. And all this because of a students' revolt, because, on the whole, of a row carried a bit far. We must brace ourselves up, we must tie ourselves up to the dike, in order not to be overthrown by this unknown wind coming from someplace or other and blowing toward a horizon that nobody sees very clearly yet.

Nobody. No, nobody can really answer, in today's crisis, the questions that everybody asks. The ship sails without a compass. And the mutineers themselves do not always know exactly how they stand in the storm they let loose. From now on they are at the helm. But whither to steer? Where to go?

The ship boys have invaded the vessel, to the huge surprise of the old sailors, who had seen worse days on other oceans and who were well trained in avoiding reefs, in crossing dangerous narrows, and in getting over the billows.

It's fantastic. Those who are responsible for the mutiny often seem as astonished as those they hustled about. I write these lines on Sunday morning at daybreak. My idea of time is pulverized, annihilated, laminated. Since Friday night I have been wandering in Paris, searching for an explanation. I asked a young student who told me about "new structures" but who didn't conceal his surprise at being here, in this pale morning, pondering with me the dimensions of what had just happened and to which one hardly dares to apply the too classical term "events."

Everything is "unreal" and yet very real. I am walking on another planet. Does this open gap on the roadway, as if an earthquake had shaken old Paris, really belong to the Rue des Ecoles? Are they real, these ocher and black calcinated skeletons of burned cars, barring the streets, piled up on the pavements like beasts aground on a nightmarish shore? And these fallen trees? Were these trees formerly along the Boulevard Saint Michel? And these heaps of paving stones at every street corner, do they really exist only in my imagination?

Military men are busy this morning cleaning these scars of violence from Paris, these purulent wounds as absurd and unhealthy as an abscess.

The Sorbonne isn't so anarchical as it was a few days ago. Fighting seems to have

[9]Reprinted in the collection of reports by Kerbourc'h for *Combat* in May 1968, entitled *Le Piéton de Mai* (Paris: Juilliard, 1968).

hardened the features and the morals of the students. The Sorbonne has become a bastion where everyone plays his part. It's only natural that a countersociety should little by little become a society. Therefore the Sorbonne also has its "police." It's only natural after all. They stop me. They ask for my card. "No newspapermen here!" I tell them that I don't give a damn about their interdictions, that I'm doing my job and I plunge into a somewhat romantic defense of freedom of the press. Nothing doing, they push me away. But I have copied in my notebook the text of one of the posters stuck up in a corridor. I read it calmly to the "policeman": "Interdictions are an attempt against freedom. Do not muzzle information and evidence by imposing interdictions and authorizations."

"Well, you're right. Forgive us, we're all a little tired," says the student responsible for order.

A little earlier, I hadn't been allowed to pass a barred street. But a student intervened: "Don't play too much at being a cop!" he said to his comrade. But the cops (the real ones) don't they also play at being cops? Everything begins as a game and ends with the Code—law, tear gas, tommy guns, machine guns, howitzers, or H-bombs. It depends.

But I prefer this morning to remember this sentence by André Breton inscribed also in the yard of the Sorbonne: "Human life would not be a disappointment for certain men if we did not feel constantly able to accomplish actions beyond our power." It seems to me, nevertheless, that it is beyond my power to tell what these nights, these pale nights, actually were. These nights illuminated with fires, flares, crackers. These nights filled with the shrill clanging of fire engines, the explosion of gas grenades, the crashes of blast bombs. These nights imbued like unhealthy sponges with an often absurd, and sometimes laughable, violence.

Friday evening, May 24, Place de la Bastille.

A barricade rises across the Rue Saint Antoine. Here, it is the old revolutionary Paris. It is also the Paris of Eugène Sue. A fellow clad in scarlet from head to foot, holding a long whip à la Zorro, leads a commando floundering in garbage before setting fire to it. The CRS[10] charge. The demonstrators in the Rue Saint Antoine are too few; the CRS storm the barricade and take the position. One feels they are vengeful, difficult to handle, their nerves strained, and like their hand grenades, ready to explode.

"I have the greatest difficulties keeping them in hand," says their commander, who adds: "It's only natural, no?"

"I don't know, I'm just looking."

"Oh, you're looking? Well, look at that baby carriage. When they came a moment ago, a woman took her baby in her arms and fled. Is that the civilization you want?"

[10] Compagnies Républicaines de Sécurité—State Security Police.

The baby carriage remains an absurd image of innocence in this sticky, sweltering universe. Two hours later, a laughing, shouting girl, hustled by a young man, will let herself be pushed along in it. Paris has taken on tonight the cruel colors of a Buñuel film.

In that same Avenue Beaumarchais, on May 17, 1966 and 1967, between the Place de la Bastille and the Place de la République, I followed the demonstration of workers on strike with the same pleasure that one feels looking at the Tour de France bicycle race or watching the crowds at the Foire du Trône. But tonight we are far from the rosy colors of a "peaceful revolution." Those who, last year, intended to rush on the unobtrusive police forces had been quickly called back to reason by their leaders. Tonight, the floodgates are open. A barricade is hastily built. Dragged along behind motorcycles, thundering sheets of metal are brought, rusty fences are piled up, a chain is formed to bring paving stones. . . .

Crack! Everything blows up! Everybody weeps, coughs, spits. Retreat of the paving-stone throwers. The CRS arrive. Some twenty minutes later, they go. All right, the demonstrators come back and rebuild the barricade.

Thus Paris, on that night from Friday to Saturday, bristles with mushrooms always cut down and always reappearing. I walk toward the Seine, so beautiful, so calm near the Ile Saint Louis. But the old stones echo the explosions of tear-gas grenades. They're fighting on the Boulevard de Sébastopol. . . .

Rue des Ecoles, a car is burning. Fires crackle everywhere. The demonstrators, students, young workers, and some veterans of prewar workers' fights have felled the lamp posts, broken the bulbs. The whole district is plunged in a strange night, punctuated here and there by burning automobiles.

The CRS throw firecrackers, which speed on the roadway, swift as frightened lizards. Then it is again the valley of tears. Again a barricade near the Mutualité. Again the pricking of the eyes, the smothering. We know the tale.

Toward five o'clock, in the bleak small hours, Place Saint Michel, prisoners with their arms up. Two of them have their hands tied up with chains found on them. A young man's knees bend, he's going to fall. No, he draws himself up, shaken with shivers.

A CRS makes him sit on the brim of the Saint Michel fountain.

"I am an American student," says the prisoner.

"You risk deportation," says the CRS (using "tu").

The young American specifies that he has been in France for only a few weeks. That he came to visit Paris. Not to go into politics.

"Funny kind of tourism," says the CRS.

"I am a student taking French civilization courses," answers the American. "And

Monsieur Duverger, who is a great political man,[11] told us we should go on the barricades. He's a great political man, Monsieur Duverger," the American repeats.

But evidently the CRS is not impressed by this "great political man" whose name he hears for the first time. However, he no longer addresses the young American as "tu."

"Next time," he says, "you won't listen to those who tell you to create disorder in France. Or else, you better stay in America."

In the Sorbonne, a room is reserved for medical first aid. A young doctor makes me feel his fingers shaking with fatigue. "Was that chlorine? No?" and he adds, addressing everybody: "Chlorine is good for sinusitis, but aside from that, it's infamous trash!" In the lecture rooms, "combatants" are resting, dazed with exhaustion. In the main yard, demonstrators wait for the departure of the CRS outside. They may be arrested if they go out now.

"It's a damn nuisance," says a young worker. "I start work at eight o'clock. What am I going to tell my boss?"

A poster has just been put up: "Who is M. Séguy?[12] A right-wing Gaullist. It's logical, since Messrs. Capitant and Pisani, who are left-wing Gaullists, have resigned as ministers of the Pompidou government and disavowed it, while M Seguy considers this government a valid interlocutor. . . ."

In the yard, a revolutionary declares in all simplicity that everyone around him, and himself, are asses.

"That's a Maoist position," throws in a contradictor.

The revolutionary goes on: "My doorkeeper may become a cultured doorkeeper. But I don't want a cultured doorkeeper. I want a doorkeeper who can think for himself. . . ."

Finally the leaders of the labor unions overtook, so to speak, their fighting troops, reached an agreement with the government, and obtained salary raises. The revolt subsided, but the student problem, and many others, remained unsettled. May '68 was, technically, a riot "pushed a bit far." Yet it accomplished what seemed unthinkable before: De Gaulle's personal rule was doomed. Within a year the general disappeared from the political scene. Perhaps that was the true aim of the whole upheaval: "Ten years, that's enough!" said one of the demonstrators' posters.

Again Breton, in *Arcane 17*:

Liberty may subsist only in a dynamic state; it is denatured and denied from

[11] Maurice Duverger, professor and sociologist.—M.J.
[12] Georges Séguy, secretary of the Communist labor unions.—M.J.

the moment it is supposed to be changed into a museum piece. . . .Deliberately setting aside its philosophical meaning, which has no relevance here, though its adversaries know how to use it to obscure the notion, liberty may be clearly defined as opposed to all forms of bondage and constraint. The only weakness of this definition is generally to represent liberty as a *state,* that is to say, as immobile, while all human experience demonstrates that this immobility brings about the immediate ruin of liberty. An unceasing power of re-creation must be maintained in man's yearning for liberty; this is why it must be conceived not as a state but as a *living force* entailing a continuous progression. It is, besides, the only way to oppose constraint and bondage, which re-create themselves continuously and in the most ingenious manner. . . . Liberty is not, like liberation, a fight against illness; it is *health.* Liberation may persuade one that health is restored while it marks only a remission of the illness, the disappearance of the most manifest, the most alarming symptoms. Liberty escapes all contingencies. Liberty, not only as an ideal but as a constant re-creator of energy, as it existed in certain men and as it can be given as a model to all men, must exclude all idea of a comfortable equilibrium and must be conceived as a continual *erethism.*

Formerly Chief Librarian,
The Museum of Modern Art, New York

Substantial citations of writings by members of the surrealist circle are noted in Marcel Jean's text. With few exceptions, they are omitted here, although further details may be found in the many bibliographies, both general and individual, listed below. For convenience, the documentation is grouped under these categories:

 I. Bibliographies (1 – 17a)
 II. General Works: In English (18 – 66)
 III. General Works: European Sources (67 – 101)
 IV. Some Surrealists (102 – 127a)
 V. Periodicals: A Selection (1919 – 1974) (128 – 156)
 Including Articles and Special Numbers
 VI. Exhibition Catalogues: A Cross Section (1925 – 1975) (157 – 196)

I. BIBLIOGRAPHIES

1. Admussen, Richard L. *Les Petites revues littéraires, 1914 – 1939. Répertoire descriptif.* St. Louis, Mo., Washington University Press; Paris, A. G. Nizet, 1970.
 Annotated bibliography.
2. Arbour, Roméo. *Les Revues litteraires éphémères paraissant à Paris entre 1900 et 1914. Répertoire descriptif.* Paris, José Corti, 1956.
3. Bazin, Germain. Notices. *In* Histoire de l'art contemporain: la peinture. Paris, Alcan, 1935.
 Biographical and bibliographical data in section on "Le Dadaïsme et le Surréalisme" covering (pp. 342 – 344) the following: Arp, Dali, Duchamp, Ernst, Man Ray, Masson, Miró, Picabia, Tanguy. Originally published in *L'Amour de l'Art,* March 1934.

4. Berès, Pierre, Inc. *Catalogue no. 15: Cubism, Futurism, Dadaism, Expressionism and the Surrealist Movement in Literature and in Art.* New York, Berès, 1948.

> Prefatory note in French by Paul Eluard. Annotated checklist of 400 items by Lucien Goldschmidt.

5. Bolliger, Hans. [Bibliography]. *In* History of Modern Painting [Vol. 3]: From Picasso to Surrealism. Geneva, Paris, Skira, 1950.

> Includes general bibliography, individual chronologies, and documentation on Arp, Chirico, Duchamp, Ernst, Picabia, Picasso, and Tanguy. Also French and German editions.

6. *Cahiers Dada Surréalisme.* See no. 137.

7. Corti, José, Librairie. *Les Livres surréalistes. . . .* Paris [1932].

> Cover by Max Ernst, photos of 10 surrealists, lists, and comments. Additional data in his: *Le Groupe surréaliste.* Paris, 1930.

8. Edwards, Hugh. *Surrealism & its Affinities: The Mary Reynolds Collection.* A bibliography compiled by Hugh Edwards. Chicago, The Art Institute of Chicago, 1973.

> Prefatory note by Marcel Duchamp. The edition of 1956 with addenda.

9. Ex Libris. [Catalogues]. New York, 1974 – current.

> A specialized dealer's sales catalogue, with classified sections on books, documents, etc., usually annotated. Includes dada and surrealist items in no. 1 (1974) and no. 2 (1975). Catalogue 3 (1975) contains nos. 612 – 985 on surrealism, compiled by Trevor Winkfield and Arthur A. Cohen. Also 5 (1976), nos. 1150-1459.

10. Gershman, Herbert S. *A Bibliography of the Surrealist Revolution in France.* Ann Arbor, University of Michigan Press, 1969.

> A supplement (57 pp.) to no. 39. Actually includes considerable dada data.

11. [Gordon, Irene]. Selected bibliography, pp. 217 – 227. *In* Dada, Surrealism, and Their Heritage. New York, The Museum of Modern Art, 1968.

> See no. 60.

12. Karpel, Bernard. Did Dada die? a critical bibliography, pp. 318 – 382. *In* The Dada Painters and Poets. New York, Wittenborn, Schultz, 1951.

> A pioneer bibliography; prefaced, classified, annotated, illustrated, indexed. About 450 citations, including Arp, Breton, Duchamp, Eluard, Ernst, Picabia, Man Ray, Tzara, etc.

13. Karpel, Bernard. Bibliography. *In* From Baudelaire to Surrealism. New York, Wittenborn, Schultz, 1950.

> A comprehensive list (46 pp.) omitted from British edition (see no. 57).

13a. Karpel, Bernard. See also no. 20, 102, 106, 111, 112, 113, 114, 117, 125, 126, 174.

13b. Lyle, John. *The Surrealist Movement.* A catalogue of books currently available in English and French. Harpford, Sidmouth (Devon), John Lyle, 1970.

> Representative, annotated checklist from a specialized bookseller. Regularly updated or supplemented.

14. Matarasso, H., Librairie. *Surréalisme: Catalogue.* Paris, 1949.

> 695 items, mainly surrealist.

15. Matthews, J. H. Forty years of surrealism (1924 – 1964). *Comparative Literature Studies* vol. III, no. 3, pp. 309 – 350, 1966.

> Comprehensive bibliography of European and American references.

16. Nadeau, Maurice. *The History of Surrealism.* New York, Macmillan, 1965; London, Cape, 1968.

> Translation: Paris, Club des Editeurs, 1958. Revision of 2-vol. edition (1945 – 48). Bibliography: "Surrealist periodicals, manifestos, tracts, leaflets, catalogues, films, and critical works," pp. 325 – 335.

17. Nicaise, Librairie. *Cubisme, Futurisme, Dada, Surréalisme.* Paris, 1960.

> An outstanding catalogue of 1072 items, many de luxe, first exhibited November 25 – December 20, 1960. It was rumored that the entire collection was not publicly sold but acquired by the government – happy thought for the researcher, who should also consult other important catalogues from Nicaise, e.g. *Poèsie – Prose: Peintres, Graveurs de Notre Temps, Editions Rares, Revues* (1964). Notable among the 493 references is a detailed itemization of Marcel Duchamp's *Boîte-en-valise* (1941).

17a. Rubin, William S. See nos. 60-61.

II. GENERAL WORKS: IN ENGLISH

18. Ades, Dawn. *Dada and Surrealism.* London, Thames and Hudson, 1974.

A compact Dolphin paperback. 62 color-plates. Brief chronology and readings.

18a. Alexandrian, Sarane. *Surrealist Art.* London, Thames and Hudson; New York, Praeger, 1970.
Translation: *L'art surréaliste*, Paris, Hazan, 1969.

19. Alquié, Ferdinand. *The Philosophy of Surrealism.* Ann Arbor, University of Michigan Press, 1965.
Translation: *Philosophie du surréalisme.* Paris, Flammarion, 1955.

20. *Arno Series of Contemporary Art.* Compiled by Bernard Karpel: New York, Arno Press — New York Times, 1968 — 71.
Reprints. Relevant titles include: *Abstract & Surrealist Art in America* by Sidney Janis (1944).— *Art in Cinema,* ed. Frank Stauffacher (1947).— *Art of This Century,* ed. Peggy Guggenheim (1942).—*Dyn,* ed. Wolfgang Paalen (1942 – 44).—*The Early Chirico* by James Thrall Soby (1941).—*Histoire de l'art contemporain: la peinture,* ed. René Huyghe (1935). —*London Bulletin,* ed. E. L. T. Mesens (1938 – 40). — *Minotaure,* ed. E. Tériade et al. (1933 – 39).—*Joan Miró* by Clement Greenberg (1948).—*Modern French Painters* by Maurice Raynal (1928). – *The Painter's Object,* ed. Myfanwy Evans (1937). – *La Révolution surréaliste* (1924 – 29). – *Le Surréalisme au Service de la Révolution* (1930 – 33).

21. *Art in Cinema: a Symposium of the Avant-Garde Film.* Ed. Frank Stauffacher. San Francisco, San Francisco Museum of Art, 1947.
Includes essays or extracts from Man Ray, Luis Buñuel, Hans Richter, and others. Reprinted by Arno Press, New York.

22. Balakian, Anna. *Literary Origins of Surrealism.* New York, King's Crown Press, 1947; New York University Press, 1966.
Bibliography.

23. Balakian Anna. *Surrealism: The Road to the Absolute.* New York, Noon Day Press, 1959; Random House, 1970.
Bibliography. Rev. and enlarged edition (paperback): New York, Dutton, 1970.

24. Barr, Alfred H., Jr., ed. *Fantastic Art, Dada, Surrealism,* New York, The Museum of Modern Art, 1936. Reprinted by Arno Press, New York.
Brief chronology by Elodie Courter and A. H. B., Jr. Catalogue of the exhibition with illustrations. Brief bibliography. Second edition added essay on "Dada and Surrealism" by Georges Hugnet (1937). Third revised (trade) edition: Simon and Schuster, 1947.

25. Benedikt, Michael. *The Poetry of Surrealism: an Anthology.* Boston, Toronto, Little, Brown, 1974.
With introduction, biographies, critical notes and new translations. The "notes" and "source data" (pp. 361-372) constitute bibliographies on Apollinaire, Arp, Aragon, Artaud, Breton, Césaire, Daumal, Desnos, Eluard, Péret, Prévert, Reverdy, Soupault, Tzara.

26. Breton, André. *Manifestoes of Surrealism.* Ann Arbor, University of Michigan Press, 1969.
Translation 1962 edition (Pauvert, Paris). Paperback, 1972.

27. Breton, André. *Surrealism and Painting.* New York, Harper & Row, 1972.
Translation by Simon W. Taylor of third edition of *Le Surréalisme et la Peinture* (no. 74).

27a. Breton, André. *What is Surrealism?* London, Faber and Faber, 1936. Criterion Miscellany, no. 43.
Translation: *Qu'est-ce que le surréalisme?* Brussels, Henriquez, 1934.

28. Calas, Nicolas, Muller, Herbert J., and Burke, Kenneth. *Surrealism: Pro and Con.* New York, Gotham Book Mart, 1973.
Partial reprint of no. 53.

29. Cardinal, Roger, and Short, Robert Stuart. *Surrealism: Permanent Revelation.* London, Studio Vista; New York, Dutton, 1970.
Pictureback edition; numerous illustrations; brief bibliography.

30. Caws, Mary Ann. *The Inner Theatre of Recent French Poetry: Cendrars, Tzara, Péret, Artaud, Bonnefoy.* Princeton, N.J., Princeton University Press, 1972.
Also *Surrealism and the Literary Imagination: a Study of Breton and Bachelard* (1966). – *The Poetry of Dada and Surrealism: Aragon, Breton, Tzara, Eluard, Desnos* (1970).

31. *Columbia Dictionary of Modern European Literature.* General editor: Horatio Smith. New York, Columbia University Press, 1947.
Significant individual and subject references passim include bibliography.

32. Cowley, Malcolm. *Exile's Return.* New York, Norton, 1934.
 Also Viking Press paperback, 1956.

33. Dunlop, Ian. *The Shock of the New: Seven Historic Exhibitions of Modern Art.* New York, American Heritage Press, 1972.
 Chap. 6: The International Surrealist Exhibition (1938).

34. Duplessis, Yves. *Surrealism.* New York, Walker, 1962.
 Translation: Paris, Presses Universitaires de France, 1950.

35. *The European Caravan. An Anthology of the New Spirit in European Literature.* Compiled by Samuel Putnam (and others). New York, Brewer, Warren & Putnam, 1931.
 The French section, pp. 45–291, with introduction by André Berge.

36. Evans, Myfanwy, ed. *The Painter's Object.* London, Howe, 1937.
 Essays by Chirico, Ernst, etc. Reprinted by Arno Press, New York.

37. Fowlie, Wallace. *Age of Surrealism.* New York, Swallow Press and William Morrow, 1950.
 Also Gloucester, Mass., Peter Smith, 1960; Bloomington, Indiana University Press paperback, 1960.

38. Gascoyne, David. *A Short Survey of Surrealism.* London, Cobden-Sanderson, 1935.
 Also Frank Cass Ltd., 1970; International School Book Service, 1971.

39. Gershman, Herbert S. *The Surrealist Revolution in France.* Ann Arbor, University of Michigan Press, 1969.
 On the literature, art, and politics of the movement. Selected chronology, 1916–68 (pp. 139–169). Extensive notes. Supplemented by no. 10.

40. Grossman, Manuel L. *Dada: Paradox, Mystification and Ambiguity in European Literature.* New York, Pegasus, 1971.

41. Guggenheim, Peggy, ed. *Art of This Century.* Objects, Drawings, Photographs, Paintings, Sculpture, Collages, 1910 to 1942. New York, Art of This Century, 1942.
 Published as a collection catalogue emphasizing surrealist artists. Breton preface: "Genesis and perspective of surrealism." Reprinted by Arno Press, New York.

42. Ilie, Paul. *The Surrealist Mode in Spanish Literature.* Ann Arbor, University of Michigan Press, 1968.

43. Janis, Sidney. *Abstract & Surrealist Art in America.* New York, Reynal & Hitchcock, 1944.
 Reprinted by Arno Press, New York.

Refers to surrealist elements, including Dali.

44. Jean, Marcel. *The History of Surrealist Painting.* London, Weidenfeld & Nicolson; New York, Grove, 1960.
 "With the collaboration of Arpád Mezei." Reprinted 1967. Translation: Paris, Editions du Seuil, 1959.

45. Josephson, Matthew. *Life Among the Surrealists; a Memoir.* New York, Holt, Rinehart and Winston, 1962.
 Also, Mexico City, Joaquín Mortiz, 1963.

46. Lake, Carlton, and Maillard, Robert, eds. *Dictionary of Modern Painting.* New York, Tudor and Paris Book Centre, 1955.
 Translation from the French: Paris, Hazan, 1954. Second revised edition: New York, Tudor (1964?).

47. Lemaître, Georges. *From Cubism to Surrealism in French Literature.* 2nd ed. Cambridge, Mass., Harvard University Press, 1947.
 Bibliography.

48. Levy, Julien. *Surrealism.* New York, Black Sun Press, 1936.
 Excerpts from texts; list of exhibitions in United States, 1930–36; bibliography. Facsimile reprint (colored papers) by Arno Press, New York.

49. Lippard, Lucy R., ed. *Surrealists on Art.* Englewood Cliffs, N.J., Prentice-Hall, 1970.
 An anthology valuable for its thoughtful choices and fresh translations. Essay and biographical comments on the leading poet-critics and major artists. Also definitions from "The Abridged Dictionary of Surrealism" and the "Editorial Statement" from *VVV.*

50. Matthews, J. H. *Theatre in Dada and Surrealism.* Syracuse, N.Y., Syracuse University Press, 1974.
 Other works include: *An Introduction to Surrealism* (1965).—*Péret's Score: Vingt Poèmes* (1965).— *An Anthology of French Surrealist Poetry* (1966).— *Surrealism and the Novel* (1966).—*André Breton* (1967).— *Surrealist Poetry in France* (1969).—*Surrealism and Film* (1971).

51. Motherwell, Robert, ed. *The Dada Painters*

and Poets: An Anthology. New York, Wittenborn, Schultz, 1951.

Documents of Modern Art, vol. 8. Second printing, 1967. Bibliography by Bernard Karpel includes the Paris personalities. Forthcoming: *The Dada Painters and Poets,* ed. by Robert Motherwell and Bernard Karpel (revised), New York, Viking Press.

52. Nadeau, Maurice. *The History of Surrealism.* With an Introduction by Roger Shattuck. New York, Macmillan, 1965; London, Cape, 1968. Translation of revised edition of *Histoire du Surréalisme,* 2 vol. (1945 – 48) published by Club des Editeurs (1958) in 1 vol. Bibliographies.

53. *New Directions in Prose and Poetry,* no. 2 [A Surrealist Anthology]. Norfolk, Conn., 1940.

Also see no. 28.

54. Paalen, Wolfgang. *Form and Sense.* New York, Wittenborn, Schultz, 1945. Problems of Contemporary Art.

55. Putnam, Samuel. *Paris was our mistress. Memoirs of a lost and found generation.* New York, Viking Press, 1947.

56. Ray, Man. *Self Portrait.* Boston, Little, Brown; London, André Deutsch, 1963.

Also: *Autoportrait.* Paris, Laffont, 1964.

57. Raymond, Marcel. *From Baudelaire to Surrealism.* New York, Wittenborn, Schultz, 1950.

Documents of Modern Art, vol. 10. Translation from the French (1933). Extensive bibliography by Bernard Karpel. Also modified paperback edition: London, Methuen, 1970, with bibliography by S. I. Lockerbie.

58. Raynal, Maurice [and others]. *History of Modern Painting* [vol. 3]: *From Picasso to Surrealism.* Geneva, Paris, Skira, 1950.

Also French and German editions. Part 5, "Surrealism," by Jacques Lassaigne. Also biographical and bibliographical notices by Hans Bolliger. For summary statement by Maurice Raynal note his "Surrealism" in *Dictionary of Modern Painting* (see no. 46).

59. Read, Herbert, ed. *Surrealism.* London, Faber & Faber; New York, Harcourt, Brace, 1936.

Texts by Read, André Breton, Hugh Sykes Davies, Paul Eluard, Georges Hugnet. Reprinted by Somerset Publishers. Praeger Publishers, New York, 1971.

60. Rubin, William S. *Dada, Surrealism, and Their Heritage.* New York, The Museum of Modern Art, 1968.

Published on the occasion of an exhibition held in New York, Los Angeles, and Chicago. In addition to a major text, includes catalogue of the show (331 exhibits), a chronology by Irene Gordon (pp. 197 – 216), and a selected bibliography (pp. 217 – 227), expanded in no. 61.

61. Rubin, William S. *Dada and Surrealist Art.* New York, Abrams; London, Thames and Hudson [1969].

A major history and evaluation: 525 pp., 851 illus. (60 col.). Chapters cover dada, surrealist painting, surrealism of the thirties, surrealism in exile. Chronology by Irene Gordon. Bibliography, pp. 492 – 512.

62. Sandrow, Nahma. *Surrealism: Theatre, Arts, Ideas.* New York, Harper & Row, 1972.

63. Shattuck, Roger. *The Banquet Years: The Arts in France, 1885 – 1918.* New York, Harcourt, Brace, 1955.

Reprinted: Anchor Books, 1961; revised edition, Vintage Books, 1968.

64. Soby, James Thrall. *Contemporary Painters.* New York, The Museum of Modern Art, 1948. Chap. 6: Matta Echaurren.

65. Tashjian, Dickran. *Skyscraper Primitives: Dada and the American Avant-garde, 1910 – 1925.* Middletown, Conn., Wesleyan University Press, 1975.

Comments on Picabia, Duchamp, and Man Ray. Bibliography.

65a. Thirion, André. *Revolutionaries Without Revolution.* New York, Macmillan, 1975.

Translation: *Révolutionnaires sans Révolution.* Paris, Laffont, 1972.

66. Waldberg, Patrick. *Surrealism.* London, Thames & Hudson; New York, McGraw-Hill, 1966.

Bibliography. Also note his text for Skira (no. 99).

III. GENERAL WORKS: EUROPEAN SOURCES

67. Alexandre, Maxime. *Mémoires d'un surréaliste.* Paris, La Jeune Parque, 1968.

By an active participant in the surrealist circle 1923 – 33.

67a. Alexandrian, Sarane. *Le Surréalisme et le rêve.* Paris, Gallimard, 1974.

67b. Alexandrian, Sarane. *Dictionnaire de la peinture*

surréaliste. Paris, Filipacchi, 1973. Collection Les Yeux fertiles.

68. *L'Arte moderna*. Vol. VII, ed. Franco Russoli. Milan, Fabbri, 1967.

 Series of paperback texts, documents, illustrations including dada and surrealism. No. 63: "Antologia critica, bibliografia ed indici del volume VII." Also issued in variant edition in boards: *L'Arte moderna 20, parte seconda . . . dada, surrealismo*. Milan, Fabbri, 1967, pp. 121–240 (numerous illustrations and colorplates).

69. Bancquart, Marie-Claire. *Paris des surréalistes*. Paris, Seghers, 1972.

 Chronology, 1884–1969. Bibliography.

70. Bédouin, Jean-Louis. *Vingt ans de Surréalisme (1939–1959)*. Paris, Denoël, 1961.

71. Benayoun, Robert. *Erotique du Surréalisme*. Paris, Pauvert, 1965.

 Numerous illustrations, bibliography.

72. Bosquet, Alain, ed. *Surrealismus, 1924–1949*. Berlin, Henssel, 1950.

 Anthology of surrealist texts in translation. With critiques, biographies, and bibliography.

73. Breton, André. *Les Manifestes du Surréalisme*. Paris, Sagittaire, 1955.

 Revised edition including original texts from 1924, 1929, 1930, 1942, 1946, 1953. Pauvert edition (Paris, 1962) translated 1969 (no. 26).

74. Breton, André. *Le Surréalisme et la Peinture*. Paris, Gallimard, 1923.

 Second edition: New York and Paris, Brentano's, 1945. Third edition: additional essays, revised and corrected, Paris, Gallimard, 1965. English translation 1972 (no. 27).

75. Breton, André, and Eluard, Paul. *Sculptures d'Afrique, d'Amérique, d'Océanie*. Paris, Hotel Drouot, 1931.

 Sales catalogue of over 300 works, held July 2–3, 1931. Reprinted by Hacker, New York.

76. Breton, André, and Eluard, Paul, eds. *Petite anthologie poétique du Surréalisme*. Introduction par Georges Hugnet. Paris, Jeanne Bucher, 1934.

77. Brunius, Jacques. *En marge du cinéma français*. Paris, Arcanes, 1954.

78. Carrouges, Michel. *André Breton et les données fondamentales du Surréalisme*. Paris, Gallimard, 1967. Collection Idées.

79. Charbonnier, Georges. *Le Monologue du peintre*. Paris, Julliard, 1952–60.

 Vol. 1: Ernst, Miró, Picabia, Giacometti. — Vol. 2: Dali, etc.

80. De Micheli, Mario. *Le avanguardie artistiche del Novecento*. Milan, Feltrinelli, 1959.

 Saggio 6: Sogno e realtà nel surrealismo (pp. 174–198).—Documenti: Surrealismo (pp. 317–358).

81. *Dictionnaire abrégé du surréalisme*. Eds. André Breton, Paul Eluard. Paris, Galerie Beaux-Arts, 1938.

 Issued on the occasion of the Exposition Internationale du Surréalisme at the gallery, January–February 1938. Reprinted by José Corti, Paris.

82. Giedion-Welcker, Carola. *Poètes à l'écart; Anthologie der Abseitigen*. Bern-Bümpliz, Benteli, 1946.

 Includes Arp, Picabia, Tzara and others. Introductions and bibliographies.

83. Henry, Maurice. *Antologia grafica del surrealismo*. Milan, Mazzotta, 1972.

 453 pp., 687 illus.; biographical notes on 90 artists.

84. Huyghe, René, ed. *Histoire de l'art contemporain: la peinture*. Avec le concours de Germain Bazin. Paris, Alcan, 1935.

 Historical anthology consisting of numbers from *L'Amour de l'Art* (Paris), including surrealist issue (March 1934). Texts by Jean Cassou and Germain Bazin; biographies and bibliographies (pp. 337–344). Reprinted by Arno Press, New York.

85. Jean, Marcel, and Mezei, Arpád. *Genèse de la pensée moderne*. Paris, Corrêa, 1950.

86. Kyrou, Ado. *Le Surréalisme au cinéma*. 2nd ed. Paris, Le Terrain Vague, 1963.

87. Mabille, Pierre. *Le Miroir du merveilleux*. Paris, Sagittaire, 1940.

88. Nadeau, Maurice. *Histoire du Surréalisme*. Paris, Editions du Seuil, 1945–48, 2 vol.

 Vol. 1: Histoire (1945). – Vol. 2: Documents surréalistes (1948). Bibliography. Revised, one-vol. edition; Club des Editeurs (1958). Translated 1965 (see no. 52).

89. Pierre, José. *Le Surréalisme*. Lausanne, Editions Rencontre, 1966.

 Histoire générale de la peinture, vol. 21. Documents, dictionary of artists and terms, bibliography.

90. Raymond, Marcel. *De Baudelaire au Sur-*

réalisme: essai sur le mouvement poétique contemporaine. Paris, Corrêa, 1933.

Reprinted 1947, 1969. Translated 1950 (no. 57). Also Spanish edition, Mexico City, Fondo de Cultura Económica (Lengua y Estudios Literarios), 1960.

91. Rodríguez Prampolini, Ida. *El Surrealismo y el arte fantástico de México.* Mexico City, Universidad Nacional Autónoma de México, Instituto de Investigaciones Estéticas, 1969. Bibliography.

92. Sanouillet, Michel, *Dada à Paris.* Paris, Pauvert, 1965.

Extensive documentation. Bibliography (ca. 350 citations).

93. Somville, Léon. *Devanciers du surréalisme: les groupes d'avant-garde et le mouvement poétique 1912 – 1925.* Geneva, Droz, 1971.

94. *Le Surréalisme en 1947.* Exposition Internationale du Surréalisme présentée par André Breton et Marcel Duchamp. Paris, Pierre a Feu, Maeght, 1947.

Ordinary edition. Also issued in boxed edition de luxe with original graphics.

95. Topass, Jan. *La Pensée en révolte: essai sur le surréalisme.* Brussels, Henriquez, 1935.

96. Torre, Guillermo de. *Historia de las literaturas de vanguardia.* Madrid, Ediciones Guadarrama, 1965.

Chap. 5: "Superrealismo." Bibliography.

97. Waldberg, Patrick, *Chemins du surréalisme.* Brussels, Editions de la Connaissance, 1965.

Includes extracts from *La Révolution surréaliste;* also Paul Eluard, Max Ernst, and André Breton; poems; biographical notes; bibliography.

98. Waldberg, Patrick. *Mains et merveilles.* Paris, Mercure de France, 1951.

Essays cover Duchamp, Picabia, Man Ray, Arp, Giacometti, Matta, Ernst, and others.

99. Waldberg, Patrick. *Le Surréalisme.* Lausanne, Skira, 1962.

English translation published by Skira, 1965. Bibliography.

100. Waldberg, Patrick, and Chénieux, J.-A. *La Documentation photographique: Le surréalisme.* Paris, La Documentation Française, 1970.

Small folio with loose texts and reproductions. Also 12 colorslides in separate plastic pocket with Waldberg commentary. On cover: "Nos. 5 – 306 et 5 – 307, juin – juillet 1970, mensual."

101. Wyss, Dieter. *Der Surrealismus: eine Einführung und Deutung surrealistischer Literatur und Malerei.* Heidelberg, L. Schneider, [1950]. Heidelberg dissertation, based on a psychoanalytic approach.

IV. SOME SURREALISTS

In his text Marcel Jean makes considerable mention of individual works. These citations are expanded in the classified bibliographies of Nadeau (nos. 16, 88) and others, e.g. nos. 8, 10, 57. In view of the substantial documentation in the general references, the following is a limited enumeration of selected titles *emphasizing bibliography.* Frequently, the range of these records goes beyond the immediate relevance of the subject per se, illuminating both his circle and his era.

APOLLINAIRE

102. Apollinaire, Guillaume. *Apollinaire on Art: Essays and Reviews 1902 – 1918.* New York, Viking Press; London, Thames and Hudson, 1972. The Documents of 20th-Century Art.

Revised version of *Chroniques d'art* (1960) with addenda, edited by LeRoy C. Breunig. Bibliography by Bernard Karpel, pp. 525 – 531.

103. Breunig, LeRoy C. *Guillaume Apollinaire.* New York and London, Columbia University Press, 1969.

Columbia Essays on Modern Writers, no. 46. Selected bibliography.

ARAGON

104. Gindine, Yvette. *Aragon, prosateur surréaliste.* Geneva, Droz, 1966.

Bibliography, pp. 103 – 117.

ARP

105. Dohl, Reinhard. *Das literarische Werk Hans Arps 1903 – 1930.* Stuttgart, J. B. Metzlersche, 1967.

Annotated bibliography, pp. 207 – 253.

106. Jean, Marcel, ed. *Arp on Arp: Poems, Essays, Memories.* New York, Viking Press, 1972. The Documents of 20th-Century Art.

Translation of revised version of *Jours*

effeuillés (1966). Bibliography by Bernard Karpel, pp. 548 – 560.

ARTAUD

107. Sellin, Eric. *The Dramatic Concepts of Antonin Artaud.* Chicago and London, University of Chicago Press, 1968. References.

BRETON

108. Alexandrian, Sarane. *André Breton par lui-même.* Paris, Editions du Seuil, 1971. Collection Ecrivains de toujours.

108a. Browder, Clifford. *André Breton: Arbiter of Surrealism.* Geneva, Droz, 1967. Bibliography, pp. 180 – 214. Originally Ph.D. dissertation, Columbia University, 1959.

109. Eigeldinger, Marc, ed. *André Breton: essais et témoignages recueillis. . . .* Neuchâtel, A la Baconnière, 1950. Ten contributions; annotated bibliography (pp. 229 – 247).

BUÑUEL

110. Kyrou, Ado. *Luis Buñuel.* Paris, Seghers, 1962. References.

CHIRICO

111. Soby, James Thrall. *Giorgio de Chirico.* New York, The Museum of Modern Art, 1955. Bibliography by Bernard Karpel. This monograph, as well as *The Early Chirico* (New York, 1941), reprinted by Arno Press, New York.

DALI

112. Soby, James Thrall. *Salvador Dali.* 2nd rev. ed. New York, The Museum of Modern Art, 1946. Bibliography by Bernard Karpel. Reprinted by Arno Press, New York.

DUCHAMP

113. Cabanne, Pierre. *Dialogues with Marcel Duchamp.* New York, Viking Press; London, Thames and Hudson, 1971. The Documents of 20th-Century Art. Translation from the French (1967). Selected bibliography by Bernard Karpel, pp. 121 – 132.

114. d'Harnoncourt, Anne, and McShine, Kynaston, eds., *Marcel Duchamp.* New York, The Museum of Modern Art, and Philadelphia, Philadelphia Museum of Art; London, Thames and Hudson, 1973. Published on the occasion of a joint exhibition with the Philadelphia Museum of Art. An anthology of a dozen contributions, including "The Works of Marcel Duchamp: A Catalog" by the editors. Bibliography by Bernard Karpel, pp. 327 – 335.

115. Schwarz, Arturo. *The Complete Works of Marcel Duchamp.* New York, Abrams; London, Thames and Hudson, 1969. Chap. 19: Elements of a descriptive bibliography of Duchamp's writings, lectures, translations and interviews (pp. 583 – 605). – Chap. 20: Bibliography of works quoted (pp. 607 – 617). Revised edition, 1972. Condensed edition, 1975.

ERNST

116. Hugues, Jean. *Max Ernst: Écrits & oeuvre gravé.* Tours-Paris, Le Point Cardinal, 1963. Supplemented in John Russell. *Max Ernst.* New York, Abrams; London, Thames and Hudson, 1967. (pp. 143 – 147); similarly Werner Spies. *The Return of La Belle Jardiniere: Max Ernst, 1950 – 1970.* New York, Abrams, 1972.

117. Motherwell, Robert, ed. *Max Ernst: Beyond Painting, and Other Writings by the Artist and His Friends.* New York, Wittenborn, Schultz, 1948. Documents of Modern Art, vol. 7. Bibliography by Bernard Karpel; supplemented in William S. Lieberman, editor, *Max Ernst.* New York, The Museum of Modern Art, 1961. Reprinted by Arno Press, New York.

GIACOMETTI

117a. Dupin, Jacques. *Alberto Giacometti.* Paris, Maeght, 1962. Bibliography.

118. Selz, Peter. *Alberto Giacometti.* New York, The Museum of Modern Art, 1965. Bibliography by Inga Forslund.

MAGRITTE

119. Hanover. Kestner-Gesellschaft. *René Magritte.* May 8 – June 8, 1969. Major catalogue with documentation.

120. Waldberg, Patrick. *René Magritte.* Brussels, André De Rache, 1965. Extensive bibliography by André Blavier.

PAALEN

121. Morales García, Leonor. *Wolfgang Paale introductor del surrealismo en México.* (Tesis inédita). México, Universidad Iberoamericana, Escuela del Arte, 1965.

 Bibliography.

PICABIA

122. Camfield, William A. *Francis Picabia.* New York, Solomon R. Guggenheim Museum, 1970.

 Published on the occasion of major exhibition. Bibliography, pp. 149 – 161.

123. Paris. Galeries Nationales du Grand Palais. *Francis Picabia.* Catalogue edited by Jean-Hubert Martin and Hélène Seckel. January 23 – March 29, 1976.

 Extensive documentation.

RAY

124. Schwarz, Arturo, ed. *Man Ray: 60 Years of Liberties.* Paris, Losfeld [1971].

 An anthology of texts (in Italian, French, English). Bibliographical notes; bibliography.

124a. Schwarz, Arturo. *Man Ray: The Rigour of Imagination.* London, Thames and Hudson; New York, Rizzoli, 1978.

 Appendix by Henry Miller: "Recollections of Man Ray in Hollywood."

TANGUY

125. Lippard, Lucy, ed. *Yves Tanguy: un receuil de ses oeuvres – a Summary of His Works.* New York, Pierre Matisse, 1963.

 Bibliography by Yves Poupard-Lieussou and Bernard Karpel.

126. Soby, James Thrall. *Yves Tanguy.* New York, The Museum of Modern Art, 1955.

 Includes index to the exhibition. Bibliography by Bernard Karpel. Reprinted by Arno Press, New York.

TZARA

127. Caws, Mary Ann, ed. *Tristan Tzara: Approximate Man and Other Writings.* Detroit, Wayne State University Press, 1973.

 "Translated and with an introduction and notes."

127a. Peterson, Elmer. *Tristan Tzara.* New Brunswick, N.J., Rutgers University Press, 1970.

 Bibliography.

V. PERIODICALS: A SELECTION (1919-1974)

For bibliography, in addition to nos. 1, 2, 10, see Nadeau (no. 16) for "Surrealist periodicals" (pp. 325 – 330), "special numbers" (p. 330), "other periodicals . . . foreign, cubist, dadaist, and parasurrealist" (pp. 330 – 332).

128. *Littérature.* Nos. 1 – 20. Paris, March 1919 – August 1921.

 Editors: Louis Aragon, André Breton, Philippe Soupault. Dada and surrealist material.

129. *La Révolution surréaliste.* Nos. 1 – 12. Paris, December 1, 1924 – December 15, 1929.

 Editors: Pierre Naville, Benjamin Péret, André Breton. Note André Breton in no. 4, pp. 1 – 3, July 1925: "Pourquoi je prends la direction de *La Révolution surréaliste.*" Reprinted by Arno Press, New York. Reprinted in facsimile by Editions Jean-Michel Place, Paris, 1975.

130. *Le Surréalisme au Service de la Révolution.* Nos. 1 – 6. Paris, July 1930 – May 1933.

 Editor: André Breton. Reprinted by Arno Press, New York. Reprinted in facsimile by Editions Jean-Michel Place, Paris, 1976.

131. *Minotaure.* Nos. 1 – 12/13. Paris, June 1, 1933 – May 1939.

 Editor: E. Tériade; later an editorial committee (Breton, Duchamp, Eluard, Heine, Mabille). Reprinted by Arno Press, New York.

132. *Bulletin International du Surréalisme.* Nos. 1 – 4. Prague, Santa Cruz de Tenerife, Brussels, London. October 1935 – September 1936.

 No. 4 issued by the Surrealist Group in England.

133. *London Bulletin.* Nos. 1 – 20. April 1938 – June 1940.

 Editor: E. L. T. Mesens. Issued by the London Gallery. Last number (18 – 20) "published by the Surrealist Group in England." Index nos. 1 – 9 in no. 10. Considerable data on surrealists and the avant-garde, biographical notes, special numbers on Magritte, Chirico, Tanguy, Ernst, etc. Reprinted by Arno Press, New York (1969) with new cumulative index.

134. *View.* Series 1 – 7. New York, 1940 – 47.

 Editor: Charles Henri Ford. "Concerned almost entirely with surrealist manifestations" (Hugh Edwards). Reprinted by Kraus Reprints, Liechtenstein.

135. *VVV.* Nos. 1 – 4. New York, October 1942 – February 1944.
 Editor: David Hare; editorial advisers: Breton, Duchamp, Ernst. Double no. 2 – 3.

136. *Le Surréalisme, même.* Nos. 1 – 5. Paris, 1956 – 59.
 Editor: André Breton.

137. *Cahiers Dada Surréalisme.* Nos. 1 – 4. Paris, 1966 – 70.
 Published by L'Association Internationale pour l'Étude de Dada et du Surréalisme. President: Michel Sanouillet. – Vice-President: Yves Poupard-Lieussou. Includes detailed bibliographic reports as well as articles, e.g. "Points of departure towards a history of Latin-American Surrealism," by Stefan Baciu (no. 2, pp. 133 – 153, 1968). Changed title, 1971, to *Le Siècle éclaté.*

ARTICLES

138. Amberg, George. The rationale of the irrational. *Minnesota Review* (Minneapolis). Spring 1963.
 Vol. 3, no. 3, pp. 323 – 347. On the "Dada-surrealist cinema" with reference to Hans Richter, Man Ray, Marcel Duchamp, Fernand Léger, René Clair, Antonin Artaud, Luis Buñuel and Salvador Dali, Jean Cocteau.

139. Calas, Nicolas. Surrealist intentions. *Trans/formation* (New York). Vol. 1, no. 1, 1950.

140. Connolly, Cyril. Surrealism. *Art News* (New York). November 1951.
 Art News "Annual 1952" (vol. 50, no. 7, part 2, pp. 131 – 62, 164, 166, 168, 170).

141. Gauss, Charles. Theoretical backgrounds of Surrealism. *Journal of Aesthetics and Art Criticism* (New York) Fall, 1943. Vol. 2, no. 8, pp. 37 – 44.

142. Hardré, Jacques. Present state of studies on literary surrealism. *Yearbook of Comparative and General Literature* (Chapel Hill, N.C.). No. 9, 1960.
 Reviews 1924 – 60; includes short extracts (p. 43 – 66).

143. Hoog, Armand. The Surrealist novel. *Yale French Studies* (New Haven). No. 8, Fall – Winter 1951.

144. Hugnet, Georges. Dada and Surrealism. *The Museum of Modern Art Bulletin* (New York). November – December 1936.

Vol. 4, nos. 2 – 3. Reprinted in Barr, 1937 (no. 24).

144a. Larrea, Juan. El surrealismo entre viejo y nuevo mundo. *Cuadernos Americanos* (Mexico City). Nos. 3 – 5, 1944.

145. Peyre, Henri. The significance of Surrealism. *Yale French Studies* (New Haven). No. 2, Fall – Winter 1948.

146. Sandler, Irving. The surrealist émigrés in New York. *Artforum* (New York). May 1968.

147. Sweeney, James Johnson. Eleven Europeans in America. *The Museum of Modern Art Bulletin* (New York). September 1946.
 Vol. 13, nos. 4 – 5, pp. 1 – 39; interviews with and bibliography on Duchamp, Ernst, Masson, Seligmann, Tanguy, etc.

SPECIAL NUMBERS

148. *L'Amour de l'Art* (Paris), July 1945.
 Special number: "L'École de Paris à New-York." Text by Germain Bazin on André Breton, Marcel Duchamp, Salvador Dali, Yves Tanguy, etc.

149. *Artforum* (Los Angeles). September 1966.
 Special number: "Surrealism," vol. 5, no. 1, pp. 5 – 87.

150. *Documents 34* (Brussels). 1934.
 Special number: "Intervention surréaliste." Edited by J. Stephan and E. L. T. Mesens. Reprinted in facsimile by review *L'Arc Brussels,* 1969.

151. *L'Esprit Créateur* (Minneapolis). Winter 1970.
 Apollinaire number: vol. 10, no. 4, pp. 265 – 351. Includes five essays in English by Octavio Paz, L. M. Porter, A. G. Greet, D. S. Rieder, R. L. Admussen. Partly supported by the University of Kansas (Lawrence, Kansas); also Spanish edition (Valencia).

152. *La Nef* (Paris). March – April 1950.
 Special number: "Almanach surréaliste du demi-siècle," no. 63 – 64. Texts by Breton, Péret, etc. Chart of "1900 – 1950" dates from surrealist viewpoint, pp. 208 – 224.

153. *Opus International* (Paris). October 1970.
 Special number: "Surréalisme international," no. 19 – 20, edited by Alain Jouffroy. Also no. 49, March 1974: "Duchamp et après."

154. *This Quarter* (Paris), September 1932.
 Special surrealist number: vol. 5, no. 1;

guest editor, André Breton. Reprinted by Arno Press, New York.

155. *View* (New York), March 1945.
Special number: ser. 5, no. 1, on Marcel Duchamp. Also issued in edition de luxe.

155a. *XXe Siècle* (Paris). No. 42, June 1974.
Includes "Le surrealisme I," pp. 75 – 160, containing 14 illustrated articles.

156. *Yale French Studies* (New Haven). No. 31, 1964.
Surrealist number; bibliography. Also note Hoog and Peyre above (nos. 143, 145).

VI. EXHIBITION CATALOGUES: CROSS SECTION (1925-1975)

Convenient recent lists will be found in no. 60 (Rubin, 1968) and no. 9 (Ex Libris, 1975). Reports of events, i.e. chronology, should be distinguished from publication of catalogues, i.e. bibliography.

157. *Paris, 1925* Galerie Pierre. *Exposition: La peinture surréaliste.* November 14 – 25.
The first exhibition of surrealist painting.

158. *Paris, 1927* Galerie Surrealiste. *Yves Tanguy et objets d'Amérique.* May 27 – June 15.
Preface by André Breton.

159. *Paris, 1930* Galerie Goemans. *Exposition de collages.*
Preface by Louis Aragon: "La peinture au défi."

160. *New York, 1932* Julien Levy Gallery, *Surrealism.* January 9 - 29.
First United States show, 9 exhibitors, cover by Joseph Cornell, extract from Breton.

161. *Paris, 1933* Galerie Pierre Colle. *Exposition surréaliste: sculptures, objets, peintures, dessins.* June 7 – 18.

162. *La Louvière, Belgium, 1935. Exposition surréaliste.* October 13 – 27.

163. *Paris, 1936* Galerie Charles Ratton. *Exposition surréaliste d'objets.* May 22 – 29.

164. *London, 1936* New Burlington Galleries. *The International Surrealist Exhibition.* June 11 – July 4.

165. *New York, 1936* The Museum of Modern Art. *Fantastic Art, Dada, Surrealism.* December 9, 1936 – January 17, 1937.

166. *Brussels, 1937* Palais des Beaux-Arts. *E. L. T. Mesens présente trois peintres surréalistes: René Magritte, Man Ray, Yves Tanguy.* December 11 – 22.
Poem by Paul Eluard; preface by Jean Scutenaire.

167. *Paris, 1938* Galerie Beaux-Arts. *Exposition internationale du surréalisme.* January – February.
Organized by André Breton, Marcel Duchamp, and Paul Eluard.

168. *Mexico, 1940* Galería de Arte Mexicano. *Exposición internacional del surrealismo.* January – February.
Catalogue and exhibition by Wolfgang Paalen and César Moro.

169. *New York, 1942* Coordinating Council of French Relief Societies. *First Papers of Surrealism.* October 14 – November 7.
Foreword by Sidney Janis. "Hanging by André Breton, his twine Marcel Duchamp."

170. *San Francisco, 1944* Museum of Art. *Abstract and Surrealist Art in the United States.* July.
Works selected by Sidney Janis. Circulated February – July: Denver, Seattle, Santa Barbara, San Francisco.

171. *Paris, 1947* René Drouin Gallery. *Matta.* July.
With essay by André Breton: "Préliminaires sur Matta," reprinted in no. 74.

172. *Paris, 1947* Galerie Maeght. *Exposition internationale du surréalisme.* July – August.
Organized by André Breton and Marcel Duchamp; "catalogue" published as boxed edition de luxe with original graphics and as ordinary paper text (142 pp.).

173. *Paris, 1948* Galerie Nina Dausset. *Le Cadavre exquis, son exaltation.* October 7 – 30.
With essay by André Breton.

174. *New York, 1957* The Museum of Modern Art. *Matta.* September 10 – October 20.
Text by William S. Rubin, also published as *Bulletin* (vol. 25, no. 1); bibliography by Bernard Karpel.

175. *Paris, 1959* Galerie Daniel Cordier. *Exposition internationale du surréalisme, 1959 – 1960.* December.
Directed by Breton, Duchamp; assistant: José Pierre. Title emphasizes E R O S. Catalogue includes "lexique succinct de l'érotisme." On cover: "Boîte alerte—Missives lascives." Also edition de luxe.

176. *New York, 1960* D'Arcy Galleries. *Surrealist Intrusion in the Enchanter's Domain.* November 28, 1960 – January 14, 1961.

Directed by André Breton and Marcel Duchamp. Text (124 pp.) with catalogue insert (150 exhibits).

177. *Milan, 1961* Galleria Schwarz. *Mostra internazionale del surrealismo.* May.
Italian, English and French text by José Pierre on surrealism and painting since 1950.

178. *Tours, 1963* Bibliothèque Municipale. *Max Ernst: Ecrits et oeuvre gravé.* November 30 – December 31.
Preface by Jean Cassou; introduction by Ernst; catalogue-bibliography: Jean Hugues, Yves Poupard-Lieussou. Also Le Point Cardinal, Paris, January 22 – February 29, 1964.

179. *Paris, 1964* Galerie Charpentier. *Le surréalisme: sources, histoire, affinités.* April 15 – September 30.
Preface by Patrick Waldberg. Books, journals, documents lent by Maurice Henry (nos. 371 – 474).

180. *Paris, 1965* Galerie de l'Oeil. *L'écart absolu.* December.
"La XIe exposition internationale du surréalisme." Preface by André Breton.

181. *Santa Barbara, 1966* University of California. *Surrealism: a state of mind, 1924 – 25.* February 26 – March 27.
Introduction by Julien Levy. Reprinted by Arno Press, New York.

182. *Berne, 1966* Kunsthalle. *Phantastische Kunst, Surrealismus.* October 21 – December 4.
Catalogue in newspaper format; 145 exhibits; biography and bibliography.

183. *Los Angeles, 1966* County Museum of Art. *Man Ray.* October 27 – December 25.
Introduction by Jules Langsner; text by the artist and friends; bibliography by Man Ray (pp. 144 – 48).

184. *Milan, 1967* Centro Francese di Studi. *Omaggio a André Breton.* January 17 – February 4.
Also Galleria Schwarz; later Centro Culturale Francese, Rome (February). Bibliography by Arturo Schwarz.

185. *Turin, 1967* Galleria Civica d'Arte Moderna. *Le muse inquietante: maestri del surrealismo.* November 1967 – January 1968.
Illustrates 272 works from Füssli to Bacon.

186. *New York, 1968* The Museum of Modern Art. *Dada, Surrealism, and Their Heritage.* March 27 – June 9.
Published as no. 60. Shown Los Angeles County Museum July 16 – September 8,

Chicago Art Institute October 19 - December 8.

187. *London, 1969* Tate Gallery. *Magritte.* February 14 – April 2.
Text by David Sylvester for the Arts Council; 3rd corrected edition, March 1969.

188. *Cologne, 1969* Baukunst Galerie. *Surrealismus in Europa: phantastische und visionäre Bereiche.* October 11 – November 29.
Emphasizes recent works from 10 countries.

189. *Venezuela, 1970* International Council of the Museum of Modern Art, New York. *El arte del surrealismo.* 1970.
"Ensayo de Bernice Rose." Printed by Editorial Arte, Venezuela, for circulation in Latin America.

190. *Berlin, 1970* Nationalgalerie. *Matta.* May – August.
Trilingual quotations; bibliography (3 pp.).

191. *Rotterdam, 1971* Museum Boymans van Beuningen. *Man Ray.* September 24 – November 7.
Also Musée National d'Art Moderne, Paris (January – February); Louisiana Museum, Humblebaek, Denmark (March - April 1972). Bibliography by Arturo Schwarz (pp. 171 – 181).

192. *Paris, 1972* Galeries Nationales du Grand Palais. *Peintres de l'imaginaire: symbolistes et surréalistes belges.* February 4 – April 8.
Major catalogue (235 pp.), many illustrations, emphasis on Magritte (pp. 116 – 186).

193. *Munich, 1972* Haus der Kunst. *Der Surrealismus.* March 11 – May 9.
Also Musée des Arts Décoratifs, Paris, June 9 – August 6, 1972. Organized by Patrick Waldberg. Chronology, biographical notes, many illustrations, 473 exhibits.

194. *Philadelphia, 1973* Museum of Art. *Marcel Duchamp.* September 22 – November 11.
Also The Museum of Modern Art, New York, December 3, 1973 – February 10, 1974; Art Institute of Chicago March 9 – April 21, 1974. Exhibition and text by Anne d'Harnoncourt and Kynaston McShine (see no. 114).

195. *Milan, 1975* Galleria Schwarz. *Le cadavre exquis, son exaltation.* February 3 – 28.
Essay by Breton, comments by Masson, Tzara, and others, 40 exhibits (plates), parallel texts (Italian, French, English).

196. *New York, 1975* M. Knoedler & Co. *Surrealism in art.* February 5 – March 6.
130 exhibits.

A la niche, les glapisseurs de Dieu, 438
"A l'Heure où l'écriture se dénoue," 215
Abel, Lionel, 399
"Absent consciousness," 103
Absentmindedness: Breton on, 125 and *n*
Abstract art, 11, 83, 412
Academic speeches: of Hare, 398–99; Lautréamont on, 47–48
"Address to the Pope," 139
Adolphe, 113, 123
"After the Deluge," 15–16, 141*n*
"Age of Light, The," 333–34
"Air Is a Root, The," 295–96
Air of Water, The, 350
Alain, 371
Alcools, 215
Alexandre, Maxime, 128, 241
"All Right, I'll Go," 173–74
Almanach surréaliste du Demi-Siècle, 429–37
American surrealist movement, 370–371
Amour la poésie, L', 172
Anarchists, 156
"Ancestors" of surrealism, 108, 123–124, 128, 425–27
Angling for Thrown-Away Sleep, 355–356
Annales Médico-Psychologiques, 315–316
Annals, 12*n*
"Annunciation," 390

Antiart: forerunners of, 11
Antipatriotism, 265–67
Antireligious writings: of Buñuel, 257; of Crevel, 314; of Ernst, 263, 264–65
Antitradition Futuriste, L', 11
Aphorisms, 66–67
Aphrodisiac Vest, 304
Apocalypse of St. Sever, 235
Apollinaire, Guillaume, 18–24, 33, 35, 58, 87, 106, 111, 117, 318, 413; Chirico and, 3–4; *The Cubist Painters*, 23–24; contribution of, 18; death of, 24; *Futurist Antitradition*, 11; imitators of, 215; influence on Breton, 58, 59; *Les Mamelles de Tirésias*, 62–63, 95; *The Musician of Saint Merry's*, 18, 19–22; Picabia and, 66; and *Les Soirées de Paris*, 55; Vaché on, 37–38
"Apparition aérodynamique des Etres-Objets," 343
Appel à la Lutte, 371
Approximate Man, The, 237, 238
Aquinas, St. Thomas, 119
Aragon, Louis, 24, 39, 55, 58, 66, 92, 108, 111, 122, 123, 129, 164, 181, 233; "A Suivre," 229–31; on anarchists, 156; "The Brothers the Coast," 175–76; *A Challenge to Painting*, 208–10; and Communist party, 314; on Dada, 239–41; "Demigod," 286–87; on Desnos during psychic experiments, 105–106; "Ex-Serviceman," 214; "Freez-

ing Hard," 55; "Her Ladyship Goes Up into Her Tower," 109–11; "Introduction à 1930," 239–41; *Littérature* and, 43; "Modern," 214; "98–28," 215; *The Peasant of Paris*, 72–76; published works in 1920s, 108–109; on Russian Revolution, 157, 158, 159; in surrealist games, 219–20; "Tant pis pour moi," 286; *The Treasure of the Jesuits*, 224–29; wartime poetry of, 418; *A Wave of Dreams*, 126, 127–28
Arcane 17, 206–10, 440, 443, 447–48
Archipenko, 360
Architecture, 6–8, 337, 338
Arensberg, W. C., 66
Arland, Marcel, 147
Arnauld, Céline, 66
Arp, Hans (Jean), 24, 63, 66, 79, 86, 207, 256*n*, 257, 351*n*, 354*n*; "The Air Is a Root," 295–96; "Great Unrestrained Sadist," 419; poetry in French by, 354–55; "Splotches in Space," 354–55
Art: Dali on, 338, 339–40; developments between 1910 and 1914 in, 11; Magritte on, 360–63; and *Minotaure*, 331–59; in New York, 410–11; in United States, Duchamp on, 412–14; Vaché on, 34. *See also* Surrealist art
Art nouveau, 336, 337, 338
"Art of Dancing, The," 70
Art of Poetry, 347*n*

"Art of Reaction: The Late Chirico, The," 392–94

"Art Poétique," 43

Artaud, Antonin, 122, 128, 139, 224, 234, 429; *The Nerve Scale*, 176–78

Association des Ecrivains et Artistes Révolutionnaires (AEAR), 314

Au Grand Jour, 164

Auric, Georges, 55, 122

"Automatic Message, The," 331, 347–348

Automatic painting, cubism and, 195

Automatism, 76, 346; in architecture, 337; Artaud on, 176–78; Breton on, 331, 347–48; and decalcomanias, 340–41; discovery of, 123; in "Manifeste," 126; and Picasso, 352, 353–354; psychic experiment in, 100–106

Ball, Hugo, 63

Balzac, 50

Bank Clerk, The (film), 153

Banting, John, 429

Banville, Théodore de, 15

"Barbaric," 16

Barbusse, Henri, 162

Baron, Jacques, 122, 123, 234; "Love," 94–95

Barr, Alfred H., Jr., 370

Barrès, Maurice, 79, 112

Barthou, Louis, 142 and *n*

Bataille, Georges, 267*n*, 404; Breton on, 235, 371–72

Bataille, Henri, 69

Baudelaire, 68, 123*n*, 124, 235; Lautréamont on, 50; on women, 156

Baur, John I. H., 395

Baxter, Robert, 429

"Beauté sera convulsive, La," 191*n*, 331

Beckett, Samuel, 277*n*, 313*n*, 417

Belgian surrealism: birth of, 214; and *Documents 34*, 363; Magritte and, 360–63

Belle de Jour, 258

Bellmer, Hans, 352; *Doll*, 304–305, 343

Belmontet, Louis, 14 and *n*

Berkeley, Bishop, 134*n*

Berrichon, P., 145

Bertrand, Aloysius, 123*n*, 124

Bird, 304

"Black Forest," 59

Black humor: "When the Spirit....," 217–19

Blackwood, Algernon, 397, 398

Blake, William, 365

Boccioni, 11

Boiffard, J. A., 122, 123, 133

Boileau, 347*n*

Book of a Thousand Nights and a Night, 398

Botticelli, 339

"Bouquet without Flowers, The," 157

Bourgeois, Louise, 4*n*

Braque, Georges, 11, 200

Brassaï, 332

Brauner, Victor, 341–43, 351*n*, 399

Breton, André, 24, 39, 55, 66, 69, 72, 87, 91, 92, 108, 111, 123, 139, 146, 223–24, 304, 313, 351*n*, 357, 368, 415; "A Suivre," 229–31; account of Mexican visit, 375; *Arcane 17*, 406–10, 440, 447–48; attacks on, 236; "The Automatic Message," 347–48; on automatic writing, 123; Baron and, 94; on Bataille, 235, 371–72; "Black Forest," 59; "The Bouquet without Flowers," 157; "Burial Not Allowed," 120; on castle for surrealists, 122; on Chirico, 58, 59, 201; *The Communicating Vessels*, 306–12; on conflict betwen love and revolutionary duty, 254; and Congrès de Paris, 79; "Le Corset Mystère," 57; "Crise de l'Objet," 301; dada and, 65, 87; Delteil and, 148–49; "The Disdainful Confession," 111–15; in *Documents 34*, 363; on dreams, 356; on Duchamp, 84–86; "Entrance of the Mediums," 100–106; *Entretiens*, 438–39; exhibition of Mexican objects and pictures, 375; "The Exquisite Corpse: Its Exaltation," 221–22; on Anatole France, 129; "Free Union," 187–89; "Freud in Vienna," 374; "G Clef," 56; "The Great Invisibles," 382–83; on *L'Humanité*, 160–61, 162; *The Immaculate Conception*, 275–81; interest in objects, 291; International Bureau of Revolutionary Literature, correspondence with, 253; *Introduction to a Speech on the Lack of Reality*, 291–92; joins Communist party, 164; *La Lampe dans l'Horloge*, 440; "Legitimate Defense," 314; on life in Marseilles after Nazi occupation, 383–85; list of surrealists, 123–24; and *Littérature*, founding of, 43; on love, 244; *The Magnetic Fields*, 59, 60–62; "The Marvelous against the Mystery," 348; "Max Ernst," 76–77; and May 1968, 443; and *Minotaure*, 331, 347; and mock "trial" of Mau-

rice Barrès, 79; on Moscow trials, 373–74; Muzard on, 190–92; *Nadja*, 181–87; *Ode to Charles Fourier*, 404–406; "On a Decalcomania without Preconceived Subject (Decalcomania of Desire)," 340–41; *Petite Anthologie poétique du surréalisme*, 350; Phare de la Mariée," 343; on Picabia, 83–84; Picabia and, 118; plays by, 95; political declarations by, 372; in post–World War II period, 438–39; preface to *La Femme 100 têtes*, 208; on reasons for writing, 66; returns to Paris, 420; on revolution, 410*n*; *Self-Defense*, 160–64; "Soluble Fish," 126; on surrealism, 123; "Surrealism and Painting," 196–200, 202, 207; "Surrealism and Psychiatry," 316–17; in surrealist games, 219–20, 298, 301; "Testimony," 403; on time, 114*n*; "Towards an Independent Revolutionary Art," 376–77; "trap-inquest," 66; travels of, 368; *The Treasure of the Jesuits*, 224–29; Trotsky and, 375, 376–77; on Trotsky and Lenin, 157–59; on Tzara, 66; in United States during World War II, 381; Vaché and, 24, 32–38; visit to Mexico, 374–75; and *VVV*, 381–82; *What Is Surrealism?*, 350, 365; "Writings Are Leaving," 281–84; writings in *Minotaure*, 331. *See also* "Manifeste du Surréalisme"; "Second Manifeste du Surréalisme"

Breton, Elisa, 192

Breton, Germaine, 156

Breton, Jacqueline, 304, 331, 341, 350

Breton, Simone, 92–93, 187

Bretoone, Rétif de la, 343

Bride Stripped Bare by Her Bachelors, Even, The, 288, 289–91, 383*n*, 403

Bridgewater, Emmy, 429

Brisset, Jean-Pierre, 413 and *n*, 414

"Bronze Piano, The," 284–85

"Brothers the Coast, The," 175–76

Brown, F. J., 429

Brunius, J. B., 399, 417, 429

Buddhists, 139

Buffet, Gabrielle, 301, 302

Bulletin International du Surréalisme, 368–70

Buñuel, Luis, 236; career of, 257–58; *Un Chien Andalou*, 236; "A Giraffe," 258–61; *The Golden Age*, 254–57; on love, 243

"Burial Not Allowed," 129

Butler, Samuel, 398

Byron, Lord, 48, 50, 68

Cabanne, Pierre, 288*n*

Cabaret Voltaire (publication), 63

Cadavre, Un, 128–29, 236, 244

Cahier GLM (publication), 356, 374

Cahiers d'Art (publication), 301–302, 303, 304–305, 352, 353–54

Cahiers de Contre-Attaque, 404

Calas, Nicolas, 399; "Alone," 400–401

"Calendar of Tolerable Inventions," 429

Calligrammes, 18

Capitale de la douleur, 210–11

Carrington, Leonora, 385, 386*n*; "The Seventh Horse," 386–89

Carrive, Jean, 122, 123

Carroll, Lewis, 365, 415, 428

Cassou, Jean, 147

Catalonia: Dali on, 266–67

Cendrars, Blaise, 55, 63

Central Office for Surrealist Research, 133

Certâ (Paris café), 72, 181, 191; Aragon's description of, 72–76

Césaire, Aimé, 389, 390

Cézanne, 200, 331, 413; surrealists on, 338, 339–40

Chagall, 200

Challenge to Painting, A, 208–10

"Chanson du Dékiouskoutage, La," 108

Chansons des rues et des bois, Les, 70

Chaplin, Charlie, 149–55

Char, René, 236, 351*n*; in games, 298–300; on love, 242

Charleville, France: re-erection of Rimbaud's statue in, 142–46

Chateaubriand, 50, 124

Chazal, Malcolm de, 434–37

Chenal, Marthe, 68 and *n*

Chess: Duchamp on, 288 and *n*; Roussel and, 328 and *n*

Chiappe, Jean, 230

Chien Andalou, Un (film), 236

Children's book for adults, 207–208. *See also* Fairy tales for adults

Child's Brain, The, 392 and *n*, 393*n*

"Chimney, The," 201

"Chiquenaude," 324*n*

Chirico, Giorgio de, 11, 76, 128, 137, 184, 360, 385*n*, 401; Apollinaire and, 3–4; arrival in Paris, 3; on artistic creation, 4–5; Breton on, 58, 202; and Breton, 87; on castle of Versailles, 8–9; changes painting style, 201–202; dream account of, 165–66; Eluard's poem to, 210–11; *The Enigma of a Day*, 298–300; *Hebdomeros*, 203–207; "A Holiday," 10;

"Hopes," 201; Morise on, 202; Motherwell on, 392–94; on music, 5; on revelation of *The Enigma of an Autumn Afternoon*, 9; on Roman and Renaissance architecture, 6–8; on world as enigma, 5–6

Chiromancy, 343

Chocolate Grinder, 85

Chroniques du règne de Charles IX, 18

Citizens of the World (movement), 438

Clair, Jean, 383*n*

Claro, Elisa, 406, 407, 408

Clarté (publication), 157, 159

Claude, Professor, 316 and *n*

Claudel, Paul, 141–42, 162

Clave (publication), 377

Clérambault, Dr., 315

Cocteau, Jean, 69, 147, 149, 162

Coeur sous une Soutane, Un, 87, 111

Cohn-Bendit, Daniel, 440 and *n*

Cohn-Bendit, Jean-Gabriel, 440*n*

Collages, 207–10, 414

Combat (publication), 443–47

"Coming of Beautiful Days, The," 303–304

Comme il fait beau, 95

Communicating Vessels, The, 277, 306–312, 407–408, 411*n*

Communism: Breton and, 410. *See also* Communist party; Lenin; Russian Revolution; Trotsky, Leon

Communist party (France): Breton on, 160–64; on May 1968 rebellion, 440; surrealists and, 160, 164, 234, 253, 314, 438

Congrès de Paris (1922), 79

Congress for the Defense of Culture, 314

Constant, Benjamin, 111, 113, 123*n*, 124

Contemporary Poetry and Prose (publication), 284–85, 365–67

Contre-Attaque, 372, 404

Cooper, James Fenimore, 47, 50

Copley, Bill, 414

Cornell, Joseph, 400, 414

Corps trop grand pour un cercueil, Le, 357

"Correspondance avec les Abonnées," 345–46

"Corset Mystère, Le," 57

"Country of My Dreams, The," 168–169

Courthion, Pierre, 343

"Cow," 56–57

Cowley, Malcolm, 175

Craven, Arthur, 108, 399, 427

Cresté, René, 224

Crevel, René, 101, 102, 117*n*, 123, 146, 215; *Diderot's Harpsichord*, 312–14; in psychic experiments, 102–103; *Spirit against Reason*, 178, 179–80; suicide of, 314

Crime and Punishment, 120 and *n*

"Crise de l'Objet," 301

"Critique of Poetry," 286

Cros, Charles, 58, 129

Cruikshank, George, 395

Cry of the Medusa, 357–58

Cubism, 118, 271; Breton on, 199; development of, 11; and Duchamp, 85; Morise on, 195

Cubist Painters, The, 23–24

Curie, Pierre, 125 and *n*

Czechoslovak surrealist group, 368

da Vinci, Leonardo, 316*n*

Dada (publication), 63

Dada movement, 78–79; Apollinaire and, 62–63; Aragon on, 239–41; attitudes toward, 73–74; beginnings of, 63–64; development of, 11; disintegration of, 79; drama and, 95; Duchamp on, 413; in Paris, 66; and Picabia, 67–69

Dalai Lama, 139

Dali, Gala. *See* Eluard, Gala

Dali, Salvador, 194, 210, 236, 254, 256*n*, 304, 314, 332, 351*n*, 352, 393; "Apparition aérodynamique des Etres-Objets," 343; on art nouveau, 336; on Catalonia, 266–67; and Communist party, 314; on *The Golden Age*, 254–57; "Honor to the Object!," 302–303; "The Object as Revealed in Surrealist Experiment," 291–92; "Psycho-atmospheric-anamorphic Objects," 296–97; "The Putrescent Donkey," 266–68; "Reverie," 272–75; on Roussel, 327; "Spectral Surrealism of the Pre-Raphaelite Eternal Feminine," 338, 339–40; *The Visible Woman*, 268–70

"Danger of Pollution," 263, 264–65

Dante, 50, 123

Daudet, Philippe, 128 and *n*

Davies, Hugh Sykes, 363, 368, 372

Davis, Garry, 438

"Day Is an Outrage, The," 385

"Days of May 1968," 441

De Clérambault, Dr., 316 and *n*

de Gaulle, Charles, 416 and *n*, 440

De l'Angoisse à L'Extase, 318

Death and the Woodcutter, 198 and *n*

Decalcomania, 341*n*

"Declaration of the Surrealist Group in England," 427–29

"Declaration on Spain," 372–73

Degas, 331

Deharme, Lise, 191–92

Delahaye, Ernest, 142 and *n*, 144

Delaunay, Robert, 118*n*

Delavigne, Casimir, 12 and *n*

Delteil, Joseph, 108, 122, 123, 147, 234; Breton and, 148–49

"Demigod," 286–87

"Demon of Analogy, The," 348–49

Derain, André, 69, 200, 271, 331, 393

Derleth, August, 396

Dermée, Paul, 66, 117, 118, 147

Dernière Mode, La (publication), 344–346

Desbordes-Valmore, Marceline, 123*n*

Déshonneur des poètes, Le, 418

Desnos, 95, 101, 102, 103, 108, 111, 122, 215, 234; *Mourning for Mourning*, 166–68; "Penalties of Hell," 91, 92–93; poem written during séance, 103–105; at séances, 105–106; on "terror," 157

Desson, André, 147

Destroyed Object, 304

Détraquées, Les, 181

"Dialogue between a Priest and a Dying Man," 261*n*

"Dialogue en 1934, Le," 363

"Dialogue in 1928, The," 222–24

Dictionary of the Academy: preface to, 47

Diderot's Harpsichord, 312–14

"Disdainful Confession, The," 111–15, 141*n*

Disque Vert, Le (publication), 146, 147

Documents surréalistes, 440

Documents 34 (publication), 363

Doll, 304–305, 343

Dominguez, Oscar, 303, 304, 340–41, 341*n*, 343, 352

Doré, Gustave, 395

Dostoevski, 120 and *n*

Doublure, La, 318, 327

Dream objects: Breton on, 291–92, 306–12

Dreams, 133; Aragon on, 128; Breton on, 120–21; Chirico on, 165–66; "The Country of My Dreams," 168–69; and surrealism, 306–12; and surrealist painting, 194; in writings in *Littérature*, 91–94

Ducasse, Isidore. *See* Lautréamont

Duchamp, Marcel, 11, 24, 66, 79, 102, 122, 318, 326*n*, 332, 352, 398–99, 400, 410, 432, 438; on art in United States, 412–14; Breton on, 84–86, 403; *The Bride Stripped Bare by Her Bachelors, Even*, 288, 289–91, 343; Buffet-Picabia article on, 301, 302; on chess, 288 and *n*; cover for *La Surréalisme en 1947*, 424; first ready-mades, 11; puns, 106

Duclaux, Emile, 383

Duhamel, Marcel, 222 and *n*

Duits, Charles: "The Day is an Outrage," 385; "Palace," 385

Dunsany, Lord, 397, 398

Duprey, Jean-Pierre: "Spectresses 2, or Prospectresses," 429–31

Dürer, 356

Durtain, Luc, 162

Du Temps que les surréalistes avaient raison, 314, 372

Duverger, Maurice, 447 and *n*

Early Chirico, The, 393

"Ecart Absolu, L'," 438

Echiquier, L', 328*n*

Editions de la Main à Plume, 418 and *n*

Editions GLM, 356

Einstein, 113

Eluard, Gala, 172

Eluard, Paul, 24, 39, 55, 58, 66, 101, 106, 108, 122, 123, 128, 129, 133, 156, 164, 191, 215, 292, 314, 346, 351*n*, 367, 368; "Capital of Sorrow," 170–71; Chirico and, 201; "Cow," 56–57; "Critique of Poetry," 286; in games, 298–300; "Giorgio de Chirico," 210–11; "Golden Mean," 336; "L'Habitude des Tropiques," 301; "Holly Twelve Roses," 285–86; *The Immaculate Conception*, 275–81; "The Lautréamont Case, According to *Le Disque Vert*," 147; on love, 243; "Paul Klee," 211; *Petite Anthologie poétique du surréalisme*, 350; "Physique de la Poésie," 343; poem in first issue of *La Révolution Surréaliste*, 137–38; poem to Max Ernst, 77–78; poems, 69, 70; "Raymond Roussel, *The Starred Brow*," 326–27; separates from surrealists, 336; on Soviet regime, 157; *Thorns of Thunder*, 365; wartime poetry of, 418; "Yves Tanguy," 211–12

Emmanuel, Pierre, 418

"Enchanted Eyes, The," 193–96, 207

Engels, 163*n*, 311

English surrealists: and *The Bulletin*, 367–68; and *Contemporary Poetry and Prose*, 365–67; "Declaration on Spain," 372–73; "International Surrealist Exhibition of July 1936," preface to catalogue for, 363–65; manifesto of, 427–29; organizers of, 363; and translations of French surrealists, 365, 367–68. *See also* London surrealist group

Enigma of a Day, The: game on, 298–300

Enigma of an Autumn Afternoon, 9

"Entrance of the Mediums," 100–106

Entretiens, 438–39

Epigrams, nonsensical, 70–71

Ernst, Max, 24, 86, 101, 105, 108, 128, 137, 207, 256*n*, 304, 314, 325*n*, 331, 332, 351*n*, 352, 385, 399, 400, 414; Aragon on, 208–209; "Arp," 78; catalogue of exhibition at Copley Gallery, 414–15; collages of, 210; "Danger of Pollution," 263, 264–65; and decalcomania, 341*n*; Eluard's poem to, 77–78; *La Femme 100 têtes*, 207 and *n*, 208; "Inspiration to Order," 270, 271–72; "The Mysteries of the Forest," 334–35; on New York life, 410–11; Péret's poems to, 212–13; "The Placing under Whisky Marine," Breton's preface to catalogue of, 76–77; "Some Data on the Youth of M.E. as Told by Himself," 401–403

Esprit Nouveau, L' (publication), 117

"Esprit Nouveau et les Poètes," 117–18, 118*n*

Euripides, 50

Exact Sensibility: The Great Paranoiac, 304

Exhibition of Surrealist Objects (May 1936), 301–302

Exploits and Opinions of Doctor Faustroll, Pataphysician, The, 30–31

"Exquisite Corpse: Its Exaltation, The," 220, 221–22, 350, 415

"Ex-Serviceman," 214

Eye of Silence, The, 341*n*

Fairy tales: Breton on, 121–22

Fairy tales for adults: *Mourning for Mourning*, 166–68; by Queneau, 169–70

"Fall of the Franc, The," 174–75

False quotation, 216–17

Fantastic Art, Dada, Surrealism (exhibition), 370

"Fantastica Americana," 400

Fargue, Léon-Paul, 55, 123*n*, 124, 128

Fascism: surrealist response to, 156, 371–72

Fascists, 230; attack on Buñuel's *Golden Age*, 257
"Fashionable Tiger, The," 421, 422–24
"Feasts," 70
Fels, 200
"Femme Féique, La," 343
Femme 100 têtes, La, 207, 208
Fergar, Feyyaz, 429
Ferry, Jean: "The Fashionable Tiger," 421, 422–24
Feu, Le, 162
Feuerbach, 311
Film reviews: in *Littérature*, 58
Fin de Satan, La, 410
First Papers of Surrealism, 403–404
"Flake House," 64–65
Flaubert, 50
Fleury, Maurice de, 135
Flood, 235
"Flower of Napoleon, The," 87–91
Flying Hearts, 301, 302
Foch, 265–66
"For You My Love," 249
Ford, Charles Henri, 399, 400
Ford, Gordon Onslow, 399
Forests and Jungles, 402
Fourier, Charles, 404–406
Fraenkel, Théodore, 32*n*, 32–33, 105, 122
France, Anatole, 119, 128–29, 157, 236
"Francis Picabia," 83–84
"Free Union," 187–89
Free Unions—Unions Libres, 415–17, 429
"Freezing Hard," 55
Freud, Sigmund, 128, 214, 234; Breton's defense of, 374
"Freud in Vienna," 374
Fribourg-Blanc, 317
"Fridays of *Littérature*," 240 and *n*
Frondaie, Pierre, 318
Frottage, 271–72
Fry, Varien, 383, 384
Futurists, 11, 85, 95, 398

"G Clef," 56
Gaby, Robert, 149
García Lorca, Federico, 354*n*
Gascoyne, David, 268*n*, 283*n*, 363, 365, 372
Gaspard de la Nuit, 123*n*
Gautier, Théophile, 15, 50
Genius: surrealists on, 154–55
Gérard, Francis, 122, 123
Géricault, 395
"Gertrude Hoffman Girls, The," 171
Giacometti, 292, 351*n*, 363; in games,

298–300; "Moving and Mute Objects," 292; "Yesterday, Quicksands," 293
Gide, André, 55, 69
"Giorgio de Chirico," 210–11
"Giraffe, A," 258–61
Giraudoux, Jean, 69
"Glossaire," 107–108
God: Breton on, 200 and *n*. See also Antireligious writings
Goemans, Camille, 360
Goethe, 50; "More Light," 374
Gold Rush, The (film), 153–54
Golden Age, 261; Dali's summary of, 254–56; fascist attack on, 257; preface to program of, 256–57
"Golden Mean," 336
Goldwater, Robert, 4*n*
Goll, Ivan, 117, 118, 354*n*
Gómez de la Serna, Ramón, 55, 147
"Gory Symbol, The," 35–37
Gourmont, Rémy de, 118
Grand Jeu (group), 284
Grand Jeu, Le, 173, 230
"Grande Actualité poétique, La," 346
"Great Dada Season" (1921), 79
"Great Invisibles, The," 382–83, 404
"Great Masturbator, The" (Dali character), 269–70
"Great Unrestrained Sadist, The," 419
Gris, Juan, 34, 240
Guilleragues, Gabriel, 385*n*
Guimerá, Angel, 266 and *n*

"Habitude des Tropiques, L'," 301
"Hair Tonic," 346–47
Halberstadt, Vitaly, 288
Hamsun, Knut, 114
"Hands Off Love," 150–55
Hare, David, 398–99
Harlaire, André, 147
Hebdomeros, 203–207, 393
Hegel, 234, 235
Heine, Maurice, 261, 429; "La Femme Féique," 343; *Minotaure* studies on violence in art, 332–33
Henry, Maurice, 351*n*; "The Bronze Piano," 284–85; in games, 298–300
"Her Ladyship Goes Up into Her Tower," 109–11
Herriot, Edouard, 143 and *n*
"Hic Jacet," 367–68
Hitler, Adolf, 416 and *n*
Hogarth, 395
"Holiday, A," 10
"Holly Twelve Roses," 285–86
Homme qui a perdu son squelette, L', 355

Honneur des poètes, L', 418
"Honor to the Object!," 302–303
"Hopes," 201
Horace, 7 and *n*
Horta de Ebro, 199
"Household Souvenirs or The Warder-Angel," 247–48
How Dogmas End, 163*n*
How I Wrote Some of My Books, 324–326, 327
Huelsenbeck, Richard, 63
Hugnet, Georges, 341, 350
Hugo, Valentine, 292
Hugo, Victor, 14, 50, 124, 325 and *n*, 410
Huidobro, Vicente, 354*n*
Humanité, L' (publication), 160–61
"Hunting the Whale," 244–46
Hurle à la vie, 358
"Hymn of the Patriotic Ex-Serviceman," 241–42
Hytier, Jean, 147

Idolatry and Confusion, 417, 429
Illuminations, 15–17
"Image, The," 41–42
Immaculate Conception, The, 275–81
Immorality: surrealists on, 150–55
Impostor, The (film), 153
Impressions of Africa, 87, 414
"Initial Project," 420–21
"Inquest on Love," 254
"Inspiration to Order," 270 and *n*, 271–72
International Bureau of Revolutionary Literature, 253
International Exhibition of Surrealism (Paris, 1938), 371
International Federation of Independent Revolutionary Art, 375, 376–77
International surrealism. *See* American surrealist movement; Belgian surrealism; English surrealists
International Surrealist Exhibition (London, 1946), 363–65
"Intervention surréaliste" (issue of *Documents 34*), 363
Intransigeant, L' (publication), 149
"Introduction à 1930," 239–41
Invisible Object, The, 363
Irving, Washington, 395

Jacob, Max, 34, 55, 69, 108, 147 and *n*
"Jacques Vaché," 216–17
James, Harry. *See* Vaché, Jacques
James, William, 383
Janco, Marcel, 63
Janet, Pierre, 315–16, 318 and *n*

Jarry, Alfred, 24, 25–31, 32n, 33, 111, 124, 235, 365, 415; *The Exploits and Opinions of Doctor Faustroll, Pataphysician,* 30–31; Jean and Mezei study on, 432–34; *Ubu Roi,* 25, 26–30

"Jarry and the Contemporary Voices," 432–34

Je Sais Tout (publication), 117–18

Je Sublime, 356–57

Jean, Marcel, 52n, 314, 351n, 352, 354n; *Angling for Thrown-Away Sleep,* 355–56; "The Coming of Beautiful Days," 303–304; decalcomanias, 341; "Jarry and the Contemporary Voices," 432–34; *Maldoror,* 425 and n; *Mourir pour la patrie,* 272

Jennings, Humphrey, 351n, 363, 372; "Reports," 365–66

Jésus-Christ rastaquouère, 66

Jolas, Eugène, 150

Jouffroy, Theodore, 163n

Jouve, Pierre-Jean, 346

Judex (movie serial), 224

Juranville, Clarisse, 216

Justine ou les infortunes de la Vertu, 261

Kafka, 432

Kahnweiler: Picasso's portrait of, 199

Kandinsky, 11

Kant, 125 and n

Kauffer, McKnight, 363

Keaton, Buster, 135

Kerbourc'h, Jean Claude, 443–47

Kiesler, Frederick, 399

King and Queen Surrounded by Swift Nudes, The, 85

Klee, Paul, 211

Klossowski, Paul, 404

La Gallo, 272 and n

Lamartine, 14, 50

Lamennais, Félicité de, 14 and n

Lampe dans l'Horloge, La, 440

Larbaud, Valery, 55

"Latest Fashion, The," 344–45

Laurencin, Marie, 33, 56

Lautréamont (Isidore Ducasse), 43–52, 58, 108, 114 and n, 123, 146, 159, 198, 202, 265, 365, 414; biography of, 43; correction of morality maxims by, 51–52; influence of, 297; insulting nicknames used by, 146 and n; *The Lay of Maldoror,* 44–47, 50, 52, 146, 297n, 425–27; in *Littérature* (new series), 87; *Poésies,* 43–44, 47–48, 50–51

Lautréamont, 47n

"Lautréamont Case According to *Le Disque Vert,* The," 147

Lay of Maldoror, The, 44–47, 50, 52, 146, 297n, 425–27

Lebel, Robert: "Quidor and Poe or the American Loneliness," 394–96; "Splitoonery, The," 431–32

Leconte, Marcel, 360

Le Corbusier, 117, 337

Lee, Diana Brinton, 372

Lee, Herbert, 372

Lee, Rupert, 372

Léger, Fernand, 371

Leiris, Michel: "The Country of My Dreams," 168–69; "Glossaire," 107–108

Lenin, 159, 235, 311, 312, 373

Lenin: Breton's review of, 157–59

Lermontov, 50

"Letter of the Seer, The," 11–15, 18

"Letter to the Chief Doctors of Lunatic Asylums," 139, 140–41

"Letter to the Rectors of the European Universities," 141, 442–43

Letters, 87

"Lettres," 58

Lettres Portugaises, 385n

Lévi-Strauss, Claude, 399

Lévis-Mano, Guy, 374

Levy, Julien, 370–71

Lewis, "Monk," 108, 121

Lhote, André, 371

Liberté est un mot vietnamien, 438

Liborio Justo, 377

Lichtenberg, Georg Christoph, 415

"Life of Foch, the Assassin," 265–66

Life of the Object, 295

Limbour, Georges, 108, 122, 123

Lisle, Leconte de, 15, 50

Literature: Artaud on, 177–78; and dada, 64–65, 69–70; Lautréamont on, 47–48; Rimbaud on, 14–15

Littérature (new series): Breton on new psychic experiment in, 100–106; contributors to, 84–87, 94, 96–98; covers of, 86–87; dramas in, 95–98; dream material in, 91–94; last number of, 111; puns, 106–107; surrealist poetry experiment in, 108

Littérature (publication), 47, 135; contributors to, 55, 58, 59–62; dadaism and, 63–65, 66, 78–79; Eluard's poems in, 70; and *L'Esprit Nouveau,* 117; film reviews, 58; founding of, 43; Lautréamont published in, 43–44; poems published in, 55–57; on why authors write, 114

"Little Contribution to the Record of Certain Intellectuals with Revolu-

tionary Tendencies, A" (Paris, 1929), 230–31

Locus Solus, 318 and n, 322–24

London Gallery Bulletin (publication), 367–68, 375, 417

London surrealist group, 415–18

Love: Ernst on, 265; and revolution, 254; surrealists on, 242–44, 278–81

"Love," 94–95

Love poems: by Eluard, 170–72; by Prévert, 248–49

"Love Poetry," 172

Lovecraft, H. P., 396–97

Lucarne ovale, La, 39n

Lully, 235

Mabille, Pierre, 332, 399; "The Painter's Eye," 341–43; on Seurat, 332

Macdonald, Dwight, 410n

Machen, Arthur, 397

Machine art, 11

Maddox, Conroy, 429

Mademoiselle Piège, 98–100

Maeterlinck, Maurice, 147

Magnetic Fields, The, 59, 60–61, 101, 103, 117, 193

Magritte, René, 209, 214, 314, 332, 351n, 352, 365, 414; *The Rape,* 350; "Thought and Images," 360–63; "Words and Images," 236, 237

Malebranche, 348n

Malet, Leo: "Screaming at Life," 358–359

Malkine, Georges, 122, 123, 209

Mallarmé, Stéphane, 39, 58, 124, 129, 198, 414; "The Demon of Analogy," 348–49; and *La Dernière Mode,* 344–46; "The Latest Fashion," 344–45

Malraux, André, 147, 371

Mamelles de Tirésias, Les, 62–63, 95, 117

Manet, 271

"Manifeste Dada 1918," 63, 65

"Manifeste du Surréalisme," 117, 118–26, 133, 179, 347; conclusion of, 124–25; and *Nadja,* 181; and painting, 196; reaction to, 117–18

Marcel Duchamp ou le grand fictif, 383n

Marinetti, Filippo T., 11, 63, 99, 156

Marseilles: surrealists in, 383–85

"Marseilles Game of Cards," 383–85

"Martyres en taille-douce," 332–33

"Marvelous against the Mystery, The," 348

Marx, 163n, 234–35, 311, 369, 373

Marxism, 52

Masson, André, 128, 137, 207, 209, 234

Masson, Lois, 418
"Masters of the Half-Century," 432–434
Materialism: Breton on, 118–19, 163*n*
Materialism and Empiriocriticism, 312
Matisse, 200, 331–32
Matta Echaurren, Roberto, 385, 400; "Sensitive Mathematics—Architecture of Time," 337, 338
Maturin, Charles, 50, 415
Mauritius, 434
"Max Ernst," 76–77
Maximes, 51
"May Day," 68–69
May 1968 rebellion in France, 440–48; press on, 443–47; wall inscriptions, 442; writings during, 441–43
Mayakovsky, 259
Medico-Psychological Society: meeting of October 28, 1929, on surrealists, 315–16
Melly, George, 429
Melville, Robert, 392*n*, 393*n*, 429
"Memoirs of a Suicide, The," 180
"Men's Folly or the World Upside Down," 335
Mental deficiency: simulation of, 277–78
Mental disorders: simulation of, 277–78; surrealists on, 140
Mérimée, Prosper, 18
"Merlin et la vieille femme," 215
Mesens, E. L. T., 214, 215, 314, 351*n*, 356*n*, 360, 363, 367, 399, 429; *Third Front*, 417–18; "To Put an End to the Age of Machinery the English Poets Make Smoke," 417–18; "Violette Nozières," 351–52
"Message, The," 248
Message from Nowhere, 417, 429
Métraux, Alfred, 399
Mezei, Arpád, 52*n*, 425 and *n*; "Jarry and the Contemporary Voices," 432–34
Milhaud, Darius, 55
Millet, Jean François, 266 and *n*
Milton, 50
Minotaure (publication), 375, 439; aim of, 331; on architecture, 336–38; on Brauner's accident, 341–43; on Cézanne, 338–40; contributors to, 331–36; covers, 332; decalcomanias, 340–41; illustrations in, 331–32; sixth issue of, 343–47
Miró, Joan, 207, 209–10, 256*n*, 257, 331, 332, 352
Misérables, Les, 14
"Modern," 214
"Modern Art and Great Art," 343–44

Modernism: Aragon on, 239–41
Modigliani, Amedeo, 63
Monde, Le, 441*n*, 443
Mondrian, 11, 360, 392
Monk, The, 121
Mont de Piété, 59 and *n*
Moore, Henry, 363, 372, 428
Moralists: Lautréamont and, 51–52
Morals, 235; Breton on, 112–13; and defense of Chaplin, 149–55; manifestoes in *La Révolution surréaliste* on, 138–55
Morand, Paul, 55
Moreau, Gustave, 308
Morise, Max, 101, 108, 122, 123, 135, 207, 223; on Chirico, 201–202; "The Enchanted Eyes," 193–96; "No Hunting," 93–94
Moro, C., 351*n*
Morocco: colonial war in, manifesto on, 159–60
Moscow trials: Breton on, 373–74
Motherwell, Robert, 270*n*, 401; "The Art of Reaction: The Late Chirico," 392–94
Mots d'Heures: Gousses Rames, 326*n*
Mourir pour la patrie, 272
Mourning for Mourning, 166–68
"Moving and Mute Objects," 292
Multiple image. *See* Paranoiac image
Museum of Modern Art (New York): Fantastic Art, Dada, Surrealism (exhibit), 370
Music: Chirico on, 5; Rimbaud on, 13
Musical reviews in *Littérature*, 55
"Musician of Saint Merry's, The," 18, 19–22
Musidora, 224
Musset, Alfred de, 14–15, 48, 50, 144
Muzard, Suzanne, 187, 190–92, 219–220, 223, 244, 306
"My Latest Misfortunes," 173
"My Pale Nights," 444–47
Mysteries of Paris, The, 47
"Mysteries of the Forest, The," 334–335
Myths, 403–404

Nadeau, Maurice, 440
Nadja, 181–87, 224*n*, 306
Nash, Paul, 363, 372
Naville, Pierre, 122–23, 149*n*, 162–64, 196, 234
Nazarin, 258
Nazis: and Breton's defense of Freud, 374; occupation of Holland, Belgium, and France, 381; surrealists and, 302–303

Nef, La, 429. *See also Almanach surréaliste du Demi-Siècle*
Nerval, Gérard de, 50
Nerve Scale, The, 176–78
Neugroschel, Joachim, 295*n*, 354*n*, 419*n*
"New Elementary Geography," 215–216
New York: surrealists in during World War II, 381, 410–12
Nicole, Pierre, 263 and *n*
Nietzsche, 4
"Night of Loveless Nights, The," 215
Nights, 123
"98–28," 215
"No Hunting," 93–94
Noll, Marcel, 122–23, 222–23
Nord-Sud (publication), 41, 55
Nougé, Paul, 214, 314, 360; "Jacques Vaché," 216–17; on love, 243–44; "New Elementary Geography," 215–16
Nouveau, Germain, 87 and *n*, 124
Nouvelle Justine, La, 261
Nouvelle Revue Française, La, 11, 65
Nouvelles Impressions, 327
Novalis, 383
Novels: Breton on, 119–21; of Carrington, 386*n*; collaborative, 355; Lautréamont on, 47–48; popular, 396–398
Novels of horror, 47*n*
Nozières, Violette (murder case), 350, 351 and *n*
"Nuit du tournesol, La," 331

"Object as Revealed in Surrealist Experiment, The," 291
Objects in surrealism, 288–305, 363; Breton on, 291–92; in Calendar of Tolerable Inventions, 429; Dali on swastika, 302–303; Duchamp's *Large Glass*, 291; Giacometti on, 292; landmarks of Paris game, 300–301; research on, 298–301
Ode to Charles Fourier, 404–406
Olvidados, Los (film), 258
"On a Certain Automatism of Taste," 336–37
"On a Decalcomania without Preconceived Subject (Decalcomania of Desire)," 340–41
"One Moment!," 142–46, 350
Oppenheim, Méret, 314
Opposition et les Cases conjuguées sont réconciliées, L', 288 and *n*
Orphism, 11, 66
Ozenfant, Amédée, 117–18

Paalen, Wolfgang, 352
Padgett, Ron, 288n
"Painter's Eye, The," 341–43
Painting: Apollinaire on, 23–24. *See also* Surrealist art
"Palace," 385
Pan, 114
Pansaers, Clément, 66
Paracelsus, 356
"Paramyths," 414–15
Paranoiac image, 270, 271–72
Parédès, 224n
Paris: fascist riots in, 371; game on changing landmarks of, 300–301; life in, compared with New York, 410–12; as setting for "The Musician of Saint Merry's," 20
Paris Police Headquarters' Special Infirmary for Lunatics, 316n
Parisont, Henri, 70n
Parket, Robert Allerton: "Such Pulp as Dreams Are Made On," 396–98
Parnasse Contemporain (anthology), 129
Paroles, 249
Parrain, Brice, 443
Partisan Review (publication), 377
Pas perdus, Les, 111, 181
Pascal, 51, 114 and n
Pasteur, 125 and n
Pastoureau, Henri: *Cry of the Medusa,* 357–58
Paul, Elliot, 150
"Paul Klee," 211
Paulhan, Jean, 66, 122; "Si les mots sont des signes," 69
Pawlowski, Gaston de, 383n
Peasant of Paris, The, 72–76
"Penalties of Hell," 92–93
Penrose, Roland, 356n, 363, 366n, 367, 372, 417n, 429
Penrose, Valentine, 372; "To a Woman to a Path," 366–67
Pensées, 51
Péret, Benjamin, 24, 66, 93, 95, 101, 102, 103, 108, 122, 123, 149n, 156, 164, 215, 222–24, 314, 341, 346, 351n, 367, 399, 438; *Le Déshonneur des poètes,* 418; "The Flower of Napoleon," 87–91; in games, 298; "Hymn of the Patriotic Ex-Serviceman," 241–42; *Je sublime,* 356; "Life of Foch, the Assassin," 265–66; Mesens's poem to, 417–18; poetry, 173–75; "Spilt Salt," 424–25; in surrealist games, 219–20; "Two Portraits of Max Ernst," 212–13; "Wink," 356–57
Péret, Elsie, 219–20

Périer, O. J., 147
Perse, St.-John, 123n, 124, 128
Petite Anthologie poétique du surréalisme, 350
"Petites Feuilles," 261
"Phare de la Mariée," 343
Philosophies (publication), 159
"Philosophy of the Lightning Rods," 159
Phonic equivalents: creation through, 324–26
"Physique de la Poésie," 343
Piattier, Jacqueline, 443
Picabia, Francis, 11, 24, 66, 79, 87, 101, 102, 108, 122, 237, 318, 413; aphorisms of, 66–67; Breton on, 83–84; on Cézanne, 338; collages of, 209; covers of *Littérature* (new series), 87; and dada movement, 63–64, 66–67; *Flying Hearts,* 301–302; on *Je Sais Tout* and *L'Esprit Nouveau,* 117–18; "May Day," 68–69; on surrealism of Goll and Breton, 118; and *391,* 66
Picasso Pablo, 11, 63, 122, 128, 207, 331, 332, 360, 393, 398, 399; automatic poems, 352–54; Breton on, 198–200; collages, 209, 211; and *Minotaure,* 331; Morise on, 195
"Picasso dans son élément," 331
Picon, 123
Placing under Whisky Marine, The (art exhibit): Breton's preface to catalogue of, 76–77
Planète sans visa, La, 375
Plastic Sense, 440
Plastique (publication), 355
Plateau, Marius, 156
Plays on words: "Glossaire," 107–108
"Playthings of the Prince, The," 385–89
Poe, Edgar, 50, 394–96, 397
Poèmes en Prose, 39n
Poésies, 43–44, 47–48, 50–51, 58, 59, 114n, 159n
Poetry: Anatole France on, 129; Rimbaud's "Letter of the Seer" on, 11–15. *See also* Surrealist poetry
Poincaré, Raymond, 229n
Poison, Drama without Words, 96–98
Politics: and international surrealism's response to fascism, 371–72; and postwar surrealists, 438; and *Le Surréalisme ASDLR,* 253–54. *See also* Communist party
Pope (Pius XI): surrealist manifesto on, 139
Position Politique du Surréalisme, 372
Poussière de soleils, La, 318

Prassinos, 354n; "Hair Tonic," 346n, 346–47
"Premières vues anciennes," 335–36
Press: and surrealism, 368–70, 371
Prévert, Jacques, 222, 416; "For You My Love," 249; "Household Souvenirs or The Warder-Angel," 247–48; "Hunting the Whale," 244–46; "The Message," 248; *Paroles,* 249
Prisons: surrealist manifesto on, 138–139
Prix de Rome, 198n, 198–99, 360
"Prolegomena to a Third Manifesto of Surrealism or Else," 382–83
Proudhon, 52n
Psychiatrists: Breton on, 186, 316; surrealist manifesto on, 140–41
"Psycho-atmospheric-anamorphic Objects," 296–97
"Psychological Novelette with Only One Theme and Practically One Character," 391–92
Pulp fiction, 396–98
Puns. *See* Spoonerisms
Pushkin, 356
"Putrescent Donkey, The," 267–68

"Queen of Diamonds, The," 171–72
Quelconqueries, 87
Queneau, Raymond, 222–23; text by, 169–70; "When the Spirit.....," 217–19
"Questions and Answers," 363
Quidor, John, 394–96
"Quidor and Poe or the American Loneliness," 394–96
Quinzaine Littéraire, La (publication), 443

Rabbe, Alphonse, 108, 123n, 124, 235
Rabelais, 432
Racine, 12, 50, 147
Radcliffe, Ann, 50
Radiguet, Raymond, 147 and n
Rape, The, 350
Ratez, Emile, 146
Ray, Man, 87, 128, 207, 209 and n, 256n, 257, 304, 314, 332, 351n, 352, 414; "Age of Light, The," 333–34; catalogue for exhibition at Librairie Six, 86–87; photographic montages of, 224
"Raymond Roussel, *The Starred Brow,*" 326–27
Raynal, 200
Read, Herbert, 363 and n, 368; introduction to catalogue of International Surrealist Exhibition, 363–65
Realism: Aragon on, 126, 127–28

Reavey, George, 78*n*, 212*n*, 353*n*; "Hic Jacet," 367–68
"Red Smoke, The," 355–56
"Réhabilitation du Chef-d'Oeuvre," 343
"Religieuse Portugaise," 385 and *n*
Religion. *See* Antireligious writings
Renaissance: Chirico on, 8
Renard, Maurice, 183*n*
Renoir, 271
Répétitions, 77–78
"Reports," 365–66
Rêve d'une petite fille qui voulut entrer au Carmel, 208
Reverdy, Pierre, 24, 39–42, 55, 69, 76, 124, 128, 137; Breton poem dedicated to, 56; "In the Open," 39–40; influence on Breton, 59; "Inn," 40–41; on nature of poetic image, 41–42
"Reverie," 272–75, 314
Révolution et les intellectuels. Que peuvent faire les surréalistes?, La, 162–63
"Revolution First and Always!," 159–60
Révolution surréaliste, La (publication), 107–108, 236–44, 441; "Address to the Pope," 139; call to order of Eluard, 146, 147; Chirico in, 201; compared with *La Surréalisme ASDLR*, 254; contributors to, 165–192; defense of Chaplin in, 149–55; denouncements of critics in, 146–47, 148–49; first issue of, 133–38; gap in publication of, 233; inquiry on love, 242–44; manifesto "Open the Prisons—Disband the Army," 138–39; manifesto on psychiatrists, 140–41; open letter to Claudel, 141–42; poetry in, 172–76; on politics, 156–64; surrealist games in, 222–24; on Vaché, 216–17
Revolving Doors, 209
Ribemont-Dessaignes, Georges, 66, 68 and *n*, 230
Rigaut, Jacques, 66; "The Memoirs of a Suicide," 180
Rimbaud, Arthur, 13–17, 33, 43, 48, 58, 111, 114, 123*n*, 124, 141, 142, 198 and *n*, 208, 235, 265; "After the Deluge," 15–16, 141*n*; "Barbaric," 16; on France, 142–44; influence on Apollinaire, 18; "Letter of the Seer," 11–15; in *Littérature* (new series), 87; poem on work, 144–45; re-erection of bust of, 142–46; "Towns," 16–17
Rimmington, Edith, 429
Rivera, Diego, 375

Rodin, 413
Roditi, Edouard: "Psychological Novelette with Only One Theme and Practically One Character," 391–92
Rodker, John, 44*n*, 146
"Rolla," 48
Romains, Jules, 55, 413
Romanticism, 395; Chirico on, 6; Lautréamont on, 47–48, 52; Rimbaud on, 12–13, 14
Rosenberg, Harold, 399
Rossetti, Dante Gabriel, 340
Rostand, Edmond, 318
Roughton, Roger, 365, 372
Rousseau, Jean-Jacques, 50
Roussel, Raymond, 87 and *n*, 124, 128, 316*n*, 318–28, 432; Duchamp on, 413–14; *How I Wrote Some of My Books*, 324–26, 327; *Impressions of Africa*, 319–22; *Locus Solus*, 322–324; *The Starred Brow* (Eluard's review of), 326–27; surrealists and, 318; on Verne, 327
Rowlandson, 395
Rupture Inaugurale, 438
Ruskin, 361
Russian Revolution: Breton on, 157–159; surrealists and, 157, 191. *See also* Communist party; Stalinism

Sade, Marquis de, 108, 112, 124, 256*n*, 332, 415, 432; Heine and, 261; "Thought," 261–63
"Sadisme d'Urs Graf, Le," 343
Sadistic criticisms, 323–33
Sadoul, Georges, 241, 314; in surrealist games, 219–20
Saint-Exupéry, Antoine de, 343
Saint-Pol-Roux, 123*n*, 124
Sainte-Beuve, 50
Salmon, André, 55
Sand, George, 50
Sansom, Philip, 429
Sardanapalus, 68
Savinio, Alberto, 128
Science fiction, 383*n*; pseudo-, 397–98; Roussel and, 322; surrealists and, 383 and *n*
Sciure de Gamme, 355
Scott, Walter, 47, 50
"Screaming at Life," 358–59
Scutenaire, Jean, 214
Scutenaire, Louis, 360
Seabrook, William, 399
"Second Manifeste du Surréalisme," 232–36
Séguy, Georges, 447 and *n*
Sélavy, Rrose, 86. *See also* Duchamp, Marcel

Self-Defense, 160–64, 314
Seligmann, Kurt, 399, 411
Selligny, castle of, 256 and *n*
Sénancourt, 50
"Sensitive Mathematics—Architecture of Time," 337, 338
Serner, Walter, 63, 66
Seurat, 33, 332
"Seventh Horse, The," 386–89
"Shadow of the Shadow, The," 135, 136–37
Shakespeare: Lautréamont on, 50
Shelley, 417
Short Survey of Surrealism, A, 363
"Si les mots sont des signes," 69
Signac, Paul, 371
S'il vous plaît, 95
Simulation: of mental disorders, 277–278; of séances, 127–28
Skira, Albert, 331
Smith, Clark Ashton, 397
Soby, James Thrall, 4*n*, 393
Soirées de Paris, Les (publication), 55
"Soluble Fish," 126
"Some Data on the Youth of M. E. as Told by Himself," 401–403
Song of Roland, The, 12*n*
"Songs of the Aims and the Kings," 70*n*
Sorbonne. *See* May 1968 rebellion in France
Soulié, Frédéric, 47 and *n*
Soupault, Philippe, 24, 39, 55, 66, 87, 101, 103, 108, 122, 123, 129, 181, 234; and automatic writing, 123; film reviews by, 58; and *Littérature*, founding of, 43; *The Magnetic Fields*, 59, 60–62; note on Théâtre Moderne, 71–72; plays by, 95; "The Shadow of the Shadow," 135, 136–37; "Songs of the Aims and the Kings," 70, 71; "Tea Time," 56
Souris, André, 214
"Souvenir de Dieu," 403
"Souvenirs sur Cézanne," 338, 339–340, 343
Soviet Union: cultural policies, 314. *See also* Communist party; Russian Revolution; Stalinism
Spanish Civil War: "Declaration on Spain" of English surrealists, 372–73
"Spectral Surrealism of the Pre-Raphaelite Eternal Feminine," 338, 339–40
"Spectresses 2, or Prospectresses," 429–31
"Spilt Salt," 424–25
Spirit against Reason, 178, 179–80
"Splitoonery, The," 431–32

"Splotches in Space," 354–55
Spoonerisms, 106, 107
Stalinism: Breton on Moscow trials, 373–74; Breton-Rivera declaration on art under, 376–77; surrealists on, 314
Stella, 14
Stewart, Jean, 421*n*
Stravinsky, Igor, 55
"Stupra, Les," 87
Subida al Cielo, 258
"Such Pulp as Dreams Are Made On," 396–98
Sue, Eugène, 47 and *n*
Suicide: of Crevel, 314; of Dominguez, 343; Rigaut on, 180, 181; and Vaché, 38
"Supernatural Horror in Literature," 397
Superstitions: Péret on, 424–25
Supervielle, Jules, 162
Surrealism: conflict over first use of term, 117; definitions of, 101, 102, 123, 134–35; and dream material, 91–94; invention of word, 18, 117; Lautréamont and, 52; list of "ancestors" of, 108; and May 1968, 441–444; and objects, 288–305; psychiatrists on, 315–16; and revival of *La Révolution Surréaliste*, 236–44; in thirties, 349–59. *See also* "Manifeste du Surréalism"; "Second Manifeste du Surréalism"
Surrealism, 370–71
"Surrealism and Painting," 196–200, 202, 207
"Surrealism in 1929" (issue of *Variétés*), 214–16
Surréalisme (publication), 117, 118
Surréalisme ASDLR, Le (publication): antipatriotism in, 265–67; Aragon's writings in, 286–87; and Breton's *Communicating Vessels*, 306–12; Buñuel in, 258–61; Dali in, 266–68, 272–75; Duchamp in, 289–91; Eluard in, 285–86; Ernst in, 263–65; first issue of, 253; on objects, 292–302; and politics, 253–54; second issue of, 275–81
Surréalisme en 1947, Le, 421–29
Surrealist art, 193–213; Aragon on collages exhibit, 208–10; Breton on, 196–200; decalcomanias, 340–41; destruction by fascist gangs, 257; Ernst and, 207–208; "Exquisite Corpse" drawings, 220–22; *frottage*, 271–72; Morise on, 193–96; Motherwell on, 392–94; Naville on, 196;

1935 exhibition of, 352; poems dedicated to artists, 210–13; in United States, 370, 403–404. *See also* Chirico, Giorgio de
Surrealist exhibitions, 352; New York (1942), 403–404; Paris (1947), 420–25; postwar, 438; report in *Bulletin International du Surréalisme*, 368–70; in United States (1931), 370
Surrealist games, 219–20; "Dialogue in 1928," 222–24; "Exquisite Corpse," 220–22; on "irrational knowledge of the object," 298–301; "Marseilles Game of Cards," 383, 384–85; "possibilities of embellishment of a town," 300–301
Surrealist poetry: of Breton, 187–89; collections of, 350, 352–59, 364–65; dedicated to artists, 210–13; in *Minotaure*, 346–47; of Prévert, 244–49; in *Variétés* (special issue), 214–15; in *La Révolution Surréaliste*, 137–38, 237
Surrealist reviews, 370 and *n*; in occupied Paris, 418, 419. *See also under individual names of reviews*
Surrealists: after Breton's death, 440; attitude toward music, 5; collaborative publications of, 350–52; and Communist party, 253, 314; influence on generation of sixties, 440; in London, 415; and *Minotaure*, 331–59; Suzanne Muzard on, 190–92; during Nazi occupation of Europe, 381–419; politics and, 156–164; post–World War II, 420–40; public appeal for united front against fascism, 371; reactions to New York life, 410–12; report on meeting of March 1929, 229, 230–31; and Vietnam in 1947, 438; in wartime Paris, 418, 419
Swastika: Dali on, 302–303
Sweeney, James Johnson, 410–11
Swift, Jonathan, 398
Symbolic experiments, 383–89
Symbolism: Breton on, 348
Synge, J. M., 58, 417

Taches dans le vide, 354
Taeuber-Arp, Sophie, 355
"Tam-tam I," 390
"Tam-tam II," 390
Tanguy, Kay Sage, 211*n*
Tanguy, Yves, 194, 207, 209, 222, 256*n*, 257, 314, 331, 351*n*, 352, 357, 411; Calas on, 400–401; decalcoma-

nias, 341; Eluard's poem on, 211–12; *Life of the Object*, 295; in Mexico, 412; in surrealist games, 219–20; "Weights and Colors," 294–95
Tanning, Dorothea, 270*n*
"Tant pis pour moi," 286
Tarot game: surrealist exhibit designed like, 420–21
Tartakover, 328*n*
Taylor, Simon Watson, 415–17, 429, 431*n*
"Tea Time," 56
Tenerife (Canary Islands), 368
Tériade, 331, 343
"Testimony," 403
"Têtes d'orage," 331
Théâtre de l'Oeuvre (Paris), 25
Théâtre Moderne, 74–76, 181
"Théâtre Moderne: Fleur-de-Péché," 71–72
Theatrical surprises, 95
Theroldus, 10 and *n*
Thibaudet, Albert, 147
Third Front, 417–18
Thirion, André, 241
Thorns of Thunder, 365
"Thought," 261–63
"Thought and Images," 360–63
391 (publication), 66, 118
Titus, Edward W., 277*n*
"To a Woman to a Path," 366–67
"To Be Followed," 230–31
"To Put and End to the Age of Machinery the English Poets Make Smoke," 417–18
Tolstoy, 111
Tourneur, Cyril, 428
"Towns," 16–17
Traité du style, 105–106, 175
Transition (publication), 149–55
Translations of French surrealists, 370
Treasure of the Jesuits, The, 224–29
Trismegistus, Hermes, 108
Trotsky, Leon, 181, 192, 373–74, 375, 376–77, 410*n*; Breton on, 157–59; surrealist pamphlet on expulsion from France of, 375
Turenne, 125*n*
"20th March XXXVI," 353–54
"28th November XXXV," 353
"Two Portraits of Max Ernst," 212–13
Tzara, Tristan, 24, 63, 79, 87, 351*n*, 354*n*; *The Approximate Man*, 237, 238; Breton on, 234; dada and, 63–64, 65; "Flake House," 64–65; in games, 298; "Manifeste Dada 1918," 63; "On a Certain Automatism of Taste," 336, 337

Ubu Roi, 25, 26–30, 433–34
Uncharted Isle, The, 397
Ungaretti, Giuseppe, 156
Unik, Pierre, 164, 219–20, 314
Urbanism: surrealism and, 118 and *n*
Usine, L', 199
Utrillo, 200

Vaché, Jacques, 58, 108, 111, 124, 128; on dada, 239–40; death of, 38; "The Gory Symbol," 35–37; influence on Breton, 59; letters to Breton, 32–38; Nougé on, 216–17
Vailland, Roger, 230
Valéry, Paul, 24, 55, 119, 147; "Modern Art and Great Art," 343–44; and naming of *Littérature,* 43
Valmore, Marceline Desbordes, 124
van Rooten, Luis d'Antin, 326*n*
Variations on an Articulated Minor, 304
Variétés (publication), 400; "A Suivre," 229–31; contributors to, 215; special issue of, 214–19, 233; surrealist games in, 219–20; *The Treasure of the Jesuits,* 224–29
Vauvenargues, 51, 112

Vauxcelles, 200
Verlaine, 68, 129; "Art Poétique," 43
Verne, Jules, 327, 398
Versailles (palace), 8–9
"Very Image, The," 365
Victor ou les Enfants au pouvoir, 96
Vietnam, 438
View (publication), 400–403
Villemain, François, 47 and *n*
Vilmorin, Louis de, 343
Violette Nozières, 350–51
"Violette Nozières," 351–52
Virdiana (film), 257
Visible Woman, The, 268–70
Vitrac, Roger, 92, 108, 122, 123, 133, 234; *Mademoiselle Piège,* 98–100; *Poison, Drama Without Words,* 96–98; spoonerisms, 107
Voie lactée, La, 257
Vollard, Ambroise, 339–40, 343
Voltaire, 48, 114*n*, 398
Vous m'oublierez, 95
Vue, La, 327
VVV (publication): art criticism in, 391–96, 398–99; contributors to, 383–89, 399–400; explanation of title of, 381–82

Wandering Jew, The, 47*n*
Wandrei, Donald, 396
Ward, James, 395
Wave of Dreams, A, 126, 127–28, 133, 179
"We Shall Know How to Live," 441–442
"Weights and Colors," 294–95
Wells, H. G., 398
What Is Surrealism?, 350, 365
"When the Spirit.," 217–19
White, Kenneth, 404*n*
White-Haired Revolver, The, 281–84
Wilde, Oscar, 69
"Wink," 356–57
"Words and Images," 236, 237
"Worker," 70
"Writings Are Leaving," 281–84

"Yesterday, Quicksands," 293
Young, Edward, 50, 108, 123
"Yves Tanguy," 211–12

Zamiatin, Eugene, 398
"Zo," 327 and *n*
Zurich group: dada movement and, 63